W9-BGS-189

Praise for Joan Acocella's

Twenty-eight Artists and Two Saints

"Electrifying. . . . Acocella engages the task, the trials, the very aesthetic of the artist, and does so in pure, clean, deceptively simple and elegantly straightforward prose. . . . Collectively, these essays deliver a sustained, breathtaking aesthetic wollop. Acocella not only makes the fine arts, and the finer points of the fine arts, accessible, she makes them necessary, vital." —*The San Diego Union-Tribune*

"The threads that run through [the essays] are Acocella's intelligence, intellectual curiosity, empathy and wonderful prose. . . . A colorful, engaging collection, one that draws French saints, New York poets, Russian orphans and Italian neighborhood characters into the continuing project of raspberry-making—that is, performance, that is, art." —*Newsday*

"While culling essays for her new collection . . . Joan Acocella discovered a loose theme: the hardships that come with creation and how various artists dealt with these obstacles—or did not. Acocella is correct in identifying the theme, and she spins out its variations with verve, wit and lucidity; her eye for detail, and pacing, is superb. Everyone should be so lucky to have such an eloquent explainer in their corner." —*The Seattle Times*

"Elegant, incisive." —*Entertainment Weekly*

"Incomparable. . . . I would like to be her friend."
—Craig Raine, *The Times Literary Supplement* (London)

"Joan Acocella's essays are more than a window into the heart of modern Europe. They are urgent and fresh bulletins written with the exquisite brilliance of a pen that is at once profound, uncompromising, and inspired."

—André Aciman

"Acocella writes brilliantly about a lot of brilliant artistic creators and a couple of saints. . . . She appreciates candor, resilience, and imagination in the figures she so lovingly evokes, and these qualities also characterize her own work, which is not only lucid and insightful but also generous and even noble. She is one of our finest cultural critics."

—Edward Hirsch

"So subtle, cogent, and pellucid are Joan Acocella's essays, so penetrating and direct, that each one is a revelation. . . . A pleasure from start to finish."

—Brenda Wineapple, author of *Hawthorne: A Life*

Joan Acocella

Twenty-eight Artists and Two Saints

Joan Acocella is a staff writer for *The New Yorker*. She is the author of the critical biography *Mark Morris*; *Creating Hysteria: Women and Multiple Personality Disorder*; and *Willa Cather and the Politics of Criticism*. She edited the unexpurgated *Diary of Vaslav Nijinsky* and, with Lynn Garafola, *André Levinson on Dance*. Acocella was a recipient of a Guggenheim Fellowship. She lives in New York.

ALSO BY JOAN ACOCELLA

Mark Morris

Creating Hysteria: Women and Multiple Personality Disorder

Willa Cather and the Politics of Criticism

André Levinson on Dance:
Writings from Paris in the Twenties
(editor)

The Diary of Vaslav Nijinsky
(editor)

Mission to Siam:
The Memoirs of Jessie MacKinnon Hartzell
(editor)

Twenty-eight Artists and Two Saints

E S S A Y S

Joan Acocella

Vintage Books
A Division of Random House, Inc.
New York

FIRST VINTAGE BOOKS EDITION, FEBRUARY 2008

Copyright © 2007 by Joan Acocella

All rights reserved. Published in the United States by Vintage Books, a division of
Random House, Inc., New York, and in Canada by Random House of Canada
Limited, Toronto. Originally published in hardcover in the United States by
Pantheon Books, a division of Random House, Inc., New York, in 2007.

Vintage and colophon are registered trademarks of Random House, Inc.

All essays previously appeared in *The New Yorker* with the exception of
"The Neapolitan Finger," "Heroes and Hero Worship," and "Sweet as a Fig,"
all of which appeared in *The New York Review of Books.* "Quicksand"
appeared as the introduction to the New York Review
Books Classics edition of *Beware of Pity.*

Owing to limitations of space, all permissions to reprint previously
published material may be found at the end of the book.

The Library of Congress has cataloged the Pantheon edition as follows:
Acocella, Joan Ross.
Twenty-eight artists and two saints : essays / Joan Acocella.
p. cm.
Collected essays originally published in The New Yorker
and The New York Review of Books.
1. Artists—Psychology. 2. Suffering. 3. Arts, Modern—20th century.
I. Title. II. Title: 28 artists and 2 saints.
NX165.A36 2007
700.92'2—dc22
[B] 2006047266

Vintage ISBN: 978-0-307-27576-9

www.vintagebooks.com

Book design by Virginia Tan

Printed in the United States of America
10 9 8 7 6 5 4 3 2 1

In memory of my father, Arnold Ross

Contents

Contents

Illustrations

xi

Introduction

COLLECTED here, with minor revisions, are thirty-one essays that I have written on artists, plus two saints, in the last fifteen years. As I was deciding what to include, I thought I was simply choosing the pieces that I liked best, and wanted to send out into the world again. But as I read through them, a single theme kept coming up: difficulty, hardship. I am not referring to unhappy childhoods. It is commonly believed that a normal pattern for artists is to endure a miserable childhood and then, in their adult work, to weave that straw into gold. This may be true. Some of my subjects (Dorothy Parker, Marguerite Yourcenar) were motherless; some had mothers such that they might have been better off motherless. But that story—early pain, conquered and converted into art—is not what interests me. My concern is the pain that came *with* the art-making, interfering with it, and how the artist dealt with this.

When I moved to New York in 1968, I fell in with a group of young artists whom I was often awed by. "*What* will they become?" I thought. They were so brilliant, so bold. And as the years passed, I found out something that my elders could have told me. There are many brilliant people—they are born every day—but those who end up having sustained artistic careers are not necessarily the most gifted. Over time, our group lost many of its members—to bad divorces, professional disappointments, cocaine. The ones who survived combined brilliance with more homely virtues: patience, resilience, courage.

Insofar as this collection of essays has a subject, that is it. In the postwar period there was a widespread assumption—cousin to the unhappy-childhood theory—that art was born of neurosis. This view, which still underlies many biographies coming out

today (see the essays on Primo Levi and Jerome Robbins), received its classic statement in Edmund Wilson's 1941 book *The Wound and the Bow*. In that collection of essays, Wilson described the psychic damage suffered in childhood by a number of artists. Then, in the final, title essay, he concluded that "genius and disease, like strength and mutilation, may be inextricably bound together." His symbol was Philoctetes, in Sophocles' play of that name. A champion archer recruited by the Greeks for their campaign against Troy, Philoctetes was bitten by a snake on the way to the war, and the wound did not heal. It festered; it smelled; it caused him to howl and have fits. The Greeks finally decided that they couldn't take him with them, so they abandoned him on a remote island, where he lived alone for ten years. But without him, they eventually found, they could not win the Trojan War. And so, in the play, Odysseus is sent back to the bleak island to reenlist the ailing warrior. That was Wilson's image for the artist's relation to society. The artist might smell or scream or act badly. Still, the world needed him. With the wound came the bow. Though many of Wilson's artistic colleagues drank themselves to death, that was the price of their work. In the famous words of Edna St. Vincent Millay, they burned their candle at both ends— a choice that made their light brighter, though briefer.

This makes a kind of sense. It describes the life of many of the artists of the early modern period: Fitzgerald, Hart Crane, indeed Millay. How could we have had the wonderful, black novels of Nathanael West, we think, had West not been a suicidally reckless driver, such that some of his friends wouldn't get in a car with him? (He died at thirty-seven, with his new wife, in a car accident. He ran a stop sign.) Don't the two things, risk and genius, seem to go together? And doesn't the pairing seem to do these people some justice? They were right; Mrs. Grundy was wrong.

But my view of things is more Grundy-esque: that what allows genius to flower is not neurosis, but its opposite, "ego strength," meaning (among other things) ordinary, Sunday-school virtues such as tenacity and above all the ability to survive disappointment. Of course, luck plays its part, too. In the interview with Penelope Fitzgerald that I describe in my essay on her, something I do not mention is her saying to me, regarding the turn-of-the-

century poet Charlotte Mew—largely forgotten today, but the subject of a book by Fitzgerald—that Mew might have had a real career had it not been for "bad luck." Hearing this, I thought it might be a species of sentimentality, or extreme fatalism, on Fitzgerald's part. Now I recognize it as a statement from a person who knew the score. Another instance of the operation of sheer luck is the story of the Triestine novelist Italo Svevo. In his thirties Svevo wrote two novels; he had to publish them at his own expense, and they were altogether ignored. He then gave up, and settled down as the director of a paint manufacturing firm. Almost certainly, he would never have written another novel had he not, in his forties, for business purposes, hired an English tutor who turned out to be the young James Joyce. At that point, Joyce had not published a book, but he was known to have literary interests, and so, eventually and shyly, Svevo brought out copies of his two, forgotten novels and gave them to his tutor. At their next session, Joyce praised these books to the skies, and told Svevo he had a rare talent. This strange accident, combined with a second one—the First World War, during which the paint company was closed down, leaving its director with time on his hands—resulted in Svevo's going back to his desk and writing *Confessions of Zeno,* a masterpiece of early modern fiction. Svevo became a famous literary personage—a development that thrilled him to his bones. He then sat down to write another novel, and again luck intervened: he was killed in a car accident.

But forget luck—it's too wild a card—and consider just the normal career difficulties: late starts, writing blocks, rejection slips. In some cases, you can blame demographics. I have done a count. About one half of the subjects of the essays in this book are women; one third are Jews; one fourth are homosexual. Members of all those groups have had difficulty getting going, and then keeping going, in face of the assumption that, being what they were, they could produce nothing useful, or nothing "universal." The women's case is perhaps the most striking. George Eliot, whose first novel didn't appear until she was thirty-nine, used to be invoked as a comforting example to late-starting female writers. But Sybille Bedford's first novel was published when she was forty-five; Penelope Fitzgerald's, when she was *sixty.* In this collec-

tion, I do not deal with Willa Cather (that is because I wrote a book on her), but she did not bring out her first novel until she was thirty-eight. Before that, I believe, she was too frightened. And like a number of other tardy female writers, she had a job serving male (mostly) writers. She was the managing editor of *McClure's,* an important magazine at the time. As a woman, she felt honored to have this position. It also made her feel safe, as the idea of writing a novel did not.

Writers are not the only ones. Martha Graham, who in large measure invented American modern dance, was not able to found a company until she was thirty-five. Before that, she spent much of her time dancing in Broadway shows, because she needed to help support her widowed mother and her sisters. Family duties often intervene in women's lives. When M. F. K. Fisher was forty-one, her mother died. Her father, the editor of the Whittier *News,* in California, had a newspaper to run, but if he was to do that, somebody had to run his house. Why not Mary Frances? By that time, Fisher had published nine books. Nevertheless, she moved back home; she felt it was her duty. (Again and again, the women collude.) From that point, she published nothing for twelve years.

Fisher's case brings up the other main problem, besides late starts, that bedevils artistic careers, particularly of the female variety: breaks in productivity. Fisher's father died four years after she moved in with him, but after he was gone, it took her eight more years to put pen to paper again. Marguerite Yourcenar had a fallow period of ten years; Sybille Bedford, two breaks of sixteen years each. The sculptor Louise Bourgeois, after an excellent early show, exhibited nothing for eleven years. The women, as I say in the essay on Lucia Joyce, seem to be more discourageable, or in the past they were.

In all this study of artists' problems, I believe that the image in the back of my mind was that of George Balanchine. I cannot briefly describe the difficulties Balanchine faced in his life—they are recounted in the essay on Suzanne Farrell—but after a childhood in which he effectively lost his family at age nine, when his mother dropped him off at the ballet school in St. Petersburg, he lived through the Russian Revolution and the subsequent civil war, during which he practically starved to death. It was then,

unquestionably, that he developed the tuberculosis that plagued him for the rest of his life. He escaped from the Soviet Union at the age of twenty and landed a good position in Europe, as the house choreographer for Serge Diaghilev's Ballets Russes. But within a few years Diaghilev died, and the Ballets Russes was disbanded. Balanchine took whatever work he could get—short stints with various troupes, music-hall assignments in between. In 1933 he came to the United States, with the promise that he could set up a ballet company there. But before he was able to realize this ambition, fifteen years passed, years that again were filled with this gig and that: Broadway jobs, Hollywood jobs. Finally, in 1948, he established New York City Ballet. At the same time, coming out of the School of American Ballet, which he had founded in New York in 1934, there were ballerinas trained in his style, to execute the dances he wanted to make. And one after another—because of pregnancy or nerves or other plans (in the case of Tanaquil LeClercq, his fourth wife and his great hope, the cause was polio, which paralyzed her at the age of twenty-six)—these women eventually became unable to dance the ballets that he had created for them. Dancers were the crucial ingredient, but there were other shortages as well. It is widely assumed that Balanchine's "leotard ballets" were dressed in leotards for artistic reasons—that he wanted that austerity. There is evidence for this hypothesis, and also for another: that in many cases, the company could not afford anything more than leotards.

This constant scraping together and making do should, one figures, have worn Balanchine down. It didn't. Never did he throw up his hands. Every three-week assignment, every premiere that had to be done (because no matter if there is no ballerina, or no pressing inspiration, every ballet company's season must have a premiere): he executed them all with honor and with whatever imaginative power he was able to muster—smaller at some times, bigger at other times. He did this for sixty-two years, and made 425 ballets. By the end of that run—indeed, in the middle—he was the greatest and most influential choreographer of the twentieth century. More than that: he made ballet an American art. And he did it all by improvising.

Balanchine is almost not an example, but a freak, of ego

strength. Furthermore, he was sustained by a kind of religious faith that is rare among Western artists today, and that cannot be worked up voluntarily. But what I hope this book will say is that many artists, whatever their late starts or their later blocks, have summoned courage like his. I am thinking of Primo Levi, leaving Auschwitz. Many concentration-camp victims went on to lives of rage and grief, as is completely understandable. Levi, who was a chemist by profession, went on to write his first book, *Survival in Auschwitz*, the noblest of the camp memoirs, which he followed up with twelve other books. There are further examples: M. F. K. Fisher, numb with grief over her husband's suicide, pacing up and down in her house as she dictated to her sister, at the typewriter, the excellent, funny *How to Cook a Wolf*. As I said, she had a break of twelve years, but after that she wrote fourteen more books. Then there is Hilary Mantel, who wanted to be a lawyer and ended up stuck on a couch with a chronic and debilitating illness. "What can one do on a couch?" she asked herself. Well, one could write. And so she became one of England's most interesting contemporary novelists.

Another instructive story is that of Mark Morris. Again because I wrote a book on him, he is not included here. But at the age of thirty-two, he moved his troupe to Brussels, as the resident dance company of Belgium's royal theater. Because the Belgians had almost no tradition of modern dance—and because (luck again) he was replacing Maurice Béjart, an artist dear to Belgian hearts—Morris was received with scorn. The reviews were sulfurous; the shows were howled at. When Morris came out to take his curtain calls, the booing practically raised the roof. And he smiled and bowed and acted as though the audience were throwing bouquets at him. Then he went back to his studio, and for the three-year term of his contract—which almost anyone else, in his situation, would have canceled—he created a number of the greatest American dance works of the late twentieth century: *L'Allegro, il Penseroso ed il Moderato* and *Dido and Aeneas,* among others. At the end of his Belgian stay, the MacArthur Foundation, in Chicago, gave him its "genius" award. I don't think this was because he was a genius, though he was. I think it was for his strength of character. Once, during his Belgian period, an inter-

viewer asked him about one of his local reviews. She was looking for a good quote: Morris telling the press to go to hell. And what he answered was: "It's just a review—it's not a gun." In this book I want to associate myself with that point of view. We should love these people not just for artistic reasons, but for moral reasons.

There are other stories: Mikhail Baryshnikov, age twelve, responding to the suicide of his adored mother by throwing himself, night and day, into ballet; Joseph Roth, all but drowned in alcoholism and postwar cynicism, surfacing to produce his great middle-period novels, notably *The Radetzky March,* before sinking again. And then there is Joan of Arc, not an artist but unquestionably a hero, beaten down by her heresy trial, recanting, then withdrawing her recantation, and finally going off—at nineteen, and frightened to death—to be burned alive in Rouen's public square.

Additionally, there are a few pieces in this collection—on Andrea de Jorio, Susan Sontag, H. L. Mencken, and others— where the career seems to have suffered no serious wounds. Such essays are included by reason of the original criterion: I still liked them. Also, it is nice to know that somebody got a break.

Twenty-eight Artists
and Two Saints

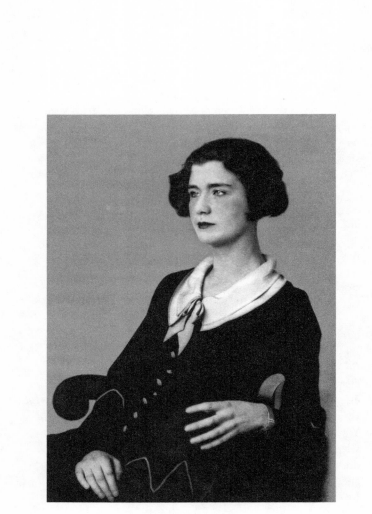

Lucia Joyce, c. 1927

A Fire in the Brain

W ILLIAM Butler Yeats, when he was riding the bus, would occasionally go into a compositional trance. He would stare straight ahead and utter a low hum and beat time with his hands. People would come up to him and ask him if he was all right. Once, his young daughter, Anne, boarded a bus and found him in that condition among the passengers. She knew better than to disturb him. But when the bus stopped at their gate, she got off with him. He turned to her vaguely and said, "Oh, who is it you wish to see?"

When I think of what it means to be an artist's child, I remember that story. There are worse fates. But in the artist's household the shifts that the children must endure—they can't make noise (he's working), they can't leave on vacation (he hasn't finished the chapter)—are combined with a mystique that this is all for some exalted cause, which they must honor even though they are too young to understand it. Furthermore, if the artist is someone of Yeats's caliber, the children, as they develop, will measure themselves against him and come up short. In fact, many artists' children turn out just fine, and grow up to edit their parents' work and live off the royalties. But some do not—for example, James Joyce's two children. His son became an alcoholic; his daughter went mad. Carol Loeb Shloss, a Joyce scholar who teaches at Stanford, has just written a book about the latter: *Lucia Joyce: To Dance in the Wake.*

Lucia grew up in a disorderly household. Joyce had turned his back on Ireland in 1904, when he was twenty-two. Convinced that he was a genius but that his countrymen would never recognize this, he persuaded Nora Barnacle, his wife-to-be, to sail with

him to the Continent. They eventually landed in Trieste, and there, for the next decade or so, he worked as a language teacher and completed *Dubliners* and *A Portrait of the Artist as a Young Man*. With the publication of *Portrait*, in 1916, he acquired rich patrons, but until then—that is, throughout his children's early years—the Joyces were very poor. Some days they went without dinner. Their first child, Giorgio, was born in 1905, a bonny, easy baby, and, furthermore, a boy. Nora adored him till the day she died. Two years after Giorgio came Lucia, a sickly, difficult child, and a girl, with strabismus. (That is, she was cross-eyed. Nora, too, had strabismus, but hers was far less noticeable.) Lucia's earliest memories of her mother were of scoldings. Joyce, on the other hand, loved Lucia, spoiled her, sang to her, but only when he had time. He worked all day and then, on many nights, he went out and got blind drunk. The family was evicted from apartment after apartment. By the age of seven, Lucia had lived at five different addresses. By thirteen, she had lived in three different countries. The First World War forced the Joyces to move to Zurich; after the war, they settled in Paris. As a result, Lucia received a spotty education, during which she was repeatedly left back by reason of having to learn a new language.

Was she strange from childhood? With people who become mentally ill as adults, this question is always hard to answer, because most witnesses, knowing what happened later, read it back into the early years, and are sure that the signs were already there. Richard Ellmann, the author of the standard biography of Joyce, and Brenda Maddox, in her *Nora: A Biography of Nora Joyce,* both note that the young Lucia seemed to stare off into space, but the strabismus might account for this. It is also said that she was reticent socially. Although she was talkative at home—a "saucebox," her father called her—she apparently went through periods when she spoke to few people outside her family. But the language-switching could explain this. A friend of the family described her, in her twenties, as "illiterate in three languages." It was four, actually: German, French, English, and Triestine Italian. The last was her native tongue, the language that her family used at home, not just in Trieste but forever after (because

Joyce found it easier on the voice). It was not, however, what people spoke in most of the places where she lived.

When Lucia was fifteen, she began taking dance lessons, mostly of the new, antiballetic, "aesthetic" variety, and this became her main interest during her teens and early twenties. She started at the Dalcroze Institute in Paris, then moved on to study with the toga-clad Raymond Duncan, Isadora's older brother. Eventually, she hooked up with a commune of young women who occasionally performed, in Paris and elsewhere, as Les Six de Rythme et Couleur. However briefly, Lucia was a professional dancer. She is said to have excelled in *sauvage* roles. But eventually she left this group, as she left every group. (I count nine dance schools in seven years.) In part, that may have been due to lack of encouragement from her family. Nora reportedly nagged Lucia to give up dancing. According to members of the family, she was jealous of the attention the girl received. As for Joyce, Brenda Maddox says he felt "it was unseemly for women to get on the stage and wave their arms about."

Finally, after seven years' training in the left wing of dance, Lucia bolted to the right wing, and embarked on a backbreaking course of ballet instruction with Lubov Egorova, formerly of the Maryinsky Theatre, in St. Petersburg. This was a terrible idea. Professional ballet dancers begin their training at around the age of eight. Lucia was twenty-two. She worked six hours a day, but of course she couldn't catch up, and, in her discouragement, she concluded that she was not physically strong enough to be a dancer of any kind—a decision, Joyce wrote to a friend, that cost her "a month's tears."

The loss of her dance career was not the only grief that Lucia suffered in her early twenties. The publication of *Ulysses,* in 1922, made Joyce a celebrity, and there were plenty of young artistic types in Paris who thought it would be nice to be attached to his family. When Giorgio was in his late teens, an American heiress, Helen Fleischman, laid claim to him; eventually he moved in with her. Lucia, who had been very close to Giorgio, felt abandoned. She was also scandalized. (Fleischman was eleven years older than Giorgio, and married.) Finally, she wondered what she was miss-

ing. She decided to find out, and in the space of about two years she was rejected by three men: her father's assistant, Samuel Beckett, who told her he wasn't interested in her in that way; her drawing teacher, Alexander Calder, who bedded her but soon went back to his fiancée; and another artist, Albert Hubbell, who had an affair with her and then returned to his wife. Lucia became more experimental. She took to meeting a sailor at the Eiffel Tower. She announced that she was a lesbian. During these romantic travails, she became more distressed over her strabismus. She had the eye operated on, but it didn't change. Soon afterward, her pride received another blow: her parents told her that they were going to get married. (Giorgio's marriage to the newly divorced Fleischman had started them thinking about legality and inheritance.) This is how she discovered that they never had been married and that she was a bastard.

The following year, on Joyce's fiftieth birthday, Lucia picked up a chair and threw it at her mother, whereupon Giorgio took her to a medical clinic and checked her in. "He thereby changed her fate," Shloss writes. That is a strong judgment, but it is true in part, because the minute an emotionally disturbed person is placed in an institution the story enters a new phase, in which we see not just the original problem but its alterations under institutionalization: the effects of drugs, the humiliation of being locked up and supervised, the consequent change in the person's self-image and in other people's image of him or her. For the next three years, Lucia went back and forth between home and hospital. One night in 1933, she was at home when the news came that a United States District Court had declared *Ulysses* not obscene (which meant that it could be published in the States). The Joyces' phone rang and rang with congratulatory calls. Lucia cut the phone wires—"*I'm* the artist," she said—and when they were repaired she cut them again. As her behavior grew worse, her hospitalizations became longer. She went from French clinics to Swiss sanitariums. She was analyzed by Jung. (Briefly—she wanted no part of him.) One doctor said she was "hebephrenic," which at that time was a subtype of schizophrenia, describing patients who showed antic, "naughty" behavior. Another diagnostician said she was "not lunatic but markedly neurotic." A third thought the

problem was "cyclothymia," akin to manic-depressive illness. At one point in 1935, when she seemed stabler, her parents let her go visit some cousins in Bray, a seaside town near Dublin. There she set a peat fire in the living room, and when her cousins' boyfriends came to call she tried to unbutton their trousers. She also, night after night, turned on the gas tap, in a sort of suicidal game. Then she disappeared to Dublin, where she tramped the streets for six days, sleeping in doorways, or worse. When she was found, she herself asked to be taken to a nursing home.

Soon afterward, the Joyces put her in an asylum in Ivry, outside Paris. She was twenty-eight, and she never lived on the outside again. She changed hospitals a few times, but her condition remained the same. She was quiet for the most part, though now and then she would go into a tearing rage—breaking windows, attacking people—and she would be put in a straitjacket until she calmed down. This went on for forty-seven years, until her death, in 1982, at the age of seventy-five.

CAROL Shloss believes that Lucia's case was cruelly mishandled. When Lucia fell ill, she at last captured her father's sustained attention. He grieved over her incessantly. At the same time, he was in the middle of writing *Finnegans Wake,* and various people around him—friends, patrons, assistants, on whom, since he was going blind, he was very dependent—believed that the future of Western literature hung on his ability to finish this book. But he was not finishing it, because he was too busy worrying about Lucia. He was desperate to keep her at home. His friends—and also Nora, who bore the burden of caring for Lucia when she was at home, and who was the primary target of her fury—insisted that she be institutionalized. The entourage finally prevailed, and Joyce completed *Finnegans Wake.* In Shloss's view, Lucia was the price paid for a book.

But, as Shloss tells it, the silencing of Lucia went further than that. Her story was erased. After Joyce's death, many of his friends and relatives, in order to cover over this sad (and reputation-beclouding) matter, destroyed Lucia's letters, together with Joyce's letters to and about her. Shloss says that Giorgio's son, Stephen

Joyce, actually removed letters from a public collection in the National Library of Ireland. When Brenda Maddox's biography of Nora was in galleys, Maddox was required to delete her epilogue on Lucia in return for permission to quote various Joyce materials. Shloss doesn't waste any tears over Maddox, however. In her opinion, Maddox and Ellmann are among the sinners, because they assumed, and thereby persuaded the public, that Lucia was insane. (Whenever Shloss catches Ellmann or Maddox in what seems to her a factual error, she records it snappishly—a tone inadvisable for a writer who, forced to swot up three decades of dance history, made some errors herself.) But the biographers are a side issue. None of Lucia's letters survive as original documents. Nor is there any trace of her diaries or poems, or of a novel that she is said to have been writing. In other words, most of the primary sources for an account of Lucia Joyce's life are missing. "This is a story that was not supposed to be told," Shloss writes. Therefore she tells it with a vengeance.

SHLOSS says that Lucia was a pioneering artist: "Through her we watch the birth of modernism." She compares her to Prometheus, "privately engaged in stealing fire." She compares her to Icarus, who flew too close to the sun. Insofar as these statements have to do with Lucia's dance career, Shloss is as hard up for evidence as all other people writing about dance that predated the widespread use of film and video recording. What those writers do is quote reviewers and witnesses. But Lucia's stage career was very short; Shloss is able to document maybe ten or twenty professional performances, and Lucia's contributions to them were apparently not reviewed. Once, in 1929, when she competed in a dance contest in Paris, a critic singled her out as "subtle and barbaric." Apropos of that performance, Shloss also quotes the diary of Joyce's friend Stuart Gilbert: "Ballet yesterday; *fils prodigue* is a compromise between *pas d'acier* (steps of steel) and neo-Stravinsky." This would be an interesting compliment if the prodigal son in question were Lucia, but what Gilbert is clearly describing is George Balanchine's ballet *Le Fils Prodigue*, which had its premiere in

Paris, with Diaghilev's Ballets Russes, three days before Lucia's dance contest.

Shloss's evaluation of Lucia as an artist is not limited to her dance career, however. Lucia, she argues, collaborated with Joyce on *Finnegans Wake.* One of Lucia's cousins, Bozena Berta Schaurek, visited the Joyces briefly in 1928, and in an interview fifty years later she recalled something from that visit: while Joyce worked, "Lucia danced silently in the background." Joyce prided himself on his ability to write under almost any conditions, so if his niece saw him, once or twice, working in the same room where Lucia was practicing, this would not be surprising. But in Shloss's mind Schaurek's report prompts a vision:

> There are two artists in this room, and both of them are working. Joyce is watching and learning. The two communicate with a secret, unarticulated voice. The writing of the pen, the writing of the body become a dialogue of artists, performing and counterperforming, the pen, the limbs writing away.
>
> The father notices the dance's autonomous eloquence. He understands the body to be the hieroglyphic of a mysterious writing, the dancer's steps to be an alphabet of the inexpressible. . . . The place where she meets her father is not in consciousness but in some more primitive place before consciousness. They understand each other, for they speak the same language, a language not yet arrived into words and concepts but a language nevertheless, founded on the communicative body. In the room are flows, intensities.

Shloss thinks that this artistic symbiosis went on for years and that out of it came the theme of *Finnegans Wake* (flow), its linguistic experiments, much of its imagery, and also, because dance is abstract, its quasi-abstract quality. In return for these artistic gains, Shloss says, Lucia's life was forfeited. Transfixed by Joyce's gaze, she became too self-aware. And magicked by her relationship with him—"one of the great love stories of the twentieth

century," Shloss calls it—she could never form an attachment to another man. Even years later, when Lucia is in the sanitarium and doing bizarre things—painting her face black, sending telegrams to dead people—Shloss believes that this was Lucia's way of giving her father material. She wasn't schizophrenic; she was working on *Finnegans Wake*.

This elevation of Lucia to the role of collaborator on *Finnegans Wake* is Shloss's most spectacular act of inflation, but by no means the only one. The less she knows, the more she tells us. On Lucia's studies with Raymond Duncan, for example, she seems to have almost no information. But here, among many other things, is what she says on the subject:

> Lucia's mind was filled with the grammar of vitality, prizing the dynamic over the static order. She imagined herself in terms of tension and its release; she felt the anxieties of opposing muscle to muscle and the heady mastery of resistances, knew the peace of working with gravity and not against it. To drop, to rebound, to lift, to suspend oneself. To fall and recover, to know the experience of grounding oneself and then arising to circle to the edge of ecstasy. Priests danced, children danced, philosophers' thoughts rose and fell in rhythmic sequence; lovers danced, and so did Lucia.

This is what you get when you tear up letters on a biographer. Underlying that passage—indeed, the whole book—are many of the irrationalist formulas associated in the public mind with dance. Painting is an art, writing is an art, but dance is a religion, an immolation. It is primitive, it is sexual, it is Dionysiac. (Shloss gives us a talk on Nietzsche.) It is an ecstasy, an obsession—the Red Shoes. Therefore it is cousin to insanity. Shloss points us to Zelda Fitzgerald, who also threw herself into ballet in her twenties, also studied with Egorova, and also went mad. (The two women even ended up in the same Swiss hospital, though Zelda was gone before Lucia checked in.) Nijinsky, too, is invoked. And Lucia's symptoms are repeatedly described as her way of dancing.

A Fire in the Brain

. . .

In some sections, however, Shloss forgets that she is writing a symbolist poem or a Laingian treatise and starts writing a biography. That, of course, is when she has some information to go on. At one juncture, she quotes from a history of Lucia that Joyce and his friend Paul Léon wrote for one of the hospitals that she was sent to: "The patient insists that despite her diligence, her talent and all her exertions, the results of her work have come to nothing. The brother, her contemporary, whom she previously idolized, has never worked at anything, is well known, has married wealth, has a beautiful apartment, a car with a chauffeur and, on top of it all, a beautiful wife." Lucia herself said to a companion that her situation was "just as if you had been very rich, and collected many valuable things, and then they were taken away from you." These are modest statements, about cars and money, not Dionysus, but they are the ones that make you want to cry.

Another poignant section of the book has to do with Joyce's efforts on Lucia's behalf. Joyce believed that Lucia's problems were somehow inherited from him: "Whatever spark or gift I possess has been transmitted to Lucia and it has kindled a fire in her brain." (In fact, the fire may have been kindled by Nora, whose sister Dilly spent a year and a half in a lunatic asylum.) He tried to find ways to heal her, please her. He bought her a fur coat ("My wish for you is warmth and beauty"), and when she lost it he bought her another one. To replace dancing, he persuaded her to take up book illustration—she drew *lettrines*, ornamental capitals—and he secretly gave publishers the money to pay her for her work. He didn't think she was crazy; he thought she was special—"a fantastic being," with her own private language. "I understand it," he said, "or most of it." If there was something wrong with her, maybe it was an infection, or a hormone imbalance. (She was given hormones, and also injections of seawater. The treatment of schizophrenia in those days was basically stabs in the dark, as it is still.) He spared no expense. In 1935, Léon reported that three-quarters of Joyce's income was going to Lucia's care. When the Germans invaded France, in 1940, and the family had to flee to

Switzerland, Joyce practically killed himself in the vain effort to arrange for Lucia to go with them. Indeed, he may have killed himself. A month after the family arrived in Zurich, he died of a perforated ulcer.

Shloss loves Joyce for the pains he took over Lucia. The enemies in her book, apart from the letter-destroyers, are Nora and Giorgio—especially Giorgio, who, though by this time he spent his days in an alcoholic haze, was always forgiven everything by his family, and who, time and again, was the first person to say that his sister should be put away. Shloss repeatedly suggests—again, without evidence—that there may have been some sexual contact between Lucia and Giorgio when they were in their teens or earlier, and that Giorgio, in his rush to institutionalize her, may have been trying to silence her on this subject.

SHLOSS's book is part of a tradition, the biography-of-the-artist's-woman—a genre that is now about thirty years old, as old as its source, modern feminism. Its goal is to show that many great works of art by men were fed on the blood of women, who were then, at best, forgotten by history or, at worst, maddened by their exploitation and then clapped in an institution. In the latter cases—Shloss's *Lucia,* Carole Seymour-Jones's *Painted Shadow: The Life of Vivienne Eliot, First Wife of T. S. Eliot, and the Long-Suppressed Truth About Her Influence on His Genius*—these books can be very indignant. (Not always. Nancy Milford's biography of Zelda Fitzgerald basically comes down on Scott's side.) When the woman is merely unacknowledged, the tone tends to be milder, as in Brenda Maddox's *Nora*—which, *pace* Shloss, says that Nora was the primary inspiration for Joyce's work—or Ann Saddlemyer's *Becoming George: The Life of Mrs. W. B. Yeats,* which tells the weird story of how Yeats's wife, Georgie, was the medium (literally) through which he reached the spirit world and thus found the subject of his late work. In recent years, possibly because most of the really shocking cases have been used up, the arguments seem to be getting subtler. In Stacy Schiff's *Véra* (*Mrs. Vladimir Nabokov*) we are shown a woman whose contribution to her hus-

band's work was to meld with him in the creation of a single, shared personality, which then wrote the books and lived the life—a bizarre phenomenon.

Francine Prose's recent book *The Lives of the Muses* tells the story of nine artists and their female inspirers. Some of the latter—for example, Elizabeth Siddal, Dante Gabriel Rossetti's wife—fared badly, but in other cases (Yoko Ono; Gala Dalí, Salvador Dalí's wife), Prose sees the woman as the exploiter of the man. A general rule one can draw from the book is that both parties, but especially the woman, do better if they don't marry each other. Prose does not see the "art wife" as an enviable role.

All these biographical studies, subtle or not, are valuable, and not only for the sake of justice (when that is what they achieve) but because they tell an important truth about how artists get their work done. Many people are brilliant, and from that you may get one novel, as Zelda Fitzgerald did. But to write five novels (Scott) or seventeen (Nabokov)—to make a career—you must have, with brilliance, a number of less glamorous virtues, for example, patience, resilience, and courage. Lucia Joyce encountered obstacles and threw up her hands; James Joyce faced worse obstacles—for most of his writing life, publishers ran from him in droves—but he persisted. When the critics made fun of Zelda's novel, she stopped publishing; when Scott had setbacks—indeed, when he was a falling-down drunk—he went on hoping, and working. Lucia and Zelda may have been less gifted than the men in question, but there is something else going on here, too, which the biographies-of-the-artists'-women record: that while nature seems to award brilliance equally to men and women, society does not nurture it equally in the two sexes, and thus leaves the women more discourageable. Nor, in females, does the world reward selfishness, which, sad to say, artists seem to need, or so one gathers from the portraits of the men in these books. One can also gather it from biographies of the women who did not lose heart—for example, George Eliot, whose books were the product of a life custom-padded by her mate, George Lewes. (Phyllis Rose, in her *Parallel Lives: Five Victorian Marriages,* reports that for twenty-four years Lewes screened Eliot's incoming letters, together with

all reviews of her books, and threw away anything that might distress her.) Then there is Virginia Woolf, whose novels would never have been written had she not had nonstop nursing care from Leonard Woolf. Virginia knew this, and seems to have decided she deserved it, or so she suggests in *A Room of One's Own*. But, male or female, once the artist walks into that private room and closes the door, a lot of people are going to feel shut out—are going to *be* shut out—and they may suffer.

The New Yorker, 2003

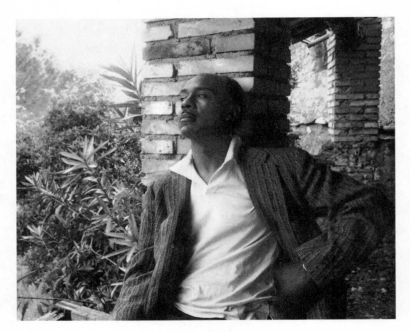

Ralph Ellison, Rome, 1957

Blocked

"YESTERDAY was my Birth Day," Coleridge wrote in his notebook in 1804, when he was thirty-two. "So completely has a whole year passed, with scarcely the fruits of a *month.*—O Sorrow and Shame. . . . I have done nothing!" It was true. Most of the poems for which he is remembered were produced when he was in his mid-twenties. After that, any ambitious writing project inspired in him what he called "an indefinite indescribable Terror," and he wasted much of the rest of his life on opium addiction. How could he have done this? Why didn't he pull himself together? A friend asked him the same question. "You bid me rouse myself," he replied. "Go, bid a man paralytic in both arms rub them briskly together, and that will cure him. Alas! (he would reply) that I cannot move my arms is my complaint."

Coleridge is one of the first known cases of what we call writer's block. Sometimes, "block" means complete shutdown: the writer stops writing, or stops producing anything that seems to him worth publishing. In other cases, he simply stops writing what he wants to write. He may manage other kinds of literary work, but not the kind he sees as his vocation. Coleridge turned out a great deal of journalism and criticism in his later years, but he still regarded himself as disabled, because he wasn't writing serious poetry.

Writer's block is a modern notion. Writers have probably suffered over their work ever since they first started signing it, but it was not until the early nineteenth century that creative inhibition became an actual issue in literature, something people took into account when they talked about the art. That was partly because, around this time, the conception of the art changed. Before, writers regarded what they did as a rational, purposeful activity, which

they controlled. By contrast, the early Romantics came to see poetry as something externally, and magically, conferred. In Shelley's words, "A man cannot say, 'I will compose poetry.'" Poetry was the product of "some invisible influence, like an inconstant wind," which more or less blew the material into the poet, and he just had to wait for this to happen. In terms of getting up in the morning and sitting down to work, a crueller theory can hardly be imagined, and a number of the major Romantic poets showed its effects. Wordsworth, like Coleridge, produced his best poetry early on, in about ten years. Poets, in their youth, "begin in gladness," he wrote when he was in his thirties. "But thereof come in the end despondency and madness."

After the English Romantics, the next group of writers known for not writing were the French Symbolists. Mallarmé, "the Hamlet of writing," as Roland Barthes called him, published some sixty poems in thirty-six years. Rimbaud, notoriously, gave up poetry at the age of nineteen. In the next generation, Paul Valéry wrote some poetry and prose in his early twenties and then took twenty years off, to study his mental processes. Under prodding from friends, he finally returned to publishing verse and in six years turned out the three thin volumes that secured his fame. Then he gave up again. These fastidious Frenchmen, when they described the difficulties of writing, did not talk, like Wordsworth and Coleridge, about a metaphysical problem, or even a psychological problem. To them, the problem was with language: how to get past its vague, cliché-crammed character and arrive at the actual nature of experience. They needed a scalpel, they felt, and they were given a chain-saw.

It is curious to see this writing inhibition arise in the nineteenth century, for many of the writers of that century, or at least the novelists, were monsters of productivity. Scott, Balzac, Hugo, Dickens, Trollope: these men published as if they couldn't stop, and they were proud of it. Every day for years, Trollope reported in his *Autobiography,* he woke in darkness and wrote from 5:30 a.m. to 8:30 a.m., with his watch in front of him. He required of himself two hundred and fifty words every quarter of an hour. If he finished one novel before eight-thirty, he took out a fresh piece of paper and started the next. The writing session was followed,

for a long stretch of time, by a day job with the postal service. Plus, he said, he always hunted at least twice a week. Under this regimen, he produced forty-nine novels in thirty-five years. Having prospered so well, he urged his method on all writers: "Let their work be to them as is his common work to the common laborer. No gigantic efforts will then be necessary. He need tie no wet towels round his brow, nor sit for thirty hours at his desk without moving,—as men have sat, or said that they have sat."

Had this advice been given in 1850, it might have been gratefully accepted. But Trollope's autobiography was published in 1883, the year after his death. By that time, romantic notions about writing had filtered down to the public. Many readers now believed that literature was something produced by fine-minded, unhappy people who did not hunt, and to this audience Trollope's recommendations seemed clear evidence of shallowness. According to Michael Sadleir, who wrote the introduction to the Oxford World's Classics edition of the *Autobiography*, the book "extinguished its author's good name for a quarter of a century." Trollope was later rehabilitated, but still today there is a prejudice against prolific writers. Joyce Carol Oates, who has published thirty-eight novels, twenty-one story collections, nine books of poetry, and twelve essay collections, and who also teaches full-time at Princeton, has had to answer rude questions about her rate of production. "Is there a compulsive element in all this activity?" one interviewer asked her.

IN the United States, the golden age of artistic inhibition was probably the period immediately following the Second World War, which saw the convergence of two forces. One was a sudden rise in the prestige of psychoanalysis. The second was a tremendous surge in ambition on the part of American artists—a lot of talk about the Great American Novel and hitting the ball out of the park. Some of those hopes were fulfilled. The fifties were a thrilling decade in American literature (Norman Mailer, Saul Bellow, Ralph Ellison, Eugene O'Neill, Tennessee Williams). But, as the bar rose, so did everyone's anxiety, and the doctor was called. Many, many writers went into psychoanalysis in those years, and

they began writing about the relationship of art and neurosis. Early on, in 1941, came Edmund Wilson's book *The Wound and the Bow*, which reinvoked the ancient Greek formula of the mad genius. After discussing the psychological harm suffered in childhood by Dickens, Kipling, and others, Wilson concluded that "genius and disease, like strength and mutilation, may be inextricably bound up together." In 1945, Wilson made the point again, by publishing, under the title *The Crack-Up*, a collection of the later writings of his friend F. Scott Fitzgerald. Famous at twenty-three, washed up at forty, dead at forty-four, Fitzgerald was already everyone's favorite example of artistic flameout, but this posthumous volume, with Fitzgerald's own description of his situation ("No choice, no road, no hope"), helped plant the idea that his early exit was somehow a normal pattern, at least for American writers. As he famously put it, "There are no second acts in American lives." In 1947, *Partisan Review* printed an essay, "Writers and Madness," by one of its editors, William Barrett, claiming that the modern writer was by definition an "estranged neurotic," because the difficulty of being authentic in a false-faced world forced him to go deeper and deeper into the unconscious, thus pushing him toward madness: "The game is to go as close as possible without crossing over." Many did cross over, he added darkly.

Not everyone agreed that writers were mental cases, but a number of psychoanalysts did, and their loudest spokesman was Edmund Bergler, a Viennese émigré who in the forties and fifties put forth what is probably the most confident theory of writer's block ever advanced. First of all, he coined the term. (Formerly, people had spoken of "creative inhibition" or the like.) Second, he proclaimed its cause: oral masochism, entrapment in rage over the milk-denying pre-Oedipal mother. Starved before, the writer chose to become starved again—that is, blocked. Bergler claimed to have treated more than forty writers, with a hundred-percent success rate. That didn't mean that the writers became like other people. "I have never seen a 'normal' writer," Bergler reported. Even if their work was going well, this was often "entirely surrounded by neuroticism in private life"—squalid love affairs, homosexuality, etc. They had recompense, however: "*the megalo-*

maniac pleasure of creation . . . produces a type of elation which cannot be compared with that experienced by other mortals" (italics his).

In today's psychology of writer's block, as in today's psychology in general, the focus is less on the unconscious than on brain chemistry. Blocked writers are now being treated with antidepressants such as Prozac, though some report that the drugs tend to eliminate their desire to write together with their regret over not doing so. Others are being given Ritalin and other stimulants, on the theory that their problems may be due to the now fashionable condition of attention deficit disorder. Lionel Trilling, the dean of mid-twentieth-century literary criticism, has long been praised for the stringency of his mind, for his refusal of easy answers. "His gospel was complexity," as his editor Leon Wieseltier put it. In a recent article in *The American Scholar,* Trilling's son, James, says to forget all that, or forget calling it a moral or intellectual virtue. In his view, his father's devotion to the idea of life's complexity, as well as his long struggle with block, was just the product of an undiagnosed case of ADD, which, by reducing his ability to concentrate, made everything seem complicated to him.

We are even getting biological theories of literary creativity. In a 1993 book called *Touched with Fire: Manic-Depressive Illness and the Artistic Temperament,* the psychologist Kay Redfield Jamison argued that manic-depressive illness was the source of much of the best poetry produced from the eighteenth century to the twentieth. This year, we were offered a follow-up hypothesis, in *The Midnight Disease: The Drive to Write, Writer's Block, and the Creative Brain,* by Alice W. Flaherty, who teaches neurology at Harvard Medical School. Like Jamison, Flaherty thinks that mood disorders may jump-start the literary imagination. (Also like Jamison, she has suffered from a mood disorder, and she feels that she owes her writing career to her manic phases.) But she goes further, speculating at length on which parts of the brain are responsible for literary creativity and its interruption. She believes that writing is generated along the pathways that connect the limbic system—a structure deep in the brain, the source of emotion and drive—with the temporal lobe, which controls our ability to grasp

linguistic and philosophical meaning. As for block, she thinks the main problem may lie in the frontal lobe, because block shares some characteristics with disorders arising from frontal-lobe damage, such as Broca's aphasia, which destroys the ability to produce normal language.

Flaherty understands that these biological theories may shock people who still cherish the idea that art comes from something other than the action of neurotransmitters, and she spends many intelligent pages trying to shepherd us through the difficulty of accepting that the mind is actually the brain, a physical organ. She thinks we can concede this without discarding the more exalted concepts of inspiration, the "inner voice," and so on. She, too, believes in those things. Nevertheless, she is a brain scientist, and she can't help offering a few Frankensteinian suggestions. For example, she describes a new technique called transcranial magnetic stimulation, in which brain activity is controlled via the manipulation of magnetic fields. She speculates that with the help of TMS, "it may soon be possible to ward off depression and at least some types of writer's block by holding a magnetic wand over a precise location on our skulls while we are watching television."

In talk therapy, the trend these days is cognitive-behavioral therapy, which teaches you to revise your thoughts and preconceptions in order to change the behavior that issues from them. Apart from one-on-one treatment, there are a number of cognitive-behavioral books for blocked writers—for example, *Break Writer's Block Now!*, by Jerrold Mundis, a novelist. Mundis also has a set of four audiocassettes that, for seventy-seven dollars, will talk you through his technique. I've listened to the tapes. The idea is to remove your fear of writing by combatting your negative thoughts with self-affirmations ("I am a richly talented writer"), by controlling in your mind the size of your project (don't start fantasizing about selling your novel to Hollywood), by thinking of what you're writing as just a draft (don't revise as you write), and, above all, by carefully scheduling your work and quitting the minute your assigned daily writing session is over (use a timer). Mundis's manner is very cheerleadery, in the way of motivational training, and his Web site, www.unblock.org, where you can

order the tapes, reads like a subway ad for a baldness cure. Still, some of his advice is good, at least for beginning writers.

MANY of these theorists regard block as a thing in itself, a mental condition that one can be stricken with. Is it? Like most of today's recognized psychological disorders, it is a concept that other cultures, other times, have done fine without. Not only did the notion of block not appear until the nineteenth century, in Europe, but many Europeans today don't seem to know what it is. According to Zachary Leader's 1991 *Writer's Block,* the best book on the subject (much of my historical information comes from it), the French and the Germans have no term for writer's block. Even in England, where the idea is supposed to have been born, modern writers tend to sniff at it. "I don't get writing blocks except from the stationer," Anthony Burgess told an interviewer. "I can't understand the American literary block . . . unless it means that the blocked man isn't forced economically to write (as the English writer, lacking campuses and grants, usually is) and hence can afford the luxury of fearing the critics' pounce on a new work not as good as the last." Burgess may be correct that writer's block, by now, is largely an American idea, a product of American overreaching. Particularly in its midcentury version, with Bergler's talk of megalomania and elation, the concept is suspiciously glamorous—Faustian, *poète maudit.* The term itself is grandiose, with its implication that writers contain within them great wells of creativity to which their access is merely impeded.

But the fact remains that some writers do stop writing, long before they want to. Why? Scientists have a rule that you don't explain things by remote and elaborate causes when simpler, more immediate causes offer themselves. In tales of block, certain circumstances turn up again and again. They are by no means sufficient causes—as we know, a condition that defeats one person may toughen up another—but they are probably contributing factors. One, paradoxically, is great praise. A story that haunts the halls of *The New Yorker* is that of Joseph Mitchell, who came on staff in 1938, wrote many brilliant pieces, and then, after the pub-

lication of his greatest piece, "Joe Gould's Secret," in 1964, came to the office almost every day for the next thirty-two years without filing another word. In a series of tributes published in *The New Yorker* upon Mitchell's death, in 1996, Calvin Trillin recalled hearing once that Mitchell was "writing away at a normal pace until some professor called him the greatest living master of the English declarative sentence and stopped him cold."

There are many other theories about Mitchell. (For one thing, "Joe Gould's Secret" was about a blocked writer.) It is nevertheless the case that, however much artists may want attention, getting it can put them off their feed, particularly when it comes at the beginning of their careers. That may have been the case with Dashiell Hammett. Hammett wrote his first four novels in three years, while he was in his thirties, and they made him famous. Then he went to Hollywood, where he made piles of money and spent much of it in bars. In 1934, when he was thirty-nine, his fifth novel, *The Thin Man,* came out, and that was the end, though he lived for almost three more decades. In his later life, he said that he stopped publishing because he felt he was repeating himself: "It is the beginning of the end when you discover that you have a style." He tried to alter his style. He wanted to go mainstream, leave the detective novel behind. He wrote and wrote, but he never accomplished anything that satisfied him.

Again, however, Scott Fitzgerald's is the paradigmatic story of early success, early failure, and not just because his talent was so great but because he saw what was happening to him and wrote about it. In 1937, he published an essay, "Early Success"—it is included in *The Crack-Up*—in which he said that "premature success gives one an almost mystical conception of destiny as opposed to will power. . . . The man who arrives young believes that he exercises his will because his star is shining," a conviction that leaves him little to fall back on when the star isn't shining. That same year, Fitzgerald, finished (in his opinion) as a novelist—and also, by this time, seriously alcoholic—moved to Hollywood in order to make some money as a screenwriter. At the studios, he tried to stay on the wagon, but he repeatedly went on weeklong benders, which, when his friends finally located him,

left him in need of round-the-clock nursing and tubal feeding. He soon found himself out of work as a result. To fill in financially, he wrote a series of stories for *Esquire* about a fictional screenwriter, Pat Hobby, whose life was an antic version of his own. Hobby, a drunk, used to get two thousand dollars a week from the studios; now he gets three hundred and fifty. (In 1929, Fitzgerald was being paid four thousand dollars per story by *The Saturday Evening Post.* For the Hobby stories, *Esquire* seems to have paid him a hundred and fifty dollars apiece.) Sometimes he doesn't even get that. He's been fired again and again, because the "boys writing behind him"—the people rewriting his material—say that his stuff is all old, and that some of it makes no sense. Formerly, he was one of the men in Hollywood who "had wives and Filipinos and swimming pools." Now his clothes look "as if he'd been standing at Hollywood and Vine for three years." To eat, he steals victuals from movie sets—during a scene from *The Divine Miss Carstairs* he scores half a cold lobster. The Hobby stories are a self-loathing comedy. Like Coleridge's notebooks, they make you want to scream. Why couldn't this lavishly gifted artist straighten himself out? He tried. In 1939, he began a novel—another wonderful one, *The Last Tycoon,* about Hollywood—but six chapters into it he dropped dead of a heart attack. Five years later, a Fitzgerald revival began, and he soon became what he is to us now, an American classic. But, as far as he knew when he died, he was a forgotten man.

Fitzgerald's and Hammett's histories are not the only ones in which writing problems are complicated by alcoholism. From the 1920s at least through the '50s, American literature was awash in alcohol. Tom Dardis begins his book *The Thirsty Muse: Alcohol and the American Writer* (1989) by noting that of the seven native-born Americans awarded the Nobel Prize for Literature five were alcoholics: Sinclair Lewis, Eugene O'Neill, William Faulkner, Ernest Hemingway, and John Steinbeck. As for problem drinkers who didn't get the Nobel Prize, Dardis assembles an impressive list, including Edna St. Vincent Millay, Hart Crane, Thomas Wolfe, Dorothy Parker, Ring Lardner, Djuna Barnes, John O'Hara, Tennessee Williams, John Berryman, Carson McCullers,

James Jones, John Cheever, Jean Stafford, Truman Capote, Raymond Carver, Robert Lowell, and James Agee. A number of these careers ended early, and badly.

When an alcoholic writer stops writing, do we call this block or just alcoholism? (Or something else: Hemingway suffered serious depression.) Such cases lack the bleak dignity generally associated with block. Instead of the lonely writer, at his desk, staring at the blank page, we get a disorderly drunk, being hauled off to detox. The relationship between writing and alcohol is a knotty problem, but it clearly involves a circular process. Many writers use alcohol to help themselves write—to calm their anxieties, lift their inhibitions. This may work for a while (Faulkner wrote all his best novels while drinking whiskey, continually, at his desk), but eventually the writing suffers. The unhappy writer then drinks more; the writing then suffers more, and so on. In my observation, American writers today drink much less than their predecessors. I asked a psychoanalyst what they do instead, to take the edge off. "Exercise," he said.

"WHOM the gods wish to destroy," Cyril Connolly once said, "they first call promising." A subdivision of the early-success problem is second-novel syndrome. The writer produces a first novel, and it is a hit; then he sits down to write a second novel, and finds his brain clenched. Jeffrey Eugenides' first novel, *The Virgin Suicides* (1993), was an enormous critical success. It also sold very well, and was made into a movie. His second novel, *Middlesex,* was published two years ago, and won the Pulitzer Prize. But between those two books lie nine years. I asked Eugenides why. One reason, he said, was that *Middlesex* was far more ambitious than *The Virgin Suicides.* (It is a sweeping family chronicle, more than five hundred pages long and full of Greek and American history.) But another reason was the circumstances surrounding a second novel:

> No one is waiting for you to write your first book. No one cares if you finish it. But after your first, if it goes well, everyone seems to be waiting. You're suddenly considered

to be a professional writer, a fiction machine, but you know very well that you're just getting going. You go from having nothing to lose to having everything to lose, and that's what creates the panic. . . . In my own case, I decided to give myself the time to learn the things I needed to know in order to write my second book, rather than just writing it in a rush because there were now people eager to read it. Finally, of course, I had to leave the country. In Berlin I regained the blessed anonymity I'd had while writing *The Virgin Suicides*. I got back to thinking only about the book. . . . Now [since *Middlesex*] I've lost the anonymity I had in Berlin and so am moving to Chicago. If things continue to go well, I will end up living in Elko, Nevada.

Eugenides survived second-novel syndrome, and so do most novelists, but some are felled by it. *To Kill a Mockingbird* (1960), Harper Lee's first novel, published when she was thirty-four, was an immediate best-seller. It won the Pulitzer Prize. It was made into a hit movie. And then came nothing. In 1961, Lee told an interviewer that she was working on her second novel, but that she wrote very slowly, producing only a page or two a day. Maybe we will hear from her yet, but she is now seventy-eight.

We will not hear from Ralph Ellison. Ellison's first novel, *Invisible Man* (1952), was also a best-seller, and more than that. It was an "art" novel, a modernist novel, and it was by a black writer. It therefore raised hopes that literary segregation might be breachable. In its style the book combined the arts of black culture—above all, jazz—with white influences: Dostoevsky, Joyce, Faulkner. Its message was likewise integrationist—good news in the 1950s, at the beginning of the civil rights movement. *Invisible Man* became a fixture of American-literature curricula. Ellison was awarded the Presidential Medal of Freedom. He was not just a writer; he was a hero. And everyone had great hopes for his second novel.

So did he. It was to be a "symphonic" novel, combining voices from all parts of the culture. It grew and grew. Eventually, he thought it might require three volumes. He worked on it for forty

years, until he died in 1994, at the age of eighty, leaving behind more than two thousand pages of manuscript and notes. His literary executor, John F. Callahan, tried at first to assemble the projected symphonic work. Finally, he threw up his hands and carved a simpler, one-volume novel out of the material. This book, entitled *Juneteenth*, was published in 1999. Some reviewers praised it; others cold-shouldered it, as not-Ellison.

Ellison's was probably the most commented upon case of block in the history of American literature, and it was a tremendous sorrow to him. He had other griefs, too. While his integrationist message was welcomed in the 1950s, by the '70s it looked to many people, particularly black writers, like Uncle Tomism, and this stately man was booed and heckled when he spoke at public events. In discussions of writer's block, it is sometimes said that a writer can be stopped when he outlives the world he was writing about, and for. That may have been true, in part, for Ellison.

LONG before the 1950s—indeed, starting with Freud's 1910 book on Leonardo da Vinci—psychoanalysts were pondering creative block, and what they saw there, as elsewhere, was unconscious conflict. According to this line of thought, the artist trawls his unconscious for his material, but every now and then, in that dark estuary, he encounters something so frightening to him that he simply comes to a halt, and no one ever knows why. Maybe so, but sometimes the conflict is conscious: the artist knows why. Such may have been the case with E. M. Forster, who published five successful novels and then, to the dismay of his readers, gave up fiction at the age of forty-five. According to some commentators, part of the problem was that Forster finally figured out, in his thirties, that he was homosexual, at which point he felt he could no longer write about heterosexual love and marriage, which had been the substance of his fiction. Nor could he publish a novel about homosexuals; such a thing could not be printed in England in his time. He did write a homosexual novel, *Maurice*, which he finished in 1914, but he had to put it in a drawer. After a ten-year gap, he produced one final novel, his greatest, *A Passage to India*—

again heterosexual, but with a newly dark view of sex—and then, for the remaining forty-six years of his life, he confined himself to nonfiction. It should be added that he expressed no regret over this, a fact that may place him outside the category of the blocked. Presumably, a blocked writer feels guilty, feels like a failure—the Coleridge pattern.

A purer and more colorful example is that of Henry Roth. Roth's first novel, *Call It Sleep,* a highly autobiographical narrative of Jewish immigrant life in New York, was published in 1934, when he was twenty-eight. It did not make much of a splash at first, but when it was reprinted in paperback, in 1964, it became a sensation. At the time of the reprint, Roth was living in complete obscurity on a duck farm in Maine. Apart from a few stories soon after *Call It Sleep,* he hadn't published anything in thirty years. Nor did his belated triumph rouse him quickly, though the royalties from the paperback allowed him to sell the duck farm and buy a mobile home in Albuquerque. But in 1979, at the age of seventy-three, he embarked on a new novel, which eventually swelled to four volumes, under the general title *Mercy of a Rude Stream.* The first volume appeared in 1994, and it was well received. In 1995 came the second volume, *A Diving Rock on the Hudson,* and this was greeted with even more interest, for in it the protagonist, Ira—who Roth gave readers every reason to believe was based on himself—begins an affair at age fifteen with his twelve-year-old sister, Minnie. The sex scenes are very raw. Ira and Minnie go to it every Sunday morning when their mother leaves to do her shopping.

Prior to the publication of *A Diving Rock,* Roth's editor, Robert Weil, then of St. Martin's, persuaded him to alert his sister, Rose Broder, to the contents of the book. "How can you do this to me?" she wrote back, and she reminded him that she was the one who had believed in him as a writer, and who had typed *Call It Sleep.* Roth responded by prefacing *A Diving Rock* with a statement that none of it was autobiographical—which many people took as further indication that it was autobiographical. Once the book came out, interviewers called Broder, and she denied the whole thing. "This is not pleasant for me," she told *The Jewish Week.* "I'm a very old lady." Soon afterward, she entered into an

agreement with Roth whereby, in return for immunity from legal action, he paid her ten thousand dollars and promised that in future volumes there would be no more sex between Ira and Minnie. Roth told Weil—his narrator also says it in *A Diving Rock*—that the incest story was a major reason that the novel was delayed for so many years.

Beneath this drama, however, there may lie another tale. When Roth wrote *Call It Sleep*, he was living with Eda Lou Walton, a well-known critic, twelve years older than he, who, he said, was "a mistress and a mother" to him. Walton later claimed that she did a huge amount of editorial work on *Call It Sleep*. When Roth returned to fiction, he had another helper at his elbow. In 1989, a seventeen-year-old high-school student, Felicia Steele, went to work for Roth as his typist, and she soon graduated from typing to editing. For a year, she and her boyfriend even moved in with Roth. Day by day, she worked on his manuscript, cutting and shaping it under Robert Weil's direction. Steele, now an English professor at the College of New Jersey, says that she was grateful to have this task: "I got a whole second education from Henry." Weil, too, says he felt honored to serve Roth's gift. For both of them, however, it was a herculean labor, requiring five years' work on thousands of pages of manuscript. So while Roth's sixty-year dry period may have been due to his feelings about his relationship with his sister, he may also, during those years, have had another, less sensational problem: that he couldn't produce a finished manuscript without a full-time editor.

THESE are among the most famous writer's block stories in modern literature—the supposed spine-tinglers—and all of them, when you look at them, come to seem unremarkable. Maybe the English are right: block is just a hocus-pocus covering life's regular, humbling facts. People made too much fuss over you, or expected too much of you. Or you just got tired. When I put the question of block to Elizabeth Hardwick, who was part of New York's high-pressure literary world in the postwar years, she seemed to believe that a major problem was just the passing of youth. "I don't think getting older is good for the creative

process," she said. "Writing is so hard. It's the only time in your life when you have to think." But loss of energy is only one problem. Some people use up their material. There has been much puzzlement among literary historians over the petering out of Melville's career as a novelist after he published *Moby-Dick,* at the age of thirty-two, and various theories have been advanced: that he was permanently embittered by the reviews of *Moby-Dick,* that he felt his novels revealed too much about his latent homosexuality, and so forth. But John Updike, in an essay on this question, says that basically Melville exhausted his storytelling capital—his seafaring years—in *Typee, Omoo,* and *Moby-Dick.* If, after those books, he wrote a couple of mediocre novels and then gave up on the form, it is no surprise.

With so many ordinary facts lurking behind its impressive name, writer's block may come to seem just that, a name, and names can be dangerous. The philosopher Ian Hacking has written about the problem of "dynamic nominalism," meaning that once you invent a category—as, for example, the category of "homosexual" seems to have been invented in the late nineteenth century—people will sort themselves into it, behave according to the description, and thus contrive new ways of being. Possibly, some writers become blocked simply because the concept exists, and invoking it is easier for them than writing. Some may also find it a more interesting complaint to bring to a psychoanalyst than garden-variety inertia. (One analyst, Donald Kaplan, has written that analysis may in fact not be good for blocked writers. They use it, he says, as a further excuse for procrastination. First I'll finish the analysis, they say, then I'll tackle the book.) But for most writers the danger of "block" is that it gives them something to scare themselves with. They are a superstitious lot anyway. Alice Flaherty, in *The Midnight Disease,* tells the story of a novelist who, at a literary dinner party, brought up the subject of block. Later, she got angry phone calls from several of the other guests, telling her that her thoughtless remark left them unable to write for days.

They have reason to be jumpy, though. Writing is a nerve-flaying job. First of all, what the Symbolists said is true: clichés come to the mind much more readily than anything fresh or

exact. To hack one's way past them requires a huge, bleeding effort. (For anyone who wonders why seasoned writers tend to write for only about three or four hours a day, that's the answer.) In the same interview in which Anthony Burgess sneered at crybaby Americans, he concluded by saying that a writer can never be happy: "The anxiety involved is intolerable. And . . . the financial rewards just don't make up for the expenditure of energy, the damage to health caused by stimulants and narcotics, the fear that one's work isn't good enough. I think, if I had enough money, I'd give up writing tomorrow."

Apart from the effort, there is the self-exposure. The American reading public knows more about Philip Roth than they know about some of their first-degree relatives, and though Roth may have had some pleasure in that unveiling, it is probably no accident that he now lives in the country, where people are less likely to meet him on the street and tell him what they think of him. (J. D. Salinger also retreated to the woods, shortly after the publication of *The Catcher in the Rye,* in 1951. Reportedly, he has gone on writing—there are tales of a room-sized safe filled with manuscripts—but he hasn't published anything in forty years. "Publishing is a terrible invasion of my privacy," he said in a rare interview in 1974.) I can say from experience that even if you are not a novelist, even if you are a reviewer of dance and books, total strangers will come up to you and say that they know how you feel, and not just about dance and books. They are right. You told them how you felt.

Anxiety over self-revelation was probably not as common in the old days, when the exposure was channelled through conventional forms (ode, sonnet) that masked the writer's identity to some extent. In former times, too, art forthrightly answered the audience's emotional needs: tell me a story, sing me a song. Modernism, in refusing to do that duty, may have a lot to answer for in the development of artistic neurosis. If art wasn't going to address the audience's basic needs, then presumably it was doing something more exalted, more mysterious—something, in other words, that could put the artist into a sweat. As long as art remained, in some measure, artisanal—with, for example, the young Leonardo da Vinci arriving in the morning at Verrocchio's studio and being

told to paint in the angel's wing—it must have fostered steadier minds. Still, I wonder whether the artist's task was ever easy. Leonardo's contemporaries reported that his hand shook as he plied the brush. And he left many works unfinished. Freud hypothesized that Leonardo's problems stemmed from the Oedipus complex. (He was born illegitimate; his abandoned mother kissed him too much.) But could they have been due to a less sexy cause—sheer ambition? Competition among Italian artists of the Renaissance was intense. In his later life, Leonardo quit painting for long periods.

Art-making should be a nice job, yet somehow, for many people, it's not. And they don't know why and would rather not think about it. Once, in an unintentionally comic essay, the analyst Donald Kaplan, who was very interested in art, reported ruefully that his artist patients rarely discussed their work with him. If they even mentioned it, they used it only as a chronological marker (" 'It was around the time I was doing those brown paintings' "). All they wanted to talk about was the circumstances around their work: noisy children, obtuse reviewers. And, once Kaplan helped them deal with these matters, they quit treatment. They didn't know and didn't care what underlay their creative function. They just wanted to get back to it, as long as it lasted.

The New Yorker, 2004

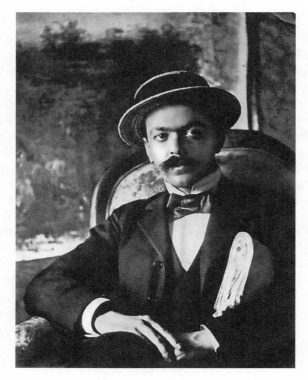

*Italo Svevo, 1892, with the page proofs
of* Una vita *under his arm*

True Confessions

I N 1907, Ettore Schmitz, a Triestine businessman, found
himself in need of a language tutor. Every year he spent a
couple of months in England—his company had a branch
there—and he was ashamed that his English was so bad. Friends
recommended a certain James Joyce, who had landed in Trieste
two years earlier and was making his living as an English teacher.
Joyce was twenty-five, poor and unkempt, a frequenter of taverns,
a borrower of rent money. He had not yet published a book, but
he was full of confidence. He thought he was a genius. Schmitz,
by contrast, was in his mid-forties, and though he was a comfort-
ably settled bourgeois, a partner in a marine-paint company, this
was due to his having married the daughter of the firm's owner.
Before that, he had worked as a bank clerk. He was a genial, witty
man, but modest, self-effacing.

In the course of their tutorials, Joyce told Schmitz that he was
a writer. He showed him the proofs of *Chamber Music,* a book
of his poetry that was about to come out, and he gave him a few
stories to read from a projected collection, *Dubliners.* Eventu-
ally, Schmitz confessed that he, too, was a literary man, in a small
way. Years before, under the pen name of Italo Svevo, he had writ-
ten two novels, *Una vita* and *Senilità* (they were later given the
English titles *A Life* and *As a Man Grows Older*), and though
the books were nothing, Schmitz said—published at his own ex-
pense, barely reviewed—perhaps Signor Joyce would be so kind
as to accept copies of them? When Joyce returned for the next
lesson, he declared that Schmitz was a marvellous writer, un-
justly neglected, and that the great French realists could not
have matched certain paragraphs of *As a Man Grows Older*—

paragraphs that Joyce then recited from memory to the dazzled paint manufacturer.

There were no grammar lessons that day. Schmitz poured out his heart to Joyce, told him of his literary labors, his hopes, his disappointments. When the time was up, he could not bear to part with this fine man, and walked him almost all the way home, bending his ear some more. Nevertheless, he took no encouragement from Joyce's praise. After the failure of his second novel, ten years earlier, he had sworn off writing, and he kept his vow. (Once, when a business acquaintance asked him if it was true that he had published two novels, he said no—that was his brother Adolfo.) In 1915, Joyce left Trieste and moved to Zurich, then to Paris. The two men remained in Christmas-card contact.

But shortly before Joyce left, something happened: the First World War broke out. Trieste was in an odd position in the conflict. It was part of the Austro-Hungarian Empire—indeed, the empire's major seaport—yet historically it was Italian, and full of irredentists, ethnic Italians devoted to their homeland's reclaiming of its former territories. At the start of the war, many members of Schmitz's heavily irredentist family fled to Italy. His home, formerly crammed with relatives and servants, emptied out. At the same time, the Austro-Hungarian authorities closed down the paint factory. Schmitz and his wife, Livia, were stuck in the house with nothing to do, whereupon Schmitz broke his vow and started writing again. When the war stopped, he didn't, and in 1922, in a lather of energy—smoking like crazy, and barely coming down for meals—he completed a new novel, *Confessions of Zeno* (*La coscienza di Zeno*). It was published the following year, again at his own expense, and it had the same reception as its predecessors.

Schmitz was terribly disappointed, but he had one last thought. He sent the book to his old English teacher. Joyce was a different man now, a famous artist (*Ulysses* had been published in 1922) and an expert literary publicist. He wrote back saying that Schmitz should immediately send *Confessions of Zeno,* on his recommendation, to Ford Madox Ford and T. S. Eliot in London, Gilbert Seldes in New York, and Valéry Larbaud and Benjamin Crémieux in Paris—an A-list of the literary arbiters of the day.

Schmitz did as he was told, and two of these arrows hit the mark. In 1926, *Le Navire d'Argent,* a Paris journal devoted to modern literature, published excerpts from *As a Man Grows Older* and *Confessions of Zeno,* translated by Crémieux and Larbaud, together with an enthusiastic essay on Schmitz by Crémieux. Suddenly, Italo Svevo was the sensation of Paris literary circles. The news made its way back to Italy, where the poet Eugenio Montale, alerted by the French, had just published a long essay in which he described Svevo's work as "the poem of our complex modern madness" and claimed that it was only because of the debased condition of Italian letters that he had been ignored. Soon Svevo's work was being translated into other languages. Dinners were given in his honor. When he entered literary cafés, people clapped him on the back and asked him to sit at their table.

"No writer ever so enjoyed his fame," a friend of Svevo's wrote. He acted as if he had won the lottery. He confessed to a journalist that on a recent trip to Paris, the birthplace of his celebrity, he could not see the *ville lumière.* All he could see was himself: "Italo Svevo among the treasures of the Louvre . . . Italo Svevo at Versailles." Hailed as the author of Italy's first modernist novel—"the Italian Proust," a French newspaper called him—he now took a look at some modernist novels. He read Proust, or said he did. He struggled through *Ulysses,* even gave a lecture on it. He discovered Kafka's work, and was bowled over by it. In 1928, he embarked on a new novel, a sequel to *Confessions of Zeno.* At the same time, he began having health problems. He went to a spa, to take a cure, with Livia and their little grandson Paolo. On the way home, in a driving rain, the chauffeur crashed the car into a tree. Everyone survived except Svevo. His heart stopped the next day.

HE had been famous for two years, but, even in Italy, his fame was unstable. During his lifetime, it was the younger writers who lionized him; the established critics were not pleased to be told by the French that they had failed to recognize a prophet in their own land, and they defended their former position. Also, nobody knew how to place Svevo. In the words of his best biographer, P. N. Furbank, "Attempts have been made to claim him for a vari-

ety of sectional interests—for Triestine regionalism, Italian irre-
dentism, and 'eternal-Jewishness' " (he was Jewish), but he always
fell short of the required commitment. Furthermore, his best
novel, *Confessions of Zeno,* was a comic novel, and comedy was not
something that people in the 1920s associated with profundity.

Those who wished to dismiss him had something substantial
to point to: his graceless Italian. Svevo's native tongue was the Tri-
estine dialect; his second language, the language of his schooling,
was German. (Hence his pen name, Italo Svevo: Swabian Italian.)
Standard, Florentine Italian was a foreign language to him. That's
what he had to write in if he wanted a readership beyond Trieste,
but he did not do it beautifully or even, on occasion, grammati-
cally. "The Italian of a bookkeeper," critics said. There is an
answer to this. Svevo's characters *were* bookkeepers. The world of
his fiction was Trieste, an unpoetic commercial city, home of
bankers and traders and manufacturers, of which he was one. As
Montale put it, "The smell of the warehouse and cellar, the almost
Goldonian chatter of the Tergesteo"—the stock exchange—"are
they not the sure presence of a style?" They may be to us, who
have soldiered through the unpoetic prose of Dreiser and Sinclair
Lewis. But the critics of Svevo's time were raised on d'Annunzio,
and to them Svevo's language was simply unliterary.

It wasn't just in Italy, though, that Svevo was treated as second
best. His work was never installed, as it should have been, in the
pantheon of the modernist novel. I know people who have read
The Man Without Qualities, both volumes, and *Remembrance of
Things Past,* all seven volumes, who have never opened a book by
Svevo.

They now have a chance to correct that oversight. Svevo is
undergoing a publishing revival. *A Life,* in a perfectly decent 1963
translation by Archibald Colquhoun, has just been reprinted. As
for *Senilità* and *La coscienza di Zeno,* they were first translated into
English in the thirties, by Beryl de Zoete, a dance scholar who fell
in love with Svevo's work and offered her services to his widow.
De Zoete's versions, entitled *As a Man Grows Older* and *Confes-
sions of Zeno,* are solid—they are what we have known for seventy
years as Svevo—and they are still in print or, in the case of *As a
Man Grows Older,* back in print, in the New York Review Books's

excellent "classics" series. But they are old, older than Svevo in a way: fussy, Constance Garnett-ish. For years they have cried out for competition, and competition has now come. Beth Archer Brombert has produced a version of *Senilità*, called *Emilio's Carnival*—Svevo's working title—that is faithful in a way that de Zoete was not. Brombert's language is very plain, and when she comes up against a knot in Svevo's prose she does not try to untie it. (De Zoete did.) We have to puzzle through it, just like the Italians. The same rules seem to have guided the distinguished translator William Weaver in his new version of *La coscienza di Zeno*—*Zeno's Conscience*. I do not like his title. The Italian *coscienza*, like its French cognate, means both "conscience" and "consciousness." There is no good way to translate it, and de Zoete's throwing up of hands, with *Confessions of Zeno*, was probably the best solution. But the title is the only thing wrong with Weaver's book. Its appearance is an event in modern publishing. In it—for the first time, I believe, in English—we get the true, dark music, the pewter tints, of Svevo's great last novel.

SVEVO had a happy childhood and a miserable young manhood. The sixth of eight children, he was born in Trieste in 1861 to an adoring mother and a gruff, decent father, a successful glassware merchant. As a child, he was mad for literature, but his father didn't want to hear about that. At the age of twelve, he was shipped off to a commercial school in Germany, where he managed to read a lot of Shakespeare and Schiller after lights-out. At seventeen, he returned to Trieste, and soon, presumably at his father's strong suggestion, he went to work as a correspondence clerk—basically, he translated letters—in a local bank. There he remained for almost twenty years, bored out of his mind. He spent his nights in the dusty reading room of the public library, submitting call slips to a bizarre attendant who, according to the poet Umberto Saba, Svevo's friend, "waited beside a window from which he eventually jumped to his death."

Svevo was now a convert to French realism: Balzac, Flaubert, Daudet, Zola above all. "Zola was his god," his wife later wrote. (As part of the Svevo boom, her lovely, genteel biography, *Memoir*

of Italo Svevo, has just been reprinted by Marlboro Press.) The laws of life seemed to him harsh, and those authors agreed. He tried to write—mostly plays, mostly unfinished—but, according to the diary of his brother Elio, the person closest to him, he burned almost everything he produced. When Svevo was twenty-five, Elio died, followed by two of their sisters. Meanwhile, the father's business had declined precipitously, and the old man wandered around the house like a ghost, some days refusing to eat or speak. Svevo lived in a permanent, low-level melancholy. "My real strength always lay in hoping," he wrote on his twenty-eighth birthday. "I'm even losing my talent for that."

Two years earlier, he had begun his first novel, *A Life,* and it was a mirror of his own life. It tells the story of Alfonso Nitti, a clerk in a Triestine bank, who spends his evenings in the public library, dreaming of writing books. Alfonso seduces a rich girl whom he does not love. (See *The Red and the Black.*) His aged mother dies—a protracted business of bedsores and smells and people making off with the furniture. (See *Nana, Le Père Goriot.*) Some of this is very smartly done, worthy of its French models, but the qualities at the heart of the story actually have little to do with French realism. There is too much grave, personal sorrow—the book throbs like a wound—to be processed by that cold machinery. Also, Svevo simply did not have enough certainty to join the ranks of Balzac and Zola. His world was not theirs, the world of causes—social, historical, economic—but something almost causeless, the *mal du siècle,* in its turn-of-the-century form: the crippling of action by thought, the erasure of the present by the future (fantasy) and the past (remorse). Bad as his circumstances are, Alfonso's main problem is internal. He cannot seem to *do* anything; he is too self-conscious, too busy watching himself. Like Joyce and Proust soon afterward, Svevo had discovered the subject of the twentieth-century novel, the self-imprisonment of the mind, but he didn't know how to write anything but a nineteenth-century novel.

Nor, for a while, did he find out. After the failure of *Una vita,* something happened that changed Svevo's life. At his mother's deathbed, a second cousin of his, Livia Veneziani, seeing his distress, brought him a glass of marsala. He had never noticed Livia

before. Now he did. She was blond and kind and rich. Over her parents' objections—he was poor and neurotic and thirteen years her senior—they married in 1896 and had a baby, Letizia ("Happiness"), the following year.

"I will love you forever," Svevo wrote to Livia, "as far as the *fin de siècle* will allow." It allowed only so much. He drove her crazy with his jealousy and hypochondria. Nor could she understand his weird ideas. He gave her Schopenhauer to read, and August Bebel's *Women and Socialism.* She looked at him as if he were insane. Also, why did he have to be Jewish? Anti-Semitism wasn't much of an issue in Trieste at that time, and Livia herself was one-quarter Jewish. Nevertheless, she was emphatically Catholic, a convent girl. After giving birth to Letizia, she fell ill and was terrified by the thought that she would die with the sin of having married a Jew on her conscience. Svevo gallantly went out and got himself baptized, though he refused to take religious instruction and never, later, described himself as anything but Jewish. (After his death, Livia returned the favor. In the late thirties, the "race office" in Rome balked at registering her as an Aryan—a problem she was told she could solve with a large bribe. Indignant, she declared herself a Jew. As a result, she had to flee Trieste in 1943. She spent the remaining war years in Treviso province, in great danger.) Yet, whatever their occasional bewilderment with each other, they were a happy couple. "My blond," he called her, "my one great, great hope, of true, solid happiness." He might be "ill"—assailed by doubts and fears—but that was all right as long as he could orbit her "health." When he was downcast, she comforted him. When he took Letizia to the fair and came back alone—he was almost pathologically absentminded—she went and got the child. In return, he became a regular person, a family man.

ACCORDING to Svevo, Joyce used to say that a novelist had only one book in him; if he produced more, they were the same book, in a new key. No one demonstrates this principle better than Svevo. Emboldened by his happy marriage, he wrote a second novel, *Senilità.* As the title tells us, it was once again about illness,

but it breathed a new assurance. Where *Una vita* wandered about a lot, *Senilità* has one subject, the love affair between its hero, Emilio Brentani, a clerk in an insurance company (who once wrote a novel), and a high-class tart named Angiolina. With no introductory fuss, we meet the two of them on the first page, walking down the street, as Emilio, pedantically discoursing on his feelings for Angiolina, begins winding himself in a knot of obsession, jealousy, and contempt that will bind him to her for the rest of the book, and as she, tapping her pretty parasol in the gravel, looks at him to judge how she should play this game. The novel is perfectly realistic and, again, partly autobiographical. (Svevo had had such a girlfriend. She later became a circus performer.) As in Proust's tale of Swann and Odette, the love affair is a metaphor. Emilio is the mind; Angiolina is the world. Or, to put it in Svevo's terms, Emilio is "sickness," and Angiolina is "health." Neither comes off well, but the business of the novel is the portrayal of Emilio's feelings, fantastically mixed, with each new impulse undermined by its opposite. In other words, this is the same story as *Una vita,* but it is far more concentrated, subtle, and disturbing. As Emilio suffers over Angiolina, his spinster sister, Amalia, by way of participating, falls equally in love with a friend of his who barely notices her. In bed at night, Emilio hears through the walls the love cries she utters in her sleep.

Senilità is also far more confident in its tone, which is steadily distanced. At the end, Emilio, having lost both Angiolina and Amalia—Amalia dies, Angiolina runs off with a bank teller—lives on rather comfortably. In his mind, he combines the two women into one, whom he worships: "He saw her before him as on an altar. . . . She represented everything noble that he had thought and observed during that period." The irony is both soft and lethal. There was nothing noble in his relations with either of those women.

Furbank calls *Senilità* "one of the solidest masterpieces of nineteenth-century fiction." I think that it is a fine piece of work, but also that Svevo still had somewhere else to go. The novel's irony is heavy; it protests too much. And there are many things in the book that undermine that stolid position. One small example: Angiolina has a younger sister, a scrawny little thing whose name

we are never given. When we first encounter her, early in the narrative, she is ten years old. She opens the door for Emilio and, seeing a stranger, raises her hand "to close the edges of her jacket across her chest—the buttons were missing." At the end of the book, after he has lost Angiolina, Emilio calls on her family again. He is received by the mother, but she promptly exits, and then the little sister, maybe twelve now, enters the room and curtsies. Emilio tells her what he meant to tell her mother, that he will never come again. She protests, and covers his face with "kisses that were anything but childish." Clearly the mother is thinking that if she can no longer offer Angiolina's services (Emilio helped support the family), perhaps the sister's will do. Emilio is disgusted and gets up to go. But first he leans down and pats the head of the little girl, "whom he did not want to leave disheartened." He remembers that she is a child. This is not the stuff of which Zolaesque novels are made. Likewise, throughout the book there are notes of sweetness and drollery which suggest that a different novel, one more forgiving of "sickness" and of life itself, is fighting to get out. It got out—in *La coscienza di Zeno*—but not for twenty-five years.

WE will never know what happened to Svevo in those years to lead him out of realism and into modernism. Perhaps it was just age and self-acceptance, or perhaps it was the war. But one thing that we know made a difference—not as a cause but as a trigger—was Freud. During his idle war years, Svevo became interested in the sage of Vienna; he even made a stab at translating him. Some critics believe that *La coscienza di Zeno* is a Freudian book—that to Svevo, as to a psychoanalyst, the hero, Zeno, is "sick," that his reasoning is self-delusion, and that if he would just confront the true causes of his behavior he would be cured. It is hard to understand how anyone coming up against the desperate comedy and muted tragedy of *Zeno* could think such things. Zeno's situation doesn't look like an illness, let alone a curable one. It looks like life, and art. According to Furbank, Svevo thought psychoanalysis was worthless as a treatment. (His crazy brother-in-law Bruno was analyzed by Freud and came back two years later crazier than

ever.) What interested him in Freud was the theory of defense mechanisms: rationalization, displacement, the whole arsenal of self-justification. This is what he himself had been analyzing for years, in *Una vita* and *Senilità,* and in his own life.

More than confirming his ideas, Freud suggested to Svevo a new kind of novelistic structure. Before, Svevo had given us his heroes' mental processes in standard third-person narrative. Emilio felt this, Emilio felt that, sometimes at tedious length. But what if, instead of observing the modern mind from the outside—its immersion in thought, its paralysis of will, its tangled motives, its confusion of time planes—what if the novelist were to record this from the inside, let the hero tell his own story, in a way that reflected as faithfully as possible the movements of his psyche? In other words, what if the novel, instead of describing a cat's cradle, *became* a cat's cradle? And so, jumping the gun on *Portnoy's Complaint* by almost fifty years, Svevo made *La coscienza di Zeno* the hero's confessions to his psychoanalyst.

THE book opens with a preface by the analyst, Dr. S., who informs us that the following material is a testimonial by his patient Zeno Cosini. Zeno, whose father believed him incompetent to manage his inheritance and therefore put an accountant in charge, is a man with little to do. He entered psychoanalysis to find out why that little was done so badly. Dr. S. got him to write up his memories, but then, just as the doctor was about to dig into this delicious material—so full of truths and lies, he says—Zeno suspended treatment. Dr. S. is publishing the manuscript in revenge.

There follows the manuscript, Zeno's account of crucial episodes in his life: his efforts to stop smoking; the death of his father; his love for a beautiful girl named Ada Malfenti and his marriage to her sister; his affair with a singer named Carla; and his business partnership with Guido Speier, the man who won Ada. All this happens in five chapters. Then comes the final chapter, again written by Zeno, but a year later, after the beginning of the First World War. In it, he announces that everything he wrote for Dr. S. was a tissue of lies. He is no longer neurotic; he has

been cured, by the war. He needs to get the manuscript back and rewrite it, this time accurately.

And so the modernist novel was born in Italy. Chronological time is gone. As in Joyce and Proust, the past is folded into the present. Also gone, as in the work of Svevo's colleagues, is truth. If we want Zeno's real story, we can choose among the conflicting accounts of three witnesses: Dr. S., the earlier Zeno, and the later Zeno. Even within the individual narratives, every story casts doubt on itself. Zeno's confession begins with a comedy, the story of his going to a sanatorium in order to stop smoking. But, without ever ceasing to be comic, the tale gently tips over into pathos. A nurse, Giovanna, assigned to supervise Zeno's detoxification, ends up giving him a handful of cigarettes because she is old and lonely and the wily Zeno has convinced her that when he is primed with nicotine no woman is safe in his presence. He smokes them all and then escapes from the sanatorium.

In the next chapter, "My Father's Death," the logic is the opposite. The story is scathing—Zeno's account of how insensitive he was to his dying father—but it is also very funny, and it has a real tragic grandeur. At one point, the father, unable to get comfortable in bed, moves to an armchair and gazes out the window at the starry sky:

> I tried to identify the exact point of the sky at which he was staring. He looked up, his trunk erect, with the effort of someone peering through an aperture too high for him. It seemed to me he was looking at the Pleiades. Perhaps in his whole life he had never looked so long at something so far off. Suddenly he turned to me and, still erect, he said: "Look! Look!" with an air of severe admonition. He went back immediately to staring at the sky, then he faced me once more: "You see? You see?"

The father is trying, before he dies, to pass on to his feckless son some important truth that he has discovered. But the very discovery, as Zeno points out, was "the first symptom of a cerebral hemorrhage." The father has found the meaning of life, and it is death.

Svevo took his psychoanalytic model seriously. Often we see

the defenses working quite openly, yet they operate with a truth that is not just psychological but literary. When Zeno falls in love with Ada Malfenti, he never notices that she is utterly wrong for him. He is a nut; she is a serious girl. She can't stand him. Finally, one night, he proposes to her. She instantly refuses him:

> I have forgotten the many scornful words she addressed to me, but not her beautiful, noble, and healthy face flushed with outrage, its lines made sharper as if chiseled by her indignation. This I never afterwards forgot, and when I think of my love and my youth, I see again the beautiful and noble and healthy face of Ada at the moment when she dismissed me definitively from her destiny.

A psychoanalytic mechanism, repression, has become a literary mechanism, omission, and Ada's words, however deleted, are burned on our brains.

Elsewhere, the situation is more mixed, unsettlingly so. Zeno eventually marries the lovely Ada's homely sister, Augusta. The marriage is happy, but at one point Augusta, who knew of his love for Ada, has a moment's vestigial jealousy, and imagines that Zeno is still pining for her sister. By this time, Ada is ill with goiter—her beauty is destroyed—and Zeno, thinking to reassure Augusta, cruelly puffs out his cheeks and bugs out his eyes in imitation of Ada's ruined face. Augusta laughs and is immediately ashamed, but that is nothing compared with what takes place in Zeno's mind. Painfully, even as he is mocking Ada's face, he feels as though he were kissing her. Later, he says, "When I was alone, I repeated that effort several times, with desire and repulsion." Nothing like this, nothing so psychologically exact and so morally confounding, had ever been recorded in the Italian novel—indeed, in the European novel.

With Svevo's shift from realism to modernism came an enormous gain in charity. In *Una vita* and *Senilità* the mistress is a bitch; death in the family is a nightmare; the hero can barely endure his self-contempt. In *Zeno* the mistress, Carla, is a sweet girl, with shining braids; the father's death is leavened with comedy; and the hero's shame is seen with a wise eye. Before Zeno

beds Carla, he has a dream about her, in which he is kissing her white neck, then eating it. But her neck never bleeds; it remains whole. Furthermore, Augusta is there, and Zeno says to her, "I won't eat it all; I'll leave a piece for you, too." This is a psychological truth, a negotiation between desire and guilt, but it is also a moral truth. Everyone gets a bite; no one is hurt. Augusta never finds out about the affair, and it is Carla who eventually breaks it off. She dumps Zeno and marries her singing teacher.

In his later years, the years surrounding *Zeno,* Svevo had a few things to say about Mother Nature. She was not on our side, he claimed, but neither was she against us. She just had a lot on her mind, and we reaped the benefits of her inattention. "Mother Nature," he wrote, "created sexual pleasure to guarantee reproduction. If, having obtained that, she allows the capacity for pleasure to go on existing, she does so only out of absentmindedness, just as certain insects go on wearing their mating colors after the mating season is over. Running a business of that size, you can't attend to every detail." And so it is in *Zeno.* Zeno loses Ada but gets a better woman, Augusta. He is defeated by Guido, but then he has the satisfaction—and the pain, he protests, the pain!—of seeing Guido defeat himself, indeed commit suicide, by accident. Guido takes Veronal, but he meant to be rescued. He was only trying to pressure Ada into investing some money in his business. But the doctor arrives too late. Zeno, standing over Guido's corpse, sees on his face "a great stupefaction at being dead without having wanted to be"—a perfect Svevianism.

But there are perfect Svevianisms on every page of Svevo. Why does Carla drop Zeno? Well, Carla asks to see his wife, and he agrees, but at the last minute, he arranges for Carla, waiting on a street corner, to see Ada rather than Augusta. Don't ask why. Perhaps he still believes that Ada is beautiful, and, out of vanity, he wants Carla to think he has a beautiful wife. Perhaps, out of decency, he cannot bear to have his innocent wife spied on by his mistress. But what he does not realize is that Ada, her ruined looks aside, knows her own husband is having an affair, and she is heartbroken—a fact that the good-hearted Carla understands instantly. If Zeno had allowed Carla to see Augusta—happy, dumpy, unaware of her husband's derelictions—everything would have been

okay. But no, Carla sees Ada, and believes herself to be the cause of that poor woman's grief, and tells Zeno to go away, go back to his wife. Zeno cannot bring himself to confess his ruse, so that's the end of his relationship with Carla of the shining braids. This is something that could have been imagined only by Svevo. He is a thorny item, a one-masterpiece master, but a master nevertheless.

The New Yorker, 2002

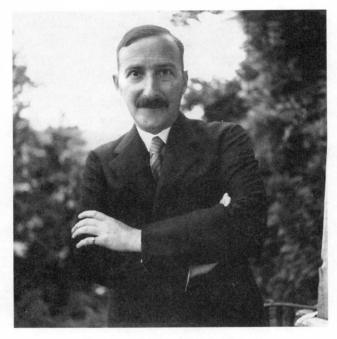

Stefan Zweig at his home in Salzburg, 1931

Quicksand

IN the 1920s and 1930s Stefan Zweig was an immensely popular writer, a man who had to barricade himself in his house in Salzburg in order to avoid the fans lurking around his property in the hope of waylaying him. According to his publisher, he was the most widely translated author in the world. Today, while he is still read in Germany and also in France, his name is barely known to the average Anglophone reader. In the last few decades, however, there has been an effort on the part of several publishers to get Zweig back into print in English. In my opinion, no book of his deserves reissue more than his one completed novel, *Beware of Pity* (*Ungeduld des Herzens,* 1938).

Zweig was a friend and admirer of Sigmund Freud's, his fellow Viennese, and it was no doubt Freud's writings, together with the experience of two world wars, that persuaded him of the fundamental irrationalism of the human mind. Absolutely central to his fiction is the subject of obsession. And so it is with *Beware of Pity.* To my knowledge, this book is the first sustained fictional portrait of emotional blackmail based on guilt. Today, it is a commonplace that one person may enslave another by excessive love, laced with appeals to gratitude, compassion, and duty, and that the loved one may actually feel those sentiments—love, too, of a sort— while at the same time wanting nothing more than to be out the door. But even in the iconoclastic thirties, gratitude, compassion, and duty were not yet widely seen as potential engines of tyranny. It was partly for Freud's cold examination of those motives that Zweig admired him—"he enlarged the sincerity of the universe," Zweig wrote—and in *Beware of Pity* he carried the analysis forward.

The story opens in 1913, in a small garrison town on the Hun-

garian frontier. Stationed there is Anton Hofmiller, a second lieutenant of the Austro-Hungarian cavalry. He is twenty-five, but having spent much of his life in a military academy, he is younger than his years. One night he wangles an invitation to dinner at the local *Schloss,* the home of Herr Lajos von Kekesfalva, a rich industrialist. He spends the evening in a daze of Tokay and admiration. The halls are hung with Gobelins; the dinner is magnificent; his seatmate, Kekesfalva's niece Ilona, has arms "like peeled peaches"; he dances the night away. Then, as he is about to leave, he remembers that his host has a daughter—Edith, seventeen or eighteen years old—and that he should ask her to dance. In a side room, he finds her, a frail-looking girl with gray eyes. He bows to her, and says, "May I have this dance, *gnädiges Fräulein*?" (All quotations of *Beware of Pity* are from the translation by Phyllis and Trevor Blewitt.) Her response is not what he expected:

> The bowed head and shoulders jerked backwards, as though to avoid a blow; . . . the eyes stared fixedly at me with an expression of horror such as I had never before encountered in my whole life. The next moment a shudder passed through the whole convulsed body. . . . And suddenly there burst forth a storm of sobbing. . . . The weeping went on, grew, if anything, more vehement, breaking forth again and again, like a gush of blood, like a hot agony of vomiting, in spasm after spasm.

Hofmiller retreats to the salon, where Ilona intercepts him. "Are you mad?" she says. "Didn't you see her crippled legs?" No, he didn't; she was sitting at a table. He bolts from the house, his heart "hot with shame."

Edith has thus made her first strike, spontaneously. (As we discover, she often has such fits when something displeases her.) But for the *folie à deux* that is the novel's subject to take root, Hofmiller must make a complementary response. Already that night, he is appalled at having given such pain: "I felt as though I had struck an innocent child with a whip." At the same time, another thought—one that will become important as the story progresses—begins working on his mind: his prestige as an officer.

He has committed a gaffe, a social error, and has thereby dishonored both his regiment and himself within the regiment: "At our mess table every piece of idiocy on the part of any one of us was chewed over for the next ten or twenty years."

The next morning, spending all he has left of his month's pay, he sends Edith a great bouquet of roses. In return, he receives a note from her, inviting him to tea. He needn't say what day he's coming, she adds: "I am—alas!—always at home." Already she is appealing to his compassion, and when, the next afternoon, he pays his call, she does so again, telling him how, before the illness that paralyzed her legs five years earlier, she loved to dance, she wanted to be Pavlova. But alas!

The following day, the innocent Hofmiller is riding out to the morning parade, his men behind him:

> I am passionately fond of riding. I could feel the blood flowing from my hips, coursing through my relaxed limbs in a warm, pulsating, life-giving stream, while the cold air whistled round my brow and cheeks. Marvellous morning air: one could still taste the dew of the night in it, the breath of the loosened soil. . . . On, on, on, gallop, gallop, gallop! Ah, to ride thus, to ride thus to the ends of the earth!

But suddenly, in the midst of this ecstasy, he remembers Edith, and is ashamed of his physical strength, physical enjoyment. He orders his men to slow to a trot. Disappointed, they obey. That, Hofmiller says, was "the first symptom of the strange poisoning of my spirit by pity."

Interestingly, antisentimentally, the object of his pity is not endearing. Edith is narcissistic and imperious—a diva of pain. At tea the day before, she had had to leave her guest early (the masseur had arrived), and, though accustomed to using a wheelchair, this time she insisted on walking:

> She pressed her lips firmly together, raised herself on to the crutches and—tap-tap, tap-tap—stamped, swayed, heaved herself forward, contorted and witch-like, while the butler

held his hands out behind her to catch her should she slip or collapse. Tap-tap, tap-tap, tap-tap—first one foot and then the other, and between each step there was a faint clanking and squeaking as of tautly stretched leather and metal [the sound of her braces]. . . . She wanted to show me, me in particular, to show all of us, that she was a cripple. She wanted, out of a kind of mysterious vindictiveness born of despair, to torture us with her torture.

In the course of the novel, that "tap-tap" will come to sound like something out of Poe, and Edith's witchlike character will become more pronounced. In a way, her father, grieving for her, his only love (he is a widower), appeals more powerfully to Hofmiller's compassion than Edith does. Even in this grotesque scene, however, Zweig makes it clear that the wounded do deserve our pity. And how are we to withhold it, though in giving it in the measure they ask—Hofmiller is soon expected at the house every afternoon—we may feel coerced?

That, in any case, is Hofmiller's reasoning as, from day to day, he doles out the greater and greater reassurances that Edith demands. She of course falls in love with him, and her doctor tells him that he cannot disabuse her as to his feelings, or not yet, for this would doom a cure that she is about to undertake in Switzerland. So he descends ever deeper into hypocrisy. In the process, Zweig gives us a piercing analysis of the motives underlying pity. Gradually Hofmiller realizes how much he enjoys the courtesies paid to him for his emotional services, how it pleases him that when he arrives at the *Schloss* his favorite cigarettes—and also the novel (its pages already cut) that he had said in passing that he wanted to read—are laid out on the tea table. Nor is it lost on him that his own sense of strength is magnified by Edith's weakness and, above all, by his growing power over the Kekesfalvas, the fact that if he, a poor soldier, does not present himself at teatime, this great, rich household is thrown into a panic, and the chauffeur is dispatched to town to spy him out and see what he is doing in preference to waiting on Edith. Beyond the matter of power, however, Hofmiller finds that the emotion of pity is a pleasure just in

itself. It exalts him, takes him to a new place. Before, as an officer, he was required only to obey orders and be a good fellow. Now he is a moral being, a soul.

That anatomy of compassion is one of the book's foremost contributions, but any psychoanalyst could have done it. What only Zweig could have created are the scenes between Hofmiller and Edith: the concrete, subtle, and hair-raising enactments of ambivalence, hers as she vacillates between appealing to his pity and asking for his love, his as he is torn between solicitude and recoil. Late in the novel, during one of his visits, she finds his attentions insufficient. She starts to have one of her fits, and to allay it, he places his hand on her arm:

> Suddenly the spasm ceased; she grew rigid again and did not stir. It was as though her whole body were straining to understand what this touch indicated, to know whether it was a gesture of . . . love or merely of pity. It was terrible, this waiting with bated breath, this waiting of a tense, motionless body. I had not the courage to withdraw the hand which had with such marvellous suddenness stilled the paroxysm of sobs, and on the other hand I had not the strength to force from my fingers the caress that Edith's body, her burning flesh—I could tell—so urgently awaited. I let my hand lie there, as though it were not a part of me, and I felt as though all the blood in her body came surging in a warm pulsating stream to this one spot.

Now she moves his hand to her heart and begins caressing it:

> There was no avidity in this fervent stroking, only serene, awestruck bliss at being allowed at last to take fleeting possession of some part of my body. . . . I enjoyed the rippling of her fingers over my skin, the tingling of my nerves—I let it happen, powerless, defenceless, yet subconsciously ashamed at the thought of being loved so infinitely, while for my part feeling nothing but shy confusion, an embarrassed thrill.

The portrait of Hofmiller standing there awkwardly as Edith fondles his captured hand, the sheer, no-exit suffocation of the situation: the great psychologists of love (Stendhal, Flaubert, Tolstoy, Turgenev) never went further than this. The scene combines their moral knowledge with a kind of neurotic, subdermal excitement reminiscent of Schnitzler, a friend of Zweig's and another legatee of Freud's. Nothing in the book is more striking than this sustained and morbid tension: the nervous laughter, the drumming fingers, the moments of happiness that convert in an instant to fury and grief, with the cutlery suddenly thrown onto the plates. Like Hofmiller, the reader is dragged down, by the neck.

A few days after the above episode, Edith will again seize Hofmiller's hand, and slip an engagement ring onto his finger. From there, the relationship moves swiftly to its fated, disastrous conclusion. Hofmiller defects; Edith commits suicide; Hofmiller spends the rest of his life in shame and despair. That very fatedness, not just in *Beware of Pity* but in his novellas too, has been held against Zweig. A number of critics have remarked on the lock-step progression of his plots and, correspondingly, on the psychological fixity of his characters. His stories are in some measure case histories, textbook portraits of neurosis, Hofmiller's indecision and Edith's guilt-wielding being prime examples. To my mind, however, Edith's character—her unlovability, even as she needs and demands to be loved—is a wonderfully bold stroke, opening up whole caverns of psychological meaning. The world's wounded "desire with a more passionate, far more dangerous avidity than the happy," Hofmiller says. "They love with a fanatical, a baleful, a *black* love."

Zweig was born in Vienna in 1881, within months of many of the great early modernists (Joyce, Stravinsky, Kafka, Virginia Woolf, Picasso), but his outlook was not the same as theirs. Silence, exile, and cunning: these were imposed on him, but they were a torture to him, and he never ceased to mourn the passing of what, in his memoir, *The World of Yesterday* (*Die Welt von Gestern,* 1942), he called the "Golden Age of Security" represented by pre–World War I Vienna. From Musil and Schnitzler and Joseph Roth, we

have learned to view Franz Josef's Vienna as a scene of empty (however gorgeous) pomp in the public sphere and neuroticism in the private sphere, but Zweig's circumstances were different from those men's. He was the son of a millionaire industrialist, and the second son, the one not required to go into the family business. Already as a teenager he had joined a group of aesthetes whose lodestar was the brilliant young Hugo von Hofmannsthal. His thoughts were only for art, which he saw in the most ideal terms. After a conversation with Rilke, he wrote, "one was incapable of any vulgarity for hours or even days." A visit to the studio of Rodin bestowed on one "the Eternal secret of all great art, yes, of every mortal achievement, . . . that *ecstasis,* that being-out-of-the-world of every artist."

Zweig's politics were correspondingly vague and soaring. In keeping with the so-called Austrian idea—that multinational, multiethnic Austro-Hungary was a symbol of human fellowship— he saw himself as a citizen not of any one country, but of Europe as a whole, "our sacred home, cradle and Parthenon of our occidental civilization." His membership in that collective fired him with humanitarianism and optimism. In 1914, he writes in *The World of Yesterday,* "The world offered itself to me like a fruit, beautiful and rich with promise."

The fact that he was Jewish did not dent his confidence. He was one of that large class of prosperous, educated, assimilated, secular European Jews who were to receive such a surprise in the 1930s. As a young man, he said, he never "experienced the slightest suppression or indignity as a Jew," and his Moravian family were "free both of the sense of inferiority and of the smooth pushing impatience of the . . . Eastern Jews." Note his willingness to disassociate himself from the despised *Ostjuden,* who at that time were pouring into Western Europe in flight from the Russian pogroms. Herr von Kekesfalva, in *Beware of Pity,* started out as one of that species, and Zweig's portrayal of Kekesfalva's early years is what, today, most of us would call anti-Semitic writing. But Zweig, as a youth, didn't really regard himself as a Jew, or not much. That was his father's world, or his grandfather's. By the time he wrote *The World of Yesterday,* in the 1940s, he had, perforce, learned to identify with the Jews and to make claims for

them as a people. "Nine-tenths of what the world celebrated as Viennese culture in the nineteenth century was promoted, nourished, or even created by Viennese Jewry," he says, and he names the names. With typical modesty, he does not include himself in the list, but by the age of nineteen he had published his first book of poems and had begun writing feuilletons for the highly regarded *Neue Freie Presse,* under the editorship of Theodor Herzl.

Mad for art, he was nevertheless unconfident of his ability to contribute to that enterprise, and so he spent many of his early years in service to other artists, as translator or biographer. During his lifetime he was valued as much for his biographical books and essays—on Verlaine, Verhaeren, Balzac, Dickens, Dostoevsky, Romain Rolland, Hölderlin, Kleist, Nietzsche, Stendhal, Tolstoy, Freud, Erasmus, Marie Antoinette, Mary Queen of Scots, and Magellan, among others—as for anything else that he wrote, though his collections of novellas were also hugely popular, with their portrayals of sex and madness breaking through the lacquered screen of upper-bourgeois manners. In addition, he wrote plays, travel books, and an opera libretto. He was a literary man of all trades, not so much an author as a "voice"—to some, the voice of Europe.

Zweig often received letters from female fans, and one such correspondence—with Friderike von Winternitz, a young writer—led to his first marriage. Friderike left her husband for Zweig, and they were together for more than twenty years, his most productive years, from the 1910s to the 1930s. Then, in 1933, Friderike hired a new secretary for Zweig: Charlotte Altmann, a shy, self-effacing German-Jewish woman, twenty-seven years his junior, whose family had just been run out of Germany. Lotte immediately fell in love with him. What he felt in return is not clear to his biographers, but at this time his mood was very bleak. His youthful confidence had been badly wounded by World War I, and as the Nazis began dragging Europe into a second war, his former optimism converted to an equally absolute pessimism. By 1933 the Hitler Youth were burning his books; in 1935 Richard Strauss's opera *The Silent Woman* was canceled after two performances because Zweig had written the libretto.

But his problem went beyond politics. He had come to hate

the bustle and noise of his Salzburg household. He was a mani-
cally devoted worker. Friderike, though she tried to insulate him,
had two daughters from her previous marriage, and she enjoyed
visitors. In her 1946 biography of Zweig she blames his defection
on "the climacteric." Maybe so, but it seems that he just wanted
out, of everything except silence and work, two things that Lotte
could help him achieve. After several years of vacillation—for he
was, by nature, as indecisive as Hofmiller—Zweig in 1938 per-
suaded Friderike to give him a divorce, assuring her that he had
no intention of remarrying and needed only to regain his "stu-
dent's freedom." The following year, he married Lotte.

By then he had escaped to London, and it was during this ter-
rible period, the late thirties, that he wrote *Beware of Pity.* Some
people have seen Lotte—vulnerable not just politically but also
physically (she had severe asthma), and utterly dependent on
Zweig—as a model for Edith, but Zweig's guilt over discarding
Friderike must have had some part in the portrait. This does not
exhaust the list of probable sources. Freud's case histories unques-
tionably contributed to *Beware of Pity.* His patients often suffered
paralyses, and tended to fall in love with their doctor. (The words
"hysteria" and "subconscious" recur in the novel.) Finally, it does
not need restating that this dark book was written during the
buildup to World War II. During the thirties and forties, Zweig
was criticized by many of his colleagues for making no public
denunciation of Nazism. His famous name would have added
heft to the anti-fascist cause. But for all his humanitarianism,
Zweig had a horror of politics. (He didn't vote; he allowed no
radio in the house; he read the newspapers only at night, in the
café, lest they disturb his day's work.) His response to Europe's
peril was indirect, symbolic: *Beware of Pity,* among other writings.

Zweig tried to mitigate the novel's depressing message. In an
epigraph to the book, he writes that there are two kinds of pity:

> One, the weak and sentimental kind, which is really no
> more than the heart's impatience to be rid as quickly as
> possible of the painful emotion aroused by the sight of
> another's unhappiness . . . ; and the other, the only kind
> that counts, the unsentimental but creative kind, which

knows what it is about and is determined to hold out, in patience and forbearance, to the very limit of its strength and even beyond.

This, as we discover later, is a quotation from Edith's physician, Dr. Condor, and Zweig may have intended it as a tribute to Freud's treatment of his patients. Hofmiller's is the wrong kind of pity; Dr. Condor's—and Dr. Freud's—is the right kind. One wonders whether Zweig actually believed this. Condor, with his supposedly good kind of pity, married a blind woman to console her for his failure to cure her. Late in the novel, we meet her: she hangs on Condor, presses on him her anxiety and gloom. Zweig, like many bold writers, posed himself problems that he could not always solve. In such cases, one has to ask oneself what feels true, what feels false, on the page. In *Beware of Pity*, what feels true are the scenes in which we are shown the futility of pity. This is a horrible lesson; it is also what makes the book radical and modern.

But however modern in his subject matter, Zweig was not what we call a modernist. Though he flourished in the twenties and thirties, his memoirs make no mention of T. S. Eliot, Virginia Woolf, Picasso, Stravinsky. He knew Joyce, but he doesn't seem to have read *Ulysses*. He went to a Schönberg premiere, but he doesn't say he liked it. The frontier of modern art, in his mind, appears to have been Rilke and Richard Strauss. This fact—that in a period of formal experimentation, he was not an experimentalist—is part of the reason that he, together with other stylistically traditional moderns (Joseph Roth, for example), has been valued by later generations at less than his true worth. At the same time, Zweig had real faults as a writer. I have mentioned the subservience of plot and character to idea. He was also fond of clanking narrative devices: the tale told by the stranger in the night; the lightning and thunder as the plot reaches its turning point. One must also note the plump, upholstered quality of some of his writing. This is a sin one is sorry to hold against him. He had a magnificently cultivated mind, strong emotions, a pronounced idealism, and a passionate devotion to nineteenth-century art. Put those things together, and it is no surprise that he was likely, in the words of one of his editors, to sing an "aria" at the end of a chap-

ter, or even a paragraph. But these blasts of hot air, rife in *The World of Yesterday,* are absent from *Beware of Pity.* As for the predictability of plot and character, and the shopworn narrative conventions, they are there, but they count for little next to the subtlety and intensity of the psychological situation.

IN 1941 Zweig and Lotte emigrated to Brazil, where they (and Zweig's income) would be safe from harm. Zweig also thought that in multiethnic Brazil he would find a happy, supranational society like that of the Austro-Hungary of his imagination. At first he seemed to adjust fairly well. He and Lotte settled in Petropolis, in the mountains outside Rio. He started a biography of Montaigne. He acquired a little dog, who, he wrote to Friderike, had won second prize in a beauty contest. He and the dog took walks every day, and he gazed at the fabulous vistas. But they were not his vistas; those were in Europe, being overrun by killers. On the night of February 23, 1942, he wrote a note of thanks to the people of Brazil and a salute to his friends: "May it be granted them yet to see the dawn after the long night! I, all too impatient, go on before." Then he and Lotte took an overdose of barbiturates. The next morning, they were found dead, in their bed, holding hands.

Originally published as the introduction to the
New York Review Books edition of *Beware of Pity,* 2006

*Simone de Beauvoir (far right) with Nelson Algren
and Sartre's former mistress Olga Bost, in Cabris, 1950*

The Frog and the Crocodile

> I love you. But do I deserve your love if I do not give you
> my life? . . . May I love [a man] and tell him I love him
> without intending to give my whole life if he asked for it?
> Will he never hate me?

HE will hate her. As we find out in *A Transatlantic Love
Affair,* a collection of Simone de Beauvoir's letters to
Nelson Algren, the affair between these two writers was
only a few months old when Algren asked Beauvoir to come live
with him. He was a novelist of the Chicago school, a naturalist, a
bard of the taverns and the poker dens. He could not leave his
city, his subject matter, to join Beauvoir in Paris. But he saw no
reason why she, who by this time (1947) had written considerably
more than he—three novels, a play, and two books of philosophy,
all of them woven on the intellectual life of Paris—should not
move to Chicago to be with him. In the above passage she is
explaining to him that this will not happen.

Coming from the now famous feminist, such a refusal seems
fitting. She needed her career, her independence. But a major rea-
son Beauvoir could not give her life to Algren was that she had
already given it to another man, Jean-Paul Sartre. The resulting
struggle in her mind—work and Sartre on one side, passion and
Algren on the other—was to affect all her future writings, notably
The Second Sex. This is the most interesting thing about *A
Transatlantic Love Affair:* the light it sheds on the book that
marked the beginning of the modern women's movement. Beau-
voir later claimed that when she started work on *The Second Sex,*

in 1946, she had no sense that women were systematically kept down. She came to realize it only as she began her research. I would suggest that the crucial research took place in Nelson Algren's bed. That Beauvoir, after seventeen years with Sartre, had no sense of the unequal division of power between the sexes is staggering, but Algren taught her the truth.

The depressing facts of Beauvoir's fifty-year relationship with Sartre have been known for some time now, at least since Deirdre Bair's excellent 1990 biography of Beauvoir. Sartre and Beauvoir became lovers in 1929, when she was twenty-one and he twenty-four, soon after both had completed the philosophy program at the École Normale Supérieure. They made a pact, designed by Sartre. Their relationship would be, for both of them, their "essential" love, but they would be permitted "contingent" loves as well. Furthermore, they would practice "transparency": each would tell the other the details of these adjunct relationships. Not surprisingly, the arrangement turned out to be one-sided. She didn't want anyone but him. He wanted every woman in sight. He soon lost interest in Beauvoir physically; her share of his sex life was to listen to his accounts of his lovemaking with others. She was then supposed to tell him her reactions, and analyze them for him. Short of physical battery, a more sadomasochistic arrangement is hard to imagine.

But it was worse. Sartre was not the sort of man whom women naturally ran after. He was less than five feet tall, with a walleye and a tic that made him shrug his shoulders and roll his head uncontrollably. Furthermore, he was reportedly a big disappointment in bed. When he was older, and famous, he had no trouble attracting women, but in his earlier years he did suffer refusals. So Beauvoir helped out. When, early in her career, she worked as a *lycée* teacher, she would use her own bed as a holding pen for girls to offer up to him. Eventually, she laid hands on a girl with a mother energetic enough to go to the *lycée* director and get Beauvoir fired. (She never taught again—a good thing.) Later, when she had a car, she drove him to appointments with his multiple mistresses.

This is not to speak of her services to his career. "His work was more important than mine," she once said. "Naturally I bowed to

this." She talked him through his writings, outlined them for him, critiqued them, edited them, occasionally wrote them. Bair describes the scenario:

> Often he practically pushed her into one of the booths at the Dôme or the Rotonde, fussing until she had her coffee, her bottle of ink, and the pile of papers neatly shuffled and ready for editing, and then he hurried off to a meeting in Saint-Germain followed by his liaison with Olga, Wanda or whoever else it might be that day. Sometimes he left Beauvoir with little more than a hastily scrawled text and the peremptory demand to "deal with this."

Beauvoir was willing, for this made her, as she saw it, the central woman in Sartre's life, whatever the incursions of others. Meanwhile, she went on with her own writing (she was an utterly dogged worker), but that, too, was laid at Sartre's feet. In *The Second Sex,* as she frankly stated in her introduction, she took his existentialism as her vantage point: her chief complaint about the condition of women was not that they weren't happy but that they weren't free—that they lacked the capacity for "transcendence" (of circumstances, of biology), that greatest of Sartrean goods. Most of her other books also disseminated his views, to the point where some people regarded her simply as his publicist. "Notre-Dame de Sartre," "La Grande Sartreuse," her detractors called her.

This servitude to Sartre damaged not just her reputation but also her self-esteem and her sexual confidence, which were already precarious. Beauvoir was a brilliant, bookish child, and in her haut-bourgeois Parisian family these were not regarded as female traits. "Simone has a man's brain," her father said. "She *is* a man." Simone took the hint and turned herself into the furthest thing possible from a woman, or at least from her convent-bred, needlepoint-doing mother. She was loud, rude, slovenly, tyrannical. (If she didn't get her way, she would vomit.) She cared about nothing but her work. As she entered into adulthood, the relationship with Sartre no doubt confirmed her in these habits. She developed a hard, humorless manner. She also became one of the worst-dressed women in Paris. ("We always know when it's sum-

mer," Algren later said. "We tell Simone . . . to take off the navy-blue wool dress and put on the cotton one.") No longer Sartre's mistress, she became his spinster sister. Small wonder that his existentialism, with its anguished freedom, appealed to her. But she acknowledged no anguish. Though she apparently had anxiety attacks all her life and would suffer violent crying jags in public, she told herself that everything was fine.

Then something unexpected happened: Sartre fell seriously in love. Before, most of Sartre's girlfriends had been younger women, who bowed to Beauvoir's authority. Many were her friends; if not, they at least knew to send her birthday cards. But in 1945, on a trip to New York, Sartre took up with a different sort of woman, Dolores Vanetti Ehrenreich. A Frenchwoman married to an American doctor, Ehrenreich worked for the United States Office of War Information, making radio broadcasts. She was rich, sophisticated, well-connected, older, and, perhaps not incidentally, one of the few women in the world shorter than Sartre. She had no intention of sending Beauvoir birthday cards. Indeed, she was determined to marry Sartre, and, as Beauvoir began to understand, that was a distinct possibility, for Ehrenreich offered him not only the sexual recreation he had with his other women but also the thing that hitherto he had enjoyed only with Beauvoir: intellectual companionship. "According to his accounts," Beauvoir later wrote in her autobiography, Ehrenreich "shared completely all his reactions, his emotions." Beauvoir panicked.

Soon afterward, she received an invitation to go on a lecture tour of the United States. On a stopover in Chicago, she called a number that someone had given her: Nelson Algren, novelist. For two days, he showed her what, in his Chicago-school view, were the local attractions: "I introduced her to stickup men, pimps, baggage thieves. . . . I took her on a tour of the County Jail and showed her the electric chair." Then they went back to his apartment and made love. Apparently, the American street kid enjoyed romancing the French existentialist, and vice versa. Still, it might have been just a passing thing had Beauvoir, upon returning to New York to fly back to France, not received a telegram from Sartre asking if she could delay her homecoming. Ehrenreich was in Paris and wanted to stay with him a little longer. Beauvoir

promptly called Algren, and they spent two more weeks together, much of the time between the sheets. She had the first orgasm of her life, and they pledged themselves to each other. Now if Sartre had a lover intent on marriage, so did Beauvoir. Such marriages were not to be, but it took Algren a while to figure that out, so the affair lasted five years, from 1947 through 1951, most of it conducted by mail.

A Transatlantic Love Affair contains only Beauvoir's side of the correspondence. Apparently, the editor, Sylvie Le Bon de Beauvoir (Beauvoir's adoptive daughter), was unable to get permission to include Algren's letters. This is a shame; Algren doesn't get his say. Still, Beauvoir's letters are fascinating. As Le Bon de Beauvoir points out in her preface, Beauvoir and Algren had little in common. She had to explain her world to him, and that is what she does. That is how she flirts, by constructing for him a kind of comic theater of Left Bank life in the forties and fifties. The political situation—the effort of France's postwar intellectuals to find some honorable ground between American capitalism and Russian Communism—is vividly sketched in, as is the literary world, which at that point was inseparable from the political. She has lunch with Carlo Levi; his politics are okay, but "he lies as naturally as he breathes," and he never picks up a check. Cocteau, "a very well known French poet and pederast," is directing Sartre's new play. He has brought in Christian Bérard to help with the sets, but Bérard spends all his time crying, because his boyfriend has passed out somewhere in the theater from an ether overdose. Gide dies—"the one who got the Nobel Prize for having written all his life long that it was fine to be a pansy"—and the day after his death the poet Anne-Marie Cazalis sends a telegram to the Catholic writer François Mauriac, who, along with the poet Paul Claudel, was among Gide's archenemies: "HELL DOES NOT EXIST. MAY ENJOY YOURSELF. TELL CLAUDEL. ANDRÉ GIDE." Most of the artists in Paris seem to walk through these pages—Camus, of course, Raymond Queneau, Giacometti (whom Beauvoir adored), Richard Wright (one of the few friends Beauvoir and Algren had in common), Violette Leduc (madly in love with Beauvoir)—

breathing and real, working like crazy all day and, at night, going to bars and getting drunk and arguing and slapping each other and seducing each other's lovers and then going off to rest for two months in the country. It is a portrait of the literary life from the inside, with the books born screaming. When Beauvoir published *The Prime of Life,* the second volume of her autobiography, one of Sartre's mistresses, Wanda Kosakievicz, took a butcher knife and chopped up a copy—along with her own wrists—so enthusiastically that she practically bled to death. To these people, art mattered.

In Beauvoir's near-English, the events seem all the more immediate, and her voice more intimate. In a foreign language, and in fear of losing Algren, she is unable to summon the self-assurance that made her, in many of her other writings, seem dry and dictatorial—"governessy," to quote Elizabeth Hardwick's review of *The Second Sex.* On the contrary, she sounds almost childlike and, at the same time, terribly intelligent and sincere. She makes charming mistakes. One night she has to write by candlelight: "The electric lamp has blown up, as it often happens." People are sending death threats in response to her and Sartre's anti-Gaullist broadcasts: "As you say, it is the worse disease not to be able of humour." She herself was said not to be able of humor; love proved her otherwise.

It also ripped her in two. A crucial fact of the Beauvoir-Algren relationship was its sexual success. Algren, Beauvoir later said, was "the only truly passionate love in my life." The experience didn't come till she was thirty-nine and had given up hope of any such thing. So when it arrived she embraced it wholly. She described herself as his wife. (He had given her a ring.) She telegrammed in panic if his letters were late. She dreamed of being eaten up by him. He called her his little frog; she called him her big croco-dile—he had a toothy grin—and she liked to imagine the croco-dile swallowing the frog. "It must be nice and warm and comfortable for a little frog to lie leisurely in your crocodile stom-ach," she wrote. Sometimes the love talk gets a little tiresome.

Still, in view of her long years as Sartre's eunuch, the spectacle of her sudden sexual happiness is touching:

> I was deeply moved when I read in your letter that you loved, as well as my eyes, my ways in love. And I thought I had to tell you these ways were just my loving for you. I had always the same eyes, but I never loved anybody in these ways.

Such words have been said before ("I only do that with you"), but in her case they were probably true. To this sexual compatibility we also owe the few endearingly dirty parts of the correspondence. In one letter she tells him, in jest, that she has written a report on the sexual behavior of the American male:

> I had a very interesting experience about it. American local males like to make love (which is strange); they do it every day, sometimes twice a day. . . . They walk quite naked in hotel-lobbies—sometimes they pretend to put a kind of towel around their belly, but they manage not to hide what would be hidden; I cannot decently tell you what they do in bed but I can tell you it is not decent at all. I described all that and many other things (their peculiar ways in boat-cabins, the use they do of mirrors, chiefly of round black ones).

Mirrors. Good for her.

Yet at the very same time that Beauvoir was offering herself as Algren's love slave she was emphatically asserting her independence. Never once did she try to fool him about the impossibility of her coming to live with him. Nor did she disguise Sartre's role in this. She reassured Algren that Sartre was lousy in bed and that she hadn't slept with him in years. Still, he needed her, she said, and she would never leave him. Actually, what Beauvoir was offering Algren was, by her postwar lights, an exemplary equality-of-the-sexes arrangement: wifely devotion when she was in his presence, but with the right to choose when she would bestow her

presence. (She promised to join him several months a year.) He, however, was no believer in equality of the sexes. As he later explained to an interviewer, he and Beauvoir had—or he thought they had—"a relationship that assumed the secondary status of the female in relation to the male."

But if his confusion was great, imagine hers. For a woman born in 1908, it was one thing to propose an egalitarian relationship, another thing to live it. From letter to letter, sometimes from paragraph to paragraph, she zigs and zags from submission to dominance. My favorite letters are the ones in which she is planning their visits together. She longs for him, she says. She is trembling with joy. She can't wait to give him everything, everything: "I'll wash the floor, I'll cook the whole meals, I'll write your book as well as mine." But, by the way, how big is this summer cabin they're going to? Will she have a room to work in where she won't have to hear his typewriter noise? And would he mind rearranging his schedule so that she can come in June rather than later, because June is when Sartre will be traveling, too? Then she realizes what she has done, and reverts to the love-slave posture: "I belong to you. . . . I am your own little love token."

It wasn't just the number of her demands that worried her. There was a pronounced inequality between Beauvoir and Algren. She was a superbly cultivated upper-bourgeois intellectual. He, though a serious writer, was a working-class tough guy, and willingly provincial. She writes to him in his language; he declines to learn a word of hers. She is fascinated by everything American; he seems indifferent to anything European. (She feels she has to explain to him not only who Cocteau and Gide are but also Léger and Pirandello and Bartók.) She does everything possible to further his career—finds him French publishers and translators, gets his essays published in *Les Temps Modernes,* the journal she and Sartre edited. Meanwhile, she delicately underplays her own career. Though she is writing *The Second Sex,* she almost never shares with him her ideas for that monumental work, and she speaks of her other books as if they were minor things. Her *Ethics of Ambiguity,* which came out in 1947, she describes to him as "a little essay about ethics: how can morals and politics be adjusted

to each other nowadays, and things of this kind." It has a pretty cover, she says—pale blue.

In her mind, she tries to make a virtue of their inequality. Compared with those fractious eggheads she hangs out with in Paris, she finds Algren "so generous and genuine." Stuck, at one point, in New York with a bunch of literary types, she says she is "wishing to feel a woman in a good man's heart." These words have a familiar ring. What is it? It is the sound of an intellectual having an affair with a garage mechanic. Now and then, she will make a dangerous little joke. When he scoffs at her notions of sexual equality, she writes back, "I thoroughly admit equality is only a myth, I never sincerely thought you were my equal." Nor does she omit to tell him that she is giving lectures, being interviewed, being translated. She wants him to know that she is someone substantial, someone worth having. But at other times she is obviously afraid that her prominence will scare him off. One gets the sense that she desperately wants this to be a real, old-fashioned love affair, the kind she has read about in novels. Theirs, she tells Algren, is "a beautiful, corny love story." Such stories, she knows, do not normally involve prickly-minded feminist intellectuals.

IN 1948 and again in 1949, the year in which *The Second Sex* was published, Beauvoir and Algren traveled together for several months, but over time he became increasingly surly and withdrawn. (That, by the way, was not just because she refused to live in Chicago. According to his biographer, Bettina Drew, he was surly and withdrawn by nature. If Beauvoir had moved in with him, the affair probably wouldn't have lasted six months.) To minister to his loneliness in her absence, she offered him his sexual freedom; he took it and, like Sartre, told her the details. As his letters became cooler, hers became pleading and desperate, and the relationship took an unpleasant turn. In 1950, he bought a cabin on Lake Michigan. She invited herself for the summer, and when she arrived he told her that he didn't love her anymore, indeed that he was thinking of remarrying his ex-wife. She thereupon stayed with him for *three* months, as he sulked and avoided

her. Soon after this grim vacation, she is begging to see him again: "I shall not assume that you love me anew, not even that you have to sleep with me. . . . But know that I'll always long for your asking me." She apologizes for her tears during the summer: "I realize how . . . boring they have been for you." He doesn't have to write to her, she says. (Nevertheless, "I go up and down stairs in the cold three times a morning" to see if a letter has arrived.) With the outbreak of the Korean conflict, she fears that there will be a world war, but she takes some comfort in this: "For the very first time I was glad that you don't love me any longer because if we never can see each other again, it will not make so much difference now."

The following year, incredibly, she returned to Algren's cabin. This time, he greeted her with the news that they would not sleep together. She spent her days writing her famous essay on Sade. (How much of her defense of Sade was the product of her complicity in Algren's sadism?) On her last day, Algren suddenly blurted out that he loved her, thus rekindling her hopes. "Please don't take your love away from me," she wrote from New York as she waited for the plane to Paris. In his next letter, he did exactly that: he wanted his life back, he said. Finally, she let him go. "Be happy," she wrote, "and keep a small place for me in the basement of your heart." In the basement? The author of these words was at that time the world's leading feminist. Somehow it doesn't help to find out that she finally got over Algren only by starting up with a new man, Claude Lanzmann, the future maker of the film *Shoah,* who was seventeen years her junior. She and Algren went on writing to each other, but her letters soon became chatty and infrequent.

The romance had a bitter sequel. Deirdre Bair says that all Beauvoir's writing was in the service of understanding her personal experience. Already in 1949 she had begun a novel, *The Mandarins,* involving a thirty-nine-year-old woman who, tied to the foremost intellectual in Paris, goes to the United States on a professional trip and enters into a love affair with a tough-guy novelist from Chicago. "It is not exactly about you, honey," Beauvoir wrote to Algren. No, not exactly. She changed his name. But pretty much the whole episode is there, souped up into the corny love story she had wanted it to be:

We threw off our clothes, letting them lie where they fell.
"Why do I want you so much?" Lewis said.
"Because I want you so much."
He took me on the rug, he took me again on the bed.

By the time *The Mandarins* was published, in 1954, the affair was long over. Still, Algren felt that his privacy had been invaded. More was to come. In 1963, Beauvoir published the third volume of her autobiography, *Force of Circumstance,* with a full description of the affair, including long excerpts from his letters to her. Algren now turned on her with fury. Reviewing the American edition in *Harper's,* he described her as a writer of asphyxiating dullness. He also went after her weak spot, her insecure femininity. When he was asked by *Newsweek* about the accuracy of her account, he said, "She's fantasizing a relationship in the manner of a middle-aged spinster. It was mostly a friendship. . . . It was casual." There followed a flurry of angry letters, after which they never communicated again. But he went on insulting her in print. In a 1972 article in *Playboy* he described a trip they once took to Tunisia ("She hadn't shut up since Casablanca"), where they visited a red-light district. As they were leaving, he wrote, a little prostitute ran up to Beauvoir, lifted her dress, and, pointing, yelled to the other whores, "See! She has one too! She has one too!"

PART of Algren's wrath, surely, had to do with the differing curves of their careers. At the peak of their affair, in 1949, they both had their first great successes, she with *The Second Sex,* he with *The Man with the Golden Arm,* which won the first National Book Award for fiction. But Algren's first triumph was also his last. In the fifties, his life fell in ruins around him. He was trapped in a loveless marriage. (He did remarry his ex-wife, Amanda, probably to punish Beauvoir. He proposed to Amanda a month after he got Beauvoir's news about Lanzmann.) He couldn't write, and when he did, the resulting novel, *A Walk on the Wild Side,* was rejected by his publisher. Brought out by another house, it was widely panned. Poor Algren had become one of the "proletarian writers"

just as that school was dying out. A man of the social-protest thirties, he was shipwrecked in the formalist fifties. In 1960, he visited Beauvoir in Paris and stayed in her apartment (though not in her bed). As she recorded in *Force of Circumstance,* "He was awakened every morning by his own anger: 'I've been eaten alive, made a sucker of, betrayed.' " He wrote one further novel, which he could not get published. Thereafter, he confined himself mostly to travel pieces and book reviews. What money he earned he generally lost at the poker tables. (He was a compulsive gambler.) During his stay in Paris, Beauvoir had to give him spending money.

Meanwhile, Beauvoir's star rose and rose. After *The Second Sex,* she published fourteen more books, several of them bestsellers. *The Mandarins* (which included a lot more, and better, than its love story) won the Prix Goncourt, France's most prestigious literary prize. In 1955, as Algren was desperately trying to restart his career, Beauvoir was writing to him that in order to leave her apartment she had to sneak out the back door of the building, so great was the mob of journalists camped at the front door waiting to interview her about her prize. In the fifties, Sartre and Beauvoir became two of the most important people in Europe. Existentialism was the cry of Paris; it prescribed the language, the emotions, indeed the wardrobe (black turtlenecks, ballet slippers) of the Left Bank. In 1960, Beauvoir reported to Algren that the second volume of her autobiography had sold a hundred and thirty thousand copies in a single month. He no doubt remembered that figure when he read the third volume and took out after it in *Harper's.*

But it was not in her autobiography, or even in *The Mandarins,* that Algren should have looked for the effect he had on Beauvoir; it was in *The Second Sex.* Many people have commented on the curious violence of *The Second Sex,* and on its "victim blaming." Though Beauvoir repeats again and again that women are socialized into inferiority, she spends far fewer words on that process than on the manifestations of women's weakness—their muddle-headedness, fatuity, vanity, envy, parasitism, resentment, frigidity, neuroticism, on and on—which, as the force of her portrayal gathers, seem to unmoor themselves from their social cause and become absolute. Her tone is one of disgust. Man, she says, is

"transcendence," action; woman is "immanence," need. A famous passage, often quoted, is her description of the male and female genitals:

> The sex organ of a man is simple and neat as a finger . . . but the feminine sex organ is mysterious even to the woman herself, concealed, mucous, and humid, as it is; it bleeds each month, it is often sullied with bodily fluids . . . a horrid decomposition. . . . Man dives upon his prey like the eagle and the hawk; woman lies in wait like the carnivorous plant, the bog, in which insects and children are swallowed up. She is absorption, suction, humus, pitch and glue, a passive influx, insinuating and viscous.

It's like something out of a monster movie. Here we see the reverberations of Beauvoir's discovery of the power of sex, its ability to create hunger in the woman. Probably the strongest words in *The Second Sex* are those devoted to the subject of female masochism. For the woman in love, Beauvoir writes, "the descent . . . to masochistic madness is an easy one." She showers the man with attentions, endearments; they "bore him to distraction." She grovels, "gathers up the crumbs that the male cares to toss her." These words, I am sorry to report, were written before, not after, Beauvoir hung around Algren's summer cabin for two years in a row, apologizing for her tears. The book, of course, ends with a ringing call for an end to all that—for free and equal male-female relationships. Such arrangements, she promises, will not preclude "love, happiness, poetry, dream." Whether that is true is something that men and women are still trying to figure out, but in *The Second Sex* we can read how unsure Beauvoir was, too, and how tempted by old-style dependency.

Not surprisingly, many feminists have had mixed feelings about *The Second Sex*. Just as, by the sixties, existentialism had been shouldered aside by structuralism—and classical philosophy itself by new theories coming out of anthropology, psychoanalysis, and semiology—so in the seventies French feminism came to be dominated by ideas born of those disciplines, above all by *différence* theory, which viewed woman's difference from man not as

a source of oppression but as a well of richness: a better way of thinking and living. Beauvoir's descriptions of femininity as a swamp, a bog, did not go down well with the *différence* theorists. The trouble got worse in 1990, four years after Beauvoir's death, when Bair published her biography, sparing no details of Beauvoir's peonage to Sartre, and when Sylvie Le Bon de Beauvoir, sweeping up the literary remains (*A Transatlantic Love Affair* is part of that process), brought out an edition of Beauvoir's previously unpublished *Letters to Sartre,* which broke the news of Beauvoir's pimping for Sartre among her *lycée* students. Now Beauvoir was not just a misogynist; she was a closet bisexual. Indignation was great; her partisans had to plead for her. There will no doubt be more indignation, more pleading, when people get a load of *A Transatlantic Love Affair.*

Beauvoir's critics should read some history books. When *The Second Sex* was published, in 1949, Frenchwomen had had the vote for only five years. If Beauvoir's mind, as her detractors claim, was swamped with "masculinist" ideas, those were the only ideas around at the time. If she omitted to tell her public about her lesbian experiences, to do otherwise would have been fatal to the reputation of any woman writer of the period. (Beauvoir's critics should also take another look at her defense of lesbianism—a whole chapter—in *The Second Sex.* For 1949, that was brave.) It is possible that the best writers on social injustice—certainly the most moving—are those who grew up when the injustice in question was not viewed as a problem, and who therefore say things that get them in trouble, later, with holders of more correct views, views that the earlier writers gave birth to. I am thinking of Abraham Lincoln's pre–Civil War statements on the inferiority of Negroes, so decried by recent historians. It is one thing to free a people whom you regard as equal. But what does it take to free a people whom you have been trained to regard as inferior, and who, by your standards, *are* inferior? It takes something else, a kind of imagination and courage that we do not understand.

In the recent flap over Beauvoir we see again what might now be called Philip Larkin syndrome: the insistence on the part of modern critics that celebrated authors' lives be as admirable as their books. In the case of Beauvoir one might answer, "Do as she

said, not as she did." (That, in fact, is the title of an article that Deirdre Bair was moved to write for the *Times Magazine* in response to the outrage over the revelations in her biography and in the *Letters to Sartre*.) But even if we did as she did, we wouldn't be doing so badly. After all, she did *not* move to Chicago, and her reasons were not just Sartre but also her career, her place in the literary life of Paris. If that career was tied up with her servitude to Sartre, good writing has sprung from more humiliating conditions. And, of course, the relationship with Sartre helped to germinate *The Second Sex*. The affair with Algren, so sexual and therefore so searing, may have released her knowledge of the condition of women, but, whatever her denials, the knowledge was certainly there before. If it hadn't been, why would she, the year before meeting Algren, have begun work on what she described as a book "about women situation." What situation was she planning to discuss?

AFTER Algren, Beauvoir returned to her old life—Sartre's work, her work. Claude Lanzmann, though he was with her for seven years and moved in with her, was not allowed to disturb her schedule. Lanzmann told Bair:

> On the first morning, I thought to lie in bed, but she got up, dressed, and went to her work table. "You work there," she said, pointing at the bed. So I got up and sat on the edge of the bed and smoked and pretended that I was working. I don't think she said a word to me until it was time for lunch. Then she went to Sartre and they lunched; sometimes I joined them. Then in the afternoon she went to his place and they worked three, maybe four hours. . . . Later we met for dinner, and almost always she and Sartre would go to sit alone and she would offer the critique of what he wrote that day.

Then she and Lanzmann went home and went to sleep.

In the sixties and seventies, the Sartre-Beauvoir relationship underwent a change. A prodigious drinker and amphetamine-

user all his life, Sartre began aging horribly. He drooled; he was incontinent; he went blind. He still chased girls, though, and Beauvoir, who was repelled by illness, let his girls take care of him. He then legally adopted one of his young mistresses, thus repaying Beauvoir for a lifetime of service by depriving her of any control over his literary remains. Beauvoir responded by creating a new life of her own. In the seventies, belatedly but energetically, she became an activist in the women's movement. She had also found a new love, Sylvie Le Bon, thirty-four years younger than she, who, as a student, had asked to meet her. They were a couple for almost twenty-five years, to the end of Beauvoir's life. (No, Beauvoir said, there was no sexual involvement. Le Bon's remarks suggest otherwise.)

Sartre died in 1980. Beauvoir went half mad with grief, throwing herself on his corpse in the hospital. After the funeral, she had to be hospitalized herself for a month. She recovered, adopted Le Bon, and lived quietly, working for feminist causes, for six more years. Algren died in 1981, and at that time she said she felt nothing for him. But clearly she felt something. When she herself succumbed to cirrhosis of the liver (she drank almost as much as Sartre) and pulmonary edema in 1986, she was buried wearing the ring that Algren had given her. She had never taken it off.

The New Yorker, 1998

Marguerite Yourcenar in her garden, 1987.
Photograph © Carlos Freire

Becoming the Emperor

IN 1981, six years before her death, Marguerite Yourcenar became the first woman ever inducted into the Académie Française, and that weighty honor has been hanging around the neck of her reputation ever since. Every book jacket, every review, speaks of it. But that wasn't all that set her apart from other midcentury writers. She was an extremely isolated artist. A Frenchwoman, she spent most of her adult life in the United States, on Mount Desert Island, off the coast of Maine, where, to isolate her further, she lived with a woman. Her background, too, made her seem different. She came from the minor nobility and didn't hide it. Most of the people who knew her, even friends, addressed her not as Marguerite but as Madame. Add to that the fact that she wrote not in English but in her native French, and in a style that was often magisterial, in an old-fashioned, classical way. (People compared her to Racine. This was at a time when we were getting Bellow and Roth.) Add, moreover, that though she was a novelist, she was not primarily a realist, that she never mastered dialogue, that her books were ruminative, philosophical. Add, finally, that her greatest novel, *Memoirs of Hadrian* (1951), was a fictionalized autobiography of a Roman emperor, and it comes as no surprise that nearly every essay on Yourcenar speaks of her work as "marmoreal" or "lapidary."

Actually, some of Yourcenar's prose is marmoreal, but not so that you can't get through it. Also, it is beautiful. What made her remarkable, however, was not so much her style as the quality of her mind. Loftiness served her well as an artist: she was able to dispense love and justice, heat and cold in equal parts. Above all, her high sense of herself gave her the strength to take on a great topic: time. Time was an obsession with her immediate predecessors in

European fiction, but whereas those novelists showed us modern people altered—made thoughtful, made tragic—by time's erasures, she erased the erasures, took us back to Rome in the second century or, in her other famous novel, *The Abyss* (1968), to Flanders in the sixteenth century, and with an almost eerie accuracy. Yourcenar regarded the average historical novel as "merely a more or less successful costume ball." Truly to recapture an earlier time, she said, required years of research, together with a mystical act of identification. She performed both, and wrought a kind of transhistorical miracle. If you want to know what "ancient Roman" really means, in terms of war and religion and love and parties, read *Memoirs of Hadrian*.

This doesn't mean that Yourcenar, in her novels, conquered the problem of time. All she overcame was the idea that this was the special burden of the modern period. Human beings didn't become history-haunted after the First World War, Yourcenar says. They were always that way.

THE child of a Belgian mother, Fernande de Cartier de Marchienne, and a French father, Michel-René Cleenewerck de Crayencour, Yourcenar was born in Brussels in June of 1903. Years later, she reconstructed the events of that morning. "The pretty room," she said, "looked like the scene of a crime." Michel was screaming at the doctor, calling him a butcher. The housemaids hurried about, gathering up the bloodied sheets and also the afterbirth, which they took down to the kitchen and stuffed into the coal fire. (Yourcenar has a kind of mania for antisentimentality. It is hard to imagine any other writer describing the burning of her own afterbirth.) Ten days later, Fernande was dead. The new baby lay squalling in a silk-lined crib.

Michel gathered up the child and returned to his family estate, near Lille, where Yourcenar lived until the age of nine, in what she later described as considerable happiness. She recalled the riot of poppies in spring. She remembered her pets: a lamb, a goat whose horns her father painted gold. According to Josyane Savigneau, the excellent, hard-nosed biographer from whom I have taken much of this information, Yourcenar later scandalized some of her

French readers by claiming that she never regretted not having a mother. She had a good substitute, a young nursemaid, Barbe, who adored her. But one day when Marguerite was seven it was discovered that Barbe, on a few occasions, had taken the child to "houses of assignation," where she went now and then to supplement her income. Barbe was instantly dismissed; she wasn't even allowed to say good-bye to Marguerite.

After that, Marguerite grew up fast. When she was nine, Michel sold the château, and the two of them moved to Paris. A man of leisure, an occupation that he took seriously, Michel wasn't home much, but neither was Marguerite. She was out scouring the city: the museums, the streets, the bookstalls. Like most girls of her social class, she never went to school. She had a few tutors, but mostly she educated herself. She taught herself Latin, ancient Greek, English, and Italian; she read everything she could find. Soon she began writing, and she expected a great literary career. "O, winds!" she called out, in a poem she wrote in her teens. "Carry me away to the fiercest heights, / To the loftiest summits of triumph to come!" With such a future awaiting her, she embraced any new adventure. At the age of eleven, she had what seems to have been her first serious sexual encounter, with a young woman. Afterward, the woman said to her that she had heard it was bad to do these things. Yourcenar's biography of her family finishes the story: " 'Really?' I replied. And . . . I stretched out on the edge of the bed and fell asleep." This was soon followed by an equally unfraught encounter with an older man, a cousin. Early initiation, she wrote, "can be a way to save some time."

Always given to understatement, Yourcenar later played down the affection between herself and her father. ("No doubt there was a strong attachment, as there is when one is raising a puppy.") But Michel clearly loved her, the more, no doubt, since she was his only relative who had not loudly deplored the fact that he was gambling away the family fortune. They eventually moved to the South of France and, in 1920, settled in Monte Carlo, where Michel could be closer to the baccarat tables. There, in the words of the Yourcenar scholar Joan E. Howard, the two became "partners in crime." They read aloud together, passing the book back and forth: Homer (in Greek), Virgil (in Latin), Ibsen, Nietzsche,

Saint-Simon, Tolstoy. In his early years, Michel had tried his hand at literature: some verse, the beginnings of a novel. Now, as he watched Marguerite doing the same—by her early twenties, she was writing all the time—he urged her on. One happy night, they worked out a nom de plume for her, an approximate anagram of Crayencour. Then he wrote to publishers, under her new name, to peddle her writings. He paid for the publication of her first two books (both poetry). He also gave her the first chapter of his abandoned novel and told her to rework it and publish it as her own story, which she did. Entitled *The First Evening,* it is the tale of a joyless wedding night, and the couple in question may have been based on Michel and Fernande. This was a very intimate and unconventional collaboration. In 1929, shortly before Yourcenar's first novel was published, Michel died. She was twenty-five. She said she cried and then almost forgot him for thirty years. He left her next to nothing—he was bankrupt by 1925—but she had a small legacy from her mother that she figured would give her ten years of freedom if she spent it carefully.

SHE passed those years partly in what she called "dissipation"—that is, a little drinking and a lot of sex, some with men, mostly with women. The rest of the time she wrote. In her old age, she said that everything she ever produced was already fixed in her mind by the time she was twenty. In any case, she now laid down her method. First, many of her narratives were set in the past. Second, they often involved towering passions compacted into tight, steel-band forms. That's the reason for the comparison to Racine, but a closer reference point is Gide, whose austere *récits* influenced almost every writer of her generation. She continued to embrace antisentimentality; indeed, she showed a fondness for brutality. And those traits, together with her highly controlled prose, encouraged reviewers to say—as they would say throughout her life—that she wrote like a man. As one critic put it, he could not find in her work "those often charming weaknesses . . . by which one identifies a feminine pen. The hand does not yield, it does not caress the paper; it is clasped by an iron gauntlet." This opinion was fortified by the fact that most of her

protagonists were men. Curiously, however, they tended to be homosexual men. Yourcenar, it has been claimed, also had the habit of falling in love with homosexual men, the most serious case being her editor at Éditions Grasset, André Fraigneau, who had great interest in her artistically and none whatsoever sexually. This injustice drove her wild throughout her early thirties. She got two books out of it.

Then, one afternoon in 1937, when she was thirty-three, she was sitting in a hotel bar in Paris talking with a friend about Coleridge when a woman from another table came over and told them they were all wrong about Coleridge. The woman was Grace Frick, an American English professor, almost exactly Yourcenar's age. The next morning, Frick invited Yourcenar to come up and see the pretty birds outside her hotel-room window. Later that year, Yourcenar sailed to the United States to spend the winter in New Haven with Frick, who was starting a dissertation at Yale. In the spring, she returned to France with a decision to make. She was still in love with Fraigneau; meanwhile, Frick was madly in love with her, and it was nice, finally, to be the loved one. Yourcenar sat down and wrote a savage little novel, *Coup de Grâce,* about a group of young people involved in the civil war in the Baltics after the Russian Revolution. At the center of the book is a love triangle. The narrator, Erick, an elegant Prussian fighting on the side of the White Russians—and a dead ringer for Fraigneau—is in love with his coadjutant, Conrad; Conrad's sister, Sophie, is in love with Erick, and throws herself at him every chance she gets. (At one point, as Erick is prying Sophie's body off of himself, he compares her clinging limbs to the suctioned arms of a starfish.) Finally, Sophie abandons the White Russian cause and defects to the Red Army. Soon afterward, her division is captured by Erick and his men. In a military execution, he shoots her—in the face.

This was Yourcenar's most autobiographical novel, which doesn't mean that it's easy to figure out, in real-life terms, who shot whom. Roughly, one can say that Fraigneau killed Yourcenar by not loving her, and now—as the title of the book, with its pun on Frick's name, tells us—she's going to kill him, or her passion for him. Soon after *Coup de Grâce* came out, in 1939, Yourcenar returned to the United States, where for the next forty years Frick

would be her companion, her translator, her household manager, and her shield against the world—possibly the most complete literary wife in the annals of art.

As Yourcenar explained it later, she had planned only to try out another winter with Grace, but the Second World War intervened, and by the time it was over she had decided to stay. (She became an American citizen in 1947.) When she was old, she said that her passion for Grace exhausted itself after two years. But Grace's passion lasted, and perhaps Yourcenar could not turn her back on that, or on the domestic comforts it provided. But there was another reason for not returning to her life in France. Its bottom, her literary career, had dropped out. Horribly, mysteriously, Yourcenar stopped writing when she arrived in the United States. For more than a decade, she published almost nothing. She and Grace lived mainly in Hartford, to be near Grace's work, first at Hartford Junior College, then at Connecticut College. Soon Yourcenar, too, began teaching, commuting to Sarah Lawrence, just outside New York City, where she gave courses in French and Italian. By all accounts, she was despondent. She had died to herself.

BEFORE she left Europe, Yourcenar had deposited a trunk in storage at a hotel in Lausanne. She had been trying for years to get it back, and one day in 1949 it arrived. Opening it, she looked first for some valuables, but they had vanished. All that was left was a bunch of old papers. She pulled her chair up to the fireplace and started pitching things in. Then she came upon the drafts of a novel about Hadrian that she had begun when she was twenty-one and had later put aside. At the sight of those pages, she said, her mind more or less exploded. It is hard to understand how she managed to produce *Memoirs of Hadrian* in two years. In a bibliographical note appended to the novel, it takes her seventeen pages to list the sources she consulted (mostly at Yale) in order to make her account factually correct: ancient texts by the score; histories in English, French, and German; treatises on archaeology, on numismatics. Then, there was the matter of writing the book,

but she said that she composed it in a state of "controlled delirium." She recalled a train trip she took at the time:

> Closed inside my compartment as if in a cubicle of some Egyptian tomb, I worked late into the night between New York and Chicago; then all the next day, in the restaurant of a Chicago station where I awaited a train blocked by storms and snow; then again until dawn, alone in the observation car of a Santa Fe Limited, surrounded by black spurs of the Colorado mountains, and by the eternal pattern of the stars. Thus were written at a single impulsion the passages on food, love, sleep, and the knowledge of men. I can hardly recall a day spent with more ardor, or more lucid nights.

Clearly, she was simply ready to write this novel, as she had not been at twenty-one. She herself said that the crux was time: "There are books which one should not attempt before having passed the age of forty." She was forty-five when she went back to Hadrian.

As the book opens, Hadrian is sixty, and dying. His life, he says, seems to him "a shapeless mass," but in this memoir, written as a letter to his adopted grandson, Marcus Aurelius, he will try to make some sense of it. The son of a Roman official, he grows up on a dusty estate in his native Spain under the care of a mystic-minded grandfather. One night the grandfather excitedly wakes him up and says that he has read in the stars that Hadrian will rule the world. Then the old man forgets the prophecy, as does the child. At sixteen, Hadrian is sent to study in Athens, and there he falls permanently in love with Greece, "the only culture," he says, "which has once for all separated itself from the monstrous, the shapeless, and the inert, the only one to have invented a definition of method, a system of politics, and a theory of beauty." Time, he discovers, is not just the present; some matters are eternal. But he is young and wild. In the wars in Dacia (Romania), his bravery

greatly impresses the emperor, Trajan, who is his cousin and guardian. He recalls with exhilaration the "Dacian footsoldiers whom I crushed under my horse's hoofs." Later, in Rome, he shows himself equally skilled as an administrator and as a courtier. He is careful to get as drunk as everyone else at Trajan's parties. He longs to succeed Trajan as emperor.

There is a difficulty, however. Hadrian has come to hate Rome's policy of conquest. It's not so much that he has lost his taste for killing, though he has. Conquest, he now feels, is wasteful. The defeated merely went home, resharpened their knives, and came back at you, forcing you to fight them forever. Instead of subduing other peoples, he thinks, why not make treaties with them and let them be, relying on the exchange of goods and ideas to spread Rome's laws? But he cannot voice these ideas. Trajan, on whom he depends, is an utterly convinced warmaker. Soon Trajan sets out on an Asian campaign, and he makes Hadrian the governor of Syria, where the young man practically goes mad under the burden of his hypocrisy and his fear—fear that Trajan, who is old and has many people around him who dislike Hadrian, will not choose him as his successor. One frenzied night, he orders a prisoner to be brought up from a dungeon and has the man's throat cut, in the hope that his escaping soul may give some hint of the future. Soon afterwards, Trajan dies, and probably as a result of some maneuvering by his widow, who loved this clever Spaniard, Hadrian is made emperor, at the age of forty-one.

His sense of time now changes. The future is everything. He enacts a thousand reforms. He outlaws forced labor, adjusts taxes, forbids execution by torture. He institutes a massive building campaign; he wants Rome to be beautiful, like Athens. Most important, he ends Rome's wars on its neighboring peoples. He envisions an empire not of uniformity but of multiplicity. (Today, we call this multiculturalism.) "The tattooed black, the hairy German, the slender Greek, and the heavy Oriental"—he wants them all, and just as they are, in their peculiar clothes and with their strange gods, except that, in keeping with Roman rule, they will clean their streets, give good weight, enforce the law. The new Rome of Hadrian's imagining was thus not so much an empire as a world. When the Greeks declared him a god, he thought—

arrogantly, touchingly—that perhaps this wasn't excessive. The gods ruled the world in the name of right. So did he.

That was the high noon of his life. Then, at the age of forty-eight, he met a Greek boy, Antinous, aged thirteen or fourteen, and for the first time in his life he fell headlong in love. Antinous was tender and artless. After the hunt, Hadrian says, he "would cast off his dagger and belt of gold, scattering his arrows at random to roll with the dogs on the leather divans." Antinous, one suspects, was just the sort of blank little beauty (he only wanted to hunt; he never managed to learn Latin) that brilliance sometimes fastens on when it is tired of being brilliant. In any case, Hadrian, after seven years of midnight toil, found this patch of sunshine and was carried to mystic heights. He rebuilt the Pantheon, which means the "temple of all gods." All the gods were showering blessings on him, and on his empire. After the opening of the Pantheon, the people of Rome staged a "fire festival" in his honor:

> I watched Rome ablaze. Those festive bonfires were surely as brilliant as the disastrous conflagrations lighted by Nero; they were almost as terrifying, too. Rome the crucible, but also the furnace, the boiling metal, the hammer, and the anvil as well, visible proof of the changes and repetitions of history, one place in the world where man will have most passionately lived. . . . These millions of lives past, present, and future, these structures newly arisen from ancient edifices and followed themselves by structures yet to be born, seemed to me to succeed each other in time like waves; by chance it was at my feet that night that this great surf swept to shore. . . . The massive reef in the distance, perceptible in the dark, that gigantic base of my tomb so newly begun on the banks of the Tiber, suggested to me no regret at the moment, no terror nor vain meditation upon the brevity of life.

He is ecstatic, prophetic—the master of time.

Time soon reminds him who the master is. Hadrian was a great sensualist, and whereas, for a while, he was happy to spend his nights with Antinous alone, he eventually drew the boy into

more complicated revels, including women. Antinous, by then nineteen, may have sensed what time would do to his position with Hadrian. Also, there was apparently a prophecy that whatever years he cut off from his own life would be added to those of his emperor. One night in Alexandria, he came to Hadrian in a robe "sheer as the skin of a fruit." The next morning, he went out and drowned himself in the Nile. Hadrian was shattered.

One last catastrophe awaited him. His idea that all of Rome's peoples, while following their own customs, would nevertheless recognize Rome as an overarching authority was not endorsed by everyone, notably the Jews. Hadrian couldn't understand the Jews: their insistence that their god was the only god, their refusal to let their sons study Greek, their barbarous custom of circumcision. He finally banned circumcision, and this, with other factors, provoked an insurrection. It took Hadrian and his army three years to put down the revolt, which they did savagely. Jerusalem was destroyed; the rabbis were executed; the rebels were sold into slavery. "Judea was struck from the map," Hadrian writes. That was the beginning of his death. Though he was the one who did it, it broke his heart. His policy of peace lay in the dust.

Of all Yourcenar's characters, Hadrian is the most admirable. He took everything in, liked everything: men, women, war, peace, Greece, Rome. He read endlessly. (Yourcenar reconstructed his library.) And he made combinations, compromises, with a goal of partial virtue, partial justice. He thought slavery was all right, but he outlawed the sale of slaves to gladiatorial schools. He agreed that women were inferior, but gave them the right to inherit and bequeath property. He thought that men were no more prone to evil than to good, and that if he could induce them to try the good they might get in the habit. His mind was as large as his empire.

What would become of that empire after his death? This is the question that torments his last years. Near the end, he finds a bitter peace:

Life is atrocious, we know. But precisely because I expect little of the human condition, man's periods of felicity, his

partial progress, his efforts to begin over again and to continue, all seem to me like so many prodigies which nearly compensate for the monstrous mass of ills and defeats, of indifference and error. Catastrophe and ruin will come; disorder will triumph, but order will too, from time to time. . . . Some few men will think and work and feel as we have done, and I venture to count upon such continuators, placed irregularly throughout the centuries, and upon this kind of intermittent immortality.

One token of that immortality is *Memoirs of Hadrian.* No other modern document takes us so deeply into the pre-Christian mind. This act of time-travel is part of what Yourcenar meant when she said one had to be forty in order to attempt certain books. Younger than that, this exemplary Judeo-Christian writer—who was a committed pacifist—could not have achieved the self-suppression required to describe her hero's joy as he trampled the Dacian foot soldiers. Age gave her more than objectivity, however. She says in an afterword to the novel that in order to appreciate Hadrian's struggle with time—the reversals, the accidents—she had to undergo the same struggles, among which her ten-year writing block no doubt figured heavily in her mind. *Hadrian* can be seen as her solution, the same one offered by Proust, whose work she loved. Art redeems us from time: in Hadrian's case, by shaping his life into a meaningful curve (ambition to mastery to exaltation to disaster to reconciliation); in Yourcenar's case, by enabling her to do that shaping, and in the process to write her first great novel, save her own life.

But the salvation is not limited to the superstructure. It goes down to the diction, the grammar. In *Hadrian,* Yourcenar gathers not just the round-cheeked boys and the fire festivals but also the less glamorous materials—the tax abatements, the judicial reforms—into sentences that throb and glow like rising suns. This is more than beauty; it's morals. If, to Hadrian and to Yourcenar, their lives seemed crazy or dull or just plain obliterated, these magnificent Latinate constructions, with their main clauses and their subordinate clauses—that is, with distinctions, with judgment—say the opposite.

Hadrian was Yourcenar's first big success—it made her famous—and the momentum she generated for it lasted close to twenty years. In the 1950s and 1960s, she wrote some superb critical essays, several of them spinoffs from *Hadrian,* and gathered them in her collection *The Dark Brain of Piranesi and Other Essays* (1962), which was beautifully translated into English by the poet Richard Howard. One striking feature of this book, and of her later critical writings, too, is the extent of her learning. Continuing the practice of her childhood, she read almost everything she could lay her hands on, and when she finished a book she liked, she would turn back to page 1 and read the whole thing all over again. She went from Western literature to Asian literature. She taught herself new languages: a lot of Japanese, some German, Spanish, Portuguese, and modern Greek. This studiousness is reflected in her criticism. There seems to be almost nothing she doesn't feel she can write about: Cavafy, Mishima, Selma Lagerlöf, Michelangelo, the Venerable Bede, plus some people we haven't heard of but whom she is rescuing for us. Of the major novelists of the twentieth century, including Joyce, she was probably the most erudite. The point of her critical writings, though, is not their show of knowledge. As with *Hadrian,* it is penetration—historical, moral—and the subject, again, is often time. In "The Dark Brain of Piranesi," the best of her essays—it is one of the most profound critical studies of our period—we learn what the great eighteenth-century draftsman, trailblazing for Yourcenar in his thousand-odd etchings of the ruins of Rome, thought about time's action on the supposedly eternal city.

These were sidelines, though. Yourcenar's main project in the 1960s was her next novel, *The Abyss.* The tone of this book is very different from that of *Hadrian.* When an interviewer raised that point with her, she asked him to consider the events intervening between the two novels. When *Hadrian* was written, World War Two had just ended, and the United Nations had been established. There seemed to be some hope for the world. Then came a series of disasters. She listed them briefly: "Suez, Budapest, Algeria." (She might have added the Vietnam War, which sickened

her. She went to sit-ins, carried placards.) If reading *Hadrian* is like gazing on white marble, reading *The Abyss* is like breaking open a clod of earth and finding strange, dark things: glints and bones and bugs, slimes and roots, sulfur and verdigris. Flanders in the sixteenth century was a sink of violence—secular wars, religious wars, peasant revolts. All this is in the book, together with the explosion of ideas that occurred at that time: the Reformation, the discovery of new worlds, the birth of modern science, the beginnings of industrialization. The hero of *The Abyss,* and the representative of those new ideas, is Zeno, the illegitimate son of a rich banking family, who leaves home at the age of twenty to find truth. He becomes a priest, a physician, an alchemist, a philosopher. He writes books, and they are seized by the authorities. He travels to North Africa, to Sweden, to the courts of the East, and often has to leave quickly, with the police on his tail. Finally, he is captured, and condemned to be burned at the stake. On his last night, he cuts open his veins and dies in his prison cell.

The Abyss is not a warm book. For one thing, it sometimes imitates Renaissance literary forms—the love lyric, the picaresque novel—and, while this true-to-period writing worked well in *Hadrian,* in *The Abyss* it has a distancing effect, in the postmodern way. Furthermore, the story has very few good people in it. Zeno himself is not altogether sympathetic. The novel's excitement lies in the vividness of the world Yourcenar calls up: the reeking taverns, the lecherous monks, the smell of honey cakes and eel pie, and of festering bodies, felled by plague. Then there are the visions that fill Zeno's expanding mind. Here is what he sees as he is dying. Night has fallen:

> But this darkness, different from what the eyes see, quivered with colors issuing, as it were, from the very absence of color: black turned to livid green, and then to pure white; that pure, pale white was transmuted into a red gold, although the original blackness remained, just as the fires of the stars and the northern lights pulsate in what is, notwithstanding, total night. For an instant which seemed to him eternal, a globe of scarlet palpitated within him, or perhaps outside him, bleeding on the sea. Like the summer

sun in polar regions, that burning sphere seemed to hesitate, ready to descend one degree toward the nadir; but then, with an almost imperceptible bound upward, it began to ascend toward the zenith, to be finally absorbed in a blinding daylight which was, at the same time, night.

Yourcenar often voiced the conviction that her characters actually existed, and lived with her, but there is no character she felt closer to than Zeno. He was a brother to her, as she put it. When she couldn't sleep, she would hold out a hand to him. Once, weirdly, she recalled going to a bakery and leaving Zeno there; she had to go back and get him, she said. In view of this attachment, the stern and furtive character that she gave to Zeno seems puzzling. Perhaps it was a defense against too great a love for him. Or, more simply, one might say that Zeno was Yourcenar's tribute to one part of herself, her love of knowledge, and that she made the tribute more pointed by cutting the other parts away. She said she expected *The Abyss* to be read by about ten people. Instead, like *Hadrian,* it was a big success.

In the 1940s, Yourcenar and Frick discovered Mount Desert Island, a starkly gorgeous spot. In 1950, they bought an old frame house there, and soon they had quit their jobs and settled in. They called the house Petite Plaisance, little pleasure. Petite Plaisance is now a museum dedicated to Yourcenar. I visited it under the guidance of its director, Joan E. Howard, who, apart from being a Yourcenar scholar, was a friend of the writer's. The house is a bright, cozy place with eight small rooms jumbled together and filled with modest treasures—delft tiles, Chinese figurines, photographs of Yourcenar's and Frick's dogs. The most striking feature of the house is the library, which stretches from floor to ceiling and from room to room: Asian literature in the parlor, Greek and Roman in the study, seventeenth and eighteenth century in the foyer, early nineteenth century in Frick's bedroom, later nineteenth century in the guest rooms, twentieth century in Yourcenar's room. The place looks like the Bibliothèque Nationale

crammed into a New England farmhouse. In the study, there is a large custom-made table on which two typewriters sit opposite each other. As Yourcenar wrote her novels, and Frick translated them, they sat face to face, a few feet apart.

This they did for almost thirty years. After *The Abyss,* Yourcenar's most important project was a three-volume biography of her family—basically, it is another historical novel—with the overall title *Le Labyrinthe du monde* (The Labyrinth of the World). These three books have wonderful parts, but that's what they are: parts. Yourcenar, it seems, had finally tired of *constructing* her books. She also let herself rant. She was a longtime activist for environmentalism and animal protection, and in *Le Labyrinthe* we hear a lot about those causes.

It was while Yourcenar was writing *Le Labyrinthe* that she was elected to the Académie Française, an event that was heavily covered in the international press. (The society had existed for 346 years without including a female in its ranks, and many of the members—Claude Lévi-Strauss, for example—opposed any change in this policy.) At that point, Yourcenar had published almost a score of books—plus translations of other writers' work—in French, but only three of them, *Coup de Grâce, Memoirs of Hadrian,* and *The Abyss,* had been brought out in English. Now her publishers got busy, and translations of her earlier work appeared in fast succession. Yourcenar wasn't troubled by the possibility that these volumes might not equal the products of her middle period. She had an odd view of her writing. Everything having come to her when she was young, she regarded it all, somehow, as one work, which she simply carried forward year by year. So she happily endorsed the translation and republication of her early books, many of which she now extensively revised. But no amount of revision could bring this material up to the level of *Hadrian* or *The Abyss,* and that fact, together with the slackly composed *Labyrinthe,* left a number of reviewers with a problem. How could they say that this eminent, and also politically attractive, figure—this unbothered bisexual, this breacher of the walls of the Académie—had written a book that was not of the first rank? Some couldn't, and found the phrases they needed to lay another

bouquet at her feet. Others, scornful of such politesse and, in the case of some New Wave types, unimpressed by marmoreal prose, asked what the big deal was about Yourcenar.

Her last years were strange. In 1958, Frick had been found to have cancer, and she fought it for twenty years. This put a terrible strain on the household. Yourcenar had a mania for travel. If she didn't mind the isolation of Mount Desert Island, that was because, under normal circumstances, she was there only half the year. The rest of the time, she and Frick were in Europe or elsewhere. But once Frick's illness progressed beyond a certain point, they couldn't leave. For almost a decade, they were stuck year-round in that little house, as Grace, more and more slowly, translated *The Abyss* and Yourcenar went stir-crazy. Their relationship suffered. Frick died in 1979, and within three months Yourcenar had left Maine.

In the lives of aging divas, it sometimes happens that a young man—often impecunious, often homosexual—walks through the door saying how wonderful Madame is, and how the people around her don't fully appreciate that. In 1978, a year before Frick's death, Petite Plaisance was visited by a French television crew that included a young American photographer, Jerry Wilson, who was the director's assistant. Yourcenar was seventy-four, Wilson was twenty-nine, and he became the last love of her life. Most of her friends disapproved; Wilson didn't like them, either. Yourcenar didn't care. She traveled with Wilson to Europe, to Asia, to Africa. At times, she thought of herself as Hadrian and Wilson as Antinous. The relationship may even have been consummated, or so say some of Wilson's friends. Wilson drank heavily, and when Yourcenar seemed to him old or slow or foolish, he sometimes hit her. Still, in her mind, it was worth it. Wilson died of AIDS in 1986. Yourcenar grieved horribly, and then, two months later, she was back on the road, this time with one of his friends.

Like Hadrian, she had her burial plot prepared, next to Frick's, in a cemetery near Petite Plaisance. Indeed, the headstone was carved, lacking only the date of death. She must have known that her career was over; if not, she would have stayed home and worked on the last volume of *Le Labyrinthe,* which she never fin-

ished. In 1987, having packed to leave for Europe again, she suffered a stroke and was taken to the hospital, where she became delirious. Soon afterward, when her friend Yannick Guillou, who oversaw her work at Éditions Gallimard, arrived and spoke to her in her native language—according to Savigneau, the only thing in the world that she loved without reservation—he said that "an expression as if of relief spread over her face, almost a look of happiness." That night, there was a date to inscribe on her tombstone.

The New Yorker, 2005

Primo Levi, 1985

A Hard Case

PRIMO Levi was a man whom people wanted on their side. Not only was he a concentration-camp survivor; with his 1947 book *Survival in Auschwitz,* he was also the camps' noblest memoirist. No breast-beating for Levi, no look-at-me, no violin song, only a plain, thoughtful record, which by its very modesty stunned the mind. He went on to write two more great books, *The Reawakening* (1963) and *The Periodic Table* (1975), plus a number of excellent ones, and he campaigned for just causes all his life. In the eyes of many, he was a Jewish saint. Peace groups demanded him for their conferences; journalists called to ask him about the future of the Jews. Strangers wrote to him, seeking consolation, prophecy. And often, by virtue of the traits these people admired in his writing—honesty, justice, abstemiousness—he told them things they didn't want to hear.

Now he has disappointed another person. Carole Angier, in her new book, *The Double Bond: Primo Levi, a Biography,* does not attack Levi. She loves his work. Yet the point of her book, announced in its title and tirelessly argued for 731 pages, is that he was a neurotic man, split down the middle. "His gentleness, justice, and detachment were not so much moral or literary choices as his own psychological imperatives," she writes. He couldn't help being that way, because "he had never resolved the inner torment of his youth." That torment was the basis not just of his late-life depressions and his presumed suicide but of all his life and all his work. It is "the key to everything."

Angier concedes that she may not have the whole truth. Levi's immediate family—his wife, his sister, his two children—refused to talk to her, and many of his friends would speak only on condition of anonymity. In other words, this is a biography in which

the key to the subject's life is provided by people who refuse to give their names. But Angier says she'll take responsibility for that. She is a character in this book, she tells us. She gives us extended accounts of her interviews with Levi's friends. (If I'm not mistaken, she reveals between the lines that she had a sexual adventure with one of them, on a mountain promontory.) She also seems to think she's psychic. Some of her chapters, she says, will be "rational," based on evidence. Others will be "irrational," based on intuition, though she believes that these may be "*more* true than the rational ones." If, on the other hand, they're wrong, that's okay, too: "there may be more truth in failure."

Those words, from her preface, are the last we hear about possible failure. Angier feels that she has solved a mystery. The story of Levi's terrible end is well known. One morning in 1987, at the age of sixty-seven, he was found dead, his skull crushed, at the base of the stairwell of his building, having fallen—or, as the police and many other people assumed, jumped—from the landing on the third floor, where he lived. Angier begins by asking us to look at the building. Its façade is "blank and stony," its windows shuttered. Clearly, it is hiding something.

In that building, in Turin, Levi was born to a respectable bourgeois couple in 1919, and, apart from a few brief absences—his year in Auschwitz, for example—he lived there all his life. He was a shy, bookish boy. According to Angier, his parents were ill-matched. The father, Cesare, an engineer, was a bon vivant. (Walking down the street, Cesare would stop to "caress all the cats, sniff at all the truffles," Levi later wrote.) The mother, Ester, was a cold, domineering woman. She had a horror of sex, Angier says, so Cesare obtained his satisfactions elsewhere. Ester therefore hated Cesare, and she drew her son to her side, forcing him to reject the things his father stood for—above all, sensuality. Levi was attracted to women, but at the same time he was "revolted and terrified" by the thought of sex. This was his "double bond," or "double bind," as Angier also calls it (confusingly, because the double bind is an old theory of schizophrenia). Yet in eschewing his father's traits, Angier says, Primo did not win his mother's

affection. She never loved him. Accordingly, he was left defense-less in the face of all emotion. He lived only in the realm of reason, and shut out everything instinctual. That is the aforementioned "key to everything."

It is worthwhile here to skip ahead to Levi's marriage, since in Angier's view it was merely an extension of the mother-child nexus. Levi married Lucia Morpurgo, a serious-minded young woman, and they moved into Ester's apartment. (Cesare was dead by then.) Thereafter, whatever Ester did not prevent Primo from doing or feeling, Lucia did—a convenient arrangement, Angier suggests, because it gave Primo something external to blame for what were in fact his own hesitations in life. Lucia was a jealous wife. She resented his work, his fame. She wouldn't have his friends in the house. The marriage was largely sexless, Angier implies.

Her evidence for these suppositions, both about the parents' marriage and about Levi's, is flimsy. Unidentified sources are heavily relied on. So are two novels, one by a cousin of Levi's and one by his employer's daughter. Furthermore, there is consider-able evidence against Angier's conclusions. She herself tells us that Lucia was always the first reader of Levi's writings—a strange cir-cumstance, if she so resented his work. And if Levi was emotion-ally blocked how do we explain the genius for friendship which, after his solitary childhood, he developed as a young man? Levi's friends adored him, and he them. This putatively pleasure-fearing man spent night after night at their houses, chatting and telling stories and playing charades.

LIFE got better for young Primo. He fell in love with his studies, and specialized in chemistry. Angier links this decision to his dou-ble bind; he was fleeing the "chaos of human affairs." Levi gave a different account. Once, charmingly, he said that he was drawn to the chem lab because he liked smells. In *The Periodic Table,* he wrote that the allure of chemistry was that it held out the promise of understanding: "I would watch the buds swell in spring, the mica glint in the granite, my own hands, and I would say to myself: 'I will understand this, too, I will understand every-

thing. . . . I will push open the doors.' " In 1941, he graduated summa cum laude from the University of Turin. He wanted to go on to graduate study in physics. Mussolini's race laws (whereby Jews could no longer attend state schools), and then the war, put an end to that plan, though Angier feels that Levi's double bind is lurking here, too. Supposedly, among the anxieties of this man who wrote more than a dozen books was a morbid fear of failure and a consequent need to limit himself.

Italian Jews were among the most assimilated in Europe. By 1920, the country had had nineteen Jewish senators and two Jewish prime ministers. Levi wrote that when he was young he felt no different from his Christian friends. A Jew, he thought, was just somebody "who should not eat salami but eats it all the same." With the advent of the race laws, he found out otherwise. In 1943, he joined a partisan band in the Piedmont hills. Within weeks, the group was betrayed and arrested, and Levi, at the age of twenty-four, was sent to Auschwitz.

In his transport, there were 650 Jews. Twenty-three survived. That Levi—a timid, scrawny man (five feet five, 108 pounds)—was one of them seems a miracle. He attributed it to luck. First, he didn't get to Auschwitz until 1944, so he spent only a year there. Second, he was soon transferred to a block where he found a friend of his, Alberto Dalla Volta. The two men became inseparable, and they made a pact to share everything they had. This agreement, to aid another man—an action rare in the camps, as Levi later pointed out—was probably even more important to his mental health than to his physical well-being. Third, and most crucial, after four months in the camp Levi met a Piedmontese bricklayer named Lorenzo Perone, who was not a prisoner but one of Auschwitz's many "civilian workers." Thereafter, for no reason other than human feeling, Perone every day, at serious risk to his own life, smuggled to this man he barely knew a mess tin containing two quarts of soup, which Levi then shared with Alberto. Without this extra ration, Levi said, he would have died. Fourth, it was eventually discovered that Levi was a chemist, and he was sent to work in one of the camp laboratories, out of reach of the brutal Silesian winter.

Finally, Levi did not become seriously ill until the very end of

his year in the camp. In January 1945, as the Russian Army was crossing Poland and the SS was preparing to evacuate Auschwitz, he came down with scarlet fever and was sent to the camp infirmary. He should have died there; the Nazi command gave orders that anyone not strong enough to join the march to Germany should be killed. But the last days of Auschwitz were very chaotic, and in the end the SS, with some sixty thousand prisoners, abandoned the camp without bothering to shoot the bedridden. On the night before the evacuation, Alberto came and stood under the infirmary window, and he and Levi said good-bye to each other. Both must surely have believed that Alberto would live and Levi would die. Instead, Alberto, together with most of the other Auschwitz evacuees, died on the march, and Levi lived.

IT is hard to find the words to praise *Survival in Auschwitz,* and this is not because of the enormity that it records but because of its internal qualities: the intelligence, the fine-mindedness, the sheer narrative skill with which Levi addresses that enormity. He later said that he modeled the book on the "weekly report" issued in chemical factories. Accordingly, he sticks to the facts, and they are fascinating. He tells us, for example, about the toilet problems in Auschwitz. At night, in the block, you had to learn to time your trip to the bucket so that you would not be the one to fill it to the rim. If you did, you had to carry it, spilling on your feet, through the snow, and empty it in the camp latrine. Many prisoners became expert in judging, during their half sleep, the sound their fellows' urine made as it hit the bucket. Half full, near-full: each made a different splash.

Levi writes with pity, and with outrage, too, but those emotions almost never come unmixed with the memory of other, less respectable feelings: the fear of smelling bad in front of women, the pain of seeing old men naked, the overriding wish to live, though others might die. Levi records how, one day, the camp was swept with excitement at the news that there was to be a distribution of new shirts, because "a convoy of Hungarians . . . had arrived three days ago." (In other words, the shirts would be from gassed Hungarians.) He tells how, after one of the infamous

"selections"—where the prisoners were forced to run naked in front of an SS officer, who then sorted their name cards to the right or to the left (that is, to be exterminated immediately or not)—the men couldn't figure out which was the death sentence, the right pile or the left. So they crowded around the oldest, weakest man in the block, asking him which side his card went to. This is not the only dark comedy. There is a whole chapter on the camp's black market, where starving men stood around, just as at the bourse, comparing barter rates for various negotiable items and scurrying to cash in their supplies of stolen nails or shoe grease when the price went up from one portion of bread to two.

The title of the Italian edition of *Survival in Auschwitz* is *Se questo è un uomo* (*If This Is a Man*), and the book's purpose is to ask that question: whether people reduced to such circumstances were still men. It's a close call. The last chapter describes the week and a half that Levi and ten other men spent, near death, in the infectious ward of the camp infirmary between the time their German captors left and their Russian liberators arrived. They had no heat, no food. Then came the Allied bombings, setting fires in the camp. Patients driven out of their quarters hammered on the door of Levi's ward, pleading to be let in. Levi and the others knew that they could not support a single additional person: "We had to barricade the door. They dragged themselves elsewhere, lit up by the flames, barefoot in the melting snow. Many trailed behind them streaming bandages. There seemed no danger to our hut, so long as the wind did not change." It must have taken guts to write that last sentence, but the problem it poses—survival versus fellow feeling—is the story of the book.

The story has a happy ending, and that is one of the reasons people love *Survival in Auschwitz*. It votes for humankind; it says that these desperate creatures were still men, or that they returned to that condition as soon as they could. One day, Levi and two young Frenchmen, Charles and Arthur, went out into the camp to scavenge. They found some potatoes; they also found a stove, and set it up in the ward, and cooked the potatoes on it, and passed them around. From then on, as Philip Roth pointed out in a 1986 interview with Levi, the book becomes like *Robinson Cru-*

soe, a tale of inspired scrounging, of a treasure hunt, almost. (On a later foray, into the SS barracks, Levi found "four first-rate eiderdowns, one of which is today in my house in Turin.") It is also the story of a contest: how many of the gravely ill men in the ward can Levi and Charles and Arthur save from death before the Russians get there? Levi does not present this as a matter of altruism. He treats it as a test of enterprise, and thus he keeps sentimentality and self-congratulation at bay. But enterprise is enough.

On the night Levi and his French friends brought back the stove and the potatoes, one of their ward-mates—Towarowski, a typhus patient—proposed that each man give a portion of his food to those who had gone on this mission. "Only a day before, a similar event would have been inconceivable," Levi writes. "The law of the *Lager* [camp] said: 'eat your own bread, and if you can, that of your neighbor.' " Towarowski's proposal, and the ward's agreement, "meant that the *Lager* was dead." That night:

> Arthur and I sat smoking cigarettes made of herbs found in the kitchen, and spoke of many things, both past and future. In the middle of this endless plain, frozen and full of war, in the small dark room swarming with germs, we felt at peace with ourselves and with the world. We were broken by tiredness, but we seemed to have finally accomplished something useful—perhaps like God after the first day of creation.

Eight days later comes the liberation. A man in the ward has died (this is the only one they lost), and Levi and Charles have gone out into the snow to deposit his body in the common grave. But the grave is full, "overflowing with discolored limbs." As they are standing there, wondering what to do, they look up and see four Russian soldiers, "with rough and boyish faces beneath their heavy fur hats," coming down the road on horseback. "When they reached the barbed wire, they stopped to look, exchanging a few timid words. . . . They did not greet us, nor did they smile." To Levi and Charles, the sight of men in a state of advanced starvation—not to speak of a ditch full of yellow corpses—was com-

mon, but to these young Russians it was not. On their faces, Levi writes, he saw shame, the shame "that the just man experiences at another man's crime." Horribly, Levi and Charles were also ashamed, filled "with a painful sense of pudency . . . and also with anguish, because we felt . . . that now nothing could ever happen good and pure enough to rub out our past."

When Levi got back to Turin, he fell in love, married, and went to work as an industrial chemist, a profession that he pursued full time for almost thirty years. (His first six books were written at night and on weekends.) He had already decided in the camp that if he lived he would write a book about the experience. Within a month of his return, he began *Survival in Auschwitz,* and he finished it in just over a year. When it was first published, in 1947, it sold only about fifteen hundred copies. At that time, no one wanted to hear about the camps. But when the book was revised and reissued, in 1958, it was a runaway success.

Heartened, Levi embarked on a sequel, *The Reawakening,* which describes his journey home from the camp. Like *Survival in Auschwitz, The Reawakening* is not just a memoir—it is a moral tale, in this case the story of Levi's remarriage to life—and, in contrast to the tight-lipped *Survival in Auschwitz,* it is loose and gay. Levi later said that by the time he wrote down these stories, more than a decade after the events, he had told them many times. Hence the book's picaresque quality—it is a string of anecdotes— and also, at times, a certain patness in the comedy. This is shtick, well polished. (And that's just fine. We *want* him to have this pleasure, of telling his favorite joke.) The guiding spirits of the book are the Russians, his liberators, a people, in Levi's view, as decent and disorganized as the Germans were criminal and efficient. Between their endemic chaos and the fact that, for much of this time, there was still a war on, it took the Russians seven months to get Levi pointed southwest rather than northeast of Auschwitz— he had a leisurely stroll through Poland, Ukraine, Belarus, Romania, and Hungary—but they fed the ex-prisoners well when they could, and gave everyone (babies included) ten ounces of tobacco a month, and put on variety shows, with singing and dancing, in the holding camps.

Survival in Auschwitz and *The Reawakening* established Levi as a writer, but a certain kind of writer: a survivor, a witness. He wanted to serve as a witness, and desired it all the more urgently as, in the seventies, neo-Fascism and Holocaust denial reared their heads. He spoke to endless numbers of school groups. He received scores of interviewers, and when, long after he had begun writing about subjects other than the Holocaust, they asked him only about the Holocaust he patiently replied. Indeed, he wrote three more books about the Holocaust. One, the novel *If Not Now, When?* (1982), was the story of a group of Jewish partisans sabotaging Nazi operations in the last years of the war. This was his answer to the widespread claim that the Jews went like lambs to the slaughter.

But the more Levi shouldered his responsibilities as a Jew the more he got caught in the toils of the Holocaust culture. Like most Italian Jews, he believed in assimilation. And he did not consider the Jews to be heroes because Hitler had tried to exterminate them. As he saw it, they were merely human—Fascism's crime was to have deprived them of that status—and humanity was what we had to understand if we harbored any hope of a just world. Accordingly, he gave Israel no breaks. "Everybody is somebody's Jew," he told an Italian newspaper in 1982, "and today the Palestinians are the Jews of the Israelis." After the Israeli occupation of southern Lebanon, and the massacres at Sabra and Shatila, he said that Menachem Begin and Ariel Sharon were bringing down shame on the Jews, and he called for their resignation. This brought a flood of letters accusing him of giving comfort to the enemy. In sum, Levi, the greatest soul, the greatest artist, of the "witness" writers, was not usable the way the others were. It was not Levi but Elie Wiesel who got a Nobel Prize.

In 1985, two years before Levi's death, *Commentary* published an article by Fernanda Eberstadt, claiming that the true, Jewish meaning of the Holocaust was beyond "so fastidious and uncertain an imagination" as his. He was a literary master, but in a "minor key." He was an aesthete, a decadent, like the Latin poet

Ausonius, who, while the barbarians were threatening Rome, retired to his estate in Bordeaux to grow roses and "compose poetry dallying in 'anagram and compliment, enamelled fragments of philosophy, the fading of roses, the flavor of oysters.' "

All this was torture to Levi, but nothing was worse than the implied message that, given his history, he was barred from writing about anything other than the Holocaust. For him to produce "just" stories, "just" essays—not about Jews—would be viewed as an abdication, a rose-smelling. By him, too. Because of this scruple, he published his first non-Holocaust book, a 1966 collection of stories, under a pseudonym—an action that greatly annoyed his reviewers. (They thought it was coy.) But everyone got over that in 1975, with the publication of *The Periodic Table*. This book once again had credentials as testimony. It was signed by Primo Levi, and it included some war stories. At the same time, much of it was not about the war, and all of it was art of the highest order, as was widely recognized. He had finally crossed over.

Like Kafka before him and Sebald after, Levi invented a new genre—in his case, the "science fable," a cross between his two professions, chemistry and literature. True to the book's title, the contents page of *The Periodic Table* reads "Argon," "Hydrogen," "Zinc," and so on. In each chapter, Levi uses one element as an anchor for autobiography or fiction or essay. Some chapters are very funny. In "Tin," for example, he tells of the small, independent chemistry lab that he and his friend Emilio set up, at the beginning of their careers, in the bedroom of Emilio's obliging parents. The lab's misfortunes were frequent:

> It is not that hydrochloric acid is actually toxic: it is one of those frank enemies that come at you shouting from a distance. . . . You cannot mistake it for anything else, because after having taken in one breath of it you expel from your nose two short plumes of white smoke, like the horses in Eisenstein's movies. . . . Acid fumes invaded all the rooms: the wallpaper changed color . . . and every so often a sinister thump made us jump: a nail had been corroded through and a picture, in some corner of the apartment,

had crashed to the floor. Emilio hammered a new nail and hung the picture back in its place.

There are other stories like that, and stories utterly unlike that—lyrical, grieving stories, and spooky stories, too. Each tale is wholly specific and individual, the way chemicals are—the way mercury dances, and lead sinks, and bromine smells. Together, the twenty-one chapters describe a huge psychological arc, parallel to the arc described on the material plane by the periodic table. The book was a best-seller in Italy, and when it was published in the United States, nine years later, in a beautiful translation by Raymond Rosenthal, Levi became an international hero. People stopped him on the street to get his autograph. "If this goes on," he said, "I'll have to shave my beard."

It didn't go on long. Levi had produced one more splendid book, a 1978 novel called *The Monkey's Wrench*. But his flame began to gutter, and his life became more difficult.

THE source of the problem, in Angier's view, was Levi's double bind. She trawls his novels, his memoirs, his stories for what they can reveal about his psychic conflicts. When he invents the "science fable," often having to do with curiosities, oddities, that's because he was frightened at how odd his psyche was. When, in *The Periodic Table*, he tells a nice story about a mine where he worked as a young man, that, too, gets a raising of the eyebrows. The mine, Levi writes, was reputed, in former days, to have been a hotbed of sexual misbehavior:

> Every evening, when the five-thirty siren sounded, none of the clerks went home. At that signal, liquor and mattresses suddenly popped up from among the desks, and an orgy erupted that embraced everything and everyone, young pubescent stenographers and balding accountants, starting with the then director all the way down to the disabled doormen: the sad round of mining paperwork gave way suddenly, every evening, to a boundless interclass fornication, public and variously entwined.

What is it about me that I find this funny? To Angier, it demonstrates Levi's internalization of his mother's horror of sex.

That's her angle on his work. As for his life, the position she takes is roughly that of a psychotherapist of the seventies. She's okay. We're okay. Why wasn't he okay? Why did he have to work all the time? Why didn't he take more vacations? And how about getting laid once in a while? She records that as a teenager he mooned over various girls, but whenever he got near one he blushed and fell silent. "What was this?" Angier asks. "Can anyone ever say?" I can say. Has Angier never heard of geeks? They are born every day, and they grow up to do much of the world's intellectual and artistic work. One wonders, at times, why Angier chose Levi as a subject—she seems to find him so peculiar. And does she imagine that if he had been more "normal"—less reserved, less scrupulous—he would have written those books she so admires?

Levi did suffer serious depressions in his later life. This is not speculation on Angier's part. He went to psychiatrists; he took antidepressants. Nevertheless, the account Angier gives us is tailored to her prior interpretations. She never tells us when he suffered his first depression, presumably because that would limit the problem, and she never seriously considers the possibility that the cause of his disorder may have been a biochemical abnormality rather than, or as well as, life circumstances. One can understand her silence on this matter. If Levi's depressions were biochemically based, what would that do to her double-bind theory?

Nor does she make much allowance for the evidence *against* depression, or for frequent relief from depression. It was during the early 1970s when, according to Angier, Levi's mental state was "so terrifying that it is hard to imagine anything worse," that he wrote the superb and funny *Periodic Table*. Likewise, in the late 1970s, when he is again supposed to have been despondent, he produced—with great ease—*The Monkey's Wrench,* which Angier herself calls "his most optimistic, most entertaining book." This is not to say that depressed artists can't produce happy work. But the record of cheerful activity in Levi's last decade—during which time he not only wrote seven books and translated four others but sometimes published more than twenty newspaper articles a year,

meanwhile taking hikes, spending evenings at his friends' houses, and fashioning little animal sculptures out of the insulated wire produced by his old company—seems to call for some qualification of Angier's view that his last ten years were a dark, dark time. It doesn't make a dent. To her credit, she records the opposing evidence. But then, in most cases, she simply moves on, unfazed, with the pathological sequence she has set up: disturbed mother-child relationship, double bind, repression, return of the repressed, depression, suicide. The book is relentlessly teleological. It shoots like an arrow to Levi's suicide.

A problem here is that we don't know if Levi committed suicide. As the Oxford sociologist Diego Gambetta pointed out in a measured essay in the *Boston Review* in 1999, there is good evidence that he did and good evidence that he didn't. In the months and weeks before his death, Levi said that he was depressed, and tortured by living with his now senile mother. Nevertheless, he was full of bustle and plans. He wrote new stories, witty stories. The day before he died, he spoke with a journalist who was writing a biography of him, and suggested that they get back to work. The morning of his death, he seemed fine to those who saw him. Shortly after ten, he told his mother's nurse that he was going down to the concierge's lodge, and asked her to take any calls. (As Angier acknowledges, a man going out to commit suicide is unlikely to worry about his phone messages.) Then he walked onto the landing and somehow went over the bannister. Could this have been an accident? Easily, Gambetta says. The top of the railing was no higher than Levi's waist, and the medication he was taking can cause dizziness. He could have leaned over, to look for someone on the stairs—perhaps his wife, who had gone shopping—and lost his balance. Such a scenario would solve a big problem with the suicide hypothesis: the gruesome and theatrical manner of his death. It is hard to believe that the modest Levi—who, furthermore, as a chemist, knew how to kill himself discreetly—would have chosen such a means.

These facts have been debated for years, in an atmosphere clouded by emotion and politics. "Primo Levi died at Auschwitz forty years later," Elie Wiesel declared. Others, also assuming suicide, grieved that this wiped out the idealism that had seemed to

inform his books. Still others clung to that idealism and said that it ruled out suicide: Levi would never have succumbed, never have given the Nazis that victory.

Angier believes that he committed suicide but that this had nothing to do with the camps: "For him Auschwitz was an essentially positive experience. It gave him a reason to live, to communicate, to write. . . . It was, as he always said, his adventure, his time in Technicolor, his university. . . . The central, painful and paradoxical truth is that Primo Levi was depressed before and after Auschwitz, but not in it. He thought of suicide before and after Auschwitz, but not in it. Depression and suicide were in him from the start." This is a bold theory, and highly questionable. (As noted, Angier regards shyness and scrupulousness as depressive symptoms.) In her view, he did not *plan* to commit suicide; he did it on an impulse. The "void" drew him, the same void that "draws all deep depressives, like a call." He went to the landing, perhaps, on his way outdoors, and he gazed into the void, in the form of the stairwell. "He leaned and looked . . . and he let go." Those are the last words of the book.

Readers can decide for themselves. (Or not decide. Gambetta says we will never know.) But, even if Levi did commit suicide, it is a species of sentimentality to think that the end of something tells the truth about it. That's the case with mystery novels, but not with lives. Nor do we have any reason to believe that life should not be sad. Many lives are sad, and fraught with double binds, which just means conflicts. We make of them what we can, and then we throw up our hands and die. The things that Levi made of his life—*Survival in Auschwitz, The Reawakening, The Periodic Table*—are in no way diminished by the possibility that he killed himself. They may even seem more remarkable and moving: the darker the night, the brighter the stars.

The New Yorker, 2002

Joseph Roth (right) with his friend Stefan Zweig, Ostend, 1936

European Dreams

I N *The Radetzky March,* Joseph Roth's 1932 novel about the
decline of the Austro-Hungarian Empire, there is an Army
surgeon, Max Demant, whose wife loathes him. She is very
beautiful. We first encounter her as Demant walks into their bed-
room. She is wearing only a pair of blue panties, and is brandish-
ing a large pink powder puff. "Why didn't you knock?" she asks
poisonously. (Quotations of *The Radetzky March* are from
Joachim Neugroschel's translation for The Overlook Press.)
Demant adores his wife, and that isn't his only problem. He never
wanted to be in the Army, but he didn't have the money to set up
a private practice. He is dumpy and clumsy and nearsighted. He
can't ride; he can't fence; he can't shoot. He is intelligent and
melancholic. He is a Jew. The other officers despise him, the more
so since his wife betrays him at every opportunity. One night, a
young lieutenant—Baron Carl Joseph von Trotta, the hero of the
novel and Demant's only friend—innocently walks Frau Demant
home after the opera. The next day, in the officers' club, a swinish
captain, Tattenbach, taunts Demant about his wife's adventure.
When Demant insults him back, Tattenbach screams, "Yid, yid,
yid!" and challenges him to a duel at dawn. According to the
Army's code of honor, Demant must go to the duel, in which he
knows he will die, and for nothing. Later, in the night, he recon-
ciles himself to this. His life has offered him little but insults.
Why regret leaving it? He takes a drink; he takes another. Soon he
feels calm, lighthearted—already dead, almost. Then Trotta comes
rushing in, weeping, begging him to escape, and at the sight of
someone shedding tears for him Demant loses hold of his hard-
won stoicism:

All at once he again longed for the dreariness of his life, the disgusting garrison, the hated uniform, the dullness of routine examinations, the stench of a throng of undressed troops, the drab vaccinations, the carbolic smell of the hospital, his wife's ugly moods. . . . Through the lieutenant's sobbing and moaning, the shattering call of this living earth broke violently.

It goes on breaking. The sleigh arrives to take Demant to the duel. "The bells jingled bravely, the brown horses raised their cropped tails and dropped big, round, yellow steaming turds on the snow." The sun rises; birds chirp; roosters crow. The world is beautiful. Indeed, Demant's luck changes. At the duelling ground, he discovers that his myopia has vanished. He can see again! He is thrilled, and forgets that he is in the middle of a duel: "A voice counted, 'One!' . . . Why, I'm not nearsighted, he thought, I'll never need glasses again. From a medical standpoint, it was inexplicable. [He] decided to check with ophthalmologists. At the very instant that the name of a certain specialist flashed through his mind, the voice counted, 'Two!' " He raises his pistol and, on the count of three, accurately shoots Tattenbach, who also shoots him, and they both die on the spot.

Thus, a third of the way through his novel, Roth kills off its most admirable character, in a scene of comedy as well as tears. The crime, supposedly, is the Army's, but behind the Army stands a larger principle. You marry a beautiful woman, and she hates you; you kill a scoundrel, and he kills you back; life is sweet, and you can't have it. For this tragic evenhandedness, Roth has been compared to Tolstoy. For his dark comedy, he might also be compared to his contemporary Franz Kafka. In Kafka's words, "There is infinite hope—but not for us."

WITH the writings of Kafka and Robert Musil, Roth's novels constitute Austria-Hungary's finest contribution to early-twentieth-century fiction, yet his career was such as to make you wonder that he managed to produce any novels at all, let alone sixteen of them in sixteen years. For most of his adult life, he was a

hardworking journalist, traveling back and forth between Berlin and Paris, his two home bases, but also reporting from Russia, Poland, Albania, Italy, and southern France. He didn't have a home; he lived in hotels. His novel-writing was done at café tables, between newspaper deadlines, amid the bloody events—strikes, riots, assassinations—that marked Europe's passage from the First World War to the Second, and which seemed more remarkable than anything a novelist could imagine. His early books bespeak their comfortless birth, but his middle ones don't. They are solid structures, full of psychological penetration and tragic force. *The Radetzky March,* his masterpiece, was the culmination of this middle phase. Shortly after it came out, he was forced into exile by the Third Reich. In the years that followed, he lived mainly in Paris, where, while he went on writing, he also swiftly drank himself to death. He died in 1939 and was soon forgotten.

Roth was a man of many friends, mostly writers—the playwright Ernst Toller, the novelist Ernst Weiss, the celebrated *littérateur* Stefan Zweig, (who fussed over him, put him up, loaned him money)—and his work was rescued by a friend. After the war, the journalist Hermann Kesten, a longtime colleague of his, gathered together what he could find of Roth's writings and, in 1956, brought them out in three volumes. With this publication, the Roth revival began, but slowly. For one thing, much of his work was missing from Kesten's collection. Because Roth was always on the move, he had no files, no boxes of books in the attic. Meanwhile, the Third Reich had done its best to wipe out any trace of his career. (In 1940, when the Germans invaded the Netherlands, they destroyed the entire stock of his last published novel, which had just come off the presses of his Dutch publisher.) Over the years, as people scanned old newspapers and opened old cartons, more and more of Roth's work came to light, and Kesten's collection had to be re-edited, first in four volumes, then in six.

The translation of Roth proceeded even more haltingly. In his lifetime, only six of his novels appeared in English, and after his death there was no strong push to translate the rest of them. Those people who knew about him sometimes wondered why

this dark-minded Jew, fully modern in his view of history as a nightmare, showed none of the stylistic experimentation that, according to the midcentury consensus, was the natural outcome of such a view, and the defining trait of the early modernist novel. He didn't write like Joyce, so let him wait. By the 1970s, however, the job of getting Roth out in English had started up again. In the eighties and nineties, it was carried forward by three editors, all Roth fans: Peter Mayer, at Overlook Press, in Woodstock, New York; Neil Belton, at Granta, in London; and Robert Weil, at Norton, in New York City. Equally crucial in this rescue operation was one translator, the poet Michael Hofmann. In the past fifteen years, Hofmann has translated, beautifully, nine books by Roth. Furthermore, his brief introductions to those volumes are the best available commentary on the writer. Many of Roth's explicators are puzzled by him, and not just because he had a nineteenth-century style and a twentieth-century vision. In the manner of today's critics, they want to know if his politics agree with theirs, and they can't decide whether he was a good Jew or a bad Jew, a leftist or a right-winger. They also don't understand why his work was so uneven. Hofmann is untroubled by such questions. He takes Roth whole. The novels, he says, "comfort and console one another," "diverge and cohere." He writes about them with confident love and no special pleading.

Thanks primarily to these people, all the novels are now in print in English. As the new translations have come out, Roth has been the subject of long, meaty review-essays. There have been Roth conferences. There is now an academic industry of sorts. Still, Roth has received only scant attention, relative to his achievement. There is no biography of him in English. (An American, David Bronsen, wrote a biography, but it was published only in German, in 1974.) Indeed, there are only three books in English on Roth's work. Even more striking, to me, is how seldom he is spoken of. In the past few years, I have made a point of asking literary people what they know about him. Most have not read him; many say, "Who?" They ask if I mean Philip Roth, or Henry. I myself didn't know his name until three years ago, when a friend put a copy of *The Radetzky March* into my hand.

WHEN Roth was born, in 1894, the Austro-Hungarian Empire, presided over by the aging Franz Joseph, consisted of all or part of what we now call Austria, Hungary, Romania, Slovenia, Croatia, Poland, Ukraine, Slovakia, the Czech Republic, and Italy. Ethnically, this was a huge ragbag, and separatist movements were already under way, but to many citizens of the empire its heterogeneity was its glory. According to the so-called Austrian Idea, Austria-Hungary was not so much multinational as supranational—a sort of Platonic form, subsuming in harmony and stability the lesser realities of race and nation. Among the most ardent subscribers to this belief were the empire's two million Jews. Because they could claim no nation within the crown lands, they feared nationalism—they felt, rightly, that it would fall hard on them—and so they were loyal subjects of the emperor. Roth shared their view. He changed his politics a number of times in his life, but he never forsook his ideal of European unity or his hatred of nationalism.

He grew up in Brody, a small, mostly Jewish town in Galicia, at the easternmost edge of the empire, six miles from the Russian border. Shortly before his birth, his father, Nachum, who was a grain buyer for a Hamburg export firm, had some sort of psychiatric episode while traveling on a train in Germany. Nachum was eventually taken to a "wonder rabbi," or healer, in Poland, and he lived with this man for the rest of his life. Roth's mother moved back into her parents' house, and there she raised Joseph, her only child, with what is said to have been a maddening overprotectiveness. He grew up very Jewish—the family was Orthodox, and the schools he attended were Jewish, or mostly—but the beginnings of assimilation were there. He spoke German at home and at school, and his teachers, faithful subjects of Austria-Hungary, gave him a solid classical education, with emphasis on German literature.

He left home at the age of nineteen, and soon landed at the University of Vienna, an institution that he came to regard with mixed feelings. (In one novel, he describes its august entrance as

"the fortress wall of the national students' association"—he means proto-Nazis—"from which every few weeks Jews or Czechs were flung down.") What dazzled him was the city itself, the center of a pan-European culture, which he aspired to join—a task that would not be easy. Already before the First World War, *Ostjuden,* or Jews from the East, were pouring into the Western capitals, and, with their soiled bundles and their numerous children, they were regarded, basically, as immigrant scum. Roth was one of them. Over the next few years, he rid himself of his Galician accent. He dropped his first name, Moses. He affected a monocle, a cane. He said his father was an Austrian railway official, or an arms manufacturer, or a Polish count. Later, in his book *The Wandering Jews,* on the *Ostjuden,* he described with scorn the attempts of Western Europe's assimilated Jews to conceal their Eastern origins, but he did the same.

His education came to an end with the First World War, which he spent as a private in a desk job. (He later claimed that he was a lieutenant, and a prisoner of war in Russia.) After the armistice, he went to work as a journalist, first in Vienna, then in Berlin, where he wrote feuilletons, or think pieces, for a number of newspapers, and in this genre he found his first voice: a wised-up, bitter voice, perfect for describing the Weimar Republic. In 2003, Norton published a selection of these essays, *What I Saw: Reports from Berlin, 1920–1933,* translated by Michael Hofmann. In them, Roth addresses some great events, but mostly he pokes his face into ordinary things—department stores, police stations, bars—and, in the manner of Roland Barthes in his *Mythologies* pieces, which also originated as journalism, he meditates on what they symbolize. His conclusion is that, whatever the sins of the prewar empires—he doesn't ignore their sins, for he was now a socialist—what has replaced them is something worse: a wrecked, valueless world, caught between bogus political rhetoric on the one hand and, on the other, a fatuous illusionism, a dream world retailed by billboards and movies, which, in his shorthand, he calls "America."

At the same time that he was producing these essays, Roth was writing his early novels. They are as dark as the journalism, but

more disturbing, because in them he seems to be writing about himself, with hatred as well as with grief. He had always been fatherless; now, with the fall of Austria-Hungary at the end of the war, he was stateless. All his novels of the 1920s are *Heimkehrer-romane*, stories of soldiers returning from the war, and what these men find is that there is no home for them to return to. They would have been better off if they had died. For some of them, Roth has compassion; he analyzes the religious awe in which they once held the state, and their brutal disabusement. For others, he has no pity, and he catalogues the lies they are now free to tell about themselves, and the ease with which they pledge themselves to the new gods, commercialism ("America") and nationalism (Germany).

One of the remarkable things about Roth's early writing is its political foresight. He was the first person to inscribe the name of Adolf Hitler in European fiction, and that was in 1923, ten years before Hitler took over Germany. But what makes his portrait of the Nazi brand of anti-Semitism so interesting is that it was done before the Holocaust, which he did not live to see. His treatment of the Jews therefore lacks the pious edgelessness of most post-Holocaust writing on the subject. In one of his novels of the 1920s—the best one, *Right and Left*—which opens in a little German town, he says that in this place most jokes begin, "There was once a Jew on a train," but on the same page he narrows his eyes at Jews who ignore such jokes. In an essay of 1929, he speculates comically on why God took a special interest in the Jews: "There were so many others that were nice, malleable, and well trained: happy, balanced Greeks, adventurous Phoenicians, artful Egyptians, Assyrians with strange imaginations, northern tribes with beautiful, blond-haired, as it were, ethical primitiveness and refreshing forest smells. But none of the above! The weakest and far from loveliest of peoples was given the most dreadful curse and most dreadful blessing"—to be God's chosen people. As for German nationalism, he regarded it, at least in the twenties, mainly as a stink up the nose, a matter of lies and nature hikes and losers trying to gain power. He was frightened of it, but he also found it ridiculous.

If Roth had continued in this vein, he would be known to us today as a gifted minor writer, the literary equivalent of George Grosz. But in 1925 his newspaper sent him to France, and there he found a happiness he had never known before. In part, this was simply because the French were less anti-Semitic than the Germans. But also it seemed to him that in this country—which, unlike his, had not lost the war—European culture, a version of the Austrian Idea, was still going forward, and that he could be part of it. "Here everyone smiles at me," he wrote to his editor. "I love all the women. . . . The cattlemen with whom I eat breakfast are more aristocratic and refined than our cabinet ministers, patriotism is justified *here,* nationalism is a demonstration of a *European* conscience." He relaxed, and began thinking not just about the postwar calamity but about history itself, and the human condition. As can be seen in Norton's recently issued *Report from a Parisian Paradise: Essays from France, 1925–1939,* again translated by Hofmann, his prose now mounted to an altogether new level: stately but concrete, expansive but unwasteful. In a 1925 essay about Nîmes, he describes an evening he spent in the city's ancient arena, where an outdoor movie theater had been installed. Here he is, sitting in a building created by the Roman emperors, watching a movie created by Cecil B. De Mille. To compound the joke, the film is *The Ten Commandments.* This is the sort of situation from which, in his Berlin period, he wrung brilliant, cackling ironies. But here he just says he stopped watching the movie and looked up at the sky, at the shooting stars:

> Some are large, red, and lumpy. They slowly wipe across the sky, as though they were strolling, and leave a thin, bloody trail. Others again are small, swift, and silver. They fly like bullets. Others glow like little running suns and brighten the horizon considerably for some time.
>
> Sometimes it's as though the heaven opened and showed us a glimpse of red-gold lining. Then the split quickly closes, and the majesty is once more hidden for good.

Though God may confide his thoughts to De Mille, he withholds them from Roth, and Roth doesn't complain. He just arranges the

elements of the vision—majesty, beauty, enigma, terror (bullets, blood)—in a shining constellation. He is moving out of satire, into tragedy.

If the change that overtook him in the late twenties was due partly to happiness, it was also born of sorrow. In 1922, Roth married Friederike Reichler, from a Viennese (formerly *ostjüdische*) working-class family. Friedl was reportedly a sweet, unassuming girl, so shy as to suggest that she may already have been unbalanced. Apart from the fact that she was beautiful, and that Roth was reckless (he was already a heavy drinker), it is hard to know why he chose her. In any case, he was soon telling her to keep her mouth shut in front of his friends. Friedl was made to accept Roth's preference for living in hotels, and he usually installed her in a hotel when he had to travel. By 1928, she was complaining that there were ghosts in the central-heating system, and that her room had a dew in it that frightened her. She had catatonic episodes, too. Realizing that she could no longer be left alone, Roth started taking her on assignment with him, and locking her in their room when he had to go out by himself. Or he parked her with friends of his, or he put her in a hospital and then took her out again. He brought her to specialists; he called in a wonder rabbi. He was tortured by guilt, and probably by resentment as well. Finally, in 1933, Friedl was placed in the Steinhof Sanatorium, in Vienna, where she remained for the rest of her life, with a diagnosis of schizophrenia.

"Roth, you must become much sadder," an editor once said to him. "The sadder you are, the better you write." It was while Friedl was going mad that Roth became a great writer. Her illness broke something in him, and, following a pattern that we can observe in many writers who go from good to great, he threw away the sophistication he had so strenuously acquired in his twenties and returned to the past. His prior novels had been set in his own time, the years after the First World War. Now he went back to the prewar years. Most of his earlier novels had featured city life; now, again and again, he placed his story in a provincial town on the frontier between Galicia and Russia. The town is heavily Jewish, though it also has an Army garrison, at whose saber-clanking officers the Jewish merchants gaze with incompre-

hension, and vice versa. There is a count, in a castle. There is a border tavern, where Jewish middlemen, for a high price, arrange for Russian deserters to escape to the Americas. The local schnapps is 180 proof, guaranteed to stun your brain in seconds. The officers drink it from morning to night, and gamble and whore. Occasionally, they get to shoot somebody—strikers, agitators—but they are longing for bigger action: war. All around the town, there is a gray, sucking swamp, in which, day and night, frogs croak ominously. Roth's classmates later said that this place was his hometown, Brody, point for point, but it has been transformed. It is now a symbol, of a world coming to an end.

Job (1930), the first of Roth's two middle-period novels, is set in a version of this town, in the Jewish quarter. In large measure, it is a novelization of the report he made on the diaspora of the *Ostjuden* in *The Wandering Jews.* That book was both scarifying and funny. *Job* is more so, because it is told from the inside, as the story of Mendel Singer, a poor man (a children's Torah teacher) who, after watching his world collapse around him—his son joins the Russian Army, his daughter is sleeping with a Cossack—is forced to emigrate to America, where he loses hope altogether, and curses God. Much of the language of the novel is like that of a fairy tale, and in the end Mendel is saved by a fairy-tale reversal of fortune. Roth later said that he couldn't have written this ending if he hadn't been drunk at the time, but in fact it is perfect, as *Job* is perfect, and small: a novel as lyric poem. The book was Roth's first big hit. It was translated into English a year later; it was made a Book-of-the-Month Club selection; it was turned into a Hollywood movie. Marlene Dietrich always said it was her favorite novel.

The success of *Job* emboldened Roth, changed his view of himself. He now broached a larger subject, the fall of Austria-Hungary. He laid plans for a sweeping, nineteenth-century-style historical novel, *The Radetzky March.* He took special pains over it, more than for anything else he ever wrote. He put his other deadlines on hold, which was hard for him, because, with Friedl's medical bills, he needed ready cash. He even did research. He had huge hopes for this book.

LIKE all of Roth's novels, *The Radetzky March* has a terrific opening. We are in the middle of the Battle of Solferino (1859), with the Austrians fighting to retain their Italian territories. The emperor, Franz Joseph, appears on the front lines, and raises a field glass to his eye. This is a foolish action; it makes him a perfect target for any half-decent enemy marksman. A young lieutenant, realizing what is going to happen, jumps forward, throws himself on top of the emperor, and takes the expected bullet in his own collarbone. For this he is promoted, decorated, and ennobled. Formerly Joseph Trotta, a peasant boy from Sipolje, in Silesia, he becomes Captain Baron Joseph von Trotta und Sipolje, with a lacquered helmet that radiates "black sunshine."

The remainder of the novel flows from that event. It follows the Trottas through three generations, as they become further and further removed from their land and from their emotions, which are replaced by duty to the state. Joseph Trotta's son, Franz, becomes a district commissioner in Moravia, and a perfect, robotic bureaucrat. Franz raises his own son, Carl Joseph, to be a soldier, and they both hope that Carl Joseph will be a war hero, like his grandfather. At the opening of chapter 2, we see the boy, now fifteen years old, home on vacation from his military school. Outside his window, the local regimental band is playing "The Radetzky March," which Johann Strauss the elder composed in 1848, in honor of Field Marshal Joseph Radetzky's victories in northern Italy, and which then spread through Austria-Hungary, as the theme song of the empire. (Roth called it "the 'Marseillaise' of conservatism.") Every Sunday, in Carl Joseph's town, the band, at its concert, starts with this piece, and the townsfolk listen with emotion:

> The rugged drums rolled, the sweet flutes piped, and the lovely cymbals shattered. The faces of all the spectators lit up with pleasant and pensive smiles, and the blood tingled in their legs. Though standing, they thought they were already marching. The younger girls held their breath and

opened their lips. The more mature men hung their heads and recalled their maneuvers. The elderly ladies sat in the neighboring park, their small gray heads trembling. And it was summer.

Winter is coming, though. Austria-Hungary is old; the march is a hymn to its former triumphs. And the people listening to it are old: trembling, remembering. The young are there, too—nature keeps turning them out—but they are entering a world that will betray them. That, basically, is the story of Carl Joseph. He has been raised to revere the empire:

> He felt slightly related to the Hapsburgs, whose might his father represented and defended here and for whom he himself would some day go off to war and death. He knew the names of all the members of the Imperial Royal House. He loved them all . . . more than anyone else the Kaiser, who was kind and great, sublime and just, infinitely remote and very close, and particularly fond of the officers in the army. It would be best to die for him amid military music, easiest with "The Radetzsky March."

Standing there, listening to the march, the cadet imagines this glorious death:

> The swift bullets whistled in cadence around Carl Joseph's ears, his naked saber flashed, and, his heart and head brimming with the lovely briskness of the march, he sank into the drumming intoxication of the music, and his blood oozed out in a thin dark-red trickle upon the glistening gold of the trumpets, the deep black of the drums, and the victorious silver of the cymbals.

At the end of the book, as the First World War begins, he will get his wish, but not in the way he imagines. Tramping along a muddy road, amid shrieking widows and burning barns, he stops to fetch some water for his thirsty men, and in the middle of that

small, decent, unmartial action he takes a bullet in the head, and dies for his emperor. Soon afterward, the Emperor dies, then the empire.

Yet all the while, beauty goes on smiling at us. Comedy, too. Roth never actually understood why Austria-Hungary had to fall, and so there are no real guilty parties in *The Radetzky March,* not even the emperor. Franz Joseph appears repeatedly in the latter part of the book, and he is just a very old man. If Shakespeare had done a Tithonus, Michael Hofmann has said, the result would have been like this. The monarch, Roth writes, "saw the sun going down on his empire, but he said nothing." Actually, he doesn't care much anymore. When he is on a state visit in Galicia, a delegation of Jews comes to welcome him, and pronounce the benediction that all Jews are taught to say for the emperor. "Thou shalt not live to see the end of the world," the Jewish patriarch proclaims, meaning that the empire will last forever. "I know," Franz Joseph says to himself, meaning that he will die soon—before his empire, he hopes. But mostly he just wishes these Jews would hurry up with their ceremony, so that he can get to the parade ground and see the maneuvers. This is the one thing he still loves: pomp, uniforms, bugles. He thinks what a shame it is that he can't receive any more honors. "King of Jerusalem," he muses. "That was the highest rank that God could award a majesty." And he's already king of Jerusalem. Too bad, he thinks. His nose drips, and his attendants stand around watching the drip, waiting for it to fall into his mustache. Majestic and mediocre, tragic and funny, he is the book's primary symbol of Austria-Hungary.

Each of the book's main characters is equally complex—a constellation, as in the sky over Nîmes. After Demant's death, Carl Joseph is forced to pay a condolence call on the doctor's wife. He hates her, because she caused Demant's death, and he hates her more because he unwittingly helped her do so. Frau Demant steps into the parlor, deliquesces briefly into her handkerchief, and then sits down with Carl Joseph on the sofa: "Her left hand began gently and conscientiously smoothing the silk braid along the sofa's edge. Her fingers moved along the narrow, glossy path leading from her to Lieutenant Trotta, to and fro, regular and gradual."

She is trying to seduce him. Carl Joseph lights a cigarette. She demands one, too. "There was something exuberant and vicious about the way she took the first puff, the way her lips rounded into a small red ring from which the dainty blue cloud emerged." The small, red ring (sex), the dainty blue cloud (her dead husband): Carl Joseph's mind reels, and Roth's prose follows it, into a kind of phantasmagoria. The twilight deepens, and Frau Demant's black gown dissolves in it: "Now she was dressed in the twilight itself. Her white face floated, naked, exposed, on the dark surface of the evening. . . . The lieutenant could see her teeth shimmering." If Franz Joseph is Roth's image of the empire, Frau Demant is his image of the world, lovely and ruinous. Carl Joseph barely gets out of that parlor alive. After such scenes, one almost has to put the book down.

In most of Roth's novels, people are ostensibly destroyed by their relation to the state. This scenario is a leftover from his socialism of the twenties. By the time of *The Radetzky March,* however, it has been absorbed into his new, elegiac cast of mind, with the result that the soul-destroying state is also beautiful. Franz Joseph is not the only one who likes military maneuvers. So does Roth. His description of Vienna's annual Corpus Christi procession, with its parade of all the armies of the far-flung empire, is one of the great set pieces in the book:

> The blood-red fezzes on the heads of the . . . Bosnians burned in the sun like tiny bonfires lit by Islam in honor of His Apostolic Majesty. In black lacquered carriages sat the gold-decked knights of the Golden Fleece and the black-clad red-cheeked municipal counselors. After them, sweeping like the majestic tempests that rein in their passion near the Kaiser, came the horsehair busbies of the bodyguard infantry. Finally, heralded by the blare of the beating to arms, came the Imperials and Royal anthem of the earthly but nevertheless Apostolic Army cherubs—"God preserve him, God protect him"—over the standing crowd, the marching soldiers, the gently trotting chargers, and the soundlessly rolling vehicles. It floated over all heads, a sky of melody, a baldachin of black-and-yellow notes.

Basically, it seems that when the state is good—when it unites peoples, as in the Corpus Christi parade, and thus exemplifies the Austrian Idea—it is good. And when it is bad—when it kills Dr. Demant and Carl Joseph, or when it just commits the sin of coming to an end—it is bad. Roth's politics were not well worked out, and that fact underlies the one serious flaw of *The Radetzky March*. Lacking an explanation for the empire's fall, Roth comes up with a notion of "fate," and he bangs that drum portentously and repeatedly. I am almost glad the book has a fault. Roth extracted *The Radetzky March* from his very innards. This rather desperate, corny fate business reminds us of that fact, and counterbalances the crushing beauty of the rest of the book.

Roth must have been pleased with *The Radetzky March:* he could now look forward to a second career, on a new level. Then, within months of the book's publication, Hitler was appointed chancellor of Germany. Roth was in Berlin at the time; he packed his bags and was on the train to Paris the same day. His books were burned in the streets of Berlin; soon they were officially banned. He lost his German publishers, his newspaper outlets; he lost his market, the German reading public. He barely had an income anymore. For the next six years, he lived in and out of Paris, in a state of fury and despair. He began mixing with Legitimists, who were plotting to return Austria to Hapsburg rule. Such a restoration, it seemed to him, was the only thing that could prevent Hitler from invading Austria. In 1938, he undertook a mad journey to Vienna, in the hope of persuading the chancellor to yield to the Hapsburgs. (He got only as far as the city's chief of police, who told him to go back to France immediately. The Anschluss occurred three days later.) He declared himself a Catholic, and went to Mass; at other times he said he was an exemplary Jew. Michael Hofmann thinks that in Roth's mind Catholicism equalled Judaism, in the sense that both crossed frontiers and thus fostered a transnational, European culture, the thing that Hitler stood poised to destroy, and that Roth so cherished.

He continued to write, not well, for the most part. In his late books, he sounds the "fate" theme tediously; he harangues us—on violence, on nationalism. He repeats himself, or loses his thread. In this, we can read not just his desperation but his advanced alco-

holism. By the late 1930s, Hofmann reports, Roth would roll out of bed in his hotel room and descend immediately to the bar, where he drank and wrote and received his friends, mostly other émigrés, until he went to bed again. He fell down while crossing the street. He couldn't eat anymore—maybe one biscuit between two shots, a friend said. Reading his books, you can almost tell, from page to page, where he is in the day: whether he has just woken up, with a hangover, or whether he has applied the hair of the dog (even in the weakest of his last books, there are tremendous passages), or whether it is now nighttime and he no longer knows what he's doing. For a few months in 1936 and 1937, something changed—I don't know what—and he wrote one more superb, well-controlled novel, *The Tale of the 1002nd Night.* (This is the novel whose entire print run the Germans destroyed in 1940.) Like *The Radetzky March,* it is a portrait of the dying Austria-Hungary, but comic this time, rather than tragic. It is his funniest book. Even so, the hero blows his brains out at the end.

IN one of Roth's late novels, *The Emperor's Tomb,* a character says that Austria-Hungary was never a political state; it was a religion. James Wood, in an excellent essay on Roth, says yes, that's how Roth saw it, and he made it profound by showing that the state disappoints as God does, "by being indescribable, by being too much." I would put it a little differently. For Roth, the state is a myth, which, like other myths (Christianity, Judaism, the Austrian Idea), is an organizer of experience, a net of stories and images in which we catch our lives, and understand them. When such a myth fails, nothing is left: no meaning, no emotion, even. Disasters in Roth's books tend to occur quietly, modestly. In *The Emperor's Tomb,* the streetlights long for morning, so that they can be extinguished.

He might have escaped. He received invitations—one from Eleanor Roosevelt, to serve on an aid committee; one from PEN, to attend a writers' congress. These people were trying to get him out of Europe. He didn't go. Many others did, and prospered. Roth's friends tended not to prosper. Stefan Zweig ended up in Brazil, where, in 1942, he died in a double suicide with his wife.

Ernst Weiss stayed in Paris, and killed himself on the day the Nazis marched into the city, in 1940. Ernst Toller escaped to New York, where, in 1939, he hanged himself in his hotel room. When Roth got the news about Toller, he was in the bar, as usual. He slumped in his chair. An ambulance was called, and he was taken to a hospital, where he died four days later, of pneumonia and delirium tremens. He was forty-four years old. The following year, as part of the Third Reich's eugenics program, Friedl was exterminated.

The New Yorker, 2004

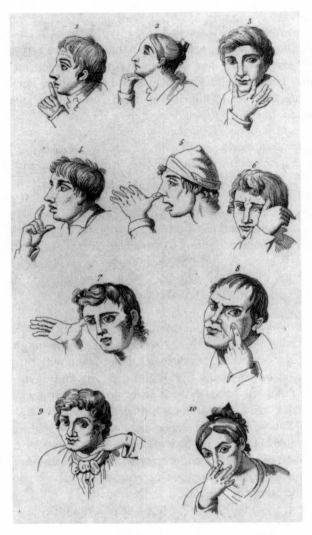

*1: Silence. 2: Negative. 3: Beauty. 4: Hunger. 5: Teasing.
6: Hard work, tiredness. 7: Stupidity. 8: Squinting,
untrustworthiness. 9: Deception. 10: Astuteness.*
From Andrea de Jorio's Gesture in Naples and Gesture
in Classical Antiquity, *ed. Adam Kendon.*

The Neapolitan Finger

I N his book *The Italians* (1964), Luigi Barzini lamented that so little had been written about his countrymen's gift for talking with their hands. To his knowledge, he said, only one person—Andrea de Jorio, a Neapolitan priest—had attempted a lexicon of Italian hand gestures, in an 1832 volume entitled *La mimica degli antichi investigata nel gestire napoletano* (The Mimicry of Ancient People Interpreted Through the Gestures of Neapolitans). Barzini offered a little sample:

> Take the chapter headed "Rage, anger." It lists ten principal ways of silently expressing such emotions. They are . . . (1) "biting one's lips"; (2) "biting one's hands and single fingers"; (3) "tearing one's hair"; (4) "scratching one's face"; (5) "firmly enclosing one's fist in the other hand and rubbing it with such force that the joints crack"; (6) "gnashing one's teeth with wide open lips"; (7) "moving one's lips with a shuddering, nervous rhythm"; (8) "stamping the ground with violence"; (9) "beating palm against palm, as if to applaud, once or twice only, with force." The only gesture not easily understood is number 10, "pretending to bite one's elbows." It is a pantomime of an Italian idiomatic saying. It means, in words, "I will do anything to avenge myself, even the impossible, of which biting my elbows is a hyperbolic example."

Upon reading this, you felt that if you could not get hold of de Jorio's book immediately, you would bite your elbows. But according to Barzini, the volume was unobtainable:

It is not included in bibliographies, encyclopedias, lists of rare books for sale, or catalogues of Italian libraries. It is unknown to specialists and scholars. The only copy I know of is in my hands. I stole it from the library of an old and unsuspecting English gentleman.

At the time when Barzini was writing, the book was indeed that rare, for reasons that have now been explained by Adam Kendon, an anthropologist specializing in gestural communication. Apparently, de Jorio's thinking was out of step with that of most prior, and many contemporary, writers on gesture. With Rousseauvian logic, they sought in gesture a universal language, more primitive, more natural, than speech. He, by contrast, regarded gesture as the product of a specific culture—a local matter, notably a Neapolitan matter—and nothing in his discussion of it indicates that he found it more grunting or sincere than speech. So while he was occasionally cited by later nineteenth-century writers, he seems not to have been considered a central thinker. In the early twentieth century, his name receded further, for around that time the study of gesture itself was largely abandoned. Only in the last few decades, with the rise of semiotics, the study of signs, did de Jorio's book float back into view, whereupon it seemed interestingly modern, not just in its culture-bound approach—de Jorio, says Kendon, was "the first ethnographer of gesture"—but, at points, in the subtlety of its discussion. Long before Saussure, de Jorio was discussing the inseparability of the *signifiant* and the *signifié*.

In 1964, the year when Barzini told us to abandon all hope of getting a copy, the book was republished for the first time, and in 1979 there was a reprinting of the first edition. But not until this year was de Jorio's treatise brought out in English. The translation, the copious notes, and the long, helpful introduction are by Kendon. Retitled *Gesture in Naples and Gesture in Classical Antiquity,* the book is part of Indiana University Press's Advances in Semiotics series, and I'm sure it will advance semiotics. Meanwhile, it will benefit the rest of us too, as a source of wisdom and delight.

DE Jorio was born on the island of Procida in the Bay of Naples in 1769—a time when, thanks to the excavations at Herculaneum and Pompeii, Naples was the most important archaeological site in all of Europe. A studious boy, he took orders at an early age; at thirty-six he was made a canon of the Cathedral of Naples. His true calling, however, was to the local industry, archaeology, and soon after taking up his post at the cathedral he assumed a more congenial one as a curator at the Royal Museum. Eventually, he wrote fifteen books on archaeology, books in which he paid particular attention to Greco-Italian vases and, in interpreting them, placed special emphasis on gesture.

De Jorio was of the realist persuasion. To him, the fact that these kraters and amphorae were two thousand years old and pictured Vulcan and Neptune, Priam and Achilles, did not mean that they weren't about life, the same sort of life that was still being lived on the very ground where the vases had lain buried. So he looked carefully at the hand gestures on the vases, compared them to gestures being used on the streets of Naples, and came up with his conclusions: the nymph or god or warrior on that vase was angry or jealous or frightened, because that's what the hands said. Neapolitans to whom de Jorio offered his interpretations were readily persuaded, he tells us. "On the other hand, to those who had been born in distant regions"—he means northern regions, for example, Germany, the great hatchery of eighteenth- and nineteenth-century archaeologists—"and who, on account of their cool and sluggish temperament, are rather unused to gesturing, these explanations seemed . . . without meaning." Hence *Gesture in Naples*. De Jorio wrote the book, he says, to elucidate classical art and to enliven archaeology, by showing his contemporaries that ancient people, or at least the ancient Greeks who founded Naples, were like them.

But he had another purpose too. Naples was a mecca not just for archaeologists but for all manner of foreigners—it was a required stop on the Grand Tour—and the tourists sent back vivid reports. At the same time, with the rise of romantic nation-

alism, many Italian writers were showing a new interest in the folklore, the folk life, of Naples. Out of these sources, high and low, there emerged a standardized portrait of the city as a place where small, nut-brown people, smelling of garlic and lemons, mended their nets, threatened each other with knives, made love, and danced the tarantella, all in full view of the public.

This notion, cousin to nineteenth-century Orientalism, gave birth to a considerable art and entertainment industry. Books, lithographs, operas, ballets chronicled the salty doings of the *basso popolo* of Naples. The fashion aroused mixed feelings in educated Neapolitans, and *Gesture in Naples* demonstrates such feelings. On the one hand, its five hundred pages of boisterous Neapolitan street theater constitute a shining instance of the stereotype. On the other hand, the book is a defense of the Neapolitans against the condescension of foreigners. At one point, de Jorio unburdens himself on the subject of writers who, having ridden a carriage through his city, think they know the people:

> Some of these writers are too quick to accuse our populace of a lack of reserve in their domestic doings. In Naples, they say, *everything* is done in the street. But please, why not take into account the open heart of the Neapolitans, their gregarious character, their celebration of friendship and finally the sweetness of the climate? Our populace, furthermore, lives with but one or two rooms per family (not to speak of the guests willingly admitted). . . . The street must then be considered by them as the *galleria* of their apartment. Therefore, if . . . writers wished to be just towards our common people, they should say, rather: *The Neapolitans do everything in their house.*

Throughout the book, de Jorio praises the Neapolitans' "exquisite delicacies" of mind, their "grace and fineness of spirit"—high-class virtues—and his evidence is their hand language. Of course, it didn't hurt his argument that he was comparing his townspeople's gestural iconography to that of ancient vase-painting, so noble, so esteemed by Germans, and using it to interpret and humanize that art. As Katharine Hepburn is supposed to have

said of Fred Astaire and Ginger Rogers, "He gave her class; she gave him sex."

THE structure of the book is unassuming—an ABC. *Amore, dolore, odore, orrore:* so de Jorio goes, essay by mini essay, down the scales of human thought and feeling. The first order of business is just to show us the gestures. He includes some drawings, but not many, and unlike gestures, drawings do not move, so he has to rely largely on words. He does very well with them. Under "deception," for example, here are your options:

1. *The fingers are put between the cravat and the neck, and are moved so that the neck is rubbed repeatedly with the back of the fingers. . . .*
2. *The thumb and index finger take hold of the cravat at some point and pull it away from the neck a little. . . .*
3. *Fingers brought close to the cravat. . . .*
4. *Mouth open and the right hand directed to it, with the fingers drawn together in a point.*

If you carefully perform these actions, you will soon find that you are doing something you have seen Anna Magnani do in a movie.

After describing the gesture, de Jorio addresses its logic. All gesture, he believes, is figurative; it makes pictures. That's why it's so interesting—more interesting, he implies, than language, which is almost wholly abstract. Some gestures are easy to read. (In "deception" numbers 1 through 3, for example, the necktie is being loosened so that the throat can accommodate the great wad of lies that the person is being asked to swallow. See figure 9 in the illustration on page 132.) Others are harder, but de Jorio always offers some reading, however speculative. Who would have thought that praying hands meant anything more than prayer? De Jorio. By pressing our hands together in this way, he proposes, we are saying to the Lord, "Here are my hands, . . . they are rendered useless, I have no power myself . . . ; therefore I have recourse to your efforts, protect me, etc."

Having described and interpreted the gesture, de Jorio moves

on to the archaeological material. He tells us which room to go to in the Royal Museum (now the National Museum of Archaeology), or which page to turn to in the writings of his colleagues, to see a vase where someone is performing the same gesture, for the same reason. He has also trawled most of ancient literature, and he tells us where, in Pliny, Petronius, Apuleius, Quintilian, Terence, Juvenal, Horace, Seneca, and on and on, we can find reference to the gesture under consideration. I must confess that these discussions of the link between Neapolitan *mimica* and ancient art—which, according to de Jorio, is the chief subject of his book—are the only parts that bored me. Perhaps if I too could walk through the rooms of the National Museum (Kendon gives updated room numbers—take this book if you're going to Naples), I would feel the appropriate excitement. Like others of de Jorio's writings, *Gesture in Naples* is in some measure a guidebook, and guidebooks don't always make for armchair reading. Furthermore, the archaeological discussions are the sections where de Jorio is arguing with Germans, a task which did not relax him. Soon, however, he lays down the vases and returns to the streets, where he finds more gestures to show us and, invoking Horace's principle of *utile dulci,* or mixing pleasure with instruction, tells us little stories about how hypothetical Neapolitans—Tizio and Cajo, Carmonsina and Celeste—would use them.

No form of *la mimica* is too humble for inclusion in the book. (I was moved to discover that Neapolitans of 1832, in giving the finger, had the same choice of fingers—middle or pinkie—that we had in Oakland in 1960.) But de Jorio's most ardent attention, his longest paragraphs, are devoted to the more complex and inflected gestures. Neapolitan *mimica,* he says, has a complete grammar. It can express time: past ("hand raised with palm turned towards the corresponding shoulder . . . and then thrust several times"), present, and future. It can specify person—I, you, they—and the sex of the person. Verb moods? Infinitive, imperative? *La mimica* can do it.

As for nouns and adjectives, they can be comparative, diminutive, superlative. Say you're in the presence of one of "those who

sing, or who hold forth in some loud discourse of self-interest or seriousness, or who talk boastfully," and you want to express your scorn. What you need is the *vernacchio,* or raspberry. But that's just the beginning. What is the degree of your scorn? If it's moderate, you'll want a reserved sort of raspberry. You fill your mouth with air, but you don't expel it; you just hold it there for a little while and then swallow it. That's the diminutive. If, on the other hand, you feel great scorn, you need the superlative, in which case you are advised to forget the mouth and transfer operations to the armpit: "Palm of the hand placed under the armpit of the opposite arm. . . . The hand is arranged so that, when compressed with violent blows given to it by the arm, because the air trapped there is pushed out by the force of the blows, it produces the same sound as that obtained by the mouth, but even more stridently." If that's not clear enough, de Jorio says, you can lift your leg at the same time. (He cites a precedent in Petronius.) Or you can choose from among the various standard procedures for adding emphasis to a gesture. If there's a bench nearby, you can pummel it with your fists. Or you can stamp on the ground or raise your eyes to heaven. Alternatively, if you are holding something in your hands, you can hurl it violently into the air.

That's assuming, however, that the concept in question is not one of those that demands a wholly new form in the superlative. Threatening, for example. If all you want to say is "Yes, yes, continue conducting yourself in this bad manner and you will see what I will do to you," then you're going to need "head raised and bent forward several times, with the eyes narrowed and menacing." If, however, the situation is more grave, if what you mean is "Wait, or give me time, so that a favorable occasion might turn up and then I will make you see if I know how to avenge myself for the wrong you do to me," then "palm held facing downwards and oscillated slowly up and down" is the ticket.

JUST as a single concept may branch out into many different gestures, so a gesture may have numerous different translations. The premier example is the *mano cornuta,* a sign so freighted with meaning that de Jorio takes thirty-six pages—the longest essay in

1: The mano in fica *("the figs") 2: The* mano cornuta *("the horns").
From Andrea de Jorio's* Gesture in Naples and Gesture in Classical Antiquity, *ed. Adam Kendon.*

the book—to get through it. The action is simple: "Index and little finger extended, the remaining middle and ring fingers folded and pressed on the thumb." (See illustration number 2, above.) As for its meanings, I will confine myself to de Jorio's main headings, with brief elucidations:

1. *Conjugal infidelity.* Someone has been cuckolded, wears "horns."

2. *Threat of extracting the eyes.* If you aim the *mano cornuta,* palm down, at someone's face, this means "I'm going to poke your eyes out."

3. *Something of no value,* as in *"Non vale un corno,"* "It's not worth a horn."

4. *Imprecation.* De Jorio elaborates: " 'May you go crazy!' 'May you die!' "

5. *Power.* "This meaning has a very important place among our vulgar people," de Jorio says. See item number 8, below.

6. *Pride,* as in *"Vieni ca te voglio rompere lle corna,"* or "Come here, I want to break your horns." See items number 5 and 8. This is about penises.

7. *Stopper.* Ditto.

8. *Phallus.* He finally says it, and then scolds us for our childishness in daring him to do so: "That the word *corno* is used among us in this sense will not cause any surprise."

9. *Hardness in the physical sense,* as in "This thing is hard like a horn."
10. *Hardness in the moral sense,* that is, unreasonableness.
11. *Amulet,* against the evil eye.

The most important meaning is the last. The *jettatura,* or casting of the evil eye—an action, motivated by envy, that can dry up a cow's milk, a man's love—was actively feared in Naples in 1832 and is not altogether forgotten about in northern New Jersey today. The *mano cornuta* protects against it. You can direct it at the *jettatore* himself, but you probably shouldn't, because you don't want him to know that you know. So you aim it at the person you're trying to protect from the *jettatura.* Or, if you're in a place where a *jettatore* may have been operating, you can just make the *mano cornuta* and wave it around, like spraying for the West Nile virus. As you do so, however, de Jorio warns, you must contextualize it with the appropriate facial expression, so that you send the correct message. When your daughter is going to the dance in a new dress, you want your *mano cornuta* to be signaling "amulet" and not, for example, "I will poke your eyes out" or, God forbid, "phallus."

The same care must be exercised with the *mano in fica,* or "the fig" ("hand as a fist with the point of the thumb interposed between the middle finger and the index finger so that it sticks out"—see illustration number 1 on page 140), a sign immortalized by the cutthroat Vanni Fucci in Dante's *Inferno.* The *mano in fica* means three very different things. First, like the *mano cornuta,* it is a protection against the evil eye, but more effective, in de Jorio's opinion. Second, it may be used as an insult, the equivalent, de Jorio says, of "go take a hike." (This is the sense in which Vanni Fucci uses it—on God!—and its meaning in Dante's time, as in modern times, was stronger than our "go take a hike.") Finally, the gesture may be employed as an obscene invitation. (While *la mano in fica* is normally translated as "the fig," this may be a euphemism. *Fico* is the Italian word for "fig"; *fica* is an obscene term for "vulva," and the form of the gesture bears out the latter meaning.) When you are using the *mano in fica,* your face must indicate which of these meanings you intend. To make an obscene

invitation you will want "a joyful, gay, or mild expression." To deliver an insult, you need an "indignant, vindictive, or violent expression."

This is by no means the end of it. De Jorio tells us how to position our feet, how to twirl our mustaches, how to do our eyes: sparkling or non. He teaches us how to produce figures of speech, rhetorical flourishes—periphrasis, metonymy, synecdoche, catachresis, antonomasia, you name it. He shows us how to do one-hand combinations, not just "Tizio is worn out from working so hard" (thumb drawn across the forehead; see gesture number 6 on page 132), but "Tizio is worn out from working so hard at his thieveries" (thumb drawn across forehead while the remaining fingers fold down sequentially, in gesture of theft). He tells us how to conceal the *mano cornuta* from a *jettatore.* If your husband is nearby, you can put your hand in his pocket and then make the sign. Or if you are serving food to the *jettatore,* you can make the horns with the fingers that are under the plate. Aim them right at her, along with the ziti. Kill two birds with one stone.

As the complications blossom and multiply, you realize that *la mimica* is not an amplification of speech, which is the way most of us think of it. The relation between speech and gesture is something to which de Jorio does not give enough space (nor does Kendon in his introduction), but in many parts of the book it is clear that his people are gesturing in silence. For example, there is an unintentionally hilarious passage in which de Jorio tells us that if there is no gesture for what we need to say, that's the time to use periphrasis, or circumlocution. Suppose a man wants to tell his friend that someone they know is mortally ill. There is no one sign for "mortally ill." So the man

> will first express "Robustness" and follow this with a gesture for "Past." Then he will denote the present (see *Ora,* "Now"), adding to it a gesture for "Negative." This will be followed by a gesture denoting the near future (see *Domani,* "Tomorrow"), and finally he will make the gesture expressing "Death."

Why, instead of making six gestures, involving three time planes and three medical conditions, this man does not just open his mouth and say "Vito is dying" is never explained. In trying to account for the efflorescence of gestural communication in Naples, Kendon in his introduction tells us that there were circumstances in which nineteenth-century Neapolitans were forced to talk with their hands—for example, in communicating from balcony to balcony or when the streets were too noisy to make oneself heard. This, however, does not seem sufficient to explain the development of an entire, hyperinflected hand-talk whose grammar and syntax often depart from the Italian language as radically as Chinese ideograms.

The unavoidable conclusion is that just as French cooking is more than a way of keeping French people from dying of hunger, so Neapolitan gesturing is not just—or even chiefly—a way of imparting information. It is an art, practiced for art's sake. De Jorio almost says as much. Commenting on the "mortally ill" periphrasis, he points out that while virtuoso gesturing of this sort conveys a message, it may also be done "simply as a matter of style, extending one's description so as to lengthen the conversation and to liven up the company." So it's not as though the Neapolitans use their hands because they lack the words. Forget words! What they need is this other language, involving performance and drama and their bodies.

Hence the beauty of the book. Just as Tizio thinks he's telling Cajo what happened to Celeste last Tuesday but in fact is expressing his personality and making his life more interesting, so de Jorio, while he says and believes that he is helping archaeologists interpret ancient vases, is actually creating a form of theater. That is what you take away from the book: scene after scene of Neapolitan life—or, as it seems, life. One man tells another that their friend is dying, and in the process has a good time, shows off his gestural chops. A third man asks a fourth man, "That guy they killed last night? Was he hanged [thumb and index finger, with tips pointing upward, squeeze the upper part of the neck] or strangled [entire hand squeezing the upper part of the neck]?" Carmonsina, who has a "correspondence" with Tizio, is trying to relay to him a message, which involves lifting her right hand to

her shoulder. Whoops, Celeste sees this, whereupon Carmonsina pretends that she is having a problem with her shoulder: "My dear, see what there is on top of this shoulder that is bothering me; perhaps my kerchief has got rumpled under my dress or perhaps there is an insect?" Others, seeking to add emphasis to their gestures, beat their fists on benches and throw objects into the air. Still others engage in the twelve kinds of whistling: "amorous call," "warning," "secret insinuation," or "as a way of charming babies," to name only four.

Not all the anecdotes are of a comical nature, but many are, and I think this was de Jorio's amulet against Biedermeier charm. How bad this book could have been! Nineteenth-century-genre-scene bad: quaint, sentimental, patronizing. It is the opposite: rough and funny and democratic, like Boccaccio or Chaucer. The achievement is the more remarkable in that *Gesture in Naples* avoids all but the most cursory reference to sex. In a book on Neapolitan gesture, not to speak of Greek vases, sex would seem an unexcludable topic, yet de Jorio, as a gentleman and a priest— and one who was writing for nonspecialist readers as well as scholars—felt he had to keep clear of that subject as well as he could. He is not prim, however. When he gets to the *mano cornuta* or the *mano in fica,* he simply says that there is an obscene meaning and that everyone knows it—which, in his day, everyone did. When, for scholars, he must indicate some specific sexual matter, he uses a clever little stratagem: he refers the reader to chapter and verse in an ancient text where that matter appears. Of course, Kendon, as a good modern editor, has looked up all these references and decoded them. So, despite de Jorio's best efforts, his book now has dirty parts—the footnotes.

That the tone of *Gesture in Naples* is fresh and uncloying is due of course to its author's character—de Jorio was reportedly a debonair man, with an excellent sense of humor—and also to his scholarly purpose, which offsets any too-muchness about Cajo and Tizio with a corrective dryness. Furthermore, de Jorio chose what for him, clearly, was the ideal genre, the chatty treatise of the *encyclopédistes,* a form that fairly exhaled the intellectual freedoms

of the period—curiosity, secularism, coffeehouse vivacity. A good comparison volume is Brillat-Savarin's *Physiology of Taste,* which was published seven years before *Gesture in Naples. Gesture in Naples* is the better book, in my opinion. De Jorio is more objective, more an artist; we do not have to hear from him, as we do, quite often, from Brillat-Savarin, what a charming old fellow he is. But the technique is the same—a treatise, derived ultimately from Aristotle, but one which, in its modern life, is something else as well: a comedy, a letter, a love song. For Brillat-Savarin, the beloved was food. For de Jorio, it was the Neapolitans, the short, handsome Greeks who made the vases two millennia earlier and their descendants, the Greco-Italian people who, outside his window, were still telling the story pictured on the vases, saying with their hands everything that human beings needed to say.

WITH his curious mind, de Jorio would have been interested to see the transformations that Neapolitan *mimica* underwent in the New World. My mother-in-law, Cristina Acocella, was born in this country, and her mother was too, but the family came from Caserta, northeast of Naples. For a number of years after I joined her family, my mother-in-law told me nothing about Italian hand gestures, and I believe she avoided using them in my presence. I was not Italian. Eventually, however, she got older, and one day, when I was complaining to her about someone, she tore a piece of paper off the edge of the *Daily News,* wrote the person's name on it, and disappeared into the kitchen. I followed her and found her putting the piece of paper in the freezer, in a plastic bag containing many similar strips. She wouldn't let me look at the bag, but I sneaked down later and opened it. It contained maybe thirty or forty names: the neighbor who looked at my mother-in-law in an odd way when the new air conditioner was delivered, the girl who recommended to my sister-in-law the cream that made her face break out, the man who told my father-in-law that the Department of Motor Vehicles was open on Sunday, and so on.

In the years that followed, my mother-in-law and I had many discussions about her bag of names. "It's primitive," I would say. "What if people knew? And what if it *works*? You could be

arrested." "Don't be silly," she would say. "It's not real. It's just a game." And then she would ask me to spell the name of the boy who was with her grandson when the latter fell off his bicycle. (She had no compunction about minors.) As she explained to me, she was not harming these people; she was just slowing them down, coagulating them, as it were. She was using the *mano cornuta,* sense number 11, modified by New World sanctions on magic and late-twentieth-century advances in refrigeration technology.

She died in August of 1987, and my father-in-law, who did not believe in the evil eye, undoubtedly cleaned out the freezer soon after. I have often wondered whether a certain number of people in the New York metropolitan area—maybe thirty or forty of them, with nothing in common except that they all, at one point, had dealings with our family—suddenly, in the late summer of 1987, experienced relief from difficulties they had had for years. One morning, as I imagine it, a stiffness in their joints eased up; a sort of fog in front of their eyes cleared. They smiled; they breathed deeply; they were ready for action. There is no way of knowing, but I have never felt safe since.

The New York Review of Books, 2000

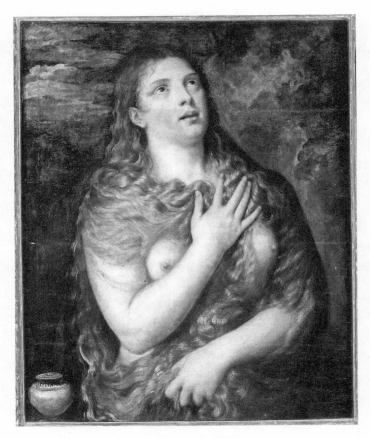

Titian, The Repentant Magdalene, *c. 1530–35*

The Saintly Sinner

THE Catholic Church presumably has enough on its hands right now without worrying about popular fiction, but the Holy See cannot have failed to notice that Dan Brown's *The Da Vinci Code,* a novel claiming that Jesus was married, has been on the *Times* best-seller list for almost three years. Brown is by no means the first to have suggested that Christ had a sex life—Martin Luther reportedly said it—but the most notorious recent statement of the theory was a 1982 book, *Holy Blood, Holy Grail,* by Michael Baigent, Richard Leigh, and Henry Lincoln. *Holy Blood,* which was one of the main sources for *The Da Vinci Code,* proposes that after the Crucifixion Jesus's wife, with at least one of their children, escaped to France, where their descendants married into the Merovingian dynasty and are still around today. Nobody knows this, though, because the secret has been guarded by an organization called the Priory of Sion, which, though it was in the habit of depositing documents in the Bibliothèque Nationale for the authors of *Holy Blood* to consult, has remained hidden since its founding in the eleventh century. One cannot briefly summarize the contents of this 475-page book. It is a fantastically elaborated conspiracy theory involving, among others, Leonardo da Vinci, Isaac Newton, Victor Hugo, Debussy, and Cocteau—all "grand masters" of the Priory of Sion—not to mention Emma Calvé and a cousin of Bonnie Prince Charlie. But the upshot is that the Priory may now be ready to go public with its story. If so, the authors warn, this would have "a potentially enormous impact." The authors conjecture that the organization may intend to set up a theocratic United States of Europe, with a descendant of Jesus as its priest-king but with the actual business

of government being handled by some other party—the Priory of Sion, for example.

And who is the woman who caused all this trouble? Who married Jesus and bore his offspring and thereby laid the foundation for the overthrow of post-Enlightenment culture? Mary Magdalene.

MARY Magdalene gets only fourteen mentions in the New Testament. Luke and Mark describe her as the subject of one of Jesus's exorcisms—he cast "seven devils" out of her—and as one of several women who followed him. In all four Gospels, she is present at the Crucifixion. Nevertheless, her role remains minuscule, until, all of a sudden, after Christ's death, it becomes hugely magnified. Each of the Gospels tells the story a little differently, but, basically, the Magdalene, either alone or with other women, goes to the tomb on the third day to anoint Jesus's body, and it is to her (or them) that an angel or Christ himself announces that he is risen from the dead, and instructs her to go tell this to his disciples. That command gave the Magdalene a completely new standing. The Resurrection is the proof of the truth of Christian faith. As the first person to announce it, Mary Magdalene became, as she was later designated, "the apostle to the apostles."

But there was a problem. Why her? Why a person who previously had been referred to only in passing? Above all, why a woman?

Since all four Gospels report that the Magdalene was the one, this indeed is probably what people said had happened. If so, however, she needed to be improved upon. That was easy enough. Today, with so many biblical literalists around, we have to fuss about what Scripture actually says, but in the early centuries after Christ's death such questions were less important, because most people couldn't read. The four Gospels, for the most part, are collections of oral traditions. Once they were written down, they served as a guide for preaching, but only as a guide. Preachers embroidered on them freely, and artists—indeed, everyone—made their own adjustments. The English scholar Marina Warner

makes this point in her book on the Virgin Mary, *Alone of All Her Sex* (1976). As Warner shows, many of the details of the Nativity so familiar to us from paintings and hymns and school pageants—"the hay and the snow and the smell of animals' warm bodies"—are not in the New Testament. People made them up; they wanted a better story. Likewise, they made up a better Mary Magdalene.

Jesus, for his time and place, was notably unsexist. In Samaria, when he talked with the woman at the well—this is the longest personal exchange he has with anyone in the Bible—his disciples "marvelled"; a Jewish man did not, in public, speak to a woman unrelated to him. In another episode, in Luke, Jesus is dining with Simon the Pharisee when a "woman in the city," a "sinner"— presumably a prostitute—enters the house, washes Jesus's feet with her tears, dries them with her hair, kisses them, and then anoints them with balm from a jar. Simon says to Christ that if he can accept that tribute from such a person then he is surely not a prophet. Christ answers that the "sinner" has shown him more love than Simon has.

According to some scholars, Christ's equanimity regarding gender was honored in a number of early Christian communities, where women served as leaders. But by the second century, as the so-called orthodox Church consolidated itself, the women were being shunted aside, along with the thing that they were increasingly seen to stand for: sex. It was not until the twelfth century that all Roman Catholic priests were absolutely required to be celibate, but the call for celibacy began sounding long before, and the writings of the Church fathers were very tough on sex. By the fourth century, Christ's mother was declared a virgin. Chastity became the ideal; women, the incitement to unchastity, were stigmatized.

How, then, could the Resurrection announcement have been made to one of that party? In what seems, in retrospect, an ingenious solution, Luke's "sinner" was said to be the Magdalene. This made a kind of sense. Luke first introduces the Magdalene by name only two verses after the story of the "sinner." Then, there were the "seven devils" that Christ cast out of the Magdalene. What devils would a woman have besides concupiscence? Finally,

unlike many other females in the Gospels—Mary the mother of James, Mary the wife of Cleophas, etc.—Mary Magdalene, when she is named, is identified not by a relationship with a man but by her city, Magdala, a prosperous fishing village on the Sea of Galilee. Thus the Magdalene was probably a woman who lived on her own, a rare and suspect thing in Jewish society of the period. Add to that the fact that Magdala had a bad reputation, as a licentious city, and that the Magdalene apparently had money (Luke says that she ministered to Jesus out of her "substance"), and we arrive at the conclusion: Mary Magdalene was the sinner who washed Christ's feet with her tears.

One wonders, at first, how it would help the Church's new chastity campaign for the first witness of the Resurrection to be a prostitute. But, as noted, the Church was pretty much stuck with the Magdalene. Furthermore, the keynote of Jesus's ministry was humility. A god who chose to be born in a stable might also decide to announce his Resurrection to a prostitute. And Luke's sinner was not just a prostitute; she was a repentant prostitute, shedding tears so copious that they sufficed to clean the feet of a man who had just walked the dusty road to the Pharisee's house. But the crucial gain of grafting this woman onto the Magdalene was that it gave the Magdalene some fullness as a character while also lowering her standing. The conflation was already being made by the third or fourth century, and in the sixth century it was ratified in a sermon by Pope Gregory the Great. Mary Magdalene, one of the few independent women in the New Testament, became a whore.

As such, she was a tremendous success. Europe, once it was converted to Christianity, was not content to have all those holy people in the Bible confine their activities—or, more important, their relics—to the Middle East. And so the Magdalene, among others, was sent west. After the Crucifixion, it was said, infidels placed her in a rudderless boat and pushed it out to sea, in full confidence that it would capsize. But, piloted by the hand of God, the Magdalene's bark arrived at Marseilles, whereupon she undertook a career of strenuous evangelism and converted southern Gaul.

Eventually, however, she tired of preaching and retreated to a cave in a mountain near Marseilles, where she wept and repented her foul youth. She wore no clothes; she was covered only by her long hair (or, in some paintings, by an appalling sort of fur). Nor did she take any food. Once a day, angels would descend to carry her to Heaven, where she received "heavenly sustenance," and then fly her back to her grotto. This went on for thirty years. Then, one day, her friend Maximin, the bishop of Aix, found her in his church levitating two cubits above the floor and surrounded by a choir of angels. She lay down on the altar steps and promptly expired.

This is a summary of various stories, but most of them can be found in *The Golden Legend,* a collection of saints' lives written by a thirteenth-century Dominican, Jacobus de Voragine, who later became the archbishop of Genoa. After the Bible, *The Golden Legend* is said to have been the most widely read text of the Middle Ages. On its basis, sermons were composed, plays written, altarpieces painted, stories told by the hearth fire. The Magdalene, according to some sources, became France's most popular saint after the Virgin Mary. In the eleventh century, an especially fervent Magdalene cult grew up in the Burgundian town of Vézelay, whose church claimed to have her relics—an assertion undoubtedly influenced by the fact that Vézelay was on one of the main routes to Santiago de Compostela, in Spain, Christendom's third most important pilgrimage site (after Jerusalem and Rome). Vézelay soon became another important pilgrimage site, substantially benefitting the local economy. In 1267, the monks of Vézelay had the Magdalene's relics dug up from beneath the church—an event attended by the king.

Some people, though, wondered how the Magdalene's body got to Burgundy, when the legend said that she had died in Provence. The Provençal Prince Charles of Salerno, a devout man, was especially pained by this relocation. And so in 1279, only twelve years after the Vézelay exhumation, a new set of Magdalene relics was discovered, in the crypt of St. Maximin, near Aix-en-Provence. St. Maximin became a competing pilgrimage site. As time passed, five whole bodies of the Magdalene, together with spare parts, were discovered in various locales. Her saint's day,

July 22, became a major holiday. In Viviers, it was said, a peasant who dared to plow his fields on that day was struck by lightning. (He survived, but his oxen died.) Numerous professions—winegrowers, gardeners, sailors, barrelmakers, weavers—took her as their patron saint. Church after church was named after her, as were many baby girls.

How did she become such a favorite? In recent years, there have been a number of so-called reception studies of the Magdalene, histories of how her image changed over time. Two good examples are Susan Haskins's *Mary Magdalene: Myth and Metaphor* (1993) and Katherine Jansen's *The Making of the Magdalen: Preaching and Popular Devotion in the Later Middle Ages* (2001). According to these writers, it was partly because urbanization in the twelfth century caused a rise in prostitution that the Magdalene, that well-known whore, became so prominent at this time. Preachers stressed—indeed, invented—her wayward youth. She was beautiful, they said, with masses of red-gold hair. And she was an heiress; she lived in a castle. But she had no male relative to arrange a suitable marriage for her, and so she abandoned herself to *luxuria*, or lust. Day by day, she sat at her mirror, applying cosmetics and perfumes, the better to ensnare innocent young men. Soon, according to the medieval preachers (who apparently regarded wealth as no deterrent to prostitution), she began to sell her body—a lesson, they declared, to all young women tempted by *luxuria*. Jansen quotes a thirteenth-century friar who put himself in the mind of such a girl, sitting before her looking glass: "She lowers her eyes; is she more pleasing with her eyes wide open? She pulls her dress to one side to reveal bare skin, loosens her sash to reveal her cleavage. Her body is still home, but in God's eyes she is already in a brothel." Preaching was only part of the campaign. All across Europe, institutions were set up, under the aegis of Mary Magdalene, for prostitutes willing to repent their ways.

While she was being held up as a warning, however, the young Magdalene was also an object of admiration. She was chosen as the patron saint not just of barrelmakers and gardeners but also of glovemakers, combmakers, perfume manufacturers, and hairdressers—in other words, the purveyors of all those fripperies

which led her to her fall. (She also became the patroness of prostitutes. In Beaucaire, on her saint's day, the local whores ran a race in her honor.) Apart from her beauty, what appealed to people was her reputed emotionalism. In medieval representations of the Crucifixion and the Deposition, the Magdalene typically appears mad with grief. Often, her mouth is open; she is screaming. Her hair flies; her cloak flies. She kisses Christ's bleeding feet. She knows that it is for her sins, too, that Christ has died. Compared with her, the Virgin is usually far more composed. The period between the eleventh and thirteenth centuries was the high tide of the worship of the Virgin Mary. According to Marina Warner, all the human failings that were removed from the Virgin were displaced onto the Magdalene, and each cult grew thereby. But, when it came to guilt over one's trespasses, the Magdalene, not the stainless Virgin, was the saint people needed. As Haskins puts it, she was "a model for mere mortals who could sin and sin again, and yet through repentance still hope to reach heaven."

This shifting image of the Magdalene—sometimes a pinup, sometimes a sermon—stabilized in the Renaissance. As the great scholar Mario Praz put it, she became a "Venus in sackcloth." In a painting by Titian from 1530–35, we see her, in her grotto, gazing up to Heaven. At the same time, between the strands of her flowing hair, we see the pearly breasts that in her life—as in all lives, Titian is saying, complicitly—were the cause of sin. But the equipoise held only briefly. In the sixteenth century came the Protestants' challenge to the sacrament of penance, which, through the sale of indulgences, had been so abused by the Church. The Counter-Reformation therefore placed strong emphasis on penance, and as part of that cleanup campaign we get notably chaste images of the Magdalene, such as Georges de La Tour's famous series, with the pious saint now fully clothed and with a skull by her side—a reminder of how beauty ends up. The Magdalene also figured heavily in the devotional poetry of the English seventeenth century. Richard Crashaw's *Saint Mary Magdalene, or The Weeper* (1646) pictures Christ "followed by two faithful fountains"—the Magdalene's two eyes—"two walking baths; two weeping motions; / Portable, and compendious oceans." This poem, together with other, like-minded representations, was suf-

ficient to establish the word "maudlin," a derivative of Magdalene, in the English language, with the meaning of "mawkishly lachrymose."

With the Enlightenment, Mary Magdalene, like other holy matters, suffered some neglect. But in nineteenth-century England she was again invoked by reformers, for prostitution was epidemic in Victorian London. More convents were established for rescued prostitutes in the Magdalene's name. (Actually, as Haskins explains, they were halfway houses, where the girls did needlework while awaiting a modest marriage or a job in a shop.) The very word "magdalen" was widely used to mean "fallen woman." At the end of the century, a great wave of prurience broke over European art; in that, too, the Magdalene had a place, and not in a devotional guise. In some paintings, she appears buck naked—full body, frontal—without even the pseudo cover of her hair. She appealed also to the "black Symbolism" of the time. In an 1888 engraving by the Belgian Symbolist Félicien Rops, she crumples over, without a stitch on, at the foot of the Cross, as she embraces Christ's feet.

In the twentieth century, the Magdalene received more exalted tributes. Rainer Maria Rilke, Marina Tsvetaeva, and Boris Pasternak all devoted beautiful poems to her. They are love poems, about her relationship with Christ, but they are grave and nuanced. Popular representations of the Magdalene in our time have been less subtle. Tim Rice and Andrew Lloyd Webber's 1971 musical *Jesus Christ Superstar* portrayed her frankly as a whore, in love with Jesus. In Franco Zeffirelli's 1977 TV movie *Jesus of Nazareth,* we first see the Magdalene (Anne Bancroft) as she is finishing up with a client. In Martin Scorsese's *The Last Temptation of Christ* (1988), based on Nikos Kazantzákis's novel, the Magdalene (Barbara Hershey) becomes a prostitute only because Jesus, her childhood companion, rejected her sexually. Not that he wanted to. Later, on the Cross, he is assailed by a fantasy (vividly filmed) of bedding her and conceiving a child. Apparently, this is too much for her; she immediately dies. So, after his fantasy, does Jesus. Mel Gibson's *The Passion of the Christ* uses the Magdalene only as a weeper at the Crucifixion, but it is a rare case.

In fact, Gibson's film is the only one in this catalogue that

conforms to current Church doctrine regarding Mary Magdalene. In the 1960s, the Church finally caught up with some of the more improbable of the saints' lives, and in 1969 the liturgical calendar was revised. A number of long-honored saints' days were dropped, for lack of evidence that the saint in question had ever existed. (That included St. Christopher, to the grief of many people still wearing his medal.) Other saints had their entries rewritten, and the Magdalene's was one. She was no longer a prostitute, the Church said, and the Song of Songs, that sexy poem, was no longer to be read on her saint's day. As the film record demonstrates, some people wanted no part of this cleaned-up Magdalene. Others began asking how she got sullied in the first place.

THE crucial development in Magdalene scholarship was the discovery of the Nag Hammadi library. Biblical scholars had understood for a long time that the orthodox Church was just the segment of the Church that won out over other, competing Christian sects, notably the so-called Gnostics. But, apart from what could be gathered from the Church fathers' denunciations of these supposed heretics, students of early Christianity knew little about them. Then, one day in December of 1945, an Arab peasant named Muhammad Ali al-Samman drove his camel to the foothills near the town of Nag Hammadi, in Upper Egypt, to collect fertilizer for his fields, and as he dug he unearthed a clay jar about three feet high. Hoping that it might contain treasure, he broke it open and, to his disappointment, found only a bunch of papyrus books, bound in leather. He took the books home and tossed them in a courtyard where he kept his animals. In the weeks that followed, his mother used some pages from the books to light her stove; other pages were bartered for cigarettes and fruit. But eventually, after a long journey through the hands of antiquities dealers, black marketers, smugglers, and scholars too, Samman's find was recognized as a priceless library of Gnostic writings—thirteen codices, containing fifty-two texts—recorded in Coptic (an early form of Egyptian) in the fourth century but translated from Greek originals dating from between the second and fourth centuries. In time, the books were confiscated

by the Egyptian government and moved to the Coptic Museum in Cairo, where they remain today. (They were published in 1972–77.) Actually, they were not the first Gnostic texts to be discovered. Others had come to light in the late eighteenth and nineteenth centuries, but most of them were not published until after the time of the Nag Hammadi discovery, which shone a sudden, bright light on this formerly obscure belief system.

Anyone who wants to know the full, surprising contents of the Gnostic Gospels—with hermaphroditic spirits, and a Demiurge (not God) creating the universe, and the story of the Fall told from the point of view of the serpent, a friend to mankind—should consult Elaine Pagels's classic *The Gnostic Gospels* (1979) or Marvin Meyer's *The Gnostic Discoveries: The Impact of the Nag Hammadi Library* (2005). Meyer is more descriptive, Pagels more analytic. What is important for this story is that Mary Magdalene is a central figure in the Gnostic Gospels and, compared with her European legend, an utterly new character. Not only is she not a prostitute; she is an evangelical hero and Christ's favorite disciple.

The key text is the Gospel of Mary. As the treatise opens, the Risen Christ is preaching to his disciples. There is no such thing as sin, he says. Also, the disciples, in their quest for the divine, should follow no authorities, heed no rules, but simply look within themselves. Having delivered these lessons, Jesus departs, leaving his disciples quaking with fear. No sin? No rules? If they teach these doctrines, they may end up getting killed, like him. At that point, Mary Magdalene takes over. "Do not weep or grieve or be in doubt," she tells the others. (This and the following quotations from the Gnostic texts are Meyer's translations.) Peter then says to the Magdalene that they all know Jesus loved her more than any other woman, and he asks her if there is anything that she learned privately from the Savior. The Magdalene responds by describing a vision she had of the soul's ascent to truth—a story she shared with Jesus. (She adds his comments.) Four pages are missing from this passage, and some readers may not regret their loss. Accounts of Gnostic visions are sometimes like people's descriptions of their dreams: bizarre yet boring—and long. The Magdalene's story seems to have struck her audience that way. Peter, the one who asked for the Magdalene's testimony, now

objects to it. "Did he [Jesus] really speak with a woman in private, without our knowledge?" he asks his brothers. "Should we all turn and listen to her? Did he prefer her to us?" Mary bursts into tears and asks Peter if he thinks she's lying. Another disciple, Levi, interrupts: "Peter, you always are angry. . . . If the Savior made her worthy, who are you to reject her?"

This text exemplifies the principle for which Gnosticism was named. In Greek, *gnosis* means "knowledge." To Gnostic communities, it meant a kind of spiritual understanding—the goal of all believers—that was achieved only through intense self-examination, typically accompanied by visions. The Gospel of Mary shows the Magdalene as an expert in this practice. It also presents her as a leader, full of confidence and zeal. Another of the Gnostic texts, Pistis Sophia (Faith Wisdom), takes the form of a dialogue between Jesus and the disciples. Of the forty-six questions put to Jesus, thirty-nine come from the Magdalene. Peter finally complains that no one else can get a word in edgewise. Another feature, then, of the Gnostic portrait of the Magdalene is the quarrel between her and Peter. Jesus repeatedly defends her, and that is the final, critical point about the Gnostic Magdalene: Jesus's preference for her. In another Gospel, she is referred to as his "companion," whom he often kissed. Some readers have taken this to mean that she was his mistress or wife, but kissing was common among people in the Middle East at that time, and the companionship seems to be based on Jesus's conviction of her superior understanding. When the disciples ask him, "Why do you love her more than all of us?" he answers, uncomfortingly, "If a blind person and one who can see are both in darkness, they are the same. When the light comes, one who can see will see the light, and the blind person will stay in darkness."

So, while the orthodox Church was busy eliminating women from positions of power, the Gnostic sects seem to have been following a different route. One of their texts says that Jesus had seven women as well as twelve men among his disciples. The Gnostic pantheon includes female divinities. But Exhibit A is the Magdalene: her leadership and Christ's endorsement of it. This is not to say that the Gnostic Gospels portray a happy, gender-blind community. In another passage in which Peter complains about

the Magdalene, this time violently—"Mary should leave us," he says, "for females are not worthy of life"—Jesus replies, "Look, I shall guide her to make her male, so that she too may become a living spirit resembling you males. For every female who makes herself male will enter heaven's kingdom." That statement, a disappointment to many admirers of Gnosticism, has been explained by scholars as a reflection of the ancient belief, accepted even by the forward-thinking Gnostics, that women stood for earthly matters, while men were more in touch with the divine. Jesus is saying that his female disciples, despite their sex, will become spiritual. Peter does not agree. So the authority of women was a point of conflict among the Gnostics, too.

We know how the orthodox Church—which, not incidentally, claimed its apostolic mission from Peter—solved this problem, and the fact that the Gnostic communities seem to have been handling it otherwise was one of the reasons that they were regarded as heretics. In any case, it was in the fourth century, at the moment when the orthodox Church was finally, after centuries of persecution, achieving stability, that the leaders of a Gnostic community near Nag Hammadi, apparently feeling that they were now in serious danger, put their most precious books in a jar and buried it in the hillside.

Their problem wasn't just women, though. As Elaine Pagels explains, the Church's whole effort at this time was to create an institution, and certain Gnostic principles—above all, the rejection of rules and hierarchies—were utterly incompatible with institutionalization. Pagels also points out that Gnosticism, for all its egalitarianism, was elitist. To qualify, you had to set yourself, over a long course of study, to discovering the divine within yourself. This was not for everyone, and the orthodox Church wanted everyone. Accordingly, the Church did not ask people to search for the divine—their priest would tell them what the divine was—and it assured them that as long as they confessed certain prescribed articles of faith and observed certain simple rituals, they, too, could enter the Kingdom of Heaven. Without these reasonable, followable rules, Pagels writes, "one can scarcely imagine how the Christian faith could have survived."

OTHER writers have been less understanding. Feminist Bible scholarship began in the early nineteenth century and carried on quietly until the 1960s, when it acquired new force in the wake of Vatican II. Soon afterward came the publication of the Nag Hammadi library. The feminists had long suspected that the New Testament, together with its commentators, had downplayed women's contributions to the founding of Christianity. Here was the proof. Writings on the Magdalene exploded after 1975. Conveniently, this happened at the same time as the rise of postmodern literary theory, which held that all texts were unstable and porous, marked by "gaps" that the reader had to fill. If anything ever had gaps, it was the revised Magdalene. She wasn't a prostitute anymore, but what was she? Young scholars tried to figure out what happened to her story. To mention only two recent books, Ann Graham Brock, in *Mary Magdalene, the First Apostle: The Struggle for Authority* (2003), and Holly E. Hearon, in *The Mary Magdalene Tradition: Witness and Counter-Witness in Early Christian Communities* (2004), took on the New Testament Gospels, claiming that they suppressed the oral traditions descending from the Magdalene in favor of traditions descending from Peter's ministry.

But the most searching and passionately argued of the books in this category is *The Resurrection of Mary Magdalene: Legends, Apocrypha, and the New Testament* (2002), by Jane Schaberg, a professor at the University of Detroit Mercy. In Schaberg's view, the Magdalene, for the past two millennia, has been "replaced, appropriated and left behind, conflated, diminished, openly opposed" by the orthodox Church. With tweezers, as it were, Schaberg goes through the New Testament, the Gnostic Gospels, and later writings to expose the textual maneuvers by which this crime was accomplished. Between the first and fourth centuries, she believes, Christianity coalesced into a few broad traditions. One was Magdalene Christianity, whose goal was to put an end to the oppression of the world's powerless. Magdalene Christianity was egalitarian in its organization, like the Jesus movement in which it originated. In that campaign, Schaberg says, Jesus was

"not hero or leader or God" but just a brother to his fellow-reformers. It was only after his death and supposed Resurrection that the focus shifted from the group to him alone, and that he was deified. Clearly, however, Schaberg sees him as having had special authority within the movement, for she proposes that he chose the Magdalene as his successor. That's what the Resurrection announcement was about, she says. The Resurrection, to Jesus, meant the ethical renewal of the world, and in making the Resurrection announcement to the Magdalene he was passing this mission on to her. But, while the Magdalene and the communities she inspired were fulfilling the assignment, other traditions, notably those descending from Peter and Paul, were branching off in other, less egalitarian directions. Those were the traditions that won, and, lest anyone recall the woman who wanted to create a different sort of Church, they "murdered" her memory, by turning her into a harlot.

Schaberg says that all this is guesswork. That's fine by her. Since the 1970s, there has been a true paradigm shift in biblical scholarship. Before, people thought that Christianity was a truth; even the reformers sought only a modification of that truth. But, with the publication of the Gnostic Gospels, abetted by postmodern theory, a number of young scholars came to regard early Christianity entirely differently—as a *process,* a vast, centuries-long argument among competing sects, during which certain choices were made. And, as these writers saw it, choices were still being made, which meant that any new proposals, however conjectural, were not only useful but essential. People don't have to worry about contradicting the New Testament, Schaberg says. That document was just a draft: "a collage of fragments, aborted ideas, blackouts, white spaces, instructions, verbal experimentations, doodles, dots." Earlier writers had also said that Christians needed to make their own Christianity—and that it should be political. In the words of the Harvard theologian Elisabeth Schüssler Fiorenza, feminist reinterpretations were a good thing, a way to "develop and adjudicate our own Christological meaning-making in the face of violence and killing today." Fiorenza's views, cousin to "liberation theology" (she calls the Magdalene one of

"the disappeared"), were embraced by many young Bible scholars. Schaberg describes herself as a "guerrilla exegete."

Not all the reformers have bared their teeth. In 2005, Doubleday brought out *Mary Magdalene: A Biography,* by Bruce Chilton, an Episcopal priest and a professor of religion at Bard College. According to Chilton, the Magdalene was one of the "shaping forces of Christianity." Especially important, as he sees it, was her visionary experience, both in the Gnostic Gospels and in the Resurrection announcement, which he takes to be a subjective, not an objective, event. Chilton, then, is one of those who believe that they can advance a more modern, acceptable Christianity by questioning the existence of miracles. Many of the Catholic reformers, like Fiorenza and Schaberg, seem to be past that stage. They belong to a Church that *really* believes in miracles, and whatever skepticism they felt regarding those fantastic events appears to have been exhausted years ago. Schaberg, when confronted with the question of whether Christ underwent a bodily resurrection, refuses to make the call. "Who knows?" she says. "Who cares?" Chilton cares. To him, apparently, as to many of the older liberal clergy, miracles are a mumbo-jumbo separating the faithful from the true meaning of Scripture. And so, in his view, Lazarus was not raised from the dead. He was probably buried alive by mistake—Jesus rescued him. Likewise, it is only "resuscitation literalists" who believe that Christ underwent a bodily resurrection. If the tomb was empty, maybe somebody stole the body. Christ was a man, with an idea about love and justice, and we should follow his lead without bothering about those old stories. By now, however, such an argument seems, itself, an old story, of limited usefulness. Many, probably most, of the world's two billion Christians do believe in miracles, and want to. This makes life more interesting and serious to them. To mount reform on a denial of miracles seems futile and also—however unwittingly—uncharitable.

The Catholic reformers, from what I can tell, are not just more radical. They also seem more likely to spawn fringe groups such as "goddess worship." In 1993, Margaret Starbird, a good Catholic who never publishes anything without letting her pastor read it

first, came out with her book *The Woman with the Alabaster Jar: Mary Magdalene and the Holy Grail.* Starbird says that when she read *Holy Blood, Holy Grail* she was "shattered" by its claim that Jesus was married: "In tears I prayed about this heretical version of the Gospel." She had to find out the truth, though, so she did seven years of research, and concluded that *Holy Blood* was right: Jesus was married to the Magdalene. Not only that, but the suppression of this secret—and of the "forgotten feminine" in general—had caused terrible trouble in the world: environmental pollution, child abuse, war. But now the divine goddess was fed up. Statues of the Virgin Mary "have been seen to shed tears in churches worldwide. . . . Even the stones cry out!" So do Disney movies, Starbird says. In *The Little Mermaid,* Ariel's true identity is the "Lost Bride," the Magdalene. The signs are everywhere. The hoofbeats are sounding. The forgotten feminine is on its way back.

Starbird goes beyond analysis; she writes a love story. Jesus was a tall, handsome fellow; the Magdalene was a shy Jewish maiden, accustomed to sitting in her garden and gazing at little birds. One day, they were introduced. "His dark eyes caressed her." We are taken through their wedding night, alas. Soon afterward, Jesus tells the Magdalene, now pregnant, that he has to go on a dangerous mission and that she must stay behind. "She buried her tears in the warmth of his shoulder." The academic feminists have very little patience with the Jesus-married-the-Magdalene plot. As Schaberg sees it, these stories are not about the Magdalene. They are about Jesus; they are an effort to make him a "real man," and not just for humanistic, Christ-is-your-friend reasons. (In the sixties, there were some naughty suggestions that maybe Jesus was gay.) Insofar as the love plot concerns the Magdalene, Schaberg writes, it is again demeaning, an effort to convert this independent woman into a "normal" female. Starbird's book bears out that theory.

She is not the only one who has resorted to fiction. There has been a boom in Magdalene novels in the past few decades, and many of them, according to Susan Haskins, are reluctant to part with the Magdalene's reputation as a prostitute. The trend is to celebrate her as a sexually liberated woman. Behind this, of course,

is second-stage feminism, but I think there is another motive as well, an effort to smuggle a little liveliness back into the Magdalene's story.

A problem for the Magdalene revival, or at least for the theologians, is that it has had to draw its reconfigured heroine from the austere philosophy of the Gnostics. A religion, in order to succeed, must offer a little fun: stories, symbols, rituals. The Catholic saints, however ill-founded their biographies, are a vivid group, each with a certain kind of hair and a certain hat, and accompanied by a lion or a dragon or something else interesting. They are like a collection of dolls or superheroes, or like the Hindu pantheon—full of color and variety. The New Testament, for the most part, gives the Magdalene no concrete life. The medieval legend filled that void, supplied her with a boat, a grotto, some friends. Take these things away, and you are back to zero. The Gnostic Gospels don't provide much of a personality for her, and what they do come up with is not endearing. The Gnostic Magdalene is a showy visionary. At one point, she responds to something Jesus has said by staring into the air for an hour. She is also a swot, the best student in class, constantly raising her hand. If I had been Peter, I would have complained, too. The feminists are of course right to point to her Gnostic virtues—the visionary faculty, the zeal—as an answer to the Church's demotion of her, and of all women. Still, we miss the red-gold hair, the ointment jar.

At one moment, however, the faceless Magdalene is given not just a face but a great, flaming personal drama. This is not in the Gnostic Gospels but in the New Testament, in John's account of the Resurrection announcement. Here the Magdalene goes to the tomb in darkness, before dawn, and she goes alone. We feel her hurry, her sense of danger. To her astonishment, she finds the stone rolled away. She runs back to the disciples and tells them, "They have taken away the Lord out of the sepulchre, and we know not where they have laid him." Peter and another disciple take over. They rush to the tomb; indeed, they race to see who can get there first. (This exemplary male competition became a favorite scene in medieval morality plays. In John's Gospel, it adds

a bright little note of comedy to the otherwise dark tale.) When they arrive, they see that the Magdalene was right: the body is gone. They go back home, presumably baffled, but the Magdalene stays behind, weeping. She looks into the tomb, and now she sees two angels dressed in white. They ask her why she is crying, and she repeats her simple complaint: "They have taken away my Lord, and I know not where they have laid him." Even with angels, she's still looking for the body. But then she turns around and sees another figure, who says to her, "Why weepest thou? Whom seekest thou?" The tomb is in a garden, and the Magdalene thinks this man must be the gardener. A third time—it's like a song—she repeats her complaint: "Sir, if thou have borne him hence, tell me where thou hast laid him." Now comes the stab through the heart. "Mary," the "gardener" says to her, and instantly she knows. "Rabboni" (roughly "My dear rabbi"), she replies, and apparently she reaches out to him, because he says, "Touch me not." (This is the Latin Bible's famous phrase *Noli me tangere*.") "But," he tells her, "go to my brethren, and say unto them, I ascend unto my Father." He then vanishes, and she is left by herself.

This scene is the New Testament's most powerful statement about the confrontation with death, about losing forever the thing you love. The setting is beautiful: the green garden, the morning light, the angels. Then we hear the cruel words: "Don't touch me." He was there; he had called her name; she had reached out to embrace him. Now she must stand back, let him go, and make her way alone. The young Bible scholars should have all our support, and we should agree with them that the energetic, far-seeing Magdalene of the Gnostic texts is good evidence that the Church should ordain women. But that is not the evidence of the Magdalene's authority on matters of the soul. John's story is the evidence.

The New Yorker, 2006

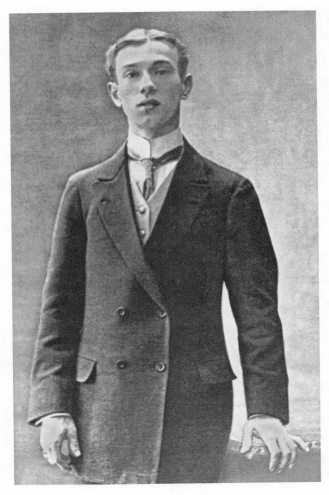

Vaslav Nijinsky, c. 1908

After the Ball Was Over

VASLAV Nijinsky, born in or about 1889 to a pair of Polish dancers, was a shy, awkward, peculiar-looking boy who was teased by his schoolmates and did poorly in all his subjects but one—ballet, at which, as his teachers at St. Petersburg's Imperial Theatre School soon recognized, he was a kind of genius. By age twenty, he had signed on as the lead dancer of Serge Diaghilev's Ballets Russes—also as Diaghilev's lover—and within a few years he was the most famous male dancer in the world. Writers could not find the words to describe him. His performances represented "the possession of the body by the spirit," Paul Claudel wrote. "For a second the soul carries the body, [then] this vestment becomes a flame, and matter has passed." The visionary note persists in descriptions of him to this day.

By age twenty-three, he had begun choreographing as well, and in two years he produced three ballets—*The Afternoon of a Faun* (1912), *Jeux* (Games, 1913), and *The Rite of Spring* (1913)— that, as far as we can tell from what remains of them, shot classical ballet into a new territory of meaning, converting that old, noble genre to the hard school of modernism. In Nijinsky's ballets, the dancers turned in, not out. They hunched over; they bunched their fists. They moved in stiff profile, slicing the air like knives. As one reviewer described it, the dancers did not so much release the dance impulse as close over it, swallow it, and then give slow, spasmodic birth to it. "Nijinsky (with Rodin, Cézanne, Picasso . . .) for his generation murdered beauty," Lincoln Kirstein wrote in his 1975 book *Nijinsky Dancing.*

These dances were modernist not just in their look but in their subject matter. All of them dealt directly with sex. *The Afternoon of a Faun,* inspired by Mallarmé's famous poem about the faun

and the nymphs, was a story of sexual awakening. (It ended with a not very stylized representation of orgasm.) *Jeux,* which took the form of a ménage à trois (a man with two women), portrayed sex as play, as experiment—a bold notion in 1913. In *The Rite of Spring,* which showed a prehistoric tribe sacrificing a young woman to guarantee the fertility of the earth, sex was relocated to the heart of darkness. Not surprisingly, all these ballets were greeted by the public with varying degrees of dismay. The editor of *Le Figaro* refused to publish his critic's review of *The Afternoon of a Faun.* Instead, he himself wrote a front-page editorial denouncing the piece as a scene of bestiality. As for *The Rite of Spring,* its premiere ignited one of French cultural history's most cherished theatrical riots. Stravinsky's now famous score for the ballet is usually seen as the principal cause of the uproar, but that may be because it still exists, whereas Nijinsky's choreography has vanished from the record.

All the while that he was creating these amazing works, Nijinsky was still the same shy, slow-spoken, lonely boy he had been in school. When Diaghilev took him to lunch with important people, he sat with his eyes lowered and picked his cuticles. When he had to explain to the Ballets Russes dancers how he wanted them to dance, he became tongue-tied and threw screaming fits. At best, he was given to mystic utterance. "It is the life of the stones and the trees," he said of *The Rite of Spring.* "There are no human beings in it." When his ballets came under attack, he was unable to defend them to the press or to the dancers, or even to Diaghilev. One by one, they were dropped from the company's repertory. *The Rite of Spring* had only nine performances, *Jeux* only five. Nijinsky made one more ballet for the company, *Till Eulenspiegel,* and that, too, was discarded within a few months. Of his four ballets, only *The Afternoon of a Faun* survives today. (In 1987, an American dance scholar, Millicent Hodson, mounted a version of *The Rite of Spring* on the Joffrey Ballet, but, from what one can tell, it was based on evidence too fragmentary to allow it to be counted as an actual reconstruction.)

At the same time that Nijinsky's choreographic career was going under, so was his relationship with Diaghilev. In a diary, written later, Nijinsky records the disgust with which he awoke

every morning to the sight of stains from the older man's hair dye on the pillow next to him. They had fights in public. On a sidewalk in Paris one day, Nijinsky shoved Diaghilev, and Diaghilev hit back with his cane. Nijinsky burst into tears and ran away, with the great, lumbering Diaghilev chasing after him.

In the summer of 1913, soon after the *Rite of Spring* scandal, the company set sail for a tour of South America. Diaghilev did not go on this trip, to his grief, for a Ballets Russes groupie named Romola de Pulszky—the daughter of Hungary's foremost actress, Emilia Márkus—had found out about the tour and bought a ticket to sail with the troupe. Romola was determined to capture Nijinsky, and, for reasons that no one has ever been able to explain, she succeeded. Prior to their sailing, Nijinsky had never exchanged so much as a word with her. Within two weeks, he had proposed, and two weeks after that, with great haste—Romola did not want her mother or Diaghilev to have time to find out and intervene—they were married, in Buenos Aires.

In all the world, it would have been hard to find a poorer match for Nijinsky than Romola de Pulszky. Where he was withdrawn, idealistic, and otherworldly, she was unapologetically *mondaine.* What she wanted in life was to wear furs and lunch with duchesses. (This was probably the source of her attraction to Nijinsky: he was famous, and she could share in his fame.) He was utterly impractical, always needing someone to arrange things for him, but she was no arranger, either. She was a pampered girl, who traveled with her maid. He was morbidly sensitive—kind and in need of kindness. She, though probably nicer to Nijinsky than to anyone else, was in general briskly self-seeking. They didn't even speak a common language; for the first few months of their marriage, they had to communicate through sign language.

A final problem with the marriage was that it got Nijinsky fired. Whatever the problems in their relationship, Diaghilev still considered Nijinsky his lover, and he was mortally wounded by the younger man's defection. Stravinsky was with Diaghilev when the news arrived. "I . . . watched him turn into a madman," Stravinsky wrote. Diaghilev wired Nijinsky to say that his services were no longer required by the Ballets Russes. Naïve, as always, Nijinsky could not understand this. "I do not believe that Serge

can act that meanly toward me," he wrote to Stravinsky. "If it is true that Serge does not want to work with me—then I have lost everything."

He had. He tried to organize a company of his own, but it failed. He even briefly rejoined the Ballets Russes. But without the protective relationship he had had with Diaghilev he could not function as a dancer, let alone as a choreographer. Always odd, he became odder. He began to imagine that every performance mishap—every rusty nail on the stage, every loose plank—was part of a plot by Diaghilev to destroy him, and his paranoia was constantly abetted by Romola, who hated Diaghilev. He withdrew into Tolstoyan philosophy: he became a vegetarian, he tried to practice chastity, he wanted to go back to Russia and farm the land. These ideas disgusted Romola, who had no intention of farming any land and was presumably not interested in chastity, either.

In late 1917, Nijinsky gave his last public performance. He was twenty-eight years old. Without a company to work for, he had no way of continuing his choreographic experiments. Furthermore, he had no income, and he now had a child to support, as well as a demanding wife. The family settled in neutral Switzerland—in a villa in St. Moritz—to wait out the war, and there Nijinsky began to break down. He sat for hours making drawings filled with staring eyes. He locked himself in his room and wept. Most of what we know of his state of mind in 1918–19 comes from the diary that he began keeping at this time, and that Romola later published, after heavy editing and bowdlerizing. Even in this form, the diary is very painful to read. Again and again, Nijinsky repeats that he is God. (Indeed, he signed the first chapter "God Nijinsky.") If the world would just listen to him, he says, there would be no more war; he must go immediately and tell Lloyd George and Clemenceau how to effect world peace. But, at the same time that Nijinsky knows he is God, he also knows, in dark flashes, that he is going insane, and his bewilderment in the face of this fact is unbearably poignant:

I cry. . . . I cannot restrain my tears, and they fall on my left hand and on my silken tie, but I cannot and do not want to

hold them back. I feel that I am doomed. I do not want to go under. I do not know what I need, and I dislike to upset my people.

In early 1919, Romola decided to take him to a specialist, the celebrated psychiatrist Eugen Bleuler. Eight years earlier, Bleuler had invented the term "schizophrenia," and that was his diagnosis in this case. Nijinsky's great career, only ten years long, was over. He lived for thirty-one years more, but he never danced again. In 1950, at sixty-one, he died, quietly, of kidney failure, in a London hospital.

THIS is not the kind of story that one wants to see turned over to a psychobiographer. Most psychobiography, in keeping with its Freudian origins, deals with the psychology of motivation: it attempts to unearth the traumas, the sexual strivings that are presumed to underlie and explain the achievements of the man or woman in question. But in Nijinsky's case there is little to unearth. There is no "latent homosexuality"; it was overt. There are no sexual obsessions to uncover; they are there in the ballets. (And they are there, everywhere, in the diary—endless ruminations on lust, on masturbation, on fornication.) As for traumas, there are certainly enough of them on the surface of Nijinsky's story. Never has such a quiet man led such a lurid life.

What we need to know about Nijinsky is not what was on his mind but how he transformed this material into art—how this tongue-tied introvert managed to become not only a great, eloquent, and (by all accounts) surpassingly glamorous dancer but also the first modernist choreographer in the history of ballet. In other words, we need a psychology of creativity. And that is exactly what most psychobiographers do not concern themselves with. Creativity—the thing that actually distinguishes their subjects from the rest of humankind and therefore needs explaining—is to them a given. They work backward from there, to libido and aggression, the things that in no way distinguish their subjects from the rest of humanity.

Nijinsky seems to have first come to the attention of a psy-

chobiographer in 1936. At that point, Romola had decided to publish Nijinsky's diary, and she asked Freud's famous colleague Alfred Adler to write the preface. Adler obliged her with an essay describing Nijinsky's madness as the product of an inferiority complex. (Adler had coined the term "inferiority complex," and he believed that this was the cause not just of Nijinsky's disturbance but of most psychopathology.) Adler reached his conclusion without ever examining Nijinsky; his only evidence was the diary, in Romola's cleaned-up version, and whatever Romola had told him about her husband. Romola junked Adler's preface; she didn't want to hear about her husband's having an inferiority complex. (She then asked Jung to write the preface, but he declined.) Out of courtesy to Romola, Adler's essay was withheld from publication, but in 1981, three years after her death, it was published in the *Archives of General Psychiatry.* Accompanying it was a backup article in which an Adlerian psychologist, Heinz L. Ansbacher, expanded upon Adler's conclusions, drawing his facts about Nijinsky's life from such sources as an ax-grinding biography by one of Nijinsky's schoolmates, Anatole Bourman, and the two extremely unreliable and self-serving books that Romola eventually wrote about her husband: *Nijinsky* (1933, ghostwritten by the young Lincoln Kirstein) and *The Last Years of Nijinsky* (1952). There have been other psychiatric articles, and dissertations, too. But, as one of the leading "mad genius" legends of our century, Nijinsky was certainly ripe for more. More has now come. Peter Ostwald, a professor of psychiatry at the University of California, San Francisco, and the author of a 1985 psychiatric study of Schumann, another genius-madman, has produced a full-scale psychobiography, *Vaslav Nijinsky: A Leap into Madness.*

Surprisingly, it is a very good book—less a psychobiography than a psychiatric history. That is, its emphasis is not on digging up hidden intrapsychic causes but on assembling a factual history of Nijinsky's psychological disturbance. And in putting together this history Ostwald, unlike his predecessors, has done extensive research. He has been to Russia to examine Nijinsky's medical records there. He has been through the files on Nijinsky in every sanatorium, every hospital, every clinic in which the unfortunate man spent so much as a night. Because Ostwald is a psychiatrist,

he was in a position to request this information, to make sense of it, and to make it make sense to us. Until his book, the only history we had of Nijinsky's last thirty years was Romola's *The Last Years of Nijinsky*, which is more a sentimental novel than a factual account. (Other biographies, such as Richard Buckle's 1971 *Nijinsky*, relied on Romola's reporting of those years.) Now we have a factual account.

What it says is that Nijinsky was fundamentally a chronic schizophrenic, a back-ward case, for his last thirty years. Periodically throughout his illness, Romola would advertise to the press that he was undergoing a miraculous recovery. The most outrageous instance occurred in 1938–39, when she had him subjected to a long course of insulin-shock therapy. After the first stage of this therapy, his doctor at the sanatorium where he was staying saw no improvement: "The patient completely unchanged. The same word salad [gibberish], the same inconsequential speech." Romola meanwhile was writing to the doctor who had administered the treatments that Nijinsky was a new man: he "goes to the bank and shopping with me, greets people, lifts his hat. . . . Isn't that flabbergasting?" She also broadcast the good news to Nijinsky's former colleagues and admirers, whom she asked to set up a Nijinsky Foundation to raise money to pay for the treatments. (They did, though Romola in the end failed to pay a large part of the bill.) In another letter to the doctor supervising the treatments she wrote, "Please be so kind and certify in English—I need this for the Foundation . . . that you can detect a significant improvement (that's true, isn't it?)." In fact, there was no significant improvement. Nijinsky's physical coordination did get better, but his speech became far worse, degenerating into echolalia. That is, he simply repeated what others said to him.

The head of the sanatorium, who had never liked the idea of insulin-shock therapy, now refused to allow any more of these treatments under his roof. Romola responded by moving Nijinsky to a different hospital, where the director was also skeptical about insulin shock but agreed to allow it on the condition that Romola refrain from any publicity. Week by week, Nijinsky would be wheeled into the treatment room and injected with insulin, whereupon he would go into deep shock, sweat, drool, turn blue

in the face, convulse violently, and then lapse into a coma, after several hours of which he would be revived by a sugar solution and return to his normal psychotic condition.

One day, after he had been receiving insulin for close to a year, a fleet of cars arrived at the hospital. Romola had invited the Paris press to come and document the miracle cure. Newspapermen poured through the wards, flashbulbs popped, champagne was uncorked. Also in the party was Serge Lifar, the director of the Paris Opéra Ballet. (As one of Nijinsky's successors in the combined role of Diaghilev's lover and lead dancer, he had a special interest, and Romola had invited him along.) Lifar demonstrated some ballet steps for Nijinsky, and Nijinsky produced a few jumps of his own. The resulting photographs were published in *Paris Match* and, later, in *Life*. They show a fat middle-aged man in a business suit, with a blank look on his face, launching himself rigidly into the air. The director of the hospital was so angry that he threatened to discharge Nijinsky, but in the next few days Nijinsky seemed somewhat improved. (He probably benefitted from the attention. By Romola's orders, he had never been allowed any visitors.) As a result, it was decided to start giving him a shock treatment every day. Soon all improvement disappeared. According to the hospital records, he was producing "pure word salad" and defecating into his pyjamas. Finally, after one year and 228 treatments, the insulin therapy was abandoned. Ostwald thinks that it may have caused Nijinsky significant brain damage, together with heart and kidney damage. (Insulin-shock therapy was discarded in the 1950s, too late for Nijinsky.)

Nor was this the last of Nijinsky's "miraculous recoveries." As late as 1946, Romola was writing to the English ballet critic Cyril Beaumont that Nijinsky's dancing was now "quite as marvellous as it used to be" and that, according to his doctor, he would "be able to appear [onstage] again." She added the request "Mr. Nijinsky and myself would be grateful to you if you would inform the public of the truth about us." At that point, the truth about Nijinsky was that he was a helpless lunatic; he could not even brush his teeth by himself, let alone dance. (And he was fifty-seven!) By Romola's account, when he was not showing rapid improvement he was a sweet, lamblike fellow. "We get many invi-

Nijinksy, at about the age of fifty, reprising his famous jump
for the press photographers, 1939

tations, his behavior is faultless," she wrote. This, too, was far
from the truth. Most of the time, he was unreachably withdrawn.
"He screws his finger into his ear . . . and murmurs to himself,"
runs a typical entry in the hospital daybook. When he was not
withdrawn, he was given to pulling his hair out, throwing chairs,
and assaulting people. Once, on a street in Budapest, he attacked
a child, hitting him so hard that the child spat blood.

How could Romola have so distorted the truth? Hope may
have had something to do with it. On the other hand, she made
her living (lectures, book contracts, endlessly abused credit) by

being the wife of the famous Nijinsky. Keeping him always in the public eye, as one who would "return someday," like Zapata, helped to insure that living. Besides, Romola never had a problem about lying. She lied constantly, and not just about Nijinsky.

As all this suggests, another point that emerges from Ostwald's account is just how unreliable Romola was. In her defense it is often said that, whatever else she did, she did not abandon Nijinsky. Beyond that, though, there is almost nothing to say for her. Ostwald is scrupulously fair to Romola, but the factual record of her selfishness, her self-aggrandizement, and her mendacity is truly breathtaking. And for long periods of time she *did* abandon Nijinsky. From 1926 to 1934, she saw him exactly twice. During this period, she went to the United States and got involved in various projects, including two protracted lesbian love affairs. (This despite the fact that for much of her life Romola claimed that she and her husband were being persecuted by an international homosexual conspiracy.) For three years, she left Nijinsky in an apartment in Paris under the care of her sister Tessa. Finally, Tessa threw up her hands, and Romola had to write to a sanatorium to send someone to get him. When the attendants arrived, they found him "in a cell, where he was ... raving and smearing feces." Romola at this time was staying at the Savoy, in London. She had not seen Nijinsky since she dropped him off with Tessa. She had been "very, very busy," she explained to the director of the sanatorium.

In 1940, when an excellent Swiss hospital offered to keep Nijinsky without charge until the war was over, Romola refused the offer. (She was annoyed because Nijinsky's private nurse had taken himself off the case—no surprise, since Romola had ceased paying him.) Instead, she transported Nijinsky by train across warring Europe and, with the bewildered invalid in tow, invaded her mother's house in Budapest. There, amid the bitter feuding that Romola invariably carried on with her family, Nijinsky went out of control and had to be taken to the state hospital in a straitjacket. Indeed, there is plentiful evidence that Nijinsky was more disorganized when he was with Romola. "He sometimes reacts to the presence of his wife by producing the most terrible obscenities," one of his doctors wrote.

Ostwald also provides evidence that what precipitated the manic attack that resulted in Nijinsky's first psychiatric hospitalization was his belief that Romola was having an extramarital affair. This is a matter that has been talked about for years. Ostwald, though he does not give the real name of the man in question—he calls him Dr. Greiber—tells us more about the episode than has ever been written before. Romola met Dr. Greiber in 1917, when the Nijinskys moved to St. Moritz. He was a hotel physician—young, handsome, and married. Romola confided in him about her husband's odd behavior, and Dr. Greiber took an interest in the case. He came to the house every day; he tried to psychoanalyze Nijinsky. He also fell in love with Romola. Many people in St. Moritz assumed that they were having an affair. So did Mrs. Greiber, with resulting damage to that marriage. (The unhappy Greiber eventually developed a morphine addiction and attempted suicide.) Nijinsky, too, as Ostwald tells it, believed that Greiber was sleeping with Romola, and, under the strain of this suspicion—a strain exacerbated by the fact that the man was always around, analyzing him, medicating him, "helping" him— he became truly unhinged: he drove his sleigh into oncoming traffic, threw Romola down a flight of stairs, roamed around St. Moritz telling people to go to church. It was at that point that Romola took him to Zurich to see Bleuler and his condition was diagnosed as schizophrenia. When they left Bleuler's office, Nijinsky went back to the hotel, locked himself in a room, and refused to come out. After twenty-four hours, the police were called. They forced open the door, and he was taken to the hospital.

Ostwald's account of the Greiber business becomes uncharacteristically cloudy at certain points. He says that the question of whether or not Romola and Greiber actually had an affair is a "moot point," while in the very same paragraph he notes that a "minor operation" that Romola claimed she had in 1918—that is, soon after she became friendly with Greiber—and that Greiber apparently helped her to obtain was almost certainly an abortion. One has to do a little reading between the lines.

My guess is that this indirection is a courtesy to Romola's daughter Tamara. Romola had two daughters: Kyra, who now lives in San Francisco, was born in 1914, and Tamara, who lives in

Phoenix, was born in 1920, during the period of Romola's presumed affair with Greiber. It has long been whispered that Tamara was Greiber's child—a supposition to which Romola herself gave support in later years when, angry with Tamara, she tried to have her removed as an heir to the Nijinsky estate by claiming that Nijinsky was not her father. Ostwald gets through his discussion of Tamara's paternity with noticeable haste, and without mentioning Greiber's name. He even tries to account for Romola's action by suggesting that she was shielding Tamara from the stigma of hereditary psychosis.

This cloud of smoke is no doubt explained by Ostwald's statement, in the preface, that he agreed to show Kyra and Tamara "all my findings and to publish nothing of which they disapproved." I don't mean to imply that Ostwald knows the truth and isn't telling us—only that he didn't feel free to discuss the question fully. What he got in return for this restraint was the cooperation of the Nijinsky daughters and "access to the family archives." If I'm not mistaken, it was also through that trade-off that he got permission to study and quote Nijinsky's diaries in their original form, before they were subjected to Romola's editing. (The copyright is owned by the Nijinsky daughters.) If so, he made a good bargain, for the diaries are very interesting. In 1979, when the original notebooks were auctioned at Sotheby's, the catalogue noted that Romola had "suppressed approximately one third of the original, excising long erotic passages, poems, including one on defecation, explicit sexual references and obsessive repetition, transposing or omitting whole pages or passages, often altering their sequence." Ostwald tells us more precisely what it was that Romola cut—namely, a number of unhappy references to Dr. Greiber, many uncomplimentary remarks about Romola ("My wife is an untwinkling star"), broodings on defecation, and a great deal of sexual material, including discussions of masturbation, incest, bestiality, and, of course, homosexuality. She deleted all the poems in the diary— poems in which Nijinsky often worked by word associations rather than by discursive logic. (This sounds like modern poetry, but Nijinsky's verse, from what Ostwald quotes, is far less discursive. For example: "I am Christ's blood. . . . I love you, always. Rockabye, rockabye.") Romola also made certain revisions in

order to remove from Nijinsky the taint of voluntary homosexuality. Of his first sexual encounter with Digahilev he had written, "I found fortune there because I immediately loved him." Romola changed "I immediately loved him" to "I allowed him to make love to me."

Even in Romola's cleaned-up version, the diaries are relentlessly obsessive and paranoid. Ostwald, however, concludes that "there is nothing basically bizarre or 'crazy' about Nijinsky's writing." I disagree with him, but it should be added that his stand on this matter reflects one of his most appealing qualities as a psychobiographer—his total lack of what is called the "bias for pathology." Where his colleagues are always peering knowingly at their subjects—distrusting their motives, rooting around for the underlying pathology—Ostwald is always bending over backward to take people at their word, to see their side of things, and, at the same time, to remind the reader that all lives, even normal lives, contain substantial amounts of irrationality and torment. He also seems to regard homosexuality as neither extraordinary nor abnormal—a welcome position in Nijinsky studies. And he extends these courtesies not only to Nijinsky but to Romola and to everyone else in the story.

This would not be a psychiatric study if it did not contain a certain number of fanciful interpretations. In attempting to account for what he seems to regard as the otherwise inexplicable modernism of Nijinsky's choreography—its angularity, its flatness, its "ugliness"—Ostwald suggests that it may have been inspired by the bodily contortions of cerebral-palsy patients Nijinsky presumably saw when, as a young man, he visited his elder brother, Stanislav, who lived in a sanatorium outside St. Petersburg. (Stassik, as he was called, fell from a fourth-story window onto his head when he was a young child. He behaved strangely ever after, and was institutionalized as an adolescent.) But why the appearance of angularity, flatness, and "ugliness" in Nijinsky's choreography of 1912–13 needs to be explained as the result of anything other than modernism is beyond me; Picasso completed *Les Demoiselles d'Avignon* in 1907.

And this would not be a study of Vaslav Nijinsky if it did not contain some misty rhapsodizing. Here are the final sentences of

Ostwald's book: "He was a saint, a genius, a martyr, and a madman. . . . He remains a myth, an apparition, an emblem, a creature of fantasy, a biological creation, a fleeting image of God. Nijinsky, the God of the Dance." This passage is out of character, though. For the most part, the book is admirably clearheaded. Ostwald's final diagnosis is "Schizo-affective Disorder in a Narcissistic Personality," which means that Nijinsky met the diagnostic criteria for both schizophrenia and bipolar (manic-depressive) disorder at the same time that he had a longstanding personality problem characterized by grandiosity, need for attention, and intolerance of criticism. One of the most endearing things about the book is Ostwald's obvious regret that he himself did not have the chance to treat Nijinsky. He is constantly shaking his head over Nijinsky's treatment (why didn't they give him musical scores? why did they jump so quickly to the conclusion that he was hallucinating?) and constantly telling us what might have been done for Nijinsky today.

AT the same time that Ostwald was writing his book, Tamara Nijinsky was working on her own memoir, *Nijinsky and Romola: Two Lives from Birth to Death Indissolubly Linked* (1991). The book is very firm on two points. One is to defend Emilia Márkus, Romola's mother and Tamara's grandmother, against Romola's published attacks on her. (Emilia took Tamara in and raised her when Romola more or less abandoned the children.) The other is to establish that Nijinsky was her father and to try to account for Romola's denial of this. These two items aside, the book is notably disinterested.

Tamara says relatively little about Nijinsky. (She lived with him for only about two years, when she was four and five; then the family was scattered.) She has much more to say about Romola. Tamara has her mother's and her grandmother's papers, so we get long quotations from Romola's correspondence: her incessant demands for money, her letters threatening to sue anyone who went near the subject of Nijinsky, her love letters to a Japanese actress. There is a draft of a letter to Lincoln Kirstein (by then cofounder, with George Balanchine, of the New York City

Ballet) in which Romola claims that since it was she who intro-
duced Kirstein to Balanchine, "George owes me his forty-one
years' bread and butter" and should not have allowed Jerome
Robbins to create for New York City Ballet his *Afternoon of a
Faun,* infringing on Nijinsky's copyright. (In fact, though Rob-
bins used the same music as Nijinsky, Debussy's famous *Prélude,*
he created wholly new choreography.) There are letters to various
people instructing them to bar researchers from consulting Nijin-
sky materials in public libraries without her permission. There are
clippings of interviews that she gave: in one she claims that Nijin-
sky is dictating to her, through a medium, how a film of his life
should be made; in another she describes a book she is working on
that "begins with the dawn of creation, and traces the history of
the dance up through . . . the 1900's."

Like Ostwald, Tamara quotes from Nijinsky's original diary,
including some juicy parts that Ostwald let pass. For instance,
Nijinsky describes how Romola's sister Tessa visited them in St.
Moritz and tried to seduce him ("lying down on the bed in her
underclothes to excite me")—an event that, if it occurred, may
well have been instigated by Romola. (One of her ways of getting
Nijinsky off his chastity kick was to push him into the arms of
other women.) But most of *Nijinsky and Romola* comes out of
Romola's correspondence. A series of letters written near the end
of her life describes a delusional romance with a Spanish grandee,
who she claims is trying to get her to marry him. She calls him
Don Alvarado. (Sometimes she calls him "Su Altezza.") He
smothers her in orchids, buys her diamonds, whisks her off to the
Palacio Real. He is thirty-seven. (She was eighty-five.) Meanwhile,
she is still in touch with Nijinsky. She has not been well, and her
doctor says she needs surgery. But Nijinsky, speaking to her
through the medium, tells her not to have the operation. Eventu-
ally, again through the medium, he changes his mind, but he is
too late. In 1978, at age eighty-seven, Romola died, of cancer, in a
hotel in Vienna. She refused to be taken to the hospital, for fear
that she would be placed in the psychiatric ward. The wonder is
that she was not placed there before.

These are the high points. There are also long stretches of
minutiae—Romola reciting the titles of the people she lunched

with, Romola accusing somebody of making off with a bracelet that her mother promised her. To read it is like going through someone's dresser drawers. The moral shock never wears off, though, for in this book we see the harm Romola did not only to her husband but, more thoroughly, to her daughters—a day-by-day, decades-long account of indifference and betrayal. Like Ostwald, Tamara bends over backward to be fair, and this makes the portrait all the more deadly. It is a sad book. And it's very inexpertly written—rambling, misspelled, apparently unedited. This just makes it sadder.

WHAT do the Nijinskys mean to us today? Why should a publisher be interested in what Nijinsky's wife wrote to a Japanese actress ten years after his death? People are still worrying about why Shakespeare willed his wife his second-best bed, but Shakespeare left us a great many plays. Of Nijinsky we have only one twelve-minute ballet, *The Afternoon of a Faun*. Still, it is a great ballet—a watershed—and, together with Nijinsky's other, missing ballets, it influenced later choreographers, notably his sister, Bronislava Nijinska, whose reputation has had a tremendous reflowering in the past decade, and who claimed that everything she did came out of his work.

Beyond the question of his place in ballet's historical record, Nijinsky's life commands our attention by the sheer romantic force of its events. What a story this is! An awkward young boy who practically overnight becomes a world-famous dancer, then creates three ballets that change dance history, then jilts the world's foremost ballet impresario, switches sexual orientations, marries a groupie, and goes raving mad, not without leaving behind an account of his conversations with God and a thorough inventory of his sexual practices: no wonder Romola thought this should be made into a movie. (It was, after her death—Herbert Ross's dreadful 1980 *Nijinsky*.)

Whatever Nijinsky was in reality, he is by now a legend, a major cultural fact, and not just because of his extraordinary story but because of the way that story ties in with certain critical issues in ballet. Ballet's relationship to time—the fact that the repertory,

unanchored by text, is always vanishing, just as the dance image on the stage is always vanishing—forms a large part of the vividness and poignance of the art. We are always losing it, like life, and therefore we re-create it, mythologize it, in our minds. Nijinsky's life—his rapid self-extinction and the disappearance of his ballets—is like a parable of that truth. If dance is disappearance, he is the ultimate disappearing act. Accordingly, he is held that much dearer. If many people today still believe that he was the greatest dancer who has ever lived, that is partly because there are so few records of his dancing. Until recently, there were no known films of him. (Ostwald says that a short 1912 film of Nijinsky dancing in *The Afternoon of a Faun* was recently televised in Russia.)

His ballets have likewise been mythologized in their absence. Who can say whether *The Rite of Spring* was in fact the great modernist masterpiece that it is now claimed to be? Perhaps it was something more like the shaggy, dull, pseudo-folkloric thing that we saw in the Joffrey Ballet "reconstruction." Many of those who were disappointed by the Joffrey version simply concluded that its flatness was due to its having been put together from such scrappy evidence—in other words, that it wasn't really Nijinsky. But who knows?

Nijinsky's life also has something to say about the connection between ballet and sex. His self-absorption, his imprisonment within himself and his body, is an experience that many dancers must have in some measure, given that they are required from puberty to live wholly within the body—caring for it, training it, studying it in the mirror—and then, as adults, have to go out night after night in front of thousands of people and practice an art that, however scientifically codified, however painstakingly inculcated, nevertheless depends entirely on the body's energy, its beauty, its responsiveness, its capacity to create symbols, incite dreams: in other words, the very things that we bring with us to bed. This is not to suggest that dancers are particularly sexy people, or prone to mental illness. In my experience, they are patient, hardworking, exceedingly disciplined people who are more likely at the end of the day to go home and soak their feet in Epsom salt than to try to extend their sexual horizons. Nevertheless, they do

live within their bodies, and it is by their bodies' actions that we know them. On the stage, particularly when they are moving to music, they can seem to us a dream of the perfect physical life, in which the body is capable of saying all that needs to be said. If that is the dream, then Nijinsky's self-imprisonment can be seen as the nightmare, and his sexual obsessions as the bogeymen. Nijinsky eventually developed a horror of sex. (This is a constantly reiterated theme of the diary, and it is the reason he took up vegetarianism: meat was thought to incite lust.) After years of having his body gazed at and exclaimed over every night in the theater and discussed every morning in the paper, such a recoil is no surprise.

Furthermore, in Nijinsky's day the connection between ballet and sex was not just symbolic. Up through the early decades of this century, it was common in Russia and also in Western Europe for ballet dancers to supplement their incomes by informal concubinage. That was one of the reasons wealthy men went to the ballet—to pick out new mistresses or boyfriends. Nijinsky was picked out early—at eighteen, during his first year as a professional dancer—by a wealthy sports enthusiast, Prince Pavel Dmitrievtch Lvov, and, for a fee, one of Nijinsky's fellow-dancers made the appropriate introductions. While Nijinsky's mother had strenuously opposed any interest he took in girls—she was worried that marriage would get in the way of his career—she smiled on the wealthy and generous Lvov, and Nijinsky became his lover. Lvov soon tired of him and handed him over to various friends— Nijinsky in his diary recalls a "Polish count" who "bought me a piano" (that detail was left out by Romola)—until, finally, again through Lvov, the young dancer was introduced to Diaghilev.

Then, there is the matter of homosexuality and its connection to ballet. Nijinsky is often seen as a paradigm of the homosexual male dancer. Not only did he live openly with Diaghilev—they shared the same hotel rooms, they were invited to parties together, they were a "couple"—but onstage he was repeatedly shown in androgynous roles: the Specter of the Rose in the ballet of that name, the Golden Slave in *Scheherazade,* the "poet" in *Les Sylphides,* all creations of Michel Fokine, Diaghilev's first house choreographer. Nijinsky triumphed in these roles—he had a real gift

for them—and as they accumulated he became a kind of sacred figure of androgyny. If to many homosexuals ballet was (and is) a kind of enchanted world in which the mixing in one person of male and female, reviled elsewhere, could be shown and glorified, then he was the presiding genius of that realm. At the same time, all the evidence points to the fact that Nijinsky was not by inclination homosexual. For every homosexual contact that can be documented—Lvov, the Polish count, Diaghilev—a clear practical gain, usually a professional gain, was involved. ("I went in search of fortune," he says of his first rendezvous with Diaghilev.) In every contact where there is no apparent professional gain—Romola, the many prostitutes he chased while he was living with Diaghilev—his choice is a woman. This, in any case, is what one can deduce from the published diary, together with what Ostwald tells us of the unpublished version. And it is unlikely that between these two sources anything important is being left out. Considering that Nijinsky tells us about masturbating with dogs (as a child) and having incestuous thoughts about his infant daughter, he is probably not suppressing evidence of homosexuality. There is also the fact that once Nijinsky's roles were being made by himself, and not by Fokine, they were unequivocally masculine. In three of his four ballets Nijinsky created starring roles for himself, and in none of them was there any ambiguity about his sexual orientation.

Over the years, there has been some nasty quarrelling about Nijinsky's sexual identity, with certain homosexuals blaming Romola for causing his madness by trying to "turn" him (this, together with Romola's feelings about her own lesbianism, was probably the source of her notion that she and Nijinsky were being plotted against by a cabal of homosexuals) and some heterosexuals claiming that Diaghilev caused Nijinsky's madness by seducing him and then discarding him when he reverted to his true, heterosexual nature (this was the position taken by the Herbert Ross movie). But, self-serving as everyone around him was, Nijinsky's sexual compromise was his own choice, and it is one that many young men have made with no unhappy consequences, let alone madness. Which is not to say that in his case it wasn't psychologically damaging.

Nijinsky taps into a final myth, that of the genius-madman. He was tagged with this label long before he went mad, just on the basis of the contrast between his onstage mastery and his off-stage ineptitude. Diaghilev's friend Misia Sert called Nijinsky an "idiot of genius." And after he went insane the formula was pumped for all it was worth. Some writers described him as a kind of Russian *yurodivy,* or "holy fool," a man who, like Dostoevsky's Prince Myshkin, was incompetent in life because his vision of divine truth was too clear. Others invoked the moth-to-the-flame metaphor: Nijinsky was a man who tested the limits—in dancing, in choreography, in sex—and paid the price; he went farther out on the limb than the rest of us, and fell off; he died for our sins. The shadow of Christ—and of van Gogh, that modern avatar of Christ—hovers at the edge of all these images. As with van Gogh, the metaphor is reflexive: he went mad because he was a great artist, and he was a great artist because he went mad.

The realities of Nijinsky's insanity make these romantic notions seem less inviting. The helpless little man whom Ostwald describes, falling asleep with his face in his food dish, is hard to square with the Promethean image of the genius-madman. And Nijinsky was a strange person long before he tested any limits. The peculiarities that he showed in his late twenties, when he did things like walking offstage in the middle of a performance, are generally interpreted by later commentators as evidence that he was going mad under the pressure of events. But, as Ostwald managed to discover somewhere in the depths of a Russian archive, Nijinsky was doing exactly the same thing at eighteen: "During a performance of *Swan Lake* on 25 November 1907, he became so flustered that he stopped dancing his variation of the pas de trois in the first act and began taking his bows while the orchestra was still playing." Nobody called him a mad genius then. He got an official rebuke from the director of the theater. Though Ostwald cannot, and does not, say for certain that Nijinsky's illness was biologically based, he produces plentiful evidence that the dancer was unstable from childhood. (Robert Craft has written that Stravinsky had some information about "Nijinsky's hereditary syphilis," but Ostwald says syphilis was ruled out by repeated hospital tests.)

Still, it is possible that there was some connection between Nijinsky's insanity and what was apparently his genius, particularly as a choreographer. Great leaps of thought may occur more easily in a brain that has some neurological idiosyncrasy. What did it take to imagine, as Einstein did, that matter and energy were convertible into each other? What did it take for a twenty-two-year-old who had never before made a professional ballet to imagine that his meanings should be conveyed not by the methods in which he had been trained since childhood—dancing to the music, producing the rounded, three-dimensional shapes of academic ballet—but by having the dancers move "through" the music in flattened profile, gliding in lateral lines, like ducks in a shooting gallery? Presumably, modernism had to hit ballet eventually, but it is strange that the medium was an artist who—unlike Stravinsky or Picasso, for example—never went through a conservative apprenticeship, never had an "early period," in which he mastered the style of his teachers before discarding it. In one stroke, his first stroke, he threw away the very grounds of his prior experience, the grounds of his thought. To do such a thing, an unusual neurological hookup is perhaps not required, but it might help. Whatever it took, that was the basis on which Nijinsky constructed *The Afternoon of a Faun.* And today, after what is probably considerable erosion of its original choreography, the ballet still carries a huge force: its rigors, its analytic coldness, its sheer, unromantic wit, perfectly poised against the warm upwelling of its meaning—the summer afternoon, the naked nymph, the faun's sudden knowledge of sex. If this is all we have left by way of art to anchor Nijinsky's legend, it is enough.

The New Yorker, 1992

Postscript: This essay was written before I saw the unedited text of Nijinsky's diary. The Nijinsky family sold the manuscript in 1979, but they retained the copyright, and it was widely assumed that

the original diary would never be published, because of the "sensitive" (that is, sexual, or demented) nature of the material. Then, in 1993, Tamara Nijinsky released the copyright to the French publisher Actes Sud, and in 1995 that firm brought out the first unexpurgated edition of the diary, entitled *Cahiers: Le Sentiment* (Notebooks: Feeling) and translated from the Russian by Christian Dumais-Lvowski and Galina Pogojeva. The American edition, *The Diary of Vaslav Nijinsky,* translated from the Russian by Kyril FitzLyon and edited by me, was published in 1999. This book clears up a few mysteries. The "Dr. Greiber" with whom Romola apparently had an affair while Nijinsky was going insane was Hans Kurt Frenkel, who worked as a specialist in sports injuries at one of St. Moritz's resort hotels. But contrary to what Peter Ostwald speculated in his biography, it is not at all clear that Nijinsky understood that Romola was sexually involved with Frenkel; indeed, the diary strongly suggests that he did not know. I have asked several people in the Russian ballet world about Ostwald's report that a film of Nijinsky dancing *The Afternoon of a Faun* may have been shown on Russian television. No one can remember such a telecast. Kyra Nijinsky, who had a psychiatric disorder that she may have inherited from her father, died in 1998.

George Balanchine (left) and Lincoln Kirstein, 1953

Heroes and Hero Worship

ONE day in 1929, in a coincidence that he later took as a sign, the young Lincoln Kirstein walked into a church in Venice and stumbled on Serge Diaghilev's funeral. Diaghilev had rescued Western ballet from near-extinction; without him, as Kirstein understood, the future of the art was in doubt. "It is hard to convey the feeling of loss one has, having seen [ballet], fearing never to see it again," he wrote in 1930. "It is exactly the same as if one were deprived of a literature, a whole language of expression; for instance to wake up one morning and know one could never read Tolstoy or Proust or Shakespeare again."

Three years later, Kirstein, age twenty-six, went to Paris and persuaded George Balanchine, the last and best of Diaghilev's choreographers, to come to the United States with the goal of starting a ballet company. In 1934 the two men opened the School of American Ballet in New York; the following year they inaugurated the first of several companies that were to culminate, in 1948, in the New York City Ballet. The rest of the story is well known. Through the medium of Balanchine's choreography and teaching, ballet in the next few decades became a modernist art, and NYCB the hub of Western ballet. If Diaghilev had once saved ballet, Kirstein and Balanchine saved it again, and as with Diaghilev, their doing so affected not just dance but art in general, and history, and urban life. Part of what made New York such a nice place to live in the fifties through seventies was that at eight o'clock the curtain rose on New York City Ballet.

For about seventy years now, Kirstein has been writing—books, program and catalogue essays, article after article, on painting, sculpture, architecture, photography, film, literature,

history, politics. He has also published two novels and several books of poetry. In 1978, Yale University Library brought out a list of his publications, cautiously entitled *Lincoln Kirstein: A First Bibliography.* It runs to 150 pages. But for anyone involved in ballet, the most important part of Kirstein's bibliography will always be his dance writings. Dance critics tend to be autodidacts, for until recently there were almost no university programs in the history of dance. Art critics, music critics, are trained to do what they do; most dance critics, myself included, are people who were doing something else altogether when one day they fell in love with dance and realized that, if they were going to write about it, they had much to learn, fast. Wherever we turned, Kirstein had been there first, and laid out what was needed. A company to watch? New York City Ballet—Lincoln Kirstein, general director. A school where we could observe classes? The School of American Ballet—Lincoln Kirstein, president. A research library? In 1940 Kirstein donated his collection of over 5,000 books and documents on dance to the Museum of Modern Art; this material was later transferred to the New York Public Library, where it became one of the pillars of the Dance Collection, now the largest dance research library in the world.

Could we use a good journal on dance? In 1942, Kirstein co-founded *Dance Index,* which ran for seven years, publishing pioneering articles on Jules Perrot, Marius Petipa, Stravinsky, Nijinsky, Balinese dance, Haitian dance, dance notation, dance lithographs, dance films. Did we need, in addition, a history of dance? Kirstein's *Dance: A Short History of Classic Theatrical Dancing,* written when he was twenty-eight, is still definitive. A book on ballet technique? *The Classic Ballet* (1952), by Kirstein and Muriel Stuart. This is not to mention the checks he wrote, the calls he made, the people he bullied and cajoled. I remember, about eight years ago, being told that the decades-long campaign to build a dormitory for the School of American Ballet students, so that they wouldn't have to be boarded out at people's houses, was finally getting off the ground. A million dollars had already been raised, from one check: Kirstein's. Other checks soon followed.

WHEN Kirstein went on his fateful trip to Paris in 1933, he was looking not just for a choreographer but for assurance that ballet was something solid and real—in other words, that he wasn't crazy to think of transplanting it to America. Ballets existed, but did Ballet exist? Was it a genuine art, with its own history and tradition? In the libraries of Paris, he found the history. Balanchine, too, told him, he says, that "the classic dance was a concrete entity, almost a three-dimensional structure." But such a structure, as they both knew, did not exist in the United States. That it does now, and that twelve years after Balanchine's death, with few, if any, interesting ballet choreographers in view, the structure is still in place, with over two hundred companies across the country, working away faithfully, is due in large measure to Kirstein.

Kirstein made history, and as his recent memoir, *Mosaic,* makes clear, he thinks he was destined to. Like many ballet people, he is a believer in signs. The fire engine that roared, scarlet and gold, past his house when he was a boy; his father's "Antonio y Cleopatra" cigar box, "embossed with tragedians framed in a red-and-gold proscenium arch"; a childhood visit to the Bayreuth Festival—"all were signposts," he says, pointing him toward the theater. *Mosaic* cuts off in 1933, long before New York City Ballet was founded, but the last sentence shows Kirstein taking off to meet with Balanchine and close the deal that will bring the choreographer to America. The book ends not with a period but with ellipses.

So NYCB runs through this book like an underground river, waiting to find its outlet, but there were tributaries, ideas that grew in Kirstein's mind, determining not just his turn toward ballet, but the whole trend of his thought. What produced these ideas? he asks. His childhood home, for one thing. Lincoln Edward Kirstein, named for his father's hero, Abraham Lincoln, was born in Rochester, New York, in 1907, the second child of a prosperous German-Jewish family that grew far more prosperous when in 1911 they moved to Boston and Mr. Kirstein became a partner in Filene's department store. They installed themselves in

a furnished mansion rented from a man with elaborate tastes. Kirstein lovingly retraces his steps through the house: the Napoleonic entrance hall, hung with green silk; the copies of Velázquez and Titian on the stairs and landing; the electrotypes of Roman statuary in the living room: The Boy Removing a Thorn, The Dancing Faun. Then there were the additions his mother made to the house, such as her "Chinese bedroom," papered in gold and upholstered in scarlet, with pillows covered in fabrics cut from eighteenth-century Chinese court robes. The family also had a set of Tiffany's "mythological" dinner service: "knives, forks, slim pincers for cracking lobster claws, coral-handled toothpicks, scimitars for roasts, small shovels, and sauce spoons—each was smartly modeled with a classical deity."

For the infant Kirstein, this house was a fairyland, a forest of symbols, and it helped to lay the ground for his aesthetic principles. First, the importance of tradition, of history. Time and again in his writings Kirstein has stressed "apostolic succession," the passing down of an art from hand to hand. This concern was certainly one of the factors that predisposed him toward ballet; because it has no recorded text, ballet is more hand-to-hand than any other art. In any case, the objects that cluttered his childhood home, from the Roman statues to the Tiffany flatware, were his first history lesson. A second principle was what he would later call "digital mastery." There is hardly a single piece of writing by Kirstein on the visual arts that does not celebrate technical skill. This, again, was surely one of the things that drew him toward ballet. Any art that requires its practitioners, throughout their careers, to go back to class for an hour and a half every morning is to him a serious endeavor. In the visual arts, technical accomplishment became, perhaps, his primary criterion of excellence—the grounds of his rejection of Abstract Expressionism ("slack improvisations of doodle and trash"), the basis for his love of nineteenth-century painting and its twentieth-century inheritors.

EVENTUALLY these principles became matters not just of art but of morality. They tied the artist to reality, and for Kirstein as for Ruskin, whom he took as an oracle when he was young, that tie

was the measure of art's truth. Apart from tradition and craft, the main theme of his writings is his distrust of the "self." The year after Balanchine's death Kirstein published an impassioned essay, "A Ballet Master's Belief," on the relation between Balanchine's work and his religious faith. In the iconography of the Russian Orthodox church, he points out, Lucifer, the Prince of Darkness, is not the hairy, brown devil that he is to the Western church. He looks exactly like the other angels—gold robes, nice wings—but for one difference. His face, hands, and feet are black. His sin, then, is lack of transparency: "willful incapacity to admit the difference between light and darkness, obsessive preference for personal difference." It is that sin, Kirstein says, that distinguishes twentieth-century modern dance from its older sister, ballet: the modern dancers' repudiation of history, their insistence on creating, each dancer for herself, a new style—in other words, their enclosure in the self. Twentieth-century painting, he feels, shows the same failing: "a coarse, permissive, idiosyncratic expressionism, rooted in self-pity and ostentation."

What these artists turned their backs on, however, was not just tradition but the thing the tradition had evolved to represent: the world. Modern painting's desertion of representation was a personal grief to Kirstein. He got over it by turning to arts that kept the faith: drawing, so closely tied to the human figure; photography, with its documentary truth; above all, ballet, with its unadorned human bodies, moving in three dimensions. "At [this] moment," he wrote in *The Classic Ballet*, "when representational art has declined into subjective expressionism, and its chief former subject, the human body in space, has been atomized into rhetorical calligraphy, the academic dance is a fortress of its familiar if forgotten dignity. To it future painters and sculptors may one day return for instruction in its wide plastic use." So ballet is reality's government in exile.

These have been his principles, not widely different from the views of other thinking people who grew up in the classicist twenties. What made Kirstein different was his commitment to action, his sense that he could actually change the direction of the arts. In part, this faith was bred in him by his father. Mr. Kirstein was part of a generation of Jews who, however wealthy and assimilated and

public-spirited they might be (Mr. Kirstein was not just a partner in Filene's but also the president of the Boston Public Library), were still regarded as people in "trade." Therefore when his son turned out to have no head for business but a thousand ideas about art, Mr. Kirstein was quite willing to encourage him. As Kirstein put it in a 1986 interview with *The New Yorker,* "My father gave me the idea that . . . *anything* could be possible for me." To make things more possible, Mr. Kirstein settled on Lincoln a sizable fortune when the latter was still in his twenties.

As early as 1933, when he was twenty-six, Kirstein wrote to his friend Allen Tate: "I am trying to jockey myself into a position where eventually I can act as I like in relation to the employment . . . of artists in this country." Actually, he had begun the jockeying long before. While still an undergraduate at Harvard, he had cofounded the literary quarterly *Hound & Horn* as well as the Harvard Society for Contemporary Art. Through them he made good connections, which he soon parlayed into further connections. In some cases, he was lucky. For example, his sister, Mina, twelve years older than he, lived and wrote in London on the fringes of Bloomsbury, with the result that Kirstein, at age fifteen, was being taken around Cézanne exhibits by John Maynard Keynes. But most of the work he did on his own, just by putting himself in the right place and being smart, genial, attractive, and rich. When he came to New York after Harvard, he installed himself in the parlor of the writer/*salonneuse* Muriel Draper, who introduced him to an intellectual "high low-life"—Carl Van Vechten, Edmund Wilson, assorted jazz singers and Communists—that after the thin, upper-class air of Boston and Cambridge he longed to descend to. In Paris, Virgil Thomson, who knew everyone, took him in hand and brought him to the artists he wanted to meet. Later, through his connections at the Museum of Modern Art, he made friends with its patron Nelson Rockefeller and thus became one of the planners of the Rockefeller Center decorations. Rockefeller inspired him, he says: "He always talked about buildings as if they were built."

Minor scruples did not deter him. One small example: he not only collaborated (anonymously) with Romola Nijinsky on her 1933 biography of her husband; he also reviewed it, in *The Nation.* "Remarkable," he called it. Romola, a notorious liar and opportunist, is one of the people he credits most gratefully for showing him how to get by in the world—how to make snap judgments, improvise, dominate. These, he says, are essential skills for anyone who wants to work in the theater. Diaghilev had been a master of them, and at Romola's knee, Kirstein imagined himself becoming "a veteran of Diaghilev's household."

IF Diaghilev was one influence, another was the Armenian spiritualist G. I. Gurdjieff, whose school, the so-called Institute for the Harmonious Development of Man in Fontainebleau, Kirstein visited in 1927, when he was twenty. To this day, Kirstein sees his meeting with Gurdjieff as the decisive event in his life: "He exerted more influence on my behavior than anyone, including my parents." Gurdjieff, he claims, was a "magician," and he means this literally. For years, even after Gurdjieff's death in 1945, he refrained from writing about him. "If I wrong him, I am afraid of his ghost beyond the grave," he wrote in 1983. Even now, he says in *Mosaic,* he feels a "paralyzing inadequacy" in trying to put down his thoughts about "Mr. Gurdjieff."

Yet strange to say, the memoir offers a hilarious account of their encounter, with Kirstein cast as Candide and Gurdjieff as a sort of crafty Armenian troll. Taken to the Institute by his friend Payson Loomis, who had fallen under Gurdjieff's spell and was working as his secretary (Loomis later transferred his discipleship to Norman Vincent Peale), Kirstein spent a day watching Gurdjieff's students dance, dig holes, and perform other improving exercises. Come nightfall, there was a community banquet, featuring hors d'oeuvres that looked to Kirstein's astonished eyes like "bits of boiled tarpaulin, wax flowers, clippings of sponge or rubber," and, for the main course, a grisly-looking roast lamb, of which Gurdjieff, with the air of conferring a great honor, made Kirstein eat the charred eyeballs. The master then got Kirstein

very drunk. The next day, before leaving, Kirstein went to thank Gurdjieff for his hospitality. In *Mosaic* their parting conversation is reproduced as a dialogue. It begins with Kirstein saying he has to hurry away because he has an appointment in Paris with Ezra Pound, "a very great poet."

> G. What kind poem he write?
> K. He writes *every* kind.
> G. Every kind. He write sex-poems?
> K. Sex-poems?
> G. No. I mean fuck-poems.
> K. No, Mr. Gurdjieff. It is Ezra Pound. He also writes wonderful translations. He has taught me a lot. . . .
> G. Yes, I know Ezra Pound very well—for long time. He likes my soup.
> K. (*incredulous*) He likes your soup?
> G. Very much he like my soup. . . . You know what Ezra Pound call my soup?
> K. Not *really* . . .
> G. You know painting?
> K. (*modestly*) A little bit.
> G. You know Rembrandt?
> K. Of course.
> G. Of course. You know Piero della Francesca?
> K. (*back on his heels*) Yes, certainly . . .
> G. Ezra Pound say my Persian-melon soup . . . is clean like Piero della Francesca, compare to shit-color Rembrandt. Now, what you want?
> K. (*silenced*)
> G. Mister, I tell you what you want. You want pay me.

Gurdjieff then cleaned out his new disciple's wallet and, having extended the conversation long enough to make him late for his train, sent him on his way.

But the comedy lasts only as long as Kirstein's description of his day at the school. When he goes on to address the guru's teach-

ings, the "paralyzing inadequacy" sets in, and the account becomes vague. This is true, in fact, of all the statements Kirstein has made in print on the subject of Gurdjieff. It is impossible to tell whether Kirstein ever spent more than one day at the school. (He mentions later contacts with Gurdjieff, but he never says what they were.) As for Gurdjieff's philosophy of life and its effect on him, all he is able to say is very general. Yet it is clear that Gurdjieff reinforced the sense of "possibility" that Kirstein's father had inculcated in him. Gurdjieff believed that most human beings sleepwalked through life, never taking willed action, never developing their "potential." To counter such inertia, one had to identify one's goals and then act on them. In his 1986 interview with *The New Yorker* Kirstein said that he learned from Gurdjieff

> the idea of behaving as if something were true even if it wasn't, and using as a kind of target or magnet a notion that if you could imagine a situation *as if* it were true, *as if* we had a theatre, *as if* there were a ballet company, . . . it became more and more precise.

In that interview and again in *Mosaic* he sketches in some of the rules that Gurdjieff taught in support of the "as if" principle: one should question oneself constantly; one should push toward "extreme situations," situations involving risk and even pain; one should recognize and embrace suffering, since it is necessary for growth.

Some of this sounds like est or any of the other yes-you-can therapies that multiplied across the United States in the sixties and seventies, and as with those therapies, or any therapy, it is possible that the conversion had less to do with the exact nature of the teaching than with the age and state of mind of the pupil. "I met [Gurdjieff] at a peak of disorientation," Kirstein writes, "when many choices appeared open, while none commanded. By his canny proposals I felt released." In other words, Gurdjieff liberated him into action. It may also have helped that the "exercises" at the school involved dancing; this probably seemed to him another sign. When Kirstein met Gurdjieff, he was already fascinated by ballet. Six years later, Balanchine's boat docked in New

York harbor, and Kirstein's life changed permanently. When something like that happens to us, we like to assign a cause, and Gurdjieff is Kirstein's cause. In his writings on dance he has often described ballet as an "extreme" situation. Ballet dancers, he says, are "committed to hazard." In other words, they are good Gurdjieffians.

MORE important historically than Kirstein's link to Gurdjieff was his encounter with Balanchine. In what is already the golden legend of Kirstein and Balanchine, one of the best-loved miracles is that Kirstein, on his trip to Paris in 1933, had the foresight to hire Balanchine, who at that point was far less respected than others of Diaghilev's ex-choreographers—for example, Léonide Massine. Therefore it came as an unpleasant surprise when Richard Buckle, in his 1988 biography of Balanchine, claimed that Kirstein might actually have preferred Massine. Using what seems to have been the manuscript version of Kirstein's 1933 diary—Kirstein, who in 1973 published an edited version of the diary, apparently let Buckle consult the original—Buckle quoted the young Kirstein praising Massine rapturously, Balanchine far more reservedly, and agreeing with someone that "Balanchine was much less serious than Massine." "If Kirstein had had unlimited means," Buckle concluded, "he might well have decided that Massine was the right man."

To believe that, one would have to see the rest of the original diary. Already three years earlier, in a 1930 essay on the Diaghilev company for *Hound & Horn,* Kirstein had characterized Massine as "the first of the 'clever' choreographers"—those responsible for plunging the Ballets Russes of the early twenties into a sort of empty chic—and described Balanchine as leading ballet out of that dry zone "into a revivified, purer, cleaner classicism." Furthermore, if Kirstein, during his stay in Paris, suffered some bewilderment over what he should do, this is no surprise, considering the state of the European ballet world at that time, with rival companies, each led by ex-Diaghilevians, competing ferociously for Diaghilev's audience. Heading the recently formed Ballets

Russes de Monte-Carlo was Massine. Directing the august Paris Opera Ballet was Serge Lifar, Diaghilev's former boyfriend (as was Massine) and a fledgling choreographer. Meanwhile, all Balanchine had was the post of choreographer at a one-year enterprise, Les Ballets 1933, that a rich Englishman, Edward James, had put together in order to provide a showcase for—and thereby prop up his failing marriage to—the Austrian dancer/actress Tilly Losch.

Furthermore, Balanchine was ill; he had had tuberculosis since his teens, and one of his lungs was collapsed. As Kirstein went around Paris, calling on various people connected with the ballet, most of them warned him off Balanchine. Christian Bérard, who was working with Balanchine at Les Ballets 1933, said that he was "entirely mysterious, invisible offstage, . . . slightly mad; really cares nothing for the ballet; is only interested in playing the piano." Pavel Tchelitchev told Kirstein to forget the whole ballet thing: "Toe dancing was finished." Tamara Toumanova's mother told him that Balanchine was finished; he would be dead in two years. Romola Nijinsky said the same thing—her trance-medium had told her.

Kirstein, as he relates in the published version of his 1933 diary (the source of the above quotations), wandered around Paris in deep confusion, waiting for a sign from heaven. Instead he got a sign from Balanchine, to whom he was finally introduced. Balanchine had no prospects in Europe; when Kirstein mentioned the American project, Balanchine said he was willing. The deal was concluded in a matter of weeks. So the two men did not speed across the globe to each other; they stumbled toward each other, both probably wishing they had better prospects.

IT is possible, however, that for Kirstein in 1933 the choice of which choreographer was not as crucial as it seems to us today. Our notion of a choreographer as sole creator of a dance show, sole leader of a dance company, is based on a phenomenon that occurred later, the rise of the great midcentury American choreographers: Martha Graham, Merce Cunningham, and, above all, Balanchine. The kind of position that Balanchine eventually

carved out for himself—total control, artistic and otherwise, over a company of a hundred dancers that was not a government institution, not a state opera house—such power had never been achieved before in the history of dance, and it gave the word "choreographer" new meaning. In the twenties and thirties, the situation was different. Diaghilev bought and sold choreographers. Indeed, if he had to, he did without a choreographer, or a good one. His idea of ballet was always the Wagnerian *Gesamtkunstwerk,* a total-art show in which choreography was no more important, and often less, than libretto, score, and décor.

This is the kind of ballet on which Kirstein was raised, and which he intended to produce. His décors would be by "independent easel painters"; his ballets would have strong, exciting libretti, about American life. In a 1933 letter to his friend A. Everett Austin—a letter pleading for the funds to bring Balanchine over—he outlined the productions he was considering: *Pocahontas, Uncle Tom's Cabin, Moby-Dick, Custer's Last Stand.* The last, he wrote, would be "after Currier and Ives, [with] the circling Indians; corps de ballet shooting at the chief dancers in the center. Ponies."

Today, the idea of Balanchine's creating such ballets seems absurd. It did not then. Both with the Diaghilev company and with Les Ballets 1933, Balanchine was accustomed to being handed detailed libretti, and he probably listened patiently to this enthusiastic American, with his ponies. Since his teens, however, Balanchine had been working toward a new type of ballet: no libretto, no set, just music and dancing. That type of ballet he eventually established as the norm at New York City Ballet—indeed, in the United States—but it was not what Kirstein expected or, in the beginning, wanted, and the transition was no doubt rocky. An example is the well-known story of the costumes for the 1946 *Four Temperaments.* The designer was the surrealist painter Kurt Seligmann, and the costumes he delivered were surrealist indeed. "I had a boulder on my head—a blob," recalled NYCB dancer Francisco Moncion, who was part of the original cast. The costume for "Melancholic," Moncion said, looked like an Eskimo Pie. Other dancers wore blinkers, tubes, bandages. At

the dress rehearsal, Balanchine took one look at these outfits, called for a pair of scissors, and began cutting things off. One wonders what Kirstein thought as he watched the surgery take place. (It was his friend Tchelitchev who had suggested Seligmann.) Soon afterward, *The Four Temperaments* was recostumed in leotards, and from then on many of Balanchine's ballets were dressed only in leotards or plain tunics. Very few had libretti.

In truth, the two men who together founded New York City Ballet had very different notions of dance. Balanchine took his inspiration from music; Kirstein cared little about music. Balanchine's idea of ballet was lyrical and visionary; Kirstein's was visual and narrative. (Once, Kirstein recalls, he invited Balanchine to go to a museum. "No, thanks," Balanchine replied. "I've been to a museum.") As Balanchine went ahead with his idea, Kirstein was able to participate less and less in the making of the ballets. Soon, as he put it bluntly in his *New Yorker* interview, "There was nothing except what [George] wished."

WHAT Kirstein did then was to manage the institution of New York City Ballet, which, together with his other services to the field—writing, editing, fund-raising, directing the School of American Ballet, helping regional companies—meant that in large measure he managed the institution of ballet in America. Furthermore, in his writing he explicated and celebrated Balanchine's vision, the vision that had supplanted his own. The primary job of dance critics in this century has been to show how "pure dance" nevertheless has meaning, how it does tell a story, but in a different way. Kirstein, partly perhaps because he had to explain this matter to himself, was in a good position to explain it to others. "The subject of Balanchine's ballets," he wrote in 1952 in *The Classic Ballet,*

> apart from love (of music, of the human body, of human beings), is the physical act or presence of the dance itself. . . . But he has also defined an intensely personal manner. . . . His unmistakable signature is in his masterful

designs for tenderness, regret of loss, mystery, exuberance, and human consideration.

Nor was Balanchine the only beneficiary of Kirstein's acquired wisdom. Perhaps his finest book was the 1975 *Nijinsky Dancing,* a study of how that unlucky genius evolved, from movement alone, metaphors for the profoundest human truths. Kirstein may have hated abstraction in painting, but he learned to love it in dance. He crossed a bridge, and that, not the crapshoot in Paris, is the miracle of the Kirstein/Balanchine story. If, in his writings, Kirstein stresses selflessness, he has earned the right.

Not all of this is in *Mosaic*—as I said, the book ends in 1933— but it is there in the mind of the aging man meditating on his youth. Unlike some of Kirstein's earlier memoirs, *Mosaic* also includes a good deal of intimate material, particularly on the stage of his life, just after his graduation from college, when he tried to shed his Harvard manners by plunging into New York's low life— dressing at the Army Navy store, taking boxing lessons, falling in love with sailors. There is a long chapter on his love affair with a seaman—Carl Carlsen, who wanted to write short stories for *Hound & Horn*—and his dream of shipping out with him. ("I would teach Carl how to write, while he taught me how to live"— a familiar fantasy.) The Carlsen chapter is touching, but Kirstein's orotund style, eloquent in other contexts, is ill-suited to tender matters. Perhaps sensing this, he now and then takes his prose to the Army Navy store, but when he does so, the results are often unsuccessful. (On an ex-jockey who worked briefly for *Hound & Horn:* "He had a tight little ass, a svelte manner, and was eager to sweat for a dingbat organ named *Hound & Horn.*") This mix of high and low is part of him, however, and a large part of what made him successful. Lofty visions, practical dealings: that's how he got so much done.

THE postmortem books on the Balanchine/Kirstein enterprise are now coming out. By far the most searching of them is the new *Following Balanchine* by Robert Garis, who spent his career as an

English professor at Wellesley. Garis grew up in Allentown, Pennsylvania, the child of seriously Baptist parents. "Do you really, really feel Jesus in your heart?" his father would ask him. Curiously, Garis came to apply this question to his experience of dance. He saw his first Balanchine ballet in 1945. Thereafter, he tracked Balanchine's work year by year, for forty years, always asking himself, what did he really, really feel about these ballets? Soon to his self-questioning he added a method, learned from the famously argumentative music critic B. H. Haggin, who became his mentor and friend. Haggin's way of appraising a piece of music was to treat it as if it were a series of choices on the part of the composer, "as if one were following a mind thinking." Garis adopted the same method; hence the highly unusual approach of his book. It is a study of Balanchine's work, but by way of studying the processes of Garis's mind—the promptings, the doubts, the sudden flashes of vision—as he examines what he takes to be the processes of Balanchine's mind.

Garis is at his best when he feels that Balanchine has posed him a question—in other words, made a choice that Garis doesn't understand. One such question had to do with Balanchine's hiring of Violette Verdy in 1958. This French ballerina, though a superb classical dancer, seemed the very antithesis of the kind of objectivity, or freedom from stage manner, that Balanchine was inculcating in his troupe at that time. She punctuated points; she *communicated* with the audience; she poured on the charm. Such demonstrativeness was typical of European ballet, but how was Balanchine going to incorporate it into the purer, cleaner style—what he saw as an American style—that he was then developing?

For the better part of a chapter, Garis meditates on Verdy's way of performing and its divergence from the NYCB norm. Her musicality, for example:

> She demonstrated what she was doing by unusually explicit . . . inflections—of rubato, of attack and emphasis, and of other ways of articulating the events in a dance structure. She led your eye along the curve in which the musical energy was propelling the dancing, she showed

you the distinct episodes happening along that curve—where the middle was, when the finale was coming.

In doing so, she gave the dances a unique urgency:

> There is a special drama . . . created when one becomes aware of a sense of motive *in itself,* which has the effect, almost, of *naming* it—when, for instance, to one's awareness of the inventiveness with which Balanchine brings the ballerina on the stage in the first movement of *Symphony in C,* Verdy's inflection added a slight pressure that let one consciously and pleasurably name the event one was watching: "the ballerina's entrance."

As for how Balanchine was going to use all this explicitness, the answer, of course, is that he molded it for his purposes. More important than the answer is the question, for it sends Garis deep into his viewing experience, and the ideas he surfaces with—the curve of the musical energy, the implicit drama of an entrance—are matters that lie at the very heart of dance.

ANOTHER question that Garis asks himself concerns Balanchine's collaboration with Stravinsky, a coming together that produced several masterpieces—*Apollo, Agon, Symphony in Three Movements*—together with *Jeu de cartes, Le Baiser de la fée, Danses concertantes, Orpheus, Firebird, Stravinsky Violin Concerto, Movements for Piano and Orchestra,* and many other ballets. One of the foremost pieties of the NYCB legend is that the relationship between Balanchine and Stravinsky was uniquely warm and trusting, with the two Russian exiles—arguably the two greatest artists of the twentieth century—sitting around drinking vodka and plotting ballets that would rock the world. The story is the more appealing in that it gives us a young Balanchine. He was twenty-two years Stravinsky's junior, and he learned a great deal from the composer, as he acknowledged. Indeed, by his account, it was under the influence of a Stravinsky score, *Apollo,* that he achieved his artistic maturity. In his words, that highly disciplined score "seemed to

tell me that I could dare not to use everything, that I too could eliminate." This, he said, was a turning point in his life. So Stravinsky and Balanchine were, in a way, father and son—a nice story.

According to Garis, however, it may have been a father–son relationship of a different sort. Characteristically, he begins with a question about Balanchine's "choices." If the collaboration was so smooth, why did Balanchine drop from repertory so many of his Stravinsky ballets: *Jeu de cartes, Danses concertantes, Le Baiser de la fée*? And why did he ruin others, in later years, by way of revising them? Why did he "trash" the beautiful pas de deux of his 1949 *Firebird*? Why did he lop off the prologue to *Apollo* and also change the finale, deleting its tragic note? From these decisions of Balanchine's, together with Stravinsky's statements about Balanchine's work, Garis develops a theory that the relationship between the two men was very tense, with Stravinsky insisting that the job of a choreographer was simply to reflect what was already in the score—as if, Garis suggests, the composer were to say, "Here, have that danced, please"—and Balanchine fighting for the right to create something of his own, not independent of, but still other than, the music. Garis describes a photograph of the two men during the 1937 *Jeu de cartes* rehearsals. In it, he says, Stravinsky dominates:

> He is leaning forward impatiently with his hands clasped in front of him, looking like an irritable French millionaire whose time is worth a lot of money. Balanchine, close to the camera and eyeing it uneasily, nervous at the thought that this moment is being recorded, looks affectingly young and tense and powerless.

(I wish the book had reproduced this photo, but it includes another one, undated, that seems to show the same thing. It is painful to look at.) In *Jeu de cartes* Balanchine let Stravinsky have his way; the composer vetoed whole sections of the choreography. Later, Balanchine fought harder for his autonomy and also, as Garis sees it, now and then turned with vengeance on ballets that reminded him of how that autonomy had been threatened.

THE story has a quasi-happy ending. In his remarks on the 1963 *Movements for Piano and Orchestra,* Stravinsky seemed at last to acknowledge Balanchine's independent genius: "The choreography emphasizes relationships of which I had hardly been aware . . . and the performance was like a tour of a building for which I had drawn the plans but never explored the result." This is only a partial acknowledgment, however—he still sees himself as the architect of the ballet—and, if Garis is right, it did not heal the wound. It didn't prevent Balanchine, twelve years later (and seven years after Stravinsky's death), from decapitating *Apollo.*

The account sounds true. It may also have a special meaning for Garis. For years, as he relates in *Following Balanchine,* he was deeply under the sway of B. H. Haggin, a man who, if possible, was more insistent on his authority than Stravinsky. "I was accustomed," Garis writes, "to believing without rancor that whatever he liked I would eventually come to like." If he felt there was a ballet on which they would not see eye to eye, he stayed away from it, for disagreeing with Haggin was "a task of considerable anxiety." In the late sixties, after twenty-five years of friendship, he finally quarreled with Haggin, and they never spoke again.

If the Stravinsky chapter is tinged with personal feeling, the rest of the book tells us much more about Garis's personality: his obsessiveness about NYCB, his competitiveness with other critics, his admittedly eccentric notion—the fruit of his "choice"-tracking—that he was actually collaborating with Balanchine. Such subjectivity is not rare among ballet fans, however. Also, because Garis is so intent on his own responses, he is candid about them. He confesses unfashionable sentiments, for example, that Balanchine's hard-edged "leotard" ballets, then as now the highbrow choice, were the ones that interested him the least. And when he missed the point of something crucial—for example, when he failed to take the measure of Tanaquil LeClercq's genius before her career was ended by polio—he admits this. If he didn't feel Jesus in his heart, he doesn't say he did. Most important, his personal emphasis never enfeebles his dance criticism. He is able to write about the drama

of the ballets with clarity and yet never violate the essential ambiguity of that drama.

Garis was part of a particular group of well-read, articulate people, many of them artists and writers, who gathered around Balanchine's enterprise in the fifties, sixties, and seventies, and he tells us something about this crowd: how they conducted their friendships at the ballet, how they huddled together at intermission, comparing their responses and arguing over the respective merits of this and that dancer. My one complaint about the book is that it doesn't offer more of this material. Garis gives us only glancing portraits, often uncomplimentary, of a few of the principals: the much-revered dance critic and poet Edwin Denby, whom he portrays as an oblique and calculating man; Haggin, with his dogmatism and his bullying. He also touches on Kirstein, whom he seems to have regarded as little more than the company's PR man, though he adds that in this view he may have been influenced by Haggin. (Kirstein had apparently interfered with some copy that Haggin submitted to *Hound & Horn*. He was thereby placed, for ever after, on Haggin's long enemies list.)

But Garis's brevity on the subject of the goings-on around the company is part of his empiricism, his determination to tell us only what he himself experienced, and in sticking to that subject, he has given us something invaluable. As art-producing organizations go, New York City Ballet was highly unusual. For a large portion of the audience, it was not just a ballet company; it was a central event in their lives. Garis was one of those people, and though the inwardness of his book is unique in writings on Balanchine—indeed, on ballet—it is nevertheless representative of the effect the company had. Under Balanchine, NYCB was a mental adventure of the profoundest kind. The adventure is over now, but Garis testifies to the happiness it gave. Here are the closing words of his book:

> Throughout the fifties and sixties I could tell that the dancing at New York City Ballet was getting better because I was getting happier as I watched it. And I knew that Balanchine wanted this. Even his applause machines were works

of high art. There was a period when the finale of *Coppélia* was my favorite thing in ballet. And at the end of a particularly great performance of *Symphony in C,* when fifty dancers filled the stage with disciplined, free vitality, I felt an exhilarated happiness. My friends felt it too, we defined it in the same way, and we agreed about its value. When that exhilaration failed to come—for it did not come at every performance—we agreed about that too, for this happiness was too important to fake. It was one of the great things in our lives, and one of the great things in the century.

The New York Review of Books, 1995

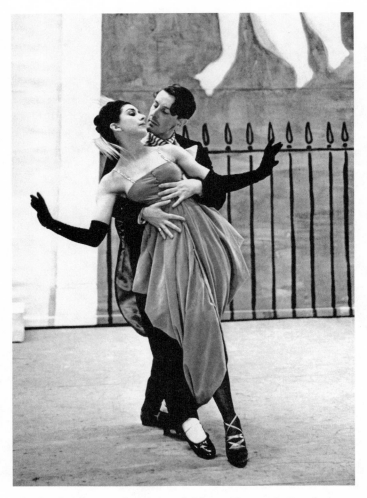

Frederick Ashton performing with Margot Fonteyn in Façade, *1941*

"Sweet as a Fig"

I N Julie Kavanagh's *Secret Muses: The Life of Frederick Ashton,* the muses are the boyfriends. Like so many others of the honored dead, Ashton, great choreographer, creator of the English style of ballet, has now been made the subject of a biography that fills in the love life—a story that, because he was homosexual, was kept well hidden from the public while he was alive. This book is not the usual treatment, however. Kavanagh does not think that the sex explains the art. Still less does she believe that her subject is somehow a lesser man, an unclothed emperor, because he didn't tell journalists what went on in his bedroom. In other words, this is not the act of vengeance that we have come to expect from the new, tell-all biography.

Kavanagh, once a dancer, later a ballet critic, now the London editor of *The New Yorker,* became a friend of Ashton's when she interviewed him for a profile in 1984, four years before his death. He authorized the book, and he knew what kind of story it would tell. Indeed, he supplied much of the information. Kavanagh repaid his trust. The book is good-spirited, even-handed. And the title notwithstanding, the boyfriends do not walk off with the project. There were other potent influences on Ashton's imagination—the Edwardian era (his childhood), the twenties (his young manhood), the English countryside, Anna Pavlova—and Kavanagh gives them their due.

It is Pavlova, dancing in Lima in 1917, who opens chapter 1:

> The curtains of a raised booth on stage were drawn aside and there she was. Anna Pavlova as the Fairy Doll, her deliberately slow, extra deep breaths making the sequins on her costume glint in the light. Set in a toy shop, *The Fairy*

Doll required the ballerina to remain still until the toys came to life; yet even stationary, Pavlova danced—flickering her huge, kohl-smudged eyes and almost imperceptibly stirring her slender arms and fingers.

At last she descended from her toy stage and began to dance:

By today's standards her technique was poor; she rarely executed more than two pirouettes, but they were done with such brio—"a sort of *flurry*," in Ashton's phrase—that she gave the effect of at least half a dozen more. Pavlova's vibrant personality, the expressive play of every part of her body and the outpouring of ecstatic energy sent a charge throughout the auditorium, creating what one critic described as "a kind of electrification of the air."

Ashton, age thirteen, was in the audience, and instantly he knew what he wanted to be when he grew up: Pavlova. That being impracticable, he decided to be a male ballet dancer, and when that too failed to work out, he gave up and became a choreographer. Still, he spent his life copying Pavlova. That animation of hers, that flutter, is what he would call forth from his own ballerinas. It became a hallmark of the English style. But what drew him to the Russian ballerina was more than excitement. The most beautiful detail in this portrait is the first one, of Pavlova's slow, deep breaths causing the light to flicker over her sequined torso. There you have Ashton: the plain, laboring body lifted by its action into poetry.

ASHTON was born in 1904 in Guayaquil, Ecuador, a pestilential backwater in which his father was vice-consul of the British embassy and manager of the Central and South American Cable Company. The family soon moved to Lima, and it was there that the boy grew up. His mother, Georgiana, was a vivacious woman who had spent her Suffolk childhood putting on backyard theatricals with her sisters and cousins. "Any talent that I have comes out of her," Ashton said. As for the father, George, he was a

gloomy, silent man who worked hard, raised carnations, and was coldly strict with his sons, particularly the youngest, Frederick, whose effeminacy repelled him.

Ashton was one of those people who seem to have been homosexual from birth. He hated sports; he loved dolls. The neighboring children had to be told by their mothers not to tease and punch him. "I was buggered by all my brothers," he told a friend. With Charlie, the brother closest to him in age, he "rather enjoyed it," he added. And whatever his difficulties, he remembered his Lima childhood—the songs sung by his half-Inca nurse, the religious processions in the streets, the long days at the beach, "having our last dip as the huge moon rose in the black sky"—as a kind of paradise. David Vaughan, author of the 1977 *Frederick Ashton and His Ballets,* has speculated that Ashton's Peruvian childhood lent him "a certain chic, a certain flamboyance" that shielded him from English dowdiness.

When Ashton turned fourteen, the paradise was lost. His parents sent him to England, to a boarding school called Dover College in Kent, where, for the next two years, he rubbed his chilblains and watched the other boys play rugby. His only relief was vacations, when he would rush to London, move in with some relative or other, and go to the theater day and night. Loie Fuller, Isadora Duncan, the Ballets Suédois, Diaghilev's Ballets Russes: he saw them all, meanwhile wondering how he could become part of that world. Finally his parents, despairing of his benefitting from an education (he was a hopeless student), removed him from school and found him a job as an office boy in London. There he languished for a few more years, wanting only to dance but knowing that his father would never allow this. Then, one morning, back in South America, George Ashton went to his office, took care of his correspondence, and blew his brains out. Georgiana returned to England, moving in with Ashton (she would live with him for the next fifteen years, until her death), and Ashton found the courage to confess his ambition to his family. With great reluctance, and only on condition that Freddie promise never to join a chorus, brother Charlie agreed to pay for lessons. And so, in 1924, at the age of twenty, Ashton began to study ballet.

SOON afterward, in 1929, the ballet world suffered a great upheaval: Diaghilev died, and his troupe, which for twenty years had been the headquarters of European ballet, disbanded. His dancers and choreographers scattered across Europe and America—a diaspora that would result in the growth of many of the national ballet companies of our century. France got Serge Lifar; America got George Balanchine. Léonide Massine and Bronislava Nijinska worked in various capitals. As for England, it became the headquarters of two ambitious Ballets Russes veterans, Ninette de Valois, an Irishwoman, and Marie Rambert, a Pole, both of whom soon founded companies—in de Valois's case, the Vic-Wells Ballet (established 1931), later to be known as the Sadler's Wells Ballet, later still as the Royal Ballet.

Another crucial figure on the English scene was Enrico Cecchetti, the most respected ballet teacher in Europe. Having taught the students of St. Petersburg's Imperial Ballet (including Pavlova) and then the dancers of the Diaghilev troupe, he had landed in London, where he was now instructing English girls in the small, sparkling steps and elaborate *épaulement* (the movements of the head, shoulders, and arms) that constituted the Cecchetti technique. Finally, there was a group of ballet writers and fans who in 1930, together with the Diaghilev ballerina Lydia Lopokova and her husband, John Maynard Keynes, founded a performing group, the Camargo Society, to preserve the Diaghilev legacy. This was a formidable collection of talents, none of them choreographic. In 1930 no city in the world wanted or needed a choreographer more than London did—which helps to explain why Ashton, though he had no musical training and only a brief ballet training, got the job.

In 1924, however, when Ashton started ballet lessons, that crisis was still a few years away. He had no idea of being a choreographer; he just wanted to be a dancer. He studied with Massine, then with Nijinska, whose arch and elegant styling of the upper body (she too had studied with Cecchetti) was to leave a permanent mark on his own work. He also studied, for years, with Rambert, who differed from Massine and Nijinska in that, not being a

choreographer herself, she longed to develop choreographers. She pressured Ashton into making his first ballet, the 1926 *Tragedy of Fashion,* about a couturier, Monsieur Duchic (Ashton danced the role), who stabs himself with his scissors when his new collection is poorly received. But Ashton thought that was just a romp. He still wanted only to be a dancer.

He also wanted to have fun. In 1925, Ashton met a Polish painter, Sophie Fedorovitch, who was to be his soul mate and his frequent set and costume designer for the next thirty years. She introduced him to her friends, he brought along some of his friends, and together these people assembled a stylish, bohemian clique—painters (Edward Burra), photographers (Cecil Beaton), poets, dancers, *Vogue* editors—who had the sort of good time that we expect from artists in the twenties. They moved in packs. They mocked themselves and the world. They played charades, put on theatricals, and gave costume parties where they came as snake charmers or corpses, copulated on the floor—usually with people of their own sex, for they were almost all homosexual—and drank till they dropped. Ashton was one of the more restrained members of the group. "I never saw him lying in a corner being had by a negro," one of his friends told Kavanagh. But after his long years of outsiderhood, he threw himself with joy into the party.

That group of friends had a decisive effect on Ashton's life and art. For one thing, they relieved him of any guilt he might have had about his homosexuality. More than that, they developed qualities in him—wit, elegance, a taste for the theatrical, a feeling for period style, an interest in manners—that were to be leading traits of his later work. They also bent his emotions in a certain way, toward friendship rather than other kinds of attachment.

IT was soon obvious to Ashton that he was not a good ballet dancer, a discovery which hurt him very much. On the other hand, with each new choreographic assignment that he accepted, it became increasingly clear that he was a gifted dance-maker. It took him a while to absorb the academic ballet technique. (Remember, he started at twenty. Most ballet choreographers have studied the technique since childhood.) In consequence, his early

works depended heavily on wit and chic. He made a Degas-dancer ballet, a Renaissance ballet, a Leda-and-the-swan ballet, but with a nice swan, not like Yeats's rapist. (It was played by Ashton, in a feathered toque, looking as pretty as Leda.) But soon he was making dances for all three of London's new ballet organizations—Rambert's Ballet Club, de Valois's Vic-Wells Ballet, the Camargo Society—and in 1935 he went on staff at the Vic-Wells.

As he mastered ballet technique, he began to shape it into a language of his own, as can be seen from the pieces that survive from those years: *Les Rendezvous, Les Patineurs, A Wedding Bouquet.* He also began to mold the English dancers, paying special attention to a teenaged girl, Peggy Hookham, soon renamed Margot Fonteyn, who was to become his personal ballerina—he made more than thirty roles for her—and thereby the paragon of the English ballet style, his style. (Many years later, Fonteyn wrote to Ashton to say how lucky she was to have fallen into his hands: "Imagine where I would have been otherwise with my no elevation, no extension, no instep and feeble pirouettes!") He also began training a partner for Fonteyn, Michael Somes. In other words, Ashton was now taking responsibility for English ballet.

HIS career was interrupted by the war. Predictably, he cut a poor and desperate figure as a soldier. But in 1946, when he returned to what was now the Sadler's Wells Ballet, he created a piece, *Symphonic Variations* (to César Franck), that is seen as a turning point not only in his own career but in the history of British ballet. Until the middle of the twentieth century almost all ballets had detailed stories. In England in the thirties and forties this narrative emphasis was especially pronounced. In the ballets of Robert Helpmann, who took over as lead choreographer at the Sadler's Wells while Ashton was gone to war, the dancers barely danced, so busy were they falling in love and getting killed. "Everything was becoming too literary," as Ashton later described it to Kavanagh. "I thought they were losing the dancing element." So, to reassert the expressive power of ballet itself, he made *Symphonic Variations,* a storyless piece in which six dancers, led by Fonteyn and Somes, conjure an unspoken emotion—a fusion of rapture and

calm, one part Greece, one part Wordsworth—solely through the action of classical dancing.

Because it had no narrative, *Symphonic Variations* also showed with the greatest possible clarity the lineaments of what was now Ashton's mature style. First, the elaborate *épaulement,* product of the combined influences of Pavlova, Nijinska, and Cecchetti, with the head, shoulders, arms, hands, fingers all exquisitely angled in relation to one another, all speaking to one another. Second, reticence, or what some English critics call "taste." In Ashton, lifts tend to be low—the woman may be raised just six inches off the floor—and in contrast to the American "six-o'clock" (180-degree) extension, Ashton's ballerinas seldom raise a leg more than 90 degrees. In part, this is in service of greater expressiveness: if the woman is lifted six inches now, she can make a different impression when, later, she is raised twelve inches. But often she is just lifted six inches. Ashton was a modest man.

The other distinctive qualities of Ashton's style are musical phrasing—a fresh, easy placement of steps against music—and a sweet naturalness of demeanor, both Fonteyn specialties. Finally, add the traits so prominent in *Symphonic Variations:* an allegiance to the academic ballet steps—*chassé, piqué, développé,* all clear, unsmudged—and a pressing but controlled emotionalism. No other choreographer, not even greater choreographers, can make you cry as Ashton can.

THERE was one final ace in Ashton's pack: a gift for narrative. Strange to say, after making his announcement, with *Symphonic Variations,* that ballet did not need stories, Ashton went on to become the greatest storyteller in twentieth-century ballet. It is as if, in *Symphonic Variations,* he displayed the bones of his art, then went on to flesh them. He produced a few more pure-dance pieces, notably *Scènes de ballet* (1948) and the superb *Monotones* (1965–1966), but they were his avocation. In 1948, two years after *Symphonic Variations,* he made his first three-act story ballet, *Cinderella,* and thenceforth he devoted his career to creating dances—*Daphnis and Chloe* (1951), *Sylvia* (1952), *Romeo and Juliet* (1955), *Ondine* (1958), *La Fille mal gardée* (1960), *The Two Pigeons*

(1961), *The Dream* (1964), *Enigma Variations* (1968), *A Month in the Country* (1976)—that seem as much the descendants of the English novel as of Russian ballet. They have the sense of place. They have the moral seriousness, the concern with how people treat one another. Above all, they show the complex psychology of the English novel.

The English are specialists in typological portraiture, and Ashton was a super-specialist. All his adult life he dined out on his impersonations—his Queen Victoria, his Sarah Bernhardt, his Gertrude Stein and Wallis Simpson, his Isadora Duncan and Martha Graham. (His Queen Victoria, reproduced among the photographs in *Secret Muses,* is so exact you would swear it was she if only Ashton had been a little fatter.) These sketches, as Kavanagh explains, were Ashton's fieldwork. His ballets are filled with the same sorts of characters, all bristling with bright detail— detail in the service not just of wit but also of charity.

The most celebrated instance is the Second Stepsister in *Cinderella,* a character both monstrous and sweet (Ashton played the role). Another shining example is Thomas, father of the rich dolt, Alain, to whom the heroine of *La Fille mal gardée* is about to be married off, despite her love for another man. Lord of the local vineyards, Thomas is bustling and self-important, and he is not on the side of the angels, but Ashton likes him too. When the local youths tease Alain, Thomas shields the boy, soothes him, tries to cover up his folly. But his affection keeps tipping over into annoyance. Why did God send him such a blockhead for a son? Who will manage the vineyards when he is old? How will he get his earned rest, his grandchildren? It is all there, in a few gestures. Such characters, descendants of Miss Bates and Betsy Trotwood, are not what we expect to find in ballet, with its wordless logic. To quote Balanchine's dictum, there are no mothers-in-law in ballet. But Ashton gives us fathers-in-law, and their feelings, and their feelings' fathers-in-law.

IN his mature years, and especially in the sixties, when he succeeded de Valois as director of the Royal Ballet, Ashton was often accused of being old-fashioned. People now wanted ballets about

sex and bombs and despair. (Kavanagh quotes Peter Brook writing in 1963: "We are ripe in ballet for a *Hiroshima Mon Amour.*") Meanwhile, Ashton went on giving them ballets about families and love and goodness. As he wrote to Marie Rambert, in his version of Italian, while on assignment at La Scala: "*Il vecchio maestro no po fare il balleto moderno e brutto e dedicato a la belleza e il lirism, que cosa fare? . . . Sa veccio elevo Frederico, dolce com un fico.*" ("The old maestro cannot make the modern, ugly kind of ballet. He is dedicated to beauty and lyricism—what can you do? . . . Your old pupil Frederick, sweet as a fig.") He thought it ridiculous that the value of a ballet should be judged by its subject matter. You "may as well say Chardin was a bad artist because he painted cabbages," he retorted.

But it was not just his subject matter that made Ashton seem conservative. Compare his work to Balanchine's, as so many critics have done. Balanchine, by virtue of his complete absorption of subject matter into movement, and his radical transformation of the academic steps, did with dance what Pound wanted poets to do with language: make it not a story but an action. While Ashton remained faithful to dance-as-narrative, Balanchine moved toward dance-as-music. (Balanchine started a ballet with its music; the choreography was his response to the music. Ashton usually started with a story and then found music to go with it.) This difference, in turn, made a difference in the kinds of emotions the two choreographers could explore. Ashton's approach was perfect for the world of moralized feelings that he was interested in, and that the English literary tradition had prepared for him. In Balanchine, by contrast, emotion is not moral; it is not even really emotional, but physical and spiritual. Ashton, for example, often makes the division between sacred and profane love. Balanchine is above that distinction, or below it. In his work, love is a labor, a transfiguring process of body and soul. The world, with its sacreds and profanes, has nothing to do with this.

One can see the difference between the two men even in the size of the steps. Ashton favored small, precise steps. Balanchine was more a bolt-thrower. One sees the difference also in the focus of movement. Ashton stressed the ballerina's upper body; Balanchine, the lower body. Arlene Croce, in her review of Kavanagh's

book in *The New Yorker,* noted perceptively that this betrays their difference in sexual orientation. It also reflects a difference in expressive ambition. Ashton was concerned with the body's social parts—head, arms, hands—the parts we uncover and use in dealing with one another. Balanchine was interested in the parts we cover—legs, thighs, pelvis—the places of birth and sex, exposure and annihilation. Though Ashton admired and envied Balanchine, Balanchine's work was actually part of that "balleto moderno e brutto" that Ashton said he could not and would not do. Balanchine's ballets are modernist; Ashton's, with a few exceptions, are not.

Ashton's art, as Kavanagh shows, was a product of his temperament. He was the most civilized of men: modest, witty, psychologically acute. Fonteyn, in her memorial tribute to him, recalled his telling her "that he could not remember innocence, that he had always seen through people to their hearts, their motives and their characters, since he was a child." He was also an exceedingly domestic creature. His house was all ribbons and flowers. (It looked, Cecil Beaton said, like "the house of an old aunt or of the girl in Spectre de la Rose.") He collected Staffordshire corn-on-the-cob jugs and pottery cabbages. He kissed his housekeeper every night before going to bed. He sought comfort, for he was plagued by insecurities, above all about his work. Bad reviews hurt him terribly. (In his view, said the critic Richard Buckle, "anything that was not a bouquet was a bomb.") In 1955, when he was in Copenhagen creating his *Romeo and Juliet* for the Royal Danish Ballet, strife within the company so unstrung him that every morning, as he walked to the theater, he would have to stop in a doorway to throw up.

HIS social life was organized around friendship. Ashton's early years had been notably undomestic. His parents moved back and forth between Guayaquil and Lima. During most of his Lima years he was farmed out to acquaintances of the family. His brothers were "utter strangers" to him, he told Kavanagh. I believe that when he became part of Sophie Fedorovitch's crowd in the twenties, he found something that he had missed throughout his child-

hood—brothers and sisters, a collective in which he fit. For all his remaining years, his life rotated around groups of friends, some of these people, such as Fedorovitch and the dancer and set designer William Chappell, holdovers from the crowd of the twenties. Many of his works were planned at weekend house parties. One of the reasons four of his ballets were set to the second-rate music of Lord Berners was probably that Lord Berners's Palladian-style house in Oxfordshire was so pleasant to stay at, with all the friends and the French food and, on one's night table, porno-graphic novels disguised as leather-bound classics.

This immersion in familial friendships probably helped to set the emotional temperature of Ashton's work. I quote from Auden's essay on Max Beerbohm:

> The great cultural danger for the English is, to my mind, their tendency to judge the arts by the values appropri-ate to the conduct of family life. Among brothers and sisters it is becoming to entertain each other with witty remarks, hoaxes, family games and jokes, unbecoming to be solemn, . . . to create emotional scenes. But no art, major or minor, can be governed by the rules of social amenity. The English have a greater talent than any other people for creating an agreeable family life; that is why it is such a threat to their artistic and intellectual life. If the atmosphere were not so charming, it would be less of a temptation.

Spoken like an expatriate. Ashton too, at one point, considered moving to the United States. (He adored New York, and felt that the Americans appreciated his work more than the English.) But he stayed in England, with his family of friends, and the qualities that Auden lists here—the charm, the wit, the reluctance to be solemn—can be seen throughout Ashton's work. They do not sink it. His moral perception was too profound, his dance imagi-nation too fertile, for that to happen. All his tastes and tendencies drew him toward the minor; still he was major. As Edwin Denby once put it, "The more trivial the subject, the deeper and more beautiful is Ashton's poetic view of it."

AND the boyfriends? Ashton's lifelong pattern, a familiar one, was to fall in love with some young man and then settle down into a long attack of yearning. This is not to say that he didn't bed the boy. Usually he did. (He had a busy sex life. "Pussy is out for all she can get," he wrote Chappell.) But then, either because the boy was heterosexual or because he lived on the other side of the Atlantic or, as the years passed, because he was forty years younger than his pursuer, Ashton was left to nurse his passion in solitude. "I never once pulled it off," he said, with apparent bitterness. "I was always the loser." But according to Kavanagh, that's what he wanted to be. As he told her, he didn't like "queer marriages—having to live with someone's ingrown toenails." Anyway, he was already married, to his friends. For him, the function of love was to create a mood of exalted repining that he knew was the generator of his ballets.

This pattern caused him a lot of problems. It meant that he spent much of his life unhappy. And when the beloved was a dancer in the company, it created havoc in the theater; dancers would storm into de Valois's office with petitions protesting Ashton's favoritism in casting. But he defended his practice, and pointed out that it was part of ballet tradition. Diaghilev did it, Balanchine did it. The personal element enlivens the art, Ashton said—"lifts the whole thing." The upper-body fluttering of his ballerinas may have been, in part, a memory of real-life loves. Kavanagh thinks this was his idea of female sexual pleasure, a state with which he identified. (He was "bottoms," she reports, not "tops.") Strange to say, in Ashton's love duets the woman's erotic turmoil is often wound round with that mood of charity, that family feeling, which was so natural to him. It is a weird combination, almost incestuous, but very intimate, gripping.

Kavanagh's book has one fault: too little context. On a number of matters—British ballet, modernism and antimodernism in England, the work produced by other choreographers of the period, and Ashton's relation to them—we need a little more background. But I mention this only to show that I noticed it. It is the defect of Kavanagh's virtues. She is sophisticated; she thinks

we know all that. She writes wonderfully—the Lima years get the full, Proustian treatment—and she manages to control a huge amount of material, the product of ten years' research. She likes gossip as much as Ashton did: she tells us what the people wore, whose nose job was a disaster (Fonteyn's—she had to have it redone), who was well hung. But none of this comes out petty or lurid. It is tittle-tattle *in excelsis,* the very texture of Ashton's life. Kavanagh clearly loves Ashton, and she does little duets with him, setting his remarks against hers. (On a teacher of his childhood: "Sweet-natured, attractive, with beautiful handwriting, Winnie Gilzean taught him—'God knows. Nothing. I was utterly unteachable all my life.' " What a joy to hear his voice again.) Kavanagh also likes Ashton's world and moves easily within it. The resulting book feels very English. Actually, it feels like an Ashton ballet: a lot of bustle and detail, but gathered under a great arc of calm.

The New York Review of Books, 1997

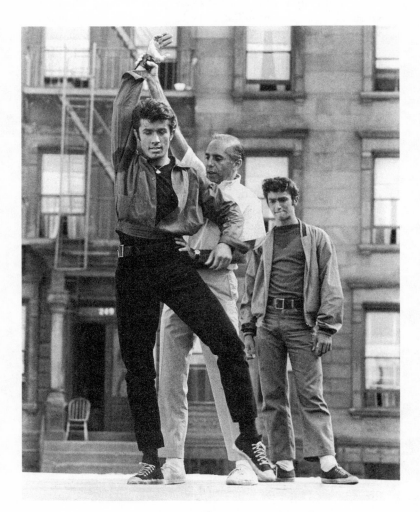

*Jerome Robbins rehearsing George Chakiris during
the filming of* West Side Story, *1961*

American Dancer

WITH Greg Lawrence's *Dance with Demons: The Life of Jerome Robbins,* one more biographer has discovered that his subject was not always a nice person, and has recorded his shock. Lawrence's name will be familiar to some. He's the man Gelsey Kirkland met—they were both banging on the door of the same cocaine dealer—toward the end of *Dancing on My Grave,* Kirkland's 1986 tell-all, coauthored with Lawrence, about her life in the ballet. Having kicked their respective habits, married, and written *Dancing on My Grave,* Kirkland and Lawrence followed it up with a sequel, *The Shape of Love* (1990), about the healing power of that emotion. Then they got a divorce, and Lawrence found a new ill-behaved artist to write about: Jerome Robbins, who died in 1998. The literary executors of Robbins's estate had something else in mind. They made his private archives available to three writers. One was Christine Conrad, a friend of Robbins's who has since produced a nice picture book, *Jerome Robbins: That Broadway Man, That Ballet Man.* Then there were two biographers, Amanda Vaill, the author of a recent book on Gerald and Sara Murphy, and Deborah Jowitt, the lead dance critic of the *Village Voice.* Lawrence was turned away, but he was not deterred. Now, less than three years after Robbins's death, Lawrence's biography has been published. Jowitt and Vaill, who are no doubt still reading Robbins's report cards, may have been pained to see the book announced. Don't worry, ladies. The Robbins story remains to be told.

Robbins was the most acclaimed and successful American-born choreographer of the midcentury. He started out in modern dance in the thirties, then went to Broadway, and, in 1940, after a late and hurried ballet training, joined Ballet Theatre (now Amer-

ican Ballet Theatre). Four years later, for that company, he made his first ballet—the now famous *Fancy Free,* with a jazzy score by the young Leonard Bernstein—about three sailors on shore leave. It was a hit, and before the year was out it was turned into a Broadway musical, *On the Town,* which was a bigger hit.

That lucky year set Robbins's pattern for the next two decades: he commuted between Broadway and ballet. For Broadway, he either choreographed or directed and choreographed *Billion Dollar Baby, High Button Shoes, Call Me Madam, The King and I, Peter Pan, Bells Are Ringing, West Side Story, Gypsy,* and *Fiddler on the Roof.* This is a partial list, and a glorious one. Robbins is widely credited as the foremost practitioner of "integrated" Broadway choreography—dancing that filled in character and advanced plot—in contrast to the just-dance vaudeville dances from which musical comedy sprang. He did that, and he did more: the "Small House of Uncle Thomas" number in *The King and I,* with its layers and layers of cultural misunderstanding; "Prologue" and "Cool" from *West Side Story,* with the sneakered boys exploding into dance; *Gypsy,* with its hilarious sendups of vaudeville and burlesque. Broadway dancing never got more artistic than this— more subtle, more witty, more stageworthy. Robbins was born to work in musical comedy. Trained, too. He studied acting, went to the Actors Studio, and knew Yiddish theater, vaudeville, and Broadway inside out—the gags, the timing, everything.

But he came to hate working in musical comedy. He was a perfectionist, and he could not bear the compromises that Broadway required: the set designers telling him that they had their own ideas, the producers telling him that the show had to open whether he was ready or not. So every year or so in the forties and fifties he would go back "home," first to Ballet Theatre, then to New York City Ballet (he moved there in 1948), and make something in the classical idiom: *Facsimile* (1946), *Age of Anxiety* (1950; based on the Auden poem), *The Cage* (1951), *Afternoon of a Faun* (1953), *The Concert* (1956). At this time there was serious question as to whether ballet could ever be an American art. People still thought it was Russian or French—in any case, old and snooty, unfit for a young democracy—and the ballets of George Balanchine, the man who finally did make ballet an American art, were

on the whole so radical that the public took a while to get the point. Robbins stepped in. His ballets told stories *(The Cage)*; they cracked jokes *(The Concert)*; they were topical *(Age of Anxiety)*; they were about young people and sex *(Facsimile)*. Again and again, they seemed to say that ballet could be down-to-earth, ours.

After *Fiddler on the Roof,* in 1964, Robbins, to what I imagine was the cork-popping joy of his Broadway competitors, walked out on musical comedy. By now, he could afford to. (Broadway made him rich. He left an estate of thirty million dollars, and that was after giving a lot of money away, notably to the Dance Collection—recently renamed the Jerome Robbins Dance Division—of the New York Public Library, which, since 1964, has been receiving a percentage of his profits from *Fiddler.*) In the late sixties, he spent some time scratching an avant-garde itch. He founded American Theatre Laboratory, a ten-member collective that for two years did such things as stage a "happening" and experiment with a Noh play about the Kennedy assassination.

Finally, at the end of the sixties, Robbins went back to New York City Ballet and in a sudden onrush of invention created the piece for which he will probably be best remembered: *Dances at a Gathering.* For several years, no doubt in emulation of Balanchine, he had been toying with abstraction. Now, in *Dances at a Gathering,* he wedded abstraction to the upbeat temper of his musical-comedy work and produced a long, expansive ballet in which ten young people just danced for an hour to Chopin piano pieces. Robbins's abstraction never went as far as Balanchine's. In Balanchine, dance is metaphor; in Robbins, it is still representation. (Though *Dances at a Gathering* has no story, there are little skits and character studies tucked into it.) But for many spectators a bit of representation was just fine. Here at last was a real American ballet, in which, without the help of sailors or jazz or any other overt Americanism, the dancers looked like us (or what we thought we were)—young, spontaneous, free, under an open sky—and at the same time confidently assimilated European art: Chopin, academic dance. This was 1969, when New York painters had finally captured the flag from Paris, and when American youth culture was changing the world. The ebullience of that

period is written all over *Dances at a Gathering,* and made people proud and happy to see the piece. In his later ballets—*The Goldberg Variations* (1971), *In G Major* (1975), *The Four Seasons* (1979), *Opus 19/The Dreamer* (1979), *Glass Pieces* (1983), *Antique Epigraphs* (1984), *Ives, Songs* (1988)—Robbins was never again as optimistic, and he occasionally reverted to storytelling. But the approach was largely the same: emotionalized abstraction, the meditations of a sophisticated mind in love with simplicity.

THAT was Robbins's career. And what, to Greg Lawrence, is the main theme of it? How mean Robbins was. His working methods, to start with, were punishing to his dancers. Because he could never make up his mind, he double- and triple-cast roles, so that the dancers never knew if they were actually going to go on. Then he made them learn multiple versions of the dance—again, he couldn't decide—so that if indeed they got onstage they barely knew what to do. Then there was the personal cruelty. He screamed at dancers, insulted their work, insulted their bodies. According to Lawrence's interviewees, Robbins was "evil" (Arthur Laurents), a "shit" (Eddie Albert), a sadist (Stephen Sondheim). "I've never worked with someone so unpleasant" (Eric Bentley). "You became like a victim of domestic violence" (Sara Corrin, an office assistant). Once, in a Broadway rehearsal, Robbins was backing up, downstage, to get a better view of the dance, and coming perilously close to the edge of the orchestra pit. Everyone saw what was happening, but no one said a word. "Off he went," the dancer James Mitchell told Lawrence. "He could have killed himself. I think he fell into the bass drums. Nobody went to his rescue, not for quite a while."

Lawrence says Robbins had "demons." He didn't like being a Jewish kid from New Jersey, the son of Harry Rabinowitz, who had an accent and ran a corset factory. Nor did he enjoy being homosexual. (Bisexual, actually.) And, apparently, his whole life long he resented the fact that his father had tried to stop him from going into dance, told him it was for sissies. To my knowledge, nine out of ten male ballet dancers in the United States had that experience, but Robbins had another, related experience. In 1953,

he was called before the House Un-American Activities Committee. Like hundreds of other American artists, he had once joined the Communist Party, and had signed petitions and helped stage benefits. But, presumably because he was homosexual and feared exposure—though other homosexual artists, such as Aaron Copland and Marc Blitzstein, stood firm—he could not face down the committee. His testimony makes shameful reading. He fell over himself to name names. As one congressman remarked gratefully, his level of cooperation was "a bit unusual." Many people never forgave him, and he never forgave himself. Before HUAC, Lawrence says, Robbins was tormented and vicious. Afterward, he was doubly so, and that is the story of *Dance with Demons*.

Of course Lawrence tells us what dances Robbins made and with whom. The book is six hundred pages long. But he offers almost no critical commentary on the dances. Nor are we told much of anything about their context. Jews in the thirties, the role of "art" choreographers in Broadway dance, postwar existentialism, the postwar triumph of Freudian theory (Robbins was in analysis), the question of ballet's place in America, the relationship between acting and dancing in ballet, the vogue of Method acting (and its cult of pedagogical brutality), the history of musical-comedy dancing, and of New York City Ballet (for example, how Robbins's return in 1969 coincided with the beginning of a terrible fallow period for Balanchine, who had just been abandoned by Suzanne Farrell): these matters, which have direct bearing on Robbins's career, are either ignored by Lawrence or simply waved at in passing. It's as if he were born yesterday. In his preface, he notes, as a supposedly telltale fact (evidence of "conflict"), that Robbins, who was born in 1918, kept his affairs with men "as clandestine as possible." How peculiar!

The story of Robbins's place at New York City Ballet is an especially gaping hole. How was it for this reportedly insecure man to spend two decades working alongside the person he knew to be the greatest dance artist of the century? Lawrence does something with this—or he pastes up a lot of quotations—but his account is remarkably unnuanced. As he sees it, Balanchine loved Robbins's work and did what he could to keep him happy. When the two men were composing ballets at the same time, Balanchine

often gave Robbins first pick of the dancers and took what was left—an extraordinary courtesy. When dancers came weeping to him over Robbins's nastiness, he calmed them down, cracked jokes ("If you had no hair on your head and a big gray beard, you'd be unhappy, too"), and got them back into the studio.

But I suspect that Robbins's sense of his inferiority to Balanchine was not unshared by Balanchine. One of the company's dancers told me that she once sat down with Balanchine to watch *The Cage,* Robbins's tale of female violence against men. (There's a long streak of misogyny in his work.) She had seen it before, and Balanchine said to her, "This time, close your eyes, just listen to the music," the music being Stravinsky's Concerto in D. When the ballet was over, he asked her what she thought of the score. "Beautiful," she answered. "Yes," Balanchine said, "and look what Jerry made of it." I think Balanchine did admire some of Robbins's ballets, but regardless of what he liked or disliked, he seems to have decided that Robbins would be useful to the company, to vary and lighten the programs. (In any given season during the seventies, the repertory was usually about one-fifth Robbins.) So for twenty-odd years Robbins, who had been king of Broadway, labored in Balanchine's shadow. This fact is never seriously examined in the book.

What we get instead are endless accounts of Robbins's cruelty in the studio, a matter that, like the work, Lawrence never places in context. Without excusing Robbins, one should keep in mind the conditions under which choreographers work—that is, against the clock and under the eye of maybe twenty people who stand there and stare at you when you get stuck and who, when you aren't stuck, rarely do the step the way you want it, with the result that the audience will never know the lovely thing you imagined. Balanchine was an angel in rehearsal, but he was the exception. Nijinsky made people cry; Martha Graham slapped her dancers. Today, with the unions, I doubt that there is much slapping going on, but I would say that some measure of screaming is to be expected in any collaborative art. Think of conducting. Toscanini's rages were legend.

If Lawrence had taken a look at the ballets, he would have found "demons" enough. Robbins wasn't just ashamed of being

Jewish, and Jersey, and homosexual. He seems also to have grieved over being narrative and psychological, over having the common touch, being a popular artist, a Broadway man. These traits were absolutely natural to him, and he looked down on them, and favored abstraction, which was not natural to him. So he made something in between. In a typical Robbins ballet—*Dances at a Gathering,* for example—the performers do not come out and start dancing. They come out and have feelings, and then they decide to dance—dance their feelings. Very often, other dancers sit and watch them. In other words, dance is not the medium; the medium is a vague sort of drama, with dance as a thing happening inside it. In many cases, the result looks self-conscious, sentimental—about ballet and ballet dancers—a fact unquestionably related to Robbins's late training and his worry that he did not belong in ballet. Furthermore, the dancing of feelings is a limited business. Dance, like music, is fundamentally abstract. You can add things to it to make it narrative. That is what Robbins did on Broadway—created dances that said, "We're going to get those Sharks," and so forth. But by this route you can't go very deep, and Robbins's ballets are a good example. Their psychology is roughly that of a high-class sitcom. This is connected, I believe, to Robbins's abiding interest in teenagers. He liked very young dancers (he was a whiz at spotting talent in the corps), and onstage his dancers act young, have young emotions: passing infatuations, passing sorrows. The picture is never adult, never this-is-what-life-is.

There are exceptions. Early on, Robbins made narrative ballets, such as *Fancy Free* and *The Cage,* that are confident and direct in a way that his later work is not. And among his mature work there are pieces, or parts of pieces—*Dances at a Gathering,* the pas de deux from *In G Major, A Suite of Dances*—that, though they are limited, are nevertheless wonderful. *A Suite of Dances,* a solo in which the dancer seems to be deciding from minute to minute what he will do next, is ostensibly a perfect instance of Robbins's studied informality, his compromised abstraction, his imprisonment in "feeling." But it does not look studied or compromised, and it seems to be less about feeling than about intelligence. (Robbins was no doubt helped here by the fact that he made the dance

for Mikhail Baryshnikov, who was not a teenager—he was forty-six—and who is one of the most intelligent dancers in the world.) Finally, there is no question that Robbins's ballets would have been more admired, then and now, if only they had not been created alongside Balanchine's grand, unfolding design.

But, as good as they got, they were never as good as his Broadway work, the thing he walked away from. People said this during Robbins's lifetime, and it hurt him terribly, the more so since he probably knew it was true, and wondered if he had made a mistake. (In 1989, he went back and did *Jerome Robbins' Broadway,* an anthology of his musical-comedy dances.) Had he left his real home only to spend the rest of his life banging on the gates of someone else's property? If Robbins is to be discussed in terms of psychological conflict, that is the conflict, and the work is the document.

The New Yorker, 2001

Suzanne Farrell as Dulcinea in Balanchine's Don Quixote, *1965*

Second Act

O N a November night in 1989, Suzanne Farrell gave her final performance with New York City Ballet, the company that she had joined twenty-eight years earlier. One last time, her hair hung with jewels, she danced the long, strange enchanted-ballroom solo that George Balanchine had created for her in *Vienna Waltzes,* and once again, on the great stage of the New York State Theater, she gathered every inch of the space into the passionate logic of her dancing. When she exited, forty dancers—the entire ensemble—entered, and they seemed small compared with her. She rejoined them for the finale, and then it was over: the ballet, and the career. Farrell bowed to the company, and they to her. Peter Martins, NYCB's director, came on and presented her with a bouquet. Next came Lincoln Kirstein, who had founded the company with Balanchine, in 1948. Kirstein handed Farrell more flowers, and burst into tears. She took his arm and laid her head on his shoulder. Then the two of them walked offstage together, leaving the fans hollering.

Farrell was the most influential American ballerina of the late twentieth century. Others before her had done what could be called modernist ballet dancing—lean and wild, as opposed to the plump and decorous nineteenth-century model—but Farrell, under Balanchine's tutelage, carried that project further than anyone else. What she performed was still classical ballet—she got out there with her hair in a bun and did glissade, assemblé—but in her the classical style seemed to have sunk to the bones of the dancing. The flesh was something else, an awakened force. When she bent down into an arabesque penchée, you thought she would never stop. (She was the first dancer I ever saw touch her forehead to her knee in penchée.) When she executed a triple pirouette,

and tilted as she did it, and then—without ever righting herself—plunged directly into the next jackknife or nosedive, you thought the walls were falling in. As Arlene Croce wrote, Farrell "made audiences sweat."

One could scarcely believe that a power so huge had come to an end. But it had, as ballet dancing does for most people, however gifted, in their forties. (Farrell was forty-four, and had already had the first of two hip-replacement operations.) And there was some comfort in the thought that she might now have time to coach New York City Ballet's younger dancers. But the company chose not to use her, and so she took her skills elsewhere. Long before Balanchine died, his work had become a staple of the American ballet repertory. After his death, many more troupes, European as well as American, began calling the Balanchine Trust, the organization that licenses his ballets and sends répétiteurs, or rehearsal directors, to stage them. As one of the répétiteurs, Farrell went to Moscow, Stuttgart, Copenhagen, Paris, Seattle, Miami, Cincinnati. In 2000, she accepted a professorship at Florida State University, in Tallahassee, and began teaching there for part of every year. At times, it seemed that the only place she wasn't working was New York.

Actually, she was still in New York, because that's where she lived, with her dog, Tex, in a rambling apartment a few blocks from the New York State Theater. Between assignments, she could occasionally be spotted in the grocery store, or walking Tex on Broadway. But in terms of the New York ballet scene, which she had been instrumental in creating, she was gone. Furthermore, wherever she went, she was never there for long. She had no troupe to call home, no base from which to launch a sustained program of teaching. She had said repeatedly that she had no thought of running a ballet company of her own, nor did she seem to have the right personality for such a job. She was known to be introverted, narrow—not your standard company director's profile. Once, a journalist asked her what she did between gigs. She answered that she was very good at doing nothing. She played solitaire, she said, and read Robert Ludlum novels.

In 1992, James Wolfensohn, who is now the president of the World Bank, sat in his office thinking about the Kennedy Center

for the Performing Arts, in Washington. Wolfensohn, an Australian who had become the chairman of the center's board of trustees two years earlier, had spent the 1970s and 1980s working as an investment banker in New York, and there he frequently went to the ballet. His favorite company was New York City Ballet, and his favorite dancer was Suzanne Farrell. Although Farrell in 1992 was still technically on staff at NYCB, "I knew she wasn't being effectively used," Wolfensohn told me. So he called her to see if she would have lunch with him. He took her to the Four Seasons—"I felt as though I were having lunch with an angel," he recalls—and he asked her if she might make some contribution at the Kennedy Center. They started small. Early in 1993, Farrell taught a group of local teenagers at the center for four weekends. "But then a buzz started," Derek Gordon, the center's vice president for education, says. Within a few years, Farrell was running a three-week summer session, for which students auditioned across the country.

At the end of the 1994 summer session, Farrell staged a recital for her students, and put together a ballet for them. Wolfensohn liked it: "So I asked her, 'Why don't you see if you could do a little program with professional dancers?' " Farrell had said she had no intention of running a ballet company, and Wolfensohn insists that he had no thought of persuading her to do so. Nevertheless, in 1995 Farrell staged two programs of Balanchine's work at the Kennedy Center, to effusive reviews. In 1999, she again mounted a two-program season, this time adding pieces by other choreographers—Jerome Robbins, Maurice Béjart—and she took her show on tour: five weeks, nine cities. By 2000, the group had a name, the Suzanne Farrell Ballet. By 2002, it had twenty-four dancers and a booking agent. No one can quite say how it happened, but Farrell seems to be directing a ballet company.

THIS year and last, I spent time watching Farrell do the two main things that she now does for a living: teach ballet to advanced students and coach professionals in Balanchine's ballets. The first day I visited her class at the Kennedy Center, she entered quietly through the studio's back door. She is fifty-seven now, but she

hasn't changed much. She doesn't seem as tall as before, but that's because she's no longer standing on her toes. (On point, she was six feet one. On flat feet, she is five feet six and a half.) In certain respects, she looks like a regular, hard-working ballet teacher. Her long brown hair is clipped back in a ponytail. She wears a baggy sweater, plus a little skirt. Still, you know you're looking at a ballerina. Indeed, offstage, the features that made her body perfect for the stage are more striking. The famous feet, with the curved arches—can you walk down a street on those things? The big eyes, the long neck seem lonely for their proper context: the lights, the tiara. The beautiful face that once housed a mystery now opens its mouth to tell other people how to make a mystery. This takes getting used to.

So do her classes, and her rehearsals. In watching Farrell work, I had expected, above all, to hear about steps. The plumb-line penchées, the cyclonic pirouettes: these, I thought, were what she would show her students how to do. She didn't. At times, it seemed that she didn't care about steps. Or, rather, she trusted the dancers' ability to do them, and so she went straight to her subject, their thinking about the steps.

A constant theme of her teaching is symbol-making. Susan Jaffe, formerly a principal dancer with American Ballet Theatre, told me about working with Farrell on *Mozartiana* for the 1995 season at the Kennedy Center. Balanchine made *Mozartiana* two years before his death, and many people believe that it is about his death. The music for the first section is Tchaikovsky's resetting of Mozart's *Ave, Verum Corpus,* a musical prayer, and as the curtain opens the lead woman (Farrell in the original), dressed in black, comes forward in bourrée—the gliding-on-point step—meanwhile raising her arms very slowly. In learning the ballet, Jaffe was having trouble with the arms, so Farrell spoke to her. She told her that Balanchine had taken those arms from a statue of the Virgin Mary in the Church of the Blessed Sacrament on West Seventy-first Street, a few blocks from where he lived. Jaffe, who also lived near there, knew the statue, which is actually a rather ordinary marble Madonna, but with lovely arms, which she holds out to us softly, as if she were giving us something nice. No surprises here: death, prayer, Madonna, mercy. And maybe it was the memory

of the statue which enabled Jaffe, when she finally performed *Mozartiana,* to use her arms as wonderfully as she did. I don't think so, though. "In that arm movement," Jaffe said to me later, "you bring your fingers together, and then open your arms. So this movement opens up into art and history—the neighborhood Balanchine lived in, and what he saw, and the history of the world." What Jaffe got from Farrell, it seems, was not so much a description as a suggestion, an idea: of something small, and one's own, opening out into something great, which then becomes one's own, too. With Farrell, Jaffe says, you work "from pictures in your mind, rather than 'Is this a good fifth position?' "

Another thing that Farrell constantly asks for, particularly from her young students, is variety. One day, I watched her work on developpé, the step in which the dancer lifts her knee, usually to the side, and then unfolds her leg in the air. Developpé is a major "show" step, the show being how high the dancer can push the leg. But Farrell doesn't care about the height. What does "developpé" mean? she asks the class. It means development, she says, like a Polaroid photograph developing, going from black-and-white to all those colors. "And I want to see all those colors"—a different energy at every stage of the leg's rising. Before it rises, too, please: "I want to see the idea, emanating from you, that you're about to do developpé." She works this way with every phrase. She wants their dancing to be oblique, shaped, shaded, nuanced.

At the same time, she wants it big and forceful. "To do a turn, and make it interesting, you don't just turn," she said to me. "You have to gather all the space inside your leg" (here, as dancers do, she used her hands, gathering into the crook of her arm what seemed like all the air in the room) "and then" (scooping strenuously now) "expel it. I mean, this" (the mighty scoop again) "is more interesting than this" (a light little turn of the arm). "Both of them are the same movement—I turned both times—but the first one was more interesting, because I inhabited more space." That's what she wants from her students, and they labor for two hours in the morning and two hours in the afternoon to produce it. When the afternoon class is over, they stagger down the corridor, bumping into walls.

FARRELL, as a dancer, had certain technical shortcomings—she wasn't a jumper, and she couldn't really do allegro (fast, small, fine-cut steps)—but no one in the world was more musical. Her connection to music seemed to be something acutely neurological. ("Even in rehearsal," she says, "when the pianist would start to play, I would get nervous, agitated.") As she sees it, music and dance are much the same thing. "There's sound in movement," she says, and space in sound. The dancer's job is to show—or make—the relation between the two: "There's a clarinet cadenza in *Mozartiana* that's very hard to count, but say you count it out, and it's thirteen counts. So you tell yourself, 'All right, I've got time for three pirouettes.' But what about the music's internal time? What if one note is louder, so it needs a bigger response from you, and that takes longer? What if the clarinettist doesn't have as much breath that night, so the music sort of fades in and out? You can't really dance to counts, or I couldn't. On any given night, at any given point, I didn't know if I was going to do three turns, or two, or four. You have to dance in the drama of the music, in *that* timing, at *that* moment."

Some people say that musicality can't be taught, but Farrell teaches it. "I would be remiss if I didn't," she told me. According to her, kids these days have no musical sensitivity. "They don't know a waltz from a march," she says, wonderingly. "When the music changes from three-four to four-four, they don't hear it." And so she makes them hear it. She claps, she taps, she chants, she waves her arms. She also assigns mind-bending rhythms. "She'd give you *fives*," Lydia Walker, one of her students, says. "Or the count would be in three, but the music would be in four. It fit at the end—the phrase was twelve counts, so the pianist did three fours, and we did four threes—but it wasn't easy."

Hard as Farrell's class is, it's partly about joy. She says that in the ten-year grind of preprofessional ballet training many dancers sacrifice their sense of pleasure in the quest for a featureless perfection, and also that they spend too much time comparing themselves with others: "I say to them, 'There will always be a dancer

who turns more times than you, whose leg goes higher, jumps better—prettier, thinner, something. But no one has what you have—your eyes, your neck, how you carry yourself. So you'd better start liking that, and showing it.' " Again and again, she tells the dancers to stop looking in the studio mirror. "I say to them, 'You know how there's a payer and a payee, and an employer and an employee? Well, there's a looker and a lookee, and you can't be both. You can't be an honest performer and a spectator at the same time.' If you want to become a boring dancer, that's how to do it, by trying to tell the audience what to see."

Very rarely do the students produce, that minute, the effect that she is asking for. Often, they dance a little worse. They had a thing they had mastered, which they thought made them look good. She has taken it away. She doesn't require them to solve the problem immediately. Even less does she expect the dancers she is coaching to do, in the studio, what they will do onstage. She doesn't believe you can rehearse a ballet; all you can do is "prepare." When she was dancing, she says, she rarely practiced right before the curtain went up: "I'd get onstage during the intermission, and I'd walk around and I'd feel my shoes and just be there, and I'd see people around me practicing double pirouettes and all kinds of things. Sometimes I'd think, Oh boy, maybe I should be doing something. But, you know, I rarely missed things in performance. The people who were practicing before—they were the ones who missed things. Because in performance you're not the same as before. Before is over. The performance is now."

FARRELL didn't invent this philosophy. "Now!" Balanchine used to say to his dancers. "What are you saving it for? Do it now!" As a boy in St. Petersburg, Balanchine lived through the Russian Revolution and civil war, and the privations of that period left a permanent mark on him. By the time he graduated from school, he was spitting blood. Later, after he escaped to Europe, in 1924, he was diagnosed with tuberculosis, and spent three months in a sanatorium. For years afterward, he was assailed by afternoon fevers and sweats. "You know, I am really a dead man," he said to

one of his early dancers. "I was supposed to die and I didn't, so now everything I do is second chance. . . . I don't look back, I don't look forward. Only now."

He applied that rule to his company. He was convinced that you could not really change a dancer. All you could do was develop what she already had. In choreographing a ballet, he would often say to the people he had assembled, "Well, what can you do?" Then, if he liked what they showed him, he would work it up, and put it in, and let the dancer complete it. Farrell recalls, "Sometimes he'd say to me, 'Oh, Suzi, you know what I mean.' And I did." Not all the dancers wanted that kind of license, but those who did were the ones who tended to grow. No twentieth-century choreographer had a more glorious record of developing ballerinas—that is, female stars—than Balanchine did. Farrell was only one. Before her came Tamara Toumanova, Marie-Jeanne, Mary Ellen Moylan, Maria Tallchief, Tanaquil LeClercq, Diana Adams, Allegra Kent, Violette Verdy, Patricia McBride. After her there were Gelsey Kirkland, Merrill Ashley, and Darci Kistler. Balanchine's assembling of this splendid lineup is sometimes regarded as a Russian mystery, but there was no mystery. He just found out what these women *wanted* to do, and made it as interesting as he could.

Then he pushed them to make it fresh, vital. Balanchine never scolded his dancers for falling. He was more likely to scold them for not placing themselves at the risk of falling. "Zombies," he would say to his class on mornings when they seemed to be dancing by rote. To wake them up, he would speak in symbols, tell jokes. "Hands! . . . Hands are important. . . . Hands will kill you. . . . Aaarrgh!" he said to the class, and strangled himself enthusiastically. Anything to upset their ballet-student calculations. Another means to that end was the notorious difficulty of his class. (About half his company couldn't hack it, and went to other teachers.) His purpose was of course to extend his dancers' range, but also to throw them off the idea of perfection. "Perfect is boring," he told them. He forbade them to look in the mirror. "I'm the mirror," he said.

In service of the same goal, maximum spontaneity, he never

wanted the dancers to have to do, onstage (class was different), anything they were visibly struggling with. When the cast of a ballet changed, he often changed the choreography to fit the new performers. As a result, many of his ballets exist in a number of versions. This drives dance historians crazy, but it didn't bother Balanchine. He told people that he did not see his work as permanent. "When I go, it goes," he said.

What this comes down to is an aesthetic of improvisation, and, while that accorded with his philosophy of life, it was also a matter of necessity. Balanchine came to the United States in 1933 to found a ballet company, but he didn't get it going until fifteen years later. There were various reasons for that: no money, no audience. (Before him, there was basically no American tradition of classical ballet.) But the worst problem was no dancers. By 1946, he finally had what might be called the first "Balanchine ballerina," Tanaquil LeClercq, who had been trained from childhood in his school, the School of American Ballet. He was very pleased; eventually, he even married her. Then, when LeClercq was twenty-seven, she contracted polio, which left her paralyzed from the waist down. He turned to others—Diana Adams, Allegra Kent—and developed them patiently. But Kent kept taking leaves in order to have a family; Adams was unconfident and injury-prone, and she, too, was trying to have a baby. In 1963, Balanchine created on Adams a Stravinsky ballet, *Movements for Piano and Orchestra.* Then, shortly before the premiere, she found out that she was pregnant, and withdrew. Balanchine was very unhappy, and said that he was going to cancel the ballet. But Jacques d'Amboise, who was cast as the male lead in *Movements,* did not want the ballet cancelled. He had a favorite dancer in the corps de ballet—Suzanne Farrell, seventeen years old—and he suggested that she could learn Adams's role. Balanchine was skeptical, but he said to go ahead and try.

In her 1990 memoir, *Holding On to the Air,* cowritten with Toni Bentley, Farrell describes what happened next. D'Amboise took her to Adams's apartment. Adams lay on the couch, covered with a blanket. D'Amboise pushed the coffee table aside, and on a polished parquet floor (impossible to dance on), with no music

("I was told to listen for 'the big boom,' 'the second crash,' 'the sixth silent note,' or 'the sort of pretty music after the messy music' ") but with only Adams and d'Amboise "grunting, clapping, and singing," Farrell learned some version of the choreography. She improvised, and then d'Amboise took her to Balanchine, and Balanchine improvised—remade the ballet for Farrell. When it was premiered, a few days later, critics said that there was a remarkable new dancer at New York City Ballet.

ROBERTA Sue Ficker, always known in her childhood as Suzi (hence "Suzanne"—the "Farrell" came out of a phone book), was born in 1945. Her father drove a meat-delivery truck; her mother was a nurse's aide. With their three daughters—Suzi, Donna (or Sug, short for Sugar), and Beverly—they lived in a four-room house in Mount Healthy, Ohio, outside Cincinnati. When Suzi was nine, her mother asked her father for a divorce. Farrell says she didn't mind much: "It was good not to hear their fights anymore." The girls carried on—Suzi and Sug as dance students, Bev as a piano student—under the leadership of their resourceful mother, Donna Holly. (She had reverted to her maiden name.) "Stage mothers" have a bad reputation, but behind most great ballerinas stand rugged examples of that species, and Holly is a case in point. One day when Suzi was fourteen, word went around her dance class that a scout from New York's School of American Ballet, Diana Adams, was coming to give out scholarships. Suzi auditioned and didn't get picked. Adams found her graceful but weak. After the audition, however, Suzi's teacher mentioned to Adams that Holly was thinking of moving the girls to New York, and Adams said that if they ever got there Suzi should go for a second audition, at the school. When this was repeated to Holly, she sold the family's furniture, found an apartment for Sug (who was eighteen and wanted to stay in Cincinnati), and set out for New York with the two younger girls and a U-Haul containing Bev's piano. On the day Suzi turned fifteen, she was auditioned at SAB, by Balanchine, and was given her scholarship. The family moved into the Ansonia, a Beaux-Arts pile, home to many theatrical

types, on upper Broadway. For three women and a baby grand, they had one room. They cooked on an illegal hot plate or ate at the Horn & Hardart Automat across the street. They also used the toilet at the Automat; the one in their room usually didn't work. There was only one bed. Suzi and Bev slept in it at night; Holly, now working as a private-duty nurse, occupied it during the day. When the girls came home from school, their mother was asleep. "We had to do our homework by candlelight," Farrell recalls in her book. "Even with the scholarships"—Bev got one, too, at the Manhattan School of Music—"there was very little cash, and Mother often worked twenty-hour shifts, arriving home completely exhausted."

In 1961, shortly after she turned sixteen, Farrell joined NYCB, and less than two years later she took Diana Adams's place in *Movements for Piano and Orchestra.* Before *Movements,* Balanchine had paid her some notice; after it, he seemed to notice nobody else. The following season, he made a ballet, *Meditation,* to Tchaikovsky. As the curtain opened, an older man (d'Amboise) was seen kneeling in despair on a darkened stage. In came a sort of vision: Farrell, her hair down, in a white chiffon dress. She danced with him, their energy and emotion mounting—triple pirouettes, hair flying—until at last, still reaching out her arms toward him, she stepped back into the wings, and he knelt again in grief. *Meditation* was not just a tribute; it was a public announcement. Balanchine was in love, and the fact that he was forty-two years older than Farrell made no difference to him.

In the fourteen months after *Meditation,* Farrell was given fifteen additional leading roles. Balanchine also went on making new ballets for her, at least one per year, sometimes three or four. In 1965, he created a three-act *Don Quixote* in which she appeared as a servant girl, a shepherdess, the Virgin Mary, and of course Dulcinea. Let me count the ways, Balanchine was saying. At the first performance, he himself stepped into the role of Don Quixote, and fell at her feet. Soon afterward, the two of them appeared together on the cover of *Life.* In the accompanying story, Balanchine was quoted as saying, "Everything a man does he does for his ideal woman." After the first performance of *Don Quixote,*

Farrell said, she and Balanchine went to Dunkin' Donuts and talked about how happy they were and "how life would go on like this forever."

AT the time, Balanchine was still married. His treatment of LeClercq was not quite as scandalous as it seemed. Their marriage had cooled years before—even, it has been said, prior to her illness—and in the meantime he had had other infatuations (with Diana Adams, for one). But LeClercq was not the only person Balanchine was pledged to. He had a company of eighty-odd dancers, who looked on in dismay as the operations of NYCB were restructured around the young Suzanne Farrell. Before, the troupe's daily class was taught by various people, including Balanchine. But by 1964 he began teaching company class every morning, and he appeared to tailor the exercises to Farrell. He seldom taught jumps anymore—and he took the jumps out of ballets she was now dancing—because she had a trick knee and was not good at them. Often, when he gave a combination, he would have Farrell demonstrate it first. "Do like Suzanne," he told the dancers.

By 1965, Farrell was the star of the company, performing the lead in twenty-eight ballets, one-third of the repertory. This meant she was appearing almost every night, frequently twice a night. As one of her colleagues put it, "No one else danced." Or, when other female principals got onstage, it was often in Balanchine's absence. Before, he had watched every one of his company's programs, to the end, from his post in the downstage-right wings. Now he left the theater when Farrell was through for the night, and took her out to dinner.

Needless to say, she was hated—a "leper," as she once put it. This is almost always the position in which the director's favorite is cast, but Farrell's personality was not one likely to soften the blow. "People often said she was aloof and formidable," Diana Adams recalled in a 1982 interview with the dance critic David Daniel. "Well, she was. . . . She was exactly the same way when she was fourteen." Eventually, a number of the other female principals—Maria Tallchief, Mimi Paul, Patricia Wilde, Patricia Neary—walked out. The unhappiness rose to such a pitch that

the audience, too, became part of it. Fans discussed it in coffee shops after the show; newspapers printed letters to the editor about it. The company was in a crisis.

STILL, what Balanchine had done was not without logic. Imagine what it meant to him, after the losses he had suffered with his earlier ballerinas, to have this young, strong, gorgeous dancer walk into his life, capable, it seemed, of doing almost anything he asked, and ready to work every day until she dropped. Fate had sent her to him, he believed, and he was not going to turn away. "Watching him teach her," Adams said, "was like seeing an engineer tuning and revving up a fantastic new machine. . . . He began to make things harder and harder. Suzanne inhaled and kept going." He made things harder still. She kept up with him. Soon, they had left the rest of the company behind.

Balanchine had always wanted greater amplitude, and soon after Farrell joined the company he desperately needed it, for in 1964 NYCB moved from City Center to the New York State Theater, in the recently opened Lincoln Center. His work now had to occupy one and a half times as much stage space as before. This challenge, and not just Farrell, was the reason he started teaching company class every day, and changed his class. Before, Melissa Hayden, one of the lead dancers of that time, has said, "he had talked for hours about the articulation of the foot." Now he was less interested in details. He wanted big steps, steps that could fill that echoing stage. But he was certainly influenced by the fact that he now had, in Farrell, a young wildcat who was dying to do big steps. And so, in collaboration with her, he developed a new style. Farrell calls it "off-balance" dancing, and its off-balance qualities—the reckless tilts and lunges—were indeed the first thing one noticed about it, but it was also new in its utterly plastic musicality and, above all, in its scale. Farrell's movement came in bolts, in waves, in tearing trajectories. (Balanchine rarely sent her out onstage without an expert partner, one who could prevent her from hurling herself into the orchestra pit.) Even when her dancing was slow, it was wild: pooling, flooding. And she performed this way not just in Balanchine's new ballets but in his old ones as

well. She changed the repertory, and, as other dancers emulated her, she changed the company. In time, she affected every American company. If, today, American ballet dancers are notably headlong—feat-doers, ear-kickers—that is due in part to Farrell. And if, when they are also profound, they are profound in a cool, exalted, unactory way, that, too, in large measure, is Farrell speaking, or Farrell and Balanchine.

But when Farrell arrived Balanchine didn't just change his style; he seemed to change his content. Before, in what might be called his classic years—from 1928 *(Apollo)* to about 1962 *(A Midsummer Night's Dream)*—his ballets had addressed sex and religion, grief and fate, but those matters, for the most part, were bound in by classicism: tempered, formalized. Now they became pressing and specific. Many of the works that Balanchine made for Farrell in the so-called "Farrell years," the 1960s, had a sort of jazz-baby sexiness. In these pieces, her costumes tended to be fringed; she tended to be partnered by Arthur Mitchell, the company's one black man, a pairing that in the sixties had sexual implications. Some observers were taken aback by such directness. In time, the profane yielded to the sacred, and that was even more surprising. Now the supposed abstractionist was filling his stage with angels and gypsies, visions and confessions. Balanchine had embarked upon a "late period," and it was Farrell who led him there.

In 1967, Balanchine separated from LeClercq and moved into an apartment of his own. Now he and Farrell not only had dinner together every night; they had breakfast together every morning. She'd leave her house, pick up a cheese Danish for him, and go to his place for coffee. Then they would walk to the theater. Farrell says they rarely discussed ballet when they weren't working. They played word games, and talked about their cats or the Bible. Outside the studio, they were usually alone. She didn't fit in with his friends. (They were old, she says, and "often talked in Russian about things that had happened before I was born.") As for her friends, she didn't have any. Eventually, she found one companion in the company, a Peruvian-born dancer named Paul Mejia,

whom Balanchine liked, and considered safe—Mejia was devoted to him—but that was it. On nights when Balanchine was not free to take her home after the show, he sent his manager to do so.

For Balanchine, this was an old pattern. Throughout his career, his working method was to fall in love with a young dancer, make wonderful ballets for her, perhaps even marry her (LeClercq was his fourth wife), and then move on to the next young dancer. Farrell knew this, and she decided that her story would be different. She wouldn't marry him—he had asked—nor would she go to bed with him. She would just dance for him, and that would be enough, for both of them. She wasn't particularly interested in sex, and, according to her, he wasn't, either. (Maria Tallchief, his third wife, recalls in her memoir that he insisted on twin beds.) Their consummation came in the studio. In Anne Belle and Deborah Dickson's film *Suzanne Farrell: Elusive Muse,* Farrell says that when Balanchine danced with her in the studio as he was choreographing his ballets, "it was extremely physical and extremely gratifying in that kind of way." It wasn't your usual sort of love affair, she adds, "but it was more passionate and more loving and more *more* than most relationships. It was terrific."

Then, gradually, it wasn't terrific anymore. She tried to see other men; Balanchine threw fits. She told him she would no longer be available for dinner every night. He said okay, and then he stopped eating, whereupon a member of his staff pleaded with her, and she began having dinner with him again. One of the men in the company said to her, "Why don't you just sleep with him? . . . Is it such a big deal?" She was shocked. Still, she saw no way out. She stopped sleeping. She cried all the time. "I was being killed by it," she said. Her dancing suffered. (By 1968, according to Arlene Croce, in *Ballet Review,* she was starting to look not just extreme but vulgar.) The only person she could turn to with her troubles was Paul Mejia, and, not surprisingly, she began to feel she was in love with him. This enraged her mother, who could not understand why she wouldn't marry Balanchine. (Who cared if he was old? He was a genius.) Farrell moved out—"with what I could carry," she says—and found her own apartment.

In the fall of 1968, Balanchine, apparently still believing that Farrell, if pressed, would marry him, flew to Mexico and applied

for a divorce. It was granted the following February, but he couldn't act right away, because he had a commission to stage an opera in Hamburg. He left New York on February 16. Five days later, in a church two blocks from the theater, Farrell married Mejia. Balanchine's assistant, Barbara Horgan, flew to Hamburg and spent ten days calming him down.

When he returned, he would not speak to Farrell, and though her casting remained the same, Mejia's did not. He couldn't seem to get onstage. One night, two months after Farrell's wedding, the company was scheduled to dance *Symphony in C,* and the dancer who was cast as the male lead in the third movement cancelled. Mejia had often performed that role. Farrell sent Balanchine an ultimatum. If Mejia did not dance that night in the third move-ment, she would not dance her famous role in the second move-ment; indeed, she would no longer dance for New York City Ballet. She was sure it would all work out. She went to the theater, she put on her makeup, and then there was a knock at the door. It was the company's costume mistress, who came in, collected the *Symphony in C* tutu, and left, weeping. Balanchine had accepted Farrell's resignation.

She was twenty-three, and possibly the most celebrated dancer in America, but she could not just join another company. She was a creation of Balanchine's style and repertory. (She had never per-formed the "classics"—*Giselle, The Sleeping Beauty.*) And, as she soon found out, other American companies were not interested in hiring her. No one wanted to alienate Balanchine. Finally, Farrell and Mejia went to Europe, and danced in Brussels with Maurice Béjart's Ballet of the XXth Century, a company that had no con-nection with Balanchine. On the contrary. Béjart's work was not so much ballet as a sort of extravagant multimedia theater. Many of Balanchine's fans felt as if Farrell had run off with a biker.

Balanchine went into a depression, and for the next two years he made little of interest. Then, as always, he recovered. In 1972, he staged his now famous Stravinsky Festival, and created for it at least two ballets, *Stravinsky Violin Concerto* and *Symphony in Three Movements,* that are among his masterworks. He even found a new woman, Karin von Aroldingen, a German dancer who was a member of the company—but not so young this time, and safely

married—and formed with her a sort of *amitié amoureuse*. He made new ballets for her, and about her, together with works for and about the other female principals he had at that time, notably Patricia McBride, who now came into her own.

But the story with Farrell was not over. After four years with Béjart, she wrote Balanchine asking if she could come back to NYCB. It is hard to get her to explain why she did this. She loved Béjart, and she insists that she learned a lot from him. All she can say is that, on a vacation back in the States, she went to a performance by NYCB and became so excited that she had to write to Balanchine, had to make a bid to dance his ballets again: "It was as instinctive as the understanding that George and I had in the studio: 'I'd like to do this—would you like to do this?'" In any case, Balanchine said yes. (To her only. Mejia took jobs elsewhere, and the two began living apart much of the time. They were divorced in 1998.) In January of 1975—in *Symphony in C,* appropriately— Farrell bourréed out again on the stage of the New York State Theater. Balanchine's passion did not reignite, but his inspiration did, and it was in this second, less tumultuous period that she spent with NYCB—not in the "Farrell years"—that he fashioned the best roles he ever made for her, in *Chaconne, Vienna Waltzes, Walpurgisnacht Ballet, Davidsbündlertänze.* His last piece, *Variations for Orchestra* (1982), was for her. His last great piece, *Mozartiana* (1981), was for her.

In 1982, when he was seventy-eight, he began having trouble with his balance, an early sign of what turned out, on autopsy, to be Creutzfeldt-Jakob disease, the human version of mad-cow disease. (According to his doctor, he once got some "rejuvenation" injections in Switzerland. Such injections often contained extracts from animal glands.) Soon, he had other problems. Sounds were too loud; things looked blurry. That fall, he was taken to Roosevelt Hospital for observation, and he died there five months later.

ACCORDING to some accounts, Balanchine had been grooming Peter Martins—a big, tall Dane who began dancing for him, as Farrell's partner, in 1967—to take over NYCB after him. Martins

had been making ballets for several years, and Balanchine had encouraged him. Yet, as Martins himself has pointed out, Balanchine never gave him a blessing as his successor. (And Martins sought it, went to his bedside for it.) Balanchine apparently didn't think he could have a successor, didn't believe that his ballets, so personal—this one about LeClercq, that one for Farrell—could survive without him. But the public wanted them to survive. So did NYCB's board. (Balanchine's ballets at that time constituted two-thirds of the company's repertory.) And to the board Martins seemed a logical choice. He was a superb classical dancer, and therefore, presumably, he could be counted on to safeguard the company's technique. Furthermore, he was handsome and clubbable: a good prospect for fund-raising. And so, with great haste—indeed, a month and a half before Balanchine died—he was installed as director. Jerome Robbins, who had long been NYCB's second choreographer, was made codirector, but it was understood that Martins would run the company.

For about two years, things went fine. Then a kind of coldness began to set in. The problem was not so much with the new repertory. If the pieces that Martins was making and commissioning were not as good as Balanchine's, what was? As long as he kept the Balanchine repertory in shape, he was doing his hard job as the great man's successor. But Martins, as it turned out, was not a "Balanchinean." Where Balanchine was an idealist, a mystic of sorts, Martins was skeptical, ironical, up-to-date. He set up seminars where dancers talked about being working mothers. He published an exercise book, *The New York City Ballet Workout,* with photographs of ballerinas doing ab crunches. And, as was soon clear from the company's performances, he could not think himself into a different place, nor could his coaching staff. The dancers—uninformed, it seems, as to what Balanchine's work was about, but still knowing that it was "great" and famous—began performing it in a tight, blank way, as if it were a lesson they were trying to recite correctly. This was noticed by the press. Dale Harris, in the *Wall Street Journal,* called the company's performances "generally dispiriting." Tobi Tobias, in *New York,* described NYCB's Balanchine stagings as "vandalism." Other reviewers,

notably at the *Times* and the *Washington Post,* defended Martins, saying that there were many ways to dance Balanchine. Caught in the middle of a fight, the dancers looked scared, and performed the ballets even more blankly.

Farrell was a logical person to do something about this situation, and Martins seemed to indicate that he was going to use her. In his speech at her retirement party, he said, "There will always be a place for Suzanne Farrell at New York City Ballet. She can do whatever she wants." He kept her on salary. Then, for three years, he asked her to do almost nothing. Finally, in 1993, the company manager called to say that Farrell was being removed from the payroll. The troupe's finances—which, in a public interview four months earlier, Martins had proudly described as being in excellent shape—were straitened, the company manager explained.

"I was fired," Farrell says. Martins puts it differently. In a 2000 interview in *Talk,* he said that he offered Farrell a job at NYCB but that she countered with all sorts of demands. For example, she expected an office of her own (he wanted to give her a desk in his office), and she asked for the title of associate director (he wanted to wait on that). "So there was this whole set of conditions," he recalled. "She didn't want it. That's the bottom line. If she's really honest with herself, she didn't want it." When I asked Farrell about this job offer, she said she had no recollection of it. "Why would I want an office?" she asked. "Do I have an office now? I want to work in the classroom. No, what happened is, he did offer me little things. He asked me to teach company class during *Nutcracker,* when no one comes to class. He asked me to stage a ballet for SAB—Balanchine's *Gounod Symphony,* an enormous piece that I had never danced in, and had hardly seen. He offered me things that he thought I would turn down. But I didn't turn them down. I took these crumbs he offered me. Eventually, he figured out that he was not going to get rid of me that way, so then the other thing happened"—the call from the manager came.

It would not be surprising if Martins, whose authority with regard to Balanchine's work was being seriously questioned at this time, did not want on his staff the person who was widely considered to be the world's foremost expert in that matter. There were

probably other reasons, too, for the company's failure to use Farrell. She was known to be standoffish. Furthermore, there is a widespread belief that great dancers do not make great teachers, that they can't bear to give it away. That rule has been broken many times—by Farrell, for example. Prior to her severance from NYCB, she had done highly praised settings of six Balanchine ballets. She was clearly an effective Balanchine coach.

SUCH was the situation in which James Wolfensohn saw an opening for the Kennedy Center. Farrell's first Balanchine season at the center, in 1995, had some rough spots, but even then one could see in it something interesting: all the dancers whom one already knew looked better than they ever had before. In the words of Alan Kriegsman, the *Washington Post*'s dance critic, Farrell seemed to move dancers "beyond their own previous standards." Still, the Kennedy Center didn't rush her. After the 1995 season, she waited four years to present her next one. To everyone's surprise, it included *Meditation,* the first piece Balanchine made for her, the one with the older man and the young ballerina-spirit. This ballet had a highly personal meaning for Farrell; with it, she has said, Balanchine had choreographed her life. No one but she had ever danced it, and consequently it hadn't been performed in fourteen years. It wasn't missed, actually. Many people remembered it as a sort of overwrought thing that might just as well be put in the drawer, like the old love letter that it was. Yet Farrell brought it out and set it on someone new, Christina Fagundes, formerly of American Ballet Theatre. Fagundes had never been a wafting sort of dancer. She was down-to-earth—a mezzo type—and she did *Meditation* in her own way. When Farrell danced it, the ballet was something that happened to the man; when Fagundes danced it, it was something that happened to her. Thus, if she was not better than Farrell had been, she was more poignant. If Farrell ever sought to show that she was willing to give what she had to others, this was the proof.

From the beginning, a crucial fact about the Suzanne Farrell Ballet was that it was a pickup company. It still is. Every year, once

Farrell figures out what she's going to do, she has to get on the phone and find people to do it. Most good ballet dancers are employed by permanent companies, which they cannot necessarily leave for a five-night gig, let alone a five-week tour. As a result, Farrell seldom has ideal casts. As Alexandra Tomalonis put it in the *Washington Post,* "She's working with schoolgirls and soloists from all over the map." Even when she is working with stars, they are often overscheduled or underrehearsed. Last season, her budget allowed her only four weeks to rehearse seven ballets, and at times that showed. There was many a mishap in the company's new production of *Who Cares?* Also, Farrell doesn't always have a choice of "types." For the lead man in *Who Cares?* you need a roguish, jazzy fellow. (He is dancing to Gershwin, and partnering three different women.) Runqiao Du is not such a fellow. He was trained in Shanghai, far from Gershwin's town, and he is sweet and open-faced. But he is the Farrell Ballet's regular lead male, so he did *Who Cares?* and probably learned a lot from the experience. The same goes for the women who occasionally fell off point in the ballet's solo variations. Farrell might have spared them by staging an easier ballet. But she staged *Who Cares?*—together with two other ballets, *Divertimento No. 15* and *Raymonda Variations,* that have similarly tricky solos. And, if one saw mistakes in them, what one didn't see was the blur, the cheating, that sets in when dancers are trying to avoid mistakes. Every tiny detail was there, and if it went awry you got to see that. Farrell is ambitious for the company, and getting more so. In 2005, she hopes to stage the three-act *Don Quixote.*

The dancers don't seem worried about the exposure. I remember, in Farrell's 2000 season, watching a young woman, Chan Hon Goh, try to get through *Divertimento No. 15.* She wasn't strong enough for it, but she didn't know that. She smiled; she kicked her leg out before the beat. She thought she was doing fine. Once, Farrell talked about Balanchine's ability to communicate faith. At times, she said, "I'm sure he went home saying, 'Oh boy, I don't know if she's going to be able to do that.' But if he worried about us, he worried in silence. He never brought it into the studio." Neither does she, apparently. And, as with Balanchine, this pays

off not just in the present but down the road. Last season, Chan Hon Goh danced the lead—Farrell's role—in Balanchine's *Chaconne,* and now she had more than confidence. In the opening pas de deux, she looked like the Winged Victory. Farrell rarely speaks in psychological terms, but she is a shrewd psychologist. At one point, I asked her about her use of metaphors—the Madonna's arms, etc.—in coaching. I was thinking that this approach was rooted in some deep, mystic chamber of dance knowledge. Well, yes, she said. Then, unmystically, she added that if you correct dancers in terms of their technique, the thing they have worked so hard on, this can be very wounding to them. "But if you give them a metaphor they go home and figure it out, and they haven't gotten a complex about it."

FARRELL has never played down what she sees as the importance, to the art of dance, of the fact that she and Balanchine found each other—"I don't think anything or anyone could have stopped this destiny that was happening," she once said. In her staging, this past season, of Balanchine's *Variations for Orchestra,* a 1982 solo for her, to Stravinsky, she inserted a second dancer, seen only as a towering shadow on a drop curtain, doing sometimes the same steps as the soloist in front of the curtain, and sometimes different steps. On the last note of the piece, the shadow dancer took an elaborate bow. This was a big change to make in a Balanchine ballet, but Farrell has said that she actually choreographed most of *Variations.* (Balanchine was very ill at the time.) If I'm not mistaken, the second dancer was her tribute to her own shadow presence—not just in *Variations* but in most of Balanchine's late work.

Still, however much she honors her own career, she does not expect, or even want, her dancers to reproduce what she did. She told me that on the first day of the *Meditation* rehearsals Christina Fagundes said to her, " 'Oh, how must you feel, teaching this part?' And I said to her, 'Look, Christina, you can never have my story. You have to find your own story.' " Farrell, with Balanchine, made the ballet once, out of their lives. Now Fagundes, with Far-

rell, had to make it again, out of her life. When a ballet is performed even once, Farrell says, "You'll never have that innocent little ballet again—that insecurity, that vulnerability, our faces all so intense." To stay intense, the piece has to become something new. "Only now," as Balanchine said.

Farrell is not troubled by the thought that the ballets will change in the process. "George trusted me," she says. "We trusted each other. Don't listen to what he said about how he didn't care if his ballets survived. He cared a great deal. He never dubbed me or anything like that, but I don't think we would have had the understanding we had if he hadn't meant me to take it somewhere else. Wasn't that just as destined as our meeting? He expected me to go on. He expected it."

What no one could have foreseen was the demands that this new assignment would make on her personality. In Diana Adams's words, Farrell was "aloof and formidable" even as a teenager. More than aloofness is involved here, though. Farrell, in her early years, was fantastically narrow—a geek, an obsessive, a human drill bit, as young artists often are. She says in her memoir that in 1963 she didn't know who the Beatles were. For her purposes, she didn't need to know. Nor did she need to know who anyone else was, apart from Balanchine. When she was onstage, she never looked at the audience. "I dance for God," she said. If others wanted to watch, that was their business. But running a company is different from performing in one. You must deal with people—administrators, musicians, dancers—and Farrell has learned to do so. "She's the least divaesque person I've ever worked with," Michael Kaiser, the president of the Kennedy Center, says. She accepts the compliment. "I'm a team player," she says. Her former colleagues at NYCB will be surprised to hear this. Nevertheless, it seems to be true—now. The shows bear it out.

The most moving spectacle I ever witnessed in a performance by the Suzanne Farrell Ballet was Peter Boal, of NYCB, in Balanchine's *Apollo*. In the seventies, Boal was one of SAB's star pupils. Ballet mothers, there to fetch their children, used to crowd around the door of the studio where he was taking class. He was an ultraclassical dancer, with an innate nobility and reserve—

qualities that were touching to see in a child, and that made him perfect for Balanchine, the only problem being that three days after Boal joined NYCB Balanchine died. For nearly twenty years, Boal has been a pillar of the company, but his career has not been what it should have been. He has never danced any way but beautifully, but at times he also looked a little weary, as if he wished he were somewhere else.

Then came the Suzanne Farrell Ballet. "When she calls," Boal told me, "the first thing I say is yes. Then we work out the details." When she called in 2001, he was on his way to Tokyo, and showed up in Farrell's studio two days before he was to dance the title role in *Apollo*. This was not a crisis—he had performed the role many times at NYCB. But in the *Apollo* that took the stage at the end of that week Boal was very different from what he had been before. He was a young man again—something I'm not sure I saw when he was a young man. In the ballet, when he was born, he was really born: fresh, disorderly, wet almost. As he grew—that is the story of the ballet, Apollo's progress from his birth to the moment when he realizes he's a god, and departs with the Muses for Olympus—he was different at every stage, differently vibrant. He flew, he jumped, he sweated, he got red in the face. *Apollo* is not just any Balanchine ballet. It is his oldest extant ballet, and possibly the most canonized. It is glazed by time and fame and use, and Boal has performed it that way. But for Farrell he peeled its skin off. In the finale, the Muses caught Boal's mood, and when the great minor chord sounded, telling them it was time to leave for Olympus, the three women reached toward him on bended knees that were perfectly classical, perfect triangles, but also pink and trembling. They were going to Heaven! They couldn't believe it!

I wonder if Balanchine's early companies—which, before 1948, were also pickup companies—did not look like this, and maybe New York City Ballet, too, in its City Center days. Art doesn't start out hallowed. It starts personal: an emergency. When Balanchine's oldest fans speak of certain moments—of Maria Tallchief in *The Firebird*, gliding across the dark stage, putting the monsters to sleep, or of Tanaquil LeClercq in *Western Symphony*, wearing her sexy black hat and banging out fouettés—it seems to me that this is what they mean: theater that isn't just a show but

something immediate, unfakable. I came to Balanchine in the late 1960s. He, too, was in his sixties then. However good he was, it is possible that he was better when he was in his twenties, and made *Apollo*. Watching Boal that night, I thought of this. Perhaps what we are seeing in the Farrell Ballet is an avatar of the early Balanchine, young and crazy. Maybe it has to be this way every time.

The New Yorker, 2003

Mikhail Baryshnikov, 1998

The Soloist

I T is raining, and Mikhail Baryshnikov is standing in a court-
yard in Riga, the capital of Latvia, pointing up at two corner
windows of an old stucco building that was probably yellow
once. With him are his companion, Lisa Rinehart, a former
dancer with American Ballet Theatre, and two of his children—
Peter, eight, and Aleksandra, or Shura, sixteen. He is showing
them the house where he grew up. "It's Soviet communal apart-
ment," he says to the children. "In one apartment, five families.
Mother and Father have room at corner. See? Big window.
Mother and Father sleep there, we eat there, table there. Then
other little room, mostly just two beds, for half brother, Vladimir,
and me. In other rooms, other people. For fifteen, sixteen people,
one kitchen, one toilet, one bathroom, room with bathtub. But
no hot water for bath. On Tuesday and Saturday, Vladimir and I
go with Father to public bath."

I open the front door of the building and peer into the dark
hallway. "Let's go up," I suggest. "No," he says. "I can't." It is more
than a quarter century since he was here last.

AFTER his defection to the West, in 1974, Baryshnikov said again
and again that he had no wish to return to the Soviet Union, or
even to the former Soviet Union. Then, late last year, he accepted
an invitation to dance at the Latvian National Opera, the stage on
which he first set foot as a ballet dancer. Why he changed his
mind is something of a mystery. Perhaps he just felt that it was
time. (He will turn fifty next week.) Perhaps he wanted to show
his children what he came from. To me all he said was "I am going
to visit my mother's grave."

Baryshnikov, actually, is not a man for sentimental journeys. He is too resistant to falseness. Nor does he like being followed around by journalists. Interviews are torture to him: "You ask me what's happened in my life, why and how I did this and that. And I think and tell, but it's never true story, because everything is so much more complicated, and also I can't even remember how things happened. Whole process is boring. Also false, but mostly boring." He politely does not point out the journalist's role in this: how the questions are pitched, and the answers interpreted, according to already established ideas about the life in question— in this case, the life of a man who escaped from the Soviet Union at the age of twenty-six. It is hard to find an article on Baryshnikov that does not describe a look of melancholy in his eyes, supposedly the consequence of exile from his Russian homeland. This is the dominant theme of writings about him, but in his view it has nothing to do with him. He has lived in the United States for almost half his life. He is a United States citizen and regards this country as his home. He has lived with an American, Rinehart, for about ten years, and they have three children who speak no Russian.

Of course, when his return to Latvia was announced, the exile theme sounded with new force. The press in Riga was sown with sentimental formulas: the prodigal-son motif, the return-home motif, the ancestral-roots motif. He refused them all. For Russia, he says, he feels no nostalgia. Though his parents were Russian, he did not move to Russia until he was sixteen: "I was guest there, always." As for Latvia, it was his birthplace, but his parents were "occupiers" (his word) there. "The minute plane set down, the minute I stepped again on Latvian land, I realized this was never my home. My heart didn't even skip one beat."

WHAT has made Baryshnikov a paragon of late-twentieth-century dance is partly the purity of his ballet technique. In him the hidden meaning of ballet, and of classicism—that experience has order, that life can be understood—is clearer than in any other dancer on the stage today. Another part of his preeminence derives, of course, from his virtuosity, the lengths to which he was

able to take ballet—the split leaps, the umpteen pirouettes—without sacrificing purity. But what has made him an artist, and a popular artist, is the completeness of his performances: the level of concentration, the fullness of ambition, the sheer amount of detail, with the cast of the shoulder, the angle of the jaw, even the splay of the fingers, all deployed in the service of a single, pressing act of imagination. In him there is simply more to see than in most other dancers. No matter what role he is playing (and he has played some thankless ones), he always honors it completely, working every minute to make it a serious human story. In an interview prior to the Riga concerts, the Latvian theater critic Normunds Naumanis asked him why he danced. He answered that he was not a religious person (quickly adding that his mother had been, and had had him secretly baptized) but that he thought he found onstage what people seek in religion: "some approximation to exaltation, inner purification, self-discovery." He may hate interviews, but once he is in one he tends to pour his heart out. (This may be why he hates them.)

Though Baryshnikov directs a company, the White Oak Dance Project, he went to Riga in October alone, as a solo dancer, and next week at City Center, in New York, he will again perform by himself—his first solo concerts, ever, in the United States. There is something fitting in this. The things he now seeks in dance—the exaltation, the self-discovery—are easier to find if one is not lifting another dancer at the same time. Furthermore, audiences these days don't want their view of him blocked by other people. But, basically, solo is his natural state, the condition that made him. The rootlessness of his childhood sent him into himself—made him a reader, a thinker, a mind—and the rule of force he worked under in the Soviet Union had the same effect: it made him cherish what could not be forced, his own thoughts. This became a way of dancing. It is not that when he is performing he is telling us who he is. Rather, he is telling us, as fully as he can, what truth he has found in the role, what he has thought about it. In many of his solos today, he seems to be giving us a portrait of thought itself—its bursts and hesitations, the neural firings—and this is something one must do solo.

It was as a presenter of new work, not just as a dancer, that Baryshnikov returned to Riga. Most of the solos he brought were from his White Oak repertory—works by people like Mark Morris, Twyla Tharp, and Dana Reitz. These pieces were far removed from the earnest Soviet ballets that the Latvians had last seen him in and that some of them would probably have liked to see him in again. (The Reitz piece, *Unspoken Territory,* has him, in a sarong, stalking around the stage in silence—no music—for twenty minutes.) In his mind, he was going to Riga not as he was then but as he is today.

To the Riga press, however, it was what he was then—the man who had been one of them and had left—that was important. Also, as usual in the Soviet Union, former or otherwise, politics came to greet him. There is considerable tension between Riga's Latvian and Russian populations. (Though Russians outnumber Latvians in the capital, Latvian independence has made the Russians the underdogs now: they must pass a Latvian-language test to get a job in the government.) The Russians wanted to know why Baryshnikov had come to Latvia, not to Russia, and why, if he gave only three interviews concerning his visit (he wanted no press, no questions), he gave them to Latvian, not to Russian, journalists.

To such problems Baryshnikov applied his usual remedy: work. The happiest I ever saw him in Riga was in a studio in his old school, rehearsing works for the upcoming program. Perched on a folding chair, watching him, was the director of the school, Haralds Ritenbergs, who had been the leading danseur noble of the Latvian state ballet company when Baryshnikov was a child. ("To us he was like Rock Hudson," Baryshnikov says.) Next to Ritenbergs sat Juris Kapralis, a handsome, bighearted Latvian whom Baryshnikov had as his ballet teacher from age twelve to sixteen. What must these men have felt? Here was the dear, small, hardworking boy they had known, now almost fifty years old and the most famous dancer in the world, rehearsing before them steps such as they had never seen. There should have been some shock, some acknowledgment of the break in history—of all the

years when so many things had happened to him, and to them, to make their lives so different. But there was none of that. What I saw was just three old pros working together. Baryshnikov would perform the steps. Then he and the two older men would huddle together and, in the hand language that dancers use, discuss the choreography. Yes, Baryshnikov said, this piece, no music. Yes, here I do arms this way, and he demonstrated a stiff, right-angled arm, the opposite of what ballet dancers are taught. I looked for raised eyebrows. There were none. The older men nodded, watched, asked questions. To them, it seemed, he was still their hardworking boy, and his business was their business, dancing. Baryshnikov showed them his shoes—jazz shoes, Western shoes—and Ritenbergs and Kapralis unlaced them, peered into them, poked the instep, flexed the sole. They were like two veteran wine makers inspecting a new kind of cork. Whatever feelings passed among the three men, they were all subsumed into work. Now, as had not happened when Baryshnikov showed me his old house or the hospital where he was born, time vanished. He had returned home at last, but the home wasn't Riga; it was ballet.

MIKHAIL Nikolaievich Baryshnikov was born in Riga eight years after Latvia, in the middle of the Second World War, was forcibly annexed to the Soviet Union. Once the war was over, Russian workers streamed into this tiny Baltic country, the size of Vermont. Among them was Baryshnikov's father, Nikolai, a high-ranking military officer who was sent to Riga to teach military topography in the Air Force academy. With him came his new wife, Aleksandra, who had lost her first husband in the war, and Vladimir, her son by that first marriage. By Nikolai, she had Mikhail, eight years younger than Vladimir, in 1948. The parents' marriage was not happy. The father seems to have been a curt, cold man. The mother, Aleksandra, was another matter, Baryshnikov says—"softer, interesting." She had had very little education but was a passionate theatergoer. She went to drama, opera, and ballet, and she took Misha with her.

Misha was one of those children who cannot sit still. Erika

Vitina, a friend of the family, says that when he ate at their house you could see his legs dancing around under the glass-topped dinner table. He himself remembers movement as an outlet for emotion. "One time I recall is when my mother first took me to visit my grandmother, on the Volga River," he told me. "Volga, it's a long way up from Latvia. We took a train through Moscow, and Moscow to Gorky, plus then you drive another seventy miles. We took taxi, or some car delivered us. It was very early morning when we arrived—little village, and very simple house, and there was my grandmother. And I was in such anticipation, because I was like five or so, maybe six. My mother said to me, 'Mikhail, hug your grandmother.' But I was so overwhelmed that I couldn't run to her and hug her. So I just start to jump and jump, jump like crazy, around and around. It was embarrassing, but same time totally what I needed to do. Mother and Grandmother stood and looked until it was over."

When he was about nine, his mother became friends with a woman who had danced with the Bolshoi Ballet in Moscow and who now gave ballet lessons in Riga. "Mother was very excited by this friendship," Baryshnikov says. She enrolled him in her friend's class. When he was eleven, he moved over to the Riga School of Choreography, the state ballet academy. (One of his classmates there was Alexander Godunov, who would also defect, and dance at American Ballet Theatre under Baryshnikov's directorship.) Soon he showed extraordinary talent. Erika Vitina stresses the mother's involvement in Misha's ballet studies: "The father had no interest whatsoever in the ballet school. The mother brought him to the ballet school, put him there. All this happened physically, hand to hand."

"I was mama's boy in a way," Baryshnikov says. He remembers how beautiful she was. (In fact, in the one photograph I have seen of her she looks uncannily like him. It could be Baryshnikov with a wig on.) "My mother was a country girl from the Volga River," he said in a 1986 interview with Roman Polanski. "She spoke with a strong Volga accent. Very beautiful, very Russian—a one-hundred-percent pure Russian bride. But to tell the whole story of my mother, it's a long story." The end of the story is that during the summer when he was twelve she again took him to the Volga

to stay with her mother and then she went back to Riga, alone, and hanged herself in the bathroom of the communal apartment. Vladimir found her. Baryshnikov never knew why she did it. "Father did not want to talk about it," he told me. Soon afterward, Vladimir left for the Army, and the father told Misha that now they would live together, just the two of them. The following year, Nikolai went away on a business trip and returned with a new wife, a new life. "I understood that I am not wanted," Baryshnikov said.

He looked for other families. He spent most summers with the family of Erika Vitina, and he stayed with them at other times as well. "Quite often," Vitina says, "he would ring our doorbell late at night, saying that he had run away. But a week later I would receive a call from the ballet school"—she, too, had a child enrolled there—"and would be told that unless I sent Misha home they would have to call the police. We spent two years in this manner. From time to time, he'd come to stay with me, and then his father would take him away again." Insofar as Baryshnikov has lived a life of exile, it had begun.

Erika Vitina recalls that his nights were often hard. Because he worried that he was too short to be a ballet dancer, he slept on a wooden plank—he had been told that this would help him grow faster (less traction)—and the blankets wouldn't stay tucked in. Before going to bed herself, Vitina would look in and cover him up again. Often, he would be calling out in his sleep, caught in a nightmare. But during the day, she says, he was "a happy, sunny boy." Now, looking back on those years, Baryshnikov is quick to dispel any atmosphere of pathos: "Children being left, it's not always like books of Charles Dickens. When you lose your parents in childhood, it's a fact of life, and, you know, human beings are extraordinary powerful survivors. My mother commit suicide. I was lucky it was not in front of me, okay? Which is truth, and Father was confused, and we never had any relationship, serious relationship. I never knew my father, in a way. But what? It's made me different? No. I mean, I blame for every fuckups in my life my parents? No.

"I got lucky," he adds. "I fell in love with dance." Every ounce of energy he had was now channelled into ballet. According to

Juris Kapralis, who became his ballet teacher two months after his mother's death, he was a child workaholic: "Very serious boy. Perfectionist. Even in free time, go in corner and practice over and over again. Other boys playing, Misha studying. And not just steps, but artistic, as actor. He is thinking all the time what this role must be. I remember, once, *Nutcracker.* He was thirteen, perhaps. I was prince, and he was toy soldier. After Mouse King dies, Misha relax his body. No longer stiff, like wooden soldier. Soft. Our ballet director ask him, 'Who say you should do this?' And he answer, 'When Mouse King dies, toys become human. Toys become boys. Movements must change.' He devise that himself. Small boy, but thinking."

I asked Baryshnikov recently whether, after his mother's death, ballet might have been a way for him to return to her. He paused for a long time and then said, "In Russia, dancing is part of happiness in groups. Groups at parties, people dancing in circle, and they push child to center, to dance. Child soon works up little routine. Can do a little this"—hand at the back of the neck—"a little this"—arms joined horizontally across the chest—"and soon make up some special steps, and learn to save them for end, to make big finale. This way, child gets attention from adults."

In the case of a child artist, and particularly one who has suffered a terrible loss, it is tempting to read artistic decisions as psychological decisions, because we assume that a child cannot really be an artist. But, as many people have said, children are probably more artistic than adults, bolder in imagination, more unashamedly fascinated with shape, line, detail. In Baryshnikov's case, the mother's devotion and then the loss of her can help to explain one thing: the *work* he put into ballet. For the rest—the physical gift, the fusion of steps with fantasy, the interest in making something true and complete ("Toys become boys"), all of which are as much a part of him today as they were when he was twelve—we must look to him alone.

IN 1964, the Latvian state ballet went on tour to Leningrad with a ballet in which Baryshnikov, now sixteen, had a small role, and a member of the company took him to Alexander Pushkin, a

revered teacher at the Kirov Ballet's school, the Vaganova Choreo-
graphic Institute. Pushkin immediately asked the director of the
school to admit the boy. By September, Baryshnikov had moved
to Leningrad and was installed at the barre in Pushkin's class.
Thereafter, he rarely went back to Riga.

Next to his mother, Pushkin was the most important person in
Baryshnikov's early life. Pushkin had begun his own ballet train-
ing in the studio of Nikolai Legat, who had helped train Nijinsky.
Later, he studied with other famous teachers. When Baryshnikov
joined his class, Pushkin was fifty-seven, and past dancing, but he
had performed with the Kirov for almost thirty years, mostly in
secondary roles. "Pas de deux, pas de trois," Baryshnikov says.
"Sometimes substitute for a principal, but he was not principal
type. Not very handsome—big nose, long legs, short body—and
not very expressive. But classical, classical. Old-school, tradi-
tional, square. Academician. Usually, it's those kind of people,
people who dance twenty-five years the same parts, who know
more about technique than people who are advancing and trying
out other sort of areas. Twenty-five years you come back after
summer vacation and tune your body into same routine, you fig-
ure out timing, you figure out method."

Pushkin had begun teaching early, at the age of twenty-five,
and he soon specialized in men. His classroom manner was
famously laconic. He rarely offered corrections, and when he did
they were of the most elementary sort. (It was said at the school
that he had two: "Don't fall" and "Get up.") Rather, as Barysh-
nikov explains it, what made Pushkin so effective was the *logic* of
the step combinations he taught—the fact that they were true not
just to classical ballet but also to human musculature. They
seemed right to the body, and so you did them right. And the
more you did them the more you became a classical dancer.
Another thing about Pushkin, his students say, is that he was a
developer of individuality. He steered the students toward them-
selves, helped them find out what kind of dancers they were.
"Plus," Baryshnikov says, "he was extraordinary patient and ex-
traordinary kind person. Really, really kind." If there is a point in
classical art where aesthetics meet morals—where beauty, by
appearing plain and natural, gives us hope that we, too, can be

beautiful—Pushkin seems to have stood at that point, and held out a hand to his pupils. In any case, he was a specialist in calming down teenage boys, getting them to work, and making them take themselves seriously. Out of his classroom in the fifties and sixties came the Kirov's finest male dancers—notably Nikita Dolgushin, Yuri Soloviev, and Rudolf Nureyev.

PUSHKIN took certain of his students very directly under his wing. The best-known example is Nureyev, who was ten years older than Baryshnikov. Nureyev had started studying ballet extremely late. "It was not until he was sixteen or seventeen that he came to Leningrad and put his leg in first position professionally," Baryshnikov says. "And he took this opportunity very—*errgghh*—like a tank. Very aggressive in terms of the education, in terms of the catch-up. And short temper. Sometimes in rehearsal, if he couldn't do certain steps he would just run out, crying, run home. Then, ten o'clock in the evening, he is back in studio working on the step till he will get it. People think he is oddball. And already his ambivalent sexuality was obvious, which in that conservative atmosphere was big problem. People were teasing him." So Pushkin and his wife, Xenia Jurgensen, another former Kirov dancer, took Nureyev into their home. He lived with them for a long time, not just while he was in school but also during his early years at the Kirov. The fact that Nureyev defected in 1961—that he was accomplished enough and brave enough to go—was probably due in large measure to them, though it broke their hearts. (When Baryshnikov first went to their house, he saw Nureyev's electric train, installed as a kind of relic, in their living room.) Sacred vessel of the Russian tradition, Pushkin bred dancers so good, so serious and ambitious, that they could not survive in Russia. Yuri Soloviev killed himself. Nikita Dolgushin was banished to the provinces. Nureyev and Baryshnikov defected.

PUSHKIN and Jurgensen took Baryshnikov in as they had taken in Nureyev. "I spent weeks, sometimes months, staying with them," he says. He also ate at their house almost every night. Jurgensen

was a good cook. "Very upper-class Russian food," Baryshnikov says. "Winter food—veal, cream." Then Pushkin and his pupil would work together, sometimes for hours, often on arms: "Find my way of moving arms, coordination. Young dancers don't think about this, only think about feet." Then, very often, it was too late for Baryshnikov to return to the dormitory, so he slept on the Pushkins' couch.

Baryshnikov was still very worried about his height. Russian ballet companies follow a strict system, called *emploi,* whereby dancers are sorted by physique, style, and temperament into certain kinds of roles and remain there for the rest of their careers. Baryshnikov, though he was still growing (he eventually reached five feet seven), seemed too short for the danseur-noble roles, the grave, poetic leading-man roles. Not just his height but also his stage presence—he was boyish, vivacious, a personality—seemed to be pushing him toward demi-caractère roles, the quick, often comic supporting-actor roles. As he put it in his interview with Polanski, "I thought I would end up as a Joker or a Harlequin somewhere," and this was not what he wanted. But Pushkin believed that his pupil would be a danseur noble, and he got him just to go on working. In 1967, Baryshnikov graduated from the Vaganova school. At his graduation performance, in the *Corsaire* pas de deux, "the scene was unimaginable," his biographer Gennady Smakov writes. The crowd howled; the chandeliers shook. Baryshnikov was taken into the Kirov Ballet as a soloist, skipping the normal starting position in the corps de ballet, and now his troubles really began.

"I joined the company when it was falling apart," Baryshnikov told Smakov. In the late sixties and the seventies, the Kirov went through a period of repression from which it has never fully recovered. In part, this was due to a society-wide tightening up after the Khrushchev "thaw." But in the ballet world there was redoubled anxiety, the result of Nureyev's defection. Konstantin Sergeyev, the director of the Kirov, turned the company into a mini police state. The repertory consisted either of nineteenth-century classics, restaged by Sergeyev, or of socialist flag-wavers. (Sergeyev himself, in 1963, made a ballet, *The Distant Planet,* inspired by Yuri Gagarin's spaceflight.) Any newly commissioned ballets were

vetted to make sure they threatened neither government policy nor Sergeyev's primacy as company choreographer. The dancers were watched vigilantly for signs of insubordination. If they looked like defection risks—indeed, if they failed to attend company meetings or had the wrong friends—they were often barred from foreign tours, which were their only means of supplementing their tiny incomes. Typically, the list of who would be going on a tour was not posted until the day of departure. Shortly beforehand, meetings would be held at which the dancers were encouraged to denounce their colleagues, so that their own names, rather than their colleagues', would be on the list. Many cooperated. Cooperate or not, the dancers were brought to their knees. Righteous suffering can ruin you almost as fast as shame. Other privileges at the Kirov—roles, choice of partners, time onstage—were also awarded less on the basis of merit than according to one's history of cooperation. The careers of what were reportedly superb artists, people who were one in a thousand, and in whom ten years' training had been invested, were destroyed in this way.

Such were the circumstances in which Baryshnikov, nineteen years old and hungry to dance, found himself in 1967. He had to fight just to get onstage—at that time, even leading Kirov dancers performed only three to four times a month—and also to get the partners he wanted. Above all, he had to struggle over his casting. He was given danseur-noble roles eventually, but only eventually. (He waited six years to dance Albrecht in *Giselle,* a part he desperately wanted.) Worse was the problem of getting a chance to perform in something other than the standard repertory. Baryshnikov wanted to dance new ballets, modern ballets, and some were being created at the Kirov, with excellent roles for him. But again and again such ballets were vetoed by the company's *artsoviet,* or artistic committee, and dropped after one or two performances. Baryshnikov was sent back to dancing *Don Quixote.*

In 1970, midway into his seven-year career in Russia, things got a great deal worse, for in that year Natalia Makarova, the Kirov's rising young ballerina, defected while the company was performing in London. Baryshnikov was on this tour, and it was to him, not to Makarova, that the authorities devoted their special

attention. As he sees it, they did not take Makarova seriously as a potential defector, because she was a woman: "They wouldn't think a woman would have guts to defect." Baryshnikov, on the other hand, sometimes had as many as three KGB agents tailing him as he walked down the streets of London. He says that at that time he had no thoughts of defection. If he was closely confined at the Kirov, that was because he was greatly valued there. He was one of the company's leading dancers. "Also," he says, "the Kirov was a home to me, and I had unfinished business. I wanted to do *this* dance, with *these* people." Indeed, when he got the news about Makarova, who was a friend and also a former girlfriend of his, he was terribly worried for her: "I thought it will be difficult for her to survive in the West, that people will get advantage of her, that she will be sorry. Can you believe how stupid?"

But the events that led to his own defection were already accumulating. Four months before the London tour, Pushkin had died—of a heart attack, on a sidewalk—at the age of sixty-two. At that point, Baryshnikov later told an interviewer, "I realized that I was totally on my own." A second important development was the London tour itself. The audience and the critics went crazy over him. (If he thought it would be hard for a Soviet dancer to survive in the West, his London reviews may have given him reason to rethink that conclusion later.) But London gave him more than good reviews: "You cannot know what it meant to travel. Just to see how other people react to you, and to measure your ability as an artist, as a dancer. And to see what's supposed to be your *life*—that your life is not just in cocoon, that other people in other countries do have same emotions." He met Western dancers. He became friends with Margot Fonteyn. He attended rehearsals at the Royal Ballet. He went to modern-dance classes. He saw American Ballet Theatre, which was performing in London at the same time.

He also met Nureyev, who was now living in London and dancing with the Royal Ballet. Nureyev went to see the Kirov performances and managed to get a message to Baryshnikov. "A man we both knew came to me and said, 'Rudolf want to see you if you want to.' " So the next morning Baryshnikov gave the KGB the slip and spent a whole day in Nureyev's big house, overlooking

Richmond Park. They talked about ballet, he says: "Russian exercises, French exercises, teachers, class, how long barre—all technique, Rudolf's obsession." At lunch, Nureyev drank a whole bottle of wine by himself. (Baryshnikov couldn't drink. He was performing that night.) Then they went out and lay on the grass and talked about technique some more. "When I left, he gave me a couple of books—one with beautiful Michelangelo drawings—and some scarf he gave me. I was very touched by him." The two men remained friends until Nureyev's death, in 1993.

With Makarova's defection, the panic at the Kirov was even worse than it had been with Nureyev's. Sergeyev was removed from his post; a number of brief, fumbling directorships followed. Baryshnikov was watched more and more carefully. If Western dancers came to Leningrad and he went out to dinner with them, this was noted in his file, and the KGB came to talk to him about it. When Western choreographers got in touch with the Kirov to see if he could work with them, they were told he was sick. He was also under pressure to go to political rallies, and privileges in the theater were made contingent on his attendance: "They'd say, if not this, then not this. Blackmail, you know?"

IN 1974, Baryshnikov staged what was called a Creative Evening—a favor sometimes accorded leading dancers. The dancer would commission an evening's worth of short works, often from young choreographers. (Whatever nonconformist ballets made it onto the Kirov stage were usually part of a Creative Evening.) The dancer would also choose the casts, assemble the sets and costumes, and star in the program. Then, after this display of openmindedness, the administration would normally shelve the ballets. For his Creative Evening, Baryshnikov hired two experimental (and therefore extra-Leningrad) choreographers—Georgi Alexidze, based in Tbilisi, and Mai Murdmaa, an Estonian. There followed several months of anguish as, faced with harassment from the administration and apathy from the demoralized dancers, Baryshnikov tried to get the new ballets onstage. Cast members dropped out; costume designs were argued over (too revealing). Shortly before the premiere, Baryshnikov was

pulled out of rehearsals to go to Moscow for another political rally. After the first preview, he met with the *artsoviet,* and they told him how bad they thought the show was. It was allowed a few performances anyway—all the tickets were already sold—but afterward, at a cast banquet, Baryshnikov burst into tears while he was trying to make a speech to the dancers. "He was talking and crying," Nina Alovert reports in her 1984 book, *Baryshnikov in Russia.* "Some people listened to him . . . while others continued to eat, scraping their plates with their forks."

The disappointments apart, Baryshnikov remembers Leningrad as a place of immense tedium: "The most interesting objects were people, saying what they would have done, if they could have. Which is what they talked about if they drank a little. But they didn't drink a little. They drank a lot." In a 1986 interview, Arlene Croce asked Baryshnikov's close friend Joseph Brodsky what would have become of the dancer if he had remained in Russia. "He'd be a ruin by now," Brodsky answered, "both physically and mentally. Physically because of the bottle. . . . Mentally because of that mixture of impotence and cynicism that corrodes everyone there—the stronger you are the worse it is."

Finally, he refused that fate. A few months after the Creative Evening, a group of dancers from the Bolshoi Ballet were leaving for a tour of Canada. The two Bolshoi veterans leading the tour, Raissa Struchkova and her husband, Alexander Lapauri, asked the Kirov if Baryshnikov and his frequent partner Irina Kolpakova could join them, to add heft to the roster. The Kirov refused; at this point, the KGB was barely letting Baryshnikov out of its sight. But Kolpakova intervened, and she was a well-placed person—not just the Kirov's leading ballerina but a former administrator of the company and a member of the Party, with excellent connections. She apparently guaranteed Baryshnikov's safe return, and therefore they were allowed to go. That was the tour from which Baryshnikov did not return. Kolpakova somehow survived as the leading ballerina at the Kirov, but Struchkova and Lapauri were forbidden ever to leave the Soviet Union again. The following year, Lapauri got drunk one night, drove his car into a lamppost, and died. By that time, Baryshnikov was the new sensation of Western ballet, and if, with his fame, he also had a sad look

in his eyes the cause was probably not nostalgia for the Soviet Union.

BARYSHNIKOV'S career as a ballet dancer in the seventies and eighties has by now been the subject of hundreds of articles, and of half a dozen books as well. It had three stages: four years as the star of American Ballet Theatre (from 1974 to 1978), one year at George Balanchine's New York City Ballet (from 1978 to 1979), then nine years as the director of American Ballet Theatre (from 1980 to 1989). What he did during this time, above all, was acquire new repertory—the thing he had most wanted to do. In just his first two years in the West, he learned twenty-six new roles, more than he would have been given in a lifetime in the Soviet Union. And the process of working with new choreographers nudged his style in new directions.

Most important was his collaboration with Twyla Tharp. In the 1970s, Tharp was undergoing a transition from modern dance to ballet. Baryshnikov was also in transition, so he made a perfect subject for her. Starting with the hugely popular *Push Comes to Shove,* in 1976, she created for him a series of ballets that seemed to be about the project facing them both: how to marry the Old World dance to the new—in particular, how to join ballet, so outward and perfect, to the inwardness, the ruminations, of jazz. In Tharp's works, Baryshnikov's dancing became more shaded, with more hitches and grace notes, more little thoughts, tucked in between one step and the next. And it was these—the transitions, the secret places between the steps—that seemed to give the dancing its meaning. The big ballet moves were still there, but they were thrown off casually, like something taken for granted. Suddenly, out of some low noodling, Baryshnikov would rise up into an utterly perfect leap, and then land and noodle some more. This was surprising, witty, but it also seemed philosophical: a meditation on history, a memory of innocence in a mind past innocence. Appropriately, Tharp had Baryshnikov do this kind of dancing alone. It influenced all his future work, affecting not just him but the choreographers who worked with him after Tharp. The more

he became that kind of dancer—inward, alone—the more they made that kind of dance for him.

At the same time, what Tharp made of Baryshnikov was in him already. He *was* a transplant, and alone, and he combined an exquisitely schooled classical technique with what seemed, even before Tharp, an increasingly ruminative quality, a deep sort of cool. He danced that way not only in Tharp's ballets but also in *Giselle,* and this gave him a special glamour. Soon he was more than an acclaimed ballet dancer: he was a celebrity, a dreamboat. Crucial to this development was the fact that in his hunger for new outlets he looked beyond live theater. He made movies (*The Turning Point,* in 1977; *White Nights,* in 1985; *Dancers,* in 1987), and television specials, too, and he turned out to be extremely filmable. Now you didn't have to live in New York to be a Baryshnikov fan, any more than you had to live in Hollywood to be a Sylvester Stallone fan. He was an electronic-media ballet star, the first one in history.

The movies, of course, made use not only of his dancing but of his sex appeal. In all three of his Hollywood films, he was cast as a roué, a heartbreaker. The newspapers, meanwhile, were doing what they could to cover his love life: his rocky affair with Gelsey Kirkland, the ballerina who had left New York City Ballet to become his partner at ABT; his long liaison with Jessica Lange (which produced his first child, Aleksandra, named after his mother); his shorter stopovers with many others. "He goes through everybody, he doesn't miss anyone," the post-Baryshnikov Kirkland told a reporter. "I should have been so lucky," Baryshnikov says. But in a male ballet dancer even medium-level skirt-chasing makes good copy. Combined with all the other factors—his "exile," his famous melancholy, his tendency to flee interviewers, his hunger for new projects—it gave him a sort of Byronic profile, as a haunted man, a man of unfulfillable desires, unassuageable griefs. He did not fashion the image, but he fitted it, and nothing could have been more attractive. Posters of him hung in dorm rooms.

In 1979, only a year after he had made the switch from American Ballet Theatre to New York City Ballet, ABT asked him to

come back, this time as the head of the company, and he accepted. The story of Baryshnikov's nine-year directorship of ABT is a long, messy, fascinating tale that has never been fully told. Briefly, he tried to modernize the company. He junked the star system and began promoting from within the ranks. He regalvanized the company's notoriously feckless corps de ballet. He brought in new repertory, including modern-dance pieces, plus crossover ballets by the most interesting American choreographers of the moment—people such as Tharp, David Gordon, and Mark Morris. Suddenly, the air began to circulate again at ABT. The corps moved with beauty and pride. The young soloists danced like demons. The new works were talked about, argued about. Before, what was interesting at ABT was merely this or that performance, usually by a foreign star. Now, for the first time since the 1950s, the company itself was a serious subject, an art-producing organization.

Not all of Baryshnikov's reforms were successful, and when they did succeed they weren't necessarily popular. Stars left in huffs. Critics deplored many of the new works. People accused Baryshnikov of trying to turn ABT into New York City Ballet, or into a modern-dance company, or, in any case, into something other than the plump, old-style, stars-and-classics institution that it had been, and which they still loved. The company's deficit swelled. The dancers went out on strike. There was constant friction between Baryshnikov and the board. He had ostensibly been hired as the company's artistic director, but the board also expected him to be its leading dancer and its No. 1 fund-raiser—roles that he declined. (He had repeated injuries; he could not dance as much. As for fund-raising, he loathed it. At parties for patrons, he was often the first person out the door.) And by insisting on a salary of a dollar a year as director—which, given his performance fees, he could afford—he felt he had given himself that right. But the wear on him was severe. In 1989, he gave notice that he would leave in 1990. A few months later, the administration went over his head and fired his second-in-command, Charles France. Baryshnikov resigned in a fury.

. . .

WHY had he taken the job in the first place? He is not a natural leader. He can't press the flesh, give the interviews, settle the quarrels, or not willingly. Yet at the time when it came, the offer of the ABT directorship was something he could not refuse. Having seen at the Kirov how badly a ballet company could be directed, he was, of course, tempted to find out if he could run one well. At the same time, there was another factor—his year at New York City Ballet. It has often been claimed that Baryshnikov's experience there was a bitter disappointment to him because by the time he arrived Balanchine was already ill (he died within five years) and could not make new ballets for him. "That's nonsense, absolute nonsense," Baryshnikov says. "That one year was most interesting time in my American career." Part of the pleasure, again, was new repertory. In fifteen months at NYCB, he learned twenty-odd roles, and though he had trouble fitting into some of them—and not enough time—there were others, particularly Balanchine's *Apollo* and *Prodigal Son,* that seemed to have been waiting all those years just for him. He was tremendous, utterly wrenching, as the Prodigal, and he was probably the best Apollo ever to inhabit that role. All the qualities needed to represent Balanchine's boy-god—childlikeness, aloneness, dignity, a sense of high mission—were already in him. He filled the ballet to its skin.

But Baryshnikov says that what was most important to him at NYCB was his sense that he had found a home. Balanchine had gone to the same school and made his professional debut at the same theater that Baryshnikov had, and, like him, had decided that to be an artist he must leave Russia. (Baryshnikov defected fifty years, almost to the day, after Balanchine left.) Balanchine had then created in the West what, in Baryshnikov's view, Russian ballet would have become but for the Revolution: modernist classicism. "I am entering the ideal future of the Maryinsky Ballet," he told reporters when he announced his switch to NYCB. (The Maryinsky was the Kirov's pre-Revolutionary name.) Also, Balanchine seems to have treated him like a son: "He told me, 'I wish I could be a little younger, a little healthier, that we could work more on new pieces, but let's not waste time. Let's do *Harlequinade,* let's do *Prodigal,* let's do this, let's do that, and think—whatever you want to do.' He cared what I will do."

The story is terrible. The homeless boy found a home, the son-less master found a son, but it was very late. Then came the invitation from ABT. Curiously, it was in part because of the gifts Baryshnikov was given at NYCB that he decided to leave. For one thing, Balanchine told him he could always come back. "I went to him and we talked for a long time," he recalls. "We talked for an hour one day, and he said, 'Come back tomorrow.' And he was very, sort of—not encouraging me, but said, 'If you can see what you want to do and can deal with people on the board and you have a clear vision, I think you should do it, take this chance.' He said, 'If it doesn't work, it doesn't work. You can come back, any-time. This is your home.' "

But it wasn't just the NYCB safety net that emboldened Baryshnikov to go to ABT. It was also what he saw as the moral lesson of NYCB, as taught to him by Balanchine and Jerome Robbins, the company's second ballet master. "Working with Balanchine and Jerry every day—just to see their *dedication* to the institution, the company, the school. Their seriousness, the seriousness of the whole setup, everything about it. Very different from the world which I come from, government-supported company, or commercially set up company like Ballet Theatre. I learn so much. Something about dance ethics, about being a dancer, and the *quality* of the work. I learn how and why to respect choreographic vision and morale of theater. And that was most important experience. On the surface I was just one of them, and that was fine. But deep inside I experienced extraordinary transformation, and I understand a lot of things, for my future work." Clearly, that was a major reason for his going to ABT. He felt he had learned something tremendous, and he wanted to use it. Those who accused him of trying to turn ABT into NYCB were partly right.

NEARLY ten years after Baryshnikov's departure from ABT, with the current administration trying desperately to restore the old stars-and-classics order, the company still reflects the changes he made: the corps still shows the verve he instilled in it, and the

young soloist-level dancers still seem to dance with a sort of wild hope, as if they might actually be promoted. But these are things you can't discuss with Baryshnikov at present. The bitterness of the ABT years is still too keen. What he sees now as the receptacle for the lessons he learned at New York City Ballet is a modern-dance company that he founded in 1990. This troupe, the White Oak Dance Project, is a great curiosity. What is a Russian-trained ballet dancer doing directing an American modern-dance company? And why is a man who during the ABT years repeatedly said that he wanted to retire from the stage—that he had had it, that his knee was killing him (it has now been operated on five times)—still performing intensively: an activity that requires him to undergo two hours of physical therapy every day, and, on days when he is performing, four additional hours of warmups and rehearsal, not to speak of the travelling and the room-service dinners? "Well," he said to me at the time of White Oak's founding, "I thought there is maybe a couple of years left, for fun." The late philanthropist Howard Gilman, a friend of his, offered to build him a rehearsal studio at the Gilman Foundation's White Oak Plantation, in Florida—in gratitude, Baryshnikov named the troupe after the plantation—and operations were set up in such a way that, unlike ABT, the company would not be a noose around his neck. He hired seasoned dancers—people who would not develop eating disorders—and he engaged them on a tour-by-tour basis. The company was not a company; it was a "project." It could vanish at any time. It had no board, no grants, no deficit. Either it paid for itself or Baryshnikov wrote a check. In other words, he set up the least institutional institution he could possibly create—one in which, for the first time, he could present and perform dance without the thousand circumstances that in his experience had compromised those activities.

White Oak has now been in existence for seven years. It is small, usually eight to twelve dancers. It is classy. (It travels with its own five-piece chamber orchestra. No taped music.) It tours for about four months a year, and it has been all around the world. For its first three or four years, the repertory was mostly by "name" choreographers: Martha Graham, Paul Taylor, David

Gordon, Twyla Tharp, Mark Morris. (Morris helped Baryshnikov set up the company.) But in the last few years White Oak has begun dangling from the treetops, offering works by avant-gardists almost unknown outside New York and also by beginners—people who are making only their second or third pieces but whom Baryshnikov finds talented. Still, the concerts regularly sell out, because he is performing in them. Two years ago, I sat in the Kravis Center, in West Palm Beach, Florida, with two thousand Republicans as they watched a big, ambitious, confusing piece called *What a Beauty!*, created by Kraig Patterson, a fledgling choreographer who is a dancer with the Mark Morris Dance Group. The audience looked puzzled. But on this program there was also a solo for Baryshnikov; that is, the audience got to see, for perhaps twelve minutes, the most exciting dancer in the world today performing alone, and therefore they got their money's worth. In a sense, the situation is an artificial one. Baryshnikov probably knows this, but it doesn't seem to bother him. He is having an adventure, presenting new choreography. He is at last putting on his Creative Evening—night after night, with no *artsoviet* to tell him what they think—and if his fame can induce people to come and see it that is fine by him. Recently, I asked him the big question: In the West, had he got what he wanted? Had he found what he came for? "Oh, more than that, more than that," he said. "I never dreamt that I would work with so many extraordinary people." That was all he wanted, just to work with interesting people.

In return for taking only a nominal fee in Riga, Baryshnikov had arranged for the state opera's general-admission prices to be lowered for his performances, but the tickets were still beyond the means of most of Riga's ballet people. (The average salary in Riga is five hundred dollars a month.) So he opened his first dress rehearsal to the staff and pensioners of the opera house and the ballet school, and before the rehearsal began he came out in front of the curtain and addressed them. It was a strange moment—packed with history, like the session in the studio—and in parts of the audience there was probably some resentment against the

local boy who made good. The people in that auditorium represented an old tradition, the one that had bred him and from which he had fled. Now they would see the new kind of dancing that he had preferred to theirs. But as he spoke, it was to their world, not his, that he addressed himself. He told them how this solo concert was dedicated to the memory of his mother; how happy he was, after so many years, to perform again on the stage where he had first danced; how pleased he was to present these dances to his theater colleagues. And he choked up—the first time I ever saw him do so—and had to stop and pause repeatedly before speaking again.

Later, he said to me, "All those people who were sitting there, they were veterans of this society, this space. All these people that I saw when I was young, they were some very good dancers or not that good dancers, some of them good actors, or some of them just beautiful women, or some of them were great character dancers, or some very enthusiastic performers. I knew them by name, I knew their history. Half of those people are dead already, but the other half, in their sixties or their eighties, are sitting in that audience. And they're all of them in me, in my body, in my brain. You know, you learn to dance when you're very young. And in subconsciousness you take pieces from every person. Even worst dancers have two moves, one move, and you say, 'What was that? How did he do that?' And already it's in you. That's why I— that's why it was very moving—because, you know, I owe them." So again he did have a family, but it was dancers. In his second concert, he shared the program with the Latvian state ballet and its school—he did two solos, they did various dances, including some that he had appeared in as a boy (the Garland Waltz from *The Sleeping Beauty,* the *Corsaire* pas de deux)—and he donated the proceeds to his old school.

Both shows were a great success, but nothing was quite like the piece that Baryshnikov closed with on the last night. This was Tharp's *Pergolesi*—a smart choice, since, like the other pieces Tharp has made for Baryshnikov, it includes ballet, and so Baryshnikov was able to show the audience his old fireworks. Actually, though, *Pergolesi* includes just about everything: folk dance, eighteenth-century dance, quotes from famous ballets *(Le*

Spectre de la Rose, La Sylphide, Swan Lake), shimmies, boogaloo, golf swings. He got a chance to do every kind of dance he knew—not just what he had learned in the West but also what he had been taught at the Riga School of Choreography. And I don't know what happened—maybe it was the bringing together of the two halves of his history, or maybe it was relief that this heavily freighted trip was nearly over, or maybe now, at the end, he just wanted to give these people everything he had—but he exploded. I have never seen him so happy onstage, or so wild. ("He's showing off!" said Lisa Rinehart, who was sitting next to me.) He gave them the double barrel turns, he gave them the triple pirouettes in attitude (and then he switched to the other leg and did two more). He rose like a piston; he landed like a lark. He took off like Jerry Lee Lewis; he finished like Jane Austen. From ledge to ledge of the dance he leapt, surefooted, unmindful, a man in love. The audience knew what they were seeing. The air in the theater thickened almost visibly. Even the members of the orchestra, though their backs were to him, seemed to understand that something unusual was happening. Out of the pit, the beautiful introduction to Pergolesi's *Adriano in Siria* rose like a wave, and he rode it to the finish. By that time, we actually wanted him to stop, so that we could figure out what had happened to us. Latvians, I was told by the locals, almost never give standing ovations. And they never yell "Bravo!" in the theater; they consider that vulgar. But they yelled "Bravo!" for him, and everyone stood, including the president of the republic.

Baryshnikov took his curtain calls with the members of the Latvian National Opera Ballet, they in their dirndls and harem pants, he in his Isaac Mizrahi jerseys—messengers of the two worlds created when Europe broke in half. It will never wholly mend, any more than Baryshnikov, child of that break, was ever able to find an artistic home. But it is hard to regret his fate. Homelessness turned him inward, gave him to himself. Then dance, the substitute home, turned him outward, gave him to us.

The New Yorker, 1998

Martha Graham dancing in Letter to the World, *1946*

The Flame

IN 1991, at the age of ninety-six, Martha Graham died, leaving her entire estate to Ron Protas, a former photographer, more than forty years her junior, who had been her closest companion for the last two decades of her life. The estate wasn't large in immediate financial terms—it was valued at $325,000—but it involved something you couldn't put a price on: her work. Graham was the most honored artist in the history of modern dance. No one except George Balanchine had anything approaching her influence on twentieth-century choreography, and, unlike Balanchine, who was carrying on the tradition of classical ballet, she more or less formulated the art she practiced. In the twenties, when she began her career, there was basically one kind of concert dance in America: ballet. By the thirties, thanks primarily to her, there was a second: modern dance. She brought to dance not just a new method but a new subject matter, the post-Freudian psyche—fear, wrath, sex—and, by wedding that subject to ancient myth, ennobled it. The most important modern-dance choreographers of the next generation, notably Merce Cunningham and Paul Taylor, worked for her before they made their names. Others studied her technique, which is now taught around the world. In the words of the critic Allan Ulrich, all American modern-dance choreographers are "the children of Martha," and all postmodern-dance choreographers are "the rebellious children of Martha." She changed ballet, too. The work of both Agnes de Mille and Antony Tudor bears her imprint to an almost embarrassing extent.

When Graham left her estate to Protas, it was thought to include the 180 dance works she created. Accordingly, for the past ten years, no one has been allowed to perform her dances, or even to teach anything described as Graham technique, without Pro-

tas's permission. And, for the most part, no one could perform a Graham piece without his supervision, for, soon after her death, Protas, who had never danced professionally and had never been formally trained in dance, became the artistic director of her company.

The history of the company under Protas has been one of gradual dissolution. Many of the old dancers, who could best teach the work to the new dancers, walked out the door, and with them went the administrative staff. The company performed less and less; its debts mounted. A fight developed between Protas and a number of the trustees. Finally, last spring, the board of the Martha Graham Center—that is, the main company, a student company, and the school—suspended operations. To the dance world, this was astonishing news. The Graham troupe was the oldest dance company in America.

The trustees said that they would reopen as soon as they could raise the money to do so, and five months later, in October, they held a press conference to announce that, the dispute notwithstanding, the State of New York had awarded the center a grant that would enable the school to start up again in January of 2001. This was a festive gathering. Marvin Preston, the company's executive director, gave a happy speech, in which he announced, "I see this as the moment we're turning the corner." People clapped and went home, only to receive a press release from Ron Protas saying that he, too, intended to open a Martha Graham school. "It is hoped that the former Martha Graham Center will turn over any grant dollars that were earmarked for a school to that project," the press release concluded. Protas's attorney, Michael Quinn, later told me, "They've put the cart before the horse." The Graham Center "needs a license from Mr. Protas to operate a school in Martha Graham's name." He added, "People who dislike Mr. Protas or think they know better how to perform these works are not respecting Martha's own wishes."

Graham did will her property to Protas. But did it occur to her that, with Protas in charge, the company she built might go under? Maybe so. Graham was an intense, volatile woman, who saw herself as a dancer, not a choreographer. She said that she made dances only in order to have something to perform. Many

people did not take that statement seriously until the publication of *Goddess: Martha Graham's Dancers Remember,* a collection of interviews by the journalist Robert Tracy, in 1996. One after another, Graham's dancers described how, in making her pieces, she usually choreographed only her own solos and most of the ensemble work. As for the other solos—and many of the major Graham pieces are a series of solos—she sent the dancers off to work them out themselves. Then she edited what they came up with. To her, dance was something extracted, with heated tongs, from the very core of the self. Why not for them also?

To someone operating from this point of view, a company that existed after her death could have no meaning. With the flame gone, what was the need of altar and priests? Graham said repeatedly that it didn't matter if her works survived her, and some see her will as proof that she meant this. Linda Hodes, a former Graham dancer—she originated the role of Joan of Arc in the 1955 *Seraphic Dialogue*—said to me, "If she had cared, she wouldn't have given the ballets to Ron Protas." The work wouldn't last, but it would play for a few years, compensating Protas for the time he spent with her in her old age. As for the five hundred students who were scattered when the school shut its doors, and the dancers who were left without work when the company closed, they would find their way, or not.

GRAHAM was the eldest of three daughters born to Dr. George Graham, a specialist in mental disorders, and his wife, Jane Beers, a descendant of Miles Standish. (The couple also had a son, who died when he was two.) The two younger girls, prettier than Martha, were favored by their mother. Martha was her father's daughter. "He wanted a boy," she later wrote, "and I became the closest thing to it." In her posthumously published autobiography, *Blood Memory,* she says that her father could intuit his patients' mental condition from their movements. "Movement never lies," Dr. Graham used to say, and this became his daughter's most famous pronouncement. Graham was imperious from childhood. When grown-ups asked her for a kiss, she would say, "My father doesn't approve of kissing. It isn't sanitary. But you

may kiss my hand." Until she was fourteen, the family lived in Allegheny, Pennsylvania. Then, because her sister Mary had asthma, they moved to Santa Barbara, California. Graham saw this divided history as formative. From Allegheny, she believed, she inherited her Protestantism, her strictures; from Santa Barbara, she got her wildness.

Like many female artists, Graham had a late start. She decided to become a dancer at the age of seventeen, after seeing a concert by Ruth St. Denis—who, with Isadora Duncan, is considered one of the mothers of modern dance—and it was at Denishawn, the famous Los Angeles school headed by St. Denis and Ted Shawn, that she received her training. But she didn't take her first dance class until she was twenty-two, and she didn't found her own company until 1929, when she was thirty-five. (Dr. Graham had died in 1914, and Martha spent her early professional years in Broadway shows to help support the family.) She caught up fast, though, and soon she had created America's first modernist dance style. Early Graham dances such as *Heretic* (1929) and *Primitive Mysteries* (1931) are remarkable, first of all, for their abstraction. They are an enactment, not a narrative. Other choreographers were experimenting with abstraction at that time, but what is striking about Graham's early work is its severity, what people then would have called its ugliness. ("She looks as though she were about to give birth to a cube," the theater critic Stark Young wrote.) Graham was part of the New York avant-garde of the twenties and thirties. In *Blood Memory,* she tells of sitting with Alfred Stieglitz and reading with him Georgia O'Keeffe's "glorious letters" from New Mexico, including one "about her waking just before dawn to bake bread in her adobe oven." The Southwest, the dawn, bread, adobe: by now it's a cliché, modernism's embrace of the "primitive," the non-European. But it wasn't a cliché then, and Graham turned it into something tremendous. *Heretic* was about society's persecution of the nonconformist. Any would-be artist in downtown Manhattan could have made a piece about that, but who except Graham could have imagined the ensemble groupings she ranged against the heretic: great slabs and walls of dancers, wedges and arcs and parabolas?

In creating such things, she was greatly helped by the composer Louis Horst. A gruff, lovable man who took his dachshunds to work with him, Horst had been the music director at Denishawn. When Graham left to go to New York, Horst followed her and became her music director and her lover. He was to be the leading composition teacher in American modern dance, but his most important student was the young Martha Graham. Horst was the only one who could criticize her, persuade her to redo her work. He taught her to be simple and trenchant. Until 1935, she used no sets and only the plainest costumes. She avoided music with melodies. Dance was a holy language, independent of all other arts: an act of pain and transfiguration.

The dozen or so women who formed her company in the thirties embraced her faith. They weren't paid, and, according to one of them, Nelle Fisher, "we almost didn't want to be, because . . . it was complete dedication, like a sisterhood." The dancers had much to bear. Frequently, Graham got blocked, and then, Fisher said, she would "have a real breakdown, weeping and storming, with Louis trying to hold her head." Agnes de Mille, in her biography *Martha,* writes that once, in the middle of creating a piece, Graham went into a depression for four days: "The company waited outside her bedroom, in a morbid stupor, as the clock ticked and the performance date drew near. At the end of the ordeal . . . Martha rose from her bed and came forth. 'Everything is clear now,' she said placidly." And she finished the piece. Graham told people that her dances had always existed. She only invoked them. Nor did she choose to; she was chosen. As she wrote in her *Notebooks* (1973), she had been given "lonely terrifying gifts."

In 1938, Erick Hawkins, a dancer and choreographer fifteen years her junior, came to study at her school. Hawkins was exceedingly handsome: "We called him 'the torso,' " the composer Otto Luening said. He was also well educated; he had graduated from Harvard, in classics. Turning away from Horst, Graham threw herself into a tumultuous affair with Hawkins. She also hired him, break-

ing her company's all-female rule. (Other men joined soon afterward, including the twenty-year-old Merce Cunningham.) With that crucial change, and with her inflamed state of mind, her work took on a new look. What had once been ritual became theater. She started using lusher music, fancier costumes and sets. Suddenly, her dances had characters, stories, denouements. Above all, the movement changed. Contraction and release—the clenching and unclenching of the torso, based on breathing—had long been the basis of her technique. Now there was a more explosive release: wheeling turns, off-center jumps, terrific falls, bodies spiralling to the floor and then surging upward again, as the gowns—full-skirted now—billowed and whipped in the air. This is what we think of as Graham's classic style. Graham had been great before. Now she had what all artists dream of, and few get: a second period. She was great again, in a new way.

It is primarily for the dances she created in these years, the late thirties and the forties, that she is famous. Many of them—*Letter to the World, Deaths and Entrances, Herodiade, Dark Meadow, Cave of the Heart, Errand into the Maze, Night Journey*—tell the same story: a woman, alone, confronts her fate, conquers her fear of it, and goes forward, into some dark territory. In the forties, Graham began consulting a Jungian analyst, Frances Wickes. Archetypes—the mother, the seductress, the goddess, the earth—now invaded her work. The rhetoric was grandiose, but the treatment subtle, textured. In *Cave of the Heart,* about Jason and Medea, Medea was as appalling as she was sympathetic. In *Letter to the World,* about Emily Dickinson, the poet's Ancestress, a stone-faced Puritan who turns her away from life, was not just frightening but also loving, motherly, which made her more frightening.

One constant in these works was a focus on sexual passion. There had been sexual themes in Graham's earlier dances, but in order to see this you had to think about it. By the forties, you didn't have to think about it. In *Night Journey,* her 1947 version of *Oedipus Rex,* Jocasta (Graham), on meeting Oedipus (Hawkins), raised her leg high in the air and went into a violent contraction. In *Blood Memory,* Graham says that that move is "the cry from her vagina." In response, Oedipus opened his cloak, churned his

groin, and climbed on top of her. At the time of its premiere, this was probably the most sexually frank dance that had ever been presented on the concert stage in America. And it wasn't just Greek mythology; it was Graham's life.

The treatment varied. In *Appalachian Spring,* Graham showed us happy sex; in *Night Journey* tragic sex; in *Letter to the World* sex refused. Graham never had much fear of sex. According to de Mille's biography, she arranged her deflowering, by a married man, when she was still quite young, and told her mother first. But, apparently, she did fear domination by sexual love, and she had reason to. For Hawkins's sake, she had plunged her company into turmoil. The dancers hated him, and now, at Graham's command, he became their rehearsal director, correcting them in dances they had helped choreograph, long before he arrived. He also began to handle bookings and fund-raising. A number of dancers left. Others stayed on, loyal and resentful. Horst, too, remained for many years, although he was increasingly shut out.

Hawkins's artistic ambitions made the situation worse still. He saw himself as Graham's peer. He demanded equal billing on the roster, and all the while that he was performing with her company he was also presenting concerts of his own work. They were indifferently reviewed, but Graham stumped for him. "I will *make* the New York critics accept him," she told de Mille. The relationship, by all accounts, was a torment to both of them. He beat her up; she beat him up. He moved in with her, moved out, moved in. In 1948 they finally married, and then things got worse. But Graham was always energized by turmoil in her private life. During the Hawkins years, she routinely performed three leading roles in one night—a punishing schedule. She went onstage electrified, and often she did not warm up beforehand. She seems to have welcomed the shock, like a sudden blow. The company saw her as fettered to a mediocrity, and at times she probably did, too. Hence another sex story that now surfaced in the work: sex murder. In the 1950 *Judith,* the heroine, as in the Apocrypha, goes to an assignation with Holofernes, the Assyrian general besieging her city, and instead of getting in bed with him, hacks his head off. Hawkins was also in analysis with Frances Wickes, and, according to Graham, he asked Wickes "if she could make him a better

dancer and choreographer than I was. Mrs. Wickes said, 'No, I cannot.' " Hawkins walked out and did not return. Soon afterward, he left Graham as well. He went on to form his own company, which had a modest place in the dance world. He died in 1994.

Graham had been through this drama before, vicariously. Ruth St. Denis, too, saw herself as a priestess; in her early years, she, too, put together a small company that had considerable success on the limited art-dance circuit. Then, at the age of thirty-five, she was approached by Ted Shawn, a divinity-school student turned choreographer, twelve years her junior, who wanted to be her dance partner. She fell in love, and married him. At his urging, they opened Denishawn, a combined school and touring company that she later considered the ruination of her career. Shawn took over administration and rehearsals. He also choreographed, and saw himself as St. Denis's equal. He booked Denishawn on the vaudeville circuit, with programs of his dances and hers. There ensued a sixteen-year artistic and marital battle, which the Denishawn dancers—including, for seven years, Martha Graham—witnessed daily. Graham and most of the other dancers worshipped St. Denis, and saw her as fettered to a mediocrity. The fact that Shawn was homosexual did not help the situation. Finally, in the early 1930s, Denishawn disbanded. Shawn founded an all-male troupe; St. Denis applied for welfare. She rarely performed thereafter.

Of Graham's infatuation with Hawkins, Horst said, "This is Shawn all over again, and she swore it would never happen in her life." There are differences between the two couples. Hawkins was not a vaudeville entertainer. If anything, he was artier than Graham, though, like Shawn, he was a minor talent. Also, Hawkins was not homosexual; he was bisexual. And neither union should be seen as a simple case of male opportunism. St. Denis wanted a man to take over the business side of her company, to leave her in peace with her art. So did Graham. Each woman probably thought that, because the man was so much younger and less gifted, she could control him. They both got a surprise.

· · ·

MANY great artists have only ten great years. Graham had twenty. Then, after Hawkins left, in 1950, she fell into a black despair. Growing older had always been a terror to her, and she postponed it as long as possible. She says in *Blood Memory* that in giving her age she always subtracted fifteen years (exactly the difference between her birth date and Hawkins's). She flirted with just about every man she met—she pinched bottoms—but now, apparently, she lost her sexual confidence. She later claimed that she never had another man after Hawkins. Spinsterhood was only one problem, however. Sex had long been the engine of her work. She told her female dancers to "dance from the vagina." In the forties, that vaginal magnetism—the woman's power to attract and repel, bless or kill—had been the subject of her dances. Now it seemed to desert her. She developed problems with her eyesight and with her memory. All this was exacerbated by heavy drinking, which began, she said, with her separation from Hawkins (though both her father and one of her sisters drank). Hawkins wasn't the only one who had left. By now, Horst, too, had decamped, after twenty-two years with her. "All her props were knocked out from under her," the veteran dancer Jane Dudley says. By the sixties, Graham was rarely sober in rehearsal. According to another dancer, she would arrive hours late, after the dancers had given up and done the work without her, and then they would have to get back into their sweaty practice clothes and start again. She was usually sober for performances, though her partner had to know her steps and cue her. On her own, she would occasionally fall into the wings.

The senior dancers—Helen McGehee, Bertram Ross, David Wood—took over. They ran the school, scheduled the rehearsals, got the shows onstage. They could not, of course, create new Graham works, so Graham sketched them out, but they were often simply reworkings of her earlier pieces, especially the sex-murder dramas. In dance after dance, the men appeared wearing next to nothing; they jutted their big legs forward, and slapped the insides of their thighs. As Paul Taylor, who danced with Graham at this time, put it, she seemed to view men as "giant dildos." In *Phaedra* (1962), Hippolytus was first revealed in a raised cubicle with multiple doors. One door opened and showed his chest;

another opened and showed his groin. It was like a pornographic Advent calendar. Bertram Ross, who played Hippolytus, said that he started getting obscene phone calls. Hippolytus was killed, of course, and the phallic heroes of many of Graham's dances of this period fared badly. They were blinded, beaten, castrated, murdered. It looked like revenge—obsessive and unrelenting.

Graham came to depend more heavily on the dancers. "I can't even create anymore," she told David Wood, her rehearsal director. Her most celebrated production of the fifties was *Clytemnestra* (1958), her one full-evening work, based on the Oresteia. In that piece, according to the dancers' own reports, Helen McGehee choreographed her role as Electra; Bertram Ross his double role as Agamemnon and Orestes; Yuriko her role as Iphigenia. It should be said that other choreographers ask dancers for movement suggestions. Furthermore, Graham's pieces were never really about footwork. They were as much drama as dance; she was as much the colleague of Tennessee Williams as of Doris Humphrey. Still, Williams wrote dialogue. Graham told the dancers who they were supposed to be in the piece and gave them verbal "images." Out of that, they had to create not just solos but duets, trios. According to the choreographer Gus Solomons, who danced for Graham in the mid-sixties, even the ensemble passages were often worked up by the dancers: "Somebody would grunt, the first witch or whatever, and we would go," each copying the one in front of him. Endings were often improvised on opening night. The dancers were thrown back on the past; they did what they knew as Graham's style. It is a tribute to the power of that style, and to the immense gifts of Graham's dancers of this period, that some of the resulting works, notably *Clytemnestra* and *Seraphic Dialogue,* have survived, and look so strong. Most of the others vanished swiftly.

Still, a number of dancers who joined the company at this time have said how much they learned from Graham—how she taught them to express themselves, taught them they had selves to express. (She also, by force of circumstance, gave them an opportunity to choreograph. Over the years, Graham's troupe probably produced more choreographers than any other American dance company.) The dancers were proud to be in her work. It was

"something big to participate in," Paul Taylor said. Graham was a serious reader, especially of poetry—Dante and Rilke were two of her favorites—and of mythology. She shared her books with the dancers. She opened their minds. And, ironically, it was in this period that she became truly famous. She led triumphant foreign tours; she received honorary doctorates. "Those were her golden years," David Wood says, "and for us it was like walking on razor blades."

What frightened Graham most was the idea that she would have to stop dancing. She went on performing into her seventies, by which time, Gus Solomons reported to Robert Tracy, "the men would literally move her from place to place, where she'd do her three steps." Gradually, she surrendered her starring roles to the younger women, but for the most part she couldn't bear to teach them the steps. Or she forgot that she wasn't dancing the role. In *Circe* (1963), she originally intended to play the legendary seductress herself, at the age of sixty-nine. Eventually, she gave the role to Mary Hinkson, but Hinkson told Tracy that in rehearsal, when her partner was lifting and lowering her, Graham said to him, "Get me down, get me down." The work had all been personal, and good for that reason. What could it be without her? And what was she without it? In 1969, at the age of seventy-four, she gave her last performance. Around this time, Ron Protas arrived.

SHE was old, a world-famous artist. He was young, in his twenties, a law-school dropout and occasional theater photographer. Sally Shaffer, who was Graham's assistant at that time, told me, "I remember, it was at the back door of City Center, on West Fifty-sixth Street. It was raining, and there was a man—collegiate look, brown scarf—with some wilted flowers in his hand and a camera around his neck. He begged me, could I get him in? He said he wanted to put together a beautiful book on Graham." (Protas disputes this account, though he says he cannot remember where or when he met Graham.) Soon he was around all the time. Graham couldn't stand him at first. She used to say, "Get that creep out of here." But Protas was persistent, and in time Graham found that she did not mind the attentions of this young man, for she had

just lost what had been her reason for living. "Without dancing, I wished to die," she wrote in *Blood Memory*.

She almost did die. Between 1970 and 1972, she was largely absent from the company, as she checked in and out of Doctors Hospital, in New York, with diverticulitis and cirrhosis. During this hiatus, she also spent a year at the home of two friends, Ben Garber and William Kennedy, in the suburbs north of the city. They fed her hot dinners, weaned her off alcohol, put her on a chaise longue, and told her to rest. They also arranged for her to get a face-lift, which cheered her up. But while she was in the hospital Protas was in regular attendance, and soon she was very dependent on him. "Ron saved my life," she would say. Graham was opportunistic, like many artists. She promised people a great deal, and then, if they asked for a great deal, she got rid of them. In the view of a number of Graham's dancers, Protas was just the sort of person she would have used for a while and then discarded. But, as David Wood said, "Protas was there at the end. She was tired, unable to control things." Protas sees it differently. He and Graham, he said, "attached ourselves spiritually to each other, to the outrage and anger of the rest of the dance world."

The primary charge against Protas, personally and artistically, is that he alienated Graham from her older dancers, the people whose minds and bodies were the repositories of her work. The first to go were the ones who had held the company together during Graham's absence: her dancers Bertram Ross and Mary Hinkson; her company manager, Leroy Leatherman. To some, she seemed paranoid, and Protas the supporter of her delusion. (Pinkerton guards were hired to patrol the theater during a New York performance following Ross's departure, in case he arrived to assault Graham.) The purge continued for years. One by one, the veterans left, and Protas took their place as Graham's primary adviser.

In 1982, Protas was made an associate artistic director; in fact, he had begun handling the company's management and bookings long before. According to many people involved, he was extraordinarily unprofessional. Signed contracts were not final. Shortly before the company was to appear in a city, Protas would call the presenter and threaten not to come if he was not given more

money or more control. He was abrasive and insulting, particularly to anyone in a position of authority regarding Graham's work—for example, the teaching staff and the senior dancers. Miki Orihara, who joined the company in 1987, said, "As a new dancer, I admired the senior dancers. You imagine that you will be like them. He tore into principal dancers. They had their own voices. How could he put them down like this, tear them down?"

Some people, even those who have broken with Protas, say that he is intelligent and creative and that he did acquire a thorough knowledge of Graham's repertory. Cynthia Parker, who was the general manager of the company in the seventies, said, "Ron made a lot of mistakes, but his heart was in the right place. He was trying so hard to make things work for Martha." If Protas was hated, that is almost always the fate of the director's favorite, and, like others in that position, he was blamed for the director's faults. Graham had a "virulent edge," as Don McDonagh, one of her biographers, put it. She slapped dancers, scratched them, threw things at them. Once she came under Protas's influence, her sins were laid at his door. And even though Protas had never been a dancer, that did not mean he could not run a dance company. A number of famous dance troupes, including Diaghilev's Ballets Russes, have been directed by nondancers.

According to a number of witnesses, the problem with Protas as an administrator lay not so much with his abilities as with his personality. "He is not an emotionally stable person, and that's to put it kindly," Diane Gray, a former star of the company, told me. (Gray, as the director of the school in the eighties and an associate artistic director in the nineties, worked closely with him.) Also, Protas identified with Graham to an extent that others found decidedly weird. "He would come into rehearsal with his head bowed slightly, looking up from under his brow, like her," Peter Sparling, a leading dancer of the late period, recalled. "Then he would dole out praise, then blame. And the blame would be cruel, even wicked. But he coiled in tightly before he struck, which is what Martha did." Graham had a nice, haughty way of tossing her scarf across her shoulders. Protas soon had it, too.

As the years passed and Graham became weaker, Protas took over more and more. He did her makeup; he took her wherever

she needed to go, and managed the occasion. He excommunicated people in her name. When Laura Shapiro, the dance critic for *Newsweek,* requested an interview with Graham, in 1990, Protas told the magazine that this would not be possible, because Graham regarded Shapiro as an "evil spirit," who "might put a curse on the new work." One day, Tobi Tobias, the dance reviewer for *New York,* was watching a class taught by Jane Dudley, one of the veteran dancers. Protas walked in and said to Dudley, "Martha hates Tobi Tobias. Get that woman out of here." (Dudley did nothing, but later she went to Graham and told her the story. Graham replied, "I owe Ron everything. He saved my life.") When Protas was thwarted, he did not forget it. "If you crossed his path," Diane Gray said, "he went out of his way to take revenge."

I met with Protas recently in the office of his press representative. He is a handsome man, probably in his late fifties. (He would not tell me his age.) In a small, hot room, he wore a wool sweater, a wool jacket, and one wool glove. The principal topic of our three-hour conversation was his devotion to Martha Graham. His eyes welled up with tears several times. "I had lost my mother," he said, "and I was bereft." Graham helped him: "I think I probably owe her my life." For decades, he recalled, there was rarely a day or night that he didn't spend with her. He took notes during her rehearsals; he videotaped her as she was coaching. "She came very close to dying, and didn't want to die. And I think she saw another way with me, someone who cared for her, and was just passionate to be with her." He went on, "She taught me so much. I didn't realize at the time what she was doing"—that she was "training me to oversee her work as she would wish it."

People were always trying to take Graham's work away from her, especially the older dancers, Protas said. "They wanted to control it." He pulled out a copy of an old company publication and showed me a photograph of him and Graham, walking across an empty stage, hand in hand. "This is a symbol," he told me. "Everyone wanted to walk with Martha like that. Everyone wanted that closeness. She didn't give it to them."

She gave it to *him,* he said, and in return people tried to get rid of him. That was what was happening now. A "faction" of the board of trustees—Protas's lawyer calls it a "cabal"—was out to eliminate him, so that they could seize Graham's work. People had slandered him, gone through his desk, taken his papers. Whatever he did, he did for Graham, out of love. "I would run away if it was just for me," he said. "But I must protect her. She left me her name. She left me everything in her life she valued, and she trained me to protect it in the way she wished, and I will, to the death."

EVERYONE seems to agree on one point: Protas got Graham back to work. In 1969, when she retired from dancing, she felt that her career was over. Three years later, she returned on Protas's arm and, over the next two decades, created twenty-eight more ballets. It is debatable whether this was good for her reputation. "She had, in effect, died," de Mille writes. What came afterward was a thudding anticlimax. For there to be a dance, Graham once said, "there must be something that needs to be danced." Indeed, in most cases there had to be something that *she* needed to dance. Now that she was retired from the stage, there was nothing that needed to be danced, and it was danced anyway.

Graham worked hard. She came to the studio for four hours a day, but often her words would trail off, and Linda Hodes, who was associate artistic director, would have to interpret what Martha presumably meant. She coached only sporadically. One old-timer told me, "If you danced past her and didn't fall down, she said okay." Frequently, she couldn't recall what came when in the dances; sometimes she forgot which piece she was rehearsing. But seasons were still being staged in her name, and she had to come up with novelties. She restaged some of her beautiful works from the thirties. (This was reportedly at Protas's urging. If so, we owe him—and the dancers, such as Yuriko and Terese Capucilli, who reset them—a great debt.) She cooked up dances out of classroom exercises. She brought in guest artists: Mikhail Baryshnikov, Rudolf Nureyev, Margot Fonteyn, Maya Plisetskaya. When she did make a new piece, it was often another version of an old piece,

goosed up by glamour. Starting in 1975, Halston designed the costumes for much of her new repertory, swathing it in lamé. He also recostumed many of the older pieces. To see the sack of Troy, in *Clytemnestra,* executed by men dressed only in backless gold shorts was to see a new take on that legendary event. The choreography, too, got sexier. *The Rite of Spring* (1984) included a forthright copulation. On the cover of the 1989 program brochure was a photograph of Oedipus, in *Night Journey,* garroting Jocasta with one hand as his other hand came down on her breast. "Bristling with fleshly sensuality," the press quote plastered across the photo declared. The company seemed to be advertising snuff ballets.

Did Graham know that the new work was bad? Perhaps, but she had labored for many years, and now she was going to have her reward. She did a Blackglama ad and got a mink. She was photographed with Madonna and the pope. Forget the work— she had done it, long ago.

Many of the critics saw that Graham's new work was feeble, and said so. But Anna Kisselgoff, the chief dance critic of the *Times,* loyally praised it, and this was the main support of her reputation. In honor of Graham's ninety-fifth birthday, Kisselgoff interviewed her, and quoted liberally from the mythopoeic utterances to which Graham was always given. "Pointing to her chest, Miss Graham said she tells her dancers to keep in mind 'the little bird that is there,' " Kisselgoff wrote. " 'The tiny creature . . . it is the heart.' " Other reviewers also exclaimed over Graham's late works and quoted her Delphic pronouncements. Such is the tribute often paid to aged female artists: how spiritual they have become! The press release for the company's first season after her death asked people to contemplate "the significance of this event, this terrible shifting and grinding of the great gears of history."

IN 1991, Graham died, of cardiac arrest. Protas scattered her ashes in the mountains of New Mexico and, by the terms of her will, inherited everything she owned. Protas says that he was named as the heir in the several versions of the will that Graham filed in the last years of her life. Some of Graham's associates, however, believe that she vacillated on the question of who should inherit the

rights to her work. When Graham was close to death, she summoned three of her trusted older dancers, Diane Gray, Linda Hodes, and Yuriko. (Yuriko, who came to Graham straight out of a Japanese-American internment camp during the Second World War, was one of her finest performers.) All three were still working for the company. "She said to us, 'This isn't how I would have liked it, but I'm leaving everything to Ron,' " Gray told me. According to Hodes, Graham said to them, "I've made a mistake." When Hodes asked why she didn't just correct the mistake, Graham replied that "her life was so hard, and she had come to certain conclusions." Gray recalled, "Martha said to us, 'I want you to help Ron.' We said yes, and we tried to uphold that for as long as we could." It wasn't long. Linda Hodes was gone a year after Graham's death. Protas says she quit; she says he fired her. Yuriko left after two years, citing philosophical differences with Protas. Gray hung on until 1997.

Under Protas, the dances were set and rehearsed by the associate artistic directors—in the late years, Terese Capucilli and Christine Dakin—but these women did not have final authority. Protas would eventually look at a piece and issue corrections. There was often screaming and tears. The problem spread beyond the company, to dealings with presenters. When the Joffrey Ballet of Chicago was planning an Aaron Copland centennial celebration, Protas made the inclusion of *Appalachian Spring,* by Graham, contingent upon the exclusion of *Rodeo,* by Agnes de Mille. (He said that Graham would not have wanted a de Mille work on the program. Some people pointed out that de Mille's biography of Graham was very uncomplimentary to him.) The Joffrey complied. Other organizations simply crossed the Graham company off their list. Diane Gray recalled, "We would often leave a place, and the presenters would say, 'Never again.' " Tour dates dwindled, and the company could not afford New York seasons, which almost always lose money. From 1995 to 1999, the Graham troupe did not perform in its home city.

Meanwhile, the deficit rose. Graham was not a businesswoman; she always figured that her friends would pull her through, and they did. Many of her seasons were paid for by Bethsabee de Rothschild, of the banking family. In 1952, Lila

Acheson Wallace, of *Reader's Digest,* bought Graham her company's headquarters, a pretty, old brick building, with a garden, at Sixty-third Street and Second Avenue. Doris Duke, the American Tobacco Company heiress, helped her out a number of times. Eventually, such friends fell away, and by the eighties the company's grant proposals were being turned down. The funders wanted to support the *next* Martha Graham. The board raised money, but never enough. As the dance writer Francis Mason, who had joined the board in 1973, told the *Times* last year, "Since 1989 we have slowly been going broke."

In 1990, the deficit reached $1.4 million. Such a figure is not unheard of for a dance company, but, once Graham herself was gone, it became even more difficult to raise funds. In 1994, the company contracted for a loan of a million dollars from U.S. Trust, which, according to Protas, Doris Duke said she would help repay. When the time came to repay it, however, Duke was dead. The bank's bills were stuffed in a folder, and its calls were not returned. ("Maybe I was maladroit," Protas later told the *Times,* "but we were in a moment of rebirth.") On occasion, the company could not make payroll. Protas sometimes covered expenses out of his personal funds. He says that over the years he loaned the Graham Center $300,000, of which it still owes him $100,000.

The funding organizations continued to hang back, and now they had another reason to do so. According to several people involved, important funders had little faith in Protas's ability to keep the company alive. "He has no business acumen and no artistic ability," Theodore Bartwink, the executive director of the Harkness Foundation for Dance, said. Some funders bypassed Protas, giving grants to other organizations to benefit the Graham Center. In 1994, for example, the Lila Wallace–Reader's Digest Fund subsidized a Graham centennial at the University of Michigan, in which the company performed. Meanwhile, the center itself was nearly bankrupt, and its building was falling down. Years earlier, writing in *Blood Memory* about how nature spoke to her, Graham had said that in her studio "we have had a little shoot of plant life come up out of the floor just near the piano. . . . We accept it as a gift." Others accepted it as evidence that the floor-

boards were rotting. Todd Dellinger, who became the company's executive director in the late nineties, said, "There were days I spent shovelling dirt to prevent rain from flooding the basement. We were deeply, deeply in trouble."

By 1997, Protas seems to have realized that something had to be done. Late that year, he had tea at the Carlyle with Janet Eilber, a Graham star from the seventies who was then directing a small troupe in Los Angeles. He had begun looking for a new artistic director, offering the position first to Yuriko, who did not want it, and then to another veteran dancer, Takako Asakawa, who also turned him down. Now he turned to Eilber. She recalled, "He said he couldn't make any headway. People wouldn't fund him, everyone hated him." Eilber agreed to take the job, and they planned a transition period of a year and a half.

The next step was to retire the debt, which, after long hesitation, the company achieved by selling its primary asset, its building. Benedetto Caiola, a real-estate developer whose daughter had been a student at the Graham school, bought the property for three million dollars and promised the company space in the building that he planned to construct on the site. The Graham dancers still choke up when they speak of the sale. Nevertheless, it allowed the Graham Center to pay off its debts and come up almost a million dollars in the black. The school and the company moved to temporary studios downtown.

Dellinger and Protas then spent a year working out a licensing agreement whereby Protas would permit the Graham Center to perform her works and run her school under the artistic direction of someone else. Under the new agreement, Protas would move his operations to the Martha Graham Trust, which had administered Graham's estate since 1998, but he would have an office, with an assistant, at the Graham Center. He would also remain the troupe's consultant, with a considerable fee and significant powers, including the right of approval over the choice of artistic director and over the casting of all the roles Graham made for herself—that is, the starring roles of her major pieces. Most important, if he had any objection to how a work was being performed and his concern was not addressed to his satisfaction, he could withdraw the company's license to perform that piece. In other

words, he retained most of the rights of a director. As Graham's heir, he was in a good bargaining position. The licensing agreement was signed in July of 1999.

During the transition, Eilber was commuting from California to New York for one week each month. The plan was that she would take over in the summer of 2000, but then, it seems, Protas began having regrets about relinquishing control.

THE board bears some responsibility for this crisis. During Graham's lifetime, it had acted as a rubber stamp, as is common and appropriate when the founding director is still alive. It consisted mostly of arts patrons and celebrities. They wrote checks and got others to do so, but they took a long time to understand that they had a problem. Then, in September of 1999, two months after signing the licensing agreement, Protas demanded that the board take on five new members, including a new chair, of his choosing. Desperate to keep peace, the trustees complied, but many of them did not disguise their displeasure. Soon, after a board meeting at which Protas felt he had been treated rudely, he spoke with Eilber on the phone, and said, in her words, "that if I didn't immediately fax him a letter of support I would never work in the Graham tradition again. I would have set my hair on fire for Martha Graham, but I didn't like to be threatened." She did not send a letter of support.

Events progressed swiftly. At a board meeting last March, Protas announced that he no longer wanted Eilber, and that he would stay on for another year to look for a replacement. At the next meeting, the trustees voted to remove him as artistic director. In May, Marvin Preston, a plain-spoken midwesterner who had become executive director just two months before, when Dellinger quit, outlined the financial situation for the board: by the end of the spring tour, the company would be $500,000 in debt, with no assets to borrow against. In response, the board took the action that so jolted the dance world: it voted to suspend operations of the Graham Center and to cancel all future engagements. The following day, Protas faxed the trustees a letter saying that he was

revoking the licensing agreement. At the next meeting, in June, the trustees voted him off the board.

During this period, ten trustees resigned, some out of sympathy with Protas, others out of frustration with the whole business. One of them, Princess Moune Souvanna-Phouma, of Laos, complained to me of the hostility to Protas—and to any trustees who sided with him. Celeste Cheatham, who also resigned, says that Protas's enemies on the board "ignored anyone who was on Ron's side." But most of Protas's allies, like the princess, had been recently appointed, by him, or were celebrities, such as Betty Ford, Vanessa Redgrave, and Gregory Peck, and they did not attend meetings regularly. (If they had, Protas might still be running the company.) The trustees who remain are old-timers, for the most part, and they are not friends of Ron Protas.

Protas believes that the board did not have to suspend operations, and that it did so mainly to force him out. Marvin Preston has a competing theory, that Protas may have foreseen the closure all along. When Preston started working with the company, he says, he looked at the figures, the contract, the leases, and asked himself, "What am I looking at? I'm looking at an organization that has been planned to stop at the end of April"—just before Protas was to have ceded the directorship.

In any case, the company was closed. Nor were many other people allowed to perform Graham's works. Frostburg State University, in Maryland, had long been planning a Graham retreat for students in the summer of 2000. When Protas discovered that several of the teachers involved had joined the company's dancers and more than fifty of its alumni in signing a public letter protesting his behavior, he demanded that Barry Fischer, the director of the retreat, fire them. Fischer refused, whereupon Protas revoked Frostburg's right to perform any Graham works, teach anything called Graham technique, or use Graham's name in its publicity. Fischer hastily put together a different program. Other people, unwilling to deal with Protas, have also dropped Graham from their schedules. The former Graham dancer Peter Sparling, who now teaches in the dance department at the University of Michigan, and who has his own company, in Ann Arbor, told me that

his troupe is no longer performing Graham pieces, and that he has ceased teaching Graham technique.

If this trend continues, it will mean the elimination of Graham from the world's dance repertory. Protas claims that he can keep Graham's work alive by licensing it to other companies. (This would also benefit him. Licensing fees go to Protas, not to the Graham Center.) But most of the organizations to which Protas has licensed Graham's repertory are classical-ballet companies. Keith Roberts, who performed Graham's work at American Ballet Theatre, told the *Times* that asking a ballet dancer to do Graham was "like asking a modern dancer to do *Sleeping Beauty*." The dancers' protest letter claimed that if other troupes performed Graham's works without a mother company existing to set standards, "the aesthetic values she devoted her life to will be gravely and forever diminished." Throughout this dispute, Anna Kisselgoff, of the *Times,* has supported Protas, as she formerly supported Graham. In October, she wrote that, although operations had been suspended, "luckily, Graham's works are being staged by other troupes." This came as a direct rebuttal to the dancers' letter.

IN part, this is a story about preservation. Dance differs from all other arts in that it is not created as a document. Literature exists as text, music as a score, but dance is created on living bodies and survives only as long as those bodies remember it and pass it on to others. This is one reason that choreographers, including Graham (and Merce Cunningham, who is eighty-one), go on working as long as they do. If they quit, chances are that their company will fold, in which case their works, ceasing to be performed, will die. The classics of Western literature date from the seventh century B.C. The classics of Western dance date from the nineteenth century A.D. Strange as it may seem to us that Graham didn't care if her works died, she was simply ratifying the historical law of dance. Of Graham's hundred and eighty pieces, only about forty are extant or reconstructible. (The others died because they went out of repertory.) That's a lot. Of the seventy-five ballets of Marius Petipa, the foremost choreographer of the nineteenth century—

or so we think, since most of his colleagues' works have vanished—about four survive, counting fragments.

Only in recent years, partly because of Graham and George Balanchine, has preservation become an issue in dance. Systems of dance notation, whereby the movement is written down in symbols (as in music notation), have been refined. Film and videotape have been put into service. But no one pretends that these recordings document the phrasing or the spirit that the choreographer actually intended. A videotape is a record of one performance, possibly a bad performance, and, more important, one seen from the outside. Even if it shows what a dancer pulled out of herself for that dance, it cannot teach a new dancer what to pull out of herself. Notation is probably more helpful, but the key in dances set from notation is coaching. Someone must stand there—someone whom the dancer respects—and say, "This is how you accent this phrase," "This is how the arc of energy is released," "This is the big moment." When restagings of pieces by dead choreographers actually work—witness the Kennedy Center's recent Balanchine Celebration, with performances of his works by San Francisco Ballet, Miami City Ballet, Pennsylvania Ballet, the Suzanne Farrell Ballet, the Joffrey Ballet, and the Bolshoi Ballet—they always have this personal note. That is because they were coached by people who danced those roles, and who have confidence, passion, and pride of ownership that they can communicate to the new cast.

Even if a dance survives in repertory and is well coached, it will change. The coaches will change it, according to their own idiosyncrasies, and they will adjust it, in keeping with shifts in taste, to prevent it from looking dated. It can be argued that Graham's dances, because of the aura of holiness that surrounds her, have not been changed *enough*. They were born of a different, more histrionic period in the theater. I have heard people at City Center giggle as She of the Ground, in *Dark Meadow* (1946), stalked across the stage with a tree pinned to her head. Ballet directors are more pragmatic. *The Sleeping Beauty,* probably the world's most honored ballet, has been revised to the point where Marius Petipa, who created it, in 1890, probably would not recognize it, and it is

the best preserved of the "classics." No one sees this as a problem. The problem is only that there is no original text. A modern-minded theater director can set *Hamlet* in a public lavatory, and the next director will still have Shakespeare's text to return to, so that he can make his own decisions. A stager of *The Sleeping Beauty* knows only the productions he has seen. Drama is a wheel, with spokes (the productions) radiating from the hub (the text). Dance is a chain, with each link attached only to the last.

In an effort to bypass this rule, the George Balanchine Foundation is now videotaping Balanchine's original dancers coaching his ballets, so as to have a record of what he wanted—a hub. The Library of Congress is trying similar methods with Graham: "layered films," including a performance, a rehearsal, and whatever documentation there is of Graham's coaching, plus footage of the original performers coaching the role (if they did so) and saying what Graham wanted. These new techniques are expensive, however, and we don't know if they will work. Today, the old method of hand-to-hand transmission is still in force, and by that method a dance will survive, roughly the way the choreographer set it, for, at most, twenty years after his or her death. This sounds terrible, but twenty years is long enough for the piece to imprint itself on the memory of future choreographers, so that the old dances will inform the new.

What, then, is the need of a mother company in Graham's case? Her best works are more than half a century old, and she had stopped coaching many of them. In addition, Janet Eilber, who may yet become the company's artistic director, said, "Bodies are different today from what they were in the forties. The technique is different, far more advanced. And people are different." Graham's pieces, she thinks, need recoaching, and some of them could use new productions—neither of which need violate their spirit. Eilber is helping to make the layered films at the Library of Congress, and she says that what is being done there must be done at the company. "The older dancers have essential knowledge, which the company has now been cut off from for thirty years"— since Protas arrived. The mother company is the place where the old meet and teach the young. That is what has been eliminated,

and, if the company remains closed, there will be no place where it can ever occur.

THE Graham Center's board of trustees does not intend this to happen, and it may have its way. Ever since Graham's death, it has been assumed that the rights to her dances depended on her will. Last summer, however, the office of the New York attorney general contacted both Protas and the board to suggest that they bring a mediator into the dispute, and it pointed out that the ownership of the dances might be in question. In Graham's time, intellectual-property law stipulated that in order for a dance to be copyrighted as someone's property it had to be "fixed"—that is, notated or filmed, with the proper copyright notices. This was not done with most of Graham's dances, which means that they may be in the public domain. What's more, Dale Cendali, the attorney for the Graham Center, said, "The work-for-hire doctrine holds that if Graham created those dances as an employee of the Graham Center they belong to the center, not to her. And she was an employee. She drew a salary, had taxes withheld." Michael Quinn, Protas's attorney, told the *Washington Post* that this challenge was a "last, desperate act of a hopeless crew that tried to hijack Martha's legacy." Protas, Quinn claims, "owns everything." He added, "It's out-and-out theft for anyone to claim otherwise." (This challenge could have huge repercussions for the dance world. How many of Balanchine's works were properly copyrighted?) Moreover, the attorney general's office is now investigating Protas for possible violation of fiduciary interest in his dealings with the company, and it is seeking permission from a federal judge to intervene in the trademark issue on the center's behalf.

The Graham school reopened on January 16. Hugh Hardy, the celebrated architect who recently renovated Radio City Music Hall, is designing the Graham Center's studios in the new building on East Sixty-third Street. According to Marvin Preston, the company will be dancing again this year, with or without Ron Protas's permission. Shortly before the school reopened, Protas tried to obtain a restraining order to prevent it from using Gra-

ham's name. The order was denied. Now he has filed suit against the center—together with several of the trustees and past and present directors of the center—alleging trademark infringement, breach of contract, defamation, verbal abuse, invasion of privacy, theft, and "the hurling of heavy objects by defendant Dellinger at Mr. Protas." (Todd Dellinger says, "They were the bronze door handles from Studio 1, and I didn't throw them at him. I put them down on his desk.") What will happen is an open question. In any case, the ghost of Martha Graham, who thrived on turmoil, will not be displeased. "Right now," one of her longtime dancers said, "she's looking down and smiling on the mess she made."

The New Yorker, 2001

Postscript: In 2002, after an extended legal battle, the United States District Court decided that fifty-three of seventy Graham works under consideration belonged to the Graham Center. As for the remainder, eleven have been declared to be in public domain, and five were awarded to the organizations that commissioned them. (Those organizations have already given, or are likely to give, performance rights to the Graham Center.) Only two of Graham's dances, *Acrobats of God* and the beautiful *Seraphic Dialogue,* are now Protas's property. In addition, the center won ownership of all Graham's sets, costumes, archives, and trademarks. The Martha Graham Dance Company resumed operations in 2002 and is now touring widely, as well as performing annually in New York. In 2005 Janet Eilber became the artistic director of the Graham Center, with full power and responsibilities.

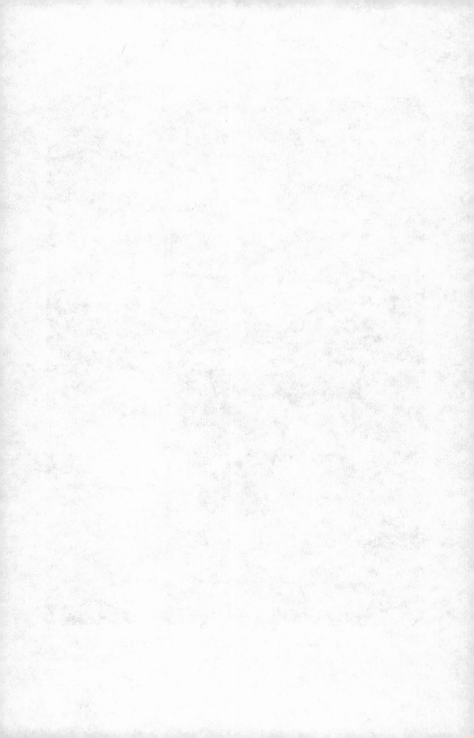

Bob Fosse and Gwen Verdon in rehearsal, c. 1957

Dancing and the Dark

IF, today, you go to see a dance act in a night club, it may well start with a single light trained on the stage, a single white-gloved hand jutting out, a single rear end gyrating meaningfully, and, then, as the lights go up, a pair of eyes staring at you as if to say, "I know what you're thinking." If you switch on MTV, chances are you'll see the same thing: the glove (Michael Jackson), the cold sex, the person eyeballing you as if this were all your idea. There is an imp of the perverse at loose in mass-culture dance, a spirit that has little to do with the blowsy cheer of old-time night-club numbers, not to speak of the innocent jitterbugging we used to see on television. One could say that this is just part of post-modern culture—its toughness, its knowingness. But it is also something more specific: the heritage of Bob Fosse, who was Broadway's foremost choreographer-director during the late sixties and the seventies.

That it *is* a specific style—one you can look at and say, "There's Fosse"—tells us something about the era in which this man worked. The period from the forties through the seventies was the heyday of the choreographer-directors, a group that included Agnes de Mille, Gower Champion, Jerome Robbins (above all), and Michael Bennett. These were people who believed that the meaning of a show could be contained in its dancing, and that the show could be fueled by the energy that comes only from dancing. One by one, they changed the American musical, bending it away from its European-operetta roots. De Mille made it realistic, vernacular—fellers and gals getting together at clambakes. Robbins, in *West Side Story,* made it urban, modern, with sneakers and social problems. Fosse made it something else alto-

gether, no longer even a representation of life but a kind of emanation from the lower brain—edgy, unwholesome.

He had a personality to match. By the late sixties, Fosse was the kingpin of the American musical. He had a string of hits behind him, and more to come. Soon he began directing movies, and showed himself, as Pauline Kael said, a prodigy in that medium. He went into television, too, directing the wonderful *Liza with a Z,* which, together with his movie *Cabaret,* made Liza Minnelli a star. In 1973, he won the Oscar (for *Cabaret*), the Tony *(Pippin),* and the Emmy *(Liza)* all in one sweep. He was at the top. Yet nothing could have persuaded him of this. He never learned to occupy his fame—never bought the suits, learned the tone, got comfortable. On the contrary, to the end of his career he regarded himself as an outsider, someone who'd snuck in off the street. According to his biographer Martin Gottfried (*All His Jazz,* 1990), Fosse had lunch almost every day at the Carnegie Delicatessen with the playwrights Paddy Chayefsky and Herb Gardner. He would order a beer and a pastrami on white with mayo (he was a midwesterner) and then push the sandwich away, drink the beer, and pour out his miseries. "Everything he does he thinks it comes out of bullshit," Chayefsky said. "It's a game, a phony."

But that was only half the story. The other half was that everyone else was a phony. As Fosse once said to a *Times* reporter, "I alternate between these terrible states of thinking I'm a fraud and this raging ego." He was an uncomfortable soul, and looked it: runty, slope-shouldered, with a caved-in chest. He dressed mostly in black—a style not fashionable in his time—and often had a hat pulled down over his brow. He said this was to cover his thinning hair, but it may also have been to hide his face. Out of his mouth, almost always, hung a cigarette. ("There was a sort of groove in his lip where it sat," the choreographer Donald McKayle says in Kevin Grubb's 1989 book on Fosse, *Razzle Dazzle.*) In 1977, when Herb Gardner's play *Thieves* was being filmed, the director needed someone to play a street junkie. Fosse volunteered, and was perfect. In some measure, he just had to be himself.

Fosse died eleven years ago, but he is making a comeback. *Fosse: A Celebration in Song and Dance,* a revue directed by Ann Reinking and Richard Maltby, Jr., will open in New York next

month. Meanwhile, the revival of his 1975 musical *Chicago* is in its third year at the Shubert Theatre, and the English director Nicholas Hytner is gearing up to make a film based on the show. In these productions, unlike the MTV trickle-down, one can see Fosse's style in its pure and narrow form. Gottfried quotes the *Daily News* drama critic Howard Kissel saying that Fosse's dances reminded him of "things that crawl under a rock," but they don't always look that way. Sometimes they look like a bad dream or a George Grosz drawing. What they seldom resemble is any dancing ever made on Broadway before Fosse got there.

IT is often said that Fosse's roots were in vaudeville, and this is partly true. He was born in 1927 on the North Side of Chicago. The father was a Hershey's-chocolates salesman, the mother a housewife; the family was large, normal, and Methodist. His primary dance teacher was a vaudeville aficionado, and paired the twelve-year-old Fosse with another boy in a tap act called the Riff Brothers. At first, they played "presentation houses" (movie theaters with live acts), along with Elks and American Legion meetings. Soon, however, they graduated to Chicago's strip clubs—the Silver Cloud, the Cave of the Winds—and it was that world, far seedier than vaudeville, that printed itself on Fosse's imagination. His work is strewn with low-life types: pinup girls, taxi dancers, sequinned dames flashing their thighs at men with cigars.

The strip clubs gave Fosse more than his subject; they supplied the emotional field. The strippers toyed with Fosse. They took him on their laps and licked his ears. Some probably did more with him. (He later claimed that at age fifteen he was named in a divorce suit brought against a waitress in one of the clubs.) But during the day, at Roald Amundsen High School, he lived the life of an innocent, clean-cut teenager. He played sports; he got good grades; he was voted Most Popular Boy in the class. No one at school knew how he spent his evenings. His parents didn't know, either. He told them he had club dates, but he didn't say what kind of clubs.

Gottfried believes that this situation created a serious, lifelong division in the choreographer's mind, and though the theory sounds pat, Fosse's work bears it out. As it is said that he got his

start in vaudeville, so it is said that the subject of his work was sex. But it wasn't really sex: it was sleaze, fraudulence—the idea of something being passed off as respectable when it is really cheesy and cheap. Sex was merely the example, the thing most likely to poke its head up from under the surface and say that the surface was false. Fosse was in psychoanalysis during the fifties, when he came of age as a choreographer. He was one of many artists in that decade—Tennessee Williams, Martha Graham, John O'Hara—who believed that beneath the Eisenhower/*Reader's Digest* world being sold to them was a censored inner world, a Real Truth, and that sex was its leading edge.

Fosse broke into show business the usual way: Broadway choruses, road shows, small parts in Hollywood musicals. (If you rent *My Sister Eileen,* you will see what a wonderful dancer he was—fast, ebullient, charming.) In the 1953 film of *Kiss Me, Kate,* he got a break. He was to dance in a brief duet, and Hermes Pan, the movie's choreographer, let him design it. This gave him ideas, and the actress Joan McCracken, his second wife (he went through women fast), pushed him further. She persuaded George Abbott, at that time Broadway's foremost director of musicals, to use Fosse as the choreographer for his upcoming show, *The Pajama Game* (1954). *Pajama Game* was a hit, so Abbott rehired Fosse for *Damn Yankees* the following year. Fosse had arrived, very fast.

Much of his choreography for these two lovable shows was in the wholesome Agnes de Mille mold that dominated Broadway dancing at that time. Even so, we can see Fosse's style being born. In *Pajama Game* there is a famous number, "Steam Heat," for three people who, in keeping with the song's title, look less like people than like a plumbing system. They jerk, they bob, they hiss, they clap, in perfect syncopation. Here we see the automatism that was to be so much a part of Fosse's mature work. Nevertheless, "Steam Heat" is still a human sort of dance. It's an act being put on by three amateurs—pajama-factory workers—at a union meeting. They're delighted with what they're doing; when they're applauded, they're goofily grateful. Though "Steam Heat" is about sex, it has no slyness. On the contrary, part of the charm is seeing these factory workers dream about a hot experience that they know about only from songs on the radio.

Still, Fosse was trying to get down. For *Damn Yankees,* he created an actual striptease, for a little devil named Lola who was attempting to seduce a big, dumb baseball player. Lola was played by the up-and-coming star Gwen Verdon, who had been trained in Hollywood by Jack Cole, foremost maker of the erotic/exotic dances (Rita Hayworth in Greek draperies) that red-peppered the films of the forties and fifties. Through Verdon, it is often said, Fosse was influenced by Cole—emboldened to make sex dances, of which "Whatever Lola Wants," Verdon's strip, is the first example. But here, too, sex is subverted by innocence. Lola *tries* to seduce her ballplayer. She does everything that Jack Cole did: casbah, flamenco, you name it. But she tries too hard. To see her struggle out of her pedal pushers on the floor and then, with a jaunty flourish, whip them through the air like a matador's cape is to see a strip act gone badly wrong—gone comic. Verdon, with her generous figure and huge charisma, may have been Jack Cole's premier sexpot, but by the time she got to Fosse she was also a wonderful comedienne—human, fleshly, decent, with an ear-to-ear grin.

With the help of Verdon, who was by then Fosse's mistress and whom he would marry in 1960, Fosse got his first job as director-choreographer, on the 1959 musical *Redhead.* (The producers needed Verdon as their star, and she insisted on Fosse as her director.) Thereafter, he would direct most of his shows and movies. At the same time, the darkness that was to affect so much of his later work began to set in. You can see it emerging in the superficially upbeat *Sweet Charity* (1966). Fosse adapted the story from Fellini's *Nights of Cabiria*—he converted Fellini's prostitute heroine into a dance-hall girl—but Fosse's Charity (Verdon again) had none of the dignity of Cabiria. She was a cheerful little fool in a heartless world, and at times Fosse seemed to side with the world. The show both started and ended with Charity's being thrown into the orchestra pit. (It was supposed to represent a pond in Central Park.) This actually looked sadistic, and to insiders who knew that the Verdon-Fosse marriage was coming apart it no doubt seemed more so.

For *Sweet Charity,* Fosse created a new, harsher sex ballet, "Big Spender." It shows the women in the Fandango Ballroom,

Charity's place of employment, standing behind a rail, displaying themselves to the customers. They are done up to look as cheap as possible: all spray net and fringe. They barely move. One snaps her fingers; one hooks a weary thigh over the rail. Now and then they sing, but mostly they whisper: "Hey, big spender, spend a little time with me." You sense that anyone who spent a little time with one of these women would have to go to the doctor afterward. The number is supposed to be a comedy, but it's a grim one—the Silver Cloud strippers as seen, with full terror, by the Most Popular Boy in the class.

THE grimness came, in part, from Fosse's life at that time, and before. "I'm afraid of failure," he told a TV interviewer, "afraid that the ideas I have, I don't have the talent to execute. . . . I threw up twice a day when I was a performer. Now I throw up three times a day." "Flop sweat," the sweat you get into when you think you've got a flop on your hands, was for him a permanent affliction. On occasion, according to Gottfried, it practically immobilized him. In 1960, when he was working on a show called *The Conquering Hero*—this one *was* a flop—Verdon said that he paced back and forth in their hotel room clutching a cheap Mexican statue of Jesus and screaming at it, "Why don't you help me?" Even when he had a success, he thought it was a failure. In 1973, when he won his Oscar/Tony/Emmy triple crown, he told his friends it was all a sham: "I fooled everybody."

The world was a fraud, and he was a fraud. Didn't his own work prove this? What Fosse loved best about show business, and what he did best, was the razzle-dazzle—the sequins and girls, the flash—but this was also the thing that made him feel cheap. So, as if to rise above it, to "frame" it, he made it cheaper, but this just made him feel cheaper still. When he looked at others—particularly at those who worked in ballet, a form in which he had never been trained—he felt like showbiz trash. He owed his dominance of Broadway in the seventies to the fact that Jerome Robbins had decamped to New York City Ballet to work with Balanchine. Of Robbins and Balanchine, Fosse said to *Rolling Stone,* "They talk to God. When I call God, he's always out to lunch."

Around 1969, he had suffered a great humiliation, with his first film-directing assignment, the movie version of *Sweet Charity.* The film was a failure, and Fosse, always prone to depression, feared that he would never work again. Then, in 1971, Verdon, whom he had cheated on almost throughout the marriage, asked for a separation. He moved out, and began living very hard. He took Dexedrine to wake up and Seconal to go to sleep. He generally drank his dinner (double margaritas). He smoked four packs of Camels a day. He also went through scores of women, often dancers in his shows, often two at a time—that is, two in bed at the same time. He had a five-year liaison with the dancer Ann Reinking, but she got the same treatment as his wives. He worked obsessively, at times hysterically. Verdon, in an interview, described him in rehearsal as a kind of monster: "His face changes. He gets ropey looking. His eyes sink into his head. . . . I've worked in insane asylums and the inmates don't look as weird as Bob." (Dexedrine no doubt did its part here.) He rehearsed dancers till they dropped, and pushed himself even further. "I had to work twice as hard as everyone else to be half as good," he said.

He hid none of his troubles. He blithely discussed his drug habits with a reporter from the *Times.* When his mother died, he told the *Post,* "I think there would have been nothing better than to have had an affair with her. I think everyone ought to have an affair with his mother." He was one of those people, often veterans of psychoanalysis, who feel that if they admit their sins they are somehow absolved of them. And why not? For—as this line of thinking goes—doesn't everyone commit the same sins? He wasn't so much a bad man as a truth-teller in a hypocritical world. In 1974, when he had a heart attack and almost died, this conviction seems to have hardened. He had gone to the edge; we hadn't. He knew the score, and he was going to tell us.

Hence the Luciferian righteousness that hangs like a low cloud over much of Fosse's later work. In the four movies that he directed after *Sweet Charity—Cabaret* (1972), *Lenny* (1974), *All That Jazz* (1979), and *Star 80* (1983)—the heroes are all refractions of himself: corruptees, but more honest than the world that corrupted them. In these movies, the very camerawork banners its brave candor. *Lenny* opens with a long closeup of a pair of lips. We

don't know whether they are male or female, let alone whose they are. What we see is just lips: speech, sex, appetite. We have the sense that if Fosse could have gone past the lips—to the tongue, the gullet, the mucous membrane—he would have, in search of a better, wetter truth. His Broadway shows, too—*Pippin* (1972), *Chicago* (1975), *Big Deal* (1986)—all used low life as a metaphor for life. Even in the 1978 *Dancin'*, which had no book, he supplied as much raunchiness as he could. In one number, "Dream Barre," a ballet class turned into a frank scene of copulation.

But the most interesting product of Fosse's late world view, because it is the most abstract product, was his choreographic style—a sort of ne-plus-ultra extension of the sex-oiled machine of "Big Spender." In the classic Fosse dance of the seventies, the dancers are seen in tight formation, and they don't actually move much. (As Arlene Croce once wrote, "Footwork has about as much to do with Fosse style as lariat-twirling.") The focus is on isolated gestures—a shoulder roll here, a finger splay there. The body part that gets the most action is the pelvis. It jerks, it wags, it oozes. Meanwhile, the dancers remain coldly removed. Their faces are often covered by hats. Their backs are stiff; to bend, they have to tilt. They look like mannequins, or Martians.

Furthermore, they are rarely characters in a drama. In the Broadway choreography of the fifties and sixties, the songs and dances were supposed to emerge naturally from the stage action. One minute the heroine was hanging out the wash; the next minute she was dancing. Fosse followed this rule up through the sixties, but then it started to look corny to him. So, in an interesting proto-postmodern shift, he reverted to his vaudeville roots, making dance numbers that were confessedly numbers. In much of his later work, there is little or no story to humanize the dancers, or to objectify them. We can't separate them from ourselves, can't say, "That's Laurey and Curly." They come from nowhere, or—as Fosse, with his *hypocrite-lecteur* philosophy, appears to be saying—from within ourselves.

IT was in this late, dark-minded period that Fosse created some of his best work, most notably the film of *Cabaret*. Just as in *Damn*

Yankees he got Verdon, with her stubborn humanness, to save the strip act, so Fosse—working, it seems, against his instincts—uses Liza Minnelli to rescue *Cabaret* from what could have been its wallow in Weimar decadence. Minnelli plays Sally Bowles, an American entertainer working in a cheap Berlin night club in the thirties. Early in the movie, Sally sings "Mein Herr," in which she tells her man that she is leaving him because it's not in her nature to be faithful, and that she means to screw her way across Europe. The staging is straight out of Fosse's late trick bag: lots of bowler hats and spread-eagled chorus girls. But if this is corruption it is seriously undermined by Minnelli's wholesomeness. She tears around the stage like a child. She waves her arms, wags her fanny, has a good time. Above all, like Verdon, she shows her body to us in a frank, happy way. In the last chorus, those big legs of hers span the stage like a suspension bridge. "Mein Herr," as it happens, *is* about corruption: Sally will indeed leave her man, she will screw her way across Europe (or at least Berlin), and, as others in the film come to oppose Nazism, she will not. She will be lost. But in Minnelli's stage manner we see the preciousness of what will be lost: innocence, fun, life. She is not the film's only saving grace. In *Cabaret,* unlike other Fosse productions, evil is not a naughty little thing (sex, drugs). It is the Third Reich. Between that reality and the big, blooming girl on whom it bears down, Fosse manages to make corruption look like something more than just his personal bugbear.

Chicago followed soon after. Developed from the same sources as the 1942 Ginger Rogers movie *Roxie Hart,* it tells the story of how Roxie, a floozie if ever there was one, parlays a murder rap (she shot her boyfriend—"He had it coming," she says) into a career in vaudeville by batting her eyelashes at the press and the jury. Most of the other characters are worse than Roxie: her lawyer, who can get anyone off for a fee; her jail warden, who can supply anything for a fee; her prison mate, Velma, a hard-as-nails babe who competes with Roxie for press coverage. In keeping with Fosse's late antirealism, the musical is staged as a vaudeville show: one after another, the characters come forward to sing their venal tales, while in the background the chorus dancers bump and grind in panties and chains.

This is about as low as Fosse ever went, and it's very funny. Verdon, the original Roxie, probably made it more so. But even the revival, which first starred Ann Reinking (Roxie) and Bebe Neuwirth (Velma), is endearing. It doesn't leer at you; it can't. The characters are too extravagant in their vulgarity. *Chicago* was Fosse's first and last *satire* on cynicism. It may also have been his satire on himself. "Razzle Dazzle," the show's most famous number, begins:

> Give 'em the old razzle dazzle,
> Razzle dazzle 'em. . . .
> Give 'em the old hocus pocus,
> Bead and feather 'em.
> How can they see with sequins in their eyes?

In Fosse's work, corruption always needed some solid counterweight in order to work artistically. Corruption alone is a corrupting subject; it brings out our righteousness and our salaciousness and nothing much better. In order to look serious, it has to be placed against some idea of goodness. That is what Verdon brought to the shows she worked on with Fosse, and what Minnelli gave to *Cabaret.* (As for *Chicago,* the show actually laughs at corruption, and thus restores the balance.) Fosse clearly sensed this need. It was he who directed Minnelli, he who chose Verdon as his leading lady. But he never wholly got the lesson through his head; he just went back and forth between doing the job right and doing it wrong.

A fine example of the latter is *All That Jazz,* his embarrassing movie autobiography of 1979. The film's hero, Joe Gideon, is a famous Broadway and Hollywood director, with a life just like his creator's. (Fosse coauthored the screenplay.) The strip-club apprenticeship, the discarded wife, the drug addictions, the heart attack—it's all there. Fosse went so far as to cast Reinking, his betrayed girlfriend, as Gideon's betrayed girlfriend. But he didn't just portray his life; he mythologized it. A beautiful angel of

death, Jessica Lange, keeps turning up in Gideon's dressing room; the movie concludes with Gideon's being zipped into a body bag. Fosse may have recovered from his bypass surgery, but he was damned if he was going to end his testament on such a benign note.

Four years later, Fosse made his last movie, and in it, inexplicably, he not only cast aside the two-bit satanism of *All That Jazz*—and of so much of his work—but actually indicted it. *Star 80* is still lurid enough, God knows. It was based on the much-publicized story of Dorothy Stratten, the murdered *Playboy* playmate. Stratten was a waitress in a Vancouver Dairy Queen when a small-time hustler named Paul Snider laid eyes on her and decided she should be in *Playboy*. He got her in there and intended to push her higher, into movies, with himself as her manager. But his plan backfired: Stratten got into movies without him, and then abandoned him. *Star 80* is hard to describe, because it is so appalling. The rejected Snider blew Stratten's brains out with a shotgun; after that, he sodomized her corpse, on a special table he'd painstakingly constructed for that purpose. In the film, the story is repeatedly intercut with shots of Snider doing this. Actually, we don't know what he's doing. All we see is his agonized, sweat-bathed, blood-smeared face. But we know, we know, that something terrible is happening. At the end, we find out what it is.

Many reviewers, and many filmgoers, were repelled by *Star 80*. But it is a compelling piece of work, a portrayal of sex as utter nullity, power without meaning. All the energy in the film—imagination, hope, effort, anguish—belongs to Snider, the putative villain, and it is all aimed at a brick wall, the blank, passive Stratten (Mariel Hemingway). Here Fosse at last went beyond the idea of corruption. In this story, there is no innocence to corrupt. (According to the movie, Snider wasn't Stratten's first.) There is just ambition, with sex as its vehicle. But the most radical thing about the movie is that it takes the point of view of Snider. "I somehow identified with him," Fosse told *Rolling Stone*, "because he was trying to get in. . . . I know that sense of them all knowing something I don't know."

Star 80, more than *All That Jazz,* was Fosse's autobiography, the story of his insecurity, and of his fascination with sex, which, in this movie, turns to dust in his hands. When Eric Roberts, who played Snider, was having trouble with the role, Fosse instructed him to play it as Bob Fosse. Gottfried tells the story: " 'Look at me,' Bob demanded. 'Look at me!' and he glared at Roberts. 'If I weren't successful . . . —look at me—that's Paul Snider. That's what you're playing.' " That Fosse should have seen in Snider—a pimp, a loser, a murderer—the image of himself is amazing, but he never lacked for boldness, or for self-hatred.

In 1987, at the age of sixty, he collapsed on a sidewalk (another heart attack) and died. It is hard to detect his influence in today's new musicals, for the movement he was part of has vanished. Apart from Tommy Tune, there are no choreographer-directors left on Broadway. When a show needs dances, the director calls one of a group of capable journeymen—Susan Strohman, Graciela Daniele, others—who are lively and upbeat, good at period style, and seemingly content with those virtues, as are the directors. Even leaving aside Fosse's tone, the sheer individuality of his choreography is not what is wanted now. His imprint is easier to trace in the mass culture—in those music videos and night-club shows, and in dance movies. When in *Fame* and *Flashdance* you see the fast cutting, the isolated body parts, you are seeing the spirit of Fosse. He may have influenced advertising as well. Fashion models who look lacquered or drugged or dead—Fosse is probably in the background here.

He was better than his inheritors, or at least more ambitious. In, in, he tried to go. In *Lenny,* he trained the camera on the lips; in *All That Jazz,* he filmed open-heart surgery—the pump itself. (He had to get special permission from the patient.) Though his motivation often seems naïve, he was nevertheless interested in who we actually are. What is forbidden? What is true? Almost everything he did was unpleasant. His work was tacky, pushy, obsessive. He was a hophead. Yet he was a moralist, of a generation that had little hope of innocence. He was clearly drawn to innocence; its presence, or its mourned loss, is at the center of his best work. He toys with it, undermines it, reembraces it, pushes it

away again—a struggle that at times seems oppressively personal. With all artists, we have to deal with the business of personality versus art, neurosis versus imagination. With Fosse, the imagination is smaller, the neurosis bigger. Still, he was an artist.

The New Yorker, 1998

Twyla Tharp, 1989

The Bottom Line

TWYLA Tharp, at the early age of fifty-one, has unburdened herself of an autobiography, *Push Comes to Shove,* and, if nothing else, it will remind the dance world of happier days. Tharp was the golden child of the seventies, and its most representative young choreographer. She was involved in all the major dance trends of the decade—the avant-garde's move into the mainstream, the high-art use of popular culture, the rise of TV dance, the truce between those old enemies modern dance and ballet, and their marriage in the so-called crossover ballet. Indeed, she led several of these trends.

The basis of Tharp's style was the rock-and-roll dancing of her youth, the fifties and sixties—in other words, rock and roll before it lost its connection with jazz. Look at a film of any one of her dances from the seventies—*Eight Jelly Rolls, The Bix Pieces, Sue's Leg, Baker's Dozen*—and you see it. The bent knees, the loose hips, the smart feet, the cool upper body, the easy, elastic relation to the beat: it's the insolence of rock (and of the nascent youth movement) combined with the wit and elegance of jazz. To transfer this kind of dancing from the sock hop to the stage, Tharp pushed much further the combination of ease and rigor that already existed in the style. In her dances, the upper body slipped and slumped and swung; meanwhile, the lower body was accomplishing miracles of speed, agility, and musicality. "Her demands in relationship to the music are more specific than almost anything I have ever done," her collaborator Mikhail Baryshnikov has said.

Furthermore, Tharp made this same opposition the logic of the ensemble. At one moment, her dancers would be sprinkled across the stage, all doing what seemed to be separate dances. The

next minute, that apparent randomness would congeal into a joint purpose—a sudden catch, a wave of unison or counterpoint—showing, as you now realized, that the dancers had been working together all along. It was like watching cell division under a microscope: at first, just protoplasm; then, suddenly, the threads, the spindle, the inner purpose. And each of the two principles, order and disorder, lent a kind of grace to the other. When the dancers were together, they never lost their spontaneity. When they were apart, you still felt their secret communion. These dances had no stories. Their dance logic was their story—the portrait of a world that could contain you and still let you be.

In the mid-seventies, Tharp took the formula to its limit by transferring it to classical ballet. Now she was pitting ease not just against rigor but against the most rigorous, most articulate style of Western dance. In *Deuce Coupe,* her first crossover ballet—indeed, *the* first crossover ballet—she mostly juxtaposed ballet with her rock-based style. But when Mikhail Baryshnikov defected from the Soviet Union and she began her collaboration with him at American Ballet Theatre, she went further. Now she had not just the most articulate style of Western dance but the world's most articulate practitioner of that style. What she (and he) achieved was a kind of apotheosis of her disorderly order. Plumb-line pirouettes suddenly melting off sidewise, grands battements so grand, so forceful, that they knocked the body off balance—not so much, however, that it didn't recover in an instant, and launch itself into some other feat of embattled perfection—and all this, moreover, while sliding and diving down the beat like an otter down a snowbank: it looked like a dream. And what Tharp learned with Baryshnikov she brought back to her company, pushing her dancers to greater heights of skill and daring.

It *was* a dream—a symbol. And that fact, not just the wit and beauty of the dancing, accounts for Tharp's immense popularity with audiences of the seventies. Her work was an idea about America: that you could indeed have freedom and order at the same time. It was also an idea about history: that you could question the past without losing it. (In several important works Tharp combined jazz with classical music, and when she made classical ballets she gave them jazzy titles: *Deuce Coupe, As Time Goes By,*

Push Comes to Shove.) Above all, Tharp's work was an idea about the sixties: that you could still have that sensibility in the seventies. You could tighten up and still be loose, "go commercial" and still be an artist, grow up without ceasing to be young. Describing *Baker's Dozen,* the triumphant work she made for her company at the end of the seventies, Tharp stresses this principle: "Chaos is only momentary. Everything fits." Order can coexist with individuality. She always thought of *Baker's Dozen,* she says, as being like Edward Hicks's painting *Peaceable Kingdom.* It was, and in the seventies, when many of the Woodstock generation were getting MBAs, that was a comforting vision. You could lie down with the lion and still be a lamb.

Then, in 1980, things changed. Almost overnight, Tharp overhauled both her style and her subject matter. No more peaceable kingdom, no more happy balance. Indeed, no more pure dance. Her dances now had stories. *Bad Smells* (1982) ended with what looked like a murder, *Short Stories* (1980) with rape. *The Catherine Wheel* (1981) featured a hellish family, with the mother pimping for the daughter, and the father humping the dog. Even passages of abstract dance, when they were there, looked different. They had a new, bladelike force. Where was all this fury coming from? According to the autobiography, it was there all along.

Tharp did most of her growing up in the desert town of Rialto, California. Her father had a car dealership, her mother a drive-in. Both parents were ferocious go-getters. The father built the family house with his own hands—plumbing, wiring, everything—in one year. On a farm that he worked during the Second World War, he liked to drive two tractors simultaneously. When he wasn't operating large machinery, he would go off and bag elk with a bow and arrow. Once, he almost bagged his wife as well. Tharp doesn't go into detail about her parents' marriage, but she describes a scene in which, during a quarrel over how high the new breakfast table should be, her father picked up a hatchet and threw it at her mother's head, missing her by inches.

Twyla learned the ropes. Once, out hunting with her father, she, too, killed an elk, and thereby imagined that she had joined

her father's "lodge." That's the first of several animal-killings in the book. On the occasion of the second—when she and her father bludgeoned a rattlesnake to death in the desert—she began to dance spontaneously. "I had tapped into the primitive drive that celebrates brave physical conquest. . . . I had created my first dance."

And then there was the mother, Lecile, nicknamed Lethal by her four children. Twyla was the first of those children, and Lecile had plans for her. When Twyla was one and a half, Lecile began giving her ear training at the piano. Soon the child was taken to a teacher, then other teachers. By the time Twyla was a teenager, Lecile, by her own estimate, was logging thirty thousand miles a year driving her daughter to lessons in baton-twirling ballet, flamenco, drums, elocution, painting, violin, viola, acrobatics, shorthand, German, and French. Meanwhile, Twyla was also going to school, and if she got anything less than an A-minus, Lecile transferred her to a new school. (Between third grade and college, Twyla attended seven schools.) In the book, Tharp reproduces a schedule that she made for herself at age twelve. It takes her, without a pause, from 6 a.m. ("put practice clothes on") to 9:30 p.m. ("eat supper, get ready for bed"). Often there wasn't any supper. Lecile was too busy to cook. Twyla ate red-hots from the drive-in candy counter and then went to bed. On weekends, and all summer, she sold popcorn at the drive-in. She didn't know how not to work. "Leisure, if it ever came, produced only dread."

She grew into a prim little teenager with a pixie hairdo and glasses, "sharp-cornered pink metal affairs to poke the eye out of any venturesome boy." Sometimes she heard the call of the wild. One of her jobs at the drive-in was to walk around with a flashlight counting heads in cars that Lecile suspected of containing more people than had been paid for. Peering into those cars, Twyla saw a great deal more than extra heads. This is an unforgettable scene in the book: the child, standing in the dark, gasping for breath among the rocking chassis. She never went with boys, though. As Lecile later explained it to an interviewer, dating would have slowed her down. Twyla agreed. Like most children in such situations, she collaborated, and became the thing that was

wanted of her, long before she knew to object. Great achievers are often produced by parents like this, whom they later accuse of damaging them in the process. There are two main themes in Tharp's book. One is the drive for success, and success in many areas—not just modern dance but ballet, Broadway, movies, television. The other is rage, mostly against her mother.

In 1960, Tharp landed in New York, thanks to another one of her mother's school transfers. (Enrolled in a college near home, Tharp had finally taken a boyfriend and gone to bed with him. Lecile found out and, to separate them, moved Tharp clear across the country to Barnard.) She was now out of her mother's reach, but for the next ten years—the years when she finished college, started dancing professionally, and began making her own dances—she labored under the feeling of being dominated by others. This is a common and understandable emotion among young artists, but in Tharp it was especially strong, as strong as her ambition. In the two years she spent performing with Paul Taylor's company, from 1963 to 1965, she would do things like say "You're kidding" when Taylor showed her a phrase he wanted her to dance. Once, recalling her time with him, Taylor said, "I can hear her now, walking around the studio, saying, 'Gimme, gimme, gimme.' " Tharp blithely quotes his remark in her book.

She moved in with a painter, Bob Huot, in 1965 and married him soon after. He was big and confident and hardworking and tough—the kind of man she liked—and he practiced a tough-guy art, minimalism. Through him, she was introduced to New York's downtown art world and its dance division, Judson Dance Theater. A number of the Judsonites were friends and girlfriends of the pioneers of minimalist art, and the dances they made were equally austere and anticommercial. Tharp's earliest choreography showed their influence. She made dances that used only three steps in forty-five minutes; dances that took place in darkness, lit only by flashlights carried by the dancers (and "mainly directed into the audience's eyes"); dances based on mathematical formulas so complicated that the dancers had to carry instructions around with them in rehearsal. Like most of the Judsonites, she had no truck with music, let alone proscenium stages or sets or costumes.

"We kind of liked the idea of making audiences unhappy then," Tharp has said, and, in case they had succeeded, her group took no curtain calls—a practice she held to for five years.

Eventually, she wearied of these rigors. Judson's rejection of the sensuous experience of dancing started to look priggish to her. By 1971, with *Eight Jelly Rolls,* her dancers were not only dancing on stages, and in attractive costumes; they were dancing to music. They even went out and got Vidal Sassoon haircuts. Tharp laid aside all her theoretical concerns—or, rather, she backed them into a cage. Systems and formulas were now reduced to a benign principle of order, against which she played off a new freedom—wit, surprise, a looping joy—all this symbolic, no doubt, of her escape from her latest oppressor, the avant-garde. She had found her great subject: order/disorder. The Judsonites dropped her, audiences embraced her, and she was on her way.

But under the pressure of her new devotion to her career—and to commercial success, which Huot deplored—her marriage hit the rocks. In 1972, she moved out, but not alone. Her son, Jesse, had been born the year before. She was now a single mother, changing diapers in the middle of rehearsal. And then there were the rehearsals. She had what was fast becoming a very successful company, for which, season by season, she had to supply new works, train new dancers, and arrange concert dates. It is a testament to the vagaries of the artistic imagination, or perhaps to the difference between apprenticeship and maturity, that when she was most free, in the sixties, all her dances were about control, and when, in the seventies, she was most hemmed in, by her child and her company, all her dances were about freedom. Planning for *Deuce Coupe* in 1973, she writes, she decided to include in it all the wonderful dances she never did as a teenager: the boogaloo, the slop, the mashed potato.

The exhilaration lasted for a few years. Then came the problem of success. The offers poured in. Would she do ballets, movies, TV programs, Broadway shows? Yes, she would. To refuse would have been to quell her new sense of mastery. She began piggybacking projects, two and three at a time. While still working with her company, she was making ballets for the Joffrey and American Ballet Theatre. When her company was just hitting its

stride—that is, when she could least afford to leave it—she took most of 1977 and 1978 off to work on Milos Forman's movie *Hair* (a terrible flop, as it turned out).

Meanwhile, she still had Jesse. She hired a housekeeper to look after him, and she would call him from the road, almost hoping that he wouldn't be there, so she wouldn't have to feel bad. Her life started to unravel: booze, bad affairs. She got herself a psychoanalyst, one Dr. Stern, and it was presumably under the influence of her discussions with him that, in the early eighties, she started making autobiographical works, full of rage. In 1982, she created her last great dance, *Nine Sinatra Songs,* and it's a wonder that she did that, in between the TV shows, the ice-skating routines for the Olympics, the movies (*Ragtime,* 1980; *Amadeus,* 1984; *White Nights,* 1985). She was on the road continually. Between 1982 and 1985, she says, she flew the equivalent of five times around the world (shades of Lecile's thirty thousand miles a year). She was now drinking so heavily that her hands shook. Jesse, at his request, went off to boarding school.

In 1984, she was approached to direct a Broadway production of *Singin' in the Rain.* She had no directing experience. The show had no star. (No one was willing to compete with Gene Kelly.) By contract, she couldn't change the script. And the dance numbers were so famous that she couldn't change them, either. Still, Tharp and the producers convinced themselves that this already legendary movie could be transferred to the stage. Predictably, it was a disaster.

Some time before this, Tharp says, Dr. Stern had told her that she was out of control. And at roughly the same time, with Dorian Gray–like logic, the book goes out of control. She is simply doing too many things that cannot be explained with dignity. Speaking of the death at the end of *Bad Smells,* she says it was based on an image planted in her mind during a trip to Mexico: an Aztec priest standing on top of a monument and slicing open a body so that the inner body fell out, and tumbled down the stairs, while the skin remained in the priest's hand like a discarded garment. Somehow the victim's heart went on beating until the body hit the foot of the stairs. With Dr. Stern's help, Tharp decided that this grisly image represented her feelings of being brutalized. The

priest was the men in her life, and also her mother. As I presume Dr. Stern told her (though she doesn't say so), the priest was Tharp as well. In the whole second half of the book, she alternates between enthusiastic aggression and feelings of victimization.

Anger, or at least surliness, had always been part of Tharp's work. It was there in the feisty teenagers of *Deuce Coupe.* It was there in Tharp herself, this tiny little tomboy bopping around the stage and, when she was offstage, running circles around her interviewers. Gradually, however, her aggression overtook her intelligence, first in her work, now in her book. The terms in which she describes *In the Upper Room,* the piece with which she made her comeback after *Singin' in the Rain,* are enough to make you shiver. The dancers "rip the space open," she says. They "burn the retina," "impacting on the eye," "socking the air," executing now a "karate kick," now a " 'black fist' victory gesture." They are a "phalanx," a "Bomb Squad," a "sea of blood." *In the Upper Room* was indeed a tough-looking piece, but also cheerful and brassy. I don't think anyone besides Tharp saw those women, in their little red dresses, as a sea of blood. Another quality that began to seep into her work in the eighties, and that permeates the latter part of the book, is gigantism. All her talk is of megahits, standing ovations, oysters, and champagne.

That's when she's happy. When she's unhappy, all her talk is of victimization: her loneliness, her bad affairs, the damage her mother did to her. This kind of thing, hard to listen to in the first place, is harder in combination with the self-glorification, for it begins to sound like excuse-making. One minute, she's talking about a gala she staged at the Rainbow Room, and her description is utterly credulous. She exclaims over the formal evening clothes the guests wore, and the goodie bags on the tables. All in honor of her. (Did nobody at her publishing company read this manuscript? Could nobody tell her when she sounded foolish?) But then, in midparagraph, she is assailed by the thought that someone—for example, her mother, who was at the party—might have begrudged her these fine things, and not taken into account "that the fur was rented, the jewels borrowed, the penthouse I took Jesse home to leaky and lonely." The leaky penthouse sort of sums it up.

This book is important as a woman's story. Tharp's drive for glory and also her aloneness, her feeling that her career precluded a decent relationship with a man, are part of the history of ambitious and talented women in our period. (When was the last time we heard a male artist complaining that his work barred him from having intimate relationships?) The book also documents, cruelly, a period in which artists are seen as having a choice between righteous isolation—actual repudiation of the public—and "selling out." Finally, and most crucially, the book explains what it means, in practical terms, to be a choreographer, a story too seldom told. To be a choreographer, one must have a company. As Tharp herself says, early in the book, "developing dance means developing dancers—the two are inseparable, and anyone who attempts to bypass this step is kidding himself." If the dancers aren't trained in your style, it doesn't matter how good your choreography is—it won't be translated into a good performance, and dance exists only in performance. Furthermore, if you don't have a company there is no way to preserve your older works. They simply die. So a company is a necessity, the fundamental tool of the choreographer's art. And then, for almost everyone, it becomes a kind of prison as well. To keep the company going, the choreographer must continually make new works for it. Whether or not the inspiration is there, the season is coming up—it was booked two years ago. There must be a premiere, preferably two premieres. And so it goes, from season to season, until, in many cases, the choreographer burns out. People sometimes wonder why there are so few great choreographers. We should wonder, rather, why there are so many. When painters get tired or bored, they can move to Ibiza for a year and cool out. Or they can take a side road: book illustration, set design, graphics. A choreographer with a company can do a little of this, maybe one side job a year, but that's the limit. For Tharp, that limit was way too confining.

Add to this the fact that the company tends to shorten the choreographer's performing career. Like many first-class choreographers—Martha Graham, Merce Cunningham, Paul Taylor—Tharp began as a first-class dancer, and dancing feeds a part of the self that choreographic achievement cannot touch. But the choreographer can't do it all. Tharp created wonderful roles for herself

in both *The Catherine Wheel* and *Nine Sinatra Songs,* but in the end she had to give them to another dancer. In *When We Were Very Young,* one of her last big roles, she ended the piece by dropping into the orchestra pit. That, she says, was her way of jumping the gun on what she saw as her future, "the double and triple whammy of forced retirement from the stage, menopause, and approaching death." Make that a single whammy. Menopause and death were still far away; retirement from the stage was death enough. Tharp estimates that she stopped dancing well at age thirty-four. After forty, she stopped dancing, except for brief comebacks. Last year, she began performing again. She is still a marvelous stage presence, but, as for dancing, she is now in her fifties. It's late.

So Tharp in this book touches on big issues. But how unthoughtful she is about them! The problem of being a woman she handles, if that is the word, simply by wishing that she were a man and by adopting the brute-force postures that she thinks of as manly. The book is full of stories of her tough-guyism: how she took no guff from ballet-company directors, how she drank with the big boys, how, whatever she did, she was never a sissy. The tougher she gets, the harder she gets.

As for the integrity-versus-commercialism issue, this is something on which we might have expected a serious statement from her, for in the seventies her career was a shining example of how an artist could "go commercial" and still be an artist. We do get a statement, early on. Commercial work, she says, differs from art in that it is exploitative. Its goal is to "sell product." Pretty strict, but okay. Then she plunges into a long confession of product-selling intention. As early as 1971, while she was making *Eight Jelly Rolls,* she would sit in the studio trying to recall the parts the audience had most responded to in an earlier version of that dance. Two years later, planning *Deuce Coupe* for the Joffrey, she did her market research beforehand, attending Joffrey performances and watching the audience, "trying to gauge what got through to them—rather like Mother stocking the drive-in candy counter." I am not shocked by these avowals. *Eight Jelly Rolls* and *Deuce Coupe* were art. If they also sold tickets, and by intention, God bless them. But I think Tharp is shocked. Schooled in the puri-

tanical avant-garde of the sixties, she is both guilty and defiant, a nun in a whorehouse. Once the art actually starts to suffer, she gets defensive. Apropos of *Singin' in the Rain,* she claims she decided that it would benefit her company—the company she effectively dissolved in order to do the show. She could bring some of the dancers with her, she figured, and they would work on repertory together: "In my quixotic world, Broadway would subsidize art." What quixotic world? And what about Broadway *as* art? The scary thing about Tharp's increasing commercialism in the eighties is not just her neglect of "art" but her contempt for the commercial projects, and hence for herself. Soon she's in so deep that she's not even defensive anymore. The talk is all bottom line, a phrase that starts to appear again and again.

On the subject of the choreographer's plight—the unbreakable tie to the company—she is most confused of all. She solved the problem in her own way. After *Singin' in the Rain,* she formed a new company to replace the old one. Two years later, she folded that one, too, in order to become a resident choreographer at American Ballet Theatre. Then, after leaving ABT, she assembled yet another troupe—this one, however, with its impermanence built into it. It is a pickup company, with dancers hired on a per-tour basis, and it looks like a pickup company: a bunch of young pieceworkers giving their all, but with no actual grounding in a company style. This is the compromise that Tharp made, for the sake of—what? Her curiosity, her need for change, her drive for stardom—a host of reasons, running the scale from integrity to commercialism. Yet the terms in which she discusses the issue have nothing to do with professional concerns—only with the same old business of aggression and victimization. Faced with the ABT offer, she looks at her company and decides that she has become its victim, caught in a "horrible codependency." She was on a "Sisyphean treadmill, a smaller and smaller person making better and better product. My bottom line was dance; the realest, truest me was a small creature yelling, 'Feed me! Feed me!' " To get fed, she decided, she needed to get rid of the company. Really? Leaving aside the fact that she wasn't making better and better product, as she calls it, one must ask how, if her "bottom line" was really dance, she could think it was a good idea to close down her

dance company. What she seems to be telling us, actually, is that her bottom line was the bottom line. In view of that imperative, the slow, toiling business of developing a company must indeed have seemed to her a "horrible codependency"—or, in any case, a pain in the neck.

The codependency breakthrough is only one of many epiphanies that litter the second half of the book. The last one comes in the last chapter. She meets a young man at the gym, eventually invites him up to her studio ("to see my etchings"), then decides that she doesn't want to seduce him after all but, instead, wants to make a dance with him. And at that moment, she says, "I beat the *re*'s." What are the *re*'s? Well, in the past, she was operating on a "drive to revenge and repair the past, fueling myself with resentment, rebellion, through reaction, by rebounding, in reclaiming, from regret"—all these motivations deriving from her relationship with her mother. It was to shove her mother out of her emotional center that she had been in the habit of scarfing up one man after another. To her, those men were simply a generic category—men. They filled a need. Now, somehow, she is released from this pattern, and in the flush of revelation she makes a dance, *The Men's Piece,* about her new "attempt to know men individually, not generically." For the record, *The Men's Piece,* which was shown in Tharp's 1992 New York season, was not about men, let alone men known individually. It was about Tharp, who also starred in it. The men in its cast were generic: three generic dancers plus a generic partner, Kevin O'Day—a big, hunky guy who perfectly fits Tharp's notion of what men are.

In the course of her struggles with herself, Tharp gave up drinking, but her work life is as busy, and as scattered, as ever. She has just finished working on another movie, James Brooks's *I'll Do Anything.* Her plans for the future include commissions from the Boston Ballet and the Martha Graham company. In the meantime, she has reassembled her pickup company for a new tour, a grueling three-month circuit of twenty-six cities—mostly one-night stands in large theaters, which, with Baryshnikov on board as a guest artist, will probably sell out. (Tharp is now undoubtedly the highest-paid choreographer in American concert dance.) When the tour is over, the troupe will disband again.

The tour begins on November 27, and the publication date of *Push Comes to Shove,* November 23, was obviously chosen to coincide with it. By its end, this autobiography, with its long tale of commercial projects, begins to look like a very commercial project itself. It fits right into that currently beloved genre wherein a star tells all about his or her journey through you-name-it—alcoholism, drug addiction, depression, codependency—and comes out okay in the end. Indeed, *Push Comes to Shove* looks to have been modeled on the dance world's most famous contribution to that genre—Gelsey Kirkland's 1986 *Dancing on My Grave.* Like Kirkland's book, it even includes a discussion of what Baryshnikov is like in the sack. (Page 208, if you want to read it in the bookstore. Tharp gives him better marks than Kirkland did.) Again, the problem is not the commercial venture but Tharp's low opinion of commercial ventures, and hence her lowered ambition for them, apart from their profitability. This book will tell you everything—the abortion, the boyfriend who socked her in the face—except how intelligent she once was.

Originally published as "Twyla Tharp's Bottom Line"
in *The New Yorker, 1992*

*H. L. Mencken, 1932. The photograph is inscribed
to Alfred Knopf, Mencken's publisher: "This was taken
by Maestro [Carl] Van Vechten at a temperature
of 94° Fahrenheit. H. L. Mencken."*

On the Contrary

MANY preeminent writers of the early twentieth century held views that now seem to us deplorable. But what Edith Wharton thought about Jews, or Hemingway about women, was enfolded in acts of imagination. They were novelists. H. L. Mencken, on the other hand, was a journalist, and so his opinions stand naked before us: his condemnation of democracy, his admiration for Germany (he opposed American entry into both world wars), his loathing of all idealists and reformers, including those "professional kikes" who in the thirties went around complaining that Adolf Hitler was being mean to the Jews. Mencken grew up at the end of the nineteenth century, the days of social Darwinism. As he saw it, the poor deserved to be poor; the hanged had it coming. If they had been superior people, they would have had a superior fate. They might, for example, have been born into a prosperous bourgeois family, found immediately the work they were made for, pursued it joyfully for half a century, and kicked off each night at ten o'clock to go have a drink with the boys. That's what he did. What was the matter with them?

A man of such complacency (his word), not to speak of such "fatal want of generosity" (Alfred Kazin's words), might well, in our day, be picked up with tongs, if he were picked up at all. But Mencken deserves to be discussed, for he was the most influential journalist that America ever produced. So it is good to have a new biography, *The Skeptic: A Life of H. L. Mencken,* and good, too, that the job was done by Terry Teachout, an arts writer *(Commentary,* the *Times,* the *Washington Post)* who, apart from having a nice style, is conservative enough not to be shocked by Mencken, and who therefore does not waste our time, in the manner of recent

literary biographers, telling us how he is morally superior to his subject.

HENRY Louis Mencken was born in 1880, in Baltimore, of German stock. As he told it, he had a serene childhood, digging in the backyard and reading great stacks of nineteenth-century literature. Like other bookish boys of the period, he dreamed of going into journalism, a world that, with its tough guys banging out their thoughts in spittoon-lined city rooms, suited his roistering temperament. At the age of eighteen, he presented himself at the Baltimore *Morning Herald;* by the age of twenty-five, he was the editor-in-chief of that paper. Then he went to the Baltimore *Sun,* where, with a few interruptions, he remained to the end of his writing life.

Newspapers weren't enough for him, though. The early 1900s saw the birth of the American "smart magazine," aimed at deprovincializing the masses of people who, since the final decades of the nineteenth century, had been leaving the farm and moving to the cities. *The Smart Set,* subtitled "A Magazine of Cleverness," was founded in 1900; *Vanity Fair* in 1914; *The New Yorker* in 1925—all in Manhattan. In 1908, Mencken joined *The Smart Set,* as its book reviewer, and, in 1914, he and George Jean Nathan, the magazine's popular theater critic, became joint editors in chief. But *The Smart Set* was light fare, elegant and snobbish, focussing on art and fashion. In 1924, Mencken and Nathan went off and founded their own magazine, *The American Mercury.* Mencken by now was tired of being confined to the arts; he wanted a journal of ideas, opinion. Nathan was not quite of the same mind, but within a year Mencken solved that problem by demoting his old friend to staff writer and taking over alone. The year after that, the magazine had a circulation of nearly eighty thousand. In 1928, Edmund Wilson wrote that half the country's college magazines were trying to sound like the *Mercury.*

That wasn't enough, either. Mencken was a sort of writing machine. ("There is always a sheet of paper," he once said. "There is always a pen. There is always a way out.") Furthermore, he

organized his life entirely around his work. He scorned the dissipation, alienation, expatriation of his fellow-writers of the twenties. He not only didn't move to Europe; he didn't move to New York, couldn't stand the place. Twice a month, he would take the train to Manhattan and spend a few days giving orders to his staff. But soon he was back in his beloved Baltimore, in the house he had lived in since the age of three, working all day in his upstairs study, checking in at the *Sun* in the evening, and then coming home to a plate of sandwiches laid out for him by his mother. He lived with her until he was forty-five, at which point she inconvenienced him by dying. He then married, and installed his bride in a duplex downtown, but when that lady, too, expired within a few years he moved right back to his old home.

Given such habits, he had time to produce not just journalism but also books—on democracy, ethics, religion, you name it. In 1919, he brought out the volume that he will be remembered for, if for nothing else, in a hundred years: *The American Language,* a long, scholarly, but also fun and funny study of what was probably the greatest love of his life, American vernacular speech. In this book you can find an inventory of antebellum terms for strong drink ("panther-sweat, nose-paint, red-eye, corn-juice, forty-rod, mountain-dew, coffin-varnish, bust-head, stagger-soup, tonsil-paint, squirrel-whiskey") along with a thousand other excellent things. The year after *The American Language,* Mencken banged out three more books. In 1925, two books were published *on* him, and the *Chicago Tribune* gave him a column, "As H.L.M. Sees It," which was syndicated throughout the United States. By then, pretty much everyone knew who H.L.M. was.

WHY was he so valued? For his campaign against provincialism, to start with. Mencken was not the first person to notice that Americans of his time were divided between a vast majority who hadn't read much more than their Bible and a small, Brahmin minority who, in disassociating themselves from that hairy horde, had become equally narrow, producing a literature that seemed to be primarily about people in Boston, having tea. In the 1910s, var-

ious critics were calling on American writers to deal with common life, in common language. Of these agitators, the most effective was Mencken. He was the reviewer who first brought Willa Cather, Theodore Dreiser, and Sinclair Lewis to national attention. (It is to the school of Dreiser and Lewis—the "revolt from the village" writers—that Mencken actually belongs, more than to the Jazz Age. He hated jazz.) But literature, to him, was a secondary concern. All his life, he had in his mind one dominating image: *Boobus americanus,* as he called it—the average American, ignorant, righteous, credulous, ready to follow any rabble-rouser who came along and yelled at him loud enough. In the United States, he wrote:

> The general average of intelligence, of knowledge, of competence, of integrity, of self-respect, of honor is so low that any man who knows his trade, does not fear ghosts, has read fifty good books, and practices the common decencies stands out as brilliantly as a wart on a bald head. . . . Here, more than anywhere else that I know of or have heard of, the daily panorama of human existence, of private and communal folly—the unending procession of governmental extortions and chicaneries, of commercial brigandages and throat-slittings, of theological buffooneries, of aesthetic ribaldries, of legal swindles and harlotries, of miscellaneous rogueries, villainies, imbecilities, grotesqueries, and extravagances—is so inordinately gross and preposterous . . . so steadily enriched with an almost fabulous daring and originality, that only the man who was born with a petrified diaphragm can fail to laugh himself to sleep every night, and awake every morning with all the eager, unflagging expectation of a Sunday-school superintendent touring the Paris peep-shows.

However disciplined his habits, Mencken, as this passage demonstrates, was a man of the 1920s in his love of naughty fun. He denounced puritanism, which he defined as "the haunting fear that someone, somewhere, may be happy." He hated religion for the same reason: it wanted to make him feel bad. Once, address-

ing the question of whether the state should intervene in cases where Christian Scientists refused medical help for their sick children, he said that we should probably let these youngsters die, since, with parents stupid enough to believe in Christian Science, their survival to reproductive age would lower the national IQ: "Being intelligent would become a criminal offense everywhere, as it already is in Mississippi and Tennessee." To revile was Mencken's delight, and when the reviled shot back he loved that, too. He saved every scrap of newsprint in which he was denounced as a public menace. In 1928, fearing that these materials would be lost to posterity, he got his publisher to bring out an anthology of them.

But the key to Mencken's popularity was his prose. His writing crackled with "blue sparks," as Joseph Conrad put it. His diction was something fantastic, a combination of American slang and a high, Latinate vocabulary that sounds as if it came from Dr. Johnson. That mix, of course, was part of his polemic, his belief that Americans should get smarter and dirtier, go high, go low. Often, he pushed the formula too hard. In my opinion, the long passage quoted above is overwrought. It is from one of Mencken's many volumes of collected essays, in which he habitually jacked up what he had put more plainly in his daily writing. I like his daily writing better. Here is a sample, from a 1933 article on the death of Calvin Coolidge:

We suffer most when the White House bursts with ideas. With a World Saver preceding him (I count out Harding as a mere hallucination) and a Wonder Boy following him, [Coolidge] begins to seem, in retrospect, an extremely comfortable and even praiseworthy citizen. His failings are forgotten; the country remembers only the grateful fact that he let it alone. Well, there are worse epitaphs for a statesman. If the day ever comes when Jefferson's warnings are heeded at last, and we reduce government to its simplest terms, it may very well happen that Cal's bones, now resting inconspicuously in the Vermont granite, will come to be revered as those of a man who really did the nation some service.

Whatever you think of the sentiment, you have to love the prose, with its easy, conversational manner. Before Mencken, we didn't often have such writing in the newspapers. He brought it in, and journalists have been using it ever since. In a way, Mencken did for American journalism what Mark Twain did for American fiction—gave it a native language, not pseudo-European but home-grown.

MENCKEN was a philistine. Though he spent many years as a book reviewer, he never cared much about art, least of all the experimental art of the twenties. To him, Stravinsky was a big nothing, Hemingway some sort of weird business that we needn't bother about. He cared only about ideas—or one idea, the American boob—and so he had only one emotion, the pleasure of despising. In Kazin's words, "Every Babbitt read him gleefully and pronounced his neighbor a Babbitt"—another Menckenian tradition that survives in today's journalism.

To Teachout, this narrowness is the key to Mencken's moral failings: "He looked at evil and saw ignorance." Hence his misunderstanding of Hitler. To him, the Führer was just another rabble-rouser, whom the excellent German people would soon tire of. (Teachout thinks that if Hitler hadn't shouted and pounded his fists, Mencken might have liked him better. He didn't mind autocrats; he was fond of Kaiser Wilhelm. The ex-Kaiser admired him, too, and, after reading his book on the errors of democracy, sent him a signed photograph.) Nor, when history proved him wrong, could he revise his views. To the end of his days, he never referred to the Holocaust in either his published work or his unpublished writings, the last of which were recently unsealed. (This, in part, is the occasion for Teachout's book, and the source of some of its most damaging material.) But, then, he took no public notice of the Depression until 1932, at which point he seemed to think it was mostly an idea invented by "charity mongers."

And so, in the thirties, he came to be regarded as a sort of crank. "Moderation in all things," he once wrote in his notebook. "Not too much life. It often lasts too long." It did for him. One

day, while he was talking to his secretary, Mrs. Lohrfinck—he was now sixty-eight—his speech turned to babble, and he was rushed to Johns Hopkins. "Mr. Mencken has suffered a stroke," the doctor said the next day, "and I am sorry to say that he is recovering." The stroke left him unable to read or write. Nevertheless, he was back at his desk in short order and, with Mrs. Lohrfinck's help, published two more books. A few years later, he was again hauled off to the hospital, this time with a massive heart attack. The doctors told the Associated Press that there was no chance of his recovering. Everyone felt sad for the old geezer; the tributes rolled off the presses. Soon, he was drinking beer on the ward and sending people out for cigars. Again he went back to work, editing his notebook entries into a new volume. (It was a best-seller.) Finally—one imagines a huge hammer coming down out of the sky—he died in his sleep in 1956, at the age of seventy-five.

THE history of Mencken's reputation as a political thinker has been odd. The leftists, of course, don't like him. Meanwhile, because of his contempt for religion, among other things, many conservatives have run like mad from any association with his name. (That doesn't include the kooks. Timothy McVeigh could quote Mencken from memory.) But Teachout, in his preface, says that in recent years some of Mencken's political views "have become a resurgent strain in American thought." He is referring to neoconservatism, a movement with which he is in sympathy. "I write, very broadly speaking, from [Mencken's] point of view," he says. Therefore he takes great pains to show us what, in Mencken's views, does not accord with his own. With regard to the Jew-baiting, he fills in the historical context, the pervasive anti-Semitism of the 1920s, and not just among Gentiles. (Mencken's 1930 book, *Treatise on the Gods,* which describes the Jews as a race lacking in "courage, dignity, incorruptibility, ease, confidence," was published by a Jew, Alfred A. Knopf.) But, while shouldering his historical duties, Teachout does not commit the common error of historicists, the throwing up of hands. He carefully tracks Mencken's anti-Semitism, not just in his unpublished writings

but in his private papers. He tells us that some people have tried to cover it up, and he demonstrates how they have tailored their quotes accordingly.

My only serious quarrel with Teachout's book is that he doesn't spend enough time on Mencken's prose. He says that Mencken was America's greatest journalist, but he doesn't defend this claim at any length. On the other hand, he points us to the man who did the job. Edmund Wilson, he writes, was always Mencken's most comprehending critic. He was also Mencken's most generous critic—a touching fact, for Wilson was almost as far left as Mencken was far right, and though he was fifteen years younger, he was Mencken's competitor. He was the book reviewer for *The New Republic,* where he showed all the virtues that Mencken, at *The Smart Set* and the *Mercury,* so conspicuously lacked: an actual love of literary art, together with sophistication, judiciousness, and an ability to generalize, to say what the "scene" was. Wilson knew his gifts, and wished they were less rare. He called on American magazines to develop "a genuine literary criticism that should deal expertly with ideas and art, not merely tell us whether the reviewer 'let out a whoop' for the book or threw it out the window." He was talking about Mencken.

Nevertheless, Wilson always made excuses for Mencken, downplayed his faults, called the reader back to the "color and rhythm" of his prose, the "lucidity, order, and force" of his ideas. Mencken's rantings about *Boobus americanus* seemed to Wilson unshaded, unhopeful, unrelenting, and he said so. Still, he made an argument for Mencken's portrait. The boob, he wrote, was a fictional creation, a work of art: "This character is an ideal monster exactly like the Yahoo of Swift, and it has almost the same dreadful reality. This 'boob' has impressed himself on the imagination of our general public in a way that has not been equaled by any other recent literary creation, with the possible exception of Scott Fitzgerald's flapper." And if, in consequence, Mencken made naïveté and prudery unfashionable, got Americans to start thinking more critically, this was "an achievement of some importance," he felt.

Others have offered the same tribute. Mencken was "a stimulant," Kazin said, and if his work was not wisdom it was "an intro-

duction to wisdom." Despite his failures as a literary critic, he probably deserves some credit for the great crop of critics who came after him—not just Wilson but the whole school of the forties and fifties (Trilling, Kazin, Jarrell, others), assured both in their ideas and in their excellent, lay-it-down prose. Wilson records that after the publication of *The American Language* people started speaking and writing in the American language. Maybe that was contribution enough.

The New Yorker, 2002

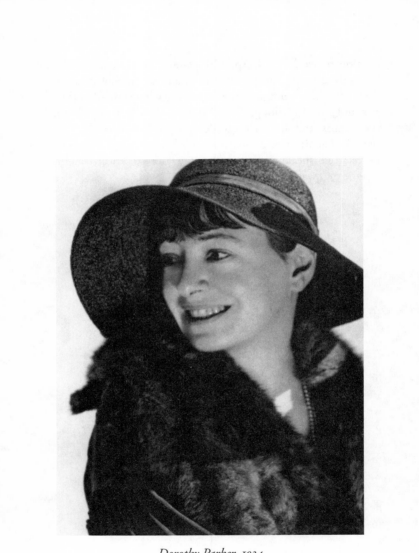

Dorothy Parker, 1934

After the Laughs

O F the many rapid-burnout cases in American letters, one of the saddest is that of Dorothy Parker. Born a hundred years ago next Sunday, she was the last child of Henry Rothschild, a prosperous German-Jewish cloak manufacturer, and Eliza Marston, an ex-schoolteacher of English ancestry. Eliza died when Dorothy was four. Dorothy soon acquired a hated stepmother, but within a few years she, too, died. Thereafter Dorothy and her siblings lived a peaceful, if motherless, life, cared for by Irish servants, in the family's four-story town house at 214 West Seventy-second Street. In later years, Parker rarely spoke of her father without scorn, but according to her most recent biographer, Marion Meade, Henry Rothschild was an affectionate and responsible parent. He sent his daughter to good schools, and when she was gone for the summer he wrote her funny little poems about how much he and the dogs missed her.

When she was twenty, her father died. She was left without money, but she did have a few salable talents. She was good at writing, and she had a quick, acerbic wit. At that time, the so-called smart magazines were being born, and Parker soon found her way to their doors. She was a staff writer for *Vanity Fair* from 1917 to 1920. From 1927 to 1931, under the nom de plume Constant Reader, she was *The New Yorker*'s lead book critic. Her light verse, which was what first made her famous, was published in these magazines, among others. Most of her short stories appeared first in *The New Yorker*. When Parker took over *Vanity Fair*'s theater column, at the age of twenty-four, she had never reviewed a play or anything else, but in her first column, which covered five musical comedies, she wittily disparaged most of what she saw. She was a "tired business woman," merely seeking an evening's

innocent diversion. And what had she got? Bad seats, noisy audiences, ridiculous shows. One play she dismissed with the line "If you don't knit, bring a book." This particular voice, with its world-weariness, its wicked merriment, its emphatically personal note, was exactly the sort of thing the new magazines were seeking.

AT the same time that Parker found the work she needed, she found congenial friends. At *Vanity Fair,* in 1919, she met Robert Benchley and Robert Sherwood, who, like her, were gifted, witty, unknown writers. The three became inseparable, and together they attended the first luncheon of what became the celebrated Algonquin Round Table. This group has been so much written about that I will dispense with the particulars here, but it must be said that Parker was the wittiest of the bunch. In a small, sweet, highly cultivated voice ("She talked like a woman who as a little girl had attended a very good singing school," one of her friends reported), she would come out with utterly withering remarks. Many of them were too obscene to be printed, but others were printed and reprinted in her friends' columns and passed around town. Meanwhile, she was doing her writing. Between 1926 and 1933 she published three collections of verse and two collections of stories, all of them big sellers. Her books column is said to have been the first thing people turned to when they opened this magazine. In 1929, she won the O. Henry Prize for her story "Big Blonde." By the early thirties, she was a celebrity. Playwrights wrote plays about her; people followed her around at cocktail parties, waiting for her to say something funny.

Success did not bring happiness. In 1917, at the age of twenty-three, she had married a young stockbroker, Edwin Pond Parker II. (She later said she had married Eddie because he had such a "nice, clean name." She did not like being half-Jewish.) Eddie enlisted in the army, and by the time he got back from the war, in 1919, Parker was part of the Round Table, a world he did not know how to enter. They separated in 1922—not, however, before Eddie, an alcoholic, helped teach Parker to drink. After Eddie, there were numerous affairs, and they took on a pattern. The man

would pursue her, and then his interest would flag. She would wait by the phone, eventually falling into despair, which she treated with alcohol. She found that if she took small sips of Scotch all day long the hours passed more easily. Then, at night, she would go out with her Algonquin friends and get thoroughly drunk. She often thought of death, and made this obsession part of her public persona. Those of her poems that are not about lovelessness ("Men seldom make passes / At girls who wear glasses") are usually about death ("Razors pain you; /Rivers are damp . . ."). When she wasn't joking about suicide, she was attempting it. Between 1923 and 1932, she tried four times to kill herself: once by slashing her wrists, once with Veronal, once with barbiturates, once by drinking a bottle of shoe polish.

This was the period of her best work, but her editors had a hard time getting it out of her. She was shameless about deadlines. And even her best pieces showed a lack of ambition. "All of her things are asides" is how her editor at *The Saturday Evening Post* put it. Parker knew this, and she responded by despising her own work. When her editor at the Viking Press sent her the page proofs of her first collection of stories, she refused to correct them. She wanted to burn them, she said. He ended up locking her in a room with himself, the proofs, and a bottle of whiskey until the job was done.

She eventually solved her writing problems by ceasing to write. In 1933, at the age of thirty-nine, she met an actor, Alan Campbell, eleven years younger than she. Unlike her other men, Alan seemed genuinely interested in her well-being. He moved in with her; he cooked, he cleaned, he helped her shop for clothes. Alan's acting was going nowhere, and he decided that he and Parker should try screenwriting. In 1934, they bought a car, got married, and drove to Hollywood.

That was more or less the end of Parker's writing career. She lived thirty-three years longer, but in those years she produced only eleven more stories. (Sadly, some of them are among her best.) She also coauthored two plays and wrote occasional magazine pieces. She contributed to about two dozen films, almost always in collaboration with Alan, but she hated the work. Probably their best film was the 1937 *A Star Is Born,* which won them an

Academy Award nomination. Parker claimed that she never saw the movie—that she went but walked out. Much as she scorned Hollywood, however, it was making her rich. In 1937, she and Alan signed a contract with Sam Goldwyn at a combined salary of fifty-two hundred dollars a week, an astonishing sum that they somehow managed to spend—on houses, clothes, and parties. Parker drank as much as ever. Alan drank more.

What high-mindedness Parker had left she invested in politics. She helped found the Hollywood Anti-Nazi League; according to Ring Lardner, Jr., she briefly joined the Communist Party. And she remained faithful to the Stalinist line long after other American leftists were repelled by events in the Soviet Union. She stopped speaking to many of her friends, accusing them of political cowardice. Eventually, she turned on Alan as well, claiming that he was homosexual. ("What am I doing in Hollywood, at my age and married to a fairy?") She divorced him in 1947, remarried him in 1950, split up with him again a year later, then moved back in with him in 1961. When Alan died, in 1963, from an overdose of alcohol and barbiturates, Parker returned to New York, where she passed her last years in an alcoholic twilight. "Don't feel badly when I die," she told a friend. "I've been dead for a long time." In terms of public perception, this was true. When she finally expired, of a heart attack, in 1967, the obituaries surprised people. They thought she had died ages ago.

So Parker used her gifts for little more than ten years. But even during that period she tended to waste herself. Her mind was dominated by one idea, the interlocking of vulnerability and cruelty. All her friends, whatever else they remembered about her, remembered her two-facedness: how, as Lillian Hellman described it, Parker "embraced and flattered a man or woman, only to turn, when they had left the room, to say in [her] soft, pleasant, clear voice, 'Did you ever meet such a shit?' " Hellman made excuses for her: "The game . . . probably came from a desire to charm, to be loved, to be admired, and such desires brought self-contempt that could only be consoled by behind-the-back

denunciations of almost comic violence." Most of Parker's friends were afraid of her, but at the same time, they were protective of her.

That pattern—appeal followed by denial, effusion followed by constriction, the female principle, as she came to view it, followed by the male principle—became the rule of her imagination. You can see it in all her work, most obviously in the poems. Line by line they go, telling us about pretty things, about flowers and keepsakes and love, until they come to the last stanza or the last line. Then Parker delivers the sucker punch. Here's a celebrated example:

> A single flow'r he sent me, since we met.
> All tenderly his messenger he chose;
> Deep-hearted, pure, with scented dew still wet—
> One perfect rose. . . .
>
> Why is it no one ever sent me yet
> One perfect limousine, do you suppose?
> Ah no, it's always just my luck to get
> One perfect rose.

It's witty, and so are some of the other poems, but in all of them the message is the same: hope will always be disappointed. And the technique is the same: she inflates the balloon, then pops it.

Parker's book columns for *The New Yorker* also follow the pattern. Almost invariably, she opens with a long comic complaint about her life. "And this was the week I meant to get all that reading done," begins a typical piece. But she couldn't read, she says, because she had the grippe or she was hungover or spring had arrived, and there's nothing she hates more than spring. She's a poor, beleaguered woman, and what do people do? They write *books,* and expect her to review them. Well, all right. (Here you can almost hear the gears shifting from vulnerability to aggression.) And she begins her perusal of the week's books, most of them ridiculously easy marks—Emily Post's *Etiquette,* Margot Asquith's essays, a collection of poems on Lindbergh's flight, a vol-

ume entitled *Favorite Jokes of Famous People,* another called *The Technique of the Love Affair,* foreign-phrase books, pornography. She takes aim and, needless to say, she scores.

A few of these pieces are still funny. There are times when, reading them, you wish Parker were here to take on Danielle Steel or Shirley MacLaine. And her reviews would no doubt seem more valuable now if the menaces they describe—Lindbergh mania, country-weekend etiquette—were still around to plague us. But many of Parker's victims are not menaces. Joke books, foreign-phrase books: who cares? Many *good* books were being published at the time, books that Parker didn't review. During the period of Parker's Constant Reader column, Edmund Wilson, in his book reviews for *The New Republic,* was writing about Robert Penn Warren, Edna St. Vincent Millay, Hart Crane, E. E. Cummings, Thornton Wilder, Lytton Strachey, André Malraux, Gertrude Stein, Dos Passos, Hemingway, and Eliot, among others. Parker, meanwhile, was shooting Margot Asquith in a barrel. On the rare occasion when she devoted a column to a writer she admired, she nevertheless found something to ridicule—how people misunderstood this writer (Lardner), how they praised that one's novel but ignored his short stories (Hemingway)—and spent most of her words on that. Finally, when she was cornered, when the column was about to end, and she had not said why the writer was good, she would unload some hysterical hyperbole (Hemingway she compared to the Grand Canyon; Gide she compared to the Grand Canyon and the Atlantic Ocean) and then beat a hasty retreat.

The Constant Reader columns are not really book reviews; they are standup-comedy routines. You don't have to listen to her opinion, she says. If she didn't like the book, maybe that's just her hangover speaking. And anyway she didn't really read the book. She skimmed it, or she threw it out the window. She doesn't care much for reading. ("I think the last thing I read was 'Sketches by Boz.' ") Even less does she care for writing. When she composes so much as a telegram, she has to go lie down for the rest of the day.

. . .

OF all the kinds of writing Parker practiced, the one she did seem to care for—the one she worked hardest on and wanted to be remembered for—was the short story, and her fiction is indeed her best work. Like many of her poems, her stories are about the relations between men and women, but in the stories she is forced to supply details. She can't just say there's a sucker born every minute; she has to say which sucker, and in the process the situation deepens and intensifies. Basically, she is held back from wit. Possibly for that reason, something curious happens to her vulnerability-cruelty formula. Instead of deploying the two forces sequentially—buildup, then letdown—she works them simultaneously. Her heroines are all vulnerability, but from the very start they are observed with a cold precision.

The best and most famous of the stories is "Big Blonde," which tells of the good-time girl Hazel Morse. "Men liked you because you were fun," Hazel learns, "and when they liked you they took you out." Hazel lands a husband, Herbie, but, once married, she no longer feels like being fun. A huge sadness descends on her. "She would cry long and softly over newspaper accounts of kidnapped babies, deserted wives, unemployed men, strayed cats, heroic dogs." To cheer her up, Herbie teaches her to drink, but it doesn't work. Herbie leaves, and the drinking remains. The years pass; Hazel drifts from man to man. One night she changes into her nightgown, swallows twenty Veronal tablets, and, without regret, goes to bed. Nettie, the maid, finds her the next day:

> The bed covers were pushed down, exposing a deep square of soft neck and a pink nightgown, its fabric worn uneven by many launderings; her great breasts, freed from their tight confiner, sagged beneath her armpits. Now and then she made knotted, snoring sounds, and from the corner of her opened mouth to the blurred turn of her jaw ran a lane of crusted spittle. . . . The doctor strode loudly into Mrs. Morse's flat and on to the bedroom, Nettie and the [elevator] boy right behind him. Mrs. Morse had not moved. . . . With one quick movement [the doctor] swept the covers down to the foot of the bed. With another he flung her

nightgown back and lifted the thick, white legs, cross-hatched with blocks of tiny, iris-colored veins. He pinched them repeatedly, with long, cruel nips, back of the knees. She did not awaken.

What makes this scene so hair-raising is that it is an inverted sex scene, taking Hazel's situation down to its root, the female body. We see the breasts, the thighs, the nightgown flung back, only now the body is fat and tired, and the occasion is no longer one of fun but one of cold scrutiny, with the three strangers staring at Hazel's nakedness, the doctor pinching her back into life. Never has female vulnerability been more terribly exposed.

"Big Blonde" is not just Parker's best story; none of the others comes near it. Still, there are about a dozen stories that are hard to forget. Most of them, like "Big Blonde," are about the hopelessness of male-female relations, but their heroines are different from Hazel; they are more intelligent, more nervous, more captious, more like Parker. We see them at the speakeasy, drunkenly complaining to their friends about neglect, betrayal. We see them having cocktails with the cad in question while he takes calls from other women. Or we see them at the other end of the phone, calling and wondering who he's in the room with. The telephone turns up again and again. To Parker it seems to have been the quintessential image of male elusiveness. The men in the stories are barely described. They are not really human; they are merely a scarce resource, like money or food—something *needed*. Only the women are real, and what is most real about them is their desperation: the dresses they choose to catch the man's eye, the pearls they have shortened to hide wrinkles at the neck, the fights they pick, the tears they shed. It is a pitiless vision, and it was Parker's only true subject.

In the late thirties, she tried writing stories about the socialist struggle, and she produced one nearly beautiful one—"Soldiers of the Republic," about the Spanish Civil War. (She and Alan went to Spain in 1937.) The story is set in a café in Valencia, and it is full of fine observation: the soldiers briefly reunited with their wives, the babies in patched dresses on their laps. But Parker keeps wrecking the story by interjecting her own guilty-liberal thoughts.

At one point, she observes a baby at the next table, with a new blue ribbon in its hair. The bow is wonderfully described—its loops, its determined gaiety. Then:

> "Oh, for God's sake, stop that!" I said to myself. "All right, so it's got a piece of blue ribbon on its hair. All right, so its mother went without eating so it could look pretty when its father came home on leave. . . . All right, so what have you got to cry about?"

This happens again and again. Parker is trying to write a story about something other than herself—about the Spanish people and their courage—but every time she climbs up out of herself she falls back in. And, of course, the thrust of these asides is not altruism but egotism, the selfishness of those who hate themselves. This she could write about, but she couldn't write about anything else.

AND that is the tragedy of Parker's career. She has no disinterestedness; she has, basically, no imagination. She seems to feel she has no right to one. People are always telling us how there is no connection between moral strength and artistic strength: how Picasso preyed on women, how Wagner hated Jews, how you can be a terrible person and still be a great artist. But the case of Parker reminds us that, while the relation between morality and imagination may be a complicated one, it does exist. Hope, forgiveness— these are not just moral actions. They are enlargements of the mind. Without them, you remain in the tunnel of the self. Parker was morally a child all her life. She had a clear vision of the bad, but it never taught her anything about the good. In the midfifties, when she was the subject of one of *The Paris Review*'s Writers at Work interviews, she was asked whether she thought Hollywood had a way of destroying artistic talent. "No, no, no," she replied. "I think nobody on earth writes down. Garbage though they turn out, Hollywood writers aren't writing down. That is their best. If you're going to write, don't pretend to write down. It's going to be the best you can do, and it's the fact that it's

the best you can do that kills you." Very brave, right? Take responsibility for what you've done. But, in fact, the criticism is excessive, unrealistic—thereby letting her off the hook, releasing her from judgment into a little ecstasy of self-loathing. For Parker, working in Hollywood was a conscious tradeoff—money for art—as it was for many other writers. And as she had just told the interviewer a moment before, she was quite willing to make the trade: "I hate almost all rich people, but I think I'd be darling at it."

Parker's politics, too, however idealistic-seeming, have an irresponsible quality. Obviously, she acquired her hatred of political oppression by way of her hatred of sexual oppression, and, though this is not a bad way to acquire a social conscience, in Parker's case the resulting political feelings were as confused as her feelings about the sexual situation. She sided with all victims, her friend Wyatt Cooper recalled in a 1968 *Esquire* article. "This sympathy extended to anyone accused of a crime; so long as they were found guilty, she was convinced of their innocence." If, on the other hand, they were found not guilty, she was convinced of their guilt. "Lizzie Borden, having been acquitted, would be forever guilty in Dottie's eyes," Cooper writes. " 'I can sympathize with almost any wrongdoing,' she once told me. 'People are horrified by child molesting, but it seems perfectly understandable to me. The only criminal activity with which I don't completely identify is arson.' "

Parker has been praised for the extreme economy of her stories, many of them less than ten pages long, most of them faithful to the unities of time and place (a taxi ride, a conversation on a patio), all of them sketching in their characters with a stroke or two and leaving much for us to guess. They deserve praise, as the aptest container for what she had to say. But surely she herself must have noticed that her finest story, "Big Blonde," was her *least* economical story, more than twice as long as her average; that it did not observe the unities but covered ten years; and that, despite the autobiographical touches (the alcoholism, the suicide attempt), it was almost the only one of her major stories whose heroine was not like her but duller and nicer—a sympathetic character. Parker's best story, in other words, is her least typical

story. It is a voyage out, and that is what she needed. Instead, she pulled in and pulled in, until at last she just disappeared.

Why did she limit herself so? You can blame the frivolity of the twenties, or you can point to those institutions of the twenties with which she was most closely associated—the Round Table, with its ban on seriousness, or *The New Yorker,* founded and edited by a Round Tabler, Harold Ross. According to James Thurber, Ross was determined to give the magazine "an offhand, chatty, informal quality. Nothing was to be labored or studied, arty, literary, or intellectual." For a while he succeeded. In its first year (1925), *The New Yorker* was full of tiresome, subcollegiate joshing. But Ross's brains and good taste—and also, I think, his curiosity, his interest in the world, a trait in short supply at the Round Table—got the better of him, and he began producing a magazine that, if light-spirited, was nevertheless serious and well written. By the time his friends from the Algonquin began writing for him regularly (Parker and Benchley in 1927, Woollcott in 1929) Ross had in some measure outgrown them. Eventually he got rid of them. He broke with Woollcott in 1939. He fired Benchley in 1940. Parker he didn't have to eliminate—she stopped filing her book reviews—but in the late thirties he started turning down her stories.

Lack of ambition was not Parker's only problem. There was also her vision of the world as a yin-yang of need and hate. Where did that come from? Two of her biographers, Meade and John Keats, point to the early death of her mother. A third biographer, Leslie Frewin, diagnoses her malady as manic-depressive psychosis. Actually, Parker had a psychiatrist—she started going to him in 1926, right before her second suicide attempt—and his diagnosis was more modest: "pathological drinker." This leaves unanswered the question of what caused the drinking, but does one have to look that far? Many, perhaps most, of the best American writers of Parker's period were alcoholics, and many died young as a result. Parker, miraculously, lived to the age of seventy-three, but from about age thirty on she was intoxicated during most of her waking hours. It is no surprise that she achieved so little. The wonder is that she achieved so much.

EVERYTHING Parker wrote that is memorable, and much that is unmemorable, fits neatly into the Viking *Portable Dorothy Parker,* the only comprehensive Parker collection still in print. According to a Viking editor, that book is one of the ten best-selling Portables—one slot below Emerson, one slot above Poe. Interest in Parker has not died. The director Alan Rudolph is making a film about her right now, starring Jennifer Jason Leigh. The script is one of those "Ridi pagliaccio" affairs: how bright the Round Tablers were on the surface, how neurotic and miserable underneath. Needless to say, the scriptwriters were not at a loss for snappy dialogue. All of Parker's famous quips are there. Conversation, actually, may have been her best genre. In any case, it is for her wisecracks, and for the poems that read like wisecracks, that she seems to be remembered by the public.

But her unique contribution was her portrait, in the stories, of female dependency. This was a central concern of nineteenth-century women writers—Jane Austen, George Eliot, the Brontës—and also of some of the men, notably Thackeray. (Parker said that she read *Vanity Fair* "about a dozen times a year." Meade believes that Parker modeled herself on Becky Sharp.) But in the twentieth century the rules changed. With the move to the city and the loosening of ties to family and class, women were thrown into a new situation—one in which they should have been freer, and in which some were (witness Sister Carrie) but in which others found themselves wholly abandoned, both by the system that had formerly hemmed them in and by the new one, which still had no place for them (witness Lily Bart). Even after women began to make their way economically in twentieth-century culture, they were still left with an ages-old inheritance of emotional dependency, the thing that marriage and the family, having created, once ministered to and now did not. If in the old days women were enslaved by men, they nevertheless had legal claims on them. Now they had no legal claims, so all the force of their dependency was shifted to an emotional claim—love, a matter that men viewed differently from women. Hence Parker's heroines, waiting by the phone, weeping, begging, hating themselves

for begging. This is a story that is not over yet. Parker was one of the first writers to deal with it, and she addressed it in a new way. Because, it seems, she identified with the man as well as the woman, she saw these women from the outside as well as from within, heard the tiresome repetitiousness of their complaints, saw how their eyelids got pink and sticky when they cried. She did not feel sorry for them. They made her wince, and we wince as we read the stories—for, burning with resentment though they are, they are even more emphatically a record of shame. Female shame is a big subject, and for its sake Parker should have been bigger, but she is what we have, and it's not nothing.

The New Yorker, 1993

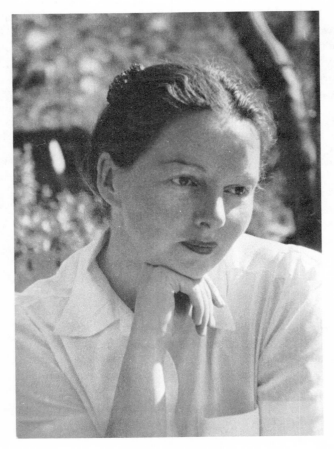

M. F. K. Fisher, 1946

Feasting on Life

IF you woke me up in the middle of the night and asked me which piece of writing by M. F. K. Fisher I liked best, I would probably say the chapter on making meals during blackouts in *How to Cook a Wolf*, a book published during the Second World War. Fisher takes the problem seriously. Don't curse God and die, she says. Cheer up! You *can* feed that family with no fresh foods, no electricity, no gas, no light, and no conviction that you'll be alive tomorrow.

Let's see. "Now would be a good time to get out the old chafing dish." Do your cooking during the day, while there is still light. Lay in a "blackout cupboard" of prepared foods, including, she says—with what must have been a major gut-clenching, for she was a great gourmet—"cheeses in glass." Yes, Cheez Whiz, or whatever it was called in 1942. "In a time of peril and unspoken fear," she explains, cheese, any cheese, is "an anesthetic. . . . Put a little bit on crackers, or on crisp toast if your oven is still working. Try it on a tired factory worker some day, or a nervous neighbor, with a glass of milk if possible or a cup of tea, and watch the unfolding of a lot of spiritual tendrils that were drawn up into a tight heedless tangle." I missed the Second World War, but in this image of a woman holding out Cheez Whiz on a cracker to a neighbor whose son is late coming home from the munitions factory, I get a sense of what the war was like for those who didn't actually fight in it.

The moral beauty of Fisher's writing is not easy to talk about, because such a fuss has been made over it. Fisher published her first book in 1937 and for the next twenty-five years had only a modest readership. Then, in the sixties and seventies, her small craft was suddenly borne aloft on the upheavals of that era: the

food revolution, the sexual revolution, the women's movement, all of them doubly strong in her home state of California. She became a hero, a prophet of the food/sex sacramentalism of the period. Today, six years after her death, her cult still flourishes. Seventeen of her twenty-six books are still, or back, in print, including a few that needn't be. And that's not counting the spinoffs. Last year, we got *A Welcoming Life: The M. F. K. Fisher Scrapbook,* with countless photographs of her—wineglass in hand—flanked by nuggety quotes from her writings. Now, from the same publisher, we have *A Life in Letters: Correspondence 1929–1991,* five hundred pages long.

One thing the letters tell us is how bewildered she was by the sudden attention she received in her late years, and how resistant to the politics behind it. The food revolution receives tart comment ("I do dislike huge piles of *sprouts* in things"). Ditto feminism. Like other freethinking women of her generation—Doris Lessing, Mary McCarthy—she had misgivings about her jackbooted legatees. Most of all, she disliked the sex angle, the idea that she was the one who initiated the "sensuous gourmet" trend in food writing. Actually, she probably did initiate it. She spoke often of the pleasures of the flesh, in such a way as to indicate that she didn't just mean eating, and occasionally she unloaded a full, hundred-pound pronouncement on the subject, as in her foreword to *The Gastronomical Me,* in 1943. People often asked her, she said, why she chose to be a food writer—why she didn't write about "the struggle for power and security, and about love, the way others do." And her answer was: "It seems to me that our three basic needs, for food and security and love, are so mixed and mingled and entwined that we cannot straightly think of one without the others. So it happens that when I write about hunger I am really writing about love and the hunger for it, and warmth and the love of it and the hunger for it . . . and then the warmth and richness and fine reality of hunger satisfied . . . and it is all one." (Ellipses hers.)

These Khalil Gibran–like words have been quoted again and again—they are the theme song of the Fisher cult—but they represent her poorly. She thought and wrote better than that, as one can find out by going back to her books. Now one can go to the

letters, too. As they reveal, food and security and love were not her only basic needs. She had a fourth one: writing. Furthermore, food and security and love were not all one. Food was easier to get.

MARY Frances Kennedy, who later married Alfred Fisher, was born in Albion, Michigan, in 1908. When she was two, the family moved to California—to the Quaker town of Whittier, where Richard Nixon, whose favorite dish was cottage cheese and ketchup, was growing up at the same time. She adored California, and, like other artists born or, more often, transplanted there (Isadora Duncan, Martha Graham), she regarded it as a fundamental source of her identity. "I really started to be me somewhere there," she said. The family lived outside town, on a ranch with an orchard and chickens and a pig and a cow and a horse named Hi-Ho Silver. She embraced the bright air, the black soil, and these things gave her the courage to rebel against her family's low-church attitudes, at least in the kitchen. She was a gourmet from childhood: on the cook's night off, she made dinner. She was also a journalist from childhood. Her father, a fourth-generation newspaperman, was the owner and editor of the *Whittier News,* and by the time she was a teenager he had her subbing for the gardening and society columnists—even the sportswriter—when they went on vacation.

Like so many good writers, she was an indifferent student, and, no doubt, it was partly to get out of having to finish college that in 1929 she married Al Fisher, a young academic. Soon they took off for Dijon, he to write his dissertation, she to take art classes, and she fell in love with France—a passion that would remain with her for the rest of her life. In a letter to her sister Anne, age nineteen, she describes the natives:

> French people eat the most intricate entrails of everything
> from the horse to the snail; they have perfectly awful table
> manners, mop up their plates after each course with a piece
> of bread, change napkins once a week, and have little sup-
> ports on which you put your knife and fork after a course;

the men go casually into any of the fifty thousand open-air johnnies that seem to line the streets, and then spend half a block nonchalantly buttoning up their trousers.

In a letter to her brother David, age ten, she tells how a French sommelier opens a bottle of wine:

> Drawing the cork is a great ceremony—waiters cluster around the wine-master, and the man who has ordered it listens anxiously to see if the pop sounds right. Then the cork is waved under his nose, and he sniffs it loudly. Finally the wine is poured, still in the cradle, into his glass, and he sips it slowly and with the most amazing noises. The waiters and the wine-master watch his face to see if he likes it, and finally go away.

She was twenty-one. She was a writer already; she just didn't know it.

Nor, beyond letter-writing, did she try it until about five years later, when she began to think of leaving Al. She knew she would need money, so she started writing magazine pieces. Soon she fell in love with a friend, Dillwyn Parrish, a painter from a family of painters. (Maxfield Parrish was a cousin of his.) She went off to live with him in Switzerland, and now she discovered something: sex. As comes out very gradually in the letters, this was not part of her relationship with Al. The son of a Presbyterian minister, he was "frightened and repelled by the actual physical act of love." With Parrish it was different. He uncorked her. They gardened, they picnicked, they talked for hours on end. He painted, she wrote; she became a writer at last. This went on for a year. In 1938, Dillwyn developed an embolism in his leg, and the leg was amputated, but the pain didn't go away. Soon his condition was diagnosed as Buerger's disease, a fatal circulatory disorder. They moved back to the United States and got married, but they had no hope. "He can't walk at all unless I hold him," she wrote to a friend. "His pain is terrible to think of." Finally, in 1941, after three years of anguish, he killed himself.

Fisher's life went into a tailspin. A year after Dillwyn's suicide,

her brother David also committed suicide, the night before he was to go into the Army. The year after that, Fisher gave birth to an illegitimate child—her first daughter, Anne. (She told everyone the child was adopted. She never revealed who the father was.) Two years after that, on a trip to New York, she met a dashing book editor, Donald Friede, and though she seems never to have trusted him—he had already been through five wives—within two weeks she became the sixth. (She telegraphed a friend: "I ACCIDENTALLY GOT MARRIED SATURDAY TO DONALD FRIEDE.") In 1946, she had his baby, her second daughter, Mary. But before long Friede's publishing career was in ruins, and he was in the throes of a mental breakdown. In 1951, after six years of marriage, she divorced him.

She remained unbroken. From 1937 to 1949, through grief and hell, she published nine books. I guess we should pause for a minute over the fact that she became a writer once she had become a sexual being. But a minute is enough. Twenty-nine was not a late age for a woman of her generation to be publishing her first book, and, as I said, she needed money. The notable thing is not that sex opened her up but that the complications and disasters that followed did not close her down again. *How to Cook a Wolf,* that brave, happy book, was dictated to her sister Norah, at the typewriter, as Fisher, still in black grief over Dillwyn, paced up and down in the house where he had shot himself only months before. *The Gastronomical Me,* which followed a year later, was "conceived and written and typed in ten weeks," as she did other work on the side and gestated a fatherless child.

Then came an experience, seemingly benign, that did almost break her. In 1949, her mother died. Her father now needed someone to run his house, and Fisher, his oldest child, decided she should do it. For four years, she remained in Whittier—a conservative town where she no longer felt comfortable—cooking, cleaning, running around after her daughters, and watching her father, who was dying of pulmonary fibrosis, hawk up phlegm and spit it into the fireplace. She had no one to talk to. She began having spells of depression and, if I read her correctly, severe anxiety attacks. She began seeing a psychiatrist.

During this whole period, she wrote next to nothing, apart

from columns, including her father's, for the *Whittier News*. (This was part of the deal. As long as she was there to help with the paper, he didn't have to sell it, though he was far too old and sick to run it.) She stopped thinking of herself as a writer. Rather, as she wrote to Norah, she was "a genteel has-been now and then asked to speak ten minutes at an arty tea." This state of mind continued long past her father's death, in 1953. She who had published nine books in twelve years brought out not a single new book in the twelve years after she moved into her father's house. Those who lament the dissolution of the American family—kids with no way to get to Girl Scouts, aging parents put into nursing homes—should remember what it was that kept the American family together: women's blood.

ONCE Fisher's father had died, she moved to St. Helena, in the Napa Valley—a region she loved—and learned to be happy again: "I stand dreaming at the windows. The vineyards are waist-high with wild mustard now. We walk along the little roads, humming and listening to the birds, with mimosa in our topknots." The rest of her life was spent in the Napa and Sonoma Valleys, with occasional stays in Switzerland or her beloved France. She had a few affairs, including one with Arnold Gingrich, the editor of *Esquire* and an important figure in the New York magazine world. He was married, but it seems they had fun for a time. She never again thought of herself as having a major talent—or, if she did, such thoughts were quickly displaced by the daughters, the dogs, the cats, and the endless parade of guests whom she loved to cook for. As she wrote to a friend in 1947, she wanted to be a good writer, "but I also want children and love and stress and panic and in the end I am too tired to write with the nun-like ascetic self-denial and concentration it takes."

Actually, after her dry spell between 1949 and 1961, she published fourteen more books, including *Map of Another Town* (1964), on Aix-en-Provence; *A Considerable Town* (1978), on Marseilles; *As They Were* (1982), a memoir; and *Sister Age* (1983), on old age. Yet she never ceased to speak slightingly of her work. Her best

book, she decided, was *A Cordiall Water,* on home remedies: "It is a rather comforting little book, the kind to be read on an air-trip or during childbirth maybe."

She grew old early, and seems to have wanted to. She had a consuming interest in aging. (She was in her twenties when she began collecting the materials for *Sister Age,* published when she was seventy-four.) The years were not kind to her. By her sixties, she had severe arthritis, so that eventually she could neither type nor write by hand, and had to dictate her work to a secretary. By her seventies, her eyesight was going, and she had Parkinson's, which affected her voice. Now she had to whisper her work to the secretary. Still, she was a fine, grouchy old lady. When her friends whined about their problems, she told them to shape up. When she got tired of family Christmases, she bowed out, and spent the day listening to records and drinking a bottle of champagne by herself. Always plainspoken, she became more so. The people who had her to dinner on February 19, 1970, are not going to be happy to learn from *A Life in Letters* what she thought of their "turd-like sausages" and "meaningless vinaigrette."

These are superb letters—long, meaty, intimate, conversational. You can practically hear her breathing. And they remind us of her faithfulness to reality, her ability to let things stay mixed and strange—to let them grow at the edges and stay loose in the center. This is one of the glories of her books. I am thinking, for example, of the great chapter in *Map of Another Town* where she describes the cavalcade of disastrous housemaids—"nitwits, sick old whores and dipsomaniacs"—who trooped through her pension in Aix: Marie-Claude, so blind that she drove her bicycle into a truck; Marie-Claire, like Rochester's wife. In each case, amid the hilarity of the portrait, we get an account of what that woman endured during the Occupation, but there is no lifting of the hilarity. The chapter is like a little Mozart opera—a comedy with a tragedy buried in it.

This play of contrasts made her, at times, a very strange food writer. When she recalls a wonderful salad eaten on a train, she praises the bugs in it almost as highly as the greens. And here is her portrait of the Marseillais:

To me they are attractive, the way a magnet is: hard, perhaps ruthless but with real scruples and ethics. I have no desire for physical contact or any attempt at intimacy with them, but I love to be near them. I feel that I understand, at least empathetically, why they are made exactly as they are, short, compact, with small graceful hands and feet and faces of stone.

Sometimes she pushes the device too hard, and wears us out. Still, such antisentimentality is the mark of a fine mind—a higher form of irony—and it was part of her morality.

Fisher had another great virtue as a writer—an enormous tact, a sense of when to end, when to omit—but this blessing is not present in her letters, because they are letters. She is writing to Norah, or Gingrich, or whomever, and is unloading after a long day. So she tells them how she had to replace the clutch in the Caravelle and what she wore to the restaurant and who ordered what. Some of this should have been cut. And when she, like the rest of us, uses the same joke on three different correspondents, things should have been arranged so that we would encounter it only once. The editors—Norah Barr (the beloved sister), Marsha Moran (the secretary to whom she whispered her late works), and Patrick Moran ("a close family friend," the press release says)— were too indulgent. We also needed many more footnotes. But never mind. This is a priceless book: a whole life, a serious life, eighty-four years long. You come out of it tired, as she did, and, like her, not necessarily smarter ("I don't feel very wise"), but less alone.

The New Yorker, 1998

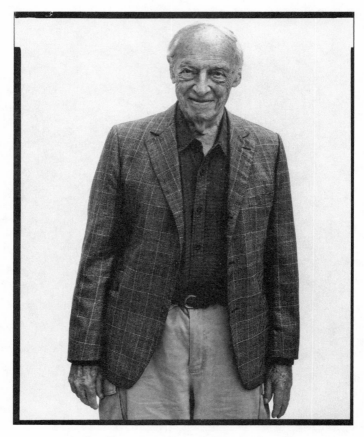

Saul Bellow, 2003. Photograph Richard Avedon

Finding Augie March

WE tend to think of young artists as a wild and crazy bunch, but often they are the opposite—depressed, grouchy people who sit around wondering why all those older artists are getting the grants and the contracts. Their work bespeaks their mood. They imitate their elders, and not admiringly, but grudgingly, in the spirit of "I can do it, too." In fact, they can't do it, because they don't really believe in it, but neither can they do what they're meant to do, because the moment of courage has not yet come. And so, for a while, they produce tight, hard things.

A textbook illustration has just been published: the Library of America's *Novels 1944–1953,* by Saul Bellow, a collection that includes *Dangling Man, The Victim,* and *The Adventures of Augie March.* The Library has now run out of dead Americans, and so, for only the second time, it has devoted a volume to the living. Bellow is an obvious choice—he is a classic—and this year is the fiftieth anniversary of the publication of *The Adventures of Augie March.* Many people, I would guess, think of *Augie* as Bellow's first novel, or, if they know that it was preceded by two others, they may imagine that the career-announcing glories of *Augie*— the grand, cascading sentences, the juxtaposition of Chicago hoodlums with Plato and Spinoza and Rousseau, and, by extension, the ennoblement of crude, new America as a worthy arena for the working out of life's great questions, formerly considered addressable only in nice, old Europe—can also be glimpsed in the early books. They can't be.

Dangling Man (1944), Bellow's first novel, is set in Chicago, his home town, in 1942 and 1943, when Americans were finally leaving to serve in the Second World War. But Joseph, the author of

the diary that constitutes the book, has not yet been inducted. So he just sits in his room, thinking. What he is thinking is that social and historical forces—war, for example—cause people to renounce their freedom, much to their satisfaction. People hate freedom, Joseph says: "We choose a master, roll over on our backs and ask for the leash." But, until the draft board calls, Joseph will hang on to his independence, and use it, he says, to find out who he is. Actually, he wants to find out what humankind is—"what we are and what we are for"—but though he ponders this question night and day, he makes no progress. Staring out his window at the busy streets, he gets even more depressed. Capitalism is hell. People are hell. Nature is ugly, not to speak of Chicago. Where, in all this, was there "a particle of what, elsewhere, or in the past, had spoken in man's favor?" He never finds out, because in the end, losing patience, he goes to the draft board and demands to be inducted. His freedom now canceled, he leaves for the war, with a sarcastic envoi: "Hurray . . . for the supervision of the spirit!"

Dangling Man is a respectful tribute to its models—Dostoevsky and Rilke, plus Sartre, I believe—and at points it is handsomely written. But looked at today, through the lens of *Augie,* it is amazingly constrained—stingy, even. The dialogue is often inert, the pace hypnotically even. There are no memorable characters. If I didn't know the book was by Bellow, I would never guess it.

The next novel, *The Victim* (1947), was braver. In 1945, soon after *Dangling Man* came out, the Allies liberated Auschwitz, Bergen-Belsen, and Buchenwald, and the facts discovered there would change what had been, till then, America's pervasive, taken-for-granted anti-Semitism. That sentiment is the subject of *The Victim.* The hero, Asa Leventhal, is an editor at a small trade magazine in New York. One night, as he is walking through the park, he is buttonholed by a down-and-out man who says that his misfortunes—he has no money, he's a drunk—are Asa's fault. Strange to say, the story may be true, or partly. Some years earlier, before he fell on hard times, this man, Kirby Allbee, had been an acquaintance of Asa's. Once, when Asa was looking for a job, he asked Allbee for an introduction to his boss, the editor of *Dill's* magazine. At the ensuing interview, the editor treated Asa rudely,

whereupon Asa, normally a restrained, cautious person, blew up and told the man off. Later, he heard that Allbee had been fired from *Dill's,* but he never gave much thought to this: Allbee had already started drinking, and was only barely hanging on at the magazine. But Allbee now reminds him of an episode that occurred before the job interview. The two of them were at a party where one of Asa's friends, Harkavy—a Jew, like Asa, and given to what Asa sees as Jewish behavior (volubility, wisecracking)—was singing old American ballads. Allbee interrupted him, saying that he shouldn't try to sing such songs: "You have to be born to them." Harkavy should sing something else instead: "Any Jewish song. Something you've really got feeling for." The incident ended in awkwardness all round, but Asa says that he soon forgot about it. Allbee says that Asa didn't forget about it, and that he staged the explosion with the editor precisely in order to get him fired. Asa ruined his life. Now he owes him.

Allbee, Bellow's first really interesting character, is not so much a man as a dybbuk. He has a yellow gleam in his eye; he turns up everywhere Asa goes, and he knows all about him. But he is not just diabolical. He is also piteous—bruised, begging, weeping. Then, in a flash, his tears vanish, and he is telling Asa how the dirty Jews have taken over the city. The problem is worse than that, however, for while Asa is repelled by Allbee he also identifies with him, sees him as his double. When the man is not with him, he still feels his nearness: "He could even evoke the odor of his hair and skin. The acuteness and intimacy of it . . . oppressed and intoxicated him." Soon Allbee has moved into Asa's apartment, where he wears his host's bathrobe and reads his mail. In a culminating scene, Asa comes home one night to find Allbee in his bed with a prostitute. (The daybed was too narrow, Allbee explains.) As the woman hurriedly dresses, Asa stares at her breasts. The whole business is appalling.

I think it is meant to convey the appallingness of anti-Semitism for a second-generation Jew of the time. Reading the book, one fairly hops up and down with frustration that Asa doesn't just tell Allbee to get lost. His failure to do so, Bellow seems to say, is part of the neurosis of assimilation. Asa remembers that his immigrant father faced the world squarely as a foe. He

had a favorite saying: "*Ruf mir Yoshke, ruf mir Moshke, aber gib mir die groschke.*" ("Call me Ikey, call me Moe, but give me the dough.") He didn't hope for decent treatment, only for survival. But Asa, like other immigrants' children, wants a respected place in the Gentiles' world, and there his troubles begin: social discomfort, fear of seeming Jewish (hence his stolidity), resentment of slights, self-hatred for ignoring slights, worry that he is imagining slights. Then comes the guilt—for example, survivor guilt. Asa, who came of age during the Depression and has had his jobless periods, can't quite believe that he is gainfully employed. "I got away with it," he thinks. And Allbee plucks exactly this string in his mind. Why should Asa, a Jew, an outsider, have a job when Allbee, a Gentile, a real American, is out of work? Indeed, as this stew thickens, one starts to question which one is the Jew. After the episode with the prostitute, Asa finally throws Allbee out, but in the middle of the night Allbee sneaks back into the apartment and tries to kill himself in Asa's kitchen. The method he chooses is gas. It's as if he were doing a parody of the Jews. The book's ambiguous title—which man is the victim?—underlines this reversal.

The Victim is a novel of ideas, and, accordingly, much of it takes place in the mind. (Now and then you wonder whether Allbee isn't something Asa has imagined.) The world is still there: apart from Allbee, there are a few vivid characters—all of them very Jewish, by Asa's lights—and when they talk we hear real, breathing human speech. The descriptions of the city, in keeping with the spell that Allbee casts over the book, have a certain sulfurous force. But Asa's personality applies a counterforce. He is an unimaginative man. Bellow presumably made him so in order to tell us what anti-Semitism is like for the average Jew, but since all the narration is from his point of view it can get pretty average, too. The book is like a boiler; the center is burning, but the walls are thick. Bellow seems to have known this as he was writing. At one point, Asa says to himself that for most people living is like running "in an egg race with the egg in a spoon . . . watching the egg, fearing for the egg." Sometimes we get sick of our caution, he

thinks. But "man is weak and breakable," so he goes on watching the egg.

Bellow had reason to do so. He, too, was a second-generation Jew, and he was entering a field, the English-language novel, in which Jews were felt to have no place. (When, after graduating from Northwestern, in 1937, he was thinking of doing graduate study in English, the chairman of the department said to him what Allbee says to Harkavy: "You weren't born to it." Do something else.) Today, Philip Roth can fill a novel with Newark Jews and posit their generational history as the story of America—indeed, call the book *American Pastoral*—and we don't blink an eye. But such a situation was unforeseen in the 1940s. In that context, it was courageous of Bellow, who longed to enter the big leagues, to make anti-Semitism the subject of his second novel, but the only way he could see to do it was by imitating European models: Dostoevsky (the interiority, the Devil, the double), Flaubert (the factuality, the polished sentences). When he was older, he described both *The Victim* and *Dangling Man* as "victim literature," by which he meant that *he* was victimized, by his insecurities, as a Jewish nobody from Chicago: "I was restrained, controlled, demonstrating that I could write 'good.'"

But he didn't know that in 1947. All he knew was that he was vaguely dissatisfied with *The Victim,* and crushed by its poor sales. Then his luck changed. Viking, a prestigious firm, came after him, and offered him a flattering three-thousand-dollar advance on his next novel. He also won a Guggenheim fellowship, after having been turned down twice. He and his wife decided to spend the fellowship year in Europe. In 1948, they moved to France, where Bellow applied himself to a new book, called *The Crab and the Butterfly.* Only one chapter of that novel survives. According to James Atlas's biography of Bellow, it is a bleak narrative about two men talking to each other from adjacent beds in a Chicago hospital. Bellow was soon having trouble with it. Furthermore, he hated Paris. The weather was gray; the French were snotty. "I was terribly depressed," he later said.

Then, as he recalled, he experienced an epiphany: "I had a room in Paris where I was working, and one day as I was going there after breakfast, a bright spring morning, I saw water trick-

ling down the street and sparkling." The shining stream, he said, suggested to him the form of a new novel. Perhaps so, but a few other circumstances should be taken into account. This was the time, the postwar years, when American art came into its home country. Not just Bellow but many others walked out from under the shadow of the European masters and invented new, personal styles. Bellow was part of a Zeitgeist, and the stay in Europe encouraged his enlistment. The more he hated France, the more he loved America, and wanted to make an art that was like America—big and fresh and loud.

Furthermore, he had received a great deal of encouragement. When he was starting out, Bellow was friendly with New York's intellectual community, both the *Partisan Review* crowd and a more louche gang in Greenwich Village. These people, many of whom were Jewish, and pained at the exclusion of Jews from America's mainstream intellectual life, were very impressed by Bellow—by his brio, his erudition, his ambition, his seeming confidence. "He examined Hemingway's style like a surgeon pondering another surgeon's stitches," Alfred Kazin remembered. The New York crowd stumped for him. When I read what Elizabeth Hardwick wrote about *The Victim* in *Partisan Review*—"It would be hard to think of any young writer who has a better chance than Bellow to become the redeeming novelist of the period"—it seems to me that she is hoping as much as describing. Manhattan's young literati desperately wanted a redeeming novelist to rise from their ranks, and they all but begged Bellow to take the job.

Finally, simply, the time had come. For years, Bellow had been old; now, in his thirties, he could be young. He laid *The Crab and the Butterfly* aside and started a new novel, *The Adventures of Augie March*. He wrote the first half very quickly, revising little. "The book just came to me," he said. "All I had to do was be there with buckets to catch it."

No halo, but only the miasma from Chicago's smokestacks, hangs over the little house in Humboldt Park—a Jewish working-class neighborhood—where Augie March grows up (as did Bellow).

Still, we are looking at a holy city. This is the first and probably the most admired beauty of Bellow's book, that it takes the dirty old world and, combining a child's capacity for awe with an adult's sense of loss, makes of it a paradise: that is, not just a place of happiness but one in which the most serious principles of life are already present, as symbol—the apple, the snake. The trick had certainly been done before: Proust's Combray, Cather's Black Hawk. It had even been done with a big city, Joyce's Dublin. But Chicago was different. With its slaughterhouses and automobile-assembly plants, it was widely considered the most hard-bitten town on earth, the very picture of industrial capitalism's power to crush the human soul, and that was the tribute paid to it by its earlier chroniclers: Frank Norris, Upton Sinclair, James T. Farrell, Nelson Algren. Then came Augie March's Chicago, hopping and pulsing with human souls of every possible variety, all of them gesticulating and shouting, demanding dinner and love and money, expounding their philosophy of life, urging its universal adoption, and generally acting as though industrial capitalism had been invented for their own personal use.

Augie's family consists of Mrs. March and her three sons. Augie is the middle child, an aimless, happy boy, who is maybe eight or ten years old when we meet him. There used to be a father, who drove a laundry truck, but he disappeared. In his place, the family has Grandma Lausch. Actually, she is not their grandmother; she is a boarder. Nevertheless, she runs the household. She comes from Odessa, where, she explains, she was married to a fine gentleman and her sons had German nannies. She still has her silk gown, her fur piece, her ostrich feathers. Now she sits in a shabby kitchen in Chicago, explaining to the feckless Marches how to chisel the city's welfare system. Thus does history enter the novel: Europe, immigration, the pain of immigration. (Bellow's mother also came from Russia with ostrich feathers in her trunk.) But Grandma Lausch is undiscourageable. She is a tsar, a Machiavel, full of force and pride and guile. When she's finished bossing Mrs. March and the boys around, she summons Mr. Kreindl, a neighbor, for klabyasch, an old-country card game, which she plays with "sharp gold in her eyes." She is the first great

personage in a book that carries on for six hundred pages without producing a single dull character. Even the animals have interesting personalities.

As Augie grows, he takes various jobs. He delivers floral wreaths for murdered gangsters; at Christmas, he is one of Santa's elves in Deever's department store. Through his eyes, we discover Chicago in the twenties, and it is a dazzlement: swanky apartments, lousy apartments, pool rooms, dime stores, boxing gyms, music halls with girls playing the "Liebestod" on bagpipes. When Augie and his friends have nothing else to do, they go to City Hall and ride the elevator:

> In the cage we rose and dropped, rubbing elbows with bigshots and operators, commissioners, grabbers, heelers, tipsters, hoodlums, wolves, fixers, plaintiffs, flatfeet, men in Western hats and women in lizard shoes and fur coats, hothouse and arctic drafts mixed up, brute things and airs of sex, evidence of heavy feeding and systematic shaving, of calculations, grief, not-caring, and hopes of tremendous millions in concrete to be poured or whole Mississippis of bootleg whiskey and beer.

Such sentences occur on almost every page. They are like hall closets; you open them and everything falls out. All of Chicago seems gathered into the book, and eventually all of America, and much of human history as well. People are compared to Peter the Great, Pasiphaë, Alcibiades, Sardanapalus, Cesar Romero. Chicago becomes the world. The fact that its citizens play klabyasch and express themselves in four or five different languages does not mean that they are marginal. It means they are central—the inheritors.

Chief among the beneficiaries are the Jews. Bellow works an interesting game here. Most of the main characters are Jews, and many scenes, particularly those of family intimacy and of deal-making, seem intended as specifically Jewish. (A few minutes before Augie's brother's wedding, we see the bride, in her gown and veil, on the phone with the photographer, trying to beat him down on his price: "Listen, Schultz, if you try to hold me up you'll

get no business out of any of the Magnuses ever again.") And Augie speaks Jewish. Those long, baroque, history-swallowing sentences have their roots in Yiddish discourse, as do the following sentences, about a woman sitting on the beach: "If you want to know what she thought, it was that back home was locked. There were two pounds of hotdogs on the shelf of the gas range, two pounds of cold potatoes for salad, mustard, a rye bread already sliced. If she ran out, she could send . . . for more."

But this is all done so easily, and so constantly, that you forget it's Jewish. Bellow objected very much to being called a Jewish novelist. He wanted to be regarded as an American novelist who happened to be Jewish, and he bestowed that same decontextualization on his characters. Anti-Semitism, central to *The Victim,* is mentioned only in passing in *Augie,* nor is there any effort to make the Jews seem more high-minded, or more likely to suffer, than anyone else. On the contrary, most of the Jews in the novel are enthusiastic lowlifes, people who run bootleg (as Bellow's father did) and have names like Dingbat, people who are just doing deals and trying to get by. Their very ignobility is a bid for respectability: Bellow doesn't feel that he has to protect them. And by that route he made the lives of Jews a normal subject for American literature.

THE novel doesn't really have a plot. Instead, it has a pattern, which is that Augie gets lectured by his family and friends on how he should wise up. He has a suggestible, delightable mind, and therefore he tends to drift. The people around him are steadier. They make plans, invent philosophies, and they try to enlist him. One after another succeeds. They hire him, hector him, buy him new clothes. But always, after a while, he says no thanks and moves on. In the early chapters, this is usually because something else has caught his eye. But, as Augie gets older, his resistance is increasingly a moral matter. He sees that human beings are all involved in a terrible struggle for power. The best description of this is provided by a man, Basteshaw, who turns up—during a shipwreck!—late in the book: "Go back to when I was a kid in the municipal swimming pool. A thousand naked little bastards

screaming, punching, pushing, kicking. The lifeguards whistle and holler and punish you, the cops on duty . . . call you snot-nose. Shivery little rat. Lips blue, blood thin, scared, your little balls tight. . . . The shoving multitude bears down, and you're nothing." To become something, and overcome your fear, Augie says, you fashion a self that can frighten the world back: "You invent a man who can stand before the terrible appearances. This way he can't get justice and he can't give justice, but he can live." Augie wants no part of it. As he watches his brother Simon, an American success story, screaming at people over the phone, meanwhile knocking things off the desk with his alligator shoes, something inside him is already out the door. He's repelled by the unkindness, but, more than that, he can't bear the renunciation of hope. He is looking "for the right thing to do, for a fate good enough."

It is a tribute to his creator's skill that Augie manages to be so virtuous, so idealistic, without getting on our nerves. Part of Bellow's strategy is to allow Augie's antagonists—his "reality" instructors—to express our doubts, with considerable mordant verve. "I know what you want," one of his friends says to him. "O paidea! O King David! O Plutarch and Seneca! . . . O godlike man! Tell me, pal, am I getting warm or not?" But these people don't change Augie's course. In the last chapter, he is still drifting. The Second World War has just ended. Augie is living in France, because that's where his new wife, who thinks she's an actress, has been offered a film job. He's doing deals, selling Army surplus, at the bidding of yet another of the book's hundred and one gonifs. As before, none of this may last. The novel runs out of steam in its last quarter or so, but that is often the case with a bildungsroman (see *Huckleberry Finn, My Ántonia*), because it is the quest that is romantic, and no ending of that, no fall into adult life, will seem a worthy conclusion.

IT would be hard to imagine a book more embedded in its historical circumstances than *Augie*. In its vitality and cheer, it was a response to the grim view of modern life taken by the American naturalists, and also by the European modernists—the "Waste-

landers," as Bellow called them. Needless to say, the book meant a great deal to the Jewish literary crowd, but you didn't have to be Jewish to care about Bellow. In the fifties, many American intellectuals, now disabused regarding the Soviet Union, began to look more kindly on their own country—"It is no longer the case," Lionel Trilling wrote in 1952, "that an avowed aloofness from national feeling is the young intellectual's first ceremonial step into the life of thought"—and it seemed to them possible that they might be given some voice in public matters. *Augie's* high-low character, its insertion of European culture into American street life, symbolized their aspiration, and the book's commercial success encouraged it. As the fifties passed into the early sixties, with the civil-rights movement and the election of John Kennedy, that hope became almost a national movement. Augie March was one of its heralds, and when I read certain of his meditations I think of those times. At one point, Augie says that we should learn to take truth in mixed form: "If the highest should come in that empty overheated tavern with its flies and the hot radio buzzing between the plays and plugged beer from Sox Park, what are you supposed to do but take the mixture and say imperfection is always the condition as found; all great beauty too, my scratched eyeballs will always see scratched. And there may gods turn up anywhere." This passage would have done very nicely as a reading at a Unitarian church service of the period, or as an epigraph to *The Family of Man*.

Today, *Augie* is no longer riding a wave of progressive politics. One must love the book on artistic grounds—for its comedy, its generosity, its density, its linguistic miracles—and also, still, for its hopefulness. Distant as we are from the uplift-minded fifties, we nevertheless get out of bed in the morning and put on our socks and our shoes and our hope. Bellow associated optimism with the United States, and it is very specifically as an American that Augie, in the last paragraph of the book, is speeding his car across Normandy so that he can arrive before nightfall in Bruges (where he has to meet a man with "a big nylon deal on his mind"), and see the pretty canals. Beneath his wheels are the barely cold bones of the war dead. He knows this, but he can't stop hoping—a habit that makes him think of Columbus. It also makes him think that,

compared with Columbus, he's something of a failure. But, he adds, "Columbus too thought he was a flop, probably, when they sent him back in chains. Which didn't prove there was no America." In those sentences, the last in the book, America is the focus of hope, as well as its symbol. Columbus's America, and Bellow's, may now seem merely a symbol. Which doesn't mean there's no hope.

The New Yorker, 2003

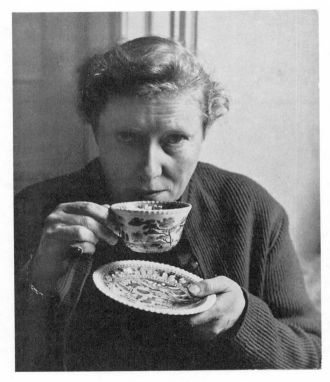

Sybille Bedford, c. 1980

Piecework

THE English novelist Sybille Bedford is more than a novelist. She worked as a court reporter, covering notorious trials—the case of Stephen Ward, the society doctor at the center of the Profumo scandal, in London in 1963; the trial of Jack Ruby, in Dallas in 1964; the proceedings against twenty-two members of the Auschwitz staff, in Frankfurt from 1963 to 1965—for magazines such as *Esquire* and *Life*. She also produced articles on food and wine. She was a travel writer, too, zooming around Europe to report back—again, for big magazines—on the shop-windows of Zurich and the sixteen lakes of Plitvice. Often, she blended the subjects of travel and food. To her, it seems, they were one subject, the goodness of life. In a travel piece on France and Italy, she can't not talk about the wines. Italian wines are "easy and companionable," she writes. "You can do with them what you never would with a hock or claret, trundle them about in a car, opened and all, fling in a handful of ice, drink them without a glass, drink them at all hours, with any food, in carefree quantities." This is the voice of a person who knows more than wine; she knows how to live, how to have fun.

She may have had too much fun, because she also spent many years not writing. Most of the long magazine pieces were bunched together in the 1950s and 1960s. The novels came out haltingly. For that reason, and also because her interests were so widely dispersed, she is something of a loose piece in the literary canon. In England, people over forty know her name; she got the OBE in 1981; her 1989 novel *Jigsaw* was nominated for the Booker Prize. But she is one of those writers who now and then come out of the woodwork, to loud exclamation, and then go right back in. "Bedford's mind is radiant," V. S. Pritchett said of one of her novels.

"When the history of modern prose in English comes to be written, Mrs. Bedford will have to appear in any list of its most dazzling practitioners," Bruce Chatwin wrote of another of her books. After the appearance of her first novel, she says, various publishers took to sending her roses and smoked salmon. She no doubt enjoyed such tributes, and then, until she felt like it, she wrote nothing whatsoever.

Very little was ever known about her private life. A journalist once asked her if she could say anything about the Mr. Bedford whom, it is recorded, she married in 1936. "No," she replied. Soon after the marriage, she left for the United States, to wait out the war, and spent six years here. Doing what? Shortly after her return to Europe, she published her first book, at the age of forty-two. Why so late a start? And what about her love life? Mr. Bedford notwithstanding, the autobiographical heroine of one of her novels has a number of heated sexual encounters with women. Was Mrs. Bedford homosexual? When Shusha Guppy, in a 1993 interview for *The Paris Review,* tiptoed up to this question, Bedford stonily answered that novels were fiction, not fact. Another interviewer, obviously groping in desperation for a topic that she might be willing to address, inquired whether she had ever owned a pet. "Yes and no," she replied. "It's a complicated question."

Now, however, at the age of ninety-four, she has written a memoir, *Quicksands,* and in it she finally answers some of these questions. The late start as a writer? When she was in her twenties, she says, she wrote three novels, all of them bad imitations of her friend and mentor Aldous Huxley. No one wanted to publish them; she gave up. Homosexual? Yes, apparently. She names the women she lived with. (Bisexual may be closer to the truth, however.) Mr. Bedford? That marriage was one of the completely pragmatic unions made around the time of the Second World War between people with endangered passports or Jewish blood (Sybille Bedford, at that time a German citizen, had both) and willing homosexuals of safer standing. After W. H. Auden stepped forward to marry Thomas Mann's daughter Erika, in 1935, Aldous Huxley's wife said, "We must get one of our bugger friends to marry Sybille." A candidate was found, who, as arranged, vanished swiftly after the ceremony, leaving Sybille a British citizen.

This was what enabled her to spend the war years in the United States. She has lived for the past three decades in London, and though she was raised in four different languages, she is an English writer.

So we find out all these things in *Quicksands,* but in a scattered, sidelong way. The main subject of the new book is her childhood, a matter on which Bedford has been as talkative as she has been silent about her adulthood. In her four novels—*A Legacy* (1956), *A Favorite of the Gods* (1963), *A Compass Error* (1968), *Jigsaw*—she told and retold the tale, turning it into a comedy, a tragedy, an allegory. Now she goes at it one more time. She can't help it.

WHO could? It's an irresistible story. From what one can put together (the sources are both fact and fiction, so accuracy is a problem), Bedford's father, Baron Maximillian von Schoenebeck, was born in the 1850s and grew up in Baden. He wanted to be a cabinet-maker, but the family needed money, so he went into the German diplomatic service. He didn't like it, though. Eventually, he solved his financial problems by marrying into a family from Berlin's *haute juiverie.* When that bride died, he took another: an Englishwoman, Elizabeth Bernard, who was rich, beautiful, brilliant, and many years his junior. As a wedding present she bought him a château near the Vosges, a few miles from the French border. Soon "the chores of maternity" were forced on Elizabeth— that is, Sybille was born, in 1911—but neither parent seems to have paid much attention to this development. Maximillian was some sixty years older than his new daughter, and he wasn't at ease with human beings, anyway. His one interest in life was collecting Renaissance antiques. As for the mother, Sybille was afraid of her. Furthermore, it was Elizabeth's habit to fall "seriously in love with another man every few years," and so she was away a lot.

When Sybille was eight, Elizabeth departed for good, and though Maximillian still had the château, he had no money to run it with. "The dining-room, the drawing-rooms, the Delft room, the library, the main kitchen and sculleries, my nursery and the guest-wing were shut up," Bedford recalls. The staff was let go.

Sybille wandered like a stranger among the Gothic carvings that filled her father's house, and tried to steer clear of the resident ghost, Bishop Wessenberg, who had committed a "foul deed" in the hall above the cellar in an earlier time. At dinner, Maximillian told stories of his youth. "I lived in his stories," Bedford later wrote. "I played with bits of wood, pretending they were the horses he had as a boy." After dinner, he would play roulette with Sybille and his one remaining servant, Lina. "*Faites vos jeux!*" he would cry to his ragtag child and his housekeeper. They staked real money—Lina's wages, Sybille's allowance—but, if the ladies lost, the funds were returned in the morning. Thus they lived for about three years, until a letter came from Elizabeth, demanding a visit from Sybille. Maximillian sent the child off and promptly died of appendicitis.

When Sybille arrived at the Italian train station where she was to join her mother, she was collected instead by a young woman whom Elizabeth had met at the local hotel. So sorry! Elizabeth had gone off with a new lover, but she would come back. In time, she did, with the man—Alessandro (as he is called in Bedford's books), some fifteen years her junior—and found, to her distress, that she was now Sybille's sole guardian. This problem was solved when the trustees of Maximillian's estate insisted on Sybille's receiving an education. Elizabeth sent her to a couple in England. (She had met them, too, at a hotel.) The English couple never arranged for much of an education, but they cashed the checks and treated Sybille kindly. Other families took her in as well. She remembers always being the child at the low end of the table, listening to what the adults were saying.

Elizabeth and Alessandro married and settled on the Riviera, in a little town, Sanary-sur-Mer, that later became a mecca for prewar intellectual refugees—the Huxleys, the Cyril Connollys, the Thomas Manns and other Germans. Sybille spent her teenage summers there, learning about French food and twenties fun. The good times soon ended, however. Alessandro had an affair with another woman, and Elizabeth eased her pain with morphine. This rapidly became a full-scale addiction, with Sybille giving the injections and driving from town to town in search of a new pharmacist who would fill her mother's prescriptions. Alessandro left

and returned repeatedly, but when Sybille was nineteen he walked out for good. On the last pages of *Jigsaw* Bedford describes his departure. Having packed his bags, he goes to Sybille's room at dawn and gives her his typewriter. If she has to live this, he seems to say, she can at least write about it.

She did, but very slowly. Only in *Jigsaw,* published when she was almost eighty, did she describe her mother's drug habit, and only now, in *Quicksands,* does she tell the end—a muffled and painful account. Like Alessandro, she finally left Elizabeth. To whom? To what? All she says is that her mother died after seven years of addiction, "I fear, though I hope not, alone." As for herself, other people, as usual, took her in.

This childhood gave Bedford the core of her art. In a tense moment in the *Paris Review* interview, Shusha Guppy speaks of Bedford's mother as a "monster." She was not a monster at all, Bedford replies: "She taught me everything about reading and people and telling stories about people." In other words, she showed her how to be a writer. The father did, too. Those tales he told of his youth became the material for *A Legacy.* But stories were not all her parents gave her. These two figures—the father who loved her, but at a distance; the mother who didn't love her much, but whom she loved—were Bedford's moral education. From watching them she learned what she would later say about life: that good-enough people, often just by trying to make some adjustment in their circumstances, fall into sin and error; that you can gather this only by what you hear at the end of the table; that life is comical and sad, and justice hard to render. Bedford is best when her moral faculties are tightly engaged. This is true not just of her novels but also of her court reporting and even of her travel writing. The nice, prosperous, democratic countries—Switzerland, Denmark—tend to get the travel-magazine bedazzlement treatment. It is the poorer, crazier countries that bring out her real powers.

MEXICO, for example. After her wartime exile in the United States, Bedford writes, she longed to visit a country with a minimum of "present history"—that is, Second World War history.

Mexico was her choice, and it became the subject of her first published book (her only full-length travel book), *A Visit to Don Otavio,* from 1953. In part, *Don Otavio* is classic travel writing. It provides a carefully meditated history of the country; it contains heart-stopping descriptions of the landscape. This being Mexico, we are also given the scenes of disorder and squalor so dear to old-time English travel writers, but we never quite get the note of astonished, white-man grouchiness that we find, to hilarious effect, on every page of Evelyn Waugh's accounts of his journeys. Bedford's astonishments, just as funny, are different. At one point, the bus on which she and her companion, "E.," are traveling to Guadalajara stops at a roadside café:

> On coming out again [we] found a mildly operatic outfit fumbling with the luggage ropes: three or four men in fine hats and bandanas tied over their faces on muleback, and a pack-mule.
>
> The driver and conductor shooed us back into the patio. "Gentlemen, we must wait for a moment," they addressed us with the disciplined calm of sea captains, "the bandits have come."
>
> "What bandits?" said E. . . .
>
> "They come down from the mountains at dusk," was kindly explained to her. "Bandits do not like to show themselves in broad daylight—there are certain prejudices—and they don't like to come out all that way at night, in the dark, when who knows what criminals and malefactors may be about."
>
> There was a clatter of hoofs, the conductor said briskly, "*Vamanos*"; we went outside and saw the train of mules cantering off. The luggage ropes had been retied; rather sloppily. Off we went.

When they arrive in Guadalajara, they find that all of E.'s clothes are gone. Balanced against this are the bandits' good manners: they retied the ropes. In Bedford's view, violence is endemic to Mexican life, but it is never committed with a whole heart. It is always mixed with courtesy, and comedy.

All of this is told with a tart, fresh empiricism. Here are the
book's opening sentences:

> The upper part of Grand Central Station is large and
> splendid like the Baths of Caracalla.
> "Your rooms are on Isabel la Católica," said Guillermo.
> "How kind of you," said I.
> "Pensión Hernández."
> "What is it like?"
> "The manager is very unkind. He would not let me
> have my clothes when I was arrested. But you will have no
> trouble."

We never find out why Guillermo got arrested, or even who he is,
but this little exchange is a perfect introduction to Bedford's style:
speed, omission, the sharp bite of event, without the tedious
explanation. She won't waste our time on what, she assumes, we
already understand. That is one of the joys of reading her: she
thinks we are as sophisticated as she is. Her writing is like the con-
versation of a clever, worldly friend who we wish would come by
more often. Her sentences are frequently incomplete, her gram-
mar nonstandard, her chapter titles a brazen lie. In *Don Otavio*,
the chapter on the town of Querétaro gets to Querétaro only in
the last paragraph, because Bedford wants to tell us about Mexi-
can provincial inns:

> The ground floor is always a large, unkempt parlour open-
> ing into the patio without much transition, full of over-
> grown plants, wicker chairs, objects without visible use,
> birds free and caged, and a number of sleeping dogs. Here
> the innkeepers jot their accounts, sort the linen, drive bar-
> gains with the poultry woman and the egg child, arraign
> the servants, play the gramophone, drink chocolate, chat
> and doze; and here the guests sit, smoke cigars, have their
> hair cut, shout for servants, play the gramophone, drink
> rum and chocolate, chat and doze. Everyone has their
> own bottle, sent out for by the *mozo* [Indian servant].
> The innkeeper would think you mad to pay him bar

prices; every time you draw cork he will supply you—compliments of the house—with . . . fried anchovies, toasted tortillas strewn with crumbs of cheese and lettuce, stuffed cold maize dumplings and pickled chili peppers.

In Bedford's world, nobody is going to get ahead, or nobody nice, but meanwhile there is mercy, free hors d'oeuvres.

Don Otavio is not just a travelogue. Buried inside it is a little novel, about the title character, a man on whose doorstep she and E. presented themselves with a letter of introduction, as people did in those days. Don Otavio is a ruined aristocrat, like Bedford's father. Unlike Baron von Schoenebeck, however, he has seventeen servants to look after him. Bedford describes his morning routine:

He appears on the terrace of the villa and claps his hands. *Niños,* the papayas must be picked. *Niño,* there are roses again in the water tank. Has the boat gone for the butter? Has Jesús made it up with his wife? Has Carmelita been able to do something about the spell on the tomatoes? Would she like the priest? The white turkey is not well: *niña,* the brandy flask, and a teaspoon. Is the cook herself again today? *Niñas,* there is that ibis sitting on the washing.

This pleasant life is soon threatened. Don Otavio has three brothers, all more modern-minded than he, and they decide that his beautiful eighteenth-century hacienda, which is their ancestral home, should be turned into a tourist hotel—the *Cherry Orchard* plot. I will not tell the ending. Everyone, whether or not he plans to visit Mexico, should read *A Visit to Don Otavio.* I will merely say that this is the only travel book I know of where one cries at the end.

Don Otavio was a success, and this gave Bedford the courage to try a novel again—not just a novel, actually, but one that explored the history of modern Germany. For Bedford and for all Western people of her time, the unavoidable event, the thing that changed their lives, was the consolidation of the Third Reich. In *A Legacy,*

through the weaving together of the lives of several families, her father's people and the clans they married into, Bedford traces the sources of this development, in tensions among the old Catholic nobility, the newly rich Jewish mercantile class, the nationalistic Prussians, and other groups. Thus *A Legacy* is not just a history of Germany but part of that great genre of early modern literature (*Buddenbrooks, The Man Without Qualities, The Radetzky March, The Leopard, Remembrance of Things Past*) that explains how we lost the old world and got the new one. Finally, like a number of those other books, it is a full-blown, extravagant historical novel, replete with the turreted houses and liveried footmen, the loves and betrayals and purloined letters—a murder, too—which customarily enliven that form. The von Felden family, based on the von Schoenebecks, are Catholic aristocrats from the South. They are quiet and stuck in their ways, the narrator says:

> I learnt that . . . they had dined at exactly one hour after sunset and that my grandfather (or was it *his* father?) explained this to his guests as a custom of the Romans; I learnt that Julius and his brothers rode out any old how but were kept to be most particular about their dress when driving, that the boys were always given brandy and hot water when they came in from skating in the winter dusk, and that Johannes the third son had danced with a bear at a fair.

Then, there are the Merzes, rich Berlin Jews based on the family of Maximillian's first wife, who is called Melanie in the novel. The Merzes go nowhere and see no one and are perfectly happy. Their household is filled with wastrel sons and poor relations. Their butler has been with them for fifty-five years. Not just at dinner but many times a day, they eat vast meals. When their daughter-in-law Sarah comes by to tell them something important, "she sat almost silent through the cream of chicken, the crayfish in aspic, the vol-au-vent, the calf's tongue and currants in Madeira, the chartreuse of pigeon and the mousseline of artichokes." Only after the Nesselrode pudding does she deliver her message: Julius von Felden (based on Maximillian) thinks it necessary for

Melanie, his intended, to share his religion. The parents are aghast, but Melanie is willing, and she sneaks out one night with her maid to do the job. But, thinking that all goys are the same, she gets herself baptized by a Protestant minister, and the whole thing has to be redone. This is Bedford's accustomed comedy—decent people, bumbling around, as in *Don Otavio*—but serious events flow from it. Accordingly, *A Legacy* is not as elastic in its structure as *Don Otavio*. Still, there are the bright rushes of talk, the fast, vivid stories of how things were. I don't know of any novel about the early twentieth century that feels more real, as if you could reach out and touch the things in it. And as in *Don Otavio*, there is the constant underflow of kindness. Life is tough; still, if you are a boy who has come in from skating or a turkey who is not feeling well, you get a shot of brandy. In 1976, Ecco Press reissued *A Legacy* as part of a series called "Neglected Books of the Twentieth Century." The Ecco people were right, and thirty years later they still are.

HAVING finished *A Legacy,* Bedford abandoned novel-writing for a number of years, turning instead to travel articles and court reporting. In 1961, she brought out a superb book, *The Faces of Justice,* comparing the judicial systems of England, Germany, Austria, Switzerland, and France. (This volume has been used in university courses on comparative law.) Later in the sixties, she returned to fiction and wrote *A Favorite of the Gods* and *A Compass Error,* which are interesting primarily for their study of mother-daughter relationships, that matter which was still eating her liver. In 1973, she published a biography of Aldous Huxley and then fell virtually silent for sixteen years.

The Huxley biography, 781 pages of the great man's lucubrations and eye disorders, may have worn her out. Likewise the death of her longtime companion, the American novelist Eda Lord, who, as we learn in a few tight-lipped paragraphs in *Quicksands,* was an alcoholic and had an unhappy end. Nor should we forget what Bedford repeatedly says of herself: that she had a "great natural sloth," that she liked going on picnics better than working. We should also keep in mind that her next projected

book was about her mother. *A Legacy* ended when its narrator, age nine, arrived at the train station to meet her mother. In other words, Elizabeth's story—her brilliance, her selfishness, her drug addiction—remained to be told. It finally came out, in *Jigsaw*, which Bedford says took years to write. I suspect it was a disembowelment. After *Jigsaw*, she assembled some collections of her magazine pieces. (*Pleasures and Landscapes*, from 2003, contains eight of her travel articles. Better, though out of print, is *As It Was*, from 1990, because it includes the court-reporting articles as well.) Otherwise, Bedford seems to have written almost nothing for another sixteen years.

Now, in *Quicksands*, she goes over her childhood once again and finishes her mother's story. She worries about repeating herself. She seems embarrassed, regretful. The book breathes a spirit of real woe ("Did I indicate that I had no family, no family to fall back on?") that is missing from her earlier reminiscences. The title, *Quicksands*, says a lot. She would tell us more, she assures us, if she had time, but she is being sucked down. In fact, she is in full command of her powers. The problem with *Quicksands* is simply that it seems undermotivated. One feels that someone talked her into writing it. With few exceptions, it is only the old material, the childhood, that really glows on the page. She knows this, and tries to make up for it. She jumps back and forth in time; we hear about Kosovo, and September 11. As a result, the book is not just elastic; it is positively chaotic. That, too, she knows; she says that the book is "an amalgam of fragments," as she seems to feel her career has been. She has a fancy epistemological defense for this, but I don't think she believes it.

She should stop apologizing. If *Quicksands* is a sort of rummage sale, what of it? And if Bedford's best books, *A Visit to Don Otavio* and *A Legacy*, were also her first books, never quite equalled in fifty years of further work, that takes nothing away from them. They were not "promising"; they delivered, then and there. Some writers are like that.

The New Yorker, 2005

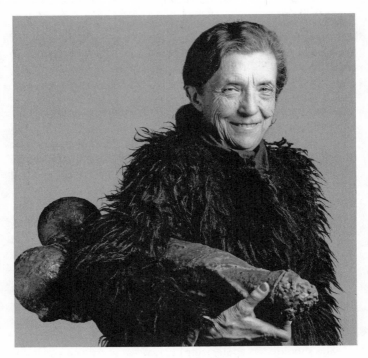

Louise Bourgeois, with Fillette, *in 1982*

The Spider's Web

THE sculptor Louise Bourgeois just turned ninety, but she still works six days a week. On Sunday she rests, because that's her assistant's day off. This leaves her at loose ends, however, so for the past thirty years she has held a Sunday salon in her brownstone on West Twentieth Street. The attendees are mostly young artists, who have come to show her their work. Last spring, I went to one of these gatherings. There were fourteen visitors, who sat on hard chairs in a small, peeling parlor. Once we had all signed release forms—to compound everyone's nervousness, the salons are videotaped—Bourgeois materialized in the doorway, a tiny woman in a pink blouse, black culottes, and black sneakers. Her hair was brushed back elegantly, and she wore gold hoop earrings. The art critic Paulo Herkenhoff helped her into a chair behind a table facing us, and from there, atop a wooden box and a pillow, to raise her high enough for us to see her, she presided for the next four and a half hours.

Bourgeois is not a dear old lady. With Herkenhoff's help, she drew each artist into a discussion of what he or she was doing. Usually she made an encouraging comment, but not always. One man showed her a series of Keith Haring–esque drawings he had made. "But it is silly, faux-naïf," she said. The man tried to explain. Finally, Herkenhoff asked her if she wanted to see more from this portfolio. "No," she answered. "I am through, I am through." People have been known to exit Bourgeois's salon in tears, but if you can take it the dynamics are interesting. The critic Amei Wallach has described a session in which Bourgeois, while modeling a piece of clay, talked about the difference between painting and sculpture:

> When you go from painting to this, it means you have an aggressive thought. You want to twist the neck of a person. . . . I became a sculptor because it allowed me to express—this is terribly, terribly important—it allowed me to express what I was embarrassed to express before.

Then she wrung the neck of the figure she was creating.

Bourgeois is one of the few surviving artists of the early modernist period. By rights she should be thinking about mass or space or something like that. In any case, she should have been spared the violent catharsis, the discharge of terror and wrath, being enacted by female artists today. But this drama is a daily event for her. She has crushing anxiety attacks. "That happens to me four times a day," she has written. And it has been happening for as long as she can remember.

Fear is the main theme of her work, but anger is a close second. "I have fantastic pleasure in breaking everything," she has said. Once, during an interview, she threw a ceramic vase onto the floor and stomped on its fragments. But mostly the violence is in the work. In one celebrated piece, a six-foot marble statue called *She-Fox* (1985), the animal has been decapitated, and there is a big gash in its throat. At the base of the statue, huddling behind the animal's haunches, is a tiny female figure. Bourgeois has explained that the she-fox is her mother and the little supplicant is herself: "I cut her head off. I slit her throat. Still, I expect her to like me."

Bourgeois has not failed to notice that her psychological difficulties may have something to do with her sex. "Women are losers," she has said. "They are beggars, in spite of women's lib." She has protested this fate. Probably her best-known sculpture, because Robert Mapplethorpe photographed her holding it, is *Fillette* (1968), a latex figure of what is unavoidably an erect penis, about two feet long, with a pair of testicles to scale. Bourgeois recalls that when Mapplethorpe asked to photograph her she was afraid; she knew that his work was about men, with big penises. So she brought *her* penis, *Fillette*, carrying it jauntily under her arm, like an Hermès handbag. She says she feels kindly toward the male reproductive anatomy, as well she might, since she had three sons. *Fillette* is not a compliment to the male sex, however. Its very

size is comical. Furthermore, its surface looks corroded, as if it were rotting.

Bourgeois was born in 1911, her parents' third child, and third daughter. As she has said, this was a problem:

> My mother must have thought, "How am I going to keep my man, presenting him with three girls in succession?" She was not without imagination and she said, "Don't you see, this little girl, we are going to name her for you. [He was Louis.] Do you know that child is your spitting image?" And my father said, "Gee, it is true. She is very pretty and she's just like me." So this is the way I made it, you see, but . . . I was supposed to make myself forgiven for being a girl.

The word her mother used for "little girl" was probably *fillette*. Hence, I believe, the title of Bourgeois's mock-compensatory penis.

Two years after Louise's birth, her mother finally produced a son, but by then Louise was already her father's favorite—which, as she tells it, meant that he dominated her relentlessly, in order to bring her up to snuff. Her feelings about that, or some of them, can be read in a large latex-and-plaster piece, a grisly assemblage of bumps and lumps, together with assorted body parts—chicken legs, lamb shoulders—called *The Destruction of the Father* (1974). Bourgeois has described the fantasy underlying the piece:

> At the dinner table, my father would go on and on, showing off, aggrandizing himself. And the more he showed off, the smaller we felt. Suddenly, there was a terrific tension, and we grabbed him . . . and pulled him onto the table and pulled his legs and arms apart—dismembered him, right? And we were so successful in beating him up that we ate him up.

She hated him, and she loved him like crazy. When he died, in 1951, she stopped showing any new work for eleven years.

So Bourgeois, this bold modernist sculptor, a contemporary of

Henry Moore and David Smith, has all the same female troubles that the women who go on *Oprah* have. Worse, she claims that she became an artist simply in order to cope with such problems. Her art, she has written, is a form of therapy, a way of preventing herself from going out and killing someone, or herself. The audience is "bullshit, unnecessary." Jerry Gorovoy, her assistant of twenty years, confirms this. According to him, on any given morning, "she's not sitting down to make art. She's trying to get through the day, and the art is the by-product." Her art, he says, is "about what went wrong."

WHAT went wrong? Bourgeois's parents were prosperous French artisans, restorers of antique tapestries. Her father traveled, hunting up the old textiles, and ran a gallery in Paris where the family sold them. Bourgeois's mother, with a staff of about twenty-five women, repaired the tapestries. Many collectors were American, so the scenes could not be unchaste. Bourgeois has recalled how her mother "would cut out the genitalia, very delicately, with little scissors, and collect them." (Another source of *Fillette*?) The resulting gaps had to be sewn over, as did the sections of the tapestry that had disintegrated. To redraw missing parts, the firm employed a certain M. Gounod, from the Gobelin works, who came on Saturdays. But sometimes M. Gounod didn't turn up. When Bourgeois was ten, she was put to work to cover for him, and so she learned to draw.

She didn't intend to be an artist. Her passions were mathematics and philosophy. That is what she studied at the Sorbonne, after twelve years at Paris's Lycée Fénelon. Best of all, she liked solid geometry, a field, she has said, "where relations can be anticipated and are eternal." Mathematics, she says, never betrayed you. Eventually, however, she discovered that mathematics offered no certainties either: "You're told that two parallels never meet, and then you learn that in non-Euclidean geometry they can easily come together. I was deeply disappointed, and turned toward the certainties of feeling." That is, she turned to art. She spent her early twenties running from studio to studio in Paris, to study with different teachers. The one she liked best was Léger, who told

her that she was a sculptor, not a painter. To pay for her art lessons—her father refused to help—she did various odd jobs. In Léger's studio she earned her way via translation services. Her English was very good, because she and her brother had had an English nanny.

In 1936, she met an American art-history student, Robert Goldwater, and two years later she married him. Not surprisingly—two of her sons are still alive—Bourgeois has said much more about her childhood than about her adulthood, and on the subject of her marriage she has been notably silent. But from her rare, sidelong remarks about Goldwater it seems that she liked him for the same reason that she had liked mathematics: he "was a completely rational person. . . . He did not betray me. He did not betray anyone. I never saw him angry in my life. Ever." Goldwater became an important art historian. He was interested in nothing but ideas, she says, with the result that "each of us remained forever, forever, mysterious to the other." But she told me that she was always grateful to him: "I was a runaway girl, and Robert saved me." (Everything Bourgeois "told me" was said in writing. She rarely gives interviews these days. I was allowed to submit a list of questions, and she answered them by e-mail.)

Goldwater moved her to New York, and she loved the city. She missed home, though, and, like a good, guilty female, she felt she had abandoned her family. In her first solo sculpture show, in 1949, she exhibited two rooms full of slim, pole-like figures—some bronze, some wood—one with wings, one with nails driven into it, and so on. She called them *Personages,* and they looked like people, whispering to one another across the space of the gallery. Soon after that show, her father died. She went on making uprights, but now they were wild, spiralling things. It was at this time that she dropped from public view, though she did not stop working. Eventually she began using latex and plaster, creating large, gluey-looking objects that resembled mouths or genitals or the interiors they led to. In *Le Regard* (The Gaze) one peered inside a sort of giant, messy clam and saw, between folds of material, a small, round, wet-looking thing. This is an embarrassing piece. We feel we shouldn't be looking.

In her early work, Bourgeois anticipated much that others

would do later: installations, minimalism, body art. She didn't get much attention, however. This was partly her fault—at times she seemed to flee attention—but it was also owing to the boys'-club atmosphere of the postwar American art world, the world of the Abstract Expressionists, with their emphasis on virility, "action," abstraction. In comparison, her work, however abstract, seemed narrative, soft.

It was only with the challenge to modernism which arose in the sixties and seventies that people started to notice her. Most crucial was the feminist challenge. *Why* did art have to be abstract? the feminists asked. Why wasn't it about the real story, about people's lives and emotions? Like many older female artists, women who had made it in a man's world and were proud of that, Bourgeois had mixed feelings about feminism. Her biographer Robert Storr, a senior curator at the Museum of Modern Art, says that she associates feminism with victimization. Nevertheless, it was the newly energized female critics and curators of the sixties and seventies who, unafraid of rotting penises and peekaboo clams, paid her the respect she had not received before. In 1966, the art critic Lucy Lippard included her in a famous show, *Eccentric Abstraction,* that was a harbinger of postmodernism. There she stood, alongside artists such as Bruce Nauman and Eva Hesse, and though she was old enough to be their mother, she looked as young and crazy as they did.

In the late sixties, she went to Italy and began making large marble figures. The work was still abstract, but it was "symbolic abstraction" (her term), and what it symbolized was often clear. Her 1967 *Sleep II,* for example, was a great stone totem worthy of the Toltecs. At the same time, it looked very much like the head of a penis. In 1973, Goldwater died, and, as sometimes happens with women artists when they are widowed, she did not wither; she flowered. *The Destruction of the Father* was made the following year. I have wondered whether it might not have to do with Goldwater as well as with her father.

Now the world caught up with her. She was given cover stories, honorary degrees, commissions for public works. In 1982, at the urging of a young female curator, Deborah Wye, Bourgeois was accorded a retrospective at the Museum of Modern Art, the

first large retrospective that the institution had ever devoted to a woman. At the age of seventy, she became world famous.

On the occasion of the retrospective, Bourgeois did something that has affected her career ever since. Before, no matter how unbuttoned her work, she tended to give reticent interviews. In 1969, when the MOMA curator William Rubin asked her about *Sleep II,* she replied, "I am not particularly aware or interested in the erotic of my work, in spite of its supposed presence." To a journalist who dared to ask her about the *Personages,* she responded, "Do you want me to talk about my personal life? . . . I don't like to do that."

Then, with the MOMA retrospective, the lid blew off. In putting together an autobiographical slide show to accompany that exhibition—and a photo essay, based on the slide show, that was published in *Artforum*—she told a story she had never gone public with before. Her English governess, it turned out, had had other duties besides teaching the children. Sadie Gordon Richmond, who seems to have been in her late teens when she moved into the Bourgeois household, was Louis Bourgeois's live-in mistress—an arrangement that his wife tolerated for ten years. The *Artforum* piece presented charming snapshots of the Bourgeois ménage—Louise and Sadie boating, Louise and Papa hiking—accompanied by a cold, wrathful text. Sadie, Bourgeois wrote, "was engaged to teach me English. I thought she was going to like me. Instead of which she betrayed me." Her mother, too, betrayed her, used her as a pawn, a duenna for Sadie and the father. As for the father, one of the photos shows *Fillette,* the disembodied penis, looming over a flight of stairs, presumably the stairs to Sadie's bedroom. Bourgeois has described the Sadie business as formative to her work: "The motivation for the work is a negative reaction against her." Or, as she put it in the photo essay, "Every day you have to abandon your past or accept it and then if you cannot accept it you become a sculptor." Though she may have deplored the feminists' claims of victimization, here she took a page out of their book. The title of the photo essay was *Child Abuse.*

That was not the end of her newfound confessionalism. She now published her diaries, offering us, for example, a childhood

memory of seeing her older sister Henriette making love with the boy from across the street. (There was blood all over. She didn't know that Henriette had her period—she thought the boy was killing her.) When journalists asked her polite questions about form and technique, she countered with statements about life and grief. "Presumably the dangling leg relates to a difficulty in articulation," an interviewer commented about one piece, in 1988. "It is about the control of pain," she replied. "This is turning into a private conversation," he said at one juncture. "I don't mind," she answered. Standing in front of her work, she would give interviewers point-for-point explications: "The three hands are a metaphor for psychological dependency," "The transparent glass represents a sickness," etc.

In the past two decades, Bourgeois's reputation has grown and grown. In 1992, the Guggenheim inaugurated its new SoHo branch with a show entitled "From Brancusi to Bourgeois." The next year, Bourgeois was chosen to represent the United States at the Venice Biennale. When the Tate Modern opened in London, in 2000, its first exhibition was by Bourgeois. This past summer, a trio of her monumental spider sculptures was displayed in Rockefeller Plaza. Then the biggest of the spiders was shipped off to Russia and installed in front of the Hermitage, in St. Petersburg, where Bourgeois was given a three-month retrospective. Some people feel that Bourgeois, as a female artist long neglected by a male-dominated art world, and a woman with an abuse story to tell, fit a little too neatly into the politics of the eighties and nineties for us to believe that her rise to fame was due to artistic considerations alone. This is certainly true. Bourgeois made a good story. People enjoy reading about "dysfunctional families," and if the dysfunction is posited as explanatory—which in Bourgeois's case it sometimes was—so much the better. Modern art is hard to explain.

Actually, Bourgeois's childhood difficulties tell us very little. The more she talks about her traumas and fears, the less we seem to understand her bold, unfrightened work. On some of her sculptures she has inscribed a text, such as "Do you love me?" or

"Do not abandon me." These are the pieces I understand the least, because the words get in the way. The same is true of the Sadie story. As Robert Storr has protested, it has become a kind of creation myth for her work, restricting interpretations to "narrowly personal or archetypally Freudian sources." Bourgeois's closet contains other things besides skeletons. She had a solid lycée education, and she knows the history of Western art cold. She is not just a suffering female but a French classicist. In *Sleep II* the dome of the Pantheon figures as strongly as the male genitals, and if it didn't the piece wouldn't be half as interesting.

It is unlikely that Bourgeois used her childhood memories to jack up her reputation. She is the furthest thing from a publicity hound. Since the mid-nineties, she has not even attended her own openings. As for interviews, she gave them for years, but she clearly feared them, and her latter-day confessionalism, like her earlier reticence, may well have been a shield against that fear. "I tell stories to keep questions at bay," she has said. Recently, at a panel on Bourgeois at the Metropolitan Pavilion in New York, I asked why she bothered, so late, to come out with the abuse story. The artist Kiki Smith said she thought that, in telling that story, Bourgeois was not so much explaining her work as putting on a sort of drama, however factual. The editor and curator Louise Neri said the same: the story was a form of "personal theater." Many public figures come up with a persona that they show to the world. This helps them preserve their privacy. But it can also foster a certain fetishism, and that has happened with Bourgeois. People who don't know her refer to her as Louise. She is often treated as a "character," the art world's favorite naughty old lady. She has colluded in this. At her most recent show, her voice, croakily singing French children's songs—"Frère Jacques" and others—was piped into one of the rooms.

But that is play, or public relations. It is not art, and Bourgeois's art deserves its fame. After the MOMA show, she burst into a new period, creating what she has called "cells." These are installations, the size of small rooms, in which she assembles various objects that tell a kind of story. In *Cell (Choisy)* we see a replica of one of her childhood homes—it was in the town of Choisy-le-Roi—exquisitely carved in pink marble. Hanging over it is a huge

guillotine blade. With the cells, as with other pieces, Bourgeois has obligingly filled in the "facts." ("The big coat is a metaphor for the unconscious.") Again, however, her explanations seem inadequate, even intrusive. We all know these words, and use them to account for our lives. The cells are something else: hallucinations, the meat locker of the mind.

In recent years, Bourgeois has tired of autobiography. When Storr, in a 1994 interview, put to her a question about her past, she replied, "I'm not interested in that anymore." When he asked her whether the antagonism in her work was in some measure sexual, she answered, "I wouldn't admit that, but you can always propose it." This was more than a decade after she had told everyone within shouting distance that the engine of her art was anger over her governess's affair with her father. Never mind. As she wrote in 1988, in an essay on her piece *The Sail,* the work speaks for itself: "Whatever the artist says about it is like an apology, it is not necessary." (Then she went on to discuss the motivations behind *The Sail* for four pages.)

TODAY Bourgeois is less concerned with anger than with repair. This is an important subject for her, because it is what her mother did for a living, and also because there are things in her life that she would like to repair. This winter, she had a show in New York which featured a roomful of large rag dolls, hanging from the ceiling and copulating. This image goes back not just to her father and Sadie but to Henriette with the boy from across the street. But whereas Bourgeois's earlier representations of that scene were disturbing—the female figure wore a leg brace (Henriette had a bad knee)—these couples were allowed to go about their business unharmed. They were a strange sight, both toylike and grave, tender and lurid. (The male genitals were sewn on, tiny and precise.) The stitch marks running up and down their bodies made them more strange. Their skin had been pierced; we felt it. At the same time, the stitching seemed restorative. Bourgeois was bringing them together, letting them live.

The same ambivalence can be seen in the series of bronze and steel spiders that Bourgeois has been making since the early

nineties—for example, the thirty-foot-tall spider that now stands in front of the Hermitage. The figure is frightening, and when you find out its name—*Maman* (Mommy)—it is more frightening. Bourgeois told me that the spider is a positive metaphor. It is a weaver, and her mother was a weaver: "She always protected me. She was my best friend. She was a monument to me." Nevertheless, there is something peculiar going on here. Remember that in *Child Abuse* the mother also betrayed the child. And consider Bourgeois's poem "Ode to My Mother":

> It is Papa's fault
> It is Nanny's fault . . .
> Maman, who's lying? . . .
> Forgive me, Maman, who lies, who lies. . . .
> Wait for me, don't run, I'm coming.

The mother's lies, the child's desperation—and that's not the end of it. Bourgeois's giant spider is not just dangerous; she is endangered. *Maman* has an egg sac, full of white marble eggs, hanging from her nether parts, and the sac has a big dent in it, as if it had been violently punched. Down this road we can scarcely go in words. But we can accept an image, a metaphor. I have seen photographs of Russian children, in front of the Hermitage, staring up at *Maman* in wonder. They like it, presumably because it says something true.

The New Yorker, 2002

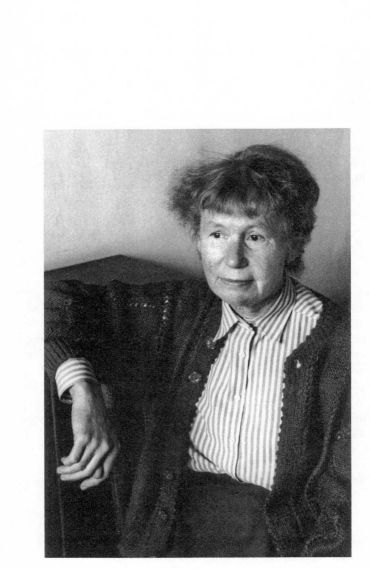

Penelope Fitzgerald, c. 1990

Assassination on a Small Scale

IN the opening scene of Penelope Fitzgerald's novel *The Beginning of Spring*, Frank Reid, an Anglo-Russian, comes home to his house in Moscow and finds that his wife, Nellie, has left him. His servant Toma hands him a letter from her and says that it was brought by a messenger. Frank asks where the messenger is. "He's gone about his business," Toma answers officiously. "He belongs to the Guild of Messengers, he's not allowed to take a rest anywhere." Born in Russia, knowing Russians, Frank proceeds down the hall to his kitchen, where he finds the messenger having tea with the cook and her assistant. They are immediately joined by the shoe-cleaning boy, the washerwoman, the maid, and Toma, all crowding into the kitchen to watch Frank open the letter. Unwilling to disappoint them, Frank reads the note, by the light of a twenty-five-watt bulb that he has installed courtesy of the Moscow Electrical Company. (The year is 1913. Frank's neighbors still have oil lamps.)

> "Elena Karlovna has gone away," he said, "and she has taken the three children with her, how long for I don't know. She hasn't told me when she will come back."
>
> The women began to cry. They must have helped Nellie to pack, and been the recipients of the winter clothes which wouldn't go into the trunks, but these were real tears, true grief.

The novel goes on pretty much this way, and so does most of Penelope Fitzgerald's work. It is the comedy of tragedy. Not only has Frank lost everything but, reticent Englishman though he is,

he has to act it out, as a drama, for the benefit of his whole big-hearted, nosy, not excessively truthful household. He is honesty, fair play, electricity, looking for a foothold in life. They are life.

"I have remained true to my deepest convictions," Fitzgerald told an interviewer in 1998. "I mean to the courage of those who are born to be defeated, the weaknesses of the strong, and the tragedy of misunderstandings and missed opportunities, which I have done my best to treat as comedy, for otherwise how can we manage to bear it?" Life, as she sees it, is an exterminating force, or for many people it is, and those people—the "exterminatees," she calls them—are her foremost comic characters. Fitzgerald's exterminatees don't get blown up by a bomb. (Actually, one does.) They just don't get anything they want, and they don't expect to. Nor, Fitzgerald says, does she. "I'm an exterminatee," she once told a journalist, "likely to be stamped out with other things unlikely to succeed."

In England today, it would take a great deal to stamp out Penel-ope Fitzgerald. She is considered a modern classic—of all British novelists "the best, possibly," A. S. Byatt (who has a stake in these matters) told Arthur Lubow in a recent piece in the *Times Magazine*. Furthermore, she achieved that status uncommonly fast and late. George Eliot, whose first novel came out when she was thirty-nine, has always been held up as the inspiration to late-starting writers, but Fitzgerald's first novel, *The Golden Child,* was published when she was sixty. That was in 1977. Her second novel, *The Bookshop,* was short-listed for the Booker Prize. Her third, *Offshore* (1979), won the prize. Writing is anguish to her, she says—torture. Yet in twenty years, from 1975 to 1995, she produced twelve books.

American publishers were slow to figure out that she was something important. Only in 1987 did her fiction start trickling into print in the United States. Eventually, she was picked up by Mariner, a division of Houghton Mifflin, and in 1997, very modestly—in paperback, in a print run of thirteen thousand—the firm brought out her most recent book, *The Blue Flower.* So far,

that edition has sold more than a hundred thousand copies. In 1998, it won the National Book Critics Circle Award, shoving aside Philip Roth and Don DeLillo, whereupon Mariner began running back and forth to the printer with Fitzgerald novels. As of last fall, with the American publication of *The Golden Child* and *At Freddie's,* all her novels are finally available in the United States. Fitzgerald is at the summit of her career, the place a first-rate novelist normally arrives at around the age of fifty. And she is eighty-three, with arthritis and nine grandchildren.

I was repeatedly warned that Fitzgerald was impossible to interview: gracious, welcoming, and utterly evasive—a stone wall. "We'll see about that," said I as, batting bugs off my interview dress, I fought my way through the clematis to Fitzgerald's door in Highgate, a pleasant old section of London. She lives in what the English call a "granny flat," a small apartment attached to her daughter's house, but, as she explains to me right away, there were no grannies here before. The house's previous owner was the playwright Arnold Wesker, and this little apartment was where he stored broken machines, "faxes and things," that he thought he might get around to fixing one day. Soon Fitzgerald is speaking to me as if she, too, were a species of malfunctioning machine.

My first question is about the curious form of her novels. They are very short (all but two are under two hundred pages), with brief scenes—illuminations, almost, as if a flashbulb were going off in the dark. "Well, right at the beginning, I wrote *The Golden Child,*" she says, "and it was supposed to be a thriller, but it wasn't really considered thrilling enough. Colin Haycraft, at Duckworth's, told me that it was too long. 'I don't think people want to read these long books,' he said. So we cut out eight chapters, and that made it rather short. Since then, I've always written them short."

I suggest to her that she must prefer them this way, for she has now written nine novels at that length.

"I suppose I have," she replies. "They ought to be longer, really. I see people in the aircraft, you know, with aircraft novels,

sort of like this." She holds up her fingers to measure about two inches, the thickness of a James Clavell novel, and looks at me ruefully, as if this were how long her books would be if she were a better novelist.

I ask about her late start as a writer. "Well, I think that everyone's got a certain amount in them that they can write about," she answers. "And they can write it early in life, or late."

I point out to her that many women writers have started late, and not by accident. It is interesting, I say, that she has never claimed that women's lot—children (she has three), low-level jobs (she had many)—prevented her from sitting down to write. "Well, I don't know as it did, really," she says. "I feel I ought to know, but I don't."

If having a family did not affect the timing of her novels, it certainly affected the novels. Fitzgerald's books are filled with children, wonderful children: outspoken, tough-minded, frighteningly precocious. Often, they state the truths their parents cannot bear to face. "Were your children like that?" I ask.

"Yes, I think so," she answers. "I think if your mother isn't very grown-up you have to be very grown-up yourself." End of subject.

Okay, how about *her* mother? I know this is a tender subject. Christina Knox, Fitzgerald's mother, died of cancer when her daughter was eighteen. ("I was just going up to Oxford University, to Somerville, which was the college that she'd been at," Fitzgerald once said. "I felt so proud to be going to the same college, then it all seemed so pointless when she was dead.") She tells me a little about her mother—that she was a suffragette and did a bit of writing herself. "It was work for publishers. For instance, I remember her doing a cut version of *Pilgrim's Progress.* But I don't know. What does one say about one's mother? I just felt she was marvelous, but she died, and, again, what can one say about that?"

In recent interviews—under, I am sure, aggressive interrogation—Fitzgerald has said that she has strong religious beliefs and feels ashamed that she has never made this altogether clear in her books. I propose to her that she can solve this problem now by explaining her religious beliefs to me. It seems to me, I say, that at times she views her characters through God's eyes. This gets a rise

out of her. "I wouldn't dare do that," she protests. "No, I wouldn't. I mean, I think that Jesus was born into the world so that we could see God's view through human eyes, so to speak. And that's easier. It's not easy, but it's possible." Well, what about the circular time in many of her novels? What about the fact that *The Beginning of Spring,* which opens with Nellie's leaving Frank, ends with her returning? In what she seems to imagine is an answer to my question, Fitzgerald points out that Nellie leaves in winter and returns in spring: "I've only been to Russia in winter, actually. Therefore, spring was about the end, as far as I'm concerned. I can't do summer, because I haven't been there in the summer."

"But you've written about a lot of things you haven't seen," I say. Indeed, she conjures whole distant worlds. *The Blue Flower,* which is based on the life of the German poet Novalis, takes place in Saxony in the 1790s, with all the historical details in place: the menus, the music, the household laundry schedule. (The wash was done three times a year.) Fitzgerald is a maniacally thorough researcher.

"Well, that's true," she replies, "but I feel that one should go to Russia in the winter, if at all, because you need snow, don't you?"

WHY do we bother to interview artists? Why expect them, in two hours, to tell us their story, or—what we're really looking for—a story that will dovetail with the work, explain it? The better the artist, the harder it is to produce such an accounting, for the life has been more fully transformed. Why violate their privacy, brush aside their years of work—the labor of creating stories that are *not* their story? The death of Fitzgerald's mother? It is there in the novels, most of all, I think, in the comedy. *Offshore,* the novel that won the Booker Prize, is about a group of marginal people living on soggy barges on Battersea Reach, on the Thames. The most endearing character is Maurice, the heroine's best friend, who lives on the boat next to hers. Maurice has tried over the years to get various jobs, but nothing ever panned out. At present, he is working as a prostitute. One night, Nenna, the heroine, comes home to find the deck of Maurice's boat weirdly illuminated:

The bright light . . . issued from an old street lamp, leaning at a crazy angle, rather suggesting an amateur production of *Tales of Hoffmann,* fitted, in place of glass, with sheets of mauve plastic, and trailing a long cable which disappeared down the companion. On the deck itself were scattered what looked like paving stones, and the leeboard winch had been somewhat garishly painted in red, white, and gold.

Maurice explains to Nenna that this is his new "Venetian corner": "I got the idea from a postcard someone sent me. Well, he sent me quite a series of postcards, and from them I was able to reconstruct a typical street corner. Not the Grand Canal, you understand, just one of the little ones." Maurice thinks maybe he will go to Venice: "I met someone the other night who made a sort of suggestion about a possible job of some kind." And if he gets the job, and puts the boat on the market, the Venetian corner, he believes, will be a selling point.

Of course, Maurice never gets a job offer from Venice. He will never see the Grand Canal, or even one of the little ones. At the end of the novel, there is a terrific storm, and Maurice's houseboat—with Maurice on it, drunk and happy—breaks its moorings and floats off toward the sea. This is a thrilling finale: giddy, hilarious, and with a kind of eschatological note, as if Maurice were sailing off to Heaven. And that, in fact, is what happened. As Fitzgerald explained to me, she lived for two years on Battersea Reach, on a barge. There she had a friend named Maurice, and he did float out to sea: "Things didn't go right with him, and he decided he wouldn't drown himself by jumping off the boat, because that would cause distress to the other boat owners, so he went down to Brighton. He took the train and went down to Brighton, and he walked out into the sea and let it close over him."

In the family that Fitzgerald was born into, in 1916, both grandfathers were bishops. Fitzgerald's father and his three brothers were prodigious children, the kind of boys who build miniature tram systems in their bedrooms and write Latin plays when they

are eight and send letters to Conan Doyle pointing out his errors of logic. (They did all this.) The baby of the family, Ronnie, when asked at the age of four what he liked to do, replied, "I think all day, and at night I think about the past."

The eldest brother, Edmund Knox—Fitzgerald's father—grew up to be the editor of *Punch*. The second, Dillwyn, became a Greek scholar and a cryptographer. (It was he who broke the German "flag code" in the First World War.) The third brother, Wilfred, was an Anglo-Catholic priest, the chaplain to Pembroke College, Cambridge, and a welfare worker in London's East End. Ronnie became Monsignor Ronald Knox, who, after Cardinal Newman, was probably modern England's most famous Roman Catholic convert. He was the Catholic chaplain to Oxford's student body and a translator of the Catholic Bible. Evelyn Waugh wrote his biography.

The years of the Knox brothers' youth were the scene of a furious battle in England—in all the West—between religion and rationalism. The scientific discoveries of the nineteenth century, notably Darwin's, had been gathered in, but how were thinking people to reconcile this new knowledge with the faith in which they had been raised? For intellectuals, there were two common solutions: either forsake religion or vault to a loftier faith, one that sought no agreement with science. The Knox brothers— for whom, as children of an Evangelical bishop, such questions were especially pressing—split those strategies between them. Wilfred and Ronald decamped from their father's low church to higher denominations. (The father never forgave Ronald for "poping," as they called it in those days. He cut him out of his will.) As for Edmund and Dillwyn, they discarded their faith, a process that was no doubt as anguishing to them as to their father. In *The Gate of Angels,* which takes place in 1912—and which Fitzgerald has said was based on her research into the Knox brothers' youth—Fred Fairly, a junior fellow in physics at Cambridge, goes home to tell his father, rector of a country village, that he no longer believes in God. He walks up the road with a heavy tread: "He would have to describe for his father, step by step, how he had expelled the comforting unseen presences which, in childhood, had spoken to him and said: Give me your hand."

Penelope Fitzgerald was shipped off from home to school at the age of seven—a separation that she says was wrenching to her. She hated school. She was a brilliant student, though, and had to be, for she needed scholarships. (The family had no money to pay for her education.) She graduated from Somerville College, Oxford, with first honors in English literature, in 1939, at the beginning of the Second World War, and in 1941 she married Desmond Fitzgerald, a major in the Irish Guards. Thereafter, for more than three decades, she had an almost ostentatiously undistinguished career. First, she worked in the Ministry of Food; then she had, as she describes it, "a very unimportant job carrying records about" at the BBC; then she edited a small literary journal, *The World Review,* in London. In 1957, the family moved to Southwold, a small coastal town in Suffolk, where Fitzgerald worked in a bookshop. Four years later, they returned to London, where they rented the barge on Battersea Reach for a pound a week—it was the cheapest housing they could find—and Fitzgerald took a job teaching at a school for child actors. In 1963, the boat sank, and the family moved into public housing.

One thing Fitzgerald declines to discuss in any detail is her marriage. She has let on that it wasn't a success, and that Desmond had a rocky work life. In one interview, she said that they never actually separated. She told me otherwise. In *Offshore,* Nenna's husband, Edward, has moved out, and she is raising the children alone. I asked Fitzgerald whether she, too, had been alone with her children on the barge, and she said yes. At one point in *Offshore,* Nenna goes to visit Edward, and he tells her, shamefacedly, that he has taken a clerical job:

"You don't have to stay there! There's plenty of jobs! Anyone can get a job anywhere!"

"I can't."

He turned his head away, and as the light caught his face at a certain angle Nenna realised in terror that he was right and that he would never get anywhere. The terror, however, was not for herself or for the children but for Edward, who might realise that what he was saying was true.

Desmond, Fitzgerald once said, "didn't have much luck in life." He was probably a model for more than one of her "exterminatees."

It was not until Desmond was dying of cancer, in the late 1970s, that Fitzgerald began her first novel. But go back earlier, to the Knox brothers. Those men wrote as they breathed: biographies, autobiographies, saints' lives, mathematical treatises, detective novels, translations of Greek poetry and of the Bible, countless newspaper and magazine columns. (Fitzgerald's father wrote a comic essay for *Punch* every week. She still remembers the sound of him pacing in his study as the printer's boy waited in the hall.) Such productivity may have been a daunting example. In any case, Fitzgerald did nothing to imitate it as long as the Knox brothers were alive. Only when the last of them, her father, was two years in his grave did she begin her first book, a life of Edward Burne-Jones. That was followed by a marvelous biography of the Knox brothers. Then Desmond began dying, and to divert him, she says, she wrote *The Golden Child,* a murder mystery—her first novel. Surely it would have been easier to go to the store and *buy* him some murder mysteries? Don't ask. At sixty, Fitzgerald became a novelist, the thing she was born to be.

AFTER *The Golden Child,* all of Fitzgerald's early novels are autobiographical. *The Bookshop* (1978) has to do with a woman working in a bookshop in a small coastal town in Suffolk. *Offshore* (1979) is the barge novel. *Human Voices* (1980) is the story of a group of young women with very unimportant jobs carrying records about at the BBC during the Second World War. *At Freddie's* (1982) takes place in a school for child actors. These books are tales of morals and manners—worthy inheritors of the Great Tradition. Small communities full of eccentrics; characters who spring to life in three strokes; conversations that tell us more than we're told—we get it all, and all renewed. The English novel is famous for its moral intelligence, but before Fitzgerald there is nothing quite like the child actors in *At Freddie's,* so innocently hypocritical, experts in emotions they do not yet have. ("All chil-

dren tell lies. But not all of them, if reproached, well up at once with unshed crystal tears, or strike their foreheads in self-reproach, like the prince in *Swan Lake*.") Nor is there anything like the damped-down sweetness with which, in the cruel world of the theatrical school, the director's secretary, Miss Blewett, comforts the institution's one genius pupil—Jonathan, nine years old—when he goes into fits of worry that he will never grow tall enough to be an actor:

> Only she could soothe his anxiety. . . . They would sit together and play a gambling game with liquorice allsorts. Miss Blewett handled the lurid sweeties with a certain air, having worked, she said, in younger days at a casino at Knocke-le-Zoute. When the game had got quietly under way, she would make kindly suggestions. Perhaps Jonathan might be auditioned for this year's *Peter Pan*.

If I am not mistaken, these early, autobiographical novels were Fitzgerald's way of explaining her past to herself, of saying to herself that her life was part of what she knew, from her long schooling in literature, as the great human tragicomedy. Had she gone on in this vein, she would have been simply a regular, excellent English novelist.

But as the novels proceed, they begin to fall apart, or come together in a new way. The scenes get shorter, and they start to contain things that we don't quite understand until those things come up again fifteen pages later. What was A-B-C becomes A-B-A, an assemblage of elements rhyming, chiming, with one another. At the same time, the books cease to end like novels, with a tying up; they end like poems, with a culminating image. The last scene of *At Freddie's*, for example, has to do with Jonathan, the genius child. Jonathan has finally landed an important role, in *King John*, where, as Prince Arthur, he must jump off a wall to his death. He is determined to do the jump exactly right, and he decides that the place to practice is a weedy little yard behind the school. It has a high wall that is perfect. He asks various grown-ups to come and critique his performance, but they are all busy

for the evening, so he goes to the yard by himself and is accidentally locked out for the night. This does not worry him:

> His object was to get so used to the jump that he could do it without thinking, and exactly the same way every time. The crates he had got hold of from the Garden [to climb to the top of the wall] were rotten . . . but by standing on the outside slats and exerting very little pressure he could manage the top of the wall quite easily. In the morning there would be someone to come and watch, and tell him whether he was right or not. Meanwhile he went on climbing and jumping, again and again and again into the darkness.

That is the end of the novel. When I read it the first time, and the second time, it seemed to me a hymn to professionalism. Yet it also had an eerie, fantastic note. This tiny child, with no food, no bed (he has no parents—he is basically a ward of the school), sailing through the night: it was like Maurice sailing off to sea. I mentioned this to Fitzgerald, and she told me that I had understood the scene better than I knew. Jonathan dies, she said. He kills himself, accidentally, leaping off the wall. But most readers didn't grasp this, she added, and that was her fault. She knew after she wrote it that the ending was ambiguous: "I tried making it clearer, but that seemed to spoil it, so I left it. To that extent the book's a failure." The book is not a failure—it's a small masterpiece—but clearly, as Fitzgerald was finishing it, something dark was brewing in her mind. If, with Maurice, she altered the facts and created a brilliant comic ending, with Jonathan she was not able to alter the facts, or to face them full-on.

With her next book, *Charlotte Mew and Her Friends* (1984), she no longer turned her eyes away. *Charlotte Mew* marks a break in Fitzgerald's career. For one thing, it is a biography, a form she had left behind when she started writing fiction. More than that, it is an almost unrelievedly tragic story. Charlotte Mew, little remembered today, was an English poet of the Georgian period. She started out as a turn-of-the-century New Woman, but every-

thing went wrong for her. She wrote only a few dozen poems, meanwhile suffering poverty, depressions, failed loves (she was a lesbian, and was punished for it), together with lacerating guilt over what little success and happiness she *did* have, in comparison with the rest of her family. Three of her siblings died in childhood; two became schizophrenic. All Mew had left was one dearly loved sister, Anne, with whom she lived. Soon after Anne died (horribly, of liver cancer), Mew went out, bought a bottle of Lysol—"It has a violent corrosive action," Fitzgerald writes, "and was the cheapest poison available"—and came home and drank it. By the time the doctor arrived, she was foaming at the mouth. "Don't keep me, let me go," she said, and died.

Writing *Charlotte Mew* seems to have had a violent corrosive effect on Fitzgerald's imagination. After that book, she ceased writing regular English novels. She renounced autobiography; she abandoned home territory. Of her four late novels, only one, *The Gate of Angels,* is set in England. *Innocence* takes place in Florence. *The Blue Flower* is set in eighteenth-century Saxony, *The Beginning of Spring* in pre-Revolutionary Russia. This change seems to have released Fitzgerald into some new emotional territory. Suddenly, in the late novels, there are scenes not just of defeat but of actual horror. In *The Beginning of Spring,* a bear cub, brought in to perform at a party, is set on fire. We hear him screaming, like a child. In *The Blue Flower,* Novalis's fiancée—fourteen-year-old Sophie, who has tuberculosis—is operated on without anesthesia. We watch the surgeon raise the knife over her small, unprotesting belly.

There is something else new in the later books: scenes of spiritual transport. Novalis has vision after vision; wherever he looks, world becomes soul. And it is not just Romantic poets who see from a high peak. Daisy Saunders, the heroine of *The Gate of Angels,* works as a probationer, or student nurse, in the men's ward at Blackfriars Hospital in London. Here is how the day begins at Blackfriars:

> When the whole of the men's ward had been persuaded
> to face the morning, the patients washed, wounds
> dressed . . . the abdominal cases on their backs, the

apoplectics on their face, the fractured skulls on their sides . . . and the bed-covers all smooth, all white, all blameless, all blank, all clean, there was a moment of balance and harmony, scarcely real, when nurses and probationers knew themselves as artists. Then a dark group, a black patch, began to move up the white rows that gave the hard-won illusion of peace, and at one bed or another, indicated by Matron, the consulting surgeon, with his train of students, paused. The white bed then became a place of anxiety and pain, or the memory of pain, or the expectation of it. When surgeon, Matron and students moved on, the probationers, at a respectful distance, straightened the sheets, the pillows and the coverlet and settled the patient, who had not only been frightened but was now suffering from the loss of his only few minutes of importance in the men's ward of the Blackfriars, and, perhaps, on this earth.

We are gazing from on high. And much in the late novels sounds as though it had been written from on high—or, at least, not in a granny flat in Highgate. If in her early novels Fitzgerald began to take liberties, now she is freed altogether. Time becomes elastic. Some chapters end almost as soon as they've begun. On the other hand, if Fitzgerald wants to take the space to include the table of contents of a late-eighteenth-century treatise on salt mining (Novalis was studying to be a salt-mine inspector), she does so. She lets her characters break into her narration; she accomplishes whole scenes in fragments. What was once Great Tradition writing is now licked by a Joycean flame. The old way is not abandoned. The books still have stories, told by an omniscient narrator. Above all, they still have the burning moral focus of the nineteenth-century novel. But they apply it on the run, in flashes—illuminations, then darkness again. They are cut versions of *Pilgrim's Progress,* as it were.

THE most daring of them is *The Blue Flower.* This is really a very strange novel. (Amazing, that it has sold a hundred thousand

copies.) Its subject, to begin with, is bizarre: the story of Novalis's love for Sophie, a little girl with a double chin and nothing in her head. He falls in love with her at first sight, when he is twenty-two and she is twelve. It takes her a year to learn how to pronounce his name. He discourses to her of the soul, and asks her if, after death, she would like to be reborn. Yes, she says, if she could come back blond. On the surface, the narration proceeds in a regular way. This happens, and that, to this person and that. But in its depth, in its tone, something else is going on, some brooding. Looking back on the novel, one feels almost as if the events had all happened simultaneously, and all the characters were refractions of Novalis. "Sophie be my guardian spirit": these are the words inscribed in the ring Novalis gives Sophie, and in some measure she is his spirit. He also has a dark angel, his little brother Bernhard. At the beginning of the novel, he rescues Bernhard from drowning in the river near their home. At the end of the novel, Bernhard drowns in that same river. A few months later, Novalis, too, is dead—he died at twenty-nine—soon followed by a number of his other siblings. (Novalis's mother outlived ten of her eleven children.) This is not to speak of Sophie's long agony. Yet Fitzgerald's touch remains light, lyrical. To pinpoint the exact quality of *The Blue Flower* is extremely difficult. It is one of the most poetic novels ever written. Fitzgerald has said that the idea for the book came to her from music. Once, during a church service in Bonn, she heard some musical settings of Novalis's poems, his *Hymns to the Night,* and she began to look into his life.

Not all of her late novels are so weird and exalted. *Innocence* and *The Beginning of Spring* are about you and me. They are very funny books and, with *Offshore,* her best "reads." Still, they make no bones about the fact that life, for most people, is basically a disaster. In *The Gate of Angels,* Fred Fairly, as he is walking home to tell his father that he no longer believes in God, hears a kind of bustle in the hedges by the side of the road:

> The bushes . . . were motionless, but from the crowded stalks and the dense hedges there came a perpetual furtive humming, whining and rustling which suggested an alarming amount of activity out of sight. Twigs snapped

and dropped from above, sticky threads drifted across from nowhere, there seemed to be something like an assassination, on a small scale, taking place in the tranquil heart of summer.

That's life in a Fitzgerald novel: assassination on a small scale. And what does it mean? Well, says Nenna's sister in *Offshore,* her husband has a theory: "He believes there's a Providence not so far away from us, really just above our heads if we could see it, that wants things to be the way they're eventually going." Don't laugh—Fitzgerald believes the same thing. She combines an old-world faith with a completely modern pessimism.

In *The Blue Flower,* immediately after the ghastly episode of Sophie's operation, Novalis and his family journey to their moldering country estate, overrun by damp and chickens. The scene of their arrival is almost not a scene but an emotion. "There was . . . a diffused sense, in that misty valley, of relaxation, of perpetual forgiveness, of coming home after having done one's best." Novalis's father embraces the old caretaker. "We have suffered," he says. The caretaker answers, "I know it, Excellency." A pearly dusk encloses them.

Here Fitzgerald hits the elegiac note. That is one way (in literature, in church) to kill pain: blend it with kindness. But what is interesting about Fitzgerald is that ordinarily she withholds that balm. She has the ingredients—cruelty, comedy, pity ("Give me your hand")—but, for the most part, she refuses to blend them. They remain separate, and go on making their opposing claims. At the end of *Innocence,* a distraught man on a farm outside Florence takes a shotgun and threatens to kill himself. An attendant dog, thinking it's time to go hunting, begins wagging her tail. In a boarding house in Jena, Novalis's Sophie is leaking pus from her third futile operation; in a nearby inn Novalis's little brother, Bernhard—the one who will drown—is inspecting the hydraulics of the hostelry's coffee urn, and his sister fails to remember the name of Dietmahler, the surgeon's assistant, who is in love with her. Dietmahler thereupon decides to give up and move to England. He used to know a Dr. Brown in England. Dr. Brown is dead, but his two sons are practicing in London. Maybe they

could get him a job. Up the street, Sophie is dying, but Dietmahler has his problems, too. Should he take his mother to England, he wonders, or should he leave her in Germany and just send money? The world is tragic, but none of its creatures ever seem to get the message. They just go on trying to make their way.

Terrifying in their meaning, these novels are still comedies, and that is the secret of their power. Reading them is like hearing someone play Mozart two rooms away: light, sweet—jolly, even—and utterly piercing. You don't know what hit you.

The New Yorker, 2000

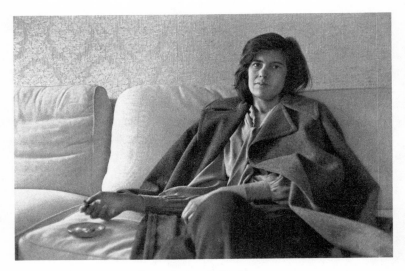

Susan Sontag in Paris, 1972

The Hunger Artist

SUSAN Sontag did two big things last year. She finished a novel, *In America,* and she underwent treatment for cancer. On a recent evening I said to her, "This is now your second novel in eight years, but it wasn't novels you were known for—it was essays. Don't you miss the essay form?" She answered something like "Essays! Pooh! Forget essays! That was the past. From now on, I'm writing fiction. I have a whole new life. It's going to be terrific." And she began charting for me her happy future. This was a person who that same morning, as she told me, had been scanned in every inch of her body for cancer. (Not for the first time. Her struggle with cancer began in the late seventies.) Furthermore, as a result of chemotherapy—specifically, a drug called cisplatin, with a platinum base—she has heavy-metal poisoning. For months last year, she was in terrible pain—she lived on morphine derivatives, meanwhile trying to finish the book—and couldn't walk without help. Now she can walk, but her balance is still uncertain. "I don't know where my feet are unless I look at them," she told me. Every day she spends three hours in physical therapy.

Also on her daily schedule, however, are piano lessons. At the age of sixty-seven, she has started studying piano. Sontag has huge reserves of hope. Or maybe hope is the wrong word—too psychological. The quality seems physical. In "Pilgrimage," an autobiographical piece she wrote in 1987, she describes the patio barbecues of her childhood: "I ate and ate. . . . I was always hungry." When, as a young graduate student, she was trying to figure out what she would do for a living, she decided to become a writer because, as she later told Edward Hirsch for the *Paris Review,* "What I really wanted was every kind of life, and the writer's life

seemed the most inclusive." A quality she repeatedly praises in the subjects of her essays is avidity: Jean-Luc Godard's need to cram into his films everything passing through his brain; Elias Canetti's deciding when he was sixteen that he would learn "everything," and pretty much succeeding; Walter Benjamin's endless book collecting. She, too, is a collector, both of subjects—she has written on literature, film, opera, drama, dance, painting, photography, politics, illness—and within subjects. Reading her *Illness as Metaphor,* a book only eighty-seven pages long, I started keeping a list of the sources she brought to bear on her argument. After Choderlos de Laclos, Schopenhauer, Kant, Rousseau, Blake, Lermontov, Sartre, Camus, Katherine Mansfield, Middleton Murry, Baudelaire (a note he wrote for an unfinished book), Frank Lloyd Wright, Gramsci, Marinetti, Osip Mandelstam, Plato, Artaud, Machiavelli, Edmund Burke, Trotsky, Solzhenitsyn, Hitler, Neal Ascherson, John Adams, John Dean, St. Jerome, Novalis, Alice James, Henry James, Wilhelm Reich, Kafka, Wycliffe, Dickens, Harriet Beecher Stowe, Thomas Mann, Ingmar Bergman, Thomas Wolfe, Friedrich von Schlegel, Oliver Goldsmith, Saint-Saëns, the Goncourt brothers, Victor Hugo, Boccaccio, Homer, Sophocles, and various science-fiction movies, I stopped. When an interviewer commented that she must have done a lot of research for that book, she answered that she had done no research. She'd read a lot in her life, she said, and "I remember what I read." More than anything else, Sontag is hungry.

When *The Volcano Lover* was published, in 1992, many people thought it was her first novel. It wasn't. In the sixties she wrote two novels, *The Benefactor* and *Death Kit. The Benefactor* is the story of a man pondering his dreams. *Death Kit* is a long hallucination occurring in the brain of a man who has taken an overdose of sleeping pills. Both books, then, were studies of consciousness. The world had little place in them. In keeping with the aesthetics of the sixties and, above all, with the so-called New Novel that the French were producing at that time, Sontag was trying to write antirealistic, anti-nineteenth-century fiction. "*Vanity Fair* and *Buddenbrooks,* when I reread them recently . . . made me wince," she wrote in 1963. "I could not stand the omnipotent author

showing me that's how life is, making me compassionate and tear-ful." Art was not life; it was *form,* life transfigured by conscious-ness—a process that, of necessity, made art difficult, reflexive, self-questioning. So in her novels she left out life and put in con-sciousness and was difficult and self-questioning, and the results were not very interesting, a fact that was not lost on her. "I didn't like what I wrote that much," she said to me. "That's why I stopped." In the meantime, she had begun publishing essays, and though she went on thinking of herself as a fiction writer—"I consider my novels much more important," she said in 1969 when an NBC interviewer asked her about her essays—she threw her-self into critical writing, concentrating on the sort of New Wave, shattered-consciousness art that she herself had tried to produce. By the time of the publication of her first essay collection, the 1966 *Against Interpretation,* with its famous title essay and its more famous "Notes on 'Camp' "—plus pieces on Lévi-Strauss, Simone Weil, Georg Lukács, Godard, "happenings"—she was a celebrity, a subject of articles in *Time* and *Vogue,* a person whom NBC wanted to interview.

As is always the case, this publicity explosion involved consider-able foolishness. As always, it compromised its subject. (Sontag, who despises television—"It's the death of Western civilization"—did not decline to go on TV.) And so, as always, the new star had to suffer some sneering from her colleagues. Reviewing *Against Interpretation* in the *Times Book Review,* Benjamin DeMott said that the book left him with the haunting image of "a lady of intel-ligence and apparent beauty hastening along city streets at the vio-let hour, nervous, knowing, strained, excruciated (as she says) by self-consciousness, bound for the incomprehensible cinema, or for the concert hall where non-music is non-played, or for the loft where cherry bombs explode in her face." Note the remark on her beauty. Sontag was indeed beautiful, and since she is a woman, this contributed both to her fame and to the scorn it elicited.

The snide remarks didn't stop her. She was a natural star, extroverted, glamorous, photogenic. Eventually, she took to wear-ing her black hair with a white streak in it, like Diaghilev. (*Satur-*

day Night Live soon had a matching wig for its Sontag sendups.) She gave interviewers her thoughts not just on the arts, all the arts, but on politics, culture, history, you name it. She was outspoken, combative—a public figure—and she looked to be having a good time. This was not the American picture of braininess (we favor the professorial) but the French model, and a number of American intellectuals had a problem with that.

But *Against Interpretation* was a brilliant book, a landmark in the history of American criticism. Not only did it serve what should be an essential function of criticism, that of introducing readers to new work, strange work, things they wouldn't ordinarily encounter—a duty no major critic had undertaken consistently since Edmund Wilson quit regular reviewing in the late forties—but, like Wilson's writings, it did so in a notably unstrange manner. Thoroughly trained in literature and philosophy, Sontag applied the standards of the past—truth, beauty, transcendence, spirituality—to the new art of the sixties, with its alienation, extremity, perversity. She talked like Matthew Arnold about things like Jack Smith's *Flaming Creatures,* a film that was closed down by the police. Thus, whatever the new art's break with history (and she proclaimed the break), she made it seem a continuation of history, something that readers could understand, even sympathize with.

And the book was ambitious. Sontag asked what art was, what its use was, why we cared about it. She used the new art as a platform on which, it seemed, she invited us to live a bigger life, with new emotions, new thoughts, a new candor. (She talked very straight: "The two pioneering forces of modern sensibility are Jewish moral seriousness and homosexual aestheticism and irony.") And the writing was marvelous—high-toned, Brahmin, but full of zest and the pleasure of performing. Her openers were always thrown down with a great flourish. Here are the sentences with which she began the essay on Simone Weil:

> The culture-heroes of our liberal bourgeois civilization are
> anti-liberal and anti-bourgeois; they are writers who are
> repetitive, obsessive, and impolite, who impress by force—
> not simply by their tone of personal authority and by their

intellectual ardor, but by the sense of acute personal and intellectual extremity. The bigots, the hysterics, the destroyers of the self—these are the writers who bear witness to the fearful polite time in which we live.

Well, maybe yes and maybe no, but she made it fun to think about. Add to this that the essays were short and easy to read. No wonder she was a hit.

In the years that followed, she brought out more essay collections, among them *Styles of Radical Will* (1969) and *Under the Sign of Saturn* (1980). Her pieces became longer, meditations on whole careers: Artaud's, Roland Barthes's, Walter Benjamin's, Elias Canetti's. Yet, as those names suggest, her concerns remained the same, mind versus reality, formalism versus realism, modern consciousness pressing against the walls of language. In 1977 she published *On Photography*, an expression of very mixed feelings about that art. (The book was a best-seller.) She followed this up in 1978 with *Illness as Metaphor*, written as she underwent her first bout with cancer, and then, in 1989, with a sequel, *AIDS and Its Metaphors*.

BUT in this post–*Against Interpretation* period one senses a restlessness in her. In the sixties and early seventies, she put a lot of time into the antiwar movement. She also went off and made films—a displacement, I believe, of the fiction-writing impulse. Nor did she always displace it. She wrote a number of short stories. In the eighties she started and then abandoned two novels, one about a dancer, the other about a Russian poet (based on her friend Joseph Brodsky) coming to the United States. She still thought of herself as a novelist.

Looking back now, one seems to see the novelist pacing around inside the essayist. The underlying argument of much of Sontag's criticism is a call for the replacement of realism by a more transforming technique. Yet a recurrent theme of her writing—a point she keeps returning to, like something personal—is the defense of reality *against* transformation. We hear about this first in the title essay of *Against Interpretation*. There the reality she is

defending is the work of art, obscured (and boy, was it) by Freudian and Marxist critics who were constantly looking past it to what they had decided it really meant. To quote the well-known last line of that piece, "In place of a hermeneutics we need an erotics of art": we need to see art, smell it, feel it, take it for what it concretely is. By the time of *On Photography,* the reality she is trying to protect is the world itself, our reactions to which are being dulled, she warns, by its constant conversion into the flat, glossy, comestible products of photography. In the following year comes *Illness as Metaphor,* where the thing she is restoring to its realness is disease, specifically tuberculosis, which her father died from, and cancer, which at that moment she was close to dying from. In the book she did not mention her own condition. Whatever she felt was fed back into her argument, a brief, violent conflagration at the end of which any idea that illness is a mark of ennoblement or of shame—something that the victim caused or, by virtue of personality, was doomed to—lies like a burnt cinder at the bottom of Sontag's rhetorical furnace. Illness is just illness, she says. Reality is just reality. Or not "just." Reality is interesting, powerful, a matter to which we should have strong, unmediated reactions. So said this antirealist.

And there is something else. A curious trait of Sontag's critical writing is that, for all its polemical thrust, it often contains opposing views. The realism/antirealism dance is one example. That occurs between essays. But even within essays she swerves and pivots, dips down and comes up somewhere else. A number of people have noticed her tendency to disagree with herself, and asked her about it—for example, Wendy Lesser, for a 1981 interview in *The Threepenny Review.* (This interview, together with many others, appears in Leland Poague's 1995 collection *Conversations with Susan Sontag.*) Yes, Sontag answered, and that's because she was always thinking, "*This,* yes. But also *that.*" To her, it didn't seem like disagreement, but "more like turning a prism—to see something from another point of view." This is not fundamentally the method of criticism. It is the method of the novel.

In 1992, a decade or so after that interview, Sontag produced *The Volcano Lover,* her first novel in twenty-five years. It made the best-seller list, as well it might have, for it was not only wonderful

but in many ways quite traditional. She who had said in 1963 that she couldn't abide the nineteenth-century omnipotent narrator, "showing me that's how life is, making me compassionate and tearful," gave us a wholly omnipotent narrator, a real bully, making us compassionate and tearful. She who had recoiled from the novel's sweaty realism—its loves, its wars, its teeming backdrops—gave us the famous love story of Emma Hamilton and Horatio Nelson, set in Naples, teeming as never before, in the time of the Napoleonic wars. The opposing voices of the essays now found their freedom in fiction, in a long list of characters with different points of view. The loyalty to reality, to the concrete facts of experience, exploded like a delayed reaction. At one point, the novel's hero—Sir William Hamilton, Emma's cuckolded husband—imagines a marble goddess in a garden coming to life. The first sense that is restored to her is smell:

> She smells the sycamores and poplar trees, resinous, acrid, she can smell the tiny shit of worms, she smells the polish on soldiers' boots, and roasted chestnuts, and bacon burning, she can smell the wisteria and heliotrope and lemon trees, she can smell the rank odor of deer and wild boar fleeing the royal hounds and the three thousand beaters in the King's employ, the effusions of a couple copulating in the nearby bushes, the sweet smell of the freshly cut lawn, the smoke from the chimneys of the palace, from far away the fat King on the privy, she can even smell the rainlashed erosion of the marble of which she is made, the odor of death.

This is more smells than have ever been smelled by anyone, let alone a streak-haired habitué of the far climes of modernist cerebration. "I thought I was a ruminator," Sontag said to me. "I thought I was a student. I thought I was a teacher. And then I discovered that I liked to tell stories and make people cry."

SUSAN Rosenblatt was born in 1933 in New York City. Her mother remained in New York only briefly. Mildred and Jack

Rosenblatt lived in China, in Tientsin, where Jack was a fur trader. Mildred soon returned to Tientsin, leaving Susan—and, later, her younger sister, Judith—in the care of an Irish-American nanny, Rosie. Rosie and the girls stayed with relatives. The parents came home for only a few months a year. Of her father Susan has a few "snapshot memories": "I remember him folding what seemed to be an enormous handkerchief, the size of a tablecloth, and putting it in his breast pocket. I can remember looking up at this giant and thinking it was the most amazing thing in the world to be able to fold that handkerchief, and make it do all those things, and it ended up this little, small thing, and you stuck it in your pocket!" When she was five, her mother came back from China alone, saying that the father would be arriving soon. Four months passed; he didn't come. "Then, one day, I was home from school on a lunch break, and my mother took me into the living room and said, 'I have something to tell you.' " Her father had died of tuberculosis. Mildred, when she returned, had brought his body back with her. Given this information, Susan was sent back to school. Lunch break was over.

The family now moved repeatedly, first to New Jersey, then to Florida, then to Tucson, where they lived in a four-room bungalow on a dirt road. Mildred was gone much of the time. "I think she had boyfriends," Sontag says. Then, when Susan was twelve, Mildred got married again, to Captain Nathan Sontag, an Army Air Corps pilot, and she asked the girls to take Captain Sontag's name—which, Sontag says, she was perfectly willing to do. "I didn't enjoy being called a dirty kike, and I had been."

Sontag has described her childhood as "a long prison sentence." She hated being a child, was embarrassed by it, and she has no memory of any of childhood's fabled satisfactions. Her mother she recalls as "very laconic and very withholding." (She was an alcoholic, as Susan found out many years later, from Judith.) Captain Sontag told Susan that if she didn't stop reading books she would never get married. "I ground my teeth, I twirled my hair, I gnawed at my nails," she later wrote. Then there is the other side of the story: those books that she read, her discovery of art. In a stationery store in Tucson she had discovered the Modern Library series, and started reading the classics. Los Angeles—the

family moved there when she was thirteen—had a thriving musi-
cal culture (Stravinsky and Schoenberg had settled there), and she
found friends who drew her into it. At a magazine stand off
Hollywood Boulevard she discovered *Partisan Review*. At home,
she says, "nothing interesting was ever discussed. They were just
talking drivel, all the time." Likewise in her school, North Holly-
wood High: "I remember sophomore English. My teacher, she
must have been on something. She used to take her shoes off
under the desk, and she would knit. She had us write précis of
articles in the *Reader's Digest*." But none of that mattered. Sontag
lived in the fire in her brain. She read Kant, Nietzsche, Dosto-
evsky, Kafka, Thomas Mann. When she read *The Magic Moun-
tain*, she says, and got to the part where Hans Castorp and
Clavdia Chauchat speak in French, she bought a French-English
dictionary and looked up each word of their conversation. When
she finished the novel, she refused to be parted from it. She went
back to the beginning and reread it aloud, a chapter a night.
Sports she hated. As for boyfriends, she had some, but aesthetic
preoccupations seem to have been uppermost in her mind. In the
autobiographical "Pilgrimage" she described herself sitting in a car
with her friend Merrill (a boy) on upper Mulholland Drive, a
popular lovers' lane. Amid the rocking chassis, she and Merrill
"quizzed each other's memory of Köchel listings. . . . We debated
the merits of the Busch and the Budapest Quartets." Then they
went home.

Sontag's transition into adulthood was violently swift, as if she
just wanted to get it over with. At fifteen, she entered college; at
seventeen, she married; at nineteen, she had a child. In her second
year at the University of Chicago, she met a sociology instructor,
Philip Rieff, ten years older than she, the future author of *Freud:
The Mind of a Moralist* and *The Triumph of the Therapeutic*. "The
day after I met him," she recalls, "he asked me to marry him. I
said, 'You must be joking!' He said, 'No, no, I'm absolutely seri-
ous. When I saw you last night, a voice said to me, "That is the
woman you're going to marry."' And I burst out laughing,
because no one had ever called me a woman before. And, I don't
know what happened, I just said okay." A year and a half later, she
gave birth to their son, David Rieff, who was to be another writer,

the author, recently, of *Slaughterhouse,* on the war in Bosnia (a cause in which Sontag, too, has been very heavily involved). Rosie, who had stayed with Susan till she was fourteen, returned to look after David. "That's one of the reasons David and I resemble each other so much," Sontag says. "We had the same mother." Then Philip took a job at Brandeis, and Susan started graduate school—first in English, then in philosophy—at Harvard.

"I really loved being a student," Sontag says. "I was living in an intellectual delirium." Her friends, and Philip's, were mostly people in their sixties, "German refugee intellectuals, largely Jewish." They talked about ideas. "Herbert Marcuse lived with Philip and me for a year, and we sat around endlessly discussing Hegel. David—he was maybe two—would come in and say, 'Hegel, Hegel, Hegel.' The culture I was involved in had absolutely no relation to anything contemporary. My idea of a thought about modernity was Nietzsche's thinking about modernity." Occasionally a gust of the now-and-happening blew past her face. "I remember once, I guess it was 1956. I used to go to my classes and go right home, because I had a child and a husband, and why wouldn't I go home? But this day, for some reason—maybe I had had a fight with Philip—I didn't go home. I went into the movie theater in Harvard Square. The movie that was playing was *Rock Around the Clock.* And I sat there, I was twenty-three years old, and I thought, My God! This is great! This is absolutely fantastic! After the movie I walked home very slowly. I thought, Do I tell Philip that I've seen this movie—this sort of musical about kids, and it was wonderful, and there were kids dancing in the aisles? And I thought, No, I can't tell him that."

She told him later. Or in any case she told him that she was moving out. In 1957 she was given a one-year fellowship to Oxford, and she spent the spring of 1958 in Paris. Now, for the first time in years, she had the experience of being on her own. Sontag has recorded very mixed feelings about Philip Rieff. To me she said, "He was passionate, he was bookish, he was pure. He was very, very unworldly. *I* was worldly, compared to him." In her new novel, the very Sontag-like narrator describes her former husband as Mr. Casaubon, the dry, notecard-accumulating scholar of *Middlemarch,* and herself as Dorothea, Casaubon's imprisoned wife.

Sontag and Rieff had what she describes as a Siamese-twin marriage: "We were together twenty-four hours a day, practically. He waited for me outside my classes. He wanted me to come to his classes. He followed me to the bathroom. I followed him to the bathroom." Vaulting from her bookish youth into this bookish marriage, she had skipped adolescence, and adolescence now knocked on the door. She decided she wanted to forget Hegel and have some fun. In 1959, after nine years of marriage, she divorced Rieff, packed up her child, and moved to New York.

"David grew up on coats," she says—the coats on the bed at parties. "I met Claes Oldenburg a couple of weeks after I came to New York. I started going to 'happenings,' and to these crazy movies that Jonas Mekas was putting on, and to Off Off Broadway plays, with all this Artaud. Artaud certainly came as a surprise to me! I learned to dance. I was practically thirty, and I learned to dance, and I became a dancing fool." New York wasn't all. In the early sixties she started spending her summers in Paris. "I went to the movies three times a day. I went to bars, I took drugs, I had a romance." In time she broadened her horizons. This summer Norton will publish *Susan Sontag: The Making of an Icon,* by Carl Rollyson, an English professor at Baruch College, and Lisa Paddock. According to their agent, the book will address the "open secret" of Sontag's "love of women," together with "the strategies behind her meteoric rise to fame." I don't know about the strategies, but as for Sontag's relationships with women, she says, "That I have had girlfriends as well as boyfriends is—what? Is something I guess I never thought I was supposed to have to say, since it seems to me the most natural thing in the world."

In those heady times in the sixties, she both lost her head and kept her head. Today, she stresses the latter. "It felt a little bit like slumming, like doing something that was good for me—to get to know what the world was about—but that obviously I was going to take back to whatever I thought my real life was. Everything I did was in the nature of 'Well, I've done that, I wasn't afraid of doing that.'" It was more, though. During her Paris summers she acquired a deeper knowledge of the work of Godard, Bresson,

Genet, Lévi-Strauss, Robbe-Grillet, Nathalie Sarraute—the people she would write about in *Against Interpretation*. In the ardor of those essays one can measure the intensity of her response to the "modern," to what was, for her, the long-delayed release from classical culture. And in the coolness of the essays, in their rigor and idealism, one can read the truth that she was never wholly released, nor wanted to be. It was to these two poles—the sheer, visceral, get-me-out-of-this-graduate-school embrace of the new sensibility and the old, thoughtful, let's-analyze-this-according-to-Hegel's-three-categories-of-whatever—that the great trajectory of *Against Interpretation* was anchored.

And then there was politics. Like most young intellectuals in the sixties, Sontag was a leftist. She had no illusions about the Soviet Union, but she nourished hopes for the Communist regimes of Cuba and North Vietnam. She visited both countries and wrote about them with some reservation but considerable admiration. In a 1968 essay in *Esquire* she characterized Ho Chi Minh's North Vietnam as "a deeply civil society which places great value on gentleness and the demands of the heart" and described how the government rehabilitated prostitutes by sending them to country retreats where people read them fairy tales and played games with them to restore their faith in humanity. As for Euro-America and its history of imperialism, "The white race *is* the cancer of human history," she declared in 1966. "It is the white race and it alone . . . which eradicates autonomous civilizations wherever it spreads, which has upset the ecological balance of the planet, which now threatens the very existence of life itself."

Those sentences came back to haunt Sontag as, in the course of the seventies, with the revelation of the abuses committed by the new Communist societies, she separated herself from the far left. In 1982, at a meeting at New York's Town Hall to support Poland's Solidarity movement, she gave an impromptu speech in which she said that Communism, all Communism, was fascism and that anyone who, in the preceding decades, had wanted to know what Communism was would have had a better chance of finding out the truth from the *Reader's Digest* than from *The Nation*. That speech was greeted with fury both on the right— why had it taken her so long to wake up?—and, needless to say,

on the left, where she was regarded as a deserter, and a comforter of the enemy. "I'm still digging my way out of the rubble," she said in a 1984 interview.

Hopeful and energetic as always, she dug her way out. She moved from utopianism ("When you want to change everything, you're forced to oppress") to more modest commitments—Bosnia, human rights—and from a relativism that could forgive Communist regimes their little transitional problems to an absolutism requiring that all societies honor certain basic freedoms. She does not apologize for her change of heart. "If you ask me why didn't I understand that any alternative to cutthroat capitalism and a society based on inequality and competitiveness not only wasn't going to work but was going to turn into some horror, either of despotism or of economic catastrophe, all I can say is that lots of people didn't understand this." As for America, she seems to have made her peace with belonging to a privileged and bossy society—her point about Bosnia is that we should have intervened—and with the fact that she lives in a large penthouse in Chelsea, with excellent views, while others don't. Western intellectuals, she told an interviewer in 1978, should "accept the fact that they're part of the ruling class and use that as a basis for leading specific campaigns on real issues."

As her political hopes crumbled in the seventies, so did her hopes for the new art. In her early essays, Sontag was very much the Jacobin: a fiery reformer, laying down the law. Classical assumptions—that there was a reality we all agreed on, that language was adequate to describe it, that stories had a beginning, middle, and end—were classical, not modern. American art had to be brought up to date, converted to formalism, to style over content, and, preferably, to a style that was transgressive or in some way distancing, to mark the distance between the modern mind and the world. But, Sontag says, "it never occurred to me that all the stuff I had cherished, and all the people I had cared about in my university education, could be dethroned. All that would happen is that you would set up an annex—you know, a playhouse—in which you could study these naughty new people, who challenged

things. And you could have it all! Little did I know that the avant-garde transgressiveness of the sixties was to become absolutely institutionalized and that most of the gods of high culture would be dethroned and mocked." She is worried, of course, that she might be seen as having contributed to this. In a recent essay, "Thirty Years Later," which she wrote as the introduction to a new edition of *Against Interpretation*, she says that, if so, she was misunderstood:

> To call for an "erotics of art" did not mean to disparage the role of the critical intellect. To laud work condescended to, then, as "popular" culture did not mean to conspire in the repudiation of high culture and its burden of seriousness, of depth. When I denounced . . . certain kinds of facile moralism, it was in the name of a more alert, less complacent seriousness. What I didn't understand . . . was that seriousness itself was in the early stages of losing credibility in the culture at large. . . . Now the very idea of the serious (and of the honorable) seems quaint, "unrealistic," to most people.

We have entered a period of barbarism, she says.

Those were the outer forces—political disappointments, artistic failures—that sapped Sontag's critical ambitions. But there were inner forces, too. The leading idea of *Against Interpretation* was its call for formalism, particularly in fiction, which to her at that time seemed America's most out-of-date art form. But, she now says, what appealed to her about formalism was mostly just the *idea* of it. As for its application to the novel, the very thing she stumped for, she didn't really like the models she held up: "I thought I *liked* William Burroughs and Nathalie Sarraute and Robbe-Grillet, but I didn't. I actually didn't." In *Against Interpretation* you can sense her reservations. The most energetic essays in that book are not on fiction but on film. (The piece on Bresson is still, thirty-six years later, the best essay on him—moving, deep, judicious.) It is telling that the writers she focused on in her later criticism were not—or not primarily—novelists but thinkers: Artaud, Canetti, Barthes, Benjamin. And she went on writing

about filmmakers: Bergman, Godard, Leni Riefenstahl, Hans-Jürgen Syberberg.

Still, the idea of formalism haunted her. It seemed to her to represent, she says, "a certain fastidiousness." There was a lot of bad art around. Why was it so bad? Because, she told herself, it focused on content, not form. Eventually, however, that explanation failed her. A crucial experience, she says, was her infatuation with dance, and particularly with New York City Ballet, beginning in the sixties. "I remember, when I started going to see Balanchine's work, I thought that what I loved in it was the austerity and the purity, the nonnarrative quality. I loved *Agon,* I loved *The Four Temperaments.* Things such as *A Midsummer Night's Dream* I merely tolerated. Also, I was very influenced by Lincoln Kirstein's writing on Balanchine's work, by his screwy Gurdjieffian take on it. Ballet, Balanchine—it was discipline, order, submission, formality. And I thought, Sure, that's what I love. But you know, that wasn't what I loved. I remember, in *La Valse,* Joseph Duell putting his white-gloved hand in front of his face, and he did it in a certain way, and I used to feel *stabbed* through the heart. I would go and see *La Valse* again and again, and I would wait for that moment. I would say to myself, 'Is it going to happen again?' And it did. And what is that about? I'm not sure, but it's not about formalism. Formalism, I think, was a good ploy, a strategy for stripping away a lot of things. But it certainly isn't an account of why these experiences are so transfiguring."

Balanchine was only part of a larger conversion. In the seventies and eighties, Sontag says, she discovered in herself a need for intensity, as opposed to the deep cool of formalism. She found it not just in dance but in opera and in other things that were, as she puts it, "sort of stand-and-deliver—you know, 'I love,' 'I hate,' 'I this,' 'I that.' " Her youth, she says, had been given over to a quest for the Truth. In an uncharacteristic psychoanalytic aside, she speculates that maybe this was the result of not knowing about her father's death, of finding out that she had been barred from the truth. But no, she says, her absolutism was part of her temperament, and was encouraged by her childhood reading. "I remember when I first read Kant—I was fourteen or something—it made perfect sense to me that your behavior should be some-

thing that could be a model for everyone else. You shouldn't do anything that wasn't right." Her early essays were written in that spirit. "I was involved in an immense self-mortification," she says. "Those essays aren't just austere"—I had remarked on their austerity—"they're positively ascetic, as if I didn't trust the sensuality of my imagination. I think I was afraid of getting lost. I just wanted to support things that were good, and that would be improving to people. I wanted to be useful and valuable, and that was natural to me, because I always had a moralistic frame of mind." Now, as the passage on the garden smells shows, she is more likely to trust the sensuality of her imagination.

Such fevers are not new to her, however. If, now, her realism is powered by intensity, her didacticism was pretty intense, too, as is often the case with didacticism. Whatever the rigors of her film analyses, they were forged in passion. At the movies, she always had to sit in the third row, center. (She still does. I have been to the movies with her, and I have neck problems as a result.) "It was about having the image very, very large and overwhelming," she explains. "I wanted to be kidnapped." And when, following her formalist nose, she found something that seemed to her exciting, everyone she knew had to experience it, too. "The *things* she made us go to!" the poet Richard Howard, a longtime friend of hers, says. "That Syberberg person—*Our Hitler?* Seven hours! We called it 'Her Hitler.' " According to Howard, she always worked in a lather: "I remember her writing those essays through the night, and listening to *Elektra,* very loud, with those women *screaming.* When she was completely wrung out, she'd take a nap on the floor by the typewriter. Two hours—then she was up and at it again." She often lost weight when she was writing. She couldn't eat.

Sontag is an enthusiast. A conversation with her is what a conversation with Rousseau must have been like. Her eyes flash. She waves her arms. She has a million ideas, and feels that all of them are right. She does not know how she seems. She tells you she doesn't like to talk about herself. (This after several hours of vivacious discussion of herself.) She says she loves to be corrected, and wonders why others don't. She is very forthcoming with information on what a precocious child she was. But this is all part of the

thrilling adventure that for sixty-seven years has been going on in her brain, and she is not about to suppress details. Also, she is still a Kantian, still trying to be a model, and seeking models. Whatever essays she now writes are mostly homages, as were her earlier essays, and the qualities she praises in her subjects are often her own qualities, or ones she aspires to. In her piece on Canetti, she speaks of his tendency to write homages: "So wholehearted is Canetti's relation to the duty and pleasure of admiring others, so fastidious is his sense of the writer's vocation, that humility—and pride—make him extremely self-involved in a characteristically impersonal way. He is preoccupied with being someone *he* can admire." This is a good description of Sontag.

When she isn't reminding me of Rousseau, she reminds me of Buster Keaton. There they both go, eyes straight ahead, utterly intent on what they're trying to do—get the girl, understand Communism—and oblivious of the felled houses, the outraged constables that they leave in their wake. Sontag has a superlatively strong ego. She rarely responds to criticism. (Actually, she's one of those writers who say they don't read reviews: "I get my son to read them for me and just tell me thumbs up or thumbs down.") She is undiscourageable. Who else, upon receiving a diagnosis of cancer, would sit down and write a book on the history of attitudes to cancer, the wrongness of any attitude that tends to stigmatize the patient, the rightness of going out and getting proper medical care? She cheered herself up, and helped others, and, not incidentally, survived, just as Keaton usually got the girl.

Now she has taken the energy of mind that she once brought to ideas and applied it to fiction, to the world. If Tolstoy, as Isaiah Berlin said, went from fox to hedgehog, she is trying to do the reverse, and loving every minute of it. Her new novel, *In America,* is a historical novel, like *The Volcano Lover.* It tells the story of Maryna Zalezowska, loosely based on Helena Modjeska, the famous Polish actress who emigrated to the United States with an entourage of friends in 1876. This choice of subject left Sontag with a lot of homework to do, on life in the 1870s in Kraków, New York, San Francisco, indeed Anaheim, where Modjeska and her

companions tried to set up a utopian farming community. Sontag threw herself into the work. She read old Baedekers, crumbling newspapers, anything she could lay her hands on. When Maryna's friend Ryzsard, a novelist—he is based on Henryk Sienkiewicz, the author of *Quo Vadis*—makes the journey first, on the *Germanic,* the ship is described in close detail. ("I have a floor plan of that ship," Sontag says. "I know *everything* about it. I know that the room where they smoked was the Smoke-Room, with a capital 'S' and a capital 'R' and a hyphen in between, and not the *fumoir,* as it was later called.") When Ryzsard arrives in New York, we learn how Central Park, which opened in 1859, looked in 1876. ("Most of the trees are too young yet to give any shade," Ryzsard complains.) When Maryna lands in America, she goes to the Centennial Exposition in Philadelphia and tells us what was there: a replica of George Washington's tomb, a huge statue of Iolanthe carved in butter, and also "this instrument for hearing at great distances, the telephone." When she gets to San Francisco, we find out about the Chinese theater ("The sun emerges, followed by a dragon, the dragon tries to swallow the sun, the sun resists") and about how many pickpockets there were in the audience.

The world! Sontag loves it! She casts her mind back to the time when she was describing Maryna's first extended stay in San Francisco. She put her in the Palace Hotel—it was the most sumptuous hotel—and she pictured her going up in the elevator. "But then I had to find out if the hotel *had* elevators, because the Otis elevator had just been introduced in 1876." She found a contemporary description of the hotel, and it turned out that the Palace didn't just have elevators—they were mirrored. "I said, 'Oh my God!' I was happy for a whole day, just seeing mirrored elevators. It's like you were *manufacturing* reality, but the reality was—*real.* You were responsible to what was actually there. You weren't—I don't know—it felt like an act of benevolence to actually, truthfully, describe, in a way that would be delicious to experience, how things were." She quickly adds that none of the description is gratuitous. "I want these things constantly to be transfigured by someone's attention, by what it *means* to them." To Maryna, an actress, very aware of herself and of the impression she is making, a mirrored elevator would have a special significance: she can see

herself, and see others looking at her. So the mirror develops character. "It's not just a detail," Sontag says. Still, one feels, somehow, that the mirror is above all a detail, a piece of reality, and for Sontag a precious one, because it multiplies reality, gives back to us the women's gowns, the men's beaver hats, the whole shining world.

Not surprisingly, Sontag finds fiction easier to produce than essays. She has always been a nervous writer. "Each time I write," she says, "it's like jumping into an icy lake." The essays might go through ten or fifteen drafts: "I'd say to myself, 'Is this true?' And then I'd say, 'No, it isn't true,' and I'd tear it up and start over." But the fiction comes much faster. *On Photography,* less than two hundred pages long, took her nearly five years. *The Volcano Lover,* maybe three times as long, took two and a half years. In fiction, she says, about 80 percent of it is there in the first draft.

But, whatever Sontag's new embrace of reality, the person who wrote the essays is still in attendance, with the result that the realism of *In America* is overlaid with plenty of formalism. The narrative technique changes from chapter to chapter. At one point, we are getting the story from a diary kept by Maryna's husband, Bogdan; at another, from Maryna's letters; at another, when Maryna returns home on a visit, from a marathon quote (there is no paragraph break for eleven pages) of her conversations with her family and friends. The book ends, like *The Volcano Lover,* with a long, passionate monologue, a stand-and-deliver—and by a person who, till then, had appeared only fleetingly, Maryna's fellow-actor Edwin Booth. But that's nothing. The book begins with the narrator, who Sontag says is a fictional creation, not herself—though, curiously, she seems to have married Philip Rieff, or someone very like him, and worked in war relief in Sarajevo in the 1990s— crashing a dinner party given for Maryna in Kraków in 1875. And as in *The Volcano Lover,* the narrator repeatedly breaks into the novel, giving us her thoughts on this and that, telling us that she, like Maryna, is of Polish ancestry (as is Sontag) and that she, like Ryzsard, is a novelist, taking real-life events and turning them into a story.

So *In America* is endlessly self-aware. It is Sontag speaking, as she spoke to us all those years in the essays. Hence the book's tone,

bright, silvery, bracing—tinkling at times. We do not lose ourselves in Maryna; we hover a little above her. As a result, some people will say, as they said of *The Volcano Lover,* that Sontag is not really a novelist, that she is still an essayist. But what is wonderful about the book is exactly this counterpoint of novelist and essayist, of innocence and knowingness. From the knowingness comes another excellence of *In America,* its cat's cradle of meanings. Of the novel's main themes, one, as the title tells us, is crucial: America, something that Sontag has been writing about for a long time. Bogdan, the most thoughtful character in the book, admires the Americans' hopefulness and confidence at the same time that he is bewildered by their lack of any tragic sense. "I am bred to a distinctively Polish appreciation of the nobility of failure," he writes in his diary. Americans don't know about this, he reasons, because they don't know about history. Maryna ponders the same thing: "Absences: plush, relics, dimness, corridors, one's own history." In this country, she says, there is no nostalgia. The decline of that illness, a doctor friend of hers predicts, will give rise to a new one, "the inability to become attached to anything."

Interestingly, however, it is Maryna, so thoroughly Old World, who turns out to be the perfect antisentimentalist, eager for success and a new life. Bogdan does okay, too. He ends up not just with Maryna but with someone named Juan María as well. So the Europeans become very good Americans. And at the end of the novel it is Booth, the American—drunk, bloody-minded, haunted by his brother's murder of Lincoln—who makes the case for tragedy, and tells Maryna how shallow she is.

Nor is the one position seen as bad and the other good. Again Sontag is saying, "This, yes. But also that." And she says it the more firmly since the conflict in question subsumes the points she herself has been traveling between: content versus form, enjoyment versus "Kantianism." In the book, that personal drama becomes a universal one. Yes, we all want to be deep. We want history—plush, relics. But we also want a little hope, and a good time, and a few more years. We honor the tragic sense of life, but we'd just as soon not be tragic ourselves. The world calls us, the more so as we are reminded that we will have to leave it some day. Sontag knows she's sixty-seven, but she says she feels no different

from the way she felt at thirty, and she thinks her best writing is ahead of her. She's already planning her next novel: "It's going to be set in Japan, in the present. I want to do a novel in the present. And it's going to be short. A hundred and twenty pages, I figure. Have you been to Japan? No? I've been there maybe twelve times. Fascinating place." The eyes widen, the arms wave, and she tells me all about it.

The New Yorker, 2000

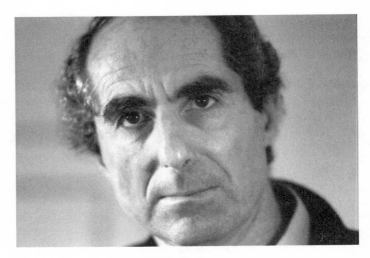

Philip Roth, 1990

Counterlives

NATHAN Zuckerman, the hero of several of Philip Roth's midcareer novels, is dogged by the notoriety of a book he wrote in 1969, *Carnovsky*, which told of a Jew reacting against his parents' first-generation respectability by chasing shiksas around town and involving them in uncanonical sex acts. *Carnovsky* was a huge hit, and everyone assumed that it was autobiographical. "Hey, you do all that stuff in that book?" the Con Edison meter reader asks Zuckerman. "You are something else, man." But the interest in the book is not just prurient. *Carnovsky* is a satire on the Jewish superego, and so it is decried by Jews and denounced by rabbis, on the ground that it will inflame anti-Semitism. A letter addressed only to "The Enemy of the Jews" is sent to the book's publisher; the mail room knows where to forward it.

Zuckerman tries to answer such charges, then tries to ignore them, then finds himself answering them again. By the time we see him in *The Anatomy Lesson*, he has been fighting the battle over *Carnovsky* for four years, and his work is at a standstill: "The endless public disputation—what a curse!" At the end of *The Anatomy Lesson*, he decides that he will give up writing and become a doctor. My son the doctor: what better atonement could you make to your parents—and, by extension, to all Jewish overseers?

I can think of one better. Imagine that you are Philip Roth, a man bearing a marked resemblance to Zuckerman. Imagine that your book *Portnoy's Complaint*, published the same year as *Carnovsky*, and treating similar matters, was the cause of a similar public reaction, with people stopping you in the street to tell you sex jokes or call you a pervert, and with public figures denouncing

you as a menace to your people. (The distinguished Israeli scholar Gershom Scholem wrote that the Jews, not the author, would pay the price for *Portnoy:* "Woe to us on that day of reckoning!") And say that, like Zuckerman, you tried to justify yourself, but at the same time dug in your heels, and that for thirty-five years—much longer than Zuckerman's agon—you went on portraying Jews who showed not only the traditionally prized Jewish traits, such as wit, brains, and moral seriousness, but also the Jewish-joke characteristics: Jews who never stop talking (a character in the 1986 *Counter-life* says that in Israel, even if you've done nothing all day, you go to bed exhausted, just from having people yell at you continually); Jews who view the world as divided between Gentiles and Jews (Portnoy's mother, Sophie, on the Gentiles: "THEY ARE ANOTHER BREED OF HUMAN BEING ENTIRELY! YOU WILL BE TORN ASUNDER!"); Jews who therefore see life as sown with peril, not just from anti-Semites (there are rugs you can trip over, convertibles you can flip over in), and who can't stop telling you to watch out. In Roth's novels, this relentless cautioning is usually done by parents. The sons, most of whom are writers, rebel, and produce comic novels about their elders. For this, guilt is heaped upon them. "Jewish morality, Jewish endurance, Jewish wisdom, Jewish families—everything is grist for your fun-machine," Zuckerman's brother says to him. If you were Philip Roth, caught up throughout your career in this quarrel, and you wanted to make peace, what could you do? Write a novel about how the Jewish parents were right all along. Produce a book about an American pogrom.

ROTH'S new novel, *The Plot Against America,* opens in 1940, and at first it seems almost a memoir. In much of his writing (not just the Zuckerman series), Roth has used details from his own life—that's why people think his work is autobiographical—but here he goes further. The book concerns a family called the Roths: father Herman, an insurance agent for Met Life; mother Bess, a housewife; older son Sandy, twelve; younger son Philip, seven. They live in a two-and-a-half-family house in the Weequahic section of Newark, where the boys attend the Chancellor Avenue School. To the extent of my knowledge, this is, point for point, the family

that Roth grew up in—the names, the city, the section of the city, the house, the school, the father's job. Later in the book, the family's phone number is given, and I'll bet that's real, too. So is the portrayal of the family's status as Jews. Though the parents in *The Plot Against America* suffered anti-Semitism when they were young, the world they now live in is secure. Most of their neighbors are Jews. They certainly see themselves as Jewish, but primarily they regard themselves as American. This was Roth's situation, too. As he once told an interviewer, he never felt threatened as a Jew when he was a child; he didn't even know that he belonged to a minority. Nonetheless, he said, he was "surrounded from birth with a *definition* of the Jew . . . as sufferer, the Jew as an object of ridicule, disgust, scorn, contempt, derision, of every heinous form of persecution and brutality." It was out of the gap between those two experiences—his sense of safety versus the constant warnings that no Jew was safe—that *Portnoy* was born, he claimed. *The Plot Against America* also comes out of that divide, but it looks very different. It is a historical novel, of a fantastic sort. In the book's first paragraph comes the statement that these events took place during the Lindbergh administration.

In 1927, Charles Lindbergh, a twenty-five-year-old stunt flier and airmail pilot from Minnesota, made the world's first nonstop transatlantic solo flight, from New York to Paris, and became an international hero. Five years later, his first child, twenty months old, was kidnapped and murdered, thus making Lindbergh not just a hero but a martyr, a saint. To escape the ensuing publicity, Lindbergh and his wife, Anne Morrow Lindbergh, a best-selling writer, moved to England in 1935. While in Europe, Lindbergh went to Germany to inspect the planes being developed there, and he became friendly with the country's new leaders. Hitler, he wrote—and this was after the promulgation of the 1935 racial laws—was "a great man." In 1938, Air Marshal Hermann Göring, "by order of der Führer," bestowed on him a medal decorated with swastikas. In 1939, Lindbergh returned to the United States and began giving heavily attended speeches in support of isolationism. The war that had broken out in Europe, he said, was Europe's problem, not ours. Certain self-interested groups were trying to push us into it—for example, the Jews, whose control

over "our press, radio, and motion pictures" was a matter of grave national concern. "We cannot allow the natural passions and prejudices of other peoples to lead our country to destruction." In other words, Jews, though they might be American citizens, were still "other peoples," foreigners.

At this moment, Franklin D. Roosevelt was preparing to run for a third term as president, a breach of tradition that many people disapproved of. Lindbergh, a Republican, was urged to run against him. In June of 1940, in Philadelphia, came the Republican Convention. This is the point at which *The Plot Against America* breaks with history. In reality, the Republicans nominated Wendell Willkie, a moderate, and, in November, he was defeated by Roosevelt. In *The Plot,* the Convention is deadlocked until, on the twentieth ballot, the weary electors receive a surprise visit. At three in the morning, Lindbergh flies into Philadelphia, strides into the convention hall with his goggles still on, and is nominated by acclamation. In November, he beats Roosevelt in a landslide.

One of the glories of the book is its counterpoint of large and small, its zooming back and forth, from chapter to chapter, between world events and the reactions to them in the Roth household. On the night of the Republicans' balloting, the neighborhood is loud with radios, as tense Jews sit waiting to find out if a Nazi sympathizer is going to run for president of their country. When, just before dawn, they find out that this is so, they wander out into the street in their pajamas. Philip, the book's narrator, describes the scene:

> Men whom I knew as . . . silent, dutiful breadwinners who all day long unclogged drainpipes or serviced furnaces or sold apples by the pound and then in the evening looked at the paper and listened to the radio and fell asleep in the living room chair, plain people who happened to be Jews [were] now storming about the street and cursing with no concern for propriety, abruptly thrust back into the miserable struggle from which they had believed their families extricated by the providential migration of the generation before.

Makes sense, right? Why should the sufferings of these people come to an end in the space of one generation, with the crossing of one ocean?

Soon after taking office, President Lindbergh signs nonaggression treaties with Germany and Japan. People who object to this, especially Jews, are branded as Communists. But their numbers are few: Lindbergh is getting 80- to 90-percent approval ratings. Among his admirers are many Jews. The Lindbergh administration has created an Office of American Absorption, or O.A.A., which is basically a program for dispersing the Jewish minority into the Gentile majority—in other words, for de-Jewing the Jews (and also for breaking up Jewish voting blocs). A Newark rabbi, Lionel Bengelsdorf—a deliciously pontifical windbag (compare Judge Wapter, in *The Ghost Writer*)—has been put in charge of the O.A.A. for the state of New Jersey, and, as he sees it, only narrow, paranoid "ghetto Jews" could find fault with this estimable project. The country's few patrician Jews—the financiers, the board members, who are mostly of German Jewish stock—also regret that so many of their coreligionists fail to see the light. Why don't these people move into regular neighborhoods and stop acting so Jewy? Then they, too, could go to Harvard and become investment bankers.

In the unkindest cut, Sandy, Philip's adored big brother, defects. As part of an O.A.A. program, he is sent for a summer to a tobacco farm in Kentucky. He comes back full of pork chops and condescension for his parents. Then, in 1942, the O.A.A. institutes a program called Homestead 42, whereby the government will move Jewish employees of certain, specially chosen corporations out of their smelly urban enclaves and into wholesome southern and midwestern communities where those companies have branch offices. Met Life is one of the participating corporations, and Herman Roth gets a letter congratulating him and his family on being selected for relocation. He says no, and this man who, having left school at the age of twelve, was proud of what he achieved as an insurance agent—proud of his suit and his tie and his car—quits his job at Met Life and goes to work hauling tomatoes for his brother Monty, a produce wholesaler. Other Jews are leaving the country on their own, emigrating to Canada. All of

this will sound familiar to anyone conversant with the history of the European Jews in the thirties. And, as in Hitler's Europe, one thing leads to another. Store windows are broken. Jews start to die.

Many people are going to see this story as a recanting. Did Sophie Portnoy and her husband, Jack, live their lives "in continual anticipation of total catastrophe"? Well, Q.E.D. In an eerie conversion, *The Plot Against America* transforms the piety-spouting, finger-shaking elders of the Roth oeuvre into prophets. Bess Roth is like Sophie—worried, protective—but she is no longer banging on the bathroom door, demanding to inspect your bowel movement. She is doing what needs to be done: hanging out the wash, making the sandwiches, going to work in a department store to save up money for a move to Canada. She is the most admirable woman Roth has ever created (that is a slow track, but never mind), and she is utterly alive and convincing.

Roth's novels, however, are basically about fathers and sons, and *The Plot* is no exception. The father in this book is one of Roth's famous yakkers, a kinsman, for example, of the father in *American Pastoral,* who can never stop telling people how to behave, for their own good, and thus driving them insane. (At the end of that book, a woman to whom he is orating on the perils of alcoholism tries to stick a fork in his eye, and you sympathize with her.) Herman Roth does the same: nightly he blankets his family in "the lecturing and the hectoring love" that he bears them. But he is a far more endearing figure. Roth once told an interviewer that when he was a child his father suffered a severe financial setback, and that the courage he showed in fighting his way back from that made him seem to his son a cross "between Captain Ahab and Willy Loman." In *The Plot,* the father also suffers a reverse, when he has to go to work for Uncle Monty. This involves a sixteen-hour workday, at a huge pay cut. He shoulders it like a champion. He is good, he is responsible, he is uncertain. Chapter after chapter, he fears that he is making mistakes, doing the wrong thing. He is strong—big-shouldered, big-chested—but his ears stick out and he talks like an innocent. (Seeing the Lincoln Memorial for the first time, he says, "And they shot him, the dirty dogs.") He is The Parent: serious, virtuous, limited, oppressive,

poignant. And every decision that he makes in the course of the book turns out to be correct.

Other books by Roth, when they err, usually do so by an excess of provocation, a refusal to get up off the whoopee cushion. *The Plot,* when it goes astray, does so in the opposite direction—sentimentality, rhetoric—and this is often in relation to the father. The endless parental haranguing? This, Roth now says, was part of the energy that enabled Jewish slum boys to fight their way out of poverty: "Ardor, for these men, was all they had to go on. What their Gentile betters called pushiness was generally just this—the ardor that was everything." Here, in two sentences, we see something like what Tolstoy, in *Anna Karenina's* famous harvesting scene, did for Levin: too much—the language is incantatory, pushy—and also, perhaps, just enough, enough to bang us on the head and say, "I really mean this."

BUT what does Roth actually mean? Is he sorry that he said all those naughty things about the Jews? Sophie Portnoy, Judge Wapter—these immortals—does he want us to forget about them? *American Pastoral* (1997), with its admirable, duty-doing Jewish hero, was seen by some as a making of amends. So was the 1993 *Operation Shylock,* in which the protagonist—called Philip Roth—actually goes on a spy mission for the Israeli intelligence service. In *The Counterlife,* we are introduced to a leader of a West Bank settlement with many warnings that he is a dangerous fanatic; then the man turns out, disturbingly, to produce a cogent argument (including a warning that there will be pogroms in America). Is Roth, now seventy-one, going down a penitential road, and is *The Plot* his newest way station?

I don't think so. One thing to notice is that the story is a fable. Roth was once asked whether, in writing *Portnoy,* he was influenced by the notoriously abrasive Jewish standup comics of the period—Lenny Bruce, for example. He replied that, if anything, *Portnoy* was inspired by the work of a Jewish sit-down comic, Franz Kafka. Kafka, together with Gogol and Swift, also lurks behind many of his other novels, as he has told us. Clearly, what Roth admires in these writers—or what he has emulated—is their

ability to couch the most extravagant, grotesque fantasy in an utterly mundane realism, so that the reader cannot say, "No, this could not happen." The other superb achievement of those writers is to combine horror with comedy. They make you laugh; they suck you in. Their writings are satires of the highest kind, and that's what *The Plot* is, too. It's not a prophecy; it's a nightmare, and it becomes more nightmarish—and also funnier and more bizarre—as it goes along. (Walter Winchell runs for president; Philip's mother tells him he can't go to school tomorrow, because we might be declaring war on Canada.) In the end, the book may not even be about the Jews. To find the actions of one's government both comical and mortally frightening is an experience that Gentiles can share, especially at the present moment, which may have figured as heavily as the Second World War in the genesis of Roth's tale.

Something else that prevents us from seeing *The Plot* as a straightforward political statement is its "multivocality." Many voices speak, in opposition to each other, and almost all of them (not Rabbi Bengelsdorf) sound persuasive. This is an old gambit of Roth's, and the one that probably annoys his detractors most; they can't figure out whose side he's on. It is also the one quality— or one of four or five (the satiric gift, the voice, the ear, the exploration of American history)—that has made him great. In *The Plot Against America,* the multivocality is achieved, for the most part, by having a political catastrophe, debated by many people in solemn moral terms, be narrated through the eyes of a child, who lacks morality, who wants only his mother and his lunch and his stamp collection, and who has no fine phrases to cover his selfseeking. When his cousin Alvin, disgusted by Lindbergh's isolationism, goes off to the European front with the Canadian Army and returns with one of his legs blown off, this is piteous, and also it's not, because we hear from Philip—who must share his bedroom with his wounded cousin—about how horrified he is by Alvin's stump (it has scabs), by his prosthesis (it has straps and clamps), by his missing leg (it will come and chase Philip in the night).

The book's foremost sufferer, though, is not Alvin but a little boy named Seldon Wishnow, who lives downstairs from the

Roths. Seldon throws a ball like a girl; all he likes to do is play chess. Philip's goal is to be a regular guy, and he wants no part of this loser. Seldon, meanwhile, worships Philip and lies in wait, each morning, to walk to school with him. In the middle of the book, Seldon's father dies. He has cancer, and finally he can't stand it anymore and kills himself. This is very sad, except in Philip's account of it. Mr. Wishnow, Philip enthusiastically tells us, strangled himself with the family's curtain cords, in the hall closet: "When Seldon, home from school, went to put his coat away, he found his father, in his pajamas, hanging face-down on the closet floor amid the . . . galoshes." Seldon's fatherlessness makes him more pathetic, of course, except in Philip's eyes. Everywhere he turns, there is that pasty face, that imploring voice. Finally, Philip hatches a plan. His aunt Evelyn is Rabbi Bengelsdorf's assistant, which means that she has influence over Homestead 42 assignments. Philip goes to her and recommends the Wishnows as candidates for that program. Seldon and his widowed mother are thus relocated to Kentucky. Good-bye, Seldon!

But then the pogroms begin, in Kentucky, among other places, and one night the Roth family gets a call from Seldon, who says that it's 10 p.m. and his mother hasn't come home: "She's dead, Mrs. Roth! Just like my father! Now *both* my parents are dead!" Furthermore, he hasn't had any dinner. The conversation that ensues is one of the finest scenes in the book. To calm Seldon down, Mrs. Roth wants him to eat something. Seldon can find no dinner food in the house, but he manages to locate some Rice Krispies, and Mrs. Roth tells him to make himself a meal of that, a proper meal:

> "Now?"
>
> "Do as I say, please," she told him. "I want you to eat breakfast."
>
> "Is Philip there?"
>
> "He's here, but you cannot talk to him. You have to eat first. I'm going to call you back in half an hour, after you've eaten. It's ten after ten, Seldon."
>
> "In Newark it's ten after ten?"
>
> "In Newark and Danville both. It's exactly the same

time in both places. I'm going to call you back at quarter to eleven," she told him.

"Can I talk to Philip then?"

"Yes, but I want you to sit down first with everything you need at the kitchen table. I want you to use a spoon and a fork and a napkin and a knife. Eat slowly. Use dishes. Use a bowl. Is there any bread?"

"It's stale. It's just a couple of slices."

"Do you have a toaster?"

"Sure. We brought it here in the car. Remember the morning when we all packed the car?"

Encapsulated in this exchange is just about every important element in the book: its moral beauty (the good, efficient, rescuing mother), its horror (Seldon is right, his mother has been killed, and though we already know this, Mrs. Roth and Seldon don't), its comedy ("Can I talk to Philip?"). In the end, the tireless Herman Roth drives to Kentucky and fetches the child, with the result that Philip, who had thought to remove Seldon from his neighborhood, instead finds him installed in his home, in the bed next to his, now vacated by Alvin. Mercifully, we are given no details about Seldon's grief. All Philip says is: "There was no stump for me to care for this time. The boy himself was the stump, and until he was taken to live with his mother's married sister in Brooklyn ten months later, I was the prosthesis." Good— he learns to be decent. (The book is a bildungsroman as well as a satire.) But, in front of us, at least—those two sentences are the last in the book—he never learns enough to hide what is less decent. He is therefore the ideal narrator for this sinuous and brilliant book, with its extreme sweetness (new in Roth), its black pain, and its low, ceaseless cackle.

The New Yorker, 2004

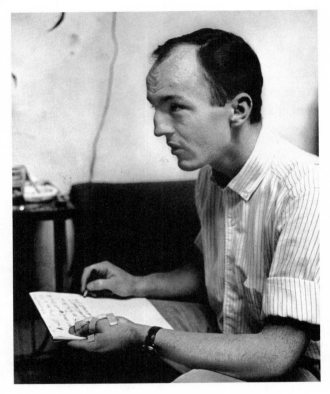

Frank O'Hara, 1958

Perfectly Frank

"THERE are roughly three New Yorks," E. B. White wrote in his famous essay "Here Is New York"—the city of the natives, the city of the commuters, and, greatest of the three, the city of the settlers, those who came in search of something. It was the settlers who gave New York its passion, White said: "Whether it is a farmer arriving from Italy to set up a small grocery store in a slum . . . or a boy arriving from the Corn Belt with a manuscript in his suitcase and a pain in his heart, it makes no difference: each embraces New York with the intense excitement of first love, each absorbs New York with the fresh eyes of an adventurer, each generates heat and light to dwarf the Consolidated Edison Company."

When White wrote those words, in 1948, Francis O'Hara, a bookish young man from Grafton, Massachusetts, was in college, composing his first poems. He had never laid eyes on Manhattan. But his ambition, as recorded in his high-school yearbook, was to live in a big city, and in 1951 he got his wish: now going by the name Frank O'Hara, he arrived in New York and fell under its spell. Over the next fifteen years, until his death, at age forty, he became the city's most representative poet, and more than that: for most of his life, he was known less for his poetry than for his ceaseless activity in New York's art world, as a curator and critic, as a friend and collaborator and encourager, as a generator of heat and light. In one of New York's most splendid moments—some would say its last splendid moment—O'Hara was for many Manhattanites a symbol of the city and a kind of paradigm of the phenomenon that White had described: the person who becomes himself, or his most interesting self, by moving to New York.

For years, I'm told, publishers tried to get someone to write a

biography of O'Hara. Now somebody has. Aptly titled *City Poet: The Life and Times of Frank O'Hara,* it is the work of Brad Gooch, a poet, novelist, and journalist who was thirteen when O'Hara died. Perhaps because he had no cushion of reminiscence to lie back on, Gooch has produced a minutely researched book. It tells a good tale that becomes sad only at the end.

O'Hara's was an ugly-duckling story. He was born to be grown up—to be an artist, to live in a city, to stay up till three—and until he reached that destination he was a misfit. When childhood memories surface in his poetry, they are almost always bitter:

> I hated dolls and I
> hated games, animals were
> not friendly and birds
> flew away.

As for his parents—Katherine O'Hara, who kept a nice house and gave covered-dish suppers, and Russell O'Hara, who owned a farming business and belonged to the Kiwanis Club and the bowling league—here's another poem:

> I ran through the snow like a young
> Czarevitch!
> My gun was loaded and wolves disguised
> as treed nymphs pointed out where
> the fathers
> had hidden in gopher holes. I shot
> them right
> between the eyes! The mothers were
> harder to find,
> they changed themselves into grape
> arbors, vistas,
> and water holes, but I searched for
> the heart
> and shot them there!

As Gooch tells it, however, the O'Haras gave their son about as benign an upbringing as could be had in a small New England

town in the thirties by a boy who, very early on, liked Proust and Hindemith better than baseball and girls. The family was not inartistic. Russell was a music lover; every night, before dinner, he would play his favorites—Rachmaninoff, Beethoven—on the music-room piano. There were aunts who bought Francis books and took him to the movies. But for the O'Haras art was just an enjoyment; for Francis it was a destiny. His favorite author was James Joyce, his favorite book *A Portrait of the Artist as a Young Man,* his favorite scene the famous beach scene, where life and art, in the person of a bare-legged girl, call to Stephen Dedalus across the Dublin strand. O'Hara heard the same call—he was to be a composer or, at least, a concert pianist—and until he could answer it he spent many years as an introverted goody-goody discussing books with his aunts. After high school, he enlisted in the Navy, and there it was the same story. He sat in an upper bunk composing symphonies while his shipmates, down below, played poker and swore. People who knew him then say he was a very nice young man: quiet, earnest, kept to himself a lot. Anyone familiar with the mature O'Hara—witty, voluble, a ball of fire— can't wait for this rather drippy young Francis to grow up and become Frank.

Gooch, in an early statement of one of his main themes, suggests that what kept O'Hara's personality so damped down during his youth was his suppression of his homosexuality. But there was a lot besides homosexuality—namely, his passion for art—to make him feel like an outsider in his hometown and in the Navy. For O'Hara, the magic formula, the thing that liberated his personality and his poetry, was the mixing of art with friendship. When he finally came into his own, all his friends were artists, and their friendships were about art. Conversely, his poetry was full of his friends, and about their friendships. Until he found these like-minded souls, he couldn't become himself.

The liberation began at Harvard, where, along with four thousand other returning veterans, O'Hara, age twenty, enrolled under the GI Bill in 1946. This was the beginning of that heady period when American artists, having spent decades gazing enviously at European modernism, finally pulled themselves together and created a modernism that was wholly their own, in the process shift-

ing the international capital of the art world from Paris to New York. The waves broke over Cambridge as well. On a not atypical weekend during O'Hara's freshman year, the Harvard Music Department sponsored lectures by Roger Sessions and Virgil Thomson, a performance of a new string trio by Schoenberg, and the world premiere of Martha Graham's *Night Journey*. During O'Hara's years at Harvard, there were readings by T. S. Eliot, Wallace Stevens, Robert Frost, Dylan Thomas, Marianne Moore, Edith Sitwell, and Stephen Spender. Among his schoolmates were John Ashbery, Kenneth Koch, Robert Bly, Robert Creeley, Donald Hall, Adrienne Rich, Harold Brodkey, John Updike, and Alison Lurie. The Cambridge literary scene was lively enough so that John Ciardi—whose creative-writing class was O'Hara's favorite course—could write a "Letter from Harvard" for *Poetry*.

This was a new world for O'Hara, a world that was full of art, and where the love of art was normal. He blossomed, and, not surprisingly, in view of its delay, the blossom was elaborate. He became expansive, brilliant, mannered. He and his roommate, Edward Gorey, furnished their rooms with chaise longues, on which, of an evening, they would recline, listening to Marlene Dietrich records and discussing their favorite authors, Ronald Firbank and Ivy Compton-Burnett, while friends dropped by for cocktails. Gooch stresses O'Hara's preciosity during these years, and he has evidence. (Reading Plato around this time, O'Hara wrote to a friend, "Really that Socrates is such a bitch!") But, as Gooch also notes, O'Hara read a lot besides Firbank. He was a passionate modernist—his gods were Joyce and Gertrude Stein—and in 1949 he gave himself a long, breathless course in Rimbaud and the French Surrealists, an experience that was to leave its mark on his later poetry. He seems, in addition, to have attended every concert, every art exhibition, every movie that Cambridge had to offer, and found time to sunbathe with his friends on the banks of the Charles. He didn't go to class much, or not the classes he was enrolled in. He treated Harvard the way he was soon to treat New York, rejoicing in it, following his pleasure.

The experience changed him utterly. By his sophomore year, he had abandoned music for poetry. Tellingly, this decision followed swiftly upon the death of his music-loving father. Another

thing that followed his father's death was his mother's descent into alcoholism. She became the worst kind of drunk—desperate, weepy, wheedling, nasty. O'Hara, who as a child had adored Katherine, came to hate her. He made his last visit to Grafton, for an aunt's funeral, at age twenty-five. After that, he did not go home again, and, though as an adult he was famously open-mouthed ("I tell everyone everything. It's the Norman Mailer in me, UUUUUUUUUUUGH"), he almost never mentioned his family. He had become Frank—at the end of his Harvard years he began signing his work that way—and he put Francis firmly behind him.

No surprise, in view of the world that now opened to him. New York in the fifties already had most of the problems it has now. Crime, racial tensions, homeless people—White describes them all in "Here Is New York." But, oh, what else it had! Jazz was in a golden age. At the Five Spot, on Cooper Square, you could hear Charles Mingus, Sonny Rollins, Cecil Taylor, Thelonious Monk, Billie Holiday. Farther uptown, at the City Center, American ballet was being born. In 1948, George Balanchine had founded a permanent company, New York City Ballet, and on his stage Maria Tallchief, Tanaquil Le Clercq, and Diana Adams were initiating new audiences into a species of artistic fantasy unknown in America a decade before. In painting, of course, the fifties was the period of the Abstract Expressionists. Jackson Pollock was already a famous man; *Life* had run an article on him in 1949. Willem de Kooning, Franz Kline, and Mark Rothko were still laboring quietly but producing their best work, and their generation was now breeding a second generation: Larry Rivers, Grace Hartigan, Jane Freilicher, Al Leslie, Helen Frankenthaler, Joan Mitchell. The excitement in the art world was boosted by the retrospectives being mounted at the Museum of Modern Art under the direction of Alfred Barr (Bonnard in 1948, Munch and Soutine in 1950, and, most spectacular, the Matisse retrospective of 1951)—shows that were the more dazzling to New York's artists in that so few of them had been to Europe. And all this could be had cheaply. For a number of months after arriving in New York, O'Hara was unemployed, and so were many of his friends, but they seem to have eaten out every night and then hit the bars or

the ballet or some other place that today you'd have to save up to go to.

They knew what they had. In those days, most young artists adored New York—painted it, wrote about it, didn't like to leave it. Even its discomforts were dear to them. Once, detained in Cambridge on a job, O'Hara wrote to a friend, "It's not hot enough, it's not crowded enough, there's not enough asphalt, and you can see over buildings too easily." New York, he and his friends felt, was giving them the kind of life Paris had given preceding generations. That the young painters had the School of Paris on their minds, and felt a conscious, prickly, underdog-pulls-ahead pride, is most obvious in Robert Motherwell's christening the Abstract Expressionists the New York School, a name then copied by the gallery owner John Bernard Myers when he dubbed O'Hara and his friends John Ashbery, James Schuyler, and Kenneth Koch the New York School of poets. As Larry Rivers later wrote, "we wanted to taste that special lollipop Picasso, Matisse, Miró, Apollinaire, Éluard, and Aragon had tasted and find out what it was like."

O'Hara had met Rivers on an early visit to New York, in 1950. They became friends instantly. Another important early friend was Jane Freilicher, so when O'Hara moved to New York, in 1951, he immediately fell in with the younger painters of the New York School. For the remainder of his years, painters and painting were his first loves. ("You know how / I feel about painters," he wrote in a 1957 poem. "I sometimes think poetry / only describes.") In late 1951—in order, he said, to be closer to the Matisse show— he applied for a job selling tickets at the front desk at MOMA. He was hired, and, except for a short break in the early fifties, he worked at MOMA for the rest of his life, eventually rising to the position of associate curator. He did most of his work in the museum's International Program, whose mission, in those Cold War years, was to get the new American art out on the road, where it could boost the nation's prestige. He helped put together the landmark New American Painting exhibition of 1958, the first group show of Abstract Expressionists to tour Europe. (By the end of that tour, Gooch says, Abstract Expressionism "was rivaling jazz as America's most influential cultural export.") He supervised

major retrospectives of Kline, Motherwell, Reuben Nakian, and David Smith and produced a steady stream of articles, interviews, and catalogue essays on other artists. In other words, he was a major player, on an official level, in the rise of American painting in the 1950s.

But the museum was just nine to five. O'Hara dunked himself, nightly, in the arts of New York. He spent long, entranced evenings in the jazz clubs. He adored movies—had loved them since childhood—and liked to go to double features in Times Square. In his poetry, when he speaks of movies, even silly ones, you can hear him holding his breath for sheer wonder:

> I went to my first movie
> and the hero got his legs
> cut off by a steam engine
> in a freightyard, in my second
>
> Karen Morley got shot
> in the back by an arrow
> I think she was an heiress
> it came through her bathroom door

But his real altar, aside from painting, was New York City Ballet, where he often went with his friend Edwin Denby, America's first great dance critic. At the ballet, one of his friends says, O'Hara "would gasp, get teary-eyed, reach out and grasp his companion by the forearm." I'm not sure this is the kind of thing I would want going on in the seat next to me, but it gives some idea of the ardor, the emotionalism, with which O'Hara embraced art. He only went after things he loved, and love, as he saw it, was what the experience was all about. He hated critics. His 1951 poem "The Critic" opens:

> I cannot possibly think of you
> other than you are: the assassin
> of my orchards.

His own art reviews were almost always appreciations.

When he wasn't at the movies or the ballet or the Five Spot, he was in a bar discussing these things with his friends. New York's bar scene in the fifties is by now well-grazed ground, but Gooch manages to make it sound interesting again. There was the San Remo, mostly a writers' bar, on Bleecker Street, where Paul Goodman held court. A few blocks north, at University Place and Eighth Street, was the Cedar Tavern, the painters' bar. (It's now a quieter establishment at University and Tenth.) The Cedar was where the Abstract Expressionists went to gossip and fight. Jackson Pollock was there every Tuesday—he lived in the Hamptons, but he came to town once a week to see his psychiatrist—and he set the truculent tone of the place. One night, in a fight with Franz Kline, he tore down the men's-room door. (According to Ronald Sukenick's history of the period, *Down and In,* Pollock was then banished from the Cedar for a month. On certain nights, he could be seen peering sadly through the window. "No, Jackson!" his friends would shout. "Two more weeks!") These revels were abetted by a truly extraordinary rate of alcohol consumption. One night, when the last call was announced at the Cedar, Kline ordered sixteen Scotch-and-sodas for himself and Elaine de Kooning. O'Hara, too, drank very heavily. He also smoked three packs of Camels a day. This was the last bash before the "personal health" movement of the sixties, and one reads about it with a certain nostalgia.

The bars were where these people went to conduct their friendships, and no one had more friendships than O'Hara. "I can no more resist people than music," he wrote to his parents while he was in the Navy, and that was when he had no friends. By the end of his first few months in New York, he had a large circle around him, and it grew yearly. (At O'Hara's funeral, Larry Rivers said that there were at least sixty people in New York who thought Frank O'Hara was their best friend.) Many of these alliances were cemented, and complicated, by the fact that they were taken to bed. Probably the two great loves of O'Hara's life were Rivers, with whom he had a stormy, on-and-off affair in the early fifties, and Vincent Warren, a sweet-tempered ballet dancer, thirteen years his junior, who was his flame from 1959 to 1961, and to whom he wrote a number of beautiful love poems. But he seems

to have gone to bed with most of his other friends as well, or, at least, with the men (and one or two of the women)—a habit that to his romantic and unfastidious mind seemed quite natural. He loved art and he loved people and he loved to be in love, particularly with people who made art. Alcohol helped. At 3 a.m., with a pint or two of bourbon in them, O'Hara and his friends did not trouble themselves long over whose door they knocked on. O'Hara one night made a pass at Rivers's teenage son. Rivers, for his part, was once intercepted by his estranged wife on his way to his mother-in-law's bedroom. Such lapses aside, however, the tone of the sexual go-round in O'Hara's circle was notably idealistic. O'Hara wanted to be one with beauty, to clasp it to him. Writing in 1961 of David Smith's recent sculptures, he said that they "didn't make me feel I wanted to *have* one, they made me feel I wanted to *be* one." If he could have gone to bed with them, too, he would have.

What he loved, he fostered. Important though he was as a curator and writer, he was probably more influential in the art world simply as a hand-holder, an encourager. He would look at his friends' work and tell them what it was, and how wonderful it was. As Kenneth Koch described it to Gooch, "they'd have all these wonderful ideas and feelings about themselves, and they'd say, 'Duh,' and Frank would say 'Yes, you put that green there. That's the first interesting thing that's been done since Matisse's *Number 267.*' " Larry Rivers and Grace Hartigan notably thrived under his encouragement, and so did others. Edwin Denby, though he was twenty-three years older, said that O'Hara was a catalyst for him. "But then," Denby added, "he was everybody's catalyst."

O'Hara's fostering of other people's work was all the more effective in that it was not, for him, a moral imperative, something he felt he should do, but something he did naturally. He was an instinctively generous person. At poetry readings, he routinely devoted large parts of his allotted time to reading the work of others—a rare practice. He was kind to the competition: of his circle of poets, he was practically the only one to hold out a hand to the Beats. On the few occasions when he went on record against another artist, it was usually for lack of generosity. He accused

T. S. Eliot of having a "deadening" effect on modern poetry, primarily by laying down exclusionary rules: "saying you're not supposed to read Milton, and so on . . . Which is ridiculous." His widely quoted criticism of Robert Lowell, from an interview published in 1966, was aimed at the same fault: failure of goodwill. Commenting on Lowell's "Skunk Hour," with its scene of the poet prowling a lovers' lane, O'Hara said:

> Lowell has . . . a confessional manner which [lets him] get away with things that are really just plain bad but you're supposed to be interested because he's supposed to be so upset. . . . I don't think that anyone has to get themselves to go and watch lovers in a parking lot necking in order to write a poem, and I don't see why it's admirable if they feel guilty about it. They should feel guilty.

O'Hara's generosity toward the world sometimes has a certain proto-flower-power coloration. "Oh! kangaroos, sequins, chocolate sodas!" one poem begins—but it is an early poem (1950). Over the years, his goodwill toughened, became more objective without becoming less good. Specifically, it was subsumed into what came to be the dominant attitude of all his mature writing, critical or poetic: attention. "Attention equals Life," he wrote in his introduction to Denby's 1965 essay collection, *Dancers, Buildings and People in the Streets.* That was his praise of Denby—that he kept his eyes open—but the description fits O'Hara as well. And this amoral, almost animal quality of attentiveness gives to O'Hara's sweetness a sturdier character. What might have been sentimentality becomes large-mindedness, zest—a capacity for interest and enjoyment that can still, across the space of decades, suck us back into the minds-on-fire spirit of those years.

That is what happens in the best of O'Hara's art criticism. An exemplary piece is "Larry Rivers: 'Why I Paint As I Do,' " which appeared in *Horizon* in 1959. In the course of this interview, O'Hara brings Rivers out on almost every important question that needed to be asked about art at that time: abstraction versus representation, style versus subject matter, Europe versus Amer-

ica, influence versus individuality. Yet all these issues seem to bump up naturally in the conversation between the two men as they stand there in Rivers's studio—with the lamp here, the dog there—chatting, pointing, carrying on their friendship. ("What is this down here?" asks O'Hara. "Is she wearing shorts?" "What's the matter with you?" Rivers answers. "Are you blind? She had a *skirt* on.") It is all wonderfully unpretentious, and this gives the issues involved a great solidity. Abstraction, representation: they seem as real as the dog. Anyone who wants to get a quick sense of O'Hara's world should get hold of *Art Chronicles, 1954–1966,* a posthumous collection of his art criticism, and read this interview.

That same unpretentiousness became the trademark of O'Hara's mature poetry. In his early years, he went through what John Ashbery has called a French Zen period, producing long, hallucinatory poems under the tutelary light of the French Symbolists and Surrealists. The prime example is his 1953 "Second Avenue," with its 478 lines full of seas and suns, snakes and snot and other items from Rimbaud's arsenal. Nor did he ever entirely put this mode behind him. His 1962 "Biotherm (for Bill Berkson)" is in the same vein. Certain critics—Marjorie Perloff in her excellent *Frank O'Hara: Poet Among Painters,* Geoff Ward in his *Statutes of Liberty: The New York School of Poets*—have found kind things to say about these long, febrile poems, but I think that almost anyone reading O'Hara's work chronologically will breathe a sigh of relief when, in the mid-fifties, another tutelary light, William Carlos Williams, takes over, and O'Hara begins regularly producing short, plainspoken poems about the world in front of his eyes: the ballet, the jazz clubs, the friends, the city. Very soon he masters the form, and we have a vision and a voice that are only O'Hara's:

> It's my lunch hour, so I go
> for a walk among the hum-colored
> cabs. First, down the sidewalk
> where laborers feed their dirty
> glistening torsos sandwiches
> and Coca-Cola, with yellow helmets
> on. They protect them from falling

bricks, I guess. Then onto the
avenue where skirts are flipping
above heels and blow up over
grates. The sun is hot, but the
cabs stir up the air. I look
at bargains in wristwatches. There
are cats playing in sawdust.
 On
to Times Square, where the sign
blows smoke over my head, and higher
the waterfall pours lightly. A
Negro stands in a doorway with a
toothpick, languorously agitating.
A blonde chorus girl clicks: he
smiles and rubs his chin. Everything
suddenly honks: it is 12:40 of
a Thursday.

Obviously, Rimbaud and the Surrealists still mean something to him. The cabs are hum-colored, and the objects are juxtaposed in a sort of montage. But the montage is not surreal—it's real, it's New York—and the objects don't fly around in that self-important, *dérèglement des sens* way. They stay put, and honk the way they should. Waterfalls pour from the sky, but they're really there, on a billboard. In the city O'Hara found his own, more modest version of Surrealist hallucination.

Unlike Surrealism, it is all grounded in real time: Thursday, 12:40. O'Hara loved things that lived in time, things that *moved*—ballet, movies, Action painting, New York—and he made himself the partner of time. In the middle of a 1957 poem, "John Button Birthday," he breaks off his thought and writes:

Now I have taken down the under-
 wear
I washed last night from the various
 light fixtures
and can proceed.

And he proceeds, but not without our feeling, through the rest of the poem, that we can hear the clock ticking in O'Hara's apartment.

This alliance with time left its mark on his art criticism. In the interviews and studio visits, where he can talk about something that is alive and going forward, he is unbeatable. In the big catalogue essays, where he is dealing with something stopped in time—a retrospective, often of a dead artist—he is nowhere near as good. The job of summation sits heavy on him; he becomes grandiloquent, ponderous. In the poetry, he rarely generalizes. What emotions he feels, what meanings he finds must be content to glint at us from within the flow of events; he won't fish them out. "The wish *not* to impute significance has rarely been stronger in lyric poetry," Helen Vendler wrote in her review of O'Hara's *Collected Poems*. "It happened, it went like this, it's over."

This avoidance of what O'Hara called "the important utterance" separates him from most of the other major poets of his time, dominated as they still were by the Pound/Eliot inheritance. Another thing that sets him apart is his unwillingness to join the priesthood of craft, that often flagellant order, founded by Eliot as the only means of expressing the infinitely difficult feelings that, in his view, were the business of poetry. To quote the famous lines from "East Coker":

> each venture
> Is a new beginning, a raid on the
> inarticulate
> With shabby equipment always
> deteriorating
> In the general mess of imprecision of
> feeling,
> Undisciplined squads of emotion.

But, Eliot concludes stoically, "for us, there is only the trying. The rest is not our business."

O'Hara found this tragic pose absurd. For him, "the rest"— that is, living—*was* his business. As for "the trying," what was so

483

hard about it? This was more or less the position he took in "Personism," an aggressively flip manifesto that he wrote in 1959:

> I don't have to make elaborately sounded structures. . . . I don't even like rhythm, assonance, all that stuff. You just go on your nerve. If someone's chasing you down the street with a knife, you don't turn around and shout, "Give it up! I was a track star for Mineola Prep."

And why make such a big moral deal out of poetry anyway? If people didn't like poetry, "bully for them."

> After all, only Whitman and Crane and Williams, of the American poets, are better than the movies. As for measure and other technical apparatus, that's just common sense: if you're going to buy a pair of pants you want them to be tight enough so everyone will want to go to bed with you. There's nothing metaphysical about it.

I don't know how many people read "Personism" during O'Hara's lifetime. (It was first published in *Yūgen,* a little magazine edited by O'Hara's friend LeRoi Jones.) But the poems were manifesto enough. With their colloquialism, with their empirical record of daily events, with the friends wandering in and out—"Jap" (Jasper Johns) waiting at the train station, "Allen" (Ginsberg, hung over) throwing up in the bathroom—and, above all, with their craft so lightly worn, the poems constituted a clear refusal, if not of the high mission of poetry, then of any duty to kneel before the throne.

As might be expected, they were coolly received. O'Hara had a special power over reviewers. They gazed on him and they turned to squares: stuffy, righteous, humorless. At best, they might concede that he had a certain charm. "His long invertebrate verse lines can be amiable and gay, like streamers of crepe paper fluttering before an electric fan," Marius Bewley wrote in *The New York Review of Books* in 1966, but the note of condescension here is typical.

I don't mean to make O'Hara into an art martyr. As Vendler

has pointed out, the fact that his early work was widely ignored is probably due more to the weakness of the early work than to any old-fogy cabal marshaled against him. Furthermore, if O'Hara wasn't taken seriously, this was partly because he often acted as though he didn't take himself seriously, or not as a poet. He didn't try to get his work published in places where it would be seen. Most of the time he didn't try to get it published at all. Often, his poems appeared only because some editor, usually of an out-of-the-way magazine or publishing house, came to him personally. Even then, it wasn't easy to get poems out of him, because he didn't know where they were. The poet Diane Di Prima described to Gooch what it was like to try to extract poems from O'Hara for a small journal she edited in the early sixties:

> I would go up to his place and he'd let me look through everything including the dirty laundry. He'd finish poems and put them anyplace. . . . The towel drawer was a very good place because I guess towels were flat. I would just take whatever I wanted. Often he didn't have another copy.

Several of his best poems were not published until after his death. Some poems he had never shown to anyone. Many were probably lost. "Memorial Day 1950," an important early poem, survived only because he showed it to John Ashbery and Ashbery copied it out in a letter to Kenneth Koch and Koch kept the letter.

Though at times O'Hara spoke proudly of his work, at other times his comments on his poetry were as diffident as his treatment of it. "I've only been doing very few poems," he wrote to Ashbery in 1961, "and they are pretty much blabbing along chicly while sitting on WC Williams' cracker barrel with my legs crossed." He also made a practice—encouraged, of course, by his having a full-time job—of writing on the fly, and he advertised this fact. When he wrote a poem in somebody's bathroom during a dinner party, he entitled it "Bathroom" (1963). Many of his poems were penned during his lunch hour, and the title of the volume in which these poems were published—in 1964, after years of dawdling on his part—was *Lunch Poems.*

Eventually, though, O'Hara acquired some standing as a poet,

at least with other poets. His rise began in 1960, with the publication of Donald Allen's *The New American Poetry: 1945–1960,* an anthology that made a big splash by virtue of its concentration on young, antiacademic poets whose work had previously been available only in the samizdat of little magazines, coffee-shop readings, and the like. The Beats were there, and the Black Mountain group, but the poet who was given the most space—fifteen poems—was O'Hara. (Allen was a friend of O'Hara's. He knew what was in the towel drawer.) Through *The New American Poetry,* O'Hara won the hearts of teenage poets across the land, a number of whom—Ted Berrigan, Ron Padgett, David Shapiro— came to New York and became, in varying degrees, O'Hara disciples. By the time he published his last book, the 1965 *Love Poems* (*Tentative Title*)—note, again, the insistent casualness—he was well known. He was then thirty-nine.

This is not an extraordinarily late age for a poet to reach before achieving fame, but O'Hara didn't live to enjoy his eminence. He died the following year, in a freak accident on a beach. And, because he died young, an annoying little cloud of extra-literary sentiment hangs over his reputation. As Richard Howard put it in *Alone with America,* O'Hara, for many people, is not just a poet but a "man-who-has-died-at-forty." A number of his friends and admirers fell prey to a certain who-killed-John-Keats righteousness on his behalf, something that he would have deplored. (In 1966, Al Leslie produced a series of seven paintings, collectively entitled *The Killing of Frank O'Hara,* that portrayed O'Hara's death in terms that would not have been inappropriate to a Descent from the Cross.) And since his death, as a kind of reparation for his spotty publishing record during his life, practically every surviving word he ever wrote has been published, including some very negligible things. This trend, together with the finger-pointing about who didn't appreciate him when he was alive, has, of course, provoked a backlash. When the *Collected Poems* came out, in 1971, five years after his death, there were a great many tart remarks about the presumed disparity between that six-hundred-page volume and the actual measure of O'Hara's gift. "I find him gay, glancing, ephemeral," William Dickey wrote in *The Hudson*

Review. "He's fun, bitchy—and here he is enshrined in a volume that rivals the Variorum Yeats."

All of this is unfortunate, for it obscures the poetry, which is not at all bitchy and, though fun, is more than fun. Despite O'Hara's antimetaphysical bent, many of his poems have a kind of dome of glory that rises up over the minutiae of his days. A shining example is "A True Account of Talking to the Sun at Fire Island," a variation on a similar poem by Mayakovsky, whom O'Hara loved. Now a favorite anthology item, it's one of the poems that were not discovered until after his death. As it opens, the sun wakes him up, addressing him like a kind but grouchy old uncle:

> "Hey! I've been
> trying to wake you up for fifteen
> minutes. Don't be so rude, you are
> only the second poet I've ever chosen
> to speak to personally . . .
>
> When I woke up Mayakovsky he was
> a lot more prompt."

O'Hara apologizes, and the sun, mollified, tells the reason for this unusual visit:

> "Frankly I wanted to tell you
> I like your poetry. I see a lot
> on my rounds and you're okay. You may
> not be the greatest thing on earth, but
> you're different. Now, I've heard some
> say you're crazy, they being excessively
> calm themselves to my mind, and other
> crazy poets think that you're a boring
> reactionary. Not me."
>
> "Oh Sun, I'm so grateful to you!"

"Thanks and remember I'm watching. It's
easier for me to speak to you out
here. I don't have to slide down
between buildings to get your ear.
I know you love Manhattan, but
you ought to look up more often.
 And
always embrace things, people earth
sky stars, as I do, freely.

 Maybe we'll
speak again in Africa, of which I too
am specially fond. Go back to sleep now."

"Sun, don't go!" I was awake
at last. "No, go I must, they're calling
me."
 "Who are they?"
 Rising he said "Some
day you'll know. They're calling to you
too." Darkly he rose, and then I slept.

In the doomed-poet drama that has been retrospectively read into O'Hara's story, this poem has been taken as a premonition of death. But to me the most remarkable thing about it is O'Hara's sense of blessedness, an emotion that surfaces again and again in his verse. Indeed, it is one of the things ("gay, glancing") held against him by those who feel that he was not a serious person. This, in turn, has led some of his defenders to overstress the sadness—presumably a warranty of seriousness—that can sometimes be detected in his poetry. The light tread of his lyrics, Geoff Ward says, "is only a step away from the grave." It is true that O'Hara had the Irish sense of life, but the note of grief would be far less persuasive if it were not accompanied, as it almost always is, by the keenest possible responsiveness to life's goodness. Even at his most depressed, when his romance with Vincent Warren is falling apart, O'Hara is witty. ("I walk in / sit down and / face the frigidaire"—presumably Vincent.) When, on the other hand, that

relationship is going well, even bad things seem good to him: "Even the stabbings are helping the population explosion."

Boyfriends aside, he finds a thousand things to like. Ballet dancers fly through his verse. Taxi drivers tell him funny things. Zinka Milanov sings, the fountains splash. The city honks at him and he honks back. This willingness to be happy is one of the things for which O'Hara is most loved, and rightly so. It is a fundamental aspect of his moral life, and the motor of his poetry. Even Ward, whose book is a poststructuralist study, offering us the unlooked-for experience of seeing O'Hara analyzed in relation to polysemy, differential valorization, and French gyno-criticism, finally throws up his hands. "The poetry of Frank O'Hara has an incomparable warmth and humanity," he exclaims. "It is only through such poetry that people in the future will think that life in New York City in the fifties and sixties must have been good." Ward is a professor at the University of Liverpool. I hope he has tenure. This is not the way a poststructuralist analysis is supposed to end.

THE facts of O'Hara's life receive full justice in Gooch's biography. Gooch has gone everywhere, interviewed everyone. As is often the case in such carefully researched books, there is too much detail. O'Hara cannot walk across Harvard Square without our being told what product is being advertised on the billboard overhead (Royal Crown Par-T-Pak Beverages). He cannot be born without our learning the name of the obstetrician, Maurice Shamer, M.D., though Dr. Shamer does not reappear in the book.

When Gooch gets to the subject of O'Hara's homosexuality, the amount of detail becomes overwhelming. If O'Hara as much as invites the postman in, if he pays a midnight call on a security guard at the United Nations, we hear about it. And when Gooch is not talking about O'Hara's homosexuality his interviewees are. This seems to be the first—or, at least, the second—matter on which he questioned everyone. Was O'Hara "out" as a teenager? No, he wasn't, but several people have to testify before this obvious conclusion can be reached. Did he make out with a Navy buddy one night on shore leave? Gooch can't be sure, but he calls

three witnesses. Did a short story that O'Hara published in the Harvard *Advocate* in 1948 have "gay overtones"? "It's quite possible," says John Ashbery, but we never find out what the gay overtones were or whether they figured importantly in the story. Much of what we get on the Harvard years is the record of O'Hara's coming out: chaise longues, Marlene Dietrich records, letters beginning "Mon ange." This is perhaps justifiable—his coming out was certainly important, and coincided with his decision to be a poet—but the subject of O'Hara's sexual preference is pursued just as energetically once he gets to New York and begins leading a much less precious sort of life—a life, furthermore, in bohemian circles, where homosexuality was in no way remarkable, and where, in consequence, he does not seem to have had any conflicts, or even any interesting thoughts, about it. O'Hara was not a famous Lothario, nor was he a famous homosexual, that is, famous, in part, for being homosexual, like Oscar Wilde or Gide. Nor can it be said that his work was notably homosexual—that his vision would have been different had he been heterosexual. Change a few details in the love poems, and they sound like what a man might have written to a woman in the fifties.

Gooch's dwelling on O'Hara's homosexuality is part of the Antithesis, a reaction to all the writings on homosexual artists in which homosexuality was unmentioned or glossed over, even when it was crucial. How long will we wait for the Synthesis, the time when homosexual artists will be treated like heterosexual artists? It will not serve the cause of justice for an artist of O'Hara's general, human appeal to be put forth as a "gay poet." Gooch does not apply that label, but the accumulation of sexual detail does it for him. And, in case you're thinking that this material, however excessive, might nevertheless be fun to read, forget it. Larry Rivers describing exactly what he and O'Hara did in bed, who put what where, who did what then—there's something grim about it, something dogged.

There's something dogged about the book as a whole. Gooch does not seem to have strong feelings about O'Hara—does not criticize him, defend him, possess him. Practically the only thing for which O'Hara gets his hand slapped is disloyalty to homosexuality. His tendency to fall for heterosexual men is described

as "self-deception," demonstrating a "lack of self-acceptance." When, on a trip to Spain, he writes to Vincent Warren that in Madrid, as in New York, "the queens always hate me and the heterosexual painters seem to like me," he is scolded by Gooch for distancing himself from his "fellow homosexuals." That failing apart, Gooch rarely judges O'Hara or his poetry. Changes in O'Hara's style are kept track of, and the work is quoted as evidence for the life, but Gooch makes no sustained argument for O'Hara as a poet. (For that, see Perloff.) His impassivity may be an act of deference. There are many, many people around who knew O'Hara. Gooch didn't, and this circumstance may have fostered a certain modesty on his part. He may also have wanted to steer clear of both the sentimentality and the antisentimentality that surround O'Hara's reputation. But the result is a little cold.

On the other hand, Gooch certainly gives us the facts, many of them germane to the poetry. It is good to find out how much O'Hara knew about music and how much he loved it—this helps to explain the unforced music of his verse—and it is interesting to learn how enormously well read he was. When O'Hara chose a plain style, it was truly a choice, not the outpouring of an artless soul. Furthermore, Gooch does manage to capture the spirit of bright cheer that blew through New York in the fifties. Those people had a lot of fun.

By the sixties, the good times were largely over. O'Hara's crowd started getting older, getting married, going on the wagon. Meanwhile, their beliefs and their reputations were slowly cast into shadow as Pop art supplanted Abstract Expressionism. In Gooch's book, James Rosenquist tells of a party at the collector Burton Tremaine's house in 1962. Andy Warhol was there, along with other Pop artists. In the middle of the party, de Kooning and Larry Rivers showed up. "Tremaine stopped them in their tracks and said, 'Oh, so nice to see you. But please, at any other time.'" They left. "At that moment," says Rosenquist, "I thought, something in the art world has definitely changed." A few years later, at a party in the Hamptons, we have de Kooning screaming at Warhol, "You're a killer of art, a killer of beauty!" O'Hara too dis-

liked Warhol. He disapproved of his morals, and he was pained by
Warhol's substitution of silk-screening and mechanical reproduc-
tion for the more human and personal brushstroke. Generous as
always, he found something decent to say about Warhol in a 1965
interview—"a terribly serious artist"—and he was friends with
other Pop artists, but, according to the painter Wynn Chamber-
lain, Warhol represented death to O'Hara: "And to all of us at that
point. He was the prophet of doom."

As O'Hara's world began to crumble, so did he. In 1961, Vin-
cent Warren, who had always been somewhat overwhelmed by
O'Hara's feeling for him, decamped to Montreal. O'Hara was
heartbroken, and never had another great love. To his friends' dis-
may, he began going to parties with rich people, and he drank
more and more. By 1962, he was starting the day with a bourbon
and orange juice, and he became a mean drunk. He had terrible
hangovers, crying jags, fights with friends. In 1965, Joe LeSueur,
the ex-lover who had shared his apartment and been his steady
friend for nine years, moved out. (O'Hara had made a move on a
young man LeSueur considered his.) The poetry dried up. During
his two years with Vincent Warren, from 1959 to 1961, he had
written close to a hundred poems. In 1964, he wrote fourteen; in
1965, two. He was better known than ever before, and he still did
his job at the museum very well, but many of his assignments
were sad tasks: retrospectives of artists, like Franz Kline and David
Smith, who had meant the world to him and were now dead.

In the summer of 1966, when he was beginning work on
another such show, a Pollock retrospective, he went for a weekend
to the arts patron Morris Golde's house on Fire Island—a party
that also included Virgil Thomson and J. J. Mitchell, the man
who had been the subject of his quarrel with LeSueur. After din-
ner, the four of them went to a bar on the beach. Golde and
Thomson left early; O'Hara and Mitchell stayed on. Around
2 a.m. they got into a water taxi, but it soon broke down, and the
passengers got out. While they were waiting for another taxi, a
jeep came down the beach. Everyone got out of its path except
O'Hara. It hit him straight on. He died the next day. It was a
death befitting his life—accidental, something that happened to
him while he was walking along. He was buried on Long Island,

in the cemetery where Pollock had been laid to rest. The funeral
was mobbed, though he had written in a 1956 poem that he didn't
want anyone there:

> When I die, don't come, I wouldn't
> want a leaf
> to turn away from the sun—it loves it
> there.
> There's nothing so spiritual about
> being happy
> but you can't miss a day of it, because
> it doesn't last.

The New Yorker, 1993

Hilary Mantel, 1995

Devil's Work

WHEN the English novelist Hilary Mantel was seven years old, she saw the Devil standing in the weeds beyond her back fence. In her memoir, *Giving Up the Ghost* (2003), she describes the vision:

> It is as high as a child of two. Its depth is a foot, fifteen inches. The air stirs around it, invisibly. I am cold, and rinsed by nausea. I cannot move. . . . It has no edges, no mass, no dimension, no shape except the formless; it moves. I beg it, stay away, stay away. Within the space of a thought it is inside me, and has set up a sick resonance within my bones and in all the cavities of my body.

This passage could serve as the epigraph for most of Mantel's novels. Her work is full of devils, literal devils, and when they are not present their place is filled by regular, shocking evil. Graves are robbed; a baby is drowned; a woman kills her mother. At the same time, the books are extremely funny. This doesn't cancel out the horror. What we are left with is a picture of people—not necessarily good people—muddlingly trying to explain to themselves the pain and unknowability of their lives. Is there a God? What's going to happen to us when we die? Eschatology crossed with comedy: this is Mantel's literary property.

In her new novel, *Beyond Black*—her ninth, her finest—she has mapped the territory as never previously, for this time the protagonist, Alison Hart, is a medium. Alison travels around the English suburbs, leading psychic meetings at which she calls forth radiant, happy spirits who want to communicate with their "earthside" survivors. She knows that whatever she offers will be

taken up, because of the utter repetitiveness of human grief. All her clients have had a miscarriage, or lost their mother or a dear old granny who understood them as their mother never did. Otherwise, they wouldn't be attending a psychic meeting. So with every voice that Alison says she is channeling there is a loud sob from somewhere in the audience. She talks the woman (it's always a woman) through her grief, and speaks of "closure" and a "cycle of caring."

All of this is bogus. Alison does communicate with the spirit world, but not with one that she can tell her clients about. They think that the afterlife will be beautiful, and make sense, unlike life. She knows that it is just like life, foolish and crazy. Some of Alison's visitants are impostors; they claim they're Elvis or Glenn Miller. Others are just bores. One old lady natters on about how she's lost a button from her cardigan. Princess Diana appears. "Give my love to my boys," she says. She can't remember their names: "Oh, fuckerama! Whatever are they called?" Alison is depressed by these undignified visitors, and by no one more than her "spirit guide," Morris, a ghost who more or less lives with her. Other mediums, she says, have spirit guides named Oz or Running Deer, who say things like "The way to open the heart is to release yourself from expectation." Morris, by contrast, is a grizzled old criminal whose fly is often undone. While she is leading her psychic meetings, he is out in the parking lot, opening car doors, loosening the straps on baby seats. This transfer of lowlife realism to the spirit world is the novel's major comic device, but *Beyond Black* is only partly a comedy. Morris says that since he's been on "the other side" he's seen the Devil but not God.

MANTEL comes from the working class—Irish Catholic immigrants, textile workers. She was born in 1952, in the village of Hadfield, near Manchester. Her mother went to work in the mills at fourteen. Her father was a clerk. Her childhood, she writes, was "distinguished by a pervasive quality of fear. The dead whistled in the walls; drawers contained photographs of babies who had failed to thrive, of a little girl burnt up in her own nightdress."

For a while when she was eight, her field of vision was filled with "a constant, moving backdrop of tiny skulls." Around that time, a curious transition occurred in her home. The family took in a lodger, named Jack Mantel, and he replaced Hilary's father in her mother's life. The father didn't move out; he just moved to a different bedroom. In the evening, the mother and Jack would stay in the kitchen, the father in the front room. This went on for four years.

Hilary was the eldest of three children—a smart, bookish girl. Her mother was ambitious for her, and when Hilary was eleven the family moved from Derbyshire to Cheshire so that she could attend a good convent school. With the move, the father vanished; Hilary never saw him again. The family changed its name to Mantel, and Hilary was told to say that Jack was her father. At the convent, Mantel became "top girl"; after graduation she proceeded to law school. She married young, at twenty, whereupon her health broke down: she began having crippling pains in her legs and her gut. Her doctors, concluding that this was all in her head, treated her with psychotropic drugs, which, for a time, turned her into a raving maniac. She left school and took a job as a social worker. In 1977, her husband, Gerald McEwan, a geologist, accepted a post in Botswana; they lived there for five years. Then McEwan's work took them to Saudi Arabia, where they spent four years. In between, Mantel became sicker, figured out from medical books what her illness was (endometriosis), underwent a hysterectomy, divorced her husband, and married him again. As a result of hormone treatment, she seems to have more or less doubled in body weight. She says she is a size 20. "I'm like a comic-book version of myself," she told an interviewer.

All these matters—Botswana, Saudi Arabia; early love, love's failure; law, geology, social work; obesity or, as she sometimes portrays it, gigantism, freakishness—turn up in her novels. But, as is so often the case with writers, no part of her life is more central to her work than its earliest part: first, her family's secrets and lies; second, the visions. Sometimes she attributes the latter—including the Devil beyond the garden—to migraine aura, but elsewhere she offers no comforting medical explanation. "I am used

to 'seeing' things that aren't there," she says on the opening page of her memoir. "Or—to put it in a way more acceptable to me— I am used to seeing things that 'aren't there.' "

As a young woman, Mantel desperately wanted to make a mark in the world. That's why she went to law school. Her illness confined her to a sofa, and so she did the one thing she could think to do on a sofa: she started writing. (She says she probably would never have gone into literature otherwise.) She began research for a novel on the French Revolution, and when she moved to Botswana she took the note cards with her and wrote the book. A publisher expressed interest, but then sent the manuscript back. That happened at around the same time as her hysterectomy—which, removing any hope of children, wounded her deeply—and the collapse of her marriage. This, she says, was the most terrible moment in her life.

After her later successes, the novel on the French Revolution, *A Place of Greater Safety* (1992), was brought out. It is the fifth in the list of her published novels, but you can tell that it was written first. It is the most conservative of her books. Despite its setting, it is also less violent than many of her other narratives. Its subject is three men who operated at the center of the revolution, Danton, Robespierre, and Camille Desmoulins: their personalities, their motives, their friendship. The dialogue is tart and natural, the pacing masterly. Even though we know what's going to happen, our hearts are in our throats. (Will Robespierre actually send his friends to the guillotine?) And the message is sorrow. At one point, Desmoulins, installed as a secretary of the provisional government, is sitting in his ministerial office. From the walls, portraits of the eminent old men who occupied this office before him, and whose regime he and his friends have just destroyed, look down on him. "It is all one to us," they say. "We are dead." As a child, Mantel was crazy about Shakespeare, and *A Place of Greater Safety* breathes his doleful knowledge, particularly about coups d'état. It is a very "grown-up" book—wise, skeptical, long (749 pages)—of the kind that writers produce when they have not yet grown up and found their real story.

After finishing it, Mantel underwent the crisis of her late twenties (the surgery, the divorce), and then she discovered her

story. Her next novel—her first published novel, *Every Day Is Mother's Day* (1985)—is utterly different from *A Place of Greater Safety*. It is short, fast, and crazy. Here is the opening paragraph:

> When Mrs. Axon found out about her daughter's condition, she was more surprised than sorry; which did not mean that she was not very sorry indeed. Muriel, for her part, seemed pleased. She sat with her legs splayed and her arms around herself, as if reliving the experience. Her face wore an expression of daft beatitude.

Muriel, thirty-three years old, is pregnant—by whom, God knows. The deed may have been done by one of the many devils that inhabit the Axon house or—so thinks the mother, Evelyn—by Muriel's long-dead father, who was the neighborhood pedophile. Evelyn believes that Muriel is simpleminded; in fact, she seems to be a sort of feral child. When she was born, Evelyn decided that there was something wrong with her, and Muriel, for much of her life, has been kept in the house, lest anyone see her.

Soon Muriel's baby is born, and in Evelyn's opinion it (the sex is never specified) is quite peculiar, with large ears and wrinkled skin. It also cries all the time. "You never cried, Muriel," Evelyn says. It is a changeling, she declares, and what you do with a changeling is this: you place it in a body of water and let it sink, and then your real child, a proper child, comes floating back to you. So Evelyn puts the baby in a cardboard box and throws an old sweater over its face. She and Muriel go to the canal in the vacant lot near their house, and drop the box in. It sinks quickly:

> Inexplicably, Muriel leaned down and put a finger into the slime, as if she were testing bathwater. There was a kind of avidity in her face. . . . They waited on the bank for ten minutes. It was quite dark now. "It must be dead," Evelyn said at last. "They won't give you anything in exchange for a corpse. Well, I did the best I could for you, Muriel."

What is amazing about this scene is its dispassion. We may be sorry for that baby, but Mantel is not going to help us. There is

only one hint of poignance: Muriel's testing the temperature of the water. Elsewhere, too, in the book, there are notes of pathos. At one point, we are given Evelyn's history. Her family broke up when she was thirteen; she was deposited with an aunt and uncle who found her expensive to keep; her uncle married her off to a strange man in his office, Clifford Axon. The uncle suspected Axon of being a sexual deviant, "but it was too late to do anything about that." Years later, as Evelyn thinks about all this, she silently addresses her daughter. "Muriel," she says, "if I could have mourned myself . . . I might have pitied you." Such passages go through one like a sword, partly just because they are so rare.

MANTEL has experimented with her gift; her books jump from genre to genre. After *Mother's Day* and an even blacker sequel, *Vacant Possession* (1986), she wrote a political thriller about Saudi Arabia, *Eight Months on Ghazza Street* (1988), which announced, if her previous books had not, her grievance over the status of women. The next novel was *Fludd* (1989), a theological mystery story. Here the Devil appears in person—he is handsome, has money, and is terrific in bed. Later, there was a coming-of-age novel, *An Experiment in Love* (1995), and, on its heels, something wildly different, *The Giant, O'Brien* (1998), which, like *A Place of Greater Safety,* is set in the late eighteenth century, and concerns a freakishly tall Irishman who, starving at home (this was during the clearances), goes to London to make money by exhibiting himself as a curiosity. The book is biting in its politics and extravagant in its style. (The giant, a professional storyteller, often speaks in the language of Celtic romance.) In 2003, Mantel published her memoir, which, for all its useful information, I admire less than her other books, because it alone seems to complain. In her novels, Mantel is unflinching, and I like her that way.

In the middle of this series, she again wrote a rather traditional novel, *A Change of Climate* (1994), about an English couple, Ralph and Anna Eldred, who, while working in a mission in Botswana, become the victims of an appalling crime. Their infant son is kidnapped, to be sold, for body parts, to a spirit healer. On one level, *A Change of Climate* succeeds just as a thriller, but it is

also a profound psychological novel. Ralph, despite what his family has suffered, refuses to admit the existence of evil; Anna, partly because of her husband's blindness, cannot forgive the world its evil. This is more than psychology, however. The Eldreds are Low Church Protestants and missionaries, people whose purpose in life is to do good. But why try to do good when evil, so much the greater power, keeps rising up and washing away your little meliorist efforts? This question is implicit in all of Mantel's novels—as a nun says in *Fludd,* "God loves us. . . . He manifests it in cancer, cholera, and Siamese twins"—but it is never so soberly examined as in *A Change of Climate.*

It's there in *Beyond Black,* too. Alison is trying to help her clients. Meanwhile, day and night, devils speak filth in her ears. (Her dreams are such that in the morning her bed looks as though it has been struck by an earthquake.) There is also the matter of her childhood. Her mother was a prostitute and soon initiated Alison into the profession. Before that, Alison was often locked in the attic. She was lucky to be there. Downstairs, surrounding her mother, was a group of men (including Morris, alive at the time) carrying on some kind of horrible trade. There were sheds in the backyard, from which the men carried bloody parcels. The sheds were guarded by a pack of ferocious dogs accustomed to eating human flesh. Alison saw a severed head in a bathtub; she thought a disembodied eye was following her to school; her legs were slashed up, either by herself or by her mother's friends.

All of this, mercifully, is told only in flashes. We don't know what is real and what is imagined, because Alison doesn't know. But much of it, clearly, is real, and, as in *Mother's Day,* it is related matter-of-factly. Only now and then does grief surface. At a certain point, one of the guard dogs attacks Alison. Her mother's friend Keith pulls the animal off of her and carries her over to the kitchen sink, where he washes the wound. There is no mention of how Alison felt as the dog sank its teeth into her forehead, but when Keith finishes ministering to her "she felt a sudden sick cold at her back as he pulled away, as his body warmth left her." (He then goes across the room and beats up her mother.) That tells us how much body warmth she has experienced. Meanwhile, she is still going to school:

She must make it [home] before dark. Clay is encrusted on her feet, and beneath them the track is worn into deep ruts. Her garments, which appear to be made of sacking—which may, indeed, be sacks—are stiffening with the day's sweat, and chafing the knotty scars on her body. . . . She stops and drinks from the ditch, scooping up the water with her fingers. She squats there, until the moon rises.

Again, such stabs of pathos are very sharp, in consequence of their rarity. Nor is the suffering all due to devils and criminals. I have stressed the *dramatis diaboli,* but in most of Mantel's novels there is a regular English reality going on that might make you wish for Hell instead. In *Mother's Day* a normal, middle-class household has a Christmas dinner that will console anyone whose recent holidays have been a disappointment. In *Vacant Possession* this same household's cleaning lady trudges upstairs to find all four children's rooms locked. Behind each door, someone is "sniffing glue and crying." The father of the family compares his ménage to the House of Atreus.

Ugly families, though, are only a subspecialty. Mantel is a master of ugliness in general. It is the engine of her satire on a world awash in fake respectability, fake cheer—a world of "closure" and "cycles of caring," of death as a cozy new job. And Mantel's ugliness is not the kind you can rationalize. It is not a matter of taste, or even, in many cases, of thought. It's physiological. In no other writer's work do people vomit as frequently as in Mantel's. We see their bad skin, their frightening coiffures. Alison's assistant, Colette, has hair that lies across her skull "like strings of white licorice." Alison is hugely overweight (size 26), a fact that Colette harps on cruelly and wittily. Much of the food in Mantel's books is disgusting; at one point Evelyn Axon eats a can of baked beans—"cold tan slime"—with her hands. The furniture could give you nightmares: curtains that look like knitted porridge, chairs warm from someone else's bottom. Cups are chipped, hedges bird-spattered; handkerchiefs often have something adhering to them. People walking in the dark tend to step on something they can't identify. And then, this being England, there is the weather. Children are blue-kneed; people rub their chilblains.

Sunshine itself is sinister. In *A Change of Climate,* when the sun peeps from behind the clouds it sends out a ray "like an arm reaching into a tent."

In Mantel's characters' lives, no emotion is more prominent than spitefulness—the wish that, in compensation for one's own pain, another person might suffer—but in these novels the environment itself seems to begrudge anyone's happiness. That Muriel should get her baby back (albeit in an unexpected form), and that the Eldreds should remain together, is a miracle. No one has any joy, but then, as Ralph Eldred's sister says, joy is a word for Christmas carols: "Survival, that's all—survival should be the ambition." Blessings do come, occasionally, but the characters barely know what to do with them. Here is Anna Eldred, who lost her first son, reacting to the birth of her second:

> When Julian was first placed in her arms . . . she felt a certain flinching, a pull away from him; she hated to place any burden of expectation on this fragile scrap of being wrapped in a shawl. She saw the tight folds of his lashless eyes, his sea-sponge mouth, forming and re-forming, the stiff mottled fingers that thrust through the cobweb knitting of the shawl: she tried to pretend she had no other son, that she was seeing a son for the first time. Julian had fair curls and soft eyes; he lay in his father's arms and trusted him. He did not remind her unnecessarily of her sharp, small, dark child, his fragile skull still showing when she lost him, the pulses visible, beating beneath that fluttering baby skin.

This is bitter. At the same time, Mantel's writing is so exact and brilliant that, in itself, it seems an act of survival, even redemption.

Today Mantel lives with her husband in an apartment building in Surrey that was once an insane asylum. Interviewers have had a good time observing that for her this might be an appropriate habitation. She politely brushes their remarks aside and says that the place doesn't spook her. She has been a very prolific writer—eleven books in twenty years—and presumably she has a

long way to go. She is only fifty-three. Life will always seem to her, I think, a place where cruelty and madness are driving forces. But there is evidence for such a view. And morality remains: fundamentally, a Roman Catholic morality. *Basic Black,* for all its blackness, ends on a note of hope—provisional, one should add.

The New Yorker, 2005

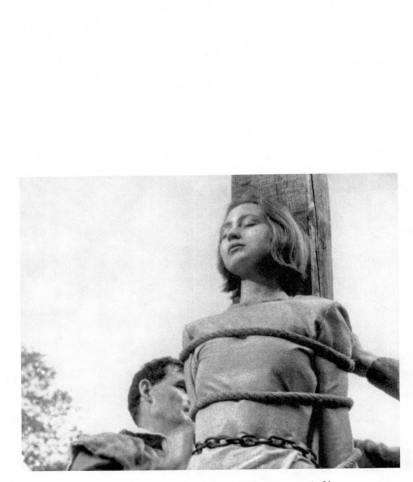

Florence Carrez at the stake in Robert Bresson's film
The Trial of Joan of Arc, *1962*

Burned Again

JOAN of Arc movies, understandably, have always been low on sex, but in the newest entry, *The Messenger: The Story of Joan of Arc,* by Luc Besson, the French action-movie director, that omission is redressed. Early in the film we have the following scene: Little Joan, maybe ten years old, comes out of church to find that her village is on fire. We are in the middle of the Hundred Years' War, and English soldiers are rampaging through Domrémy. Joan enters her house, and there she finds her older sister Catherine. (She has just told her confessor how much she loves this sister.) Catherine had been about to climb into a cupboard to hide from the English, but now she stuffs Joan in the cupboard instead, closes the door, and stands in front of it. In come three English goons. Two of them sit down to eat the family's dinner. The third— leering, filthy, appalling—approaches Catherine, lifts her, pins her against the cupboard (we get a shot of her feet dangling above the floor), and impales her on his sword, which, now wet with her blood, pierces the cupboard as well, barely missing Joan. He then loudly copulates with Catherine's dead body—bang, bang, bang, against the cupboard—as Joan, together with the camera, watches his contorted face through cracks in the cupboard door. The two other soldiers, distracted from their dinner, also watch. When the man finishes, he does up his fly and says to his mates, "Your turn." Thus begins the career of Besson's Joan of Arc. In past ages, Joan has been seen as a mystic, a saint, a national hero. Now, in keeping with the times, she is a victim of post-traumatic stress disorder.

JOAN, as she testified at her trial, was thirteen when she was first visited by voices from Heaven. It was summertime, around noon,

in her father's garden. At first, it seems, the voices just told her to be a good girl and go to church, but eventually their instructions became more pointed. The Hundred Years' War was a dynastic conflict over whether the Plantagenets (English) or the Valois (French) were the rightful rulers of France. The English invaded France, and by the 1420s they had divided the country in half. Most of the lands below the Loire were held by the Valois, under Charles, the uncrowned, uncertain, unwarlike Dauphin. The lands above the Loire were controlled by the English, in alliance with the Burgundian dynasty. Joan's village was in the north, in Anglo-Burgundian territory. There is no evidence that Joan had an older sister Catherine, let alone that she witnessed the murder of such a sister, but she certainly saw her village suffer, as all of France suffered. (In the war's hundred years, the country's population was halved.) In 1428, the English laid siege to Orléans, on the border between north and south. If they took that city, they could cross the Loire and invade the rest of France. That was the situation which Joan's voices eventually addressed. They instructed this illiterate peasant girl, who had never been more than a few miles from her village, to go to Orléans, raise the siege, and then take the Dauphin to Rheims to be crowned King Charles VII of France. In other words, they told her to end the Hundred Years' War.

She did so. Or, by inspiriting the French soldiers at Orléans, she provided the turning point in the war. How Joan managed to get to Charles, and persuade him to arm her, and then convince the Valois captains that she should join the charge at Orléans is still something of a mystery, but at that point the French forces were so beaten down that they were almost willing to believe that a virgin had been sent by God to deliver them. And once Orléans was saved, under her banner, many of the French came to see her as an angel, an actual heavenly messenger. Meanwhile, the Anglo-Burgundians regarded her as a witch. (See Shakespeare's *Henry VI, Part 1*, where she *is* a witch.) She was a subject of international debate, but not for long. Seventeen when she set out for Orléans, she was eighteen when the Burgundians finally captured her and sold her to the English for ten thousand pounds. The Church then put her through a four-month heresy trial—basically a fake trial. (Her chief examiners were firmly in league with the English,

who demanded her death.) She was nineteen when she was taken out, barefoot, to the marketplace in Rouen and burned alive.

All that happened in the fifteenth century, and it gave Joan a privileged place in the high and low culture of Europe ever after. For years following her death, people claimed that she was still alive, that someone else had been burned in her place. (There were Joan sightings, like Elvis sightings. There were also Joan impersonators.) Paintings, plays, epic poems were devoted to her. But it was not until the nineteenth century that she really came into her own. As George Bernard Shaw pointed out in the preface to his play *Saint Joan,* she was born before her time. She was, he said, one of the first Protestant martyrs: it was her claim that she had a direct, unmediated connection with God—and that she, not the Church, would judge the truth of her voices—that got her condemned as a heretic. Furthermore, in her insistence that race and national boundaries overrode dynastic inheritance, she was one of Europe's first nationalists. By medieval standards, the English monarchy's claim to France was arguably quite legitimate.

But it wasn't just nationalist sentiment that endeared Joan to the nineteenth century. Her story had everything that century liked. First, medievalism, and medieval spirituality: the voice of God, arriving to a child in her father's potato fields. Second, primitivism: the fact that she was a child, and a peasant, and so, by nineteenth-century lights, morally superior to the educated, the mature, the ordained. Third, sentimentality: if, as Poe said, there was nothing more poetical than the death of a beautiful woman, then, as Dickens and Harriet Beecher Stowe proved, the death of a beautiful girl was even better.

Joan was thus made by God for nineteenth-century artists, and they heard the call. Verdi and Tchaikovsky devoted operas to her; Gounod a music drama, in which Sarah Bernhardt later starred. The century also saw more than eighty new plays about Joan, the most influential being Schiller's 1801 *Maid of Orleans,* fired with the revolutionary zeal of the period and, in the give-them-everything-they-want spirit of early Romanticism, adding a star-crossed love between Joan and an English soldier. There were novels, too—both Dumas *père* and Dumas *fils* had a go at the story—and essays and books by De Quincey, Lamartine, Jules

Michelet, Anatole France. In his monumental *History of France,* Michelet wrote, "Let us remember always, O Frenchmen, that our Fatherland was born in the heart of a woman, from her tenderness and her tears, from her blood which she shed for us." She was the mother of her country, the George Washington of France.

THE man who burned Joan's image into the modern mind, however, was not one of those famous writers but a scholar named Jules Quicherat. The proceedings of Joan's heresy trial, so sensitive politically, had been carefully recorded by court notaries. Likewise the proceedings of the so-called nullification trial, by which, after the testimony of more than a hundred witnesses, the Church revoked the verdict against her twenty-five years after her death. By the nineteenth century, most of these documents were sitting in the Bibliothèque Nationale. Quicherat called them up from the stacks, edited them, and published them in five volumes (1841–49), whereupon a great change came over the Joan legend. Before, she had been a heroine, an icon. Now she became a nineteen-year-old girl. The trial testimony tells us a huge amount about her: her childhood games, her love of fine clothes, how impressed she was by Charles's court. (There were more than fifty torches in the room, she reported.) As a result of Quicherat's work, we know more about this French farm girl than about any human being before her time, including—as we find out in Régine Pernoud and Marie Véronique Clin's book *Joan of Arc*— Plato, Caesar, and Christ. The transcripts also show her to have been an immensely appealing person. Sometimes, in reading the history books, one wonders how Joan got soldiers to follow her. She was, after all, a peasant, not to mention a girl. Furthermore, she did not allow her men to swear, to gamble, or to have women. Worse, she forbade pillage, which for many of her soldiers was the chief source of pay. But when you read the trial testimony you understand why these men wanted her as their captain. You would have, too, she was so wonderful—fiery, frank, and blithe. Here is an excerpt from a letter she sent to the English king as she prepared to take off for Orléans:

I am the commander of the armies, and in whatever place I shall meet your French allies, I shall make them leave it, whether they wish to or not; and if they will not obey, I shall have them all killed. I am sent from God, the King of Heaven, to chase you all out of France.

She was the same way at the trial. Again and again, her judges tried to trip her up, lead her into heretical statements. Again and again, she answered them boldly, commonsensically, even wittily. As the transcripts prove, she did not embrace sainthood. Unlike Francis of Assisi, for example, she never engaged in soul-struck behavior—never ran naked or threw herself on thornbushes. When the old Duke Charles II, fallen ill, summoned her and asked whether he would recover, she told him she had no idea and then gave him a lecture on his personal conduct. (He had fathered five bastards.) Nor did she have any interest in becoming a martyr. The most poignant thing about the trial transcripts is how hard she tried to save herself—how, facing, with no help (she had no lawyer), thirty-odd theologians and legal scholars maybe twice her age, she fought, reasoned, and bargained—and how afraid she was of dying. At one point she tells the judges that her heavenly guides have promised to save her, but that she doesn't know whether they intend to do this on earth or in the afterlife—a distinction that is important to her:

> St. Catherine told me that I would have help; and I do not know if this will be deliverance from prison or deliverance when I face judgment. . . . My voices say, "Take everything serenely, do not shrink from your martyrdom; from that you will come finally to the kingdom of paradise." And my voices say that simply and absolutely, without fail. I call this a martyrdom because of the pain and hardship that I suffer in my imprisonment. I do not know if I will have to suffer worse.

She is thinking that maybe, by "martyrdom," the voices just mean imprisonment. This is the most painful moment in the trial.

Another thing that the transcripts revealed was that, like Galileo, Joan recanted. Worn down by the long trial, she finally signed a statement abjuring her mission from God and agreeing to change into women's clothes. (She had worn short hair and men's clothing throughout her military career.) Then, four days later, she withdrew her recantation. There are many competing explanations for her change of mind. I favor the one put forth by the Joan scholar Marina Warner: "She found she could not bear the nonsense that such a denial made of her past." Still, she does not seem to have fully understood what was in store. When, two days after her "relapse," they came to prepare her for burning, she wept and tore her hair. She died terrified, screaming to Jesus to help her.

For four centuries Joan was treated as a saint, but she was not a saint. After Quicherat, the movement for canonization began. In 1909, she was beatified; in 1920, she was canonized. And before and after, spurred by the transcripts, the canonization hearings, and wartime nationalism, there was an explosion of Joan art. Mark Twain wrote a book about her; Charles Péguy, a series of passionate Christian Socialist poems. Arthur Honegger composed an oratorio, *Joan of Arc at the Stake,* with a text by Paul Claudel. More new plays came out—seventeen in 1909, the year of her beatification, then twenty-nine more in the years between the two world wars—including, if we add post–Second World War offerings, dramas by Maeterlinck, Anouilh, and Maxwell Anderson, together with Shaw's famous play. Martha Graham made a Joan ballet. On Broadway in the forties and fifties, according to an old Manhattanite friend of mine, "You couldn't get Joan of Arc to shut up."

But in our century Joan's primary medium has been film. By the end of the First World War she had already been the subject of six movies, the most important of which was Cecil B. De Mille's *Joan the Woman,* the first entry in what would be that director's long catalogue of bloated, Bible-quoting spectaculars. Geraldine Farrar, the opera star, neither young nor thin, who plays Joan,

flings her arms up to Heaven a very great deal. But the action scenes, in which De Mille is clearly trying to steal the palm from D. W. Griffith's *Birth of a Nation,* were revolutionary for their time. The movie fairly pullulates with people running around in Pied Piper outfits. For the battle at Orléans, De Mille used four-teen hundred men, and he worked them hard, as he did Farrar. According to Agnes de Mille, Cecil's niece, Farrar spent "whole days in a fosse up to her waist in muddy water, a cowboy guard around her dressed in bobbed wigs and fourteenth-century hats, fending off broken spears, falling beams and masses of struggling extras." For the closeups at the stake, they doused Farrar in flame-retardant fluid, stuffed cotton up her nose, surrounded her with oil-filled tanks, and lit them.

The De Mille movie was a milestone in the history of cine-matic grandiosity yoked to cinematic realism. It was also a signifi-cant episode in the history of the political uses of Joan. In the film her tale is enclosed in a frame-narrative featuring an English sol-dier who, stalled in the trenches of France during the First World War, is inspired by Joan's sacrifice to go on a suicide mission, thus saving the day for his regiment. Released in 1916, *Joan the Woman* was an unequivocal call for the United States to join the fighting in Europe.

In the years that followed, with *entre deux guerres* nationalism, the rise of Fascism, then the Second World War and the Cold War, Joan did further political duty onscreen. One movie that is almost never shown is a 1928 silent, *La Merveilleuse Vie de Jeanne d'Arc,* by Marco de Gastyne, a Parisian filmmaker of the twenties and thirties. The text is almost hysterically nationalist. The pho-tography, too, glorifies the *patrie.* The battle scenes were shot out-side the walls of Carcassonne; the coronation scene, at Rheims; the trial, at Mont-Saint-Michel. And though Gastyne gives us angels flying in the sky—he likes God as much as France—his focus is on Joan the soldier, with peasants rising up across the land to follow her into battle. The film is clumsily made, but it has a rare poetry. When Joan, side-lit at her parents' hearth, sits listen-ing to neighbors harried by the war, and a little cat that she is holding crawls out of her arms and runs away, we see, with per-

fect, breathing concreteness, her childhood—actually, her life—slipping away from her. Much of the beauty of the film is owing to its Joan, an unknown, big-nosed seventeen-year-old named Simone Genevois. In the scene where they prepare her for her death she is simply amazing, wiping the sweat and tears off her face.

The medieval scholar Kevin Harty believes that Victor Fleming's 1948 *Joan of Arc* was another political manifesto. In a crucial scene in that movie, Charles pusillanimously declines to take advantage of the victory at Orléans and go after the rest of France. Likewise, as many Americans felt at the time, the United States was foolishly refusing to capitalize on its Second World War victory and go after the Soviet Union. Whatever the specific politics of the film, it has all the smug righteousness of the Cold War period, and nothing in it is smugger than its Joan, Ingrid Bergman. The role was an obvious choice for Bergman. After *Casablanca, Gaslight,* and *The Bells of St. Mary's* (in which she played a nun), she was already a saint to much of the American public. Furthermore, she had starred in the Maxwell Anderson play. As a child, she had idolized Joan—together with Jo March, another hair-cropper, Joan has long been an inspiration to serious-minded girls—and she seems to have felt she didn't actually have to portray this alter ego of hers: she could simply *be* her. "It wasn't like acting at all," she said. And indeed it isn't like acting; she just stalks around in her monobosom armor, looking holy. The film was savaged by the reviewers, and its main effect was to set Bergman up for her fall when, the year after its premiere, she left her husband and daughter for Roberto Rossellini and, the year after that, bore him an illegitimate child. Posited as a saint, she now seemed all the more a sinner. She was denounced on the floor of the United States Senate.

THOSE are the "epic" Joan movies, but already by 1923 Shaw, in his *Saint Joan,* had inaugurated another tradition of Joan-staging—the political analysis, the discussion of issues. Before Shaw, Joan's judges were often portrayed as a pack of cruel, cyni-

cal functionaries. Shaw made them honest men. To quote his preface: "If Joan had not been burnt by normally innocent people in the energy of their righteousness her death at their hands would have had no more significance than the Tokyo earthquake, which burnt a great many maidens." In his eyes, Joan's story was a conflict not between good and evil but between good and good—individual good versus public good, as in *Antigone*. It was not an exemplary tale, from which one could learn how to be virtuous, but a tragedy, from which one could learn only what it meant to be human.

After Shaw's death, Otto Preminger secured the rights to the play, and the resulting movie was one of the oddest things ever to come out of Hollywood. To start with, it was two movies: an English one, with people like John Gielgud playing the politicians—Europeans knew what necessity was—and an American movie, with Americans, who presumably knew what personality was, supplying the stars. The second oddity was the stars. For Charles, Preminger chose Richard Widmark, who portrayed the Dauphin as a species of neurological patient (he twitches, he limps) and also, if I'm not mistaken, as the fifties' notion of a homosexual (he sniggers, he pouts). The casting of Joan was made into a contest. Eighteen thousand applications were received, including one from the teenage Barbra Streisand. Preminger chose a seventeen-year-old unknown, Jean Seberg, from Marshalltown, Iowa, to whom—in the effort, he said, to keep her unspoiled—he gave no training and little direction. Seberg played it pert and baby-talking. You turn your eyes away.

Preminger's *Saint Joan* was preceded by one of the most aggressive publicity campaigns in Hollywood history. Once Seberg had been chosen, the press was invited to her every act of preparation—the fitting of her armor, the cutting of her hair—and to the shooting. Article after article came out, drumming up excitement, and then, when the movie was released, in 1957, the critics walked in and trashed it, singling out Seberg's performance for special contempt. Soon afterward, Preminger sold her contract to Columbia. This early history does not go unmentioned in accounts of how, in 1979, at age forty, Seberg was found wrapped

in a blanket and nothing else, "dead for several days" (the *Times* obituary) from a barbiturate overdose, in the back of her Renault on a street in Paris.

OBVIOUSLY, the major job for the Joan chroniclers, on stage or film, was to decide what the story was, what was important about it. Shaw had made a bold choice: Joan's life was about the great world, about politics. Five years later, the Danish film director Carl Dreyer, in his *Passion of Joan of Arc*, made the opposite choice: Joan's life was about the inner world, about suffering. For his star he hired Renée Falconetti, a former member of the Comédie Française. A stage actress—*Joan* was the only film she ever made—she could presumably suffer big. To aid in that process, he telescoped the action into one day, from trial to burning. Most of the film is just the trial, a back-and-forth between the examiners, asking their questions—we see them in close-up: their nasty smiles, their sweaty bangs—and Joan, also in tight close-up, giving her replies. Typically, Falconetti pauses for a long time before answering, and weeps, and rolls her eyes to Heaven. There are a number of distasteful accounts of how Dreyer managed to extract from Falconetti this tortured performance. Jean Hugo, who served as one of the film's art directors, reported that every morning, when Falconetti arrived on the set, Dreyer managed to bawl her out for something or other. Once he had reduced her to tears, he would turn on the cameras.

The film scholar Robin Blaetz retells this story in support of her claim that the history of Joan movies is largely a chronicle of misogyny: "Joan of Arc's chief attraction may lie in the chance to pornographically depict the death of this potent female with chains, ropes, and lascivious camera work." Dreyer's film is regarded as one of the world's great movies—"Falconetti's Joan may be the finest performance ever recorded on film," Pauline Kael has written—but I think Blaetz has a point. The handling of Falconetti is finally oppressive; you feel beaten up by it. (I should add that a fresh print was recently discovered—appropriately, in the broom closet of a Norwegian mental hospital. Dreyer's original negative was destroyed by fire, so he assembled a second ver-

sion of the movie from outtakes. The second negative was lost in another fire. Reportedly, what we've been watching all these years are damaged copies of that second version, full of fuzz and specks and blur that I, for one, took to be part of the movie's pain. The original, now on video, from Home Vision, is clean as a whistle.)

I'm not the only one who sagged under the weight of Dreyer's Joan. So did Robert Bresson, whose 1962 *Trial of Joan of Arc* is a sort of anti-Dreyer. Bresson follows roughly the same curtailed script—just the trial and the burning—but whereas Dreyer's Joan, before replying to her judges' questions, paused so lengthily for those Murillo-martyr close-ups, Bresson's Joan, Florence Carrez, barely takes a breath before answering. Then she lowers her eyes, lest we dirty her with our pity. The trial is not a drama. It is a kind of catechism, something recited rather than enacted. Tellingly, the most poignant shot in the movie is not of Carrez's face but of her little feet, rushing awkwardly, as if she were being prodded from behind, along a muddy path from the prison to the pyre. Overhead, a flock of pigeons takes off into a fathomless sky. Bresson is often described as a Jansenist; this film supports that view. In a way, it is the holiest of all Joan movies—dry, fast (sixty-five minutes), and humbling.

Both Dreyer and Bresson may have been responding to the role that Joan has occupied in French politics. Socialists have claimed her; Communists, too. But for more than a hundred years, ever since France's humiliating defeat in the Franco-Prussian War, it has been the right, above all, that has pinned her to its banner. Sprung from the soil, scourge of foreign invaders, Joan became a figurehead for that late-nineteenth-century *Volk*-worship which led directly to fascism: the Vichy government put her on their posters. Today she is doing similar duty for the National Front's campaign against immigrant workers. Jean-Marie Le Pen, founder of the National Front, calls her his "little sister."

Some of that history may be lurking behind Dreyer's and Bresson's discarding of Joan's military career—a radical step, for she was a soldier above all—and dealing only with her last days. However else the two films differ, both refuse to give us the right's Joan Triumphans; they give us Joan the girl, in big trouble. And I think

that in this sense they served as sources for Jacques Rivette's 1994 *Joan the Maid*. Probably because of its length—four hours, in the shortest version—Rivette's film has had very limited distribution in the United States, but Facets has just brought it out on videotape. Go get it. It's the best Joan movie ever made. Rivette restores the "epic"—the battles are back—while at the same time keeping a tight focus on the girl. His Joan is Sandrine Bonnaire, who brings to the movie all the self-containment, not to speak of the cheekbones, that she showed in Agnès Varda's *Vagabond*. She is young, human—she cries when she's wounded—but there is a kind of magic circle drawn around her. In my favorite scene, she asks her confessor to teach her to write her name. She has letters to send; she wants to sign them properly. We see the two figures framed in light at a window: the big, sweet, football-player-resembling monk and the skinny little girl. She has all her dignity—she does not apologize for being illiterate. Still, we feel her exposure, her weakness. (She is a peasant; they will burn her.) Slowly the monk guides her hand. Laboriously she forms the letters: JEHANNE. Rivette's movie is realistic, without Dreyer's cry party; it is abstemious, without Bresson's recoil. Accordingly, it does better than any of its predecessors in portraying Joan's tragic period, which began long before her trial. After the coronation, Charles basically abandoned her (he had got what he wanted), and she was forced to go freelance. In the movie we see her, with maybe forty men, before the sky-high walls of Paris. "Give the city to the King of France!" she yells to the Anglo-Burgundians on the battlements. "Fry in hell!" they yell back. A few minutes later in the film, she is captured.

Now, five years after Rivette, we have the Besson movie. Could it, too, have been a reaction to the right's idea of Joan? Maybe so. By giving her the revenge motive (sister Catherine's murder), Besson strips her of her holy mission. At the end of the movie, after a bit of recovered-memory therapy with what seems to be her inner psychiatrist—an actual character, indeed Dustin Hoffman, who appears and disappears like Tinkerbell, saying things like "So the memory's returning?"—she admits that she fought for vengeance, and that God didn't necessarily call her. The film also weeps a lot over the horrors of war, as the right is not wont to

do. On the other hand, Besson dishes out those horrors with a rare enthusiasm. We get a severed hand, a severed foot, a decapitation. A dog dines at length on a dead man's belly. And, to make it more vivid, all this has a curiously sexual tinge. When blood flows down Joan's face at Orléans, it doesn't look like blood. It's pink and thick and shiny, as is the Communion wine that, soon after Catherine's murder, Joan pours down her face, meanwhile crying to Jesus, "I want to be one with you *now!*" What Besson seems to be saying is that, as a result of Catherine's misadventure, sex got linked with violence in Joan's mind. But maybe I'm giving him too much credit. Maybe those two things are just linked in his mind, as in the minds of most action-movie directors. His work has an extra twist, though—something about *women* blowing people away, and having nervous breakdowns in the process, because they don't actually want to do these bad things. (See his *La Femme Nikita.*) Joan was just adapted to the scenario. The actress-model Milla Jovovich, Besson's ex-wife, plays Joan with bug-eyed frenzy. "She's nuts," one of her comrades-at-arms says. Amen.

None of this, however, will do Joan's reputation any harm. Her cult is big enough to absorb it. There is now a whole discipline of "Johannic studies," together with a subdiscipline of "Johannic-reception studies"—the history of representations of her. The postmodern folk are on her trail: the women's-studies people, the queer-studies people, the deconstructionists. (In a recent essay Steven Weiskopf, of Indiana University, finds that Joan fits a "paradigm of abyssal indeterminacy.") Meanwhile, the devout have not deserted the field. Throughout the Christian world, Joan is venerated in churches and schools—on the Internet, too. Virginia Frohlick, founder of the Saint Joan of Arc Center, in Albuquerque, has a Web site where she tells us about her relationship with Joan, her "very best friend." On another Web site, you can see a picture of Joan's banner, hear the hymn sung by the priests in her army, and, should you be one of those who think that Joan was a transvestite, a lesbian, a feminist, a Protestant, or a Wiccan, get a talking-to from the St. Joan of Arc Anti-Defamation League. There's a Clash of Arms "war game" devoted to Joan; there's a rock group named after her. Three more movies are reportedly in the

works. Madonna and Sinead O'Connor have both said they'd like to play the Maid. We haven't yet seen the end of the Johannic reception or, I'll bet, the worst of it, but somehow Joan always slips through the net, small and fleet, brave and glad.

The New Yorker, 1999

Acknowledgments

I thank the editor of this collection, Victoria Wilson, and her energetic assistants, Zachary Wagman and Petrina Crockford. I also thank the people who originally edited the essays: Barbara Epstein, Henry Finder, Edwin Frank, Deborah Garrison, Alice Quinn, Dorothy Wickenden, and above all Virginia Cannon. Finally, I am extremely grateful to Robert Cornfield, who prodded me to do this book and helped me all along the way.

TEXTUAL PERMISSIONS

Grateful acknowledgment is made to the following for permission to reprint previously published material:

Louise Bourgeois Studio: Excerpt from "Ode to My Mother" by Louise Bourgeois. All works and words of Louise Bourgeois are © Louise Bourgeois. Reprinted by permission of Louise Bourgeois Studio.

Counterpoint: Excerpt from *Visit to Don Otavio* by Sybille Bedford. Copyright © 1953, 1960 by Sybille Bedford. Reprinted by permission of Counterpoint, a member of Perseus Books, LLC.

Farrar, Straus and Giroux, LLC: Excerpts from *Lucia Joyce: To Dance in the Wake* by Carol Loeb Shloss. Copyright © 2003 by Carol Loeb Shloss. Reprinted by permission of Farrar, Straus and Giroux, LLC.

Farrar, Straus and Giroux, LLC, and Éditions Gallimard: Excerpts from *Memoirs of Hadrian* by Marguerite Yourcenar, translated by Grace Frick. Copyright © 1954, renewed 1982 by Marguerite Yourcenar. Published in France as *Mémoires d'Hadrien* by Éditions Gallimard. Copyright © by Éditions Gallimard, Paris. Reprinted by permission of Farrar, Straus and Giroux, LLC and Éditions Gallimard.

Harcourt, Inc., and Faber and Faber Ltd.: Excerpt from "East Coker" from *Four Quartets* by T. S. Eliot. Copyright © 1940 by T. S. Eliot and renewed 1968 by Esme Valerie Eliot. Rights outside the United States from *Collected Poems 1909-1962* by T. S. Eliot controlled by Faber and Faber Ltd., London. Reprinted by permission of Harcourt, Inc., and Faber and Faber Ltd.

Houghton Mifflin Company and The Wylie Agency, Inc.: Excerpt from *The Plot Against America* by Philip Roth. Copyright © 2004 by Philip Roth. All rights reserved. Reprinted by permission of Houghton Mifflin Company and The Wylie Agency, Inc.

Textual Permissions

Indiana University Press: Excerpts from *Gesture in Naples and Gesture in Classical Antiquity* by Andrea de Jorio, translated by Adam Kendon. Reprinted by permission of Indiana University Press.

Alfred A. Knopf: Excerpts from "Autobiographia Literaria," "The Critic," "I walk in, sit down . . . ," "I went to my first movie . . . ," "John Button Birthday," "Personism: A Manifesto," "Poem (I ran through the snow like a young Czarevitch," "A Step Away from Them," "Steps," "A True Account of Talking to the Sun at Fire Island," and "You know how I feel about painters . . ." from *Collected Poems* by Frank O'Hara. Copyright © 1971 by Maureen Granville-Smith, Administratrix of the Estate of Frank O'Hara. Reprinted by permission of Alfred A. Knopf, a division of Random House, Inc.

The New Press and Victor Gollancz, Ltd.: Excerpt from *A Transatlantic Love Affair: Letters to Nelson Algren* by Simone de Beauvoir. Notes and English translations by Silvie Le Bon de Beauvoir, Sara Holloway, Vanessa Kling, Kate LeBlanc, and Ellen Gordon Reeves. Copyright © 1997 by Silvie Le Bon de Beauvoir. Rights in the open market controlled by Victor Gollancz, Ltd. Reprinted by permission of The New Press, www.thenewpress.com, and Victor Gollancz, Ltd., a division of The Orion Publishing Group Ltd.

The Overlook Press: Excerpt from *The Radetzky March* by Joseph Roth, translated by Joachim Neugroschel. Copyright © 1932 by Gustav Kiepenheuer Verlag, Berlin. Translation copyright © 1995 by Joachim Neugroschel. Reprinted by permission of The Overlook Press.

Viking Penguin: "News Item," excerpts from "One Perfect Rose," and "Resume," and various prose excerpts from *The Portable Dorothy Parker,* edited by Brendan Gill. Copyright © 1926, 1928, renewed 1954 and 1956 by Dorothy Parker. Reprinted by permission of Viking Penguin, a division of Penguin Group (USA) Inc.

Williams Verlag AG: Excerpt from *Beware of Pity* by Stefan Zweig, translated by Phyllis and Trevor Blewitt. Copyright © 1976 by Williams Verlag, Zürich, and Atrium Press, London. Reprinted by permission of Williams Verlag AG.

Yale University Press: Excerpt from *Following Balanchine* by Robert Garis. Reprinted courtesy of Yale University Press.

Index

Page numbers in *italics* refer to illustrations.

Index

Index

Index

Index

Index

Index

Index

Index

Index

Index

Index

Index